MADRID 1937

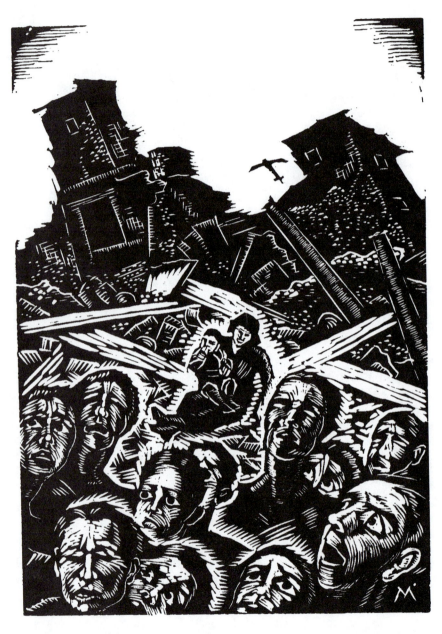

Maria M. Schroetter, "Fruits of Fascism," from *For Spain and Liberty,* a collection of twenty-one artists' responses to the war published by the Chicago chapter of the American Artists' Congress in June of 1937.

MADRID 1937

Letters of the Abraham Lincoln Brigade
From the Spanish Civil War

Edited by Cary Nelson &
Jefferson Hendricks

Introductions by
Cary Nelson

ROUTLEDGE
New York London

Published in 1996 by

Routledge
29 West 35 Street
New York, NY 10001

Published in Great Britian in 1996 by

Routledge
11 New Fetter Lane
London EC4P 4EE

Library of Congress Cataloging-in-Publication Data

CONTENTS

ACKNOWLEDGMENTS

This project has been under way for more than six years and we have had help from a considerable number of people. Our first thanks must go to the Lincoln veterans and their family members who trusted us with their letters and their memories. The veterans in the New York office—particularly Moe Fishman and Len Levenson—have lent their boundless energy and long experience to our efforts for years. At no time, however, did they demand to see the manuscript we were working on or place any restrictions on the material we used. Several other Lincoln vets gave critical assistance at key moments, including Steve Nelson, Bob Reed, Abe Smorodin, Bill Susman, and Milt Wolff. Several, including Harry Fisher, Moe Fishman, Len Levenson, and Mary Rolfe, talked with us repeatedly about the 1930s and generously supplied us with archival materials about the Spanish Civil War. Mary Rolfe, Bill Sennett, and Sam Walters sent us thick packets of photographs and answered numerous queries about them. Other photographs came from David Friedman, Herb Freeman, Len Levenson, Mary Rolfe, and Lee Rosetti.

We give special thanks to those who sent us letters and/or gave permission to publish them: Al Amery, Mary Baranger, Vita Barsky, Leona Beal, Hon Brown, Julie Carran, Lilian Chodorow, Dan Czitrom, Milt Felsen, Moe Fishman, Harry Fisher, Herb Freeman, Miriam Friedlander, David Friedman, Carl Geiser, Lottie Gordon, Toby Jensky, Clarence Kailin, Sidney Kaufman, Freddy Keller, Len Levenson, Christine MacLeod, Virginia Malbin, Carl Marzani, Ben Minor, Luba Nusser, Mary Rolfe, Lee Rosetti, Adolph Ross, Hank Rubin, Ely Sack, Bill Sennett, John L. Simon, Jeanette Smith, Jenness Summers, Mildred Thayer, May Tisa, Sam Walters, Ted Veltfort, Jeffrey R. Wachtel, Marge Watt, Milton Wolff.

The following list gives the present location of the letters we have used in the book:

ALBA (Abraham Lincoln Brigade Archives), Brandeis University: Alex (Chapter 11), Joe Dallet, Canute Frankson, Harry Fisher, Carl Geiser, Toby Jensky, Hyman Katz, James Lardner, Fredericka Martin, Harry Meloff, Dewitt Parker, Ely Sack, Paul Sigel, Harold Smith, Paul Wendorf.

Adelphi University: Sandor Voros. Voros's letters are published here with the permission of Erica Doctorow, Director of the Special Collections Library at Adelphi.

Ernest Hemingway Archives, Kennedy Library (Boston): Evan Shipman.

University of California at Berkeley: Clifton Amsbury, Cecil Cole, George Foucek, Ben Gardner, Donald MacLeod, William Sennett, Eugene Wolman.

Columbia University: Edward Barsky, Ave Bruzzichesi, Leo Eloesser, Rose Freed, Lini Fuhr, Martin Hourihan, Fred Keller, Mildred Rackley, Ann Taft.

Stanford University, Lane Medical Library: Leo Eloesser. Eloesser's

letters are published here with the permission of the Archives and Special Collections Division.

University of Illinois at Urbana-Champaign: Fred Lutz, John Tisa, Edwin Rolfe, John L. Simon, Milton Wolff.

University of Washington (Seattle): Thane Summers.

Privately held: Al Amery, Archie Brown, John Cookson, Moe Fishman, Jack Freeman, Jack Friedman, Dave Gordon, Sidney Kaufman, Leonard Levenson, Carl Marzani, Robert Merriman, Leon Rosenthal, Lawrence Kleidman, Lee Royce, Theodore Veltfort, George Watt.

The following are the sources of previously published letters—"Clyde" (Chapter 10) in *Letters From the Trenches: From Our Boys in Spain* (New York: Workers Alliance of America, c. 1937), pp. 15–16; John Cookson: Clarence Kailin, ed. *Remembering John Cookson: A Wisconsin Anti-Fascist in the Spanish Civil War* (Privately published, 1992); Joe Dallet: *Letters from Spain: By Joe Dallet, American Volunteer, to His Wife* (New York: Workers Library Publishers, 1938); Joe and Leo Gordon: Dan Czitrom, ed., "Volunteers for Liberty," *The Massachusetts Review* 25, No. 3 (1984), 347–365; Herbert Hutner: "My Dear Mr. and Mrs. Wolman," *Among Friends* 1, No. 2 (1938), 11, 23; Hank Rubin: "Dear U.C.L.A.," *The California Daily Bruin*, October 15, 1937, p. 3 and April 6, 1938, p. 3; Wilfred Mendelson: Joseph Leeds, ed. *Let My People Know: The Story of Wilfred Mendelson* (Privately published: 1942). *Letters from the Trenches* is a thirty-three page mimeographed pamphlet. *Remembering John Cookson* was only issued in a limited edition of thirty copies.

Except as noted in the captions, illustrations come from Cary Nelson's collection. The only exceptions are the notice of the memorial service for Harry Meloff, which we preferred to print without a caption, and which comes from Brandeis, and the portraits of Toby Jensky and Ave Bruzzichesi, which come from the archives of the American Medical Bureau to Aid Spanish Democracy at Columbia University. The two illustrations labeled "Moscow" come from the International Brigades Archive at the Russian Center for the Preservation and Study of Documents of Recent History.

Archivists at a number of schools were repeatedly helpful. These include Victor Berch and Charles Cutter at Brandeis. Berch's encyclopedic knowledge about the war is a resource for anyone working in the area. Nancy Romero, Gene Rinkel, and the staff of the Rare Books and Special Collections Department at the University of Illinois provided long-term assistance. Karyl Winn at the University of Washington microfilmed letters at short notice. Lottie Gordon and the staff at the Marxist Reference Center located rare Spanish Civil War items we could not find elsewhere.

The considerable task of typing and proofreading this book could not have been accomplished without Patty Roberts and Anne-Marie Bruner at Centenary and Matthew Hurt and Robert McCruer at Illinois. Daniel Bloomfield at Illinois helped us decipher medical terminology in holograph. Andrew Lee of the Tamiment Library provided a careful and thorough critique of the glossary.

Our home institutions provided regular support for our research. Richard

Wheeler, the English Department, the College of Liberal Arts and Sciences, and the Research Board at the University of Illinois at Urbana-Champaign helped with travel and photographic expenses. The University of Illinois Library, Library Friends, and the Chancellor's and President's Offices helped with the substantial cost involved in obtaining and preserving archival material. The English Department at Centenary College, and especially Lee Morgan, the current Chair, and Earle Labor, the former Chair, provided continued advice and encouragement; Ed and Dell Harbuck gave generous support through the Harbuck English Fund at Centenary College, which provides much-needed travel monies; and Dean Robert Bareikis and the Faculty Development Committee of Centenary College offered continuing support through the Lyons Travel and Research Funds, and the Humanities Research Chair for 1993–1995, which provided funding for the extensive travel, photocopying, and typing which a project such as this requires.

A series of distinguished Americans offered eloquent statements in support of the project: Harry Belafonte, Ruby Dee and Ossie Davis, Ronald V. Dellums, Howard Fast, Stephen Jay Gould, Ring Lardner, Jr., John Sayles, Pete Seeger, and Howard Zinn. Their comments appear on the book's jacket.

Publication of a book of this length and quality would not have been possible without timely and generous support from several sources. Grants to support the cost of publication came from the Committee for Cultural Cooperation Between Spain's Ministry of Culture and United States' Universities, the Boehm Foundation, and the University of Illinois at Urbana-Champaign Campus Research Board. We acknowledge this support with considerable gratitude.

Finally, a note about military terminology and its relationship to our subtitle. Through much of the war there were five brigades of international volunteers fighting on the Republican (or Loyalist) side, on behalf of the Spanish people and their democratically elected government. Among these brigades was the Fifteenth brigade, which was mostly English-speaking, though it was commanded by a Spaniard and included a Spanish battalion and eventually a number of Spanish soldiers throughout. A brigade was generally composed of four battalions of about seven hundred men each, plus support personnel. The brigades in turn were organized into divisions. At various times in its history the Fifteenth brigade included the Abraham Lincoln battalion, the George Washington battalion, the Mackenzie-Papineau battalion, and the British battalion. Americans in significant numbers served in the first three of these battalions, but some Americans were attached to other battalions and brigades entirely. Americans also served in the transport division, the medical services, and elsewhere as needed. Since 1937 the term "Lincoln Brigade" has been used to refer broadly to all the Americans who came to the aid of the Spanish Republic from 1936–39. There thus never was a military unit called the Lincoln brigade, though there was a Lincoln battalion, but the term "Lincoln Brigade" has had cultural and political warrant for nearly six decades.

Vol. I. - N.º 18 ★ SPECIAL ANNIVERSARY NUMBER ★ Madrid, October 11, 1937

The VOLUNTEER FOR LIBERTY

organ of the international brigades

OCTOBER 14, 1936-1937 ☆ ONE YEAR of the INTERNATIONAL BRIGADES

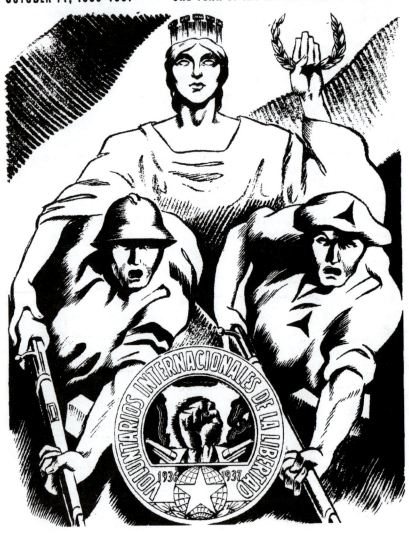

INTRODUCTION
I DREAMED I SANG "THE INTERNATIONALE" TO ADOLF HITLER

"No men entered earth more honorably
than those who died in Spain"
 —Ernest Hemingway,
 "On the American Dead in Spain" (1939)

Who might have imagined, reflected British poet Louis MacNeice, thinking about the moment before the Spanish Civil War began, "that Spain would soon denote / Our grief, our aspirations." There, on the battlefields of Spain, he continued, "our blunt / Ideals would find their whetstone." Indeed, "our Spirit / Would find its frontier on the Spanish front, / Its body in a rag-time army." Some 2,800 American volunteers joined that mostly unprofessional, more rag-tag than rag-time army; most of them were wounded and more than a quarter of them died in Spain. They came from almost every state in the Union and from every walk of life. They joined with volunteers from over fifty countries to form the International Brigades (IB) and to fight in support of the democratically elected government of Spain.

Late in 1938, when the International Brigades gathered in Barcelona so the Spanish people could honor them on the eve of their departure, Dolores Ibarruri (La Pasionaria), the folk hero and deputy who was perhaps the Republic's most well-known orator, stood before the crowds to pay tribute to these volunteers:

> You came to us from all peoples, from all races. You came like broth-
> ers of ours, like sons of undying Spain; and in the hardest days of the
> war, when the capital of the Spanish Republic was threatened, it was you,
> gallant comrades of the International Brigades, who helped to save the
> city with your fighting enthusiasm, your heroism and your spirit of sacri-
> fice....In deathless verses Jarama and Guadalajara, Brunete and Belchite,
> Levante and the Ebro sing the courage, the self-sacrifice, the daring, the
> discipline of the men of the International Brigades....And they asked us
> for nothing at all....they did aspire to the honor of dying for us....You can
> go proudly. You are history. You are legend. You are the heroic example
> of democracy's solidarity and universality.

In the years since, Ibarruri's speech has been reprinted hundreds of times and echoed in the words of hundreds of other writers. How did the 1936–39 Spanish Civil War come to represent so much more than itself—democracy's very solidarity and

universality—and why has the commitment made by 40,000 international volunteers to defend the Spanish Republic remained such an enduring symbol of selflessness, courage, and idealism?

The first question is not so difficult to answer, for the legacy of the war grows out of its history, the key elements of which are not in dispute. For in a longer historical perspective the Spanish Civil War amounts to the opening battle of World War II, perhaps the only time in living memory when the world confronted—in fascism and Nazism—something like unqualified evil. The men and women who understood this early on and who chose of their own free will to stand against fascism have thus earned a special status in history. They were not drafted; they volunteered, and they did so long before most of their countrymen realized the world was in danger.

Viewed internally, on the other hand, the Spanish Civil War was the culmination of a prolonged period of national political unrest—unrest in a country that was increasingly polarized and repeatedly unable to ameliorate the conditions of terrible poverty in which millions of its citizens lived. Spain was a country in which landless peasants cobbled together a bare subsistence living by following the harvests on vast, wealthy agricultural estates. The hierarchy of the Catholic Church, identifying more with wealthy landowners than with the Spanish people, was in full control of secondary education; education for women seemed to them unnecessary and universal literacy a danger rather than a goal. Divorce was illegal. The military, meanwhile, had come to see itself, rather melodramatically, as the only bulwark against civil disorder and as the ultimate guarantor of the core values of Spanish society.

When a progressive Popular Front government was elected in February 1936, with the promise of realistic land reform one of its key planks, conservative forces immediately gathered to plan resistance. The Spanish Left, meanwhile, celebrated the elections in a way that made conservative capitalists, military officers, and churchmen worried that much broader reform might begin. Rumors of plotting for a military coup led leaders of the Republic to transfer several high-ranking military officers to remote postings, the aim being to make communication and coordination between them more difficult. But it was not enough. The planning for a military rising continued.

The military rebellion took place on July 18, with the officers who organized it expecting a quick victory and a rapid takeover of the entire country. What the military did not anticipate was the determination of the Spanish people, who broke into barracks, took up arms, and crushed the rebellion in key areas like the cities of Madrid and Barcelona. It was at that point that the character of the struggle changed, for the military realized they were not going to win by fiat. Instead they faced a prolonged struggle against their own people and an uncertain outcome. The military leaders of the rebellion appealed to fascist dictatorships in Italy, Germany, and Portugal for assistance, and they soon began receiving both men and supplies from Benito Mussolini, Adolf Hitler, and Antonio Salazar.

The 1936 Spanish election had already been widely celebrated as a great victory in progressive publications in Britain, France, and the United States. In the midst of a worldwide depression, the military rising was thus immediately seen as an assault against working people's interests everywhere. But the rapid intervention of German and Italian troops gave what might otherwise have remained a civil war a dramatic

international character. Almost from the outset, then, the Spanish Civil War became a literal and symbolic instance of the growing worldwide struggle between fascism and democracy. Indeed, the Republic, the elected government, perceived the country as being invaded by foreign troops. By the time the pilots of Hitler's Condor Legion reduced the Basque's holy city of Guernica to rubble the following April, many in the rest of the world had come to share that opinion as well.

It is important to remember in this context the curiously contradictory character of American life during the Great Depression. Hand in hand with widespread poverty and suffering went a certain fervent hope for change and a belief in the possibility of finding collective solutions to common economic problems. The government elected in Spain in 1936 seemed like it would contribute materially to those solutions.

Fascism, on the other hand, presented the forces of reaction in their most violent form. Its territorial ambitions became apparent when Japan invaded Manchuria in the winter of 1931–32 and when Italy invaded Ethiopia in 1935. Meanwhile, Hitler elevated religious and racial hatred to national policy almost immediately after establishing his dictatorship in 1933. A relentless series of anti-Semitic campaigns, beginning with a 1933 boycott of Jewish firms and followed by the formal liquidation of Jewish businesses and a prohibition against Jewish doctors continuing their medical practices, culminated in 1935 when Jews were stripped of all rights of citizenship. When Hitler and Mussolini immediately allied themselves with the rebel generals, and when their leader Francisco Franco himself began to make pronouncements about conducting a holy war against a progressive conspiracy—rhetoric with long-standing anti-Semitic connotations—the cultural and political status of the Republic's enemies became clear.

In retrospect, it seems possible that world history might have proceeded differently had the democracies taken a strong stand against fascism in Spain in 1936. But they did not. Despite almost universal support for the Republic amongst British intellectuals and widespread support amongst the working classes, the British government preferred not to act. It was not only that they feared anything that might lead to a wider war in Europe, a fear that would eventually lead to British Prime Minister Neville Chamberlin's infamous Munich appeasement policy of 1938, but also that British businessmen and a majority of the British Cabinet felt more sympathetic with Franco. Large corporations in America also worked on Franco's behalf. In France, the government's sympathies were with the Republic, but the government was weak and feared not only a wider war but also any acts that might alienate its own military.

After providing the Loyalist government with a score of planes, France decided instead to propose an international policy of Non-Intervention that would bar all foreign aid to Spain. In fact, if Franco and the rebellious generals had been denied Italy's and Germany's aid in the early days of the war, the rebellion might well have collapsed. But Hitler and Mussolini simply ignored the Non-Intervention agreement. Meanwhile, Mexico responded by shipping rifles to the Republic, and the Soviet Union sold the Spanish government arms in exchange for Spain's gold reserves. But it was not enough over time to counter-balance the men and supplies Franco received. Over and over again, throughout the war, government campaigns would be overwhelmed by superior arms. And just as frequently in the letters that follow you will hear the hope that non-intervention will be overturned. For the Americans this was not an abstract

matter. Better machine guns would have kept some of them alive at Jarama. More planes and artillery would have made a difference at the Ebro.

On July 18, 1936, a carefully coordinated series of military uprisings were staged all across Spain. Success or failure sometimes depended on accident, sometimes on clever strategy. In one small city the military commander pretended to support the Republic, armed the workers, and sent them to help secure Madrid; he then took over for the rebels. In Barcelona, on the other hand, anarchist workers seized arms and put down the rebellion with violent street fighting. After a few days, the rebels held about a third of the country, though there were large stretches of Spain under no real military control. Meanwhile, the government kept control of most of the navy when ships' crews rose up and threw their rebellious officers overboard. That left the rebel generals in serious difficulty, for their best troops, the Army of Africa, were in Morocco with no means of transport to the mainland. At that point Hitler and Mussolini provided support that proved critical—planes to move the Army of Africa, now under command of General Francisco Franco, to Seville. It would be the first major airlift of troops in military history. Hitler would later observe that "Franco ought to erect a monument to the glory of the Junkers 52. It is this aircraft that the Spanish revolution has to thank for its victory" (Thomas, 370).

The first battles in the field, still in mid-July, took place over the mountain passes that would have given the rebels access to the capital city of Madrid. The people of Madrid had organized into militias based on political affiliation, and these untrained troops paid dearly to defend the passes through the Guadarrama mountains to the city's north. In any case, the battles resulted in a stalemate. The rebels, now calling themselves the Nationalists, began to organize to attack Madrid from the southwest. Four columns moved across the Spanish countryside, systematically murdering government supporters in each town they captured. On October 1 Franco took overall command of the rebel armies. Meanwhile, in the major cities a period of chaos was coming to an end. For a time the militias had carried out summary executions against their enemies, but gradually more centralized control prevailed.

As the rebel columns approached Madrid there was widespread expectation that the city would fall. The government fled to Valencia, leaving the city's defense to General Miaja. Then several remarkable events occurred. On November 7 Madrid's defenders found a highly detailed plan for the conquest of the city on the body of a fascist officer. The plan was so specific that the Loyalists concluded it could not be changed even if the rebels guessed it might have been captured, and it enabled the city to position its best forces exactly where they would do the most good. The following day the first International Brigades marched through the city, signalling world support for the city's defenders and placing a number of people with battlefield experience at key points. That night Fernando Valera, a Republican deputy, read this statement over the air:

> Here in Madrid is the universal frontier that separates liberty and
> slavery. It is here in Madrid that two incompatible civilizations undertake
> their great struggle: love against hate, peace against war, the fraternity of
> Christ against the tyranny of the Church....This is Madrid. It is fighting

for Spain, for humanity, for justice, and, with the mantle of its blood, it shelters all human beings! Madrid! Madrid!

The Spanish capital had come to stand for something much more than itself; it was now the heart of the world. For a time, indeed, international volunteers often declared themselves off to defend Madrid.

The first volunteers came spontaneously, though their individual decisions were often based in antifascism. A number of foreign nationals were in Barcelona for the "Peoples' Olympiad," scheduled in protest against the 1936 Olympics to be held in Berlin. When the Olympiad was cancelled by the outbreak of war, some of these men and women stayed on to fight. British painter Felicia Brown joined the street fighting in Barcelona and was killed in August. Two British cyclists in France crossed the border and volunteered. André Malraux, the French novelist, organized a squadron of a dozen pilots, the "Escuadrilla España," based first in Barcelona and then in Madrid. Before long, American volunteers were in the skies over Madrid as well.

But perhaps most telling of all decisions to volunteer were those by German and Italian exiles from fascism, some of them escapees from Nazi concentration camps. Some were already living in Barcelona; others made their way to Spain from elsewhere in Europe. It was thus in Spain that German and Italian antifascists in significant numbers took up arms against the fascist powers they could not fight at home. German volunteers formed the Thaelmann Centuria; Italians organized themselves into the Gastone-Sozzi Battalion and the Giustizia e Libertà Column. In all, perhaps 1,000–1,500 foreign volunteers fought in the Barcelona area in the opening two months of the war. Not many lived to see the war's end. Two years later, in September of 1938, other German volunteers, now members of the Thaelmann Battalion in the International Brigades, were occupying a hill of unforgiving rock in the Sierra Pandols west of the Ebro river. They faced a vastly superior fascist force in full counterattack and were ordered to retreat. Their reply came back, saying, in effect, "Sorry, we've retreated before fascism too many times. We're staying." Shortly thereafter their positions were overrun.

The International Brigades themselves became a reality when the Moscow-based Comintern (Communist International) decided to act on Spain's behalf. Negotiations with the Spanish government took place in late October. Stalin's motivations, no doubt, were pragmatic. He probably hoped, for example, to use an alliance to help the Spanish Republic as a way of building a general antifascist alliance with the Western democracies. But it was too soon. That alliance would come, but only after Munich, after Spain had fallen, and after the West tried every imaginable means of appeasing Hitler. In any case, early in November, about the time the attack on Madrid commenced, word reached New York to begin recruiting Americans for service in Spain.

Although the task had to be carried out in secret, it was less difficult than one might think, for antifascism was already intense among the American Left. Indeed, future Lincoln Battalion members were already taking public stands. Poet and journalist Edwin Rolfe began publishing newspaper articles attacking Nazism in 1934. In Philadelphia, Ben Gardner was arrested for disorderly conduct at a demonstration at the German consulate. A pro-German judge sentenced him to a year in the county jail.

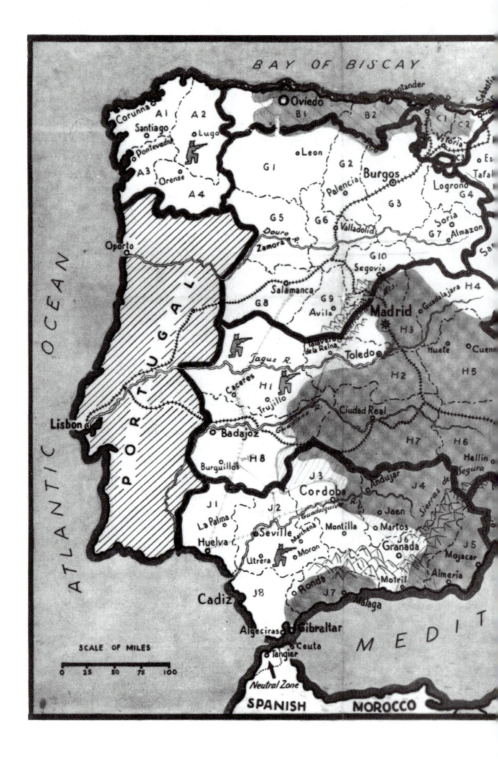

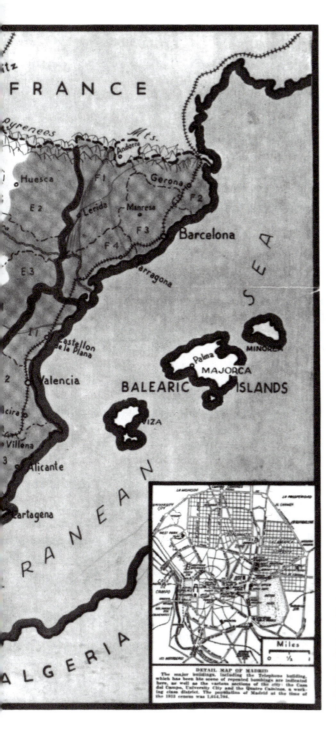

"Sunday Worker map of Spain," published in January, 1937. The Republic held the shaded areas to the north and the east; the rebels held the unshaded area to the west bordering on Portugal. Heavy lines mark major geographical areas.

And in New York harbor in 1935 seaman Bill Bailey scaled the mast of a German pas-
senger ship, the Bremen, that was flying the swastika. With the enraged crew shouting
beneath him, Bailey cut the black flag loose and flung it into the water. Two years later
these men would all be in Spain.

Despite the diversity of their backgrounds, one may make some generalizations
about the Americans who volunteered. The youngest were three eighteen-year-olds,
the oldest were fifty-nine and sixty. Over eighty of the volunteers were African
Americans, and the International Brigades were entirely integrated. In fact, the Lincoln
Battalion was commanded for a time by Oliver Law, an African American volunteer
from Chicago, until he died in battle. It was the first time in American history that an
integrated military force was led by an African American officer. Most of the American
volunteers were unmarried, although, as their letters reveal, many had relationships
back home they tried to sustain by correspondence. Their median age was twenty-
seven, their median birth date 1910. About eighteen percent came from New York and
most of the rest came from other cities. Perhaps a third were Jews, not surprising in
view of their antifascist motivation (Carroll, 15–18).

The volunteers came from all over the country and from a wide variety of occupa-
tions. Larry Kleidman was a seaman, as were Sydney Kaufman and Cecil Cole. Martin
Hourihan, Hyman Katz, and Paul Wendorf were teachers. Leo Eloesser was a physi-
cian, Ben Gardner a painter, Canute Frankson an auto worker, Joe Dallet a Dartmouth
graduate who became a union organizer and steel worker, Ely Sack an accountant,
Harold Smith a clerk, Fred Lutz an electrician, Dewitt Parker a statistician, Clifton
Amsbury a social worker, Toby Jensky a nurse, Mildred Rackley an artist, Edwin Rolfe
a poet and a journalist. Jack Friedman worked on his family's farm in Accord, New
York. Many, including John Cookson, Carl Geiser, Don MacLeod, Hank Rubin, and Ted
Veltford, were students. MacLeod was an undergraduate in school at Berkeley, Rubin
at U.C.L.A. Cookson, born in 1913, was a graduate student in physics at the University
of Wisconsin at Madison, just fifty miles east of his family's farm near the town of Cobb.
Paul Sigel, twenty-one years old, took his final exams at New York University's School
of Engineering just before leaving for Spain. Milton Wolff, who had dropped out of high
school but continued to study art intermittently, found odd jobs when possible and
socialized with other members of the Bensonhurst, Brooklyn YCL. He would start out
as a machine gunner in Spain and end up being the Lincoln Battalion's last commander.

In some cases, however, a job title alone will not suffice. When New Yorker Moe
Fishman dropped out of the City College of New York and became a driver it was both
an economic and a political decision; he had joined the progressive movement.
Leonard Levenson, who was born in New York in 1913 and had grown up in the city
and earned a law degree there, was working as a fingerprint clerk at FBI headquarters
in Washington at the time he left for Spain. Too young to be selected for formal train-
ing as an agent, he had taken the job anticipating a decision. Meanwhile, his friends
and the experience of the depression were radicalizing him. By the end of his FBI stint,
he was secretly reporting to a Communist Party representative about unionizing
efforts at the FBI. Joe Gordon was working and organizing in the cannery industry in
San Diego when he was beaten up and run out of town. He joined the U.S. Army but
went AWOL to volunteer for Spain. You will meet all of these and many others in the

pages that follow. While it is unnecessary to provide full biographical information on all our sixty contributors, a few condensed life histories—some representative and some exceptional—may be useful. Information on some of the other volunteers appears in the introductions to individual chapters.

Rose Freed provided a brief personal history for the American Medical Bureau to Aid Spanish Democracy. It survives in the AMB Archive at Columbia University:

> I was born on Lewis Street in the heart of the East Side, on June 10th, 1911, the second of five children that came to Jacob Freed, a designer of ladies' coats and dresses, and Sara Serveter, a beautiful young Jewish-Polander whose family traces its lineage back to Rabbi Isaac Serveter, one of the many Jews who fled Spain during the Inquisition. My father must have read Greeley, for when I was but six months old the migratory impulse struck him and we went west—to Alliance, Ohio. A short time there and we rooted in Cleveland, the metropolis on the shores of Lake Erie. Was fourteen when my family decided they missed the sound and smell of the big city. A well-intending aunt had secured rooms for us in advance on Havermayer Street, Brooklyn—a pushcart market! We got the sound and smell of the big city alright!
>
> Graduated from P.S. 166 in Brooklyn, in June '26. Conditions at home necessitated my going to work immediately after this. Worked in a shoe factory during the day and got educated at night in Washington Irving Evening High School, from which I graduated. My college education was obtained the same way, only during those days I worked in a bow-tie factory, a department store, and in a plumbing supply store as a bookkeeper, at different times.
>
> Got a job at the Greenpoint Hospital four years ago as laboratory technician in charge of the Urinology and Blood Chemistry departments. I left this position on January 12th to serve the cause of democracy in Spain.

On the other side of the country, Archie Brown, born in 1911, was equally embedded in the conditions of his time. At age thirteen he left Sioux City, Iowa, the town of his birth, and by himself rode freight cars to California. In the early years of the Great Depression he struggled unsuccessfully to help unionize farm workers in California's Imperial and San Joaquin valleys. Then he shifted his attention to the arena that would occupy him repeatedly thereafter—the California waterfronts, participating in several strikes before leaving for Spain in 1938 (Carroll, 45–6).

Brown's was a characteristic Lincoln pedigree, as in many ways was Edwin Rolfe's. Born Solomon Fishman in 1909 to Russian immigrant parents in Philadelphia, his family moved to New York when he was five. He grew up on Coney Island, only a few blocks from the beach, in an environment that seemed rural in midwinter and teemed with visitors in the summer. Both his parents were active in the Communist Party, though his father joined the dissident Lovestonite faction and was expelled in 1928. Fishman was publishing poems in his late teens and by the time he left high school his poems had become decidedly revolutionary in tone. It was at that time that he began to call himself Edwin Rolfe. Not fond of Party functionaries, he resigned and spent a

year and a half at the University of Wisconsin. As the Depression deepened, however, he was drawn to politics again and rejoined the Party in New York, working on both the *Daily Worker* and *New Masses*. A founding editor of *Partisan Review,* he published his first solo book of poems in 1936. The following year he left for Spain.

Less typical, perhaps, was Al Amery. Born to a working class family in Massachusetts in 1906, he frequently spent time on his uncle's tobacco farm in Connecticut while growing up. At age seventeen he got his parents' permission to enlist in the Navy and ended up spending two years in China and the Philippines. Discharged in San Pedro at age twenty-one in 1927, he was soon conned out of his Navy savings. A period of odd jobs followed, after which he decided to sign up with the U.S. Army's 11th Cavalry at Monterey. Three years later he was on his way back to Massachusetts to look for work, but the depression made that mostly impossible. Seeing no alternative, he joined the Army once more, this time near home, for two more years. A civilian again in 1935, he worked unsuccessfully to become a writer, meanwhile discovering that "work" in the depression sometimes meant getting cheated out of your wages entirely. It was at that point that he met a local Party member and began to read the philosophical literature of the Left. The reading and conversation were enough to send him to Spain when the opportunity arose.

If Amery's connection with the Left was marginal, Bill Sennett's was substantial. Born in 1914 in Chicago to Russian immigrant parents, Sennett spent his childhood there and in Gary, Indiana. His father was a barrel-maker, and the regular language at home was Yiddish. Unhappy in the family, Sennett ran away from home twice as a teenager, once riding the rails to California. A brief early marriage got him permanently out of the house in 1932; a year earlier he had joined the Youth Section of the International Workers' Order (IWO). His impulse was social rather than political, but public lectures at the IWO began to politicize him. Before long he was in the Young Communist League (YCL) and soon he was active in the Unemployed Councils. Arrested several times for helping evicted tenants move back into their apartments, he was sometimes beaten up by the Chicago Police while in custody. Classes at the Party's district training school followed, along with participation in a National Hunger March in Washington and organizing among African Americans on Chicago's south side. He also met Augusta Machen, to whom his letters are addressed, and they were later married. Sennett became a section organizer for the YCL on Chicago's west side in 1935, meanwhile earning money working for Spiegel, a mail-order company. He was fired from Spiegel for attempting to unionize the firm. When the International Brigades were formed, Sennett was ready to volunteer. Except for a brief stint in the infantry, he spent most of his time in Spain in the transport regiment.

A number of the other American volunteers were foreign born. Among these was Canute Oliver Frankson, who was born in Old Harbor, Jamaica, about 1890. He arrived in the U.S. with his wife Rachel on April 30, 1917, eventually making his way to Detroit, where he found work in the auto industry. He joined the transport regiment in Spain, drove trucks, became Head Mechanic at the International Garage, taught classes, and eventually left Spain when he became ill.

Sandor Voros was born in Hungary in 1900. His first military experience was in his native land, as a cadet in the Austro-Hungarian Army. He arrived in New York in 1921

and found employment in the fur trades. Toward the end of the decade he became interested in writing, drafting several plays and publishing a few short stories. But he also became interested in politics, joining the Communist Party and becoming managing editor of the Hungarian newspaper *Uj Elore*. Transferred to Ohio in 1931, he became active in organizing for the Newspaper Guild. Toward the end of his time in Spain, while still a strong supporter of the cause of the Republic, he began to become alienated from the Party and from the International Brigades, in large measure because they found a book he had written on the medical services unsatisfactory and asked Edwin Rolfe to rewrite it. He broke with the Party on his return and published an anti-communist autobiography, *American Commissar,* in 1961.

Amery, Brown, Frankson, Freed, Rolfe, Sennett, and Voros all survived the war, but at least seven hundred and fifty Americans did not. Jack Freeman was born in 1919 in New York. His parents were Polish immigrants who came to the United States from a village near Warsaw. When he left for Spain in 1937 he was in his second or third year at City College. He had worked as an editor on a student newspaper and had been arrested at an anti-war demonstration. His father was also politically active, serving as a Communist Party functionary until he was expelled as a member of the Lovestone faction in 1928. Jack was on the front lines as a mapper and observer repeatedly in 1937 and through the Americans' final battles in the summer and fall of 1938. At the end of the war, his father struggled unsuccessfully—through official U.S. State Department sources—to find out what had happened to his son. Finally, a returning veteran gave him a few details, recorded in an address book at the time: "Jack—Killed Sept 7, 1938, in Sierra Pandols near Corbera, Hill 281. Rumors that he was buried in a small cemetery in olive grove." His brother Herbie, to whom some of his letters are addressed, was almost fourteen at the time Jack died.

By the time large numbers of American volunteers began arriving in Spain early in 1937, the flamboyant early days of the militias were over. The militias had been reorganized into Mixed Brigades more firmly under government control. In those first months untrained and lightly trained men and women had held the fascist advance at the very outskirts of the capital. Barricades had been built across Madrid's streets in anticipation of fighting in the city itself. As the front stabilized, the University campus overlooking the wooded Casa de Campo on the city's western edge was heavily entrenched, with both sides holding some of the shattered buildings. Mount Garibitas, the highest point in the area, was taken by the fascists and provided a good site from which to shell the city. But the Republic's fully organized People's Army was yet a dream; it would take the bloodletting at Jarama, described in Chapter 3, to persuade many of its necessity. Meanwhile, most Americans passed through the massive fort at Figueras near the border and headed on to Albacete, a provincial capital midway between Madrid and Valencia that was the administrative center for the International Brigades. From there they moved to one of several nearby villages where individual battalions trained.

In March an overconfident Italian-Spanish force commanded by one of Mussolini's Generals, Mario Roatta, suffered an embarrassing defeat at the battle of Guadalajara, northeast of Madrid. That, for all practical purposes, put an end to major assaults on the capital, though it continued to be shelled throughout the war. The next important

battles took place in northern Spain, as Franco set out to overrun the isolated Basque provinces loyal to the Republic. On April 26 Hitler's Condor Legions firebombed the ancient Basque town of Guernica, a place of no military importance, and reduced it to rubble. It was the single most telling indication of fascist ruthlessness toward civilians to date, a lesson residents of cities in Europe and England would themselves learn in time. It led Picasso to produce his massive painting "Guernica," perhaps the most famous work of graphic art to come out of the war. Meanwhile, the Spanish government attempted to take pressure off the north with a major offensive west of Madrid in the summer of 1937. It was called the battle of Brunete; the American role there is detailed in Chapter 6. Though Franco's northern campaign was delayed, it did not stop. After eighty days of fighting, Bilbao was taken on June 19th, Santander on August 26th.

Meanwhile, the Popular Front government (a coalition of middle-class republicans, moderate socialists, and communists) had endured a civil war within the civil war in Catalonia. The government was about to integrate the remaining Catalan militias into the People's Army, a step the radical Left regarded as "a euphemism for disarmament and repression of the class-conscious revolutionary workers" (Jackson, 119). Believing that the government was exclusively concerned with defeating Franco and indifferent or antagonistic toward the major social revolution needed in Spain, an anti-Stalinist Marxist group, the POUM, provoked several days of rioting and sporadic fighting in early May of 1937 in Barcelona. They were joined by the more radical contingents of Catalonian anarchists. This gave the Spanish communists—a rather small party at the outset of the war that had gained membership and prestige in the months since—the excuse they needed to crush the POUM, a group they reviled beyond reason. In the ensuing crackdown the POUM leader Andrés Nin was taken prisoner and murdered, and other enemies of the Communist Party were tortured. By mid-June the POUM had been declared illegal. For some, this meant the betrayal of all the more utopian aims of the Spanish Left and a certain disillusionment with the cause of the Republic. For others, a crackdown seemed essential because a unified leadership focused on winning the war was indeed necessary; a full social revolution would have to wait until fascism was defeated. What is clear is that the internal dissension on the Left damaged the spirit of resistance in Catalonia. Negotiation and compromise, rather than violence, would have served all parties better in the face of Franco's armies.

Although International Brigade members did not have fully detailed knowledge of events in Barcelona, their letters show consistent antagonism toward the POUM. Moreover, because they were being bombed, strafed, and shot at by Franco's troops, they certainly considered winning the war the first priority. And their own experience confirmed the need for a unified military command that could train recruits; coordinate troop movements with aircraft, artillery, and tanks; and supply food, ammunition, and medical services, tasks that were quite beyond the Catalonian militias.

In any case the ensuing months were taken up for the Lincolns not in intrigue but in battle. Like the perspective of Spanish soldiers in the field, the Lincolns' view of the war was thus quite different from that of those Spanish nationals who were occupied with political struggles in Madrid and Barcelona. The battle of Brunete in the unbelievable heat of July of 1937 was followed by Quinto and Belchite in August, and Fuentes de Ebro in October. Then, after a brief period of training, the Lincolns faced

the snows of Teruel in January and February of 1938. Taken by the Republic for a time, Teruel was recaptured by a massive Nationalist counterattack in February.

Franco followed up that victory with a major offensive aimed toward the Levante and Catalonia. Launched on March 9, 1938, it involved 100,000 men and over six hundred Italian and German planes. In the histories of the American role in Spain the events are known as "The Great Retreats," for that is what the Republic's forces had to do. They were faced with continuous bombing from the air and a Panzer-style massed tank assault at key points on the ground. At the end of the month El Campesino's division made a last stand before the city of Lérida, but Franco's offensive continued. It was to prove the single worst blow against the Republic in nearly two years of war, for on April 15 the rebels reached the Mediterranean and cut the Republic in two. By the end of the month Franco held a fifty-mile stretch of coast. Some felt the war was over, but the Republic held on, buoyed by a brief resupply of arms and by the hope that the democracies would surely now repeal the Non-Intervention policy, for Germany had invaded Austria on March 12. Did the world need still more evidence of fascism's ambitions?

To resist, to hold on, was in part to buy enough time for the world to confront reality. Unfortunately, the British commitment to an appeasement policy was already in place. The Republic now had enough arms for one last great campaign, training and planning for which began immediately. It was to be a crossing of the Ebro in July of 1938, into territory lost in March and April. Initially successful, the Republic's forces were gradually pressed back by the rebel counter-offensive. Even in August or September, arms might have made a difference, but the watershed event of the fall of 1938 was not to be the resupply of Spain's democracy. It was to be Munich.

At the end of September, British and French representatives met with Hitler and Mussolini and granted Hitler Czechoslovakia. Shamefully, Czech representatives were not invited. Meanwhile, with that agreement another unrepresented nation's fate was effectively sealed, for with the signing of the Munich Accord it was clear that the democracies would not stand against fascism in Spain. The Internationals were withdrawn, and Spain fought on alone for several more months. In late November Hitler resupplied the Nationalists with arms. Franco started his final offensive, taking Barcelona in January. At the end of March, Madrid fell. On April 1, 1939, the Spanish Civil War officially came to an end.

For many, however, the suffering was not over. It was not to be a civil war ending in reconciliation, for Franco began a reign of terror aimed at the physical liquidation of all his potential enemies. Concentration camps were set up. Tens of thousands were shot. Mass executions would continue until 1944. Meanwhile, World War II was under way, and many of the Lincolns took up arms against fascism again.

The outlines of this story are familiar to most students of modern history, and the history of the Lincolns themselves has been retold many times. Oddly enough, however, despite the Lincolns' fame on the Left, we have not yet had their story told in their own words. We have not heard the voices of the volunteers themselves in detail before and not heard the many personal narratives they recorded in the midst of the war.

The title of this collection, *Madrid 1937,* honors both the real and the symbolic commitments the volunteers made when they left for Spain. The subtitle adopts the stan-

dard, if sometimes controversial, designation of the "Lincoln Brigade," a term adopted to embrace not only the Americans who served in the Lincoln Battalion but those who served in other battalions as well. The title of this introduction, "I Dreamed I Sang 'The Internationale' to Adolf Hitler," signals the kind of unknown story this collection records. As it happens, several of the Americans dreamed they confronted Hitler while they were in Spain and recorded these dreams in the letters they sent home. We learn about some of those dreams here, just as we learn about Langston Hughes reading his poems before the Regiment de Tren, about Fred Lutz crawling through tunnels under Belchite, about Edwin and Mary Rolfe experiencing fascist bombings in Madrid and Barcelona, and about numerous other first-hand experiences that general histories have not been able to include. The title of the introduction also, however, alludes to another sort of dream that recurs throughout these letters: the dream of a more equitable social order, a dream that—in the Great Depression of the 1930s—seemed not only possible but necessary.

Given the number of books written about the Lincolns, and the huge number of books about the Spanish Civil War (about 15,000), it may seem surprising that no one has gathered a major collection of American volunteers' letters before. During the war itself there were several small pamphlets of Americans' letters published across the country, including Joe Dallet's posthumous *Letters from Spain* and *From a Hospital in Spain: American Nurses Write*. A number of newspapers also published letters from time to time, and Marcel Acier's international collection *From Spanish Trenches* (1937) included a number of letters by Americans. Acier unfortunately had to remove political (and some personal) passages from the letters he used, so that collection is not as useful as it might have been. But no major collection of American letters appeared. After the war the veterans themselves planned to gather letters for publication, but World War II intervened, and then the long night of McCarthyism descended. In those years no major publisher would have touched such a book.

Meanwhile, the letters themselves held special value for the veterans and their families. Repeatedly in Spain, men in battle lost all their possessions. Thus the only mementoes volunteers had were often the things they sent home, like their letters or diaries, or the things they acquired on the way out of the country. One sister of a volunteer who died in Spain warned us her brother's letters would be quite tattered; she had been unfolding them and rereading them for fifty years. A former wife of a volunteer told us she never missed him but regularly missed rereading his letters from Spain. The widow of a volunteer who died in Spain treated his letters for more than fifty years as her most private possessions; on her deathbed she changed her mind and decided to give us his letters for publication. It is only in the last few years that aging vets have finally faced the necessity of depositing their letters in libraries. In other cases, we gained access to privately held letters only after slowly building relationships with veterans or their families.

Unlike the letters written while travelling to and from Spain, most of the letters written in Spain—and thus most of the letters in the book—were reviewed by International Brigade censors. The same practice, of course, was used for American troops during World War II, because it was essential that battle plans and troop movements not be revealed. In Spain the IB also used volunteers' letters as a way of gauging the morale

of each battalion. Nevertheless, it was quite easy for people talking with reporters on their way to Paris to give them letters to mail from there. This happened with some of the letters we publish here, and with a number of other letters we read and considered for publication. In fact, volunteers often noted that a particular letter was travelling with a reporter and would not be examined by the censor. Except for one letter dealing with problems in the medical services and a few letters complaining about particular personalities, we found no difference between letters that were and were not censored.

The real issue was thus self-censorship. Many of the volunteers overreacted to the fact of military review and left all detail out of their correspondence; those letters did not make it into this book. Other writers realized they could give quite specific accounts of military actions if they waited until a particular battle or campaign was over. Some Lincolns made that a regular practice, and those letters are well represented here. Self-censorship also probably had a few other effects. Knowing that their letters would be read may well have made the Lincolns reluctant to be erotically explicit in what they wrote. If they thought a particular officer was incompetent, they would also probably not have said so in a letter. In order to avoid worrying their friends and families, many writers also minimized the danger they were in and downplayed their wounds when they were in the hospital. But other Lincolns wrote quite harrowing battlefield letters that must have terrified readers back home. It is also likely that anyone thoroughly alienated from the International Brigades would not say so in a letter going through the censors, though the extremely small rate of desertion from the Lincolns suggests very few would have been inclined to write such letters. Finally, comparing these letters with postwar memoirs shows that—except for a few events not covered—the Lincolns were willing to address most important subjects in their letters. They often do so here with an intimacy and immediacy not found in any retrospective account.

The powerful emotions in many of these letters also reflect the special vulnerability these men and women felt. They came because of their political convictions, but they were also thereby isolated from most other Americans, the majority of whom supported the Republic but did not recognize the reality of the world's peril. They also came in violation of U.S. law, since both travel to Spain and service in a foreign army were forbidden. So the need to communicate with sympathetic friends and family was especially intense, as was the need to be reassured that those back home were doing everything possible to support the cause. Anxiety about letters delayed is one of the most recurrent topics here. And delays came for many reasons—the time required for reviewing the letters, the time required for transporting them to France to mail them from there (thereby not informing the U.S. Postal Service that the letter's author was in Spain). Perhaps the only equally common subject is the request for cigarettes. If there were any non-smokers in America in 1937, there weren't many of them among the Lincolns.

The idea for this book came to us in Mary Rolfe's walk-in closet in San Francisco in 1989. There we began to read 350 pages of letters her husband, Edwin Rolfe, had sent home from Spain. Further research in the Abraham Lincoln Brigade Archives at Brandeis University, at the University of California at Berkeley, and at the University of Illinois at Urbana-Champaign convinced us it was time for a substantial collection of

S.R.I. 63E
Plaza del Altozano
Albacete
Spain
August 10 - 1937

Darling -

I forgot to ~~once~~ enclose the picture
I mentioned in my other letter, so here's
a new note - in handwriting this time -
and I hope I won't forget the inclosure
now.

It-very hot here, and I have the
shutters closed to keep out the sun; a
jug of water at my side and a cigaret
(Raleigh) in my lips. I feel, baro-
metrically speaking, like
this: or this:

Otherwise O.K.
 Well, here's the photo I men-
tioned, and that's all there is
to this letter.
 Love + love
 Ed

A holograph letter from American volunteer Edwin Rolfe, written in Madrid and addressed to his wife Mary in New York. The return address is a code that will enable the S.R.I to direct incoming letters to the proper location.

April 5, 1937
Soccoro Rojo
Room 17:1
Albacete, Spain

Carissimo padre e madre,

Dalla vostra lettera sento che mi rimproverate, perche no lasciato la casa senza avertivi, sento che avete ragione, ma che volete, avevo timora di darve troppo dispiacere, ma ora sono contento perché mi trovo in ottima salute fisica e morale.

Lea vostra lettera mi ha fatto molto piacere. Sono contento che la famiglla si trova in buona salute. Caro papa, siento de la tua lettera la plopaganda velenosa che fa la radio dei capitalisti contro de noi. Lasciali che strillano pure questi illusi, loro poltrano dire quella che vogliono ma ciò no conta, si vedrá alla fine; e sta pur sicuro che la loro fine sará disastrosa. Noi qui combattiamo con uno spirito anti-fascista e i nostri nimici lo anno probato al loro spesso. A me niente mi manca e mi sento propia bene. Qui siamo trattati con molto reguardo dal governe e dei cittadini. La tua lettera lo compresa perfettamente e non avere nesun timora per me.

Saluti e braci a te e mi madre e tutte la famiglia. Vi scriveró piu e longo.

Vostro figlio —
Giovanni

A holograph (hand-written) letter from American volunteer John Tisa to his parents.

letters written by American volunteers. With the project under way, we contacted the national office of the Veterans of the Abraham Lincoln Brigade in New York. They sent out a letter urging veterans or their friends and family members to contribute letters in their possession. We followed up with phone calls, letters of our own, personal visits, and research at other libraries. We ended up with over 15,000 pages of letters written home by Americans in Spain. From those we have selected for publication not only letters of obvious general historical interest but also letters that give an intimate sense of the voices, character, and experiences of individual American volunteers.

The chapters, each with its own introduction, deal with individual topics, like the experience of training or the volunteers' reasons for going to Spain, and they are placed in roughly chronological order. Thus the second chapter covers the journey to Spain, the last chapter deals with the trip home, and the four chapters devoted to battlefield events are placed in chronological sequence. The chapter on Madrid comes earlier in the book than the chapter on Barcelona because the Americans were in Madrid more often in 1937, and in Barcelona more often in 1938. But some of these topics run the entire length of the war, and some subjects, like the centrality of the struggle against fascism, recur throughout the book.

The Acknowledgments gives the present location of the originals of the letters we used and thanks the many people who have helped us on this project. Our editorial interventions have been minimal. With the exception of the letters by Freed, Frankson, Fuhr, Kleidman, Malbin, Martin, Taft, and Wolff, which had been retyped, along with those few letters reprinted from 1930s publications, we were working with original letters, most of them in holograph. Our aim throughout has been to publish the letters as they were written; we have made no deletions. In the case of hand-written letters, however, we have provided standard paragraph indentation and punctuation in cases where people used extra space to serve those functions in their originals. Since spelling errors were relatively infrequent (averaging about two per letter) and thus not a significant element of the style of the letters, we silently corrected them. When nonstandard spelling was clearly part of the writer's style, we preserved it. We also preserved the standard coinages of the war and those occasions when Americans combined Spanish and English words, since the latter exemplifies their cultural situation. We did find some letters with large numbers of spelling errors, but we ended up not using them in the book. Almost none of the writers underlined book or newspaper titles, partly because time was often short and partly because the titles would be so familiar to their readers; to make things easier for our readers, we have italicized titles. We have added occasional place names or other information in brackets. All items in brackets, therefore, are our editorial additions. The more we worked on the project, the more we realized that conventional generic distinctions between letters and diaries did not always apply here, since people often tore out pages from their diaries and sent them home in lieu of letters and sometimes sent entire diaries home when their pages were filled. We have therefore included some diary entries when they were especially interesting.

In conclusion, we should note that there is a special poignancy in publishing the letters here that were written by volunteers who died in Spain, in giving public voice for the first time to a group of Americans who were silenced by fascist bullets or bombs.

Both their letters and the letters by survivors take us back to a unique time when young Americans saw themselves as citizens of the world and believed the world's peril merited them risking their lives. These were volunteers who dedicated their lives not to their own advancement but to the common good. We now offer these remarkable letters—impassioned, eloquent, humorous, intimate—to a new generation of readers.

REFERENCES AND RECOMMENDED READING

Alvah Bessie, ed. *Heart of Spain* (New York: Veterans of the Abraham Lincoln Brigade, 1952). Perhaps the best anthology of poems and short prose pieces about the war.

Peter N. Carroll, *The Odyssey of the Abraham Lincoln Brigade: Americans In the Spanish Civil War* (Stanford, Calif.: Stanford UniversityPress, 1994). The first book to give a detailed account of the Lincolns' postwar experience, it includes new insights into the civil war as well.

Carl Geiser, *Prisoners of the Good Fight* (Westport, Conn.: Lawrence Hill & Company, 1986). The story of the Americans who were captured in Spain.

Gabriel Jackson, *A Concise History of the Spanish Civil War* (New York: John Day, 1974). The best short history of the war as a whole.

Arthur H. Landis, *The Abraham Lincoln Brigade* (New York: Citadel Press,1967). Not the most readable book on the Lincolns but immensely valuable as a source of detailed information available nowhere else.

Cary Nelson, ed. *Remembering Spain: Hemingway's Civil War Eulogy and the Veterans of the Abraham Lincoln Brigade* (Urbana: University of Illinois Press, 1994). Previously unreleased tape of Hemingway reading his famous eulogy to the American dead, with explanatory essays.

Edwin Rolfe, *Collected Poems,* ed. Cary Nelson and Jefferson Hendricks (Urbana: University of Illinois Press, 1993). Rolfe was theLincoln Battalion's poet laureate and the American poet who did the most sustained work on the Spanish Civil War.

Robert A. Rosenstone, *Crusade of the Left: The Lincoln Battalion in the Spanish Civil War* (New York: Pegasus, 1969). The best narrative account of the Lincolns in battle.

Hugh Thomas, *The Spanish Civil War* (Revised and enlarged edition,New York: Harper and Row, 1977). The most thorough one-volume general history of the war.

Milton Wolff, *Another Hill: An Autobiographical Novel about the Spanish Civil War.* (Urbana: University of Illinois Press, 1994). Wolff was the Lincoln Battalion's last commander.

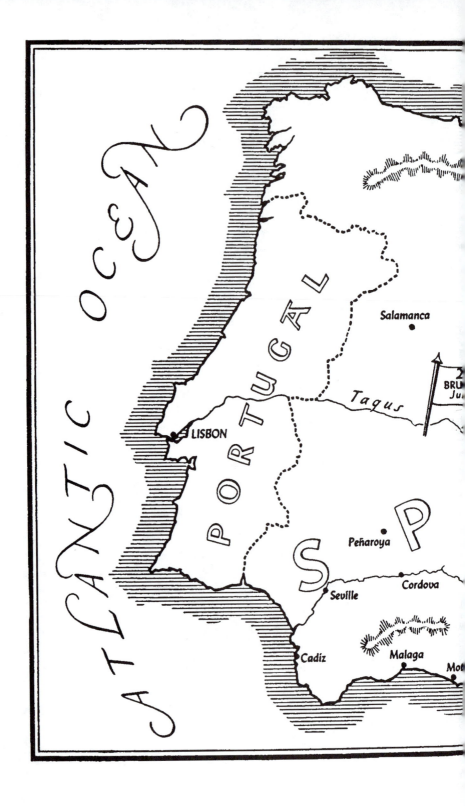

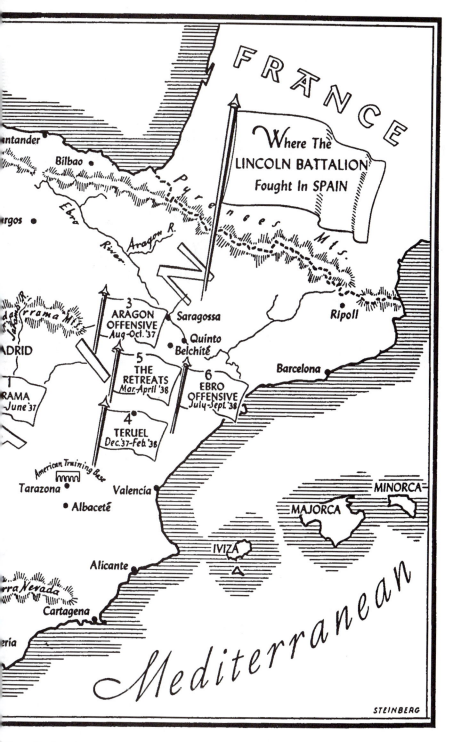

Where the Americans fought in Spain. Reprinted from Edwin Rolfe, *The Lincoln Battalion* (1939).

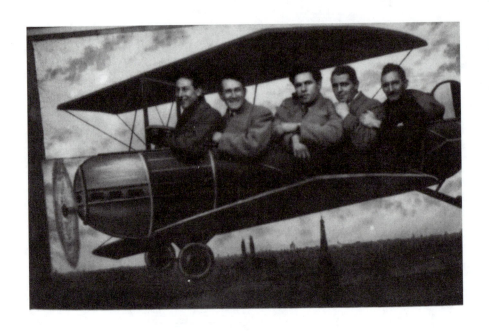

A group of Americans on their way to Spain, at the Paris Exposition in 1937. The first four, begin-
ning with the pilot on the left, are Bill Susman, Danny Sugrue, Joe Gordon, and Maurice Moran.

CHRONOLOGY OF THE SPANISH CIVIL WAR
(emphasizing the Lincoln Battalion involvement)

1931

King Alfonso XII leaves Spain after Republican and socialist candidates are victorious in the nation's municipal elections.

1936

February 16 — Popular Front coalition of left-wing parties wins Spanish national elections and forms new Republican government

July 17 — Right-wing military uprising against the Spanish government is declared in Spanish Morocco

July 18 — Insurgents successful in taking Seville

July 19 — Insurgents are defeated as they attempt to take Barcelona

July 20 — Insurgents defeated in Madrid; Republican government seeks aid from France; Insurgents appeal for help to Germany and Italy; Franco takes control of Insurgent armies

July 25 — Hitler agrees to support Franco

July 26 — German and Italian planes land in Morocco

July 27 — Insurgents control Seville with reinforcements flown in from Morocco on German airplanes

August 8 — France closes its border with Spain; unofficial "Non-Intervention" policy begins

August 14 — Insurgents take Badajoz; over 4,000 massacred in the next ten days

September 5 — Irún burned as Nationalists take city

September 9 — The Non-Intervention Committee first meets in London

September 27 — Insurgents take Toledo; rescue rebels in Alcázar

October 1 — Franco named Generalissimo; becomes supreme head of Nationalist government and armies

November 6 — Republican government leaves Madrid and moves to Valencia; General Miaja named head of Madrid Defense Junta

November 7–23 — Insurgents attack Madrid from the north and southwest

November 8 — International Brigades arrive in Madrid

November 18	Germany and Italy recognize Nationalist government
December 22	Italian forces arrive in Spain to support Insurgents
December 25	The first Americans leave New York harbor on the S. S. *Normandie* to fight for the Republic

..

1937

February 5–27	Battle of Jarama
February 8	Nationalists capture Malaga
February 16	Lincoln Battalion first moved to the front lines at Jarama; the first Lincoln casualty, Charles Edwards, on the 17th
February 27	Lincolns attack Pingarrón Hill ("Suicide Hill") in Jarama Valley; of the 500 who went over the top, more than 300 were killed or wounded
March 8–18	Battle of Guadalajara; Italian troops defeated by Republican army with substantial International Brigade support
March–May	Americans form two new battalions—the George Washington Battalion and the MacKenzie-Papineau Battalion (consisting mostly of Canadians)
April 26	Guernica bombed by German planes; over 2,500 civilian casualties
May 3–8	Fighting in Barcelona between CNT, FAI, POUM, and the PSUC and police
May 17	Juan Negrín replaces Largo Caballero as Republican prime minister
late June	Lincoln Battalion recalled from Jarama front after spending over four months in the trenches; billeted at Albares, about 35 kilometers north of Tarancón, before being sent to Brunete campaign
July 6–26	Republican offensive at Battle of Brunete, just west of Madrid
July 6	Lincolns attack and take Villanueva de la Cañada near Brunete; 30 Lincolns killed
July 9	Lincolns charge the Romanillos Heights and Mosquito Crest ("Mosquito Hill"); over 135 casualties; they dig in and are bombarded by the German Condor Legion
July 14	Because of high casualties the Lincoln and Washington Battalions merge into one battalion
August 19	Lincolns leave Albares for the Aragón front

August 24	Republican offensive in Aragón; the Lincolns attack Quinto, a small town about 35 kilometers southeast of Zaragoza
September 6	Belchite, about 50 kilometers south of Zaragoza, falls to the Lincolns after 4 days of house-to-house fighting. The Lincolns suffer over 250 casualties in the battles of Quinto and Belchite
October 13	Lincolns and the MacPaps unsuccessfully attack Fuentes de Ebro near Zaragoza; the two battalions suffer over 300 casualties
October 19	All of Northern Spain in Nationalist control
November 30	Republican government moves to Barcelona
December 14	Republican offensive begins at Teruel

1938

January 1	Lincolns and MacPaps, as part of the Teruel offensive, are moved from the Aragón region to Argente, 30 kilometers north of Teruel
February 15	Lincolns and MacPaps sent to Segura de los Baños, about 70 kilometers north of Teruel; they take Monte Pedigrossa; Americans also in action elsewhere in the area
February 19	Lincolns moved from Segura de los Baños to just southeast of Teruel
February 22	Nationalists recapture Teruel
early March	the Lincolns and MacPaps are billeted in and around Belchite, just south of Zaragoza
March 9	Nationalists begin major offensive in Aragón; the Lincolns retreat south out of Belchite and are overrun by rebel offensive, with many taken prisoner; the beginning of the Great Retreats
March 15	Lincolns retreat into Caspe, about 70 kilometers east of Belchite; of the 500 Lincolns who left Belchite, only 100 remain
March 16–18	Continuous bombing of Barcelona
March 18	Lincolns are in reserve at Batea, about 40 kilometers southeast of Caspe; joined by more than 100 new recruits as well as stragglers finding their way back, the battalion strength is back to around 400
April 1	The Lincolns are overrun near Gandesa; the battalion suffers heavy casualties, among them Commander Robert Merriman; during the next week they re-assemble at Mora la Nueva on the Ebro, only 120 Lincolns remain

early April	The Lincolns in training at Darmos, near Mora la Nueva, where they are joined by more than 400 young Spanish recruits
April 15	Nationalists break through Republican forces and reach Mediterranean at Vinaroz; Republican Spain split in two
May–July	Lincolns still in training on the east side of the Ebro, in Marsa; their number are increased to almost 700
July 24	Republican army begins Ebro offensive; the Lincolns cross the river near Asco and quickly take Fatarella
July 28	Lincolns in battle at Villalba de los Arcos, about 10 kilometers north of Gandesa; by now only 400 of the 700 in the battalion are still in action
August 2	Lincolns just east of Gandesa; pounded by artillery in the "Valley of Death"
August 15	Lincolns sent back to front, to Sierra Pandols southeast of Gandesa; the battalion strength is down to 300, with fewer than 100 Americans; they are bombarded by artillery and aircraft for ten days, but hold Hill 666
September 6	Lincolns begin action around Corbera for five days
September 21	Juan Negrín, Prime Minister of the Republic, announces to the League of Nations at Geneva a unilateral withdrawal of all international troops from the Republican army; the Lincolns are near the front lines just east of Corbera
September 23	Jim Lardner, son of Ring Lardner, Jr., is one of the last Lincolns killed in action
September 24	The Lincolns are withdrawn from the Ebro region
September 30	Munich Pact seals fate of Czechoslovakia, and of Spain's last chance for intervention; Neville Chamberlain declares "Peace in our time"
October 29	Farewell parade in Barcelona for the International Brigades
November	Lincolns in Ripoll, in northern Catalonia near the French border, awaiting expatriation
November 16	Ebro campaign ends with Republican armies retreating across river
December 2	Over 300 Americans cross over into France
December 23	Nationalists begin offensive in Catalonia

..

1939

January 26 Nationalists capture Barcelona; nearly 100 more Americans escape to France

February 27 France and Britain recognize Franco regime

March 27 Nationalists take over Madrid

April 1 Franco declares war ended; more than 90 Americans in Nationalist prisons, most to come home that month

September 1 Hitler invades Poland; World War II begins

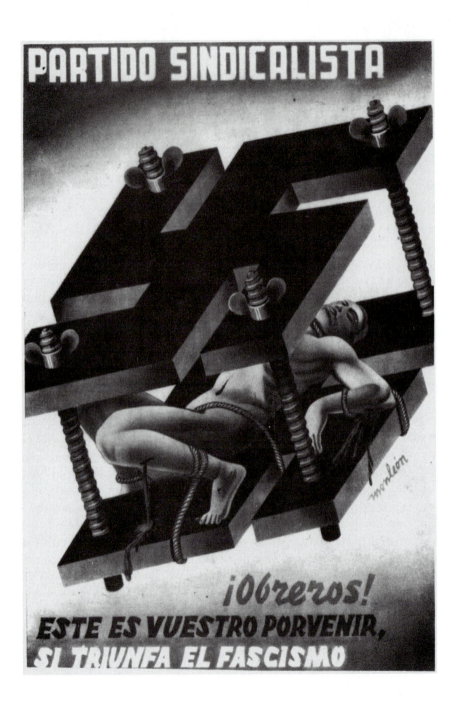

A postcard which depicts a Spanish worker being crushed within a press composed of two swastikas. (Workers! This is your future if fascism triumphs.)

I
WHY WE WENT
The Crusade Against Fascism

Why did 2,800 young Americans volunteer to risk their lives in a war in Spain in the middle of the Great Depression? We have little chance of understanding this extraordinary fact now unless we begin by recognizing that—however remarkable these decisions seem to us—it was not in the least remarkable that thousands of Americans *considered* fighting in Spain. Then, as now, isolationism was a strong force in the country. But there was a strong counter-force as well, one strangely less common now, despite increased ease of travel and communication: internationalism. A significant number of Americans in the 1930s saw themselves as citizens of the world, and the rise of fascism seemed to them not merely to threaten Europe but to threaten the world as a whole. In retrospect, most of us would agree with them, but they paid a heavy price for being right. Hundreds of Americans, more than twenty-five percent of those who went, lost their lives in Spain. Many who returned were severely wounded. For decades many suffered from political persecution. Subsequent history, if anything, makes the historical vision and idealism that propelled these Americans halfway across the world even more poignant. In their letters we can hear as clearly as we could wish both the differences in their backgrounds and the universal antifascism that held them together. Hy Katz writes partly as a Jew; Canute Frankson writes partly as an African American; Jack Friedman writes partly as a communist, but all of them share a core insight into the politics of their time. Many of the Americans wrote repeatedly, trying to convince friends and relatives of their reasons for going. In a pattern characteristic of the gender politics of the time, many were particularly concerned about worrying their mothers and some chose not to tell their mothers about their decision beforehand. But the common ground to their individual decisions is otherwise clear. As one American volunteer wrote in 1937, "Why did I go to Spain? First of all, because the victory of the system of oppression known as fascism would make my life meaningless."

Antifascism was already strong on the American Left before war broke out in Spain. By 1934, Nazi terror was being regularly reported in progressive newspapers. Many of the future Lincoln volunteers, moreover, were children of immigrant parents and thus felt a more immediate sense of connection with Europe. Many of them also felt considerable solidarity with the international working class. When military officers, strongly supported by wealthy land owners, rebelled against the progressive Spanish government, Americans on the Left recognized it as part of a Depression-era struggle against wealth and power already being waged at home. For a number of African Americans, finally,

fascism sealed its character when Mussolini invaded Ethiopia. Thus, when Hitler and Mussolini rapidly lent Franco their support, politically conscious progressive Americans immediately recognized the global importance of the Spanish conflict. Indeed, many of those on the Left who *didn't* volunteer to serve in Spain anguished about it for years afterwards.

All of this helps us to understand why it was plausible for Americans to care about the war and consider going to Spain. That leaves open the partly individual question of how and why each person came to make his or her decision. We can begin to glimpse the distinctive elements in each individual's choice in the list of reasons in James Lardner's letter here. On the other hand, when Edwin Rolfe was writing about this subject a few months after returning from Spain—in his book *The Lincoln Battalion* that would be published at the end of 1939—he realized the question could never be fully answered:

> Just what it was that sent each single one of these Americans across the Atlantic to fight for the independence of Spain will never be completely known. The bridge between the impulse and the act is a highly personal process, one that men rarely divulge to others, even when they themselves are conscious enough to trace its intricate path. There is a no-man's land between conviction and action into which the great majority of humankind never venture. Today, the final determining factor which set each single one of the Americans in motion on this dramatic crusade has died with 1,000 of them. The others, who have returned, will probably guard some small part of the secret all their lives.

from EUGENE WOLMAN

Los Angeles, California
March 13, 1938

Dear Dad:

This is one of the toughest letters I ever expect to have to write, but I feel sure you will understand. As you know, ever since hostilities commenced I have wanted to go over there but my Union activity was such that I felt it my duty to remain here. Now things have reached that point where I feel free to go.

Although I know your love, I believe you will sympathize with my emotion and determination. The only one I feel unhappy about is Mother, and somehow I feel she too will understand. After all, she was spared any unhappiness in the last war, and unless these forces are stopped we are sure to have another war in which Milty, Harvey, Roland, Howard, Elmer and I would surely be dragged. You see, in two of these cases at least, it is your own fault for being the virile Father of two such healthy young animals who would be sure to be among the first drafted.

I am not going as a fighter, but as a worker, probably transport and freight car loading, while my languages should also come in handy.

My car is in the process of being sold and I shall be starting with the group for New York this Wednesday, probably by bus. It is an honor to have been accepted as one of

the many applicants. I considered giving the car to Miki and Milty as a wedding present, but it has reached that stage where it would be more of a liability than an asset. Please cancel the insurance you have been so kind as to pay.

The California committee is responsible for us getting to New York, after that the N.Y. agency takes over. If a real war came the rest of us and I would be forced to fight for something that was not even to our advantage while here I have a chance to strike a well-aimed although indirect blow at those forces which would make life hell for all of us.

To Mother I am only writing that I am leaving for New York this Wednesday and that I shall probably arrive around Sunday and that I shall probably be in New York for one week or one day, but that I am going places and doing things. If you think it wise send this letter along to her. If you think it better I don't come home at all, since I have already been away so long, say so, and I will have none the less love for you.

I hardly expect you to try, but if Mother should, let her know that nothing she can say or do can alter my decision. Quite likely I seem selfish, but if you consider what I am doing it will appear at least an enlightened selfishness. If I believed for one moment of any attempt at stopping the process (although such an attempt would be fruitless of necessity), I would not write. Such sabotage would be guilty of Trotsky and no one else. Naturally, in this undertaking absolute secrecy is necessary. If you believe there is any possibility of Mother acting rashly please do not inform her. I know her for a very good, very courageous, very generous person, but she is sometimes excitable.

As for the honeymoon couple, I would not want them to alter their plans on my account. If they happen to be home by then that will be so much the better. Do you want the old Corona or shall I present it to some of my comrades?

Remember, absolute secrecy. Believe me, I love you all very dearly, but after months of deliberation I know and I feel it in my heart that I am doing right.

<div style="text-align: right">

Gene

Very much love,

Your Son, Brother, &

Comrade

</div>

· ·

from HYMAN KATZ

<div style="text-align: right">

11/25/37

</div>

Dear Ma,

It's quite difficult for me to write this letter, but it must be done; Claire writes me that you know I'm in Spain.

Of course, you know that the reason I didn't tell you where I was, is that I didn't want to hurt you. I realize that I was foolish for not understanding that you would have to find out.

I came to Spain because I felt I had to. Look at the world situation. We didn't worry when Mussolini came to power in Italy. We felt bad when Hitler became Chancellor of Germany, but what could we do? We felt—though we tried to help and sympathize— that it was their problem and wouldn't affect us. Then the fascist governments sent out agents and began to gain power in other countries. Remember the anti-Semitic troubles

in Austria only about a year ago. Look at what is happening in Poland; and see how the fascists are increasing their power in the Balkans—and Greece—and how the Italians are trying to play up to the Arab leaders.

Seeing all these things—how fascism is grasping power in many countries (including the U.S., where there are many Nazi organizations and Nazi agents and spies)—can't you see that fascism is our own problem—that it may come to us as it came to other countries? And don't you realize that we Jews will be the first to suffer if fascism comes?

But if we didn't see clearly the hand of Mussolini and Hitler in all these countries, in Spain we can't help seeing it.

Together with their agent, Franco, they are trying to set up the same anti-progressive, anti-Semitic regime in Spain, as they have in Italy and Germany.

If we sit by and let them grow stronger by taking Spain, they will move on to France and will not stop there; and it won't be long before they get to America.

Realizing this, can I sit by and wait until the beasts get to my very door—until it is too late, and there is no one I can call on for help? And would I even deserve help from others when the trouble comes upon me, if I were to refuse help to those who need it today? If I permitted such a time to come—and as a Jew and a progressive, I would be among the first to fall under the axe of the fascists—all I could do then would be to curse myself and say, "Why didn't I wake up when the alarm-clock rang?"

But then it would be too late—just as it was too late for the Jews in Germany to find out in 1933 that they were wrong in believing that Hitler would never rule Germany.

I know that you are worried about me; but how often is the operation which worries us, most necessary to save us? Many mothers here, in places not close to the battle-front, would not let their children go to fight, until the fascist bombing planes came along; and then it was too late. Many mothers here have been crippled or killed, or their husbands and children maimed or killed; yet some of these mothers did not want to send their sons and husbands to the war, until the fascist bombs taught them in such a horrible manner—what common sense could not teach them.

Yes, Ma, this is a case where sons must go against their mothers' wishes for the sake of their mothers themselves.

So I took up arms against the persecutors of my people—the Jews—and my class—the Oppressed. I am fighting against those who establish an inquisition like that of their ideological ancestors several centuries ago, in Spain. Are these traits which you admire so much in a Prophet Jeremiah or a Judas Maccabeus, bad when your son exhibits them? Of course, I am not a Jeremiah or a Judas; but I'm trying with my own meager capabilities, to do what they did with their great capabilities, in the struggle for Liberty, Well-being and Peace.

Now for a little news. I am a good soldier and have held several offices in the few months that I've been in Spain. I am now convalescing from a wound in my thigh, received Oct. 13. I'm feeling swell now; I got such good treatment in the hospital that I've gained an awful lot of weight. Now, I'm at a seaside resort which was once inhabited by Franco and other swanks. In New York, when it got cold, we used to hear about people going to Florida, but who would ever have thought that I, too, would someday celebrate Thanksgiving (and Armistice day) by swimming and playing volley-ball, dressed only in tights?

I'd better stop writing or I'll have nothing to say next time. I've been writing to you regularly, thru the Paris address, which did not turn out very reliable. I only received one letter from you, which Claire typed the first week in September. Now all this will be changed; you can write me direct:

H. Katz
S.R.I. #17.1
Plaza del Altozano
Albacete, Spain

Write me everything all over again. Claire tells me you've fixed up the house beautifully; I know you did it mainly for me and I appreciate it. I'll bet I won't recognize the place when I get back.

Write me about everyone in the family. I lost the address list, so I couldn't write to them. Send me another list with all the addresses: Grandpa, Sidney, Uncle, Judith, Sarah, Jonah, and everybody else. Also of the folks in Palestine.

Give them all my regards.

> Lovingly,
> Chaim

P.S. Hello Leibsche,

I'm sorry about the trouble you went to in Paris.

How are you? How does it feel to be back? How were things in Palestine when you left?

We have a good bunch of Palestinians here, fighting with us, showing the fascists a thing or two.

Whatever gave your wife the idea that I might be in Spain? Maybe the same thing which moved me to come here. Watch out, she may unconsciously have the mind of an antifascist.

I hope you're enjoying your stay in New York, and I hope you stay long.

> Yours,
> Hymie

..

from CANUTE FRANKSON

> Albacete, Spain
> July 6, 1937

My Dear Friend:

I'm sure that by this time you are still waiting for a detailed explanation of what has this international struggle to do with my being here. Since this is a war between whites who for centuries have held us in slavery, and have heaped every kind of insult and abuse upon us, segregated and jim-crowed us; why I, a Negro, who have fought through these years for the rights of my people, am here in Spain today?

Because we are no longer an isolated minority group fighting hopelessly against an immense giant. Because, my dear, we have joined with, and become an active part of, a great progressive force, on whose shoulders rests the responsibility of saving human civilization from the planned destruction of a small group of degenerates gone mad in

their lust for power. Because if we crush Fascism here, we'll save our people in America, and in other parts of the world, from the vicious persecution, wholesale imprisonment, and slaughter which the Jewish people suffered and are suffering under Hitler's Fascist heels.

All we have to do is to think of the lynching of our people. We can but look back at the pages of American history stained with the blood of Negroes; stink with the burning bodies of our people hanging from trees; bitter with the groans of our tortured loved ones from whose living bodies ears, fingers, toes have been cut for souvenirs—living bodies into which red-hot pokers have been thrust. All because of a hate created in the minds of men and women by their masters who keep us all under their heels while they suck our blood, while they live in their bed of ease by exploiting us.

But these people who howl like hungry wolves for our blood, must we hate them? Must we keep the flame which these masters kindled constantly fed? Are these men and women responsible for the programs of their masters, and the conditions which force them to such degraded depths? I think not. They are tools in the hands of unscrupulous masters. These same people are as hungry as we are. They live in dives and wear rags the same as we do. They, too, are robbed by the masters, and their faces kept down in the filth of a decayed system. They are our fellowmen. Soon, and very soon, they and we will understand. Soon, many Angelo Herndons will rise from among them, and from among us, and will lead us both against those who live by the stench of our burnt flesh. We will crush them. We will build us a new society—a society of peace and plenty. There will be no color line, no jim-crow trains, no lynching. That is why, my dear, I'm here in Spain.

On the battlefields of Spain we fight for the preservation of democracy. Here, we're laying the foundation for world peace, and for the liberation of my people, and of the human race. Here, where we're engaged in one of the most bitter struggles of human history, there is no color line, no discrimination, no race hatred. There's only one hate, and that is the hate for fascism. We know who our enemies are. The Spanish people are very sympathetic towards us. They are lovely people. I'll tell you about them later.

I promised not to preach, but by all indications this seems more like a sermon than a letter to an old friend. But how can I help it, being face to face with such trying circumstances? I'm quite conscious of the clumsiness of my effort to write an intimate letter, but your knowledge of my earnestness and sincerity, with your intelligence and patience, will enable you to understand and be tolerant. Later, after I've overcome this strain, I'm sure I'll be able to write more intimately. The consciousness of my responsibility for my actions has kept me under a terrific strain. Because I think it has caused you a lot of unpleasantness.

Don't think for one moment that the strain of this terrible war or the many miles between us has changed my feelings towards you. Our friendship has meant a great deal to me, and still means much to me. I appreciate it because it has always been a friendship of devoted and mutual interest. And I'll do whatever is within my power to maintain it.

No one knows the time he'll die, even under the most favorable conditions. So I, a soldier in active service, must know far less about how far or how close is death. But as long as I hold out I'll keep you in touch with events. Sometimes when I go to the

fronts the shells drop pretty close. Then I think it's only a matter of minutes. After I return here to the base I seem to see life from a new angle. Somehow it seems to be more beautiful. I'd think of you, home and all my friends, then get to working more feverishly than ever. Each of us must give all we have if this Fascist beast is to be destroyed.

After this is over I hope to share my happiness with you. It will be a happiness which could not have been achieved in any other way than having served in a cause so worthy. I hope that the apparent wrong which I committed may be compensated for by the service I'm giving here to the cause of democracy. I hope that you're well, and that you will, or have, forgiven me. My sincere desire is that you are happy, and when this is over that we meet again. But if a Fascist bullet stops me don't worry about it. If I am conscious before I die I don't think I'll be afraid. Of one thing I'm certain: I'll be satisfied that I've done my part.

So long. Until some future date. One never knows when there'll be time to write. There's so much to do, and so little time in which to do it. Love.

Salud.

Canute

..

from JOHN COOKSON

June 27, 1937

Dear Dad,

When I received your letter of May 26 yesterday, you received in reply one word "Happy"—this has a two-fold meaning, one—I was happy to hear from you and two—I am very happy here.

I'm terribly surprised that the *Press-Gazette* had in it that I was here but can well believe it since I've seen clippings of a number of small Wisconsin papers with names of fellows over here who I personally know hadn't told anyone. But before I left I wrote you a number of times that I wanted to see you badly but you were unable to get down. When I left Madison I had told but two people and they were not my landlady. Incidentally, I have sent back cards to various people from England and to the rest of the world, saying I'm there in France studying. You see, if I come out of this thing alive I would like very much to be able to come back and finish the few months for my Doctorate of Philosophy at the University. So I hope you will correctly guard these things.

Of course you are very surprised I'm here but it is the result of clear and cool judgement after a number of months. As you know we've spent many hours together in Madison talking about the next war. You remember how we planned to meet that war. Therefore you can well remember my hatred and fear of war. Thus it must still more surprise you that I'm here. Also, you know I've never been adventuristic nor had any suppressed desires. Such can not explain my actions. Further, my University work and all the wonderful laboratory equipment which was available to me was the strongest attachment I had. Also I stopped when near the final drive for my Doctorate. Further, to come here, I knew meant possible loss of citizenship and least of all loss of my US Army Commission. But you also know that by conviction and action, theory and

practice, I had turned "revolutionary" the past two years. *The most revolutionary thing one can do now is to fight fascism.* The truth of this I am now more certain than ever before. Hence, since I have tried to follow my life in accordance with dialectical materialism it was the only action I could take. No one spoke to me about it. I had collected $100, mainly reserved for next semester's fees at the University, went to NY and came here.

Never one moment have I regretted my actions. Even when during the third week and in a base town (read "New Masses" for March 18, I believe is the date) during one of the severest aerial bombardments any town has suffered (33 fascist planes, 70 bombs, none of our planes), even though they fell within 3/4 of a block and you could hear their whistles, and we were put to work digging out the dead while they fell—*I had no regrets.* In fact my thoughts were mainly and characteristically enough on the theory of probability and of vibrations! But since then I'm *plane-conscious* and always drop flat when I see one. In fact I can hear them before any of the other comrades.

In May they still hadn't sent me to the front and I had quite a nice, safe job offered 150 miles from the front. I applied for transfer to the front and got it in 24 hours. Well, I'm still alive. The last step also was perfectly voluntary and taken only because I couldn't conscientiously stay away from the real work, especially when so many of my friends came back wounded or didn't come back at all, having gone away never to be able to return. There is no bravery, etc. such as the C press is talking so much about, but merely we all want the respect for each other. In fact I may fall down on the job at the crucial time but I'm "praying" I shall be able to hold up O.K. Ever since mother's death I find I don't have the fear of it which I had before.

Well, anyway, since I'm here I've been trying to learn as much as possible. In the last Co. I was in we had 14 nationalities and 60 men. I have learned to speak German quite fluently, French enough to get by and some Spanish, which I read a great deal. But most significant and important is the revolution in my mind. I shall never think the old way. Now the works of Marx and Lenin are becoming clear in the light of contemporary events and experiences. One realizes on the one hand how little he knows, and on the other hand the methods for changing the world become more comprehensible.

Another thing, when here for the first couple of months I was of very poor health. I came here in a run-down condition. While particularly bad they sent me to a beautiful health-resort by the Mediterranean in Southern Spain. But I didn't improve much. However here I'm gaining weight, and haven't been sick, nor catch cold when it rains knee-deep. Am in the same latitude as at home but it is hot as hell here. The pears, peaches, apples, and figs are about ready to ripen.

Because of military censorship I can't tell you where I am nor much of what one does. By the way the censor cut out the portion of your letter between "I hope you will write me & tell me that you are all right.??????. Lots of love, etc."

I just heard from London on my improvised one-tube short-wave radio that Roosevelt has sent the National Guard to open two steel plants in Ohio. Well, labor should have no illusions about him now.

I am going to send a whole series of letters to you now. You can always get me at the Paris address or to

Name

Socorro Rojo Internacional
Staff Battalion 19
Brigada 15
Albacete, España
Anyway, I've gotten letters addressed merely name–Spain! In record time.

Salud

John

• •

from JOHN COOKSON

Socorro Rojo Internacional
Albacete, España
October 2, 1937

My Dear Aunt Mabel:

Today just eight months after I entered this country I have received your beautiful letter. It is always heartening to receive letters since they are so rare, and so many of your friends forget you ever existed.

Now there is just one theme in your whole letter—that is, you cannot understand why I am over here. I have written many friends and other relatives but unfortunately they do not grasp it, they fail to get the point I wish to put across.

You say I should not waste my life—for money. So I feel that you think I am here for money! Why this is false is clear when one remembers a soldier gets (at the present exchange rate for the peseta) something like 18¢ a day and at the front 21¢ a day, and as an officer I get at the front some 75¢ a day and return 50¢ of this back to the organizations for relief, then this argument completely fails. Nor can it explain why 3000 other Americans, most of them with jobs have left them for a similar purpose.

Yes, ever since you pointed out the North star to me 22 years ago, I have followed it in the dual sense of the French way of "Etoille"—star and destiny. The light of scientific truth can never be neglected by the humans. I am absolutely certain of my convictions and you know now I have followed them in the face of death. Yes, I was called crazy when I believed Italy would invade Ethiopia. I would have been called and was called crazy last January when I left for Europe. In Germany and Italy and other countries men were killed for harboring the idea that 30,000 Frenchmen, 3,000 Americans, and tens of thousands of people of 40 nationalities have put into effect—of giving active aid to the Spanish people. Now what do we find? England, the mighty British Empire reversing his stand, the American people reversing their stand, the greatest scientists, politicians, writers, artists, and statesmen calling for active help for Spain and many giving their work and life here. So I say one is not in bad company.

The whole thing can not be properly understood unless we are capable of understanding the role fascism is playing in the modern world. Fascism is but a powerful organization of finance capital for thwarting the people and the working class in particular to achieve their own well-being at the expense of a powerful minority. Mussolini was put in power by a billion dollar loan from Wall Street. Now he thinks he can do the same thing with Spain. Hitler was supported by the Krupps and Thyssens and when he took power he destroyed ruthlessly the great Social-Democratic party which

represented one-third of the German people, their great trade union—the most progressive and largest in the world, not counting all the minor parties and organizations from left to right. Both countries have embarked upon ambitious war programs, and under the mask of destroying Bolshevism are openly and secretly attacking the democratic powers and even the semi-democratic powers (such as the Hitler March putsch in Rumania this year) for their tin, lead, mercury, coal and iron. Fascism, in its fanatical attempt to solve its economic problems can only resort to power of war, and so we must characterize fascism as "Fascism is War." Those things which represent the advance of human knowledge mean nothing to it, and we find the great writers, like Thomas Mann, and thousands of the world's most famous scientists like Einstein driven into exile. If Spain turns fascist, then Belgium and France can not hold off the menace there. Then England, China, and America. But we cannot tolerate a long period of history, and I least of all as an embryo scientist, of fascism. For scientific investigation is thwarted. Yes, war is bad, and I believe I know that more realistically than anybody, especially you. To see whole villages shelled and bombed into dust, to see fields strewn with uncountable dead, of friends maimed for life, to see the beautiful city of Madrid shelled daily, with the innocent noncombatants (mainly women and children since the men are at the front) makes any sincere person say "war is nothing glorious." Therefore we must make that society where the economic basis of war is forever destroyed. Already in Spain the economic base of fascism is destroyed (in Loyalist Spain).

Yes, war is so terrible that it might even be best to endure the barbarism and degradation and oppression of fascism. But there is a contradiction here. For from every analysis, Fascism is war, hence some wars have to be fought to avoid future wars. The Spanish war is one. The Chinese war is another. If the people of the world really knew and when they will know they will want to—they could stop war. They could stop this towering burden of armaments, and ever-increasing armaments races. They would take the first steps for Spain to grant her just demands (instead of binding her hand and foot as they have) to purchase arms so she can restore order—so she will have guns instead of brooms and pitchforks and clubs that thousands of Spaniards fell fighting with. They would stop the flow of materials from Germany to France. They would make Mussolini take his "volunteers" home. And in 6 weeks complete order would be restored.

Yes, I was called crazy when I dared mention last year the second world war was dangerously near. I was called "Red and radical" when defending the Loyalist government last August on. But all of that is different. Even the highest powers realize the nobility and dignity of the great Spanish government. They realize now (although still reluctant to take action) that if the Loyalists win, peace will result for Western Europe. They see the true aggressive, provocative war aims of the fascist powers. The peoples of the still democratic countries are seeing who are the fascist agents in their own countries. Yes, on every hand, there is far more hope than before.

So, I repeat once again, in brief, I had been absolutely convinced in the beliefs and theories I held. Philosophically, they were part of the same method that I could use in my theories of physics and mathematics (you recall, one of my papers was published adjoining one of Dr. Einstein), and although I loved my quartz crystals and tensor analysis dearer than anything else, I closed all since I had such a conviction in my

beliefs of the historical urgency of the existent situation—that to defeat fascism would insure a final victory for the forces of progressive and advanced humanity. I am sure I had no ideas of grandeur, for I had no special usable abilities—ever since I have been here I have been merely an unknown second lieutenant—but as I said above tens and tens of thousands from all over the world went through greater sacrifices, and tens of thousands are dead, and time has proven us correct—and so I repeat I feel I am in good company.

To be hungrier than ever before in your life, to be thirstier than ever before until you were like a beast instead of a human, to be more scared than ever before, to think you were going to die as the bombs from Mussolini's airplanes or the shells exploded after being shot from Adolph's guns, to be more tired than ever before—all of these things which I submitted myself to voluntarily, as have 3,000 other Americans, are surely not for 21 or 75¢ a day, nor for any adventurism, nor for any other hypothesis you may advance—they can be but for one thing—to follow the bright star of your beliefs to the bitter end, though it be death itself.

Remember, no one person is worth very much in this world. There are tens of thousands of young physicists that can do the work better than ever I can. I do not see it as a waste of one's life.

Yes, you are right, to waste one's life for money is the greatest human sin. That is why I shall always work and fight for a society where the initiative to work is not one of profit, but one where the greatest good is done for the greatest number. I realize that it is hard to do such in a University controlled by a Mellon who even in his grave cheats the government of $350,000,000 and puts an iron grasp on the economic theories he feels are fit to be taught. I feel joyful I have escaped these bonds.

Yes, I shall feel very joyful, for you state that even though you may not understand me, you shall trust me. That is all I ask of you.

May I continue to receive many more letters from you. And remember, even when I get time I still work out my mathematical theories in Spain.

The Spanish people have a very common greeting for "Good-bye" which is "To your Health" and is given by

<div style="text-align: right">

Salud,

John Cookson

</div>

P.S. Your letter which was of July 27, reached me only today (Oct. 2) since it was forwarded to the German Brigade, the Ernst Thaelmann's.

· ·

from WILFRED MENDELSON

<div style="text-align: right">

June 22, 1938

</div>

Dear Folks,

Congratulations to a brainy set of parents and a crackerjack sister. Your letters arrived this afternoon—the first for any American at the training base and I am the envy of all...

I read them over several times and am beginning to get used to the idea of having received them from you.

I've got to admit it had me crying from joy—but absolutely unashamedly. And now

I want to confess about my first letters. I was feeling a little low and so tried to avoid personal remarks because I didn't know how to handle them, so tried to cover up by writing about Spain in general, and wasn't successful there either.

But now, I'm quite adjusted. I'm absolutely happy, the food agrees with me and I have a husky appetite, which is sometimes difficult to satisfy. But we are all becoming expert foragers and learning how to make up for the possible deficits in the meals.

I am happy because I am absorbed in my work (did I tell you this before?) as editor of the Brigade wall paper and as assistant to the Political Commissar; by the way I expect to become Commissar for our Brigade recruits next week.

Our bunch, which is a true cross-section of America, auto workers from Detroit, steel men from McKeesport and Pittsburgh, sailors and longshoremen, are quite united and this will certainly show good results at the front.

Listen, Pop, you know I hardly could say goodbye. Everything was stiff and formal and touchy. I regret it now. But I want pictures of you to keep constantly at my side. Jeanette writes about you forgetting to give me money, but I am still 27 dollars ahead at this writing, which is just about 27 more than most.

As for taking care of myself, let me tell you straight that the greatest proletarian force in the world is seeing to that. From instruction to military generalship to equipment—tanks, planes, heavy and light guns.

Maybe you could use some of my pesetas—we make 10 a day, about 40¢ American money. But living is cheap what with a haircut costing 1 peseta and practically anything can be bought with a cigarette.

One word to Sam on the Jewish question. The real international language here is Yiddish. Jews from Germany, France, England, Poland, Czech, Hungary, Rumania, all the front ranks of their respective movements have come to battle the common enemy of the workers, and of the Jews as a special oppressed minority.

And Spain is perhaps a fit arena for this struggle. Here it was that the Medieval Inquisition drove the Jews from their homes and their livelihoods. Today Jews are returning welcomed by the entire Spanish people to fight the modern Inquisition, and in many cases the direct descendants of the ancient persecution—the Catholic Jesuit hierarchy—the feudal landholders combined with the finance capitalist oligarchy.

Yes, Pop, I am sure we are fighting in the best Maccabean tradition. And so goodbye for the present.

Salud and love for a speedy victory and return.

Wilfred

. .

from LEO GORDON

Aug. 26, 1937

Dear Gus,[1]

I suppose I did leave kinda abruptly. There's just one defense I have. It was

[1] Joe and Leo Gordon, brothers born in Brooklyn in 1914 and 1915 respectively, abandoned their family name, Mendelowitz, and adopted the name Gordon in the early 1930s. Both went to Spain. Their letters were written to Gussie Moskowitz, a cousin in New York.

necessary. As a matter of fact, it was the only way. Some time ago I informed Agnes that I wanted to go. She nearly passed out. She refused to discuss the question at all. Had I persisted, it would have broken us up eventually. It was then I knew that if I were to go at all it would have to be done on the q.t. If you think I could have done otherwise you just don't know Agnes. I'm sorry I hurt her. It's the toughest part of being out here. But look at it this way. On all sides of me in camp, the same problem confronts hundreds of the boys. I talk to them. One tells of how he managed to circumvent his mother. He told her he was going out west as a salesman. Thru some arrangement, she gets his letters post-marked from California. Then there's a Canadian who's all busted up cause he learned that his wife and kids are penniless. There are many other cases. What's your solution? Stay home & fight fascism in the U.S. while the fascists take over Spain? That wasn't the way the fighting Lincoln Battalion was built. Sentiment didn't stop the fascists at the Jarama River or at Brunete.

In the book *It Can't Happen Here* Doremus Jessup comes to this conclusion. Although at first deterred from fighting the powers-that-be because of his family, position and responsibilities, he later decides that these are age-old excuses that men have used to keep them from the struggle. After all, it's only a matter of time before there will be very little choice as to what sector one will be able to handle a rifle. Before long, Spain may be the quietest spot on the globe.

I hope Agnes snaps out of it. I've already sent two letters. My staying at home wouldn't have altered her financial status. On relief, one can live as cheaply as two. Thanks a lot for wanting to give her a hand. I wish she'd take advantage of your offer.

Chosie is going home. It may be a matter of weeks or months however. These things aren't done instantaneously. I met him about two weeks ago in a hospital in Albacete. He had picked up a piece of shrapnel in his leg at Brunete. Chosie has established a reputation in Spain that will live as long as the Republic exists. A hard bitten soldier who never knew the meaning of fear, he participated in every major engagement. In moments of crises, of swift battle and instant death, when some of the stoutest hearts cracked (names that would astonish you) he never deserted his post. They talk of his exploits, stories that never got back to the States. Others got the publicity, but Chosie did the job. The history of the Americans in Spain is yet to be written. If it's in any way accurate, the name Joe Gordon will be plastered all over its pages. You may think that I'm melodramatic in my description. Actually I've been understating the facts.

I've been palling around here with a guy from my neighborhood, Hy Stone. Another tradition. Back home, he was sort of a quiet, retiring kind of egg. Out here he went thru hell and spat in the devil's eye. Here's the story. Near Brunete his company underwent a terrific bombardment. His entire command was killed (commanders don't live very long). Hy was appointed adjutant (second-in-command). Actually he ran the show. At about that time he rec'd news that both his brothers had been killed. They watched him closely, fearing that he would break. Hy compressed his lips—and went into action. The rest is on the books. 'Cause Hy Stone was cited for bravery shortly after. To give you an index of his character. He spent a coupla hours telling me the most important part of the war was ducking into cover & digging in at every available opportunity. A friend of his cut in and casually remarked that he thought Hy was a damn fool

for running along a ridge once in order to draw enemy fire so that he could discover their positions. That happens to be the closest substitute to suicide yet known to science.

There's a Negro section leader in my company who is very popular. Very intelligent, good at sports (yes, we have them occasionally) and a born leader. Once while marching down a road we passed a vineyard. All the fellows looked at the grapes longingly but in vain. There are certain restrictions about picking fruit. Sort of protect property if you know what I mean. Coming back we walked thru the same field. Suddenly Milt blew his whistle—an airplane signal! The entire mob dived into the bushes out of sight. Presently we heard the recall signal. Everybody emerged grinning widely—with peculiar bumps protruding out of their shirts. I got into a talk with him one day and learned that he was Milton Herndon, brother of the famous Angelo.

I can't tell you anything about the war that you don't know. In fact you're in a better position to get this information than I am. Right now, I'm in a machine-gun company learning the various operations that go with that phase of the work. You can tell Agnes that this is a very safe job cause the guns are always behind the infantry which means that they are far removed from the front lines. We are getting a lot of intensive training. Which has thus far removed a lot of excess poundage from yours truly. Living conditions are fair. Which means that you eat adequately and sleep adequately but that you can't exactly dissipate on luxuries.

We always have a flock of notable visitors. Last one was Ralph Bates—who is a regular guy.

There's another Negro comrade here who knows Yank. He used to work with him in the Workers Alliance. His name is Charlie Lewis.

I kinda miss Staten Island. Not the Island so much as the water. Here we've got to tramp 7 or 8 miles to get to a swimming hole. So don't forget to appreciate the place a little more for my sake. When you write, let me know what Agnes is doing etc. I hope to get a letter from her soon since yours was able to get here. Give my regards to all.

Leo

The correct address is: Leo Mendelowitz-274, S.R.I., Plaza de Altazano, Albacete, Spain.

from JACK FRIEDMAN

Saturday [Feb. 1937]

My dear George,

For one to start writing his farewell when one is not certain that it is to be his farewell kind of puts one on the spot. All that I now require is my passport to set me on my way, and, while I have applied for it, I will not know for another five days or so whether the State Department will grant it. However, since it is about ninety percent certain that I will go, I would like to say a few parting words, although I will write again before I leave.

I have taken this opportunity as a matter of course. Ever since I accepted the communist solution as the correct one for suffering humanity, I have always been of the

firm conviction that we would some day, somewhere, have to express our ideas in a most positive and active fashion. That day has come and the place is Spain. Sometimes it is necessary to sell *Daily Workers* on a street corner, we do that. At times we must educate from the soap box, we do that, then there are leaflets and strikes and demonstrations etc. We do all these things because it is necessary and important. Today it becomes vital that some of us go to "work" in Spain, and of course we go in the same manner. (It does not take silver-tongued orators or loud brass bands and flag waving to send us on our way, rather we hide and sneak and work in an undercover manner in order to offer all we can to a cause that is right. Rather we are pushed on by the certain knowledge that we are enlisted in a struggle that is for all humanity and one that must some day triumph.) Let me tell you, George, that to see the happily envious faces of the comrades who remain is in itself a great reward. But it is folly to think only on the barricades can one serve. Great is the honor that we must pay to those in Spain whose tireless work made the barricades possible. Without a Lenin prior to 1917 there would have been no 1917. And so for those that remain the task becomes more profound. I do not appeal to you to become aware of the great struggles that lie ahead for us in this country, and neither do I ask you to enlist in that struggle. I know full well that you are aware and that you are enlisted.

(I do ask my dear brother and comrade that, if I go and do not return, that as a tribute to me and all those who performed our last assignment on the barricades that you put forth all your energy in such a manner that our work will not have been in vain.) My greetings to you Hank and Milt, Salud. We all started together, it makes one happy to feel that we are all walking along the same path and will continue to do so.

<div style="text-align: right">Comradely
Jack</div>

P.S. Willner received your letter, thanks. Suggest that you send your letters for me care of Willner unless I notify you otherwise.

• •

from JACK FRIEDMAN

<div style="text-align: right">Wed. [Feb. 1937]</div>

My dear George:

In several hours I will be off, aboard the SS *President Roosevelt*.

There is little I can say at this time, perhaps if I were more articulate I could speak at length. Certainly I do not have to justify my action or waste words in an effort to support it. Those who feel that I must justify my action, I refer them to the bloody hand of Hitler, no further justification is needed. The dead babies on the streets of Madrid are more articulate than any master of words. The "nice" people on the other side of the house must now speak. Theirs is the task to convince humanity that it serves civilization when mothers and their babes in arms are slaughtered in a sewer of Madrid. Let them be articulate and explain to the world that it serves progress when men ask for liberty they should be given death. They dare not and have not the courage to speak on the real issue.

Of course I will write all I can. My best wishes to all my comrades. Milt, Hank,

Roger, and Leon. You must all remember many fine comrades are going; with that your task becomes greater. We expect much of you.

> NO PASARAN
> Jack

· ·

from JACK FRIEDMAN

March 17, 1937

My dear Joe:

One thing that I regret more than anything else is the fact that I was not able to say goodbye to you. So I now take this opportunity to do so–till I see you in Accord tipping a bottle of beer....I have just finished a 500 mile trip to the south of France with some of my friends. Needless to say this trip is one of the big events of my life. If someone should ask me, "Why are you here?" I would have to put the blame on Joe Freeman. Yes, Joe, I am glad that I am here and I shall always remember you as the person who helped to send me here....From what I can find out, our friends are doing very well. I will be able to say more about this in several days....There must be a little heaven somewhere for guys like you. If I don't see you before, I will hope to see you there.

> Best wishes,
> Jack

· ·

from JAMES LARDNER

Barcelona, May 3, 1938

Mother, darling,

This is a letter which I started to write on April 10. At that time I thought I was going to have to break the news to you gently, but you seem to have heard it before I had the chance. I have kept putting off writing to you because each day it seemed as if on the next I would know what I was going to do and where I would be stationed. I still don't know exactly what the situation is, but I am leaving in half an hour for Badalona, about seven miles up the coast, where I will learn the rudiments of artillery in company with a new mixed international unit. It looks as if French will be the medium of instruction. I shall let you know more as soon as I can.

This is a most exclusive army. It has taken me twelve days of going from person to person and office to get where I am. I have listened to advice of all varieties, a large part of it against my enlisting at all. The decision has been very much my own, and I took it after a great deal of consideration. My closest friend and principal adviser here has been Vincent (Jimmy) Sheean, who told me not to join, which shows you how stubborn I am, if you didn't know. Ernest Hemingway's advice was that it was a very fine thing if I wanted to fight against fascism, but that it was a personal matter that could only be decided by me.

I don't know how closely you have followed the war, but I imagine you must have an exaggerated idea of the danger of our position. On the map it looks as if Catalonia were a small fragment of territory about to be pushed into the Mediterranean, but in reality

it is a lot of country, and I don't think it will ever be conquered. There are too many people here who are fighting for things they believe in, and too few on the other side.

My views on the whole question are too complicated for me to try to explain here. I hope you are on our side and will try to convince your friends that I am not just being foolish. Not that I mind being thought foolish, but American opinion is a very important factor.

I have made up a list of reasons why I am enlisting in the International Brigade, which is fairly accurate, as I did it for my own information. I am copying it here so that you may see for yourself which are the real ones. Some of them are picayune and most of them would have been insufficient in themselves, but all have something to do with it:

> Because I believe that fascism is wrong and must be exterminated, and that liberal democracy or more probably communism is right.
>
> Because my joining the I.B. might have an effect on the amendment of the neutrality of the United States.
>
> Because after the war is over I shall be a more effective antifascist.
>
> Because in my ambitious quest for knowledge in all fields, I cannot afford in this age to overlook war.
>
> Because I shall come into contact with a lot of communists, who are very good company and from whom I expect to learn things.
>
> Because I am mentally lazy and should like to do some physical work for a change.
>
> Because I need something remarkable in my background to make up for my unfortunate self-consciousness in social relations.
>
> Because I think it will be good for my soul.
>
> Because there is a girl in Paris who will have to learn that my presence is not necessary to her existence.
>
> Because I want to impress various people, Bill for one.
>
> Because I hope to find material for some writing, probably a play.
>
> Because I want to improve my Spanish as well as my French.
>
> Because I want to know what it is like to be afraid of something and I want to see how other people react to danger.
>
> Because there may be a chance to do some reading and I won't have to wear a necktie.
>
> Because I should like once more to get in good physical condition.

The first four reasons and the ninth, especially the first, are the most important ones in my opinion, but you may decide for yourself. I have also considered a few reasons why I should not join the army, such as that I might get seriously wounded or killed

and that I shall cause you many weeks of worry. I am sorry for your sake that they are not enough to dissuade me. If it is any comfort to you at all, I still hate violence and cruelty and suffering and if I survive this war do not expect to take any dangerous part in the next.

If you still consider me one of your sons, you can send me an occasional letter and possibly a package now and then. My address here, I think, will be in care of the Brigades Internacionales, but for a while I think it will be simpler to communicate through the Sheeans. Anything edible would be appreciated, milk chocolate or raisins, or anything in cans that does not require preparation.

<div style="text-align:right">

Love,

Jim[2]

</div>

[2] Lardner was in Spain as a New York *Herald Tribune* correspondent when he decided to sign up with the International Brigades.

American volunteer Jack Friedman in Spain.

"In Madrid is the destiny of Europe." Postcard.

II

JOURNEY TO SPAIN
The Perils of a Sleeping World

INTRODUCTION

For most Americans, of course, the trip to Spain began in their own country. We follow one volunteer, Archie Brown, as he takes a bus from California to New York. There he is delayed, waiting for new arrangements to be set up after the French border with Spain is officially closed to volunteers. The delay gives him a chance to sample the progressive culture of the New York Left during the Great Depression, from going to meetings to attending plays; it was a world many of the volunteers knew well, and Brown's letters give us a chance to see it in miniature. We also learn something about racism in 30s culture and about the way the American volunteers fought against it.

The chapter weaves a coherent narrative out of many voices, as the volunteers board ship for a complex trip their government considered illegal. American passports during the war were stamped "Not Valid for Travel in Spain," and volunteers knew their citizenship might be threatened by military service in Spain. Some adopted new names as a result. For that and other reasons some degree of secrecy was appropriate. Those recruiting volunteers and arranging travel wanted to avoid prosecution for violating American law. There was also fear that efforts might be made to block groups of recruits from boarding ship, thus volunteers travelled in partial secrecy, sometimes not telling relatives of their plans until they arrived in Spain. In most cases travel costs were eventually covered by the Spanish Republic, but some Americans made their passage by stowing away aboard ship. After arriving in Paris, one leader from each group would report to the American liaison office for further orders. The trip itself also had many hazards. For most it ended with an exhausting but exhilarating hike across the Pyrenees mountains into Spain. Experienced guides, some recruited from a previous career in smuggling, led volunteers across at night, carefully avoiding border patrols. A less frequent route was by boat from Marseilles to the Spanish coast. For a few, as we learn from Jack Freeman's eyewitness letter about the "City of Barcelona," that voyage was fatal.

from ARCHIE BROWN

Feb. 15, 1938

Dear Hon [Brown]:

I'm dropping you this note waiting for the bus to take off from L.A. in about 40 min. It is now 3:20 in the p.m. and you are probably wondering what I am doing here this

late.

It's not such a long story, but a miserable one. You know there were four of us who were going and another guy who had wanted to go, but for one reason or another had fallen thru. More about this guy later.

The two Spanish descent fellows were fine calibre, non-party people, but burning with hatred for fascism. Both were married. The older fellow was divorced and had two kids, 13 & 16. They were both taken care of. One was with the mother and one was with the folks.

The younger one had a three-year-old baby. He had talked it over with his wife and they had agreed, it would be the best if he went to Spain to lick the fascists. They came from Mountain View and knew some people that I was acquainted with.

This extra guy was just going to N.Y. You remember T. introduced him to us. He was down in Panama, in the Canal Zone with Dean during the strike. He related some hair-raising stories of his adventures. It seems he knew that country very well. He is a sick man, and isn't supposed to drink.

Nevertheless, he and the small guy found out that they had been shipmates and proceeded to get drunk. This Jimmy can't drink. I knew it and warned him. He assured me that he could take care of himself. To make a long story short he got very nasty, yelling all over the bus and picking fights with all of us.

I was determined to send him back, when we got to L.A. That's what I've been doing all day, looking up people, nursing Jimmy's hangover, maneuvering to get him to bed and out of the way. Tonight he is being told that he is going back. I'm sitting here hoping he doesn't show up.

There was some compensation however. I lunched with Seema & Emma. (They paid for it). Seema bought me a carton of cigarettes —the darling, and I kissed her for it. I went out to Emma's place & took a shower and a shave. I'm sleepy, but feel good.

Your folks are O.K. and Seema is busy with a mass meeting, with some very distinguished speakers as Toledano, who is speaking via telephone from Mexico City. Some class eh?

I'll write often, my darling. Don't forget I love you so much.

<div align="right">Archie</div>

. .

from **ARCHIE BROWN**

<div align="right">Mineral Springs, Texas
Thurs. Feb. 17, 1938</div>

My Darling:

There is still not much doing. We just ride, stop, eat, ride and ache.

We finally got rid of the sea-slut. No longer do we hear her canary voice. There is a colored girl riding with us, and we began to encounter trouble upon entering Texas. She was born in N.Y. and came out to Calif. on the train, therefore never experiencing much discrimination.

They won't feed her in the dining rooms, she has to go in back. Rather than do that, she was simply refusing to eat. The surprising thing is that all of the passengers are incensed, but don't quite know what to do. One fellow took the lead and brought her in

this morning. He was going to tell her she was his wife. Several of us agreed to put up a beef. But it missed fire. She went to the can and most of us were eating by the time she came back.

Tony and I put up an argument when she was told to go in back, and walked out. I didn't let them punch my ticket.

I was leery about taking too active a part—so this man Tony brought the food out to her.

That's all now—I love you.

Archie

··

from ARCHIE BROWN

Feb. 21, 1938
New York

My Darling:

I arrived yesterday and just got myself located today. I had a little trouble as yesterday was Sunday and I couldn't go to the hotel assigned right away, as I had to get my suit pressed and hat cleaned. You should see that damned hat now, the cheap thing shrunk on me. Any hoo here I am and I don't know when I'll leave.

What to tell you? You know all about my trip, I wrote everything that happened. We really had a good time. There were 21 of us, mostly male, there were five girls and women. They were a good lot, except that shrew that stole the young 'un's money. There was a 19 year old baby that was married, and she was returning to her husband in the Missouri Ozarks. First she wouldn't admit that she was married—then she lost some $4 out of her purse and as I was sitting next to her she thought I took it. We went thru a process of elimination and finally discovered that she had let this other gal hold her purse while in the washroom and that she had been out of her sight for at least five minutes. There was nothing to do but take up a collection, which we did and collected $5.50. Then she was happy—but I wouldn't sit with her anymore and she was mad. Otherwise we sang and slept. I told them all about unions and told the colored girl about the National Negro Congress.

This colored girl was returning home to her husband after having gone with her employers to L.A. She was a maid and all around slave. She told me this old couple (65) spent $40 a month for rent alone, had a tremendous food bill. They were that thrifty type that Hearst speaks about. You see they would eat supper anywhere from 7 to 9 pm. About 6:45 the "lady" would come around and change the menu. All the prepared stuff would go into the garbage can and new stuff prepared. And of course they were against the unions. She finally got homesick and came back.

Have you seen the papers? Hitler is going to take over Austria—probably go after some African colony, and Mussolini will probably increase his agitation among the Arabs. The British tories are trying to come to some arrangements with these gangsters. Probably an attack upon the Soviet Union. The trouble is it's much easier for the Fascists to take weaker countries and colonies. Now some of these babies in the United States are going to have to take some kind of a stand. It's going to be very hard to sit on the fence. We'll probably see a big fight in Congress.

I'm writing this letter in the YCL National Office. As I sit here a guy comes in bubbling all over. He tells me he is from the Fair Play Branch in Brooklyn. He says "Remember how hard it was to get people to come down on Sunday? Well yesterday we had about 40 people come to the headquarters, some for the dramatic circle, some for the fencing class and others just held impromptu educational discussions," etc., etc....Having to defend our fair name against this outstanding achievement, I showed him that clipping you sent me. He thought that was fine, and was kind of envious. So thanks for the clipping and of course the letter, my Honey.

While we're at it, or are we, I want to bring up something. You say that you are working in the *People's World*. If it don't last I suppose you will go south. I suppose that you will come back to Frisco. At least I hope you do. If you stay in L.A. I believe you have more of a chance getting lost, in some no doubt important but nevertheless routine work. I think, despite the fact that you haven't gotten very far, you should stay with the Aux and build that girls' group. I have no reason to believe that you are better fitted for that than anything else. All I can go on is that you are acquainted with the Aux people, you know generally the idea, of what we want to accomplish there and no one else is quite in the position that you are. Also, and this is most important—it looks like the movement for youth clubs are growing, at least in the waterfront unions. And you could really go to town. Maybe you could also help get things organized in the women's section of the warehousemen. And maybe you could get known among those gals. What do you think sugar?

I'll find out about that ambulance business. I don't know exactly how but I'll try. So far I haven't made top connections. It will probably take a few days. Of course if you can make it, your work in SF might be delayed a little while.

That's all for now my sugar. Don't forget I love you.

<div align="right">Archie....</div>

••

from ARCHIE BROWN

<div align="center">Feb. 22, 1938</div>

My sweetheart:

The first days of excitement are nearly over. I'm beginning to be lonely. I woke up last night, a little cold (maybe because these clowns forgot to put a blanket on the bed), and started to move over to you. But of course you weren't there.

I miss supper at home terribly and I miss you so much. We get a dollar a day for meals, which is just about enough to eat on, now that I'm beginning to lose my appetite. Meals here are very high unless you eat scantily and eat poor food. I have to locate the proper places to eat, then I guess I'll be all right. I'll have to skimp along fairly carefully, so that I can take care of the laundry too. I'm going to do some washing tonite.

I don't know how long this business is going to take. I'm going up tomorrow and see if I can't work another angle. Meanwhile we'll hope for the best.

I attended the Party Builders Congress Open Session at Madison Sq. Garden last night, and it was a wow!

There wasn't the usual pageantry, because they intended to make it a real education meeting and they did: 20,000 people listened to Ford, Foster & Browder (thru a letter,

as he was sick) analyze Hitler's actions and the fight for world peace.

Ford outlined the past History of the U.S. and did a good job. He showed that neither Washington, Jackson, Lincoln or Frederick Douglass were isolationists when it came down to brass tacks. All of them invited foreign help, and cooperated with foreign nations fighting for independence. He cited the French & Polish troops that came during the Revolutionary War. The fact that Washington was greatly pleased when they sent him the key from the French Bastille. He also cited Lincoln's letter of thanks to Karl Marx, during the Civil War.

Foster and Browder exposed the lie that the Communists were for war and that they were only pretending to be for democracy. They showed how by averting war the working class was strengthening itself, building so strongly that in conjunction with their allies the farmers & middle classes they could move on thru a people's front gov't to Socialism.

The same for democracy: The Communists prospered best in democratic countries, not under fascism. We were really the defenders of democracy and only want to extend that democracy to its fullest blossom—Socialism.

I met Luba, and Doris Libson. Doris came out here to get married. Luba thinks she might stay. I saw a bunch of ex-Californians including Rapport, Jackson, Sam Darcy, Celeste Strath etc.

I went to see a show here called "Casey Jones," thru a comrade who got passes. It was really good. Charles Bickford took the lead. It was put on by the Group Theatre. It has received favorable comment from the papers.

We're trying to arrange to have the branches here take care of the fellows. More about that later.

I love you. Write soon.

Archie

. .

from ARCHIE BROWN

Feb. 25, 1938

My Darling:

I just got thru taking a shower, and there was no one here to wash my back. Now I have to go down to some restaurant and get some eggs.

Do you know if Bob is coming out or not? I just want to be ready to warn the boys here, that a tornado is coming to town.

I went to see the "Return of Maxim" and it was a honey. Be sure to see it when it comes to San Francisco. It's as good and better than the first.

I don't know what to write you sugar, except that I miss you terribly. I knew of course that I would before I left, but it doesn't help much.

Last nite I went to the "Spartacus" Club where they are trying to build a youth movement of downtown Manhattan boys & girls. You'd see North Beach all over again. The same tough bunch of hooligans. The adults have threatened to kick them out.

It seems that, not satisfied with coming to dances free, they proceeded to knock holes in the walls & wreck the furniture. But that wasn't the pay-off.

The Greek comrades have been trying to get the Greek women, who are a very

timid lot, to come to the hall. Finally several of them came up, with their hearts in their mouths. Coming up the stairs they saw water running down the bannisters. Looking up they saw a couple of these guys peeing down the banisters. The ladies just took off like deer.

And the Party organizer says to the League Comrade in charge, "What kind of pissing business is this?"

Before I forget, Luba wants to stay here, and has written for her transfer, but has received no action. She asked me to see what I could do. I wonder if you could get in touch with Kate and ask her to speed up Luba's transfer. She can't get into the work here without it.

Goodbye for now—I love you Hon.

 Archie

Hon, send me my union book & all my clearance cards— '34-'35-'36-'37. Love.

• •

from ARCHIE BROWN

 March 4, 1938
 [New York City]
Dear Hon:

Even tho I haven't received a letter from you within the last few days, here is an answer anyway. I have read about the floods you have been having, and I suppose that has a lot to do with the mail not getting here. From the accounts we see in the press the flood must be pretty terrible. I can't remember when they flooded downtown L.A. before. The *Daily* reports that the Party and YCL has issued a call for its members to help with the rescue work. That's good stuff. The papers also report that the floods took effect as far east as San Bernadino. Did it hit Ontario too? Were you people marooned? I hope that you didn't suffer any ill effects. All the farm needs now is a flood.

After a real cold spell here, with a biting wind blowing 40 miles an hour, it warmed up for two days. Now it's cold again, only the wind is not blowing so much. Since I moved out of the hotel, I have been able to put on some decent clothes. I go around in my cords and hickory shirt. When it's real cold I wear my sweater and the leather coat. That keeps the top warm, but the wind blows up my cords and it's cold. If it keeps up much longer, I'm going to have to get some warm underwear. I'm still awaiting word. Fisk was waiting here with me, but left the other nite. Using my prestige to the utmost, I might be able to make it. I'd hate like hell to go back to Frisco, and have the boys shoot questions at me.

I'm not having such a bad time here. I ran into Dave Lyons and a couple more guys and they are taking care of my entertainment. All I need is you to make things complete. You know how much I miss you honey—you know because I miss you like you miss me. I attended another branch, the Office Workers branch, which is reputed to be the best in the country as far as industrial branches are concerned. The meeting I attended was a business meeting, where they took up a three-months plan. That particular meeting was rather long and at times trying. But you could see that they were doing work and had a good line towards work in the union. The main line was to edu-

cate their union membership (which is mainly a youth membership), along the lines of a correct peace understanding.

Have you noticed how our press has put everything into explaining correctly that issue? That (peace and democracy) is the key towards stopping reaction at this time. The fascist[s] and their helpmates in democratic countries are trying to strengthen their economic and military forces by attack on weaker countries and colonies. If they can succeed, then the next step is to tackle the bigger countries, until the middle ages (stream lined of course) are brought back with a vengeance. The gentlemen of Wall St. are more afraid of real democracy than of fascism. If you really want to get a good understanding of the problems of peace and democracy, be sure to follow Broder's articles in the *New Masses*. And if you want to know how the fight for democracy can lead to Socialism read the article "Lenin and Collective Security" in the January *Communist*.

I saw a play "One Third of a Nation," put on by the WPA theatre. It was on the housing question and it was a honey. You remember "Power." Well it was put on in the same way, "the living newspaper." Only these people knew their stuff, they had this combination of vaudeville, movie, stage acting combination down pat. It really exposed the slums, and called for action by the people to put pressure on Congress and the States to kick thru with funds for slum clearance and new buildings. We were honored by the presence of Mrs. FDR. I'm told she attends these things quite regularly.

Now my fine feathered friend, you had better send me a letter, or I'll get mad. And no phoney excuses about floods, hurricanes or storms. That's the excuse all the other gals give me. I really shouldn't be treated the same way by my own wife. Really baby, I want to hear from you. I hope this gets thru and I get an answer real soon. I love you so much.

Archie.

..

from JACK FRIEDMAN

[Feb. 1937]
Thursday

My dear George,

I am in N.Y. at the moment and for what I consider a noble purpose. That noble purpose is service in Spain. I came here yesterday and will be examined to-morrow by those in charge. The main thing in my case will be a physical examination, aside from that it is almost a certain thing that I am going. If everything goes through I will leave within a week or ten days. Of course all expenses are taken care of but I would like to have a few extra sheckles in my pocket and that is my purpose in writing to you in such haste and haphazard form. If you can spare it I would like to have you send me about twenty dollars. I want you to send it registered air mail to George Willner at the *New Masses*. Promptness will be necessary. You must promise me that in the event that it will inconvenience you too much please don't send it, I will tap other sources. When I am definite beyond a doubt I will write to you at length and my farewell.

Jack

●●●

from EDWIN ROLFE

Sunday, June 5 (1937)

3 p.m.

Dearest little darling [Mary Rolfe]—

I've been on board ship for three hours now (four & 1/2, if you count the time before we left N.Y. harbor) and I'm still excited about the voyage. A Finnish gentleman has introduced me to his wife and his dog. We have all eaten our first meal aboard ship; and we (editorial *we,* of course) are not yet seasick, nor do we expect to be. The English accents are delightful and funny; as if a swarm of moving-picture cockneys were steering and manning the boat. Every third steward is an underfed Eric Blore. The waiters too—though they are far skinnier; have to be in order to slide between the closely-packed tables in the third-class dining room; where, incidentally, I had dishwater soup, fat mutton, tasteless potatoes and apple-pie al la mode & coffee in the company of another Finnish family: 4 females and one emaciated male. Began warming up toward end of meal, when we began passing sugar & milk at each other.

It seems that we're going to stop at Boston tomorrow to pick up other passengers, and I'll try to mail this to you when we dock.

You've never seen (and neither had I before today) how green the sea really is: and when the foam bubbles off the side of the boat, it's the color of green ink when you've been cleaning a fountain-pen with water in the wash stand of 4F, 119 E. 17th.

Darling, here are all the kisses (imagine them) which lipstick & haste prevented me (and you) from giving each other this a.m. Be good, careful, happy and gain some weight. And give my love to Leo, Jane, Vera, my family and especially to Stanley. Tell him (explain that I had to leave before I could see him for long).

All my love, sweetheart

S.

●●●

from EDWIN ROLFE

Sunday, June 13, 1937

Hello, dearest—

The ship is about 200 miles from Plymouth now, and we expect to dock there at 10 A.M. tomorrow. Only British subjects and those who have English visas will be permitted to land. From Plymouth the ship will go on to Ostend, and there I'll board the train for Havre, going to Paris. Which means that by Thursday the 17th I will be in Paris—Thursday at the very latest. There is much I could write about this trip, but the outstanding impression is that it has been too damn long. The Lancastria is a slow boat. The most it made in any one day was 403 miles. And when you add the 26 hours wasted on the very first day going to Boston, you'll realize why, after eight full days on board I'm still on board, with no land in sight. Now, with the sea-trip almost over, I can safely say that I escaped seasickness—which is fairly unusual when you consider that fully 50% of the passengers got sick during our first spell of rough sea. I thought for awhile that day, that I too was going to succumb; I felt slightly dizzy; and the sight of rows of people lining the rails and throwing it up, as well as the kidding of the

experienced sea-travellers, had a decidedly ill effect on me. I was afraid to go down for dinner, for fear I would puke on the table and spoil the meal for the five Finns who sit with me. But a fellow whom I met on board told me how to escape it: he walked up and down the deck, briskly, with me for a half-hour; then we played a fairly long game of shuffleboard, and finally he advised me to go down and eat heavily but avoid liquids. Which I did—and I came through with colors flying—but not in the wind.

My cold is still with me—and perhaps a bit worse because of a couple of dips I took in the pool, which is a small, canvas-covered bay on the upper deck capable of holding no more than 10 or 12 swimmers at a time. But I think it's breaking up now. Further news of this will reach you from Ostend or Paris.

Recreation on board is very limited: Sometimes I read; or I sleep on my deck-chair, which cost 63¢ for the entire voyage. Or I play at any of a number of games, which are too few for the passengers aboard, once I played a little half-size fiddle in the general room, while a 12-yr-old pianist accompanied me. Sometimes I join a number of other passengers in the men's smoking room; there we drink ale or stout or ginger-ale; and occasionally we play poker for small stakes. Nobody ever wins much and nobody ever loses much. I think the passengers as a body are fed up with this slow ship: all of them talk of booking passage on the Normandie or the Queen Mary for the return voyage.

Meanwhile, several odd characters—students, painters, plumbers, Vanderbilt's English Chauffeur, seamen, barbers, etc.—help us to pass the time. There are as many accents on board as there are people. And for the first time I understand why people who spend 2 weeks in England pick up a British accent. It's easy for a good ear and a facile mimic.

Darling, the other afternoon I picked up your picture and held it in the palm of my hand and wished I were back in N.Y. Then I picked up the picture and kissed you on the cheek, although I imagine my lips covered much of the rest of your body. Then I compared your solo picture with the snapshot of the two of us together; I kissed the other picture and held it to my cheek, and tried to imagine how it would feel if you were with me in the person & flesh, as well as in the image; but it was too easy to imagine you right there in my stateroom, so I cut it out, lest someone catch me unawares. Then I kissed the wallet good afternoon, and thought of you in that little tight-bodiced green checkered dress that you used to wear when I first met you. You must get another one like it before I return. Remember!

Forgive me for the dopey remark I made to you that last morning. The one about never forgetting a face. It has bothered me much all through the trip, and I wish I'd never said it. But I had to make some sort of flippant remark, otherwise I could not have broken away as easily as I did.

I'm going to try to write to Leo, to Stan and others, but if I don't get the time, give them my love yourself. And kiss Vera on the forehead for me.

And, for yourself, all my love, darling—and I hope you put your hair up with curlers every night, and that you're becoming a wow of a pianist. Love, and love.

Ed

• •

from ARCHIE BROWN

May 26, 1938

My dearest:

I don't know how comprehensive & satisfying this letter is going to be. It's the first I could possibly write you before now. When we left N.Y. I dropped you a line saying goodbye. Two of us left the "hard way." But I'm getting ahead of myself. A group was being sent over and there was the chance to stow a couple away.

For various technical reasons I was one of those chosen. So that a.m. we went down and met a man who introduced us to another man who told us "Now walk aboard as if you owned the joint." That wasn't so hard for me, as I'm used to walking aboard ship, but that's where the fun started—after we got on.

I was given $25 to give to a man who was supposed to have everything fixed. At the last moment he got cold feet, and there we were. Finally one of the boys told us to go up on the tourist deck and mingle with the passengers until the boat sailed. We did, and I spent one of the most agonizing hours of my life. Every moment I expected someone to accost us and ask for tickets.

Finally they gave the half hour signal & called for all those going ashore. Then I watched all the familiar finishing moves. The last batch of baggage goes aboard, the mail truck rushes up with the mail, the last visitor is rushed over the gangway as the lines are being let go—the whistle blows & we move out into the stream.

Ken (the other fellow) and I hold our breath. We waved to someone out in the crowd. The docks began slipping away. N.Y.'s skyline grew upon us. The buildings began to merge in the haze. We were nearing the 12 mile limit, where the pilot boat was to leave us, and then they couldn't send us back until the other side. The tension got worse as we waited for something to happen. We didn't know what to do. We didn't know whether to go below or wait until someone came up. We both needed a shave badly. The fellows who were going regular looked at us with wonderment in their eyes.

Finally we went down to the barbershop and got shaved. Then we dispatched one of the boys to see someone in the crew.

To make a long story short it was finally decided that we hibernate with the boys as passengers. There was nothing else we could do. For two days we lived in apprehension. Finally after the bedroom steward was greased when he called me Mr. Garcia, the tension eased.

Everybody knew where the boys were going. It was funny. We were not supposed to congregate. So the boys travelled from group to group. Luckily everyone figured that's just the way we should act. The crew outdid themselves in supplying us with food. The comrades went out of their way to give us their bunks, and brought us fruit & other edibles from the dining room.

At night we would go up in the lounge & drink beer & dance. The third day out I went up to watch the sunset. It was beautiful. About 9 p.m. it began. (We gain a lot of daylight travelling east, even tho the day is only 23 hours long.) The clouds turned a golden orange. The sea was calm, the waves barely exerting themselves to rise. They seemed loath to lose their crest, it would mean getting a new one. The golden hue deepened to a red & the waves caught fire. But a slow fire. Joe had dialed a soft French

tune on the short wave set & everything was at peace. Some day my darling you & I are going on a honeymoon.

Suddenly I was jarred loose from my reverie. The radio announced the latest crisis in Czechoslovakia. Then I see that group of Germans talking excitedly. We always suspected that they were Nazis. The ship was honeycombed with them. Even in the crew, tho they were in the minority & isolated to the steward's department. They kept asking the boys if they were going to Spain. Of course they got nothing out of them. One of the Germans that we suspected of being a Nazi was a young girl of 19 or 20. All I have to say is that's one time a Nazi got screwed by a Communist. (Not me now—one of the other boys.) She wanted to come to Paris with him—but he said no.

The last night was exciting to say the least. That is we were all on pins, figuring a way to get off. I fell asleep for about a half hour. I was squeezing a blackhead on my way home, when who should come to meet me halfway but you. It made me very happy. I held you tight for a long time & we both cried hysterically—but happily.

At the crew gangway, the Master of Arms stopped us & asked for passes. He looked at the ones we gave him and said they were phony. Time stood still for a minute. Then he gave us our passes & motioned us on. I think they had a good laugh.

Paris is beautiful. Such teeming pulsating life. The women with few exceptions are decidedly not beautiful. Even the ones in the cat houses are not. Or I should say—they particularly are not. The cat houses here are every bit as bad as they tell about—disgustingly so. But the people of Paris are decidedly not immoral. The hot spots are decidedly isolated & looked upon as a necessary evil.

We took a different train in from Le Havre to Paris & the boys were worried. Upon arrival they threw up such a hullabaloo so that the comrades in charge demanded they keep quiet. France is a beautiful country. So green. Their countryside is mainly landscaped. We ran along the Seine for miles. You could see the intensive cultivation of the land. Every farm was marked off in squares—with no spare space in between.

As the train ran along we came upon section gangs. We raised our fist in the air & gave them the "Popular Front" salute. Their picks and shovels went up into the air and they excitedly returned the salute, shouting at us. Life is sweet.

After we made the rounds of the gin mills & coffee houses (where they serve excellent sandwiches & fair coffee) we came home about 3 a.m. From the window I watched the daylight come in. Such a town—such a lovely strange skyline. Frisco & Paris are kin in spirit.

You won't hear from me for some time. So keep a stiff upper lip & fight like the comrade I know you are.

I love you my dear.

Archie

· ·

from CANUTE FRANKSON

Tarancón, Spain
July 23, 1937

My dear:

We stopped outside of this town to get a rest and something to eat. The commander

of the convoy with one of the men is in town getting food. The rest of them are all stretched out over the field sleeping. I've not received an answer to any of my letters. And according to the men who are here longer than I, it will be another month before I get one. That's not so hot.

I'm just about starved enough to eat a calf with its hair on. I'm also very tired. But if I go to sleep now, I'll only have to wake up when the food gets here. And then I wouldn't like that so well....How are you? Are you angry? Or, have you forgiven me?

I ought to tell you about my experience on the "Queen Mary" coming over. That ship is really a marvel of man's inventive mind. It's size and beauty is a credit to the genius of the human race. I sure appreciated the opportunity of being on that ship. But I'm still burning up. Because they segregated, or may I say, jim-crowed me. I cannot yet see how segregation, that despicable scourge of human society, could be alongside of such beauty. But it sure enough was. And with bells on. I spent hours in the salons looking at the pictures and carvings. It surely is an expression of the most modern art and culture. I wondered how the creators of such art could also be responsible for the jim-crow policy administered with such subtlety, as only the British know.

But on second thought I realize that creative genius is not the creator nor the instigator of racial segregation and discrimination. Such sordid products of human degeneracy can only be the work of a class which suppresses and exploits man's genius for its selfish gains. The men who built the "Queen Mary" are representatives of progress. Those who own it are our exploiters. They are representatives of Fascism, destruction, and war. The more I think of it the more justified I feel in having come here to help to stop the Fascist madmen. They would crush and enslave these lovely people under their iron heels. But we won't let them.

When I went into the salon to get my table number the chief steward was talking to a woman. After waiting for about five minutes he asked me if I wanted something. Suddenly I thought of a Georgia Cracker. I gave him the card with my name, and cabin and berth number. He was sitting in front of a table. The diagram of the dining room was inlaid on its surface. Each table was represented by small, rectangular blocks. Removable slips with numbers, in slots, represented the seats.

He looked down at the diagram, swirled around in the chair, looked up at me, then at the woman. He frowned, took off his cap, took a handkerchief from his pocket and wiped his face. The woman walked around uneasily. She kept her eyes shifting from one to the other of us. He shifted two slips from a table of two—one to a table of six, the other to a table of eight, then gave me a number corresponding to the table of two. He forced a sickening grin as he handed me the little card with the number. I thanked him coldly.

After chasing all over the vast dining room I found the table in one of the farthest corners, all by itself like a despised step-child. I was furious. But as everyone in the dining-room was staring at me I decided not to demonstrate. As I was about to sit down I noticed a picture on one of the walls representing an English hunting scene. For the moment I was distracted from my thought of some sort of revenge. Walking over toward the picture I discovered that each color and shade was not brought out by the painter's brush, but by the skillful inlaying of small pieces of hard-woods in their natural colors. I was so enchanted by the genius which created such a masterpiece that

for the moment I actually forgot the injustice of the ship management. I had seen some Mosaic work, but never knew that it could be done in wood.

I felt awfully disgusted when I returned to the table, but after the waiter came, in spite of his disgustingly submissive attitude, I felt a little better. When he returned with the first course of the meal he found, to his utter surprise and dismay, someone sitting at the table with me. He informed us that it was quite against ship rules to change tables. You know, sir, he added with his nauseating grin and politeness, it is the management. So far as I'm concerned it is perfectly alright for you to sit with the gentleman. Finally he took Hutner's order and brought him silverware and napkin.

[Dan] Hutner [another American volunteer] came over to my table because the men and women at his table and the adjoining one decided that something should be done about my sitting alone in the dining room. They had sensed the segregation, had a discussion on the subject and decided that some action should be taken. They decided that one of them should sit through the trip with me and he had volunteered.

They elected a committee and contacted the chief steward and told him, in no uncertain terms, that they did not like the idea of segregation. The chief gave them his slimy grin and told them how sorry he was but he thought that the passengers would not care to sit at a table with me. When they asked him if my feelings were not considered, he said he hadn't thought of that. They demanded that I be removed. But that, he explained, was quite impossible, as everything was already entered in the ship's log. And, of course he was very, very sorry. We could see how sorry he was, the dirty liar. When they told him that one of the passengers had volunteered to sit with me, he turned as white as a sheet. Then, I wished he would croak, the snake. Some of the women proposed a demonstration. But we discouraged that. It would not have been the wisest thing to do at that time, and under the circumstances. From then on most of my time was spent explaining to sympathetic people our problems. They asked many questions about us. Many of them wanted to know more about us than they read in the Hearst's Press.

Now, some of our so-called leaders would still have us believe that white people are our enemies. They go to all extremes to convince us that we must be loyal to our race leaders and especially to our race businessmen. But such is Kelly Miller's, George Schuyler's and DuBois' contribution to America's jim-crow system. It's beginning to smell in our nostrils. We just simply can't breathe much more of it.

Those people on board the "Queen Mary," you may note, were all whites, and strangers to me. But they were all workers. Some were shop workers, office workers, others domestic servants. Most of them were on their way to England, Ireland, and Scotland to visit relatives. Others were on their way to other parts of Europe. They are the people who represent progress and democracy. They are the people who fight with us against a common enemy for theirs and our freedom. For them we must have our rights as men. There must be no more jim-crow system. There must be no more lynching of our people. And with this kind of spirit that will be some day in the very near future an accomplished fact. The sad thing about it all is that it is from such people like those our so-called leaders would separate us. But they won't. Their preachment of isolation—for that is what it amounts to—is a plan to continue the system of segregation by which they live in their beds of ease. They must satisfy their masters who live by

such treachery, and whose puppets they are.

But fortunately, we are not, any more, an isolated group, but an integral part of the progressive forces of the world. Those of our race who lay the claim to leadership must inevitably be identified with the progressive forces or be trampled underfoot. We, the common people, are joining hands with our white brothers who are on the progressive side of the fence. And we're going places. So God help those who choose to try to stop us.

Those men and women on the luxurious "Queen Mary," who valiantly defied the powers and spiked their lies, are symbols of a movement, a force, an unconquerable will to save the human race from ultimate destruction. This period in world history calls for immediate and decisive action. There are two distinct camps. We, by heritage, cannot be identified with the camp of re-action. We must choose the side of progress.

We must unite all our forces. We must support, and help to put into action, the program of the National Negro Congress. Its program of *United Action* must be our slogan. We must encourage and urge our men and women who toil to join their respective unions. We must rally our people to support all men and organizations which fight for Negro rights. We must teach our people. We must convince them that the howling mob which lynches our people are victims of a system which keeps both lyncher and lynched in poverty and degradation by preaching and fostering bitter hatred between the races.

It is your duty in your social clubs and church groups to tell the people of our contribution to the cause of human liberation here in Spain. Tell them that our real enemies are those who supply Italy and Germany with arms with which to mercilessly slaughter Spain's innocent women and children. They are our moneyed lords. Those same gentlemen who use their Father Coughlins, Huey Longs, Lemkes, and Landons to deceive and betray us. And, unfortunately, those of our moneyed class who are victims of the same system. Their Liberty Leagues, Ku Klux Klans, Vigilante groups, and Black Legions have killed many of our people, particularly those who had proven to be our most honest and tried leaders.

We must not fall into the trap of racial isolation. That's just what the enemy wants us to do. We are a part of the American progressive movement. We have one common enemy, and can only win by uniting our forces. Anyone who opposes unity, consciously or unconsciously, is our enemy. Whether he is black or white does not matter. The Negro who opposes unity while he preaches race loyalty and race consciousness is by far the worst of the enemies.

We are doing our part here. You and especially our people must take some part in the struggle. Because if Fascism gains power in America we and the Jews will be the baits. They did it in Germany. We are a strong military force, but the final victory is dependent on the international aid we get. The harder the blow here against the Fascist beast, the easier it will be to extract his teeth at home.

Tell the children in your Sunday School of the homes we have here for the war orphans whose mothers and fathers have been murdered by Fascist bombs. Many of these homes are supported by contributions from the sympathetic countries. Others from donations from our small pay. Don't forget: every person who respects the rights of others and has the slightest trace of democracy left in him will help. The small

donation may mean a meal or even a glass of milk for one of these orphans. And there are many.

The fight is hard. The enemy is strong and cruel, vicious. But no existing force can ever withstand the tremendous advance or crush the formidable resistance of a united people defending its freedom and its country. And above all we are fighting not only for Spain, but for the cause of humanity and peace. I'll write again as soon as conditions permit. Until then—

Salud.
Canute

• •

from BEN GARDNER

Cunard White Star
RMS "Berengaria"

Dear Al [Alice Gardner]:

Have made up my mind to settle down for a few minutes & give you a picture of our trip etc. Tomorrow afternoon we land at Cherbourg. Am awaiting it anxiously, especially due to the boredom on this ship. It seems like the middle class & self styled petty bourgeoisie don't even know how to have a good time. They drink tea, see the rottenest & cheap movies far surpassed by the cheapest ones in any city, they promenade the decks, wrap themselves in blankets on chilly days & look & talk aimlessly & superficially. They invariably try to talk a la English accent & above all they eat & eat & eat. Of course I wouldn't say that I am blue all the time. We have some friends & a couple of acquaintances who understand things. Above all the 6 days on the Ocean is just something you have to go thru. I have been feeling fine doing very little reading, but plenty of eating & sleeping. Know very little or hardly any news. I understand the Blum Cabinet fell, but can't understand as yet the real situation. Hope I can get an English paper in Paris or I'll remain ignorant.

Now Alice Dear, I want to know how you feel in health & how you stand up to things. I can tell you that it was very hard for me to stand up there & look at you realizing that I won't see you for some time. Those last minutes when the ship began to move from the pier were terribly hard. You disappeared & I just couldn't find a place for myself. I was dying for just another glance. Honest you feel like jumping off & swimming to your dearest one. I couldn't get over it for a few hours at least that it was an actual reality. I know how you felt. I could see you fighting to hold your tears back & I was wondering whether you can stand such a test after all we have gone thru. I am sure you will. Many a day I wanted to talk to you for hours to explain how bad I felt about it. How it can't be otherwise than to part for a few months. I couldn't do it. Forgive me please for all the little, petty & unnecessary squabbles we had. We both didn't mean any of the fights real serious. We know each other too much. I realize that I should have been more patient & understanding but I think it all had to some degree, to do with my last two years' work, not feeling adjusted etc. Please let me know truthfully, how you feel physically, home, work etc. as soon as I send an address. Lots of Love to you always. With a much deeper feeling for you than ever. Regards to all the comrades. I remain yours.

Love Always
Ben Pobersky

Will write more interesting things after seeing Exposition.

. .

from JACK FRIEDMAN

Sat. Feb. 27 [1937]

My dear George,

At this moment we are speeding across France on our way to Paris from Le Havre. Incidentally the French trains go like hell and the countryside is most beautiful. Along the way we can see people working in their gardens, it seems they have a very early spring.

While the trip across was quite pleasant I shall remember it for its political significance. Many lessons were learned, some of which will be used to good advantage by the Americans. Here was the situation. Our group consisted of about fifty men. On board there were Trotsky provocateurs, Nazi agents, and representatives of the Department of Justice. Each of them trying their damndest to discover our mission with a view of blocking our efforts. Remember that one remains a subject of the US even while the boat may be in a French harbor. We dared not talk to any one for fear he might be a spy. While I am proud of my own record on the way over we must admit that many of them fell short of the requirements. We were admitted to France, but thanks should be given to the popular front and its attitude on the affair. The officials merely closed their eyes. You guys back home must learn how to act under these conditions. I can not sufficiently stress its importance. We had the opportunity to meet guys we would have sworn were OK only to discover they were phoney, they had credentials of every sort and a fine make up. We must at once learn how to conduct ourselves under these and similar conditions. The Americans at present have little or no ability along those lines at present, develop it and soon. You remember we used to think Joe and Charmion [Freeman] were silly in that respect; we were silly; they have been through the mill. I assure you those that "choose" to come back will be better men.

Of course I could write at length of a million things, but remember that I am obligated to write to many people. I will write again soon and perhaps at greater length. I salute the boys in Iowa. Carry on, things are happening at great pace.

C———
J.

. .

from BEN GARDNER

Cafe Central
Haute Place—St. Jean
June 30, 1937

Dearest Sweetheart:

I am spending here [just] a couple of days, so I can only write briefly. In traveling

thru France one certainly finds something to enjoy & learn. You see villages that are almost like those depicted in the geography books. You see quaint & antique houses & methods of transportation of centuries gone by alongside the modern automobile, etc. This part here is dotted with mountains & the houses are spread alongside & on top of the mountains. Every bit of useful ground is cultivated & olives & dates grow here. Almost every boy & man rides a bike & boy do they ride on the winding highways! The French language is beautiful if you can pick it up quick & if not it's a hell of job to get around. So you better polish up on it kid: Because next time we'll go together. Last night we took a walk along a winding road & the mountains right over us. Kid, I could have sat in one of those spots with you all night & just drunk it in. Talk about romance with a dear little wife like you, not a better place in the world I have seen so far. In traveling I will no doubt find places even more beautiful & I shall pick out the best spot for us two. To get to something even more interesting. Imagine towns of 60 & 70 thousand where from the Mayor to the street everyone is C.P. Of course you will find some S.P. & a few fascists who just have to keep in their holes & like it. Furthermore, will you be thrilled with me if I tell you I met one of these Mayors & another official & shook hands with them. I felt like the whole City Hall was mine, ours. Hope we can see that very speedily in America. I am traveling further today & after visiting a few additional places I am leaving for the Soviet Union. Since I left N.Y. I haven't seen an English paper with exception of the lousy English *Daily Express,* so you can imagine I am ignorant of the news in U.S. as well as [in] general. When I send a return address please let me know as much as possible the news. That means all kinds of news & I'll devour it like a hungry wolf. Alice, please don't cry, & if you do don't do it too much. Let me know how the apt. is. Does the landlord make himself a nuisance etc.? How is your work in the Union? Give them all my sincerest regards & tell them to carry on the work. To you I wish good health & love from the bottom of my heart. How I wish I could see you & kiss you once more. But where there is life there is hope. So Auf Wiedersehen. Regards to the family. Lots of Love. Yours always,

<div align="right">Ben</div>

• •

from BEN GARDNER

<div align="right">June 5, 1937</div>

Dearest Sweetheart:

Right now we are in the first Spanish village after traversing the mountains for 14 1/2 hours. Alice, if I were to write the whole letter describing the hike it would hardly describe it. One [must] experience it in order to understand it. Briefly, I can tell you that we walked thru places that none [of the] fifty of us believed was possible. Walking all night thru places where the man in front of you could not be discerned. Some comrades dropped by the wayside & had to be helped. [Illeg.] darkness, rain & believe it or not we came in feeling 100% fine. I feel better now than I did in the States. Continuing this further on, in another town, after a couple of days rest I can only add that I with other American comrades had the honor to be on guard duty at night. It wasn't so much the guarding itself as the wonderful feeling of holding a rifle with bayonet, guarding Democracy. For the first time in my life I felt that it is not capitalist property I'm

guarding, as I did in the National Guard, but the property of the workers, the people of Spain. We expect to leave today for our base. It will probably take 2 or 3 days & until then I will not get the opportunity to write to you. Right now I'm taking a sun bath with a group of comrades from many countries. Believe me some of us speak half a dozen languages. A couple of words in French, Yiddish with German comrades & so on. I understand that most of the comrades from Philly have already left for the front, with exception of the very recent ones. So I will not be able to see them as I promised to some comrades. Our small group from Philly has turned out to be in excellent shape, politically, morally & physically with exception of Fred the seaman who remained to get glasses. Tell Mac that I won't be able to write due to the fact that it is difficult & give my regards to all comrades & friends & send my love to Mom, Pop & the kids.

Will write as soon as we get to the final place with a return address.

> Love, Yours,
> Always,
> Ben

P.S. If this letter is a jumble it is only because it reflects traveling & consequently no proper concentration. June 7, 1937 I just met Joe & boy was I happy to see him.

..

from WILLIAM SENNETT

> Paris, France
> Feb. 28, 1937

Ma Femme:

A few days in Paris and I speak French. Notice! This is a lively and interesting place. Living, with American money is very cheap. A person can live on about 200 Francs a week, which is around $8.50 in American money.

The authorities at Le Havre held up a group of around 200 before getting off the boat telling us that the border was closed and that those who intended to get to Spain had better turn around and get back home. Apparently there were some people on board who were intending to get to Spain!

Starting with this paragraph I am writing March the first. I am so busy I couldn't finish yesterday. I have just been fondling a Spanish baby 11 months old. Its father was killed at the front a few weeks ago. His mother is with him. It is pitiful.

I have been staying in at different Hotels here and have found some peculiar (to us) French characteristics. Every hotel has a douche toilet. They all do not furnish soap. The toilets in the cheaper hotels are funny. In order to move your bowels you can't sit on a pot but there are foot rests and you crouch—on the streets there are on most corners open places for places to urinate. Women walk right by while men urinate and they consider it natural. Men walk out buttoning up their pants on the streets!

Prostitution is legalized here and women have cards as a licensed prostitute. These cards are supposed to be given every week after examination to certify that they have no venereal disease. But that is no guarantee. Among the boys here the penalty for seeing a prostitute is expulsion from the C.P. and YCL and I as the leader of the Americans

here have to deal with these people very sharply.[1]

Most of the boys including Rudy and Charley have been able to see something of Paris in the last few days, but I have no time. Tonite I have a few hours to spare so I'll try to go someplace.

I hope things are coming out all right back home with the car. Also how is our little puppy? Be sure to teach her some tricks. I would like to know that you are eating 3 good meals daily. It would warm my rather callous heart.

I have bought a watch here for $10.00 that would cost about $25.00 in the states. My other watch didn't keep good time. I gave it to Rudy.

Darling I've got things to do now and I've got to close. I may write tomorrow. Maybe.

<div align="right">With all my Love
Bill</div>

• •

from WILLIAM SENNETT

<div align="right">Mar. 2, 1937</div>

Bon jour ma Femme:

It is a beautiful Tuesday morning—I awoke at 8 A.M. and am in a position to write this short letter to you.

Last nite four of us went to the world famous Folies Bergere. The prices ranged from 10 francs to 70 francs (.50 to $3.50). Their entertainment would rate at the Oriental Theatre. The type of burlesque there is much cleaner and things are done more openly. They had a dance where a girl with only a small patch in the lower region and her breasts completely exposed practically went thru all the motions of sexual intercourse with 3 men. Different positions, etc. etc. At the end of the dance the fellow was laying on the girl—to the French that sight is nothing. It is artistic.

After the show was over (at midnight) while waiting for a taxi one of our boys was stopped at the door by a high class prostitute (in an evening gown). One of the boys went over to see just how she peddled her wares. Finally I got a taxi and went over to the fellows and said OK, let's go—you should have seen that woman when she saw the boys leave, she was amazed.

I am beginning to get used to some of the horrors (mild as yet) of war. A fellow was just carried out into a cab who returned from the front. His knee was shattered by a dum dum bullet and his whole leg and arms are paralyzed. He's pretty cheerful tho.

I got my new watch today—it looks swell—cost 185 francs (about $8.50)—one of the boys bought it for me. Also got a new scarf for around $1.15. Today I'm getting a French Beret; I may take a picture with it (if possible) and send it to you.

Yesterday I didn't mention Cicero. But I want you to know that I have confidence that you will build it up. If you have difficulties see Molly more often—keep in regular touch with the District and try to learn from other branches—act a lot on your own and develop yourself politically. Gee Gus, if you applied yourself I know that in a short time

[1] As Sennett himself no doubt soon realized, the prohibition against visiting houses of prostitution proved unenforceable.

you could be a section organizer—no kidding—your main fault now is not enuf confidence and aggressiveness—when you do something or propose it analyze it. Say it with decisiveness.

Darling, I must again end because of the press of business. It is 10:30 and people are milling around—the day begins——

Keep me in mind every once in a while—give my regards to the people you see— tell Johnny Marks and Irving Herman I don't want to write them at the D.O., but say that we have a splendid group and that I, a Chicagoan, am in charge of the Americans in Paris————

Love————I wish you were with me

<div align="right">Willie</div>

. .

from PAUL SIGEL

<div align="right">Spain
June 27, 1937</div>

Salud Miriam,

June 5 to the present time is quite a time to be traveling, but being here is sure worth it. You'll probably see the letter I sent to Mama, so I'll try not to repeat myself.

Last night I met Bernie Abraham here. He was just back from the front for one day. He's in the Washington Battalion, which is now stationed at the front. He gave me reports about Harry and Ernie. They're all O.K. and acting like seasoned campaigners. Bernie had one fascist explosive bullet that was a dud. It was a Remington bullet. Some "neutrality."

I want to tell you about something that happened in Paris. The last night we were there Joe Taylor, one of the people we met there, and myself went to have a look at the Exposition. We went thru the gates and out on a balcony. There in front of us was the Eiffel Tower rising up in a tremendous arch reaching towards a twilight sky. Beautiful modern buildings lined both sides of a wide plaza that was thronged with people, push-carts, autocars, buses, auto-trains, etc. Through the center, running perpendicular to the plaza and between the Tower and where we were standing, the Seine flowed serenely through the hustling and bustling mob of international tourists. Sight-seeing boats and small craft were busily plying back and forth across and up and down the river, affording the "furriners" another method of glimpsing the Exposition. The myriad colors of the buildings and drapings were distributed thruout the scene in a brilliant outburst of glory.

At any other place, any one of these sights would have caught and held the eye for many minutes. But here there was something that was far more outstanding than anything else in the Exposition. On the right side of the plaza, on the shores of the Seine, stood a beautiful marble building, about 80 ft. high. On top of the building, reaching to the sky it seemed, stood a man, a worker, and a woman. The man had his fist clenched reaching toward the sky. Across the plaza was the German building topped by a large eagle. It looked as though the man and woman on the Soviet building were going to reach across the few hundred intervening feet and smash the eagle and the whole fascist building.

Gradually the twilight deepened and, as it grew dark, the Exposition began to light up. As each part lit up there was an audible "ahhhh" from the people all around. When the German building and Eagle lit up there was a very audible "Boooooooo," etc. However, when the Soviet exhibit was illuminated, the feeling was so strong that there was spontaneous clapping and cheering. When night had completely fallen the Eiffel Tower was suddenly illuminated in a brilliant burst of emerald green, and with two searchlight bands reaching straight up as far as we could see. The whole view before us was indescribably beautiful. I say indescribably, because I know I cannot adequately describe our feelings. And I guess I might as well quit going into raptures. Suffice it to say, the three of us were left with such a deep impression of the sight (especially the so-emotionally powerful Soviet exhibit) that it will not be erased from our consciousness for a long while.

Incidentally Joe Taylor and myself became swell pals, traveling together all the way, and bunking together here in the barracks.

Hey Bert—Ernie Arion is in our company. He's been here for about four months— he's in the telephone patrol and is an instructor now. I'm in a dilemma now. He wants me to come into the telephone patrol with him for one thing—they're liable to utilize my "electrical abilities" in some other ways for another thing—and I want to stay here in the infantry—Oh well, wherever I can help best, that's where I'll probably be.

I've got to quit—I'm getting writer's cramp now, I haven't written for so long. Give my regards to all the boys and keep awriting (or rather start) to me. The address is:

S.R.I. No. 272, Plaza Del Altazona
Albacete, Spain

How are you making out, Mim? Tell me all about it.

Paul

• •

from JOE DALLET

Perpignan Prison, France
March 30, 1937

Dearest,

Twenty-five of us, seventeen Americans and eight Canadians, were picked up in a French fishing boat Saturday morning in French waters near the Spanish coast. We were just on a pleasure tour but were arrested by the non-intervention commission and have been in a filthy jail since.

We saw our lawyer who appears quite confident that we will be out in a few days. Steve is with me and asks that you write Margaret at once and tell her. The spirit, discipline, etc., of our boys are wonderful in spite of all the hardships, and we are treated splendidly by many political prisoners who were arrested crossing the frontier.

The jail food is uneatable but from tomorrow on we will be having plenty of food sent in by French friends. There is nothing for you to worry about. I will write again as soon as I know more. This letter must pass through the censor so is necessarily limited. We don't get any newspapers here and hardly know what is going on outside, although the lawyer says that our arrest brought front-page headlines in the French

press. We are naturally sore that we were arrested this way when we had done nothing at all wrong but as soon as we are out again and continue on our tour everything will be all right. The Mediterranean is beautiful from a small fishing boat; we had a swell trip until we were stopped.

I am signing off now; it's almost 5 P.M. when we must return to our cells until 7 A.M. There's nothing to worry about only it's rotten being cooped up here when it's so nice outside. We only get two half-hour periods each day to exercise in the prison yard.

We saw beautiful snow-capped mountains and lovely flowering fruit trees in the valleys below during our tour of Southern France. We went for hours in an auto in and out of the valleys. Some day you and I must travel this land together and hire us a small sailing boat and sail along the coast. Much love.

<div align="center">JOE</div>

• •

from JOE DALLET

<div align="right">Perpignan Jail, April 2</div>

Dearest,

There is quite a bit of news which I will try to tell you in an orderly manner: (1) The American vice-consul was here to quiz us and tell us that he had instructions from Washington to lift our passports until after our trial. (2) We have had preliminary hearings. Mine was yesterday, and after sticking to my fishy-sounding "tourist" story for over an hour and being threatened with six months extra for "mocking French justice," I finally, under lawyer's instructions, admitted we were going to Spain to work. Our lawyer, who is an S.P., seems convinced that we will get out immediately after our trial, which is set for April 15. He is also convinced (and here I doubt him) that we will *not* be expelled from France. The preliminary hearings are held at Cerette, 30 kilometers away from here. Today five of our boys (we go there a group of five each day) refused to talk or sign anything unless I was there, and the whole court was held up until the lawyer and a cop had come over here and gotten me in his car and taken me over there. Now it is set that I get out each day to go over with the five that are to be examined. We go in chains but we walk a couple of kilometers each way and it is a good change. Everyone stares and we raise our right fists in a salute and more than half of them return the salute. It's swell. My picture was in the *Perpignan Independent* today, taken as I came out of jail, fist raised. A group of railroad workers were reading the paper— they looked from it to me, smiled, nodded and then all saluted at once.

The jail is simply full of political prisoners who give us everything they've got. The outside friends are now sending in food daily (and today sent in also a jug of wine). We are hungry, however, for decent tobacco. Any tobacco, etc., you can send will be appreciated. More than smokes, though, I want letters from you.

Morale and discipline remain high. Our defiance was the talk of the prison—refusing to doff hats when cops entered, etc., unheard of before. We have fought for and won the right to be all together; and we have so much demoralized the prison regime that they have finally segregated us in private quarters, which we are now cleaning up and making really ship-shape with our own KP, sanitary, canteen, discipline, physical-education and general education committee.

Please write often but always remembering the censor. Remember what letters mean to class-war prisoners. Much love.

JOE

P.S. To add to a long list of queer things that have happened: (1) Me sitting at a piano in the room of the concierge of the Cerette Court, playing Chopin to a group including all the gendarmes, the assistant prosecutor, etc. (2) The gendarmes running to catch the last train from Cerette to Perpignan and Steve and I running after them instead of in the opposite direction. Asked if they weren't scared that we'd run away, they smiled, patted their revolver holsters and said "no." (3) Each day when we head towards Cerette we head towards the snow-covered mountains between us and Spain. Cerette is only four kilometers from the border. Yours

JOE

· ·

from JOE DALLET

Perpignan Jail, April 9, 1937

Dearest,

Your two letters were drunk up as eagerly as I drink the sunlight in our brief half-hour in the prison yard afternoons (the walls are too high for us to get any sun when we go out in the morning).

Important news—our trial has been advanced. It will be held this P.M. and I will not mail this until after sentence is pronounced and we know how things stand. Our lawyer, an S.P. who handles all our cases in this region and has done so for five years, is confident that everything will be O.K. in every sense of the word, and that we will be out, etc., by the end of the week.

Four Englishmen and one young American got transferred in with us after we put up a bitter fight. They had been lost two days in the mountains and were in bad shape physically and in worse shape morally. But we fed them chicken, pork chops, fish and wine last night (more than they could eat—thanks to our French friends outside who are more than generous). We fought for and won the right to get our razors and shave (for the first time since we're in) and now they're in much better spirits. Our gang is certainly clicking fine and it has had a healthy effect on the others. There is one bad egg among them but we will effectively isolate him.

Steve has been doing a swell job with our class and collectively we've had a good effect on the couple of weaker guys among us. He's a wonderful instructor—really inspiring. In afternoon lectures we've fairly well covered the world labor movement.

This prison is an old monastery or nunnery. The whole layout proves it. The day before yesterday our main dish was veal cutlets and those huge delicious French beans in great quantities. That night the vaulted halls that used to echo with the strains of organ music echoed with a veritable symphony of other sounds.

Last night the S.P. and C.P. of Perpignan held a joint demonstration for us. A whole flock of political prisoners have come in within the last few days. Almost every country in the world is now represented and there are some really wonderful guys. A series of thumb-nail sketches of those here, their backgrounds, etc., would make the finest

reading. Will try to do something along these lines when I get away. We have a wonderful English kid, T. Freeman, with us, whom we added to the top committee of the jail Soviet and also got him elected head of the English group. Their original captain had no prestige with them.

Continued Saturday morning

We had our trial, a semi-comic-opera affair, and got twenty days, which means that we get out Friday morning of the same week you receive this. Our lawyer made a really eloquent address. Summarized, it follows: "There are laws and laws, crimes and crimes. Theirs is a political crime—that they loved liberty, democracy and peace. Before this court I want to pay homage to these 25 Americans who left homes, jobs, families and friends to fight for their ideals. Let us not forget 1914 to 1918 when many more Americans came to our beloved country to fight for these same ideals. Every true son of France should pay homage to these prisoners. I beseech this tribunal to temper justice with the greatest mercy and sentence them to 15 days, so that by tomorrow night they can be on their way."

The court was packed with workers as were the streets outside. The three judges seemed to have it all settled beforehand and in two minutes handed down their verdict. Even the prosecutor was far from bloodthirsty. The owner of our fishing boat and the two French seamen with him got suspended sentences of three months and two months respectively. So you see that the People's Front really does mean something, even though they do jail antifascists. Even better—the judge and prosecutor flatly refused the American Consul's request that he be given our passports. They convinced him that the passports were a necessary part of the dossier of the case and that neither he nor we could have them. The Consul threatened to take it up with the American ambassador, but I think nothing will come out of it. Our solidarity and discipline impressed him so much that he didn't even try to speak to the others this time but sent for me only. I was polite but non-communicative. He went away empty-handed and empty-headed.

The lawyer has turned out to be a swell guy. He was here just a while ago to tell us the latest news, bring us cigarettes and tobacco and see if there was anything we needed. He was immensely pleased yesterday after the trial when in spite of being handcuffed and the cops trying to pull our arms down, we all went out of the court with raised fists. Men, women and children of every age and description were packed around us, all giving the antifascist salute. The cops kept me and Steve to the last, hoping in this way to keep us from setting the example to the others, but every fist went up just the same and stayed up in spite of all threats. It was an inspiring demonstration. The lawyer tells me the papers are full of it and he volunteered to send you a copy. Did he ever send you that picture of me? The photographer yesterday also agreed to send you a picture of yesterday's demonstration.

Please pardon the lousy writing but the pen is terrible, we have no tables and there is such a shortage of paper that I have to write as small as I can. The Johnny Bulls that are with us are tremendously impressed with our discipline and organization and tell us that if theirs had been as good they'd be safely over the border instead of in the jug with us. Fifteen hundred people attended the C.P.-S.P. indoor mass meeting here

Thursday night in our behalf. The local committee is now weighing the advisability of organizing a meeting to greet us when we come out at which we would speak.

We've made a big impression with our marching through the streets in chains with clenched fists raised. They try to duck all the main streets generally and take us through the back alleys, but Monday 14 of us marched in perfect step, two by two, and in the railway station as well as in one crowded square we burst into the *Internationale* and many spectators joined in.

I can't describe yesterday's demonstration in Cerette. The whole damned town was out. They waited throughout the trial and were overwhelmingly with us. They wrung our free hands and shouted encouragement, solidarity and real proletarian love. The effect on us was almost intoxicating. I was thinking afterwards that those who, in addition to political understanding, can feel the warm bonds and heart-throbs with and of the masses, can never get seriously demoralized and never lose faith in the ability of the masses to triumph over all difficulties and obstacles. The attitude of the political prisoners too is an inspiration. A twenty-one-year old German boy, two and one-half years in a concentration camp, his hands, his face, head and body showing the scars of cruel beatings, his eyes sparkling with joy at meeting comrades, undaunted by all his past misery and the terrors of the mountain up ahead, anxious only to get out and over across the line and convinced he can persuade many German fascists to desert. Incidentally, even the French provincial press is full of stories of fascist desertions.

There was a Greek in jail who spoke a lot of English. He claimed to have put in several months in the government army. But his stories did not jibe with those of obviously good comrades who had been on the very front where he claimed to have been. Also he was too bloody inquisitive. So we finally organized his complete ostracization and stuck a sign on his back, *Jaune,* which is the French equivalent of scab or traitor. So solidly did the prisoners stick (and this was when we were in the main bull-pen) that the sign stayed on for over four hours before he found out about it.

The other day an Italian was arrested and testified that he'd been recruited for Spain by reps of the French C.P., who offered him 10,000 francs and 50 francs per day to go to Spain. The judges had called me over that day to translate for the Englishmen and afterwards had me sit down in his office so I could read his paper (that day the cops didn't let us read), so I heard the Italian's whole testimony. At the railroad station afterwards I confronted him with his story in front of all the politicos and told them what he'd said. He hung his head and was too scared to speak. We all threatened him and I was surprised how well I was able to curse in French. I found out yesterday when they got him back in jail they beat him up and then completely ostracized him.

There is a Cockney seamen with us now, Bishop—short, built like a gorilla with a chest like a barrel, covered from head to toe with marvelous tattoos—who's a peach. He lost two brothers already in Spain, was caught once two months ago at the border, jailed for 13 days and deported, has a wife and two kids at home to whom he writes almost daily—was caught this time after three nights in the mountains, was hungry all those three days and nights, was beaten up when he tried to get away from the gendarmes, and swears he'll make it next time if he has to crawl the whole way bare-assed on his belly.

Of such stuff is the proletariat made. Incidentally he has a swell sense of humor and

knows countless songs of the sea, the struggle for Irish liberation, etc. We have among us a few young guys, inexperienced and raw, who've come forward as really responsible leaders who have definitely established their authority among the others—one a Canadian S.P. who is ready to join us now.

In the busses on the way to court yesterday we travelled through miles of grape country. The two weeks since we've come here have made a great change in the countryside. Brilliant green is bursting everywhere. And we could see in the infinite care with which the small French peasant has built up rock walls to guard his two-by-four plot in the steep hillside from erosion—another proof of the land-hunger of the peasantry.

I really hope, over and over again, that some day we will have the time, money, and opportunity to loaf a while in this country. In several towns I have made real friends who have begged us to visit them and who would turn their places inside out to make us welcome.

The nights are terribly long. They lock us in at 6 P.M. and we stay there until 6:30 A.M. But Steve and I are in together and we generally talk until about 10, then try to sleep. But you don't have any exercise to amount to anything during the day, so sleeping the whole night through is almost always impossible. French jail bugs are much less numerous than American ones, but still they're enough to give you something to scratch at. Incidentally most of the boys, including myself, broke out quite a bit from the lousy food of the first week, and that's something to scratch. It's not half as bad this time, though, as it was the time you took care of me, and although it still itches like hell it seems to be going away. Much much love to you, my dearest.

JOE

• •

from JACK FREEMAN

Sept. 25, 1937

Dear Herb [Freeman],

I received a letter from Pop several days ago in which he mentions that you have sent me a personal letter. As yet I have not received it altho I have been waiting for a letter from you for a long time. I suppose you've been expecting one from me for just as long, but it is hard out here to concentrate your mind for long enough to get off a decent letter.

By the time you get this letter it will be more than five months since I left home and more than four that I've been in Spain. I guess it's pretty safe now to describe my arrival here. You know, of course, from hints in my past letters and from stories floating around back there, that I was on the "City of Barcelona," the ship that was torpedoed by an Italian submarine. You've probably read the main details in an issue of the *Sunday Worker* (Aug 1, I think).

Every once in a while it strikes me that my being alive at all at present is just a pretty damn lucky accident. My cabin on the boat was in the rear part, just aft of the engine room. Our usual orders were to stay below deck all the time, either in our cabins or in the passageways. But this Sunday afternoon shortly after dinner I had begged and gotten permission to go to the middle section of the boat where most of my American

friends were quartered, to attend a meeting of the English-speaking comrades. After the meeting I stayed to schmooze around with a few of the guys. We were leaning over the railing, three of us, looking at the shore, not more than a mile away, and the water of the Mediterranean, which is every bit as blue as it's cracked up to be. This was well within Spanish waters, not more than 60 kilometers from Barcelona as a matter of fact. Every once in a while we would pass a fishing village with the boats drawn up on the beach. From a distance the boats looked like fish lying out in the sun. Some of the hills came rolling right down to the water. Everything looked bright and completely peaceful. We were feeling quite happy at finally being practically in Spain after so much delay in New York and in France.

Suddenly we heard a dull thud—not a bang, not sharp at all, like a heavy push. The boat shook and threw me from the railing against the cabin wall. The people started running from the back of the boat towards me. I don't know what I thought had happened—hit a rock probably—but I certainly wasn't thinking of a torpedo, because even then I wasn't thinking war. Anyway I started yelling, "Don't get excited. Don't get panicky." I had yelled this 3 or 4 times when I saw dense brown smoke all around the deck toward the back end of the boat. Then I figured the trouble for sure & somehow I got into a life-boat which was about 10 ft away. I've never been able to recall whether I jumped, hopped, crawled, or climbed into that life-boat, but I got in. Somewhere around this time I bruised my leg, how I don't know. This was the only casualty I suffered, and I didn't discover the scab until several hours later. I was one of the first in the boat but it filled up very rapidly, since it was right amidships & most easily reached. The damned ropes were tied with wires but there were two American sailors (not crew members) in it and they freed us with hatchets. As we were sliding down to the water one of these sailors remarked "We must have hit a mine." We shoved off a little way from the big boat, but most of the people in the boat, French & Spanish, were too excited at first to do any organized rowing, so we went very slowly and I had a chance to see what was happening in the water around us and on the big boat.

The torpedo—we now knew it was a torpedo because some of the guys in the boat had actually seen it coming in the water—had apparently hit just aft of the engine room, in other words, had gone directly through my cabin. Those of the comrades who had been sleeping or resting below decks, two in my cabin, had had no chance at all. The back quarter of the ship had jumped up when the torpedo hit and then sunk almost immediately. Two lifeboats which were hung here went down with this section before they could be untied. Most of the fellows either jumped or were thrown into the water. The life-belts were below deck in the cabin and there was no chance to go down & get them except for a few in the forward part of the ship.

The rest of the ship from the engine room forward also sunk very quickly. In less than seven minutes (that is, later we estimated the time at about this) there was nothing above the water besides the point of the prow and one poor guy who couldn't swim standing right on the point, and then that went down too.

It was a pretty dirty business. Some fellows were killed while they were asleep, some were trapped below decks (we could hear them singing the "Internationale"), some were hit by pieces of wood or iron and a few were drowned, altho most of those who got into the water had plenty of drift to hold onto until they were picked up. But

considering the speed with which the ship went down we got off surprisingly well with a much smaller ratio of losses than, for instance, most torpedoed boats in the World War. As a matter of fact, the *Daily Worker* in this case exaggerated the wrong way and gave a higher figure of losses than there actually were.

Before we got to land we had one more scare. Just before the big boat went completely down, we suddenly heard a motor and looking up saw a plane coming head on toward us. Now when a plane flies directly at you you can't see any of its insignia; and for all we knew, perhaps we had been bombed & maybe the plane was now coming to strafe us—you know, spray us with its machine guns. The guys in the water started yelling at each other to duck and one fellow in our boat dived out. I just bent down to the bottom of the boat (I don't know how I thought that would protect me), but I never felt so damned scared in all my life. There was this big thing heading right for the part in my hair and I knew there was absolutely nothing I could do about it. I guess I was even too scared to crap in my pants.

But much to our relief the plane suddenly turned just about 100 yards ahead of us and dropped a bomb over the spot where it thought it had seen the sub. It must have missed though, for we saw no oil or wreckage aside from our own ship's.

Fishing vessels from a nearby town reached us after a while and picked up the fellows in the water. We got our rowing organized and reached the beach without any more trouble. The people of the town just flooded us with clothes and blankets and gallons and gallons of cognac. The barracks in town were converted into a hospital and general headquarters for the rescued. I've never seen such goings on as when friends met each other in that barracks. Even I jumped onto at least three guys whom I never expected to see again. But the fellow with whom I had travelled across from New York and thru our long stay in France didn't come thru.

Except for the foolishness in yelling at people not to get excited and the scared feeling when the plane headed at us I kept my head pretty well. I hope I bear up as well later on. But then I did have all the luckiest breaks and I didn't have to go thru all the tough spots that some of the others did. The torpedo went thru my cabin but luckily I wasn't in it; there were only two lifeboats which got off safely and luckily I was in one; a plane headed at us but luckily it was a Loyalist plane. In other words, *luckily.*

I started this letter yesterday, but since then I have gotten Pop's letter of August 5 with yours in it. It took that letter seven & a half weeks to reach me.

As you know from my other letters, I've been here for a hell of a long time but haven't done much yet. I was put into a battalion which the government decided to give extra special training so we stayed in camp almost four months. For a while I was a group leader, which is a sergeant, but my rank was never confirmed because I left before the battalion moved up to the line. Then I went to the base of the IB where I worked in four languages, Spanish, French, German, and a little English. I finally got myself transferred back to a fighting unit and I am now in the Lincoln Battalion working as observer and mapper on the battalion staff. My job is to discover as much information as possible about the enemy and draw maps of their positions and main weapons. It is very interesting work but pretty risky. I have no rank for the very good reason that so far I've done nothing to deserve a rank. We'll see later.

Meanwhile, I came up to the Battalion just in time to meet them coming back from

action in the Aragon offensive. Now we are in reserve positions, which just means camping out in an olive grove so far from the front lines that only at night can we sometimes hear artillery fire. To make it even worse for me, altho it is better for the rest of the brigade, we are just as likely to go into a rest position as we are to go up to the lines. In any case, I'll let you know soon.

I've tried to make up for not writing until now by writing a long letter, so now I want you to write a lot. My address Papa knows. The number is now 17.1. If we ever get to another big town, I'll try to send you a Spanish Pioneer pin.

Love to Mama. Tell Pop I'll write soon to him.

> Your brother, "the big stiff"
> Jack

P.S. Get down on your knees to Jack Schwartz for me and give him my apologies for not answering his letters. Tell him "Never give up hope." Put cigarettes in the envelope when you write.

••

from JOE DALLET

Spain, April 22 [1937]

Dearest,

By the time I write this you should already have my cable saying that all is well. Incidentally, Ralph Bates loaned me part of the money to send it, and it was he who took it to Barcelona to send it off.

Our journey was a masterpiece of organization from every point of view. Our scouts checked every kilometer before we passed over it—our guides took us up and down goat-paths and creek-beds from 10 P.M. until about 5 A.M.—and then we were safely across. Do you know the Pyrenees? They are magnificent, and cruel. Three of our group played out and had to be virtually carried the last half of the trip, and one German also (38 crossed together). Incidentally, Bates, a top-shot in the International Brigade, carried one of the guys himself until he almost gave out himself. The nearly full moon was a big help. Some groups have crossed in such darkness that they couldn't see their footing at all and had to hold on to the coat of the man ahead in order to keep in contact. The length of the trip is caused by the need to skirt all frontier gendarmes and non-intervention posts. Sometimes you have to avoid a good road (actually we avoided all roads) and go up and down a mountain to get to the other side of it, instead of simply circling it. The last peak was a 5,000-foot climb over loose and jagged rock, through thick stiff underbrush, etc. And we had to race against sunrise to get over without being seen. I carried a 165-pound guy practically by myself that whole climb. Christ! When we crossed the line we almost cried for happiness—some people did cry and I had a hell of a job restraining myself.

I came through in swell shape, only a bit stiff. I'm the only one in our group who didn't go to bed today—I didn't need it and I'll go early tonight. For a while we were afraid that the need to carry the cripples would make us too late to beat the sunrise—and it was a real desperate race.

Never did I see so many stars—and the moon glistened white on the towering snow-

capped peaks while down below in the valley the lights of the little French towns made a pattern that was really lovely.

We rest up here for a day or two (are compelled to do so by the authorities in spite of our plea to be allowed to proceed at once to our base) and while here get some preliminary training. Within a few days we'll proceed to the main place.

I've got to start to learn Spanish. Bates promised to organize a good class in it. Incidentally, he's also going to start a paper for the English-speaking columns. He strikes me as a real guy. Our main guide was a marvelous specimen. Perfect rhythmic, measured stride, effortless, never stumbled, never missed his footing, never dislodged a stone or rustled a leaf. I walked just behind him for a few hours (until I started carrying Bill Wimmer) marvelling at the grace and poetry of his motion. Equally remarkable was his knowledge of every half-inch of the twisting terrain. It was a most interesting trip—and so successful I could still holler for joy and if you were here I'd crush the breath out of you.

Here I found out that a lot of top guys who bought me farewell drinks before I left and cursed me for a lucky devil for leaving weeks ahead of them—these same guys have been safely here more than ten days already. We now have a strong staff politically and the general caliber of our recruits arriving is much higher from the point of view of military experience than at the start.

Dearest, a bridge game is about to start; the sheet is nearly filled and the other things I want to tell you can't go through the mail. Except that I adore you and can't wait to reach A. [Albacete] and get your letter.

JOE

from EUGENE WOLMAN

April 19, 1937

NOSOTROS PASAREMOS
(we shall pass)

At last, what I have waited for for the last ten months, and in a larger sense all my life, has come to pass. We have passed, not the final battle, but at least the first barrier. We are here.

Imagine Meeting You Here.

Picture a jumpy frontier. Our cab driver proceeds as close to the border as he dares. There we are met by a guide who rushes us through a field until we suddenly come upon a group of squatting comrades. Shushed into silence, we too, quickly hug the ground.

As I translate for the Americans, a face is thrust between me and the moonlight. The comrades shush our enthusiastic greetings. Instead we content ourselves with intermittent pummellings.

Manuel and I have met after three weeks, just in time to cross into the Land of our Dreams together. The first thing he must tell me is how wonderful you were to him and how I have the best Mother in the world.

Have you Ever?

Have you ever threaded through armed guards on an unknown road during a night so dark you could only follow the comrade before you by touching his coat or holding his hand?

Have you ever climbed relentlessly up stony mountain paths in Nettleton Oxfords so supple each stone feels as if it were a knife cutting into your foot?

Have you ever climbed ever upward with your breath coming in gasps while below you the barking of the bloodhounds grows ever more hysterical as they feel themselves drawing closer and closer to their quarry?

Have you ever, finally, as dawn breaks, reached a haven of a new land, within whose limits, bright and exciting prospects open before you?

If you have not, you must try it sometime, or better still, wait until I can tell you more.

My address henceforth will be:

M. Adami C.I.A.P.E.
1 Cite Paradis, Paris

You can enclose my letter in a smaller envelope within a larger envelope addressed to Adami.

Gene

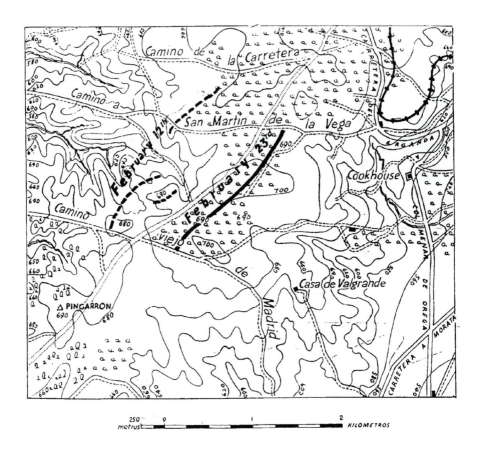

A wartime relief map of a portion of the Jarama campaign. The heights of Pingarrón (lower left) command the area, and the Americans attempted to seize them on February 27th. International Brigades Archives (Moscow).

III

JARAMA
The Fog of War

INTRODUCTION

Before all else, for some Americans, there was Jarama. Before any military training, before a visit to Madrid, before gaining much, if any, sense of Spain's people or its land-scapes, there was Jarama. There were several Americans fighting in Spain during the first months of the war, before the International Brigades even existed, including several pilots in the air over Madrid, but Jarama was the baptism of fire for the first organized American battalion. Other traumatic battles would follow, but Jarama holds a special status in the memories of the American volunteers and in the history of the Lincolns in Spain. Given the chaotic battle conditions and the high number of casualties in the Lincolns' major engagements there—February 23 and 27, 1937—it is not surprising that detailed letters about Jarama are so rare. In fact, the letters we have seen were all written a month or so after the February battles were over. In some cases, volunteers' letters lead up to Jarama, stop, then resume in March.

To give some sense of the immediate experience of Jarama, we are publishing for the first time portions of the diary of a front-line American physician in Spain, John L. Simon, along with entries from the diary of the Lincoln Battalion's commanding officer, Robert Hale Merriman. A third-year student from Philadelphia's Jefferson Medical College, born in Philadelphia in 1913 and thus twenty-five years old at the time of his departure, Simon travelled to Spain in the semi-clandestine manner of the volunteer soldiers, announcing his medical training only after he arrived. At that point he was assigned to front-line medical duty, giving emergency medical treatment, evaluating wounds, and evacuating men to the hospitals. Eventually, he was recognized as a doctor in Spain. He later served in the hospitals as well, in some cases treating the Jarama wounded. He attained the rank of captain and ended up with more front-line service than any other American medical officer in Spain. Merriman, twenty-eight years old when he arrived in Spain, had grown up in California the son of a lumberjack and a writer. A graduate of the University of Nevada and a graduate teaching assistant in economics at Berkeley when he left for Europe, Merriman was in charge of the training program for the Americans at Villanueva de la Jara. There he put to good use the knowledge he had gained from four years in R.O.T.C., but the training would be cut short by events. Given the rank of captain, Merriman was placed in charge of the Lincolns on February 15, after the first commander, James Harris, was removed because he became irrational under pressure.

In the overall history of the war, the Jarama campaign is part of the story of the rebel effort to capture Madrid. Having failed to take the city in the fall of 1936, Franco's forces

tried another maneuver a few months later—to cut Madrid's vital lifeline to Valencia, encircle the city, and force its surrender. The Madrid-Valencia highway runs southeast out of the capital, through the multiple hills of the Jarama river valley. The front, essentially a northwest/south line cutting through the capital's western edge, made an encircling movement north or south of the city a plausible strategy. The northern route had already been tried and failed. There the bodies of men of both sides were piled in mountain passes to mark Franco's furthest advance. In February of 1937, the southern front below Madrid was activated.

Delayed by rain, the rebel assault southeast of the city began on February 6. About 40,000 fascist troops pushed eastward through the Jarama valley and brought the Madrid-Valencia road under artillery fire. That left the road still in government hands and still usable at night though very much imperiled. On February 12 several battalions of the new fifteenth International Brigade went into action. That day the 600-man British battalion was assigned to a key hill. Nearly 400 were dead or wounded by the next day. By February 15, when the Americans climbed aboard trucks for the trip to the front, thousands of men already lay dead at various points on the field or in rapidly dug graves. Many of the Americans had had at best minimal training. Along the way, the trucks pulled over and gave the men their first chance to fire a few practice rounds of live ammunition into a hillside. Near Morata, the column was strafed by German planes. By February 16, when the Americans were digging themselves in on a hillside, the fascist advance was largely stalled, but the lines were unstable, and the Republic planned a counterattack.

On the 23rd, the Lincolns faced irregularly placed fascist positions from 50 to 200 yards away. At 11 a.m., following orders, despite inadequate support from their own guns, they left the trenches and entered a shattered olive grove between themselves and the enemy. Some caught sight of their captain, John Scott, as he repeatedly dashed forward, dropped to the ground, and fired. His untrained men did their best at imitation, but withering enemy machine-gun fire soon scattered them, and the men began to die. Some took deceptive refuge behind the olive tree roots, but the raised mounds put them on a straight line with the fascist machine guns, and the loosened dirt offered little protection. The men were largely on their own, receiving no orders, out of touch with command. A Cuban section, atop a ridge and silhouetted against the sun, made especially easy targets. When Scott himself was mortally wounded, the advance collapsed. Under cover of darkness, some of the survivors crawled back to the Republican trenches.

Twenty men were dead, almost sixty others were wounded. Over the next two days snipers increased the toll. Then on February 26 seventy new men arrived; some, like Boston actor John Lenthier, still wore the civilian clothes in which they had travelled to Spain.

The following day the Lincolns were to assault Pingarrón Hill, fortified with three lines of machine-gun emplacements. The final yards before the guns were an open stretch, up a steep incline. There was absolutely no cover. Without enough artillery support to

neutralize the machine guns, a frontal assault would be suicidal, but the Lincolns were promised that and more, including fifteen tanks and bombing and strafing by a score of planes.

But the morning passed with none of the anticipated support materializing. The new People's Army had simply not matured to the point where it could coordinate all these elements of an attack; the promise was wishful thinking. As for the new Americans, training in the multiple arts of war had been confined to a day. The troops did not even know one another's names. In this context, no order could be carried out with confidence; every action felt like a blunder. The ordinary and inevitable fog of war would be intensified and it would extend all the way up the line to brigade command, with misinformation ruling the day and bad communication devolving into no communication at all.

Captain Robert Merriman reached Fifteenth Brigade Headquarters by field telephone and told them it would be madness to attack. He was ordered to proceed. Climbing out of the trench to lead the assault, his shoulder was immediately shattered in five places. But the wave of men went over the top anyway. Some of them, naively, wore full packs that slowed them down and made them even easier targets. Under impossible fire, the attack disintegrated. By nightfall, the field was littered with more than 100 American dead and wounded. The battalion was cut in half. Then a rain began, chilling the wounded in mud and in their own clotting blood. The Americans were no longer a functioning fighting unit.

Robert Merriman's diary records his experiences as he passes through Barcelona and then picks up his story as the battalion moves to the front. John Simon's Jarama diary begins at Figueras, the ancient fort that was the gathering point for volunteers who had just crossed the border from France. It proceeds through Albacete to the Jarama front, where Simon must attend to the men undergoing the actions described above.

••

from ROBERT MERRIMAN'S DIARY

JAN. 7. Barcelona beautiful. Streets aflame with posters of all parties for all causes, some of them put out by all combinations of parties. Windows all taped with paper-tape done in criss-cross patterns. Keep the windows from crashing upon first air raid. Instruction everywhere concerning what to do in case of air raid. Small shops still owned and operated by owners. UGT victory. Neutralized now.

JAN. 8. Some street lights are deep blue for air raids. Car speeds on the streets marked CNT, FAI, POUM, PSUC, UGT, etc. Saw a booth where stuff taken from rich homes was raffled off for red aid (POUM). All businesses are currently marked UGT or CNT, or both on many occasions. Buildings taken over are labelled in large notices. Foreign capital is being protected. Stores with paper on windows—colors of the countries which own them shown. Closed however. Night watchmen (*serenos*) now without keys, since they were often required to give up keys or be dealt with badly personally.

They still walk the streets with sticks and lights which are flashed up the walls. Many stories: some say all is quiet and orderly, others say all is gangster-ruled and the people are being marked and taken out one-by-one to be shot.

All seem to agree that merger of CNT and UGT may solve problems. Hard slow work though. Much literature sold on streets. University professors say that soon they shall broadcast the courses to the troops, since most of the students are mobilized. Being arranged now. It appears that FAI was a real progressive and necessary force, even with its tactics, but they may later cause it to diminish in popular support.

FEB. 13. Convoy at 12. Stragglers—Harris failed to show. In charge of battalion, led convoys, left Albacete…brought men in after stalling to allow them to fire new guns. Upon arrival in new town, air attack, Mexican planes did them up. Men ran and showed early weaknesses. Up to line and shown position. Met General Gall and Nathan Springhill. Went to staff officers' meeting and got plans of work. I worked all night without sleep.

FEB. 16. Worked all during night and early morning. Trenches finished just before daylight panic. Cubans fired and Irish followed also, wounded our own men. Took up new outline. Went to staff meeting of officers and Nathan gave the word to be in reserve—talked to officers.

Marion, dear, I love you! I am willing to die for my ideas. May I live for them and you!

FEB 17TH. Received orders to go into action and announced Cooperman caught. Calm and I hope the men are. Afraid of some officers at the last moment. The actual fighting with weapons is the highest stage a real communist can ask for. About to lead the first battalion of Americans in this war. Life is [good] because I made it so. May the others live the life I have begun and may they carry it still further as I plan to do myself. Long live communists!

FEB. 18. Long live the Soviet Union! Men may die but let them die in a working class cause.

Men may die and mean to die (if necessary) so that the revolution may live on. They may stop us today but tomorrow we take up the march.

FEB. 19. Early in day, air raid. Bombs just missed us and how close! [Charles] Edwards killed by bullet through head while scouting. I was bawled out for not keeping the men down, by General Gall. Later in day other air raids came even closer. Some fights in the air. We are definitely located. Went to inspect trenches after dark and artillery started on us. Plenty tough and lost one man. [Misak] Chelebian killed by shrapnel. Occasional firing and during the night cross fire. Harris out.

FEB. 19. Great changes in the battalion setup. Nathan out. Copic in. Klaus Chief of Staff. General to Division. Harris sent to hospital and got back. Steve Daduk cracked up, and I recommended him to rest home. Adjutant is now [Douglas] Seacord.

Constant changes. Men ate well. Irish taken out to sleep and one was wounded. Quiet night, although earlier carried out evacuation when planes sighted. Copic gave me hell, although Klaus said to do it. Slept much.

MARCH 13. I am now writing on the 13th of March after a long period during which we were in the front lines and after the [illeg.] was lost.

About the 20th, in the evening, we received an order to move forward to Thaelmann Battalion. We formed Company Two and Klaus was ready to lead us. In the midst of this Harris showed up acting as if in command. He was still abnormal and talked loudly and accused me of having him confined in Albacete. He confused men with his talk about placing artillery under order of Ortiz. Out of the question. He talked about importance of position to which we were going, etc. Left with Klaus and counteracted my order so that we lost one company entirely. Great mess. Some still thought him in command and finally [Samuel] Stember and I went with Klaus and found a quiet sector and as so allowed us to return. Harris told to stay behind and only showed up once, although he woke people during the night bellowing and warned about fascists and directed whole armies in front of the people and so forth. Decided to send him back to the hospital.

Another time later ordered to move up to old Dimitroff position. Men there, and then order [illeg.] to go back again. About the 21st we moved to old Dimitroff position in reserve, with orders to leave without packs or blankets. First bad one of Wattis. No such order ever came out of the General's staff. Since we only went to a new reserve position, never did get all packs and blankets back for the men. On Feb. 23 we received orders to move across the road and support the 24th Spanish Brigade and later we advanced between them and the road. Found places for ourselves and moved forward while tanks (ours) burned and exploded throwing plates and shells all over. Scott worked well. He and Morris wounded and Scott later died in hospital. Van Brugge badly wounded. [William] Henry in charge of Company One. Called to meeting before we finished advancing and Seacord placed in charge. 24th Brigade and Dimitroff on left refused to move up, and we had to withdraw slightly. Spanish labor battalion helped us dig in until firing stopped them. We could have broken through that night if we had been given support. Decided to have us move into Dimitroff trenches across the road. Pick and I went to trenches and located our new position and went to end of trench, found one of our men there, and sent him with word to bring all men across road into trench. Instead, all men withdrew and left group and Dimitroff's men withdrew and left Pick and me with 800 meters of trench and open space and only a few hand grenades. Pick finally had to go and finally I went through all of orchard. Found men all in rear and Pick leading them to trench. Lucky no men lost. Never found out who gave the order to retreat. Moved into trench and started to dig a crossroad on left to set up supply base section. Dimitroff had lost 30 men here and yet had never dug a trench.

First day hard and several men lost. By second day, the labor battalion had improved situation and we were better off. Moved battalion headquarters in the front line and Stember went below and caused talk. At meeting of staff, Franco-Belge battalion criticized for not advancing when English did. In general, brigade has had a bad time. Numbers small and enemy heavily armed with machine guns. Tough run and long retreat (2 kilometers). Capture of English section has not helped in general.

Battalion much smaller after the attack of the 23rd, and rest needed but impossible because the trenches which we inherited are shallow and poor.

First day boys had little to eat and drink, and it meant death to carry food across the road. Mood gradually improved. Staff planned to give each battalion rest and wash up down below. One night 26 captured prisoners and they gave information which coincided with ours and late attack at night was planned. Airplanes, tanks, armored cars, artillery, Cubans, first-aid men, and main attack to be on our right. 24th Brigade and Americans to protect them at their left flank after they had passed us 50 yards or more. Pivot movement to road and then our brigades to move forward. Plan good and sounded like good use of all arms.

Early on Feb. 27 weather bad and attack put off until 10 A.M. At 9:50 artillery started and at 10 the 24th Brigade to go forward. We waited, without promised machine-gun support, without telephone, artillery going to left and not helping us or the 24th Brigade either. The armored cars were behind the hill, no tanks in evidence, no horses. 24th failed to move forward. Ceiling low, no planes. Finally Klaus, near the front, sent word for us to advance.[1] Wattis, the suspicious one, came forward again to our trenches.[2] Some wanted to shoot him as they wanted to shoot Harris on the 21st. Finally got through on telephone by ourselves and established bad communications. Stated several times that the 24th had not advanced. Machine-gun fire on our boys too heavy for any action. The plan of attack fell to pieces all along the line. Our boys plenty brave—runners went one-by-one—great boys, and it grieves me to see them go. Copic finally told me to go and bawled me out for failing to move at 10 o'clock. I said that the 24th had not yet moved and he said that they were ahead of us 700 yards and we were their second line. He gave us 15 minutes to make up the distance. He was never more wrong in his life. We had put out our airplane signal—Joe Streisand was lost during this—and the order was to put it in our most advanced position. After Copic, I observed the signals of the 24th Brigade and it was 700 meters behind our trench even yet. Nothing to do, since our boys were in the field and out of runners. Three planes came instead of 20 and didn't do much. No runners, so I passed a signal to advance to try to break through.

Saw [D.F.] Springhall coming toward me when I climbed up to pass on the signal and was wounded. Murrow addressed me and I gave word to leader of Franco-Belge to move some men in our trench to back us up. They did this. Saw Cunningham and Hans and Pike. We tried to advance but many killed, and returned. The second time they refused to go forward. Seacord had been killed and no one left to take command. Cooperman took it over, with Thompson second. Had tough time getting out of canyon. Saw Stern and others.

Rushed to Colmenar even though I wanted to stop and have it out with Copic. In Colmenar it was a butcher shop. People died on stretchers in the yard. I had to sit up. [Robert] Pick in front of me badly wounded and on stretcher. Heard that Springhall

[1] Lieutenant Colonel Hans Klaus, Chief of Operations, Fifteenth Brigade. He had served as an officer in the Imperial German Army.

[2] English staff lieutenant George Wattis.

had gotten it at the same time. Went to operating room. Pulling bullets out of a man who had become an animal. Viennese girl—swell—real stuff. Several doctors operating on stomach exploring for bullets while others died. Question of taking those who had a chance at all. After doctor put my arm on a board and I wanted to eat, they took my revolver and glasses. Finally told that Springhall was waiting for me and we were going to the American hospital in Romeral.

Nightmare of the ride. Lost our way. Three-and-a-half hours going but had to give up while I lay on the floor of the ambulance. Springhall could talk, which surprised me since he was shot through the head and jaw. Finally arrived and heard English and saw fine, clean, new hospital. Immediately ate while on the stretcher, and went to bed. During night others came in and Morse was operated on. Coming along. Finally transferred to Alcázar de San Juan. Another bad trip.

· ·

from A DOCTOR'S DIARY • JOHN SIMON

FEB. 14. [Figueras] Most wonderful place I ever saw. All languages understood—regardless of what you say, someone can understand it. Singing of all songs in a great big ancient fort—"*alouette*," Red songs, German, French, Greek, Armenian, Yiddish.

We ate beans in an enormous hall, & red wine. I didn't like using the plate over which someone else had eaten bread, but consoled myself with the thought that a lady doctor was present, doing the same thing. She is French, tho, & probably they're not so particular as we are.

Incidentally, there are even women in this fortress where the men sleep. I'm going to sleep in a blanket, in my clothes—which I haven't had off since the boat yesterday—this is Sunday night.

The toilets are about as modern as you'd expect in a fort built maybe 1500. You have to crouch down on them, taking care not to fall back....You will not think me over-squeamish when I tell you I was not the only one who sought the grass outside in preference. Of course newspapers are at a premium.

The Spanish scenery is something wonderful. I got the kick of my life when I first saw the snow-capped Pyrenees. And all the buildings are different from at home. Of course in the electric twilight, sitting in this barn they call a fort, I can't describe it. I'm going to sleep.

TUESDAY. Last week we were nothing—today we were disappointed when only a moderate-sized crowd greeted us at Barcelona. At ____, near where we had spent the night & done our first drilling, had sent out all its population to greet us. I could not look at the people without having tears come to my eyes—these were the most wretched-looking people I have ever seen. Today I saw my first pair of wooden shoes—on an old man, working about the camp. And the children who cheered & saluted us—with the *Rot Front* clenched fist of the International Brigade—were literally clothed in rags. A few were clean; most were tousle-haired, filthy. I could stand to look at the children, but when their elders joined them—the 18-year-old girls laughing, some of the older women in tears—then I had to look away, for fear of disgracing

myself in the eyes of my comrades. Yet not all of them, I think, are in this respect above suspicion.

My stodgy, bookish language is inadequate to express the thrill that comes to one who, attempting to follow the teachings of Marx & Lenin, finds himself about to fight for the most oppressed & wretched group of people he has ever seen. Certainly the logic of those men receives an additional confirmation in the experience of the merest pedant who aspires to take part in the application of their teachings. And that was why one could not stand to look from the red flag, with the Hammer & Sickle, before us, to the victims of centuries of brutal feudal suppression, in the most backward country of Europe.

And Spain is just that. We are all filthy—washing & toilet facilities are inadequate. Of course army life strains these to the utmost. The most primitive, anachronistic customs exist—for lunch we had wine from a flask to which was attached a stalk at the side—one is supposed to drink without touching the glass to his mouth.

The International Brigade has all kinds of people—lawyers, doctors, cooks, carpenters, aviators. There is one comrade who fought on the barricades & was shot four times, one of the bullets passing thru his body. One begins to understand what devotion to the proletariat means....A number of comrades came over the Alps on skis; some Czechoslovaks hiked from their country. A comrade from a fascist country arrived with a passport that he would have had trouble, known as a class-conscious worker, in obtaining thru the regular channels; a little cleverness, that harms no one, sometimes takes the place of a great deal of effort.

The example of proletarian discipline that such comrades as these present is inconceivable to one who has not seen it himself. In the first place, there never has been an army like this. The Red Army of the Soviet Union has the spirit—but there is not the same cosmopolitanism, even with all the nations of the Union, that there is here, where orders are given, and obeyed, in German, French, English, & it often seems a few others.

I had always dreaded army life, with the brutality with which it has always been attended under the domination of any class except the class that has for its aim the abolishment of classes forever. Here, we are, as the commandant himself said, not only soldiers but brothers. And as brothers we behave. An officer, when the men fall out, is just another comrade, & the men, off duty, treat one another with all the consideration attended to officers. Bullying is non-existent. Personality difficulties are discussed seriously—they are political questions, & considered with the gravity it accords to matters to which it applies that word.

With all this, the most excellent spirit prevails among the men. Officers' commands are obeyed—but with an enthusiasm that all the whips of the capitalistic army officers cannot produce. And that is why in one day the International Brigade can produce the results it takes the bourgeoisie weeks to get. The men are ready to die with their officers—who after all are only workers like themselves, with no more, no less to gain—whereas no officer in a bourgeois army is quite sure that he will not be shot in the back the first time his men go into action.

The relation of the Americans to the other national groups and to the Spanish population is unique. In the Brigade, it is always the Americans who start the singing. The

juvenile qualities, of which our people are accused by the slightly effete savants of Europe, come into good stead by infusing their enthusiasm into the more mature working class groups from the European countries. Then, too, Americans are still thought of by most Europeans, even by many European workers, as being almost universally rich. That these "rich" Americans should have crossed the seas to fight for them impresses the Spanish people, & explains the extra loud cheers the populace greets us with. At the same time, our prestige in the I.B. itself is great for the same reason.

The European comrades are quieter, more serious-minded. They have seen the fascist peril closer at hand than we—many of us still think as across the ocean in the "land of Opportunity." The Spanish people, too, are impressed by the antifascists who have escaped from the clutch of Hitler & Mussolini in their own homes, to cross swords with their fascist henchmen in order to protect the Spanish people from the same menace. So wherever the I.B. goes, there are the same clenched fists in salute.

THURS. FEB. 18. I'm not sure of the date, but it is Thursday. 2 weeks ago I was still home—today I was assigned work. I have learned much more from Franco direct than from Marx direct. I never believed that one could be so dirty, certainly not more than 2 days, & live. Now I face realistically the fact that I will not get a bath till it is warm enough outside.

Yesterday I was thrilled to see orange & lemon orchards, but more so to see real toilet paper.

FRI. FEB. 19. Children are playing in some newly-dug trenches.

There is a great big hole in a street in this town—nothing to do with the war, but the children play in it & no effort is made to repair it.

This book will probably serve as my calendar. I have no other way of keeping time.

SUN. FEB. 21. Gave one of my good handkerchiefs (from Ruth) to a German from Cologne who was on the Madrid front from October on. He gave me the low-down on the front. All one's possessions are lost after going there, but one doesn't mind it; afterwards, he gets all new ones. After the war, he thinks we'll get new clothes or money for them—those of us who can still wear clothes. He himself was with the Thaelmann battalion, with 900 men, of whom 17 are still alive.

After I had written these notes about the street trenches on Friday, they bombed us. I had occasion to see people hiding in them, even was in one myself for a few seconds. When the planes first came, I was not scared, merely interested—when for a while nothing happened. I was even disappointed. I thought air raids, & the threat of them, was common, & that running for shelter was almost a routine matter. In hiding, I even went to sleep. But after a neighboring building was bombed, I stumbled thru the wreckage, listening to the groans of the wounded. Then no more were bombing parties a pastime comparable to bridge. The trouble is you can't dig the wounded (and secondarily the dead, tho fine distinctions are of course impossible) because most of the time the orders are "lights off." When everyone else is quiet—myself, I don't believe the fliers can hear us anyway—someone will call out in a long harangue & refuse to be silenced. The wounded are usually quiet once dug out. A woman I heard

kept crying "Hijo, hijo," [son, son] till finally realizing its futility—then she tried to help them extricate her arms & legs from the debris. The buildings here lack steel frames & therefore crumble like huge egg-shells, in one big pile. Of course, digging people out is very dangerous because any movement may start a landslide.

After trying to help, I found my way to one, then another, hospital. I understand I think it was then that I [illeg.] wounded [illeg.] the state of primary shock. One old woman just sat in a chair, all acted as if they expected to die. There were a number of corpses. Several of the boys told me they had their first experience touching dead bodies then & were horrified at first. I remember one body—a child or young person. All the pictures we have seen are just like what I myself have seen—any description would be useless, since the camera shows the same thing better than words can. But when you see the films in a movie house, you know that at the end of it you will leave the movie house alive. There the wounded have ceased to groan. In the real thing you are not sure you won't follow in a half-minute. The fascists bombed here for 4 hours. The day I left home I went to the "Cameo" to see movies of "Spain in Flames" & "*No Pasaran.*" (About this time I wrote home "I am well & very happy. Love, John.")

FEB. 22. Just saw a wagon of Spaniards traveling along the road. Everywhere one sees these miserable people leaving their homes & everything they have known. Last night when we went to eat supper they were crowded in their doorways watching us—some apparently in mourning, some weeping, some in frightened expectation of another air raid. If I am homesick, certainly I have plenty of company in this desolate country.

Oddly enough, it was just before the air raid Friday that some of the boys went to a brothel, one of them for the first time. He is a fine, very talented fellow, an actor, of aristocratic stock—nobility, highwaymen, & all that—rogues as well as gentlemen. One of his ancestors, a travelling entertainer, seduced a Lady Hamilton, mistress of the house at which he was staying, & fled with her to America. The boy had a hard job persuading his mother not to join the D.A.R.

This boy did not particularly enjoy the brothel. The organizer of the party did. He is a lawyer at home, who came because he thought the legal profession should be represented.

There is a wonderful Cockney with us—professional soldier type, not a Communist originally, tho he says that now he is a better one than anyone else. He says the spirit of the boys pleases him greatly—it really appears we are able to accomplish more than a bourgeois army—capitalists take warning! I was very much moved to hear him talk that way, & when someone told him he should get 2 men to wash the dishes I immediately said (I always was a sentimental son of a gun) "You've got one already, Corporal." To which he replied "One volunteer is worth 10 press-men, as we know in the British army." We have even the Mulvaney, Ortheris, Leroy tradition here, God damn it, we've got everything!

Washing the dishes was no cinch. We used sand & cold water at first, later hot water & soap, which was well worth the trouble of heating the water. I have always been long on dish washing at home—it is such an easy way to make a hit—when visiting not-too-formal people. Here it was different!

The most diverting occupation here is discussing philosophy. We can do this for hours at a time, because we have the brainiest young people in the world! I am here also, & their company is very congenial to me.

This is Washington's birthday. Here we can celebrate it without hypocrisy. Can they say the same at home?

FEB. 24. Irony: to read on the wall of a schoolroom, bombed by the fascists, the words: *"De Nuestra Constitucion Articulo 25. No podran ser fundamento de privilegio juridico: la naturaleza, la filiacion, el sexo, la clase social, la riqueza, las ideas politicas ni las creencias religiosas."*[3]

Also, picture of Edison with words *"Niños, imitad la tenacidad y voluntad del insigne inventor D. Tomas Alva Edison."*[4]

Today we found butter & spring beds. But got no chance to sleep in the latter. Altho this is a war of a different kind from the Great War, we act very much, in respect to food, like the soldiers in "All Quiet." Never thought I'd feel lack of [illeg.] here. Pupin's relative.

DATE? Tues. we got on buses. Wednesday A.M. we got to Morata. We slept on the hill that night. Thurs. I arrived at the "Dimitroff Hospital." Two nights have passed since, so today must be Sat. If so, date is Feb. 27.

John Lenthier was killed yesterday, when he went over the top. He is the one who pulled "Comrade Dimitroff has said, comrades, & he is right!" We called him Long John. He was the actor of whom I wrote above. Max, Defeo, Melvin are all right.

MON. MAR. 1. The above was written yesterday, but they tell me today is Mon. Mar. 1. So I guess I was wrong. And the boys went over the top two days ago, so I suppose John died on the 27th. What's the difference?

Today I washed my hands.

TUES., MARCH 2. Today I washed my hands and face.

I was really wrong about the date—I had forgotten one night here. So John Lenthier lived one day longer than I had thought.

Yesterday the boys in the battalion had a meeting because of the bloody defeat they suffered when they went over the top. A commandante gave them an official story, explaining why things came off badly—the machine guns, etc. He said they would have rest—two days in Morata where they could wash. Then they laughed. Then the boys took the floor—I've never heard anything like it. Boys were crying because they didn't know how to use their rifles. The machine-gunner broke into tears as he explained how the guns wouldn't work, how they were not properly equipped. One soldier explained

[3] From our Constitution, Article 25. The following cannot be the basis of legal privilege: origin, (political) affiliation, gender, social class, wealth, political ideas or religious beliefs.

[4] Children, emmulate the tenacity and resolution of the famous inventor (Don) Thomas Alva Edison.

how a boy went over the top with full equipment—and died. Another built a mud wall between himself & our trenches—he didn't know which side the fascists were on. Another tried to dig a hole with the muzzle of his gun. The fascists cut down the trees with their machine guns, then killed our men hiding behind them. The little Frenchman from the brigade was a straw in the wind—he never had a chance.

[WED.] MAR. 3. It is a quarter to eleven o'clock, & I am lying on my bed—the floor, of course, with a candle; I am on guard over a comrade who tried to hang himself because ordered to the front tomorrow. Such is the life of a medical officer. I have learned more medicine here than I would have at home—I now administer drugs with confidence—my confidence & the men's. I enjoy their respect as a physician. Myself, I know full well that 3/4 of all medication is placebo anyway. At the same time as the one man tried to hang himself, another threw a fit. I gave him phenyl-ethyl-malonyl urea [Phenobarbital, for seizures], & those around him KBr [potassium bromide, a tranquilizer]. Of course there is always a disturbing feeling that at any moment it may be all over—the prescribing & the diagnosing—every day men are nipped by "stray" bullets. But without that, I would doubtless invent something that would bother me just as much: I always do. I just learned today, for example, that my friend—my first friend here, the young *enfermero* [male nurse] at the hospital whom I talked to while I was waiting for the American physician the day I arrived (the twenty-fifth)—was shot thru the heart after the attack last Saturday. He was a boy of 19, I believe, who had been to the front; he had appealed to me very much & had impressed me as of great value to us. I wonder what his girl will do. He was given the chance to return from Spain—as too young, for purposes of publicity, & had rejected it. His profession, incidentally, was journalism. Well, he was shot on the road, on the way to a hospital or some place to rest because of his defective heart, which had been bothering him—any of us might as easily stop a bullet.

SAT. MAR. 6. It is pleasing to think that across the lines from us there are fascists & that we are shooting at them (I fired some shots at them myself yesterday). It reduces the class struggle to such a simple, comprehensible matter. "Bullets," as Comrade Lenin has said, "are the final argument." Accordingly, the present undertaking has an air of finality about it very pleasing to puzzled intellectuals.
 "Diez y ocho" [eighteen]—this was the answer the Spanish kids gave us when we asked them how old they were when they came up to our trenches. One even, realizing that it sounded fishy, had the guts to say he was 19. One claimed his 18th birthday will be *"mañana."* One pulled out a birth certificate. We know that Spaniards are small, but these kids had no beards. I, who have been at the front only 9 days, felt 100 years old. But we hope to God they don't send the kids over the top. We finally soothed them, assuring them that we believed what they said was *"verdad."*

Mon. Mar. 8. We live much as one lived in the Golden Age, before the fall of man, neither toiling nor spinning, neither plowing nor tilling the soil. We sit around our mud huts & talk. Life would be idyllic. One becomes accustomed enough to the sound of rifle fire & even artillery produces only temporary perturbation. No one is wounded.

But death is definitely among us. Always there are the dead bodies—taken from the field where they have lain since Feb. 23 & Feb. 27. The odor is by now quite marked. And they are *"schrecklich schwer"* to carry. Last night, under cover of darkness, we went to the trenches of the right flank where one of our ill-advised attacks (or two) had taken place. 4 men went over the sand-bags; stretchers were passed to them. Everything is in readiness in case someone of the living should be shot. One waits in the trench, shivering in the night dampness & in the suspense. After some time, a noise is heard outside. A man comes over the bags, dragging the front end of the *"brancard"* [stretcher]. In a moment the whole thing is in the trench, stinking body & all. Then you try to carry the loaded stretcher thru the trench for perhaps a quarter mile—between the men, some sleeping, some conversing on either side of the trench. Sometimes you have to wait for an obstinate group to break up & permit your progress. A word about *"Toden"* [death] frequently clears the path. Then all the bodies are dumped in a small clearing, about which friends & the idly curious troop while the papers & other belongings are removed. Suspense only ends when you know that the last of the stretcher-bearers is again within the trench, back from no-man's land (then you know you won't be called upon to go over the top to administer first aid) & when you know which of your friends are among the reclaimed. Some of us are still hoping against hope that there may have been a mistake about John Lenthier, and that he may turn out to have been wounded.

Nothing here belongs to one individually—blankets, mess-kits—all are shared. Not even the color of one's fecal deposits belongs to him alone—all are uniform.

The food we get is very good. We were discussing it yesterday. One comrade said it was better than the American army gets in peace-time. I said it is better than many American families get in peace-time. The comrade demurred, but the majority was with me. The number of undernourished children in our public schools at home proves it—none of us would be undernourished, were he to live on our food forever.

…in sanitary engineering, the ancient Hebrews were infinitely in advance of us, since their law compelled them, when making camp in time of war, to carry a small spade with which to inter their excreta, while we leave ours uncovered. I, however, in respect for the practices of my ancestors, & in shame at the negligence of all else but the direct work of killing that is the rule in our modern war, make a half-hearted attempt to kick with my foot some earth over my own feces.

If there were not the ever-present fear of death, this life would kill us with *ennuie*—there would be nothing idyllic about it.

WED., MAR. 10. The Spaniards build lousy trenches, but wonderful mud-huts. While we Americans had deep, safe trenches, well-protected by sandbags, we slept in holes in the mud, covered over with half shelters when we had them, propped up with stakes or bayonets. The Spaniards' trenches are too shallow, their sand-bags leave big windows thru which one can look out to kingdom come. But whereas we used the olive groves simply as toilets where we would be protected from enemy fire, the Spaniards have made of every tree a perfect mud-hut, with a main supporting stay—the trunk with a leafy roof, & with mud walls. The floors always have some grass on them—while we Americans were content to rest on our blankets atop the stones. The architecture of the Spanish huts is somewhat complex, & I'm not at all sure that anyone could build

one, whereas anyone can build a dwelling American style. Our hospital, or rather first-aid station, is a most elaborate structure with a grass-covered shelf for sleeping purposes.

Probably the Spaniards are better soldiers architecturally than we, since more damage is done to morale by uncomfortable sleeping quarters than by an occasional comrade who may receive a bullet thru his head. In respect to the trenches, too, it must be remembered that the Spaniards are shorter than we are, & can better accommodate themselves to low trenches. The reasons for the difference in building habits are significant, of course.

I've taken to wearing my spoon in my boot. The boys have taken to fighting about eating utensils. Not that we are really short of them—they can always be picked up from the ground—but we are short of water to wash them.

FRI. MAR. 12. I did not yet report how on Wednesday I gave away my overshoes, incongruous relic of civilization. They had been resting for some time at the Dimitroff Hospital—incidentally the last place on earth where I had the pleasure of viewing my stethoscope....

Last night I waited in the lines from 8 to 12 to see some fascist deserters—but saw none. They do come, tho, & I hope to see some later. It is also pleasing to note the large number of fascist shells, etc., that turn out to be duds. One thinks of our comrades in their factories....

Just now I'm in the 1st aid outpost, where I slept the last 2 nights. Shells are exploding, & my dugout vibrates.

Today the epidemic of body lice is definitely upon us.

I often wonder whether I am held up as a hero or as a villain at home.

During rain, in my mudhole, I may be helping to make the world safe for democracy, but I feel uncommonly like when caught in a shower during summer vacation in the woods. But it's a lousy feeling.

SUN. MAR. 14. I'm wearing a belt knife that till this morning belonged to a man named Tomlinson. Now nothing belongs to him. His forehead felt like pulp.

SAT. MAR. 20. The Spaniards are like children—at least when they're sick or wounded. But Marquette assures me that they are not alone in calling for *"madre"* or *"padre"* when wounded—the Americans behave the same. He strokes the faces of the wounded—they like that. But the Spaniards make one almost cry to see them stripped to the waist—their physical development is that of our children or adolescents. They have had no food—our rations, which we have considered scanty the last few days, the Spaniards, interspersed in our ranks, consider most luxurious. We even gave one sick Spaniard tonight a blanket & patted him on the back. They all seem ridiculously helpless and childish. But if you go up to them in the trenches, in the American or English companies, where they have been put to keep them from running away, & ask them whether they are *"Español,"* they answer *"Ingles"* or *"Americano"*—& god help you if you dare to hint they're Spanish.

The Dr. feels that the men in the trenches should not be too much pampered.

MAR. 23. There is no firing when the airplanes are overhead—everybody stops to watch them. What a war!

Famous last words: Those planes are ours.

Last night for the first time I ate artichokes with assurance & enjoyment.

FRI. APRIL 2. Yesterday I lured J.B.S. Haldane to our hut, to discuss poison gas with Marquette. He looks much more mellow than his very decided photograph on the passport he showed me, to prove his identity. I imagine the passport photo is similar to the one used for publicity purposes in the States. The boys say he is the adviser of the government on poison gas, but I didn't think he knew so much about it as all that from our conversation. He knows Bassett of Penn. Med., whom he once boiled.

Ernest Hemingway was around the other day, looked about our first-aid station, & announced when departing, "I suppose everyone has lice."

Haldane told me it was not he, but his father, who did the work on alveolar air. (See London "*D.W.*" Ap. 5.)

APRIL 8. Yesterday I met a Comrade Seldes & asked him—as they say everybody did—whether it was Gilbert or George. It was George—"the left-wing Seldes," as he assured us—of "Iron, Blood & Profits," "Sawdust Caesar," etc. Today I met Sidney Franklin, the American bullfighter, whom you saw in Eddie Cantor's picture "The Kid from Spain." He wanted some gasoline & they held out on him under the mistaken impression that he was Joey Franklin of the *New York Post* who has not always been so sympathetic. Josephine Herbst was also here, & I had a talk with her. She has a home near Doylestown. Her people came from Germany in the early 1700s, & she is sorry not to be able to believe that Germany will be the next place in which she agrees with the photographer who was here too—Ivanz—who made the official gov't films of the defense of Madrid.

APRIL 10. April 8 I gave up my post as head of lst-aid station (which I had since Marquette left) & went to the farm-house. April 9 I came to Tarancón. I slept last night at #25; this morning moved to a better house.

APRIL 22. The apathetic wounded comrade in bed, with head bandaged, with one spot the size of a half dollar over his forehead, where it leaks thru from his brain, & a lone fly sounds. He never talks, rarely moves—his eyes wander about the room. No sound except "Ay—Ay" when they dress him in the morning.

The comrade with the stump of an arm, cut off at the shoulder, who shrieks thru the ward when they dress him. He always covers his shaven head & scrawny neck with the sheets during the operation. His eyes are enormous, his face ashen gray, his nose large, his arm & legs skinny. Now Kay lets him walk about the ward several times a day.

Bruno Lubecle, from Germany, never took part in politics before. He volunteered in Spain, where he had been living since 1934, when the war broke out. He was eyed with suspicion for the first four weeks, but because of his World War experience & his travels over the world, so that he could speak many languages, they put him in the division.

He received multiple wounds with machine gun—they stink to high heaven, & after they dressed, drained, washed, & douched them this morning they had to give him a hypo of morphine. Now he hopes that he will get his lieutenant's stripes—which all the kids (who spend all their time in writing) in the division have—when he gets back, so he can go to Madrid without asking permission!

Today I saw a comrade move his toes, with the tendon showing beside the tibia. Beautiful chance to learn myology!

Dia	22	noche	sala [ward] 2
1	cama	[bed]	37
2	"		37.2
3	"		37
4	"		37
5	"		36
6	"		38.3
7	"		37

The nurse just read out to this room of the wards the temperature list above—just like the school teacher reading out our marks! I think the listeners have the same suspense!

APRIL 24. On the phone the other day, the other party asked me how many languages I was speaking!

There must be a great deal of H_2O_2 in Madrid, judging from what one sees here, where apparently there is not quite so much. Everyone here is just graying out. Felicita, when asked a catty question by Frau F. (when I seemed much interested in Felicita—Frau F. is inclined to be jealous, & understands less Spanish than I!) explained that she always asks the boys if they prefer blonde or brunette. She is just at the stage where she can please both tastes. Felicita has a history. She was born in Argentina, & came to Spain when 18. She fought in '34 in the war, & has been a CP member for 2 years (you have to be 22 or so if you're a Spanish woman in order to get into the CP, so she says. I'll have to find out. She's 25 now.) The fascists took her prisoner. She disclaimed all knowledge of politics. They therefore put her in the trenches. She took out her trade union book hidden in her stocking & showed it to a Socialist guard, explaining she was a Communist. Felicita urged the other to escape with her. The guard was much afraid at first, but finally Felicita succeeded in reassuring her, & they went over the parapets together to rejoin their comrades.

Felicita has been wounded in a number of places; after the escape she was filmed three times. She expects to address the youth here in a few days. Quite lively, full of fun, not undersexed. Taught me how to say cuckold & fairy in Spanish.

The second page of an October 21, 1937, entry from John Simon's diary. It reads in part: "One likes to imagine that at the end we will all go home again, that the game will be over, that all the ones who have been killed will pick themselves up & come home to make their bow, with the rest of the stage corpses. But one knows that this will never happen. Max & John are dead forever."

Loyalist soldiers guarding the women and children of Spain.
Frente Libertario (Madrid), April 7, 1938

IV

IN SPANISH TOWNS AND CITIES
Solidarity with a People at War

• •

INTRODUCTION

Most books on the Americans in Spain have inevitably concentrated on their military exploits. It was, after all, a war, and the majority of Americans went there as volunteer soldiers. But the story is a larger one, not only because Americans were there in other roles but also because their experiences in Spain extended beyond the battlefield.

When the Americans went to Spain—whether as combatants, nurses and doctors, or as social workers—they went there to resist worldwide fascism and to defend a democratic country under assault from within and without. Not long after arriving, however, they understood themselves as well to be defending Juan and Maria, Hilario and Concepcion. In other words, they met the people next door and down the street. They saw towns and cities as human communities in peril. No matter how graphic the news photos of shelling victims in Madrid were, the presence of real victims in their lives—and eventually of people they knew—was inevitably still more powerful. Furthermore, it was in these towns and cities that they also saw farming communities in relative peace.

It is thus here—and in the chapters on Madrid and Barcelona—that a certain distinctive poetry enters these letters, different from the equally compelling letters written at the front. For the people of these towns and cities embodied everything the cause of Spain represented. To make them and their homes real to friends and family members across the ocean was to express a unique kind of international love—to bring together the people that mattered to them in a shared space of historical recognition.

• •

from ALFRED AMERY

May 13, 1937
[Madrigueras]

Dear George & Lawrence:

I am writing again from the same situation in which I wrote last time. It is well known that new places and new things strike one with a bright flash of attraction at first; and then, in time, are apt to become dull and monotonous. However, this tendency, I believe, is due as much to the "inner man" as to outward circumstances. Actually, here, in this little stone and cement-built village, I see no reason for growing tired of it. The women are pretty, happy, and cordial; the people are hospitable, the children amusing, and there is always something to do. We are nearly always busy.

In addition to all this, I have of late been enjoying myself in a very interesting fashion.

The day after coming here I started to exercise my Spanish on a roguish young boy of eleven. He introduced me, later, to two of his young friends, aged nine and ten respectively, but all more like young men than the children of the States. Still, as a matter of fact these children are healthy, happy, and strong. They are *"Pioneros"* that is, members of the local Y.C.L. (Young Communist League, I guess).

Well, Sunday, my young friends insisted that I go to the show with them. (The town has within the last month improvised a theatre.) In going to the show with them I paid the way of two of them. Eureka! This, though I knew it not at the moment, was the password to the bosom of their families.

The next evening I was invited to supper at the house of one *"amigo."* At first dubious about accepting the invitation of a ten-year-old boy, I decided to take a chance, and had a very good time.

Domiciano's mother, father, and older brother welcomed me with many "Salud's." And luckily carrying my small dictionary, I managed by racing through its pages to answer questions and make an occasional, very difficult statement.

The food was excellent and plentiful. The people, of course, are farmers. And for dessert I had the first sweet I've had in weeks, and also one of my favorites—honey. All the honey I could eat.

It was a very pleasant meal, the four members of the family eating out of one bowl in the center of the table, and drinking out of one ingeniously made vase, while I had a plate and glass for myself. Incidentally, the dining room was surprisingly clean. It was spotless and dustless, with a large, Spanish type of fireplace at one side.

Well, yesterday, I was invited to Tuanjose's house for this evening, and invited to eat at Domiciano's again tomorrow. So you can see that in addition to exercising my Spanish, entertainment is not lacking nor is good food.

Incidentally, at Domiciano's the main topic of conversation at first was in reference to my conjugal status, or lack of it, about my intentions in that way, whether I would like to marry a Spanish girl, and about my folks in the States.

I have given each of the boys a jackknife for a present, and enjoyed their obvious pleasure in receiving them.

Tonight, I expect to be able to speak better than I did before, as I make fairly good progress in the study every day. It is making my stay here very pleasant.

The town is nothing but an agricultural village, but I like its placid spirit—not as much ruffled by "our" presence as might be expected. It is a bright, compact, cozy, little community of likeable and fine-spirited humans.

Life has gone on here in the conventional, traditional rut for centuries; people using the same old wells, the same narrow streets, and the same stone and mortar houses. It is only lately—as you know—that the spark has brought fire—and such fire! That old adage about "can't change human nature" is annihilated by one mere glance at the people. In a period of two years at the most such changes have been wrought here as would have been thought impossible a few years ago. Make no mistake about it, this country is going places.

As far as we know here, the news from the States is fairly good. I am glad that Herndon is free. It may be that in my situation I cannot get a true perspective of trends and possibilities; but however that may be it seems to me, more than ever before, that

Headquarters of the JSU in a small town on the outskirts of Madrid, 1937. Note the photographs on display on the balcony above and the posters on the wall below.

the world is approaching a turning point; a turning point within the next ten years, at the most, which will surely mean the beginning of the true victory for us.

About my companion. I only have one with me now who came across on the same ship with me. He [Milt Felsen] is very intelligent, a graduate of Iowa University, of Jewish parentage, and possessed of incorrigible morale. In the States he was a secretary of a section of the American Students' Union. The other companion whom I mentioned before, the Albanian, is in another part of the country. The Albanian proved to be one of the best men I have ever known—and I have seen a good many, good and bad. With us, as usual, we have mugs and dopes as well as good men and geniuses. The good men, however, are by far in the majority.

At present I can write no more. Hoping that you will answer as soon as possible, and sending comradely greetings,

<div style="text-align:right">

Sincerely,
Alfred L. Amery

</div>

Socorro Rojo Internacional, Place Altozanos, 20 G.P., Albacete, Spain.

• •

from ALFRED AMERY

<div style="text-align:right">

May 24, 1937
[Villanueva de la Jara]

</div>

Dear George & Lawrence:

Since I last wrote we have moved. In most ways our new situation is better. The town is larger, cleaner, less dusty, and more attractive than the one we have moved from. However, when we first entered, the people were not so pleasing.

Having learned that I can write more freely than I have been I shall explain the attitude of the people and tell something of my own affairs.

A few months ago there were some French and Belgians quartered in the town. Literally, they raised hell while they were here. They got drunk, molested women, and made nuisances of themselves in general; so much of this in fact, that no others have been quartered here until our arrival, months after the vandals. Now, however, after a few days here, I am happy to write that we Americans are making a splendid impression. The children are all in love with us, the young women smile and speak to us, and most of the old folks say, "Salud, Camaradas," when they see us. This is a people's army as it should be. With only a handful of exceptions we have excellent self-discipline, we have enthusiastic attention to training, and we cooperate and get along together very well.

You know what my past experiences have been. I have seen men by the thousands. And I can say with good judgement that here we have the best of the workers and a surprising number of intellectuals. We have (in the "Tom Mooney Battalion") professors, several college students and graduates, singers, actors, writers, skilled workers, clerks, and many besides the workers.

An example of one of the exceptions and of what happens to these unfortunates is a sailor of Irish descent, a "tough guy" who got drunk last night and wanted to beat up the battalion and the town.

Yesterday was pay day. Change being scarce in the town we found it difficult to get change in order to buy what we need. One method of getting change is to buy an expensive article like a quart of rum or cognac. About the only other method available at the moment is to buy a lot of tobacco, a pair of shoes, or a supply of clothes. Personally, I haven't got change yet. I have left a bill at a pastry shop and taken dough-nuts and a credit slip in exchange. Well, you see how it works, and you must understand that little matters of local inefficiency are apt to irritate some people. The Irish sailor bought a bottle of rum, partly in order to change his bill, and no doubt with other, less serious reasons lingering in his head. He got drunk, and after a bloody struggle with the guards was thrown in the guard house. This morning, with swollen lips and eyes, and his clothes bespattered with blood, he was placed before the scornful eyes of the whole battalion and shamed to a condition lower than a dog's by the appropriate words of the battalion commander. He will do 3 days in the guard house and draw no pay next pay day. His conscience must wrack him with indescribable tortures. From the looks of him this morning as he was marched away, I am in doubt as to whether he will be able to face his comrades again and do his duty. His case will be interesting. I shall watch him.

We have no others as bad as he in a positive way, though we have a few negative incorrigibles. Such cases are inevitable. Incidentally, the method of holding them up to shame before the scorning eyes of all as punishment is second to none.

To conclude the news: I am in a machine-gun company; I am content with my work and my comrades; our company commander is a very intelligent negro, well-liked by everyone; we are very busy, and learn fast.

Oh—one fact—it would do you good to see the uses the churches are put to. One church we used as a mess-hall. The one here is a town hall, theater, and lecture-hall. It is encouraging.

Best regards
Alfred L. Amery

P.S. We hear good reports of Negrín and the new administration.
P.S. You have undoubtedly read of Caballero's resignation and the formation of a new cabinet headed by a Socialist, Negrín.

Here, we think this speaks very well for the elasticity and the durability of the Popular Front. I shall not bother to tell what I have heard as you will no doubt have more and truer facts on the situation through the "Daily" than I can get here, myself. But I'll add that we feel more confident than ever of victory, and of a fairly successful political outcome for the people after the victory on the battlefields.

from FREDERICK LUTZ

Spain, JunJ126e 16 '37

Dear Shirley [Gottlieb]:

It is now 6 A.M. and I sit at the typewriter at a window in a very lovely house and this is what I see:—A long slope from the house rising to the horizon. At the top is a grove of the inevitable olive trees. Below these are many checker board-like patches—some freshly plowed, some with tall green grain, some with the stubble of harvested

grain. One of the patches is a level spot with heaps of grain and large cement rollers standing on it. This last place is the grain threshing place where the patient mules drag the rollers round and round to thresh the grain. Near the grain field stands the ruins of a very ancient church. At the lowest part of the slope is a grove of tall poplar trees and at the base of these is a pool where the women of the town are busily scrubbing clothes on flat rocks. A tree-lined road winds its way by. On my left I look out another window onto the town square in the center of which is a fountain with two spouts which empty into large tanks. This fountain is the town's water supply and many women and kids surround it filling earthen jugs, some of which they carry away, some of which they load on the backs of sleepy looking donkeys. Horses and donkeys drink from the tanks. A herd of goats, each wearing a tinkling bell around her neck, is driven thru the square. Kids are playing around everywhere. Swallows are soaring round and round the towers of the large church which faces the square and many other birds are filling the air with song. A bright warm sun shines on all.

What does this mean, say you, I thought he was fighting fascists? It means this my dear girl—that, after four months of fighting the bloody fascist spoilers of this lovely land, the Lincoln Battalion has gone for rest. After rest it will return once more to do its best to free this country and its most likeable people from the cruel and murderous grasp of the fascist bandits of Italy and Germany. In the meantime we saunter around the country, play baseball, ping pong, volley ball, chess, checkers, read, swim, listen to the radio, take trips to Madrid, visit the very friendly townspeople, sleep and eat.

Why are your letters so far apart? You promised that you would write once a week. If you only realized what it means to receive a letter from home and from some people in particular. On the whole your letters have been very pleasing in spite of their infrequency. Try to do better; don't wait for me to write because I can't often find the time and it is your duty to keep me cheered and amused. Do your duty.

I wish you would cut all the stuff about "someone towering" and "summits I shall never reach." That's ridiculous.

I thought that when I did not receive a letter from you for so long that you were still in jail for trying to collect money for us. We were all amused by the newspaper account of your arrest and the magistrate's remarks. My sister sent me the clipping.

Of course I met Ford and Bob Minor. It was part of my job to take them around the trenches. I can't find it at the moment but when I do I'll send you the copy of the photograph of us in the trenches.

I'm not rolling a cigarette in the picture. That was a snapshot taken without my knowing it from the interior of a dugout and I'm administering consolation to a comrade who received some sad news from home—hence my serious mien. How can you suppose my rolling a cigarette? I retain all my old virtues (?)

Your description of my dear friend Watson is perfect. I can see the narrowed eyes and the jaw. Give him my love when you next see him.

I enclose some photos which I depend on your passing on to my sister; please don't fail to do this.

Tell Pat I received his cablegram asking for the Philadelphians to write. I have shown them the message, and they all promise to do so.

It is now 10:30 P.M. and outside in the square the propaganda loud speaker is

playing the ever-thrilling "Internationale" and the townspeople and the troops are all singing. You know I can't get over the thrill of hearing the "Internationale" and the "Youthful Guardsman" sung by everyone everywhere I go. Today for instance I went to the woods to rest in the shade to read *Studs Lonigan* and little groups of kids I'd met here and there almost invariably would be singing one or the other. Or else if one walks along the twisting streets at night these or other revolutionary songs are sung by someone or other.

We are certainly doing our best to win the hearts of the population or perhaps I should say to entrench ourselves deeper in them because from the very beginning they have been most friendly. I came to the town with the advance party to prepare the quarters for the men, and the mayor turned over to us the best buildings in town. We give dances, have shows with magicians and dancers from Madrid, Sunday night we will have a movie, Tuesday we give a fiesta to the kids.

Give everyone—Suzy, Henry, Sonia (she wrote me one very cold letter), Jackson, Carl, Pat, Gats, etc., etc., etc.—my love and tell them to write. Incidentally you may as well drop the business of the double envelope; our dear government probably knows all about it now. Did I tell you that I appear in the movie that was taken of the Battalion? It should soon be showing in the States, so be sure to see it.

Do you still intend to go Commonwealth? Why don't you become a nurse and come here with a medical unit? How nice that would be for me or would it not?

You said once before that Benny wanted to write—why doesn't he?

Please write often yourself because now that the government is in an increasingly stronger position a big offensive drive on all fronts will soon begin and who knows what may happen to many of us.

Well much love and greetings anti-fascist.

Comisario Politico de Batallon Lincoln, Your

Fred

● ●

from HARRY FISHER

June 19, 1937

Dear Sal & Hy Johnson—Louise—Hickey—Nat—Jack—etc.,

I didn't intend to write while on this leave, but this town has left so many impressions that I must write them for you.

I sit under a cool tree in the evening. Pretty girls and children walk by on the road arm in arm singing songs. I say "salud" as they come near. They stop singing and they all raise their clenched fists and in a chorus answer "salud". Then they pass and continue to sing.

A jackass is loaded down with wheat just harvested and is passing on the road. Behind it walks a seven-year-old girl with a twig in her hand, taking the jackass to its destination. I say "salud" to her. She looks at me and smiles and answers "salud". She is noticeably proud that a soldier has noticed her doing her share of work.

An old man is passing. His back is hunched with age. He walks with a cane. Again the mutual greeting, "salud". He stops and asks me about the front. I tell him *"mucho malo for fascisti."* He hobbles away happily.

A group of young children are waiting outside our canteen, knowing Americans are buying candy which is very scarce here. We give our candy to the children. The children follow us around, happy and proud when we notice them.

About ten of us, all young fellows, have just had a good drink of wine. We are walking down a narrow side street. We sit down on a doorstep opposite many women and children and sing songs to them. The children giggle, thinking we are very funny. The women, some with babes in arms, have big smiles on their faces. We become very friendly and talk with them. When we leave, they all shout "salud" to us.

A group of children are watching their first game of baseball. They look amazed, not knowing what it is all about.

At night, in the main square, our propaganda truck, is playing some American dance records. The American comrades dance with the Spanish girls—American style, except they stay a few inches apart. How graceful the Spanish girls are. You would never believe that this is the first time they ever danced this way. The "Internationale" has ended the dance. The full moon shows the flushed, happy faces of the girls. Everybody is happy—at least for the moment.

War?—It doesn't exist. Of course not. We spent many months only 150 meters away from the fascists. We became accustomed to bombs and bullets. Now we are many kilometers away from the front. No bullets flying around. No trench mortars exploding. Everything is peaceful. Peasants are harvesting their crop. Children are singing. Girls are smiling. War?— Of course it doesn't exist—not for the moment.

An English comrade has just returned after many months in a hospital. He was wounded in the neck while covering an advance of the Lincoln Battalion Feb. 27 with a machine gun. Pieces of the bullet are still in his neck and can't be removed. In 18 months he will lose his voice. He's a grandfather about 55 years old. Headquarters tried to send him home. He refused to go home—insists on staying with Lincoln Battalion, because as he says, "I love every one of you damn Yankees." His eyes still twinkle. His eyes make him look young. His hair is getting grey. He tells you this is the sixth war he's been in—the first one he's proud of. He won't go home because we need his experience. He also boasts that he is fighting for his grandchildren.

Two girls just stopped here. They are from the next town. They are jealous. They think we should have stayed in their town. Oh, what pretty breasts they have. My hands itch. As they bend over to speak to me, I can see a good part of their breasts, small and round. Surely they must notice my staring, popping, eager eyes. Oh—how beautiful. But they continue to bend and let me stare. They don't seem to mind. I don't.

Yesterday I was walking with a Spanish comrade. An old lady stopped us and had a conversation with him. When we walked away, I asked him what she said. He told me that she said she prayed for us every day and that God was with us.

A colonel from brigade headquarters is speaking to us soon. I'll have to end now. Keep on writing.

How is Louise? Does Ben still keep her busy? I hope you have sent me pictures. I'd like to see your mugs again.

> Salud
> Bozzy
> My regards to all—

• •

from LEE ROYCE

July 4, 1937

Dear Hy & Sal,

I am going to try and make this letter interesting by trying to give you some of the impressions I have received since I arrived here.

At the present time, I feel that the Spanish Republic is highly organized. Now there is plenty of food, plenty of work, and a general feeling of satisfaction pervades the country. When I first arrived the place was a madhouse, no less.

Most of the men that return from the front are a little insane for a while. The strain and hardship there almost invariably causes them to react violently to the peace and quiet of the cities behind the lines. As one commander said (about me, incidentally): "Many things happen at the front!"[1]

The sex problem is a difficult one for the men of the brigade. To prevent the spread of disease, the government closed most of the houses of prostitution, and the Spanish women—as far as I know—are amazingly virtuous. Of course there is also the language difficulty.

This repression is hard to understand as, generally, the Spanish are a free and easy people. They like to live simply and unaffectedly. They make me feel like a straight-laced old preacher.

Coming back to the mild forms of insanity that I mentioned, I spent a night in jail to find out what a democratic government's prisons were like. I picked a quarrel with two policemen in one of the city's largest hotel dining rooms. Six armed men escorted me to the jail. I was not manhandled or mistreated in any way, and when I demanded that they leave my cell door open, they obligingly opened it for me. After a time my conscience began to bother me and I behaved myself. I was confined for about 20 hours and they released [me] with the admonishment: "Don't drink quite so much." Incidentally, I had been drinking Champagne.

I wish that I could describe, adequately, my reactions to the society I find here. In spite of all the hardships here, I believe that I am quite happy. Now and then I take too many drinks and bawl out the leadership, or complain about everything—or possibly go out and find a Spaniard to browbeat—but everyone takes it in the best of spirit and, inevitably, I feel damned ashamed of the whole escapade and resolve to better the quality and quantity of my work in atonement. Here we have the greatest possible individual freedom: so much in fact that many of us slave-minded, former pawns of aristocracy

[1] A passage from an April 1995 letter from Harry Fisher to the editors deserves quotation here: "Royce was in action only once, on Feb. 27, 1937, at Jarama. Because he had been in the U.S. army, he was put in charge of a group. He led them over the top and more than half were killed and some wounded. He felt as though he was responsible and went out of his mind. When I joined the Lincolns at Jarama, in April, 1937, I asked about Royce. Some said he deserted, some said he went berserk. Near the end of the war, he was sent to the front when men were badly needed. When German bombers flew over us he again went berserk, and had to be held down. He was sent to the rear and returned to Ohio...to me, he'll always be a hero who was badly wounded—not physically but mentally. It's the worst kind of a wound."

cannot comprehend how things go on. For instance, I know men at the front who have gone insane worrying, because they thought others were not deeply enough concerned with the military situation.

In the small towns, where poverty has always been the most oppressive, the people are extremely friendly. They make strangers feel like old, intimate friends. In some of the cities there is an element that agitates against the Inter. Brigade. They are mostly Trotskyites and Fascist sympathizers. Their line is that we are beggars come here to eat off the Spanish people.

By the time you receive this the "big push" will be launched. I have every confidence that it will be successful.

<div style="text-align: right">As ever,
Lee</div>

P.S. I haven't seen Harry [Fisher] for two months. I am now in the Motor Transport.

● ●

from SANDOR VOROS

<div style="text-align: right">Spain, July 30, 1937</div>

Honey [Myrtle Hausrath Day],[2]

Here is Friday, another week gone by without hearing from you. At that I have no grounds to complain because lately I have received more letters from you than most of the fellows did from their gal friends. As a matter of fact it is my turn to apologize for I don't remember writing to you since Monday although I did plan to do so every day.

My last letter, if I remember correctly, dealt with the subject of Women in Spain. There is one appendage to that—a rather amusing one. Since love blooms also in time of war there are cases where members of the International Brigades fall in love with some Spanish beauty and want to get married. This is a very involved procedure, you have to have witnesses to prove that you are not already married, etc. I was told—I haven't checked on it so I do not vouch for the accuracy of this—that quite a few fellows did get married and entered the marriage chambers with palpitating heart to be met there by the parents of his newly acquired wife who said in effect:

"You got married, oh yes; to be sure. But if you think you can now sleep with the gal you have another guess coming. Once the war is over and we see that you are really sincere in remaining here and you got yourself a job and settled down to found a family—well that will be a different story. But till then—*nada* (nothing doing)."

I have heard this story repeated with various choice morsels added or subtracted according to the imagination of the guy who told it. The story teller usually tells it that he had heard it from one who knew the guy to whom it happened. In some instances it was the gal who uttered the above described words, in other versions it was the parents who broke in just at the last moment when the irreparable damage was about to be done. In those latter cases you always get the description with all the lurid details about what the bride looked like, how the fellow reacted to it, etc. The stories all seem

[2] Day was also the Secretary of the Detroit office of the American Medical Bureau to Aid Spanish Democracy.

A motorcycle courier for the International Brigades.

to agree in one thing—that the marriage certificate is a huge sort of a document all a yard long if not longer with a million and one questions on it.

This I think concludes my chapter on Spanish women till I can speak with more first-hand knowledge.

By the way yesterday we had quite a day. By accident we found that there was seven of us Clevelanders in the same city—one of those coincidences that seldom happen. We took advantage of it by having dinner together and afterwards having our picture taken. Lottie's husband, Dave, is one of them. The picture ought to be ready by the middle of next week—my copy of course goes to you.

That's about all for the present. It just occurred to me that I haven't received from you any letters as yet that you have written in reply to my letters that I sent beginning with the time that your first letter arrived. The above sentence is rather involved but I haven't the time to rephrase it. In short, once I receive your letters in answer to my letters dated after July 3d (the time your first letter arrived here), we'll have established a regular two-way correspondence.

I still haven't received any other package of cigarettes outside of that pack of 50 Camels you mailed on July 6th. I suppose somebody else had smoked them. At any rate take a couple more chances and send a tin every now and then in a heavy manilla envelope. That might be safer. But be sure to notify me of the exact dates so as to give me a chance to trace them. I have a sneaking suspicion that you are not paying for the stamps anyway so even if you would send three or four packs a week the cost wouldn't be prohibitive.

> With much love
> Sanyi

* * *

from MILTON WOLFF

> August, 1937, Spain
> In the grey light of morning.

Ann Lenore,

I don't know what to begin to say…the past days have been so dismally the same. I just can't reach back to my thoughts of other days—beautiful days.

Maybe it was four days ago…the sun shone then, tho not for long. That day travelling the road that runs along the hills that hold the valley. And the poplar trees mark the course of the stream below, in gold. Autumn in Spain is not a violent, riot of passionate colors. I can remember an autumn in the Allegheny Mountains…crimsons, russets, oranges, purple—a multitude of colors. Gold in Spain is Autumn…the yellow comes slowly, mellow. The poplar, the willow, and the grapevine; only the olive tree stands deep green against time.

From this window, the plaza lies below.…You can see the trough and fountain. In the rain the farmer comes, bundled up in gay-colored shawls and ponchos, leading burros and mules to drink. The women, in black, come with clay jugs, on hip or head, for water.…They gossip and laugh with the men in the rain. The children, dressed in fashion heterogeneous, with books under arm, make for the *"escuela."* Singing childish songs…their voices young and silvery through the rain. This is the town, "The

frightened huts....", the mongrel dogs, the mud, the rain....

Soon I will go to Madrid on leave. When I have slept in a clean bed, had a hot bath, enjoyed the company of women—when I get away from soldiering a little while— maybe I'll begin to remember....

> Salud!
> Milton

· ·

from LEON ROSENTHAL

> Aug. 15, 1937
> Sunday, 11 P.M.

Lee [Rosenthal] honey,

Well—I'm going to bed now so I'll bid you good-nite in this way. I wrote you this morning, but you don't mind a short additional note do you? I'm sending you in this envelope a set of 20 postcards. Let me know if you get them.

Today we went to the movies & sat thru 3 feature pictures—American, German & Soviet films—the 1st two were awful but the Soviet picture "Revolt of the Fishermen" was good. Coming out of the movies, we dropped into a restaurant for supper & met 2 International Brigade Americans. They turned out to be Cubans. One is a major—the other is his chauffeur. The major has 21 bullet wounds—the last ones acquired at Brunete—he is 23 years old & is one of the leading revolutionists of his country. He is the commandante of a "shock" brigade. That's what our army is made up of!

Tomorrow A.M. we'll do more shopping & then leave for Albacete. We may take the major with us & leave him at the convalescent home.

That's all for now honey—I just wanted to say "good-nite" & sweet dreams to you— I'll write more from Albacete.

> Good nite, sweet wife
> Forever yours,
> Leo

· ·

from LEON ROSENTHAL

> Wed. Sep. 29, 1937
> 11:30 A.M.

Lee, honey—

A million pardons for the long delay. Since last Tuesday (Sep. 21) I've only sent you a pamphlet (On Fri. 24) and a short note—I've had absolutely no time to write. Even now—as I write I haven't the assurance of sufficient time & quiet to compose the letter I want to write—but I must send you some word after 8 days—so I'll begin this letter anyhow & see how far I can get.

I am sitting in the truck—we are parked as usual in the village square—it is very hot from the sun beating on our car-roof—all the clothes we washed yesterday are hanging overhead & all around—drying & adding humidity to the heat—Joe, the chauffeur is working hard trying to repair the water-pump of the truck's motor—tools are lying all around—but I am squeezed into a corner & the letter must go

on—No—I'm going to sit on the sidewalk & write—now that's better—the sun is like in July—Indian summer in Spain!

Last nite I got 3 of your letters. The one of the 10th (containing Betty's & Rose's letter) the one of the 8th & an old one—June 15—that's been all over Spain after me but finally caught up. (It's the 3rd letter you wrote—telling me of your accident on horseback at Cedarhurst, etc.) You say you've written 2 letters on the 7th but I only got this one (postmarked 8th). But, as you see, all mail gets here, in time.

Well to start from last week. Things were going along pretty much the same—day after day, either playing at fiestas or giving dance programs & news reports in the local village square at nite. Then, Friday we had a big meeting, at which our new division commander, Hanns, spoke & Commissar Inspector Luigi Gallo also spoke—of course using the sound truck. Then Saturday we again went to some other towns for troop reviews—and Sunday we left here—the sound truck being sent to a distant destination. And did it rain—boy-oh-boy—Spain has got it! Our fibre loud speaker cones got soaked & ruined & now I'm trying to have some wooden ones made. Sunday nite we slept in a stable & the next day reached our destination, but were sent back here—our original starting point. On the way we had to climb steep mountains on makeshift mud roads—the mud was almost knee deep & did we have fun getting the truck up—ropes, chains, tent-cloths & human muscle finally won out, however & we got back "home." Poor Joe—did he work hard—encrusted with mud from top to tip—and so yesterday all day we were busy cleaning & repairing the truck & apparatus & then we had work to do & finally we got down to the creek for a much needed bath & laundry job.

When we were here before, we had a room in a private home to sleep in, but now, since we got back so late—someone has the room & there is no other available—so I slept one nite in the church & last nite outdoors, but I'll have to cast around for better quarters. The chauffeur sleeps in the truck—there is only room there for one & since he is not in perfect physical shape (one lung only) I let him sleep there always.

That brings this right up to date. As for Sam—he is not around now. He was having a little digestive trouble—so I took him to the doctor—who prescribed a regimen & diet—but that requires self-control & Sam preferred to eat what he wanted. So now—he is in a hospital somewhere—he's been away since Friday & I don't know just where he is or how long he'll be gone or if he'll return to the truck. None of this to Alice, of course. As far as the work goes, Joe is more than willing to help & learn & the work goes on as before—only quieter & more efficiently. Also I have more time & opportunity in sight for reading, etc.

Yesterday I shaved after 5 days—no chance to do so before. Have late papers (even a copy of NMU—"Pilot") to read & will catch up this afternoon if I am free. I am in good health & need nothing—I even have left almost a full package of the razor blades you gave me along—hope to see you before they run out.

Now that covers everything here & I'll return to your letters. In the one of the 7th—you first say you'll wait for me until December or January & then you say—no—you're going to try to get on the "Caravan". Well, for the 35th time, here's my advice & I think it is fair: If you are already set & accepted to go on the "Hospital Caravan"—then I don't want you to change your mind if you are so dead set on coming here—but if not—if there is no possibility in sight & nobody to pay your way & guarantee you the work you

want—then forget about it. I *do fully expect* to be home in December or January & I think you should, as you say, wait and plan until then. I am sure that by that time my services on the sound-truck will not be needed & the war, if not over, will be past the climax & the Republic will be merely "mopping up." So, wait for me, honey—don't waste your hard-earned money & be a good girl & try to be patient for another few months, you little animal, you! But, seriously, I miss you something awful—last nite as I lay on the straw-pile trying to fall asleep—they were dancing, singing & playing piano & guitar in a house a block off—& I couldn't sleep so I lay there & thought of you—of our reunion & all such sweet things—but I picture our reunion in New York—not here.

12:30 (Well—honey—we must eat—see you later).

1:00—Back again & just bought a couple of melons for later. I just saw—in one of our brigades' publications a picture of an ambulance—which is about the same chassis & body as our sound truck—so I added our superstructure in ink to give you an idea what this thing looks like from the outside. As for inside—just imagine—a rack & panel amplifier with phonograph, large meters on a panel, gasoline engine, generator, multi-graphing machine, typewriter, large spools of wire, extension speaker & 6 ft. horn (like on top) 3 or 4 tool chests, 4 or 5 rucksacks, drawers of tools, blankets, tent cloths, fire extinguishers, & endless odds & ends, plus the usual 2 or 3 "hangers arounders" and the Galician Paulina (who has been vacationing with us for a month, but is now leaving for Valencia at my "suggestion"), not to forget a box containing 1 1/2 hams (some day I'll tell you where I got them), and 3 rifles and ammunition. Now you have some idea of what our sound truck looks like. But from the very beginning, I insisted on the same standard of neatness & cleanliness as at home & Joe, at least, cooperates to keep the truck clean.

Finally, I got a letter from Jimmy Garry—dated Aug. 10th & he also sent the July "Radio Progressive" which gave me great joy.

To come back to your letters—your mother is right in opposing you going to Spain & I give her credit for good judgement. You ask what I've done with all my clothes—I still have my suit in a package, my raincoat & even the bathrobe—as long as I have a place to keep these things I will—for I'll need them again. My needs?—nothing in the way of clothes or supplies—all I want is to lick the fascists & come home.

I'm glad to hear from the girls that you have such a nice new apartment. $75 is a lot of rent but I suppose it evens off with the commutation cost removed.

I'm surprised that by Sep. 10th you hadn't received any of my letters from the front. Let me know the dates of all letters you get. Do you know that those letters from the front were written at Saragosa's back door? At nite we used to watch the lights of the city of Saragosa—the louses know that we don't bombard civilians so they are arrogant enough to burn lights at nite, whereas we are careful even in the smallest village not to show any lights at nite.

And—congratulations again on becoming a citizen. I'll save an extra kiss to make it final when I see you. I'll continue sending mail to c/o Alice until I get the new address. I'm waiting anxiously for news of Jack's appointment—keep me in touch.

Well—that's about all for the present—there's lots more of course that I could

write—but it wouldn't be news & it would not adequately express how much I love you—ink is not the proper fluid for expressing my *feelings* toward you—! (Excuse the interruption, but I just killed about 100 out of the 1,000,000 flies that are annoying me.)

I don't feel satisfied with this letter—8 pages & I don't feel as if I've had a complete chat with you—your letters seem much more complete than mine—but I try my best—I'll surely express every little thing to you soon, my plum peaches. Darling, my longing for you has taken over my spirit so completely that no matter what I am doing, or how busy, I always, asleep or awake, feel your absence. No doubt you feel the same—but think, we'll have the fun of a brand new romance & honeymoon—its almost worth being apart. What do you say?

Yes, I know what you say—"iron bars do not a prison make—nor words a hot time—get back home, put your cards on the table, woman ain't made out of wood"—O.K. honey—it's a date—I still hope to see you on New Year's Eve—keep the home fires burning—this war will be over soon—read the articles in the "Volunteer" I sent today.

With a last tight, hot, close fitting hug & wet, tonguey kiss & bite I leave you to wail for——your Leo

. .

from HARRY FISHER

Oct 3, 1937

Dear Sal, Hy, & Louise:

I finally received Hy's fine letter written Sept 2. I read it while my nerves were a bit tense, because of what happened during the day, and it quieted my nerves down a bit.

Here is what happened yesterday that upset me. Irving, I and a few other fellows were spending the afternoon in a small, pleasant town on the coast. Suddenly everybody was looking up in the sky, and sure enough—four huge bombers were roaring by. Just as they got near the town, they dropped some of their bombs. So once again I heard that familiar, terrifying hiss of falling bombs, and then the nerve-wracking explosions, even though most of the bombs fell in the water.

But what shook me up was the effect of the bombing on the women and children. As soon as the bombs began falling, women and children began crying and yelling and ran about aimlessly. Irv, I and the other fellows tried to calm them down and get them to lie where they were. The planes came back a second time, seven of them. This time Irv and I were with a seven-year-old boy and a middle-aged man. The boy was trembling and sobbing. He couldn't understand what it was all about. I tried to calm him down by saying, "es nada"—it's nothing. But I noticed I was nervous myself. When the sound of the bombs hissing downwards came, the boy lost all control of his nerves and shook like a leaf in a gale. It was pitiful. The planes came back a third time and dropped bombs. By now the whole population was terrified. I don't think any damage was done, but it sure scared the people. After it was over, I saw a group of women and children come out of a tunnel with water knee deep. They were all wet and most of them were sobbing hysterically.

And talk about Spanish pride. The middle-aged man who fell next to us was very ashamed to lie on his stomach in a street in such an undignified way. When he got up, he explained he was doing this for the sake of his mother, as his death would hurt her.

Last night I began to think how awful it all was. Yet this was nothing as compared to Bilbao and Guernica. What brutal agony those people must have gone through—those who lived through it. This incident brings home clearly the methods of fascism—Terrorizing women and children.

Can you also imagine how much torture the civilians of Canton went through when Japanese bombers did their job? We here in Spain follow the events of China with just as much concern as the events in Spain. I watched some wounded comrades read about the bombing of Canton and their faces expressed both horror and anger. Just imagine what the next world war will be like.

It was very interesting reading about the [illeg.] of Fox. The reason he liked me is because, while everybody else ignored him, I used to spend many hours talking with him. It so happens that he is an Italian—so I used to talk about fascism to him.

You write as though you have a guilty conscience because you haven't come to Spain Hy. I thought I dispelled that idea once. As far as artists are concerned they have shown that they are good fighters. Mark Rauschwald is a good example. Since he was wounded, he's been doing murals on the walls of a hospital.

Another fellow from the dept. store union is here with us. He was wounded at Quinto and is here to recuperate. His name is Morty—I don't think you know him. We haven't heard from Leon for some time, but a doctor tells us that he saw him recently in good shape driving an ambulance on the Córdoba front. So the only one we have to worry about now is Butch. Just as soon as we get to the base, we'll find out.

I'll be here for a few more days. Then to the base—and then I don't know. It may be necessary to wait awhile before being sent home, but I'll be home sooner or later. Just as soon as I get an idea, I'll let you know. I was thinking of surprising you, but I think this way is better. Don't forget to put mom at ease.

The rest here has done me a world of good. I'm sure I put on enough pounds to make up for those I left at the front. I feel good and strong and lazy, which proves I am normal.

Tell Hickey I'm proud of him. Lou Zucker wrote about him collecting 200 bucks for Spain—that is his branch. That's real good work. Greet him for me.

Also greet your family Hy—including Joe, Lou and their wives, Phil & Jean, Ben, Syd, your folks and all our friends.

Say Sal are you preparing those two soft-boiled eggs, coffee and cake? Don't make any more the first night, as I'll be too nervous with happiness to eat. Oh, but watch out for the second night! And make Louise warm up in her dancing for an exhibition. Oh, boy, am I looking forward to seeing you all again. Every night I try to picture it before falling asleep. But it won't be long.

<div style="text-align:center">Love—Salud
Bozzy</div>

Address my mail—Name
c/o Socorro Rojo
Service de Cadres
Albacete, Spain

It will reach me quicker this way.

· ·

from FREDERICK LUTZ

The Front, October 23, '37

Dear Shirley,

Another of your frequent and most welcome letters arrived today and this afternoon I find the time to answer it along with some others, including two from your friend Sonia. (What in the world ails you two females? As to your question concerning her, which is prompted solely by curiosity, I refuse to commit myself in black and white; no matter what the answer is, it might be used against me.) Yes, your letter reads as if you had been on an emotional spree. For God's sake why did you ever send my letter off for publication; now I'll have to be more guarded in what I say.

Very interesting what you say about the new Party headquarters, what's the rent? Has Dieter used his caveman methods? Is that the proper approach? If so, I see now why I failed. Please, you and my sister, stop getting together and "reading between the lines"; your womanly intuitions are all wrong. I merely visited the hospital while in the neighborhood on an errand for the Divisional General. Hasn't Leo told Suzy yet?

Heard Langston Hughes last night; he spoke at one of our nearby units—the Autoparque, which means the place where our Brigade trucks and cars are kept and repaired. It was a most astonishing meeting; he read a number of his poems; explained what he had in mind when he wrote each particular poem and asked for criticism. I thought to myself before the thing started "Good God how will anything like poetry go off with these hard-boiled chauffeurs and mechanics, and what sort of criticism can they offer?" Well it astonished me as I said. The most remarkable speeches on the subject of poetry were made by the comrades. And some said that they had never liked poetry before and had scorned the people who read it and wrote it but they had been moved by Hughes's reading. There was talk of "Love" and "Hate" and "Tears"; everyone was deeply affected and seemed to bare his heart at the meeting, and the most reticent (not including me) spoke of their innermost feelings. I suppose it was because the life of a soldier in wartime is so unnatural and emotionally starved that they were moved the way they were.

You ask about my coming home; while, as I think I've said before, I would like to see *some* people again, I would like to stay on here till the finish and then see some more of Europe. But I saw Steve Nelson and Bob Minor the other day in one of the big cities and they say I've been here long enough and must soon return to the dear old USA. Don't get too excited over this because "soon" may involve months. I'm one of the very few old veterans left and am becoming quite senile and hoary.

Tell Uncle Benny that I'll get around to writing to him one of these days and that I call him "uncle" only for reasons of affection. Yes, I'm a member of the firm. Incidentally I gave Pat and Carl as references, so you might explain to them who I am in case there are any inquiries. Get my sister to retell to you the story of my automobile accidents, which resulted in nary a scratch and merely one slight bruise. I seem— so far—to lead a charmed existence. Do you think that would explain my escaping, so far, the clutches of various designing females? Thanks for the kind estimation of my more maturing personality. Well three more letters lay before me and I must be fair to everyone so I'll close to you with

Affection, love, and, of course, Greetings Antifascistic

Frederick

P/S [censored] I enclose one of our Brigade bulletins in the form we have to issue since the mimeo machine broke down. Incidentally, you're a mimeo expert aren't you? And you're looking for a job, how about it? The pay is low, but then you'll have me to administer justice to you.

. .

from BEN GARDNER

10/24/37

My address now is
c/o S.R.I Plaza Del Altozano
22E
Albacete, Spain

Dearest Sweetheart:

I believe it's about a week since I have written to you last. Somehow this last week has seemed to me one of the longest. Even though I received a letter from you some 10 days ago which I answered promptly, still I longed for mail from you terrifically. Possibly it's because I am in a new atmosphere, new kind of work, new people, etc. At the front it was different. With all the hardships & facing death daily, nevertheless, my comrades were a part of me. We fought, slept, etc., & lived together day by day, minute by minute. Especially those intimate to me, I miss them terribly, feel a great affection towards them, with all the shortcomings men may have. Never before did I feel such a deep regard for comrades, especially those who took the fight with a real antifascist & bolshevik stamina. I long for news of these comrades & in war time it is not easy to get news of comrades who don't get a chance to write in battle or near the front line. This coupled with the fact that you are not by me makes one feel blue many times. Of course I have very little or hardly any time to think, meditate, or worry. But during the free moments I feel constantly something missing. There is of course no miracle about this strange malady. If I could see you for one hour at least & talk to you, it would be suffi-cient to last me for many more necessary weeks & months. I realize now how much your coming to see me in jail 3 times a month, even only for 15 minutes meant to me. But, please sweet, don't get me wrong! I'm not disgusted, merely lonesome for you, which is of course natural for people who have been together for so long & have gone thru so much. As I stated in [my] last letter I'm doing work in the rear, which is very necessary & useful, but since I'm not fully acquainted with the daily routine & haven't found the friends necessary for intimate comradely conversations, I still feel kind of not settled completely. Of course this I hope will not last long. At present I'm kept busy 10 to 12 hours a day & even more. I have met additional comrades from our District. One is Vully (something like that). Mary Powers knows him well. He developed tremen-dously. Also 3 fellows from outside [the] city. Since I'm cooped up the whole day I doubt if I can write good letters like you asked me to, so I'll try to make it up by send-ing material, posters, etc. I hope you can make use of them. Tonight I copied a

quotation Angelo Herndon wrote on a poster & I'm giving it to you because it struck me as very good & sensible. "A man who loves his fellow-man must not grow tired—cannot afford to rest.—There is too much work to be done—too little time to do it. All that has happened to me this far has been for me a sort of apprenticeship in the revolutionary struggle—a kind of prelude to life as I must live it." How do you like it, Alice? Enclosed I'm sending a red hanky with a sickle & hammer & star to you. Will send more next time I write. Also one of our Bulletins.

<div style="text-align:right">Love, Always Yours,
Ben</div>

- -

from HARRY FISHER

<div style="text-align:right">November 30, 1937</div>

Dear Kids:

It's about time I dropped you a letter. I've been so damn busy during the past week that it was difficult enough just to write a postcard. But my conscience has been bothering me and I must write a letter to you so that I can sleep peacefully tonight.

You can see by the typing that I'm working in an office. It's a very tough job, keeping me on the go from morning till night, but something I like a lot. I never knew I could be so happy and busy at the same time. I'm being broken in as the secretary of the American Commissar at the base, here in Albacete. It's a very important job, held during the past seven months by a young student from the University of Chicago. This comrade is getting another important job, and I'll soon be taking his place. Meanwhile I'm working with him. The only handicap I have is that I don't speak all the languages that are spoken here. John [Murra], the young student, speaks French, German and most of the others as well. All I speak besides English is a bit of Spanish. Anyways I think I'll get along and at the same time I'll be learning more of the languages.

I've been getting very few letters lately, and look forward to the time that they will start flowing in again. I suppose that most of the fellows think that I'm on my way home and so have stopped writing. Get the word around that I'll be here for a while yet and have the guys write often to me.

What really worries me is that you will worry about me and feel that I should come home right away. This is something I hope doesn't happen. I'm glad that I have an opportunity to stay here longer and be useful, as I really came here to stay until the war is over. I can assure you that it won't be necessary for me to stay more than a few months, but during these few months I'll be kept busy. If it weren't for the fact that I miss all of you so much, I'd never think of going home until the war is over, but hell, nine months isn't such a long time. I can stand a few more months. Gosh, if you only knew how much I missed you during the days I was resting after being taken out of the front. I was quite weak for a while, for about two weeks, finding it very difficult even to walk. I spent most of those days in bed on the Mediterranean coast, and began thinking of all the old days, and how much fun we used to have. Then I took stock of everything—whether it was worth my while to have come to Spain and whether it did me any good. I can assure you that it didn't take me long to find the answer. Nothing has awakened me to the extent that my stay here in Spain has. I'm convinced that I want to

stay in the revolutionary struggle for the rest of my life. The thing is so clear and simple here. There are two sides to it and the fascists are always facing you. Do you remember Hy, how we used to talk of the day that we would be behind barricades, how political differences would disappear, that Democrat, Socialist and Communist would fight shoulder to shoulder? I remember that last day in Belchite, while we were building a new barricade on a street corner, that I smiled to myself. When we had those discussions, they were only theoretical. I never thought that some day I would be behind barricades. It wasn't theory any more—it was practice—it was real.

Don't think that I feel that war is glorious. I'm not Mussolini's son. It is impossible for anyone to go through this war without being a real hater of war in the future. You have no idea how ugly and brutal it all is. I've seen strong comrades go crazy almost— and seeing a strong comrade weaken is heart-breaking almost. It's much worse than seeing one die. There is one British comrade, a damn good fellow, who had a bomb drop 20 yards from him. He got a bad case of shell-shock or something, so that he goes around shaking. One side of his body is completely paralyzed, so that he can hardly walk. He can't move his head. He's a pitiful sight to look at. Yet I remember him just a few months ago, big, happy, strong. You can imagine how I feel when I see him now. What is surprising about this case is that the comrade's brain is normal and that he is sorry only because he can't be of much more use.

There is another comrade [Robert Colodny], a fellow I became very friendly with on the boat on the way here, who is a student from the University of Chicago, who was shot in the head. For 18 days he was unconscious, and then in agony for weeks after. Today he walks around, knowing that little by little his right arm is wasting away, until soon he won't be able to use it at all. A hard pat on the head of this comrade would most likely kill him. Yet he has fine spirit. He had a chance to go home but didn't want it because he felt he could still be of some use, being some kind of gas expert. So he is still around and cheerful. Do you blame me for wanting to stay longer in Spain with such fellows as these? Fortunately I am healthy—so it's much easier for me.

You know, it's funny. There were some fellows I took a dislike to during the early days while we were training. How things have changed. Some of the fellows I disliked turned out to be the best. I learned a lot during these months.

I've been rambling on just putting down whatever came into my mind. I don't know if this letter makes any sense, but there you are — you know what's on my mind.

Just a few more things. I met Leon Tenor the other day. I was damn happy to see him. He had been driving an ambulance on the Southern front for the past half year. Now he is out someplace on the coast taking a well-earned rest. I found out that Pat is working in a hospital and I'll write to him in a day or two. Jack Small, as far as I know is still ill in some hospital. As soon as I find out where he is, I'll write to him. Irving is still having his foot treated and is coming along very nicely. Irving C., from Ohrbachs, is working at a hospital. I guess that is all of the people you know of here. Oh yes, Royce is still around someplace. He told me to send his regards anytime I write to you.

I bought a pair of those things you drum with in your hands as you do the Spanish tango — castanets I think you call them, for Louise. If it is possible, I'll mail them. Otherwise I'll have to wait till I can take them home. I know Louise will be an excellent dancer by the time I get home, for I'll bet she's a fine dancer now. I'm looking forward

to seeing her dance. It might not be a bad idea for Louise to teach me how to dance, so I can lead a normal social life.

Please write often, and I promise that you'll hear from me regularly.

Love and Salud
Bozzy

Give my love to mom and Ben and greetings to all.

• •

from HANK RUBIN

December 14, 1937

Dearest Audrey:

The fronts have been very quiet lately, except perhaps for the army of the air. The other day enemy bombers appeared near Granen, the Jefatura, but were driven off by our chatos (snub-nosed planes). A magnificent air duel occurred in which 3 fascists were shot down, while another went down after crashing into one of ours.

The bombers are protected by the fighting planes which engage our planes and allow the bombers to escape. One of my buddies was driving an ambulance a few kilometers away. He had just passed a gasoline truck when two Fascists sneaking from home strafed the both of them and blew up the truck.

The next day the fascists took on our little village in earnest. Dropped all sorts of high powered eggs. From a distance of 3 kilometers away, observers thought that the whole pueblo was wiped out, so heavy were the bombs and so dense the fumes. Yet when it was over, there were about six or seven houses partly or wholly crumpled, and a few civilians wounded. For this they spent more than $10,000. Their object is to terrorize, and yet even at that they do not really succeed.

Of course the villages are terrified of the sound of the damn *avion* siren. We all hate it. But a few hours after a bombing they are back to their houses, hauling away rubbish, dusting off the fallen plaster, or boarding up broken windows as the case may be. And telephone units and power line units immediately go along testing the lines.

It is a type of reconstruction which we never find evidence of when we capture an area which has suffered damage from us. Only those things which are absolutely needed by the military are put back into order. The peasantry never does. It's really a good illustration of the differences which occur under fascism.

Salud!
Hank

• •

from LAWRENCE KLEIDMAN

December 18, 1937—At
Teruel

Dear Family;

I'm so full of news that I don't know where to begin. I am now living through an inspiring period of Spanish history and can watch the play unfold from my position on the stage. My last letter was from a little town near Madrid, waiting for a fascist attack.

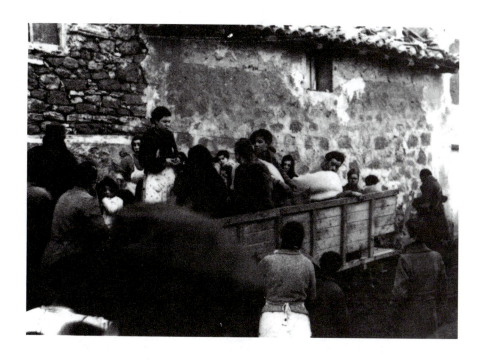

Evacuating civilian refugees from a town expected to be attacked.

The situation is quite changed now, but I'll begin from the beginning.

One afternoon we were suddenly ordered to pack up and leave, a runner coming out to our field maneuvers to inform us. We left that night for Valencia and points north. The next day we read that the first American ship to touch Loyalist Spain was anchored in Valencia with a cargo of wheat, gasoline and oil. We immediately elected a delegation to visit the ship and greet our brothers from the N.M. Union.

Luckily, I was one of the delegation of three elected. I turned my men over to the political commissar and after drawing 150 pesetas from the battalion clerk, we left for the ship with light hearts and a bright outlook. When we got aboard there was a fine welcome from the crew who were all good union men. In fact, two of them had jumped the ship when she docked and tried to join the International Brigades.

We found that the crew had already been scheduled to play a game of football with a Spanish Army team, so we went along with them to a big stadium which to our surprise was packed with cash customers. It seems that the S.R.I. (I.L.D.) had played up the arrival of the ship and there were reporters there and YCLers with flowers and we were tendered a banquet later. I played fullback with the army and the game ended with a 6-6 tie. After the banquet, we went out with a couple of girls and had a swell time. That night I slept in a swanky hotel with hot showers and a big soft bed, the first I slept in, in Spain.

The next day we spent wandering around the city, which reminds one of a beehive, humming with activity. There are *refugios* for air raids all over, but the people show no signs of nervousness or fear, only hate.

I bumped into McCuiston late in the day. He's working as an engineer in a laundry. He was well gassed up when I saw him, so I guess he's the same as ever. There were no trams running north that night, so we stayed at the S.R.I. Next morning, we caught a troop train, but it only went a few kilometers, so we took the highway and made Benicasim that afternoon, late. Benicasim used to be a resort for the bourgeoisie of Europe. It consists of a string of beautiful villas stretched along the sandy Mediterranean shore. I knew that Harry Rubin was here and I went to see him. He's getting along fine, although at one time he was not expected to live. I also saw Kayo who was hit in the head with a piece of shrapnel and although the wound was light, it affected his injury (an old injury) and he's out of the war. Hy Greenfield passed through here 4 days ago—he's been sick but he is supposed to go to the front with us but I haven't seen him yet. Dave, the Cass boys, and Dorsky are still driving trucks, but I didn't see them either.

We slept at Benicasim that night and grabbed a *camion* early the next morning. On that truck, Barcelona bound, was a group of young comrades going to worker's training school. We had a swell discussion with them practically all day, and that night we arrived in Reus where we had to branch off for the front.

Now I had been in Reus twice before, coming and going from the Aragon front. It is situated in the center of Catalonia, and has always been a headquarters for Trotskyism and other anti-government forces. In the past you could always sense and feel the inward hostility of the people, especially toward International Brigade members, manifested by posters—signs posted on walls, failure to give us the Salud, etc. However, everything is changed now, and such a change. The people couldn't be more friendly

and the posters all call for unity. The main party slogan of "Unity to win the war" has expressed the real sentiment of the masses, and the Spanish people are rolling towards their revolutionary destiny like one man. This spirit crops up throughout the Spanish Army and results in unbelievable acts of heroism and sacrifice. Instead of the I.B. leading the Spanish in battle, they are living up to all the traditions of a real bolshevik army and together we are starting to really roll those bastards back. The morale is wonderful under the most difficult conditions and with the new uniforms and equipment coming in, it looks like this war might be over before you think. I would write more about this front and what we are now doing, but it would not pass the censor and anyway, you'll read about it in the papers.

Tell Jean that I consider her as one of the family, but will write her separately when I get time. I'm very busy now. Received a letter from Bob. Give him my regards. I will write him when I get a chance. Sending two pictures, one was in Spanish papers—other is delegation. Love and Luck.

<div style="text-align:right">

As ever,
Niche Nevo

</div>

• •

from SANDOR VOROS

<div style="text-align:right">

January 3, 1938

</div>

Well, Sweetheart, the coach came and I persuaded the authorities to let it proceed despite the heavy snowstorm. It was a mistake. We got stuck in the snowstorm on a mountain a million miles from nowhere and had to spend the night there: no food, no blankets, no smokes, one window of the coach broken—it wasn't what you can call a pleasant experience. We tried to keep warm by thinking of the boys in the trenches who must have had [an] even worse time of it, but even this didn't help much. Someday I'm going to write a little piece on how it feels to become numb by degrees—the feeling of pain, acute pain, intense agony, then gradual numbness.

We were rescued next day and reached a little town where we were able to secure food but no lodging. We spent a couple of hours in the [local] "Fonda," a tiny Spanish inn, just jammed with people, loathing to go back to the coach. At the inn one of the comrades, an artist, whiled away the time by making sketches of us. I am enclosing the one he made of me. The Spanish are a wonderful people—I wish I had time to describe the friendly comradely, nay, family atmosphere in that inn. Unfortunately there is no time; we are due to pull out any minute now for Valencia. I want to mention one more thing, however, before I close—throughout the trip for some strange reason, your image never left me for a minute.

Maybe because it was New Year's, I relived every minute of your visit last year and went over it in my mind about ten times. It was a weird sort of a thing—outside snow a yard high, snow drifting into the coach—you feel yourself going numb and carry on an imaginary conversation with a girl—I saw you in your overcoat just as you came to the house, bustling around, warming yourself near the fireplace, moving around the room in your usual lithe, weaving manner, saw you go upstairs into my room, powdering your face, putting on cold cream—someday we'll have a grand time talking this

over—at present I am worried that I am getting soft and all this daydreaming is just a manifestation of it. On the other hand, daydreaming was always one of my characteristics and, as for your playing such a prominent part in it, it is the most natural thing in the world.

Well this is all for the present—

> much love and happy
> New Year's
> Sanyi

•••

from CECIL COLE

January First [1938]

Jeff old man—

Living up to my New Year's resolution (for today only) I sit me down and take my typewriter in lap. A New Year, why not a new idea? *¡No sé! Pero, busque todo el día y nada pasa. Posiblemente estoy muy borracho—es muy posible pero no he bebido nunca éste día.*[3]

Anyway, it is a new year and here it is a new world. It snowed hard all night and today we awoke in a totally different looking world. New values everywhere. Caused, of course, by the covering up of old outstanding characteristics of the land. Perhaps we can in this new year not cover up the old characteristics but wipe them out of the world entirely and introduce another and more suitable life for the entire world.

I am all alone now. The rest of the Brig. moved yesterday and I had to wait for an automobile which now belongs to the department. Now, because of the snow, I may not be able to leave here for several days. Oh yes, I forgot to tell you that I am now in the Department of Information. It has the scouts under it. You remember that I was the chief of scouts in the battalion and the chief of information there before I came here to the Brigade staff. Well, of course I am not good enough to be the chief of information here, but I am now his first assistant. Incidentally, he doesn't drive and so I get to drive the car everywhere we go.

Boy if you would only be here to see the scenery; it's really stupendous. A little village in the mountains which looks like it was painted on a backdrop of some old world stage setting. Nestled into craggy cliffs, it has a road which winds up above it and down along the same cliffs lined with old cyprus trees to a church that looks for all the world like a tiny castle. It would make a marvelous setting for a movie. Only now with all the snow it reminds one more of a Christmas card. There is another pueblo about nineteen kilometers from here, which you have to climb a torturous road in the cliff [to get to], and finally enter by [way of] a tunnel of about a hundred yards thru this same cliff. It has the appearance of an old volcano crater, but it seems to have extremely good soil. There is a little lake which is fed by melting snow which caps the cliff all around the valley or crater: the only outlet to the lake is through the same tunnel where you enter. In the tunnel a small river flows beside the road, and leaving the tunnel it plunges in a

[3] I don't know! But I searched all day and nothing happened. Possibly I am very drunk—it is very possible, but I have not drunk anything this day.

fall of over two hundred feet. There is much to be said of the town in the valley; from an artistic point of view it is about all one could ask for. Most of the people in this part of the country are very friendly and I have been asked to dinner in several homes. Needless to say I do have a hard time with my little knowledge of the Spanish language, but they are very understanding and help all they can. They are very patient and are quite clever at understanding what I mean to say even tho I may say it in a way that is only partly related to what I mean. Also, needless to say, that through their help and almost constant contact my Spanish is improving little by little. In fact many of them are surprised at how well I do speak. You see most of the men don't care to learn the language, I mean particularly care to, so I do speak almost fluently in comparison to the majority of men here. It's really lots of fun to learn the language this way. There is only one drawback and that is that there are four distinct languages spoken here. They are Castillano, the official language of Spain, which is spoken mostly around and in Madrid; Catalan, which is spoken all thru Catalonia and is not even remotely related to Spanish that I can see, nor is it spelled or pronounced the same; then there is Valenciano, which is, as you may have already guessed, spoken in and around Valencia, this has fewer users and is quite closely related to Castillano, the main difference being in the pronunciation and grammar; lastly there is Asturian Spanish, which is something I haven't come in contact with much. Only a few of them who are in our Brigade. Then of course there are those who talk a bastard language which is a combination of two or more of the various languages here. I guess I fall in that class, tho most of mine is Castillano, harking back to high school days. I suppose, the lord knows, I didn't learn a great deal there. However, I really do get along better than some of the Spanish themselves; for I have met several who were unable to speak or understand one of the languages I have mentioned, and I have met many who had never before heard these other languages. Yes, it is sad but true, many of our boys are leaving their pueblos for the first time, and for many who had never read and who came from places which were rather inaccessible, we were a new race of whom they had only vaguely, if ever, heard.

Well I guess I have shot the breeze long enough and so I'll slow down to a stop here. It is now 10:35 P.M. here, so it must be about 2:35 New Year's day where you are. Can you remember what you were doing at that time? Well, I was just getting ready for bed at that time. Do be sure to write soon and give me all the news, especially the outcome of the Rose Bowl game. Give my hearty New Year's greetings to all our friends and to your family especially.

<div style="text-align:right">as always, yer pal
Thug Mullig.[4]</div>

P.S.—Just before I transferred from direct connection with the scouts, a fellow came into them by the name of Amsberry. He says you signed his affidavit for a passport when he came over. He lives on Hillcrest Rd. about opposite the Cross Roads. I am not sure, but I think I remember him. It's hard to tell now for he has adopted a foul beard and soup strainer. Who is he and what are his merits? Altho he is purported to have

[4] Cole was adopted as a child. "Thug Mullig" is a play on his name prior to adoption, Charles R. Mullinger.

graduated from the university and does show a little intelligence, he doesn't seem to be overly bright nor have a great deal of energy. He's a good enough fellow, but somehow I'm just not attracted to him as I might be. He is so slow and so wordy in everything he does. It may well be that I am so absorbed with other things, which seem to me of greater importance, that I think he is dull, but he does make so many comments on so many things that have little if any interest and doesn't say anything on the things that are so obviously interesting, new, and of some importance. Oh well, I guess that it was that I expected more of him than he had to give. I was at first hanging on his words for all that has been doing since I was home, but he didn't seem to know much about that, so interest lagged. Now I have made him quartermaster of the unit and he is doing a fair job of it, tho I have had better quartermasters with the same length of experience. Anyway, who is he etc. etc.? I really must close now, so Happy New Year!

<div align="right">"Cec"</div>

●●

from LEON ROSENTHAL

<div align="right">

Feb. 8, 1938
Tuesday, 4 P.M.
A little town in Extramadura

</div>

Lee honey,

Picture yourself sitting next to me, your back against an old stone fence—before us stretches the greenest of green meadows—the hills over here and over there are beautifully cultivated & their shades of brown & green, broken by the darker green of olive trees form a most pleasing frame around the neat little village—with its little houses & clean streets—like a city built of children's toy blocks. Over to the left—see the cows are grazing—the first cows & pasture land we've seen since France. The one with the bell on its neck—that's a bull—so don't even think of trying to milk him. See those horses and jackasses grazing—all have their forelegs tied so they can't get wanderlust. Hear the chickens & ducks down below, in the pond? And the roosters crowing from the village? See the young shepherd boy leading his flock over the hill—and the grey pigs waddling along too? And the daisies shooting up all over the fields—and the warm Spanish sun—Lee, it's wonderful and so good to have you near me to enjoy it. Aragon is so bleak, bare, unfertile except for the little valleys that the farmers labor so hard to irrigate. Since August we've been in Aragon—now we are in a delightful region & I'm in love with it at first sight. You see so many rabbits on the road & the young burros & lambs are quite cute when they cavort about with the joy of living. Oh—look—the bull went to the pond to drink & all the cows followed him & the heifers raced to get there first & the old man stood by waiting for the whole family to assemble. But to get on with my letter.

There's another reason why I feel happy today—your sweet letter of Jan. 13th came—after nearly 3 weeks of no mail. I'm overjoyed that you've adapted a more sensible attitude and don't suffer my absence so much now that you know we are going to win the war. Your loneliness & worry have caused me a lot of troubled thought and I tried in my letters to get you to be more patient & assured—so now that you are a bit more resigned altho still sad, it is better for your mind & health & so I feel good about

it. Your description of yourself is so clear—I can see my tall, plump darling—with her lovely kissable face & hair pinned back like a real Lena—wait till I get ahold of that bun of hair! From your letter I gather that my sister is out of work—what happened to her Newark job? I'm oversatisfied that you & Jack get along & that people come to visit my mother occasionally—you've no idea how that thought helps! And so—you've made me feel very good with your letter—even tho you skip over your physical condition. Are you still sick? Tell me the truth, now & take care of yourself.

We came here by way of Valencia and Albacete. Leaving Friday evening—we arrived Sunday nite. The first nite we slept in a village near Valencia at the home of one of our comrades from the Comisariedo. It was the first time I've slept in a bed since October in the Barcelona hotel! In the morning we went to the orange fields and to the seashore. We visited the colony of refugee children & saw their ultramodern school building. The farmers showed us thru the orange packing plant—they call their navel oranges "Californias"—the Valencia province is wonderful soil. They rotate crops & get bountiful yields of all fruits & vegetables. The government buys up all the harvest. There is no burning of coffee or plowing under of cotton. In Valencia oranges sell at 4 kilos (8.8 lb.) for one peseta (2¢). After three hearty meals in five hours & despite pleas to "stay another day so we can prepare real Valencia fish for you"—we were on our way. In Valencia we stopped and I rushed over to the square to get the books of drawings I spoke of. But I couldn't find the store I wanted & in another I hurriedly bought a book of Goya's works, cartoons by Puyol & two small folios of color reproductions (very poor) of Goya & wop Rafael thrown in. That's all there was—no El Greco or Velasquez—but I have the address of the printing shop in Madrid & I'll get them yet. I had no time to get the book I promised for Beatrice—but will, when possible. The book of Goya is excellent—as soon as I can get to a town where there's a civil post office—I'll send the package. When I send it, let me know as soon as it comes—if it comes I'll send the others. If not I'll wait & deliver all in person.

We arrived in Albacete that nite & slept there. In the morning we tried to get the loudspeakers—but there are none there—the American brigade has them. Also I went up to see the American commissar, but there isn't any—there are no more language commissars in Albacete—everything is done thru the regular army organization. But I saw the comrades of the 15th Brigade personnel bureau—they told me Sam is at the seashore for vacation—but they don't know what he'll do when he returns. There's no other sound truck & the 15th Brigade has none either. In the Albacete post-office—I was too late to see the censor (noon-time) but I left a note & if there are any letters missing they'll send them to me. Also I got a letter from Albacete today—they have put more men on the post-office work & the service will be better now.

And so, finally we arrived down here in Extramadura and this picturesque village. Which means of course that perhaps before this letter reaches you—there will be good news from a certain front. The People's Army is on its way!

Now—it's drawing close to 5 and I've got to get back to the village to play some discs. And so darling—it is like those Saturdays when you used to hitch-hike up to Peekskill to see me—I had no house to receive you in—but we felt at home on the green grass—near the water, under the sun—those afternoons of love close to nature were precious & rare but the parting always sad. That's how I feel now—as if we had

been sitting here together & now I look up & you're gone again. But tonite I'll dream of you again—I can't make a date to meet you tonite because my hammock couldn't take it—huh?

Love & regards to all—altho you don't mention how everybody is—I hope they all still have work and that everyone's in good health—how is Syd, by the way?

Honey bunch—take care of your health & don't ever worry about me. Sweet, sweet darling, kiss me hard & let me hug you close to me in your cute blue nightie.

<div style="text-align: right">

Love & love & love & love & love,

Leo

</div>

• •

from CARL GEISER

<div style="text-align: right">

Sunday, Feb. 20, 1938

</div>

My dear Impy [Sylvia Geiser]:

This Sunday afternoon reminded me of one of my last memories of my mother, when I spoke with her on a Sunday afternoon at her bedside, and she trying to amuse or interest me, told me of the story she was reading of a little boy who hated Sundays, because on Sundays there was nothing he could do. I was only 7 at the time, but it so fitted in with my opinion of Sundays at that time that I never forgot it. And today I have no prescribed tasks to perform, nor any urgent—pressing work, and I almost sympathize again with the boy in the story.

This Sunday is being spent in the following manner. Reading several chapters of Bates' *The Olive Field,* writing you a long letter, taking a walk, reading several articles from Vol VIII of Lenin's *Selected Works,* and a few hours work at the office taking care of some comrades who have arrived for the school.

We had hoped to open the schools tomorrow, but there is still no sign of the students from the Brigade, so it may be delayed 3 or 4 days or even 2 weeks.

This morning I explored the house in which I am sleeping. I am the only one in it now. It will be the quarters of the school. It is near the center of town, white (as are all Spanish buildings I have seen) of one-story and an attic. Houses here are built with a single front wall the whole length of the street. It looks like one building a block wide from the street, with a number of small doors for people and some larger ones for burros & carts. But the buildings do not actually adjoin each other, for behind this solid wall you find patios. In fact you never know when you enter a door from a street whether you will step into a room, or a patio, or a driveway to a vulgarized patio in the rear, which leads to the stables, rabbit warren, outhouse, tool shed, etc.

These houses are often five to six hundred years old, always of stone and mortar, covered with a very wicked whitewash with a remarkable preference for your overcoat over the wall. The only wood is in doors, windows, and rafters. Floors are either concrete or tile. The rafters are covered with a layer of slender canes, similar to bamboo, fastened together with mortar & covered with red tile. But always red. Of course, after the first hundreds of years they may become a bit moss-covered.

The rooms inside are seldom all the same level, which makes traveling about at night very disconcerting. Of the 6 rooms on the first floor, one can be heated—by an open fireplace—but the drafts get you there! Water is obtained from a well dug below

the wall separating us from our neighbor. And both of you can draw water from it, though we can't see each other. You use a pail, rope & pulley. The water is about 25 feet down.

There is electric light, but the wiring breaks every known fire regulation. But there is no danger for I doubt whether these houses would burn.

But the interesting part is the Wine Rooms. There are 15 huge clay vases, some 8 to 10 feet high, perhaps 6 feet across, with a capacity of 100 to 125 gallons. And then you see a steep stairway downwards. You have to use a candle. Some 8 feet down there is a nitch on each side, in which rests about a 50 gallon vase. Some 10-12 feet further down you come broadside into a large H. And here are about a dozen more huge clay vases taller than your head. Why are they put 20 feet underground? The temperature is more even there. It's always quite cold.

Of course, they are all empty, but I can imagine they once held a fine stock of liquors and wine.

But these wine cellars are very valuable now, as dugouts during air raids.

> With all my love,
> Carl

from CANUTE FRANKSON

> Badalona, Spain
> April 13, 1938.

Dearest:

This is my birthday. At all events I should be happy. Especially since I've survived eleven months of war. And particularly since a bomb fell where we are staying, yesterday, and did not get me. The horrid slaughter of human beings haunts me so much I can hardly sleep at nights. Then, there's always the airplanes overhead. Very few nights that the siren does not awaken us. Some of the men get up frightened and screaming in the dark when they hear the siren. It's quite creepy, but somehow I'm able to hold myself together. I don't seem to get frightened by the bombs.

There are about two hundred and fifty of us here. We're awaiting the decision of the high medical tribunal. If they decide favorably I'll be on my way home pretty soon. We surely will be glad when we get orders to quit this place. Conditions are not very good. Then there's always the danger of a raid. We're only six kilometers from Barcelona, and as the enemy planes are chased from there they pass by this way and unload their bombs if they have a chance.

Last night I was with some children—about fifteen of them, ranging from six to about twelve years. We were playing some games. After it got too dark to play we sat down for a chat. They asked me about my people. The average child in one of these larger cities is very intelligent. They talk very seriously. They wanted to know what was taught in our schools; if we had artists and teachers. I told them of some of our artists and famous orchestras. I also told them of some of our great singers. But I did not forget to tell them that some of the things which they saw in the American pictures here were not true of us; that this was done to keep constant hate between the two races. I told them also of the jim-crow system and the lynch mob. It is very difficult to convince

them that our people are really lynched in America.

Then, they told me of the hardships they were living under; their fear of air raids; and their experiences with machine gun and rifle fire in street-fighting when the Fascist rebellion broke out. They gave me a very detailed description of the street-battles and the barricades. They told of how they'd be in the street playing when the firing would begin, and as they run for shelter they'd hear the bullets whiz by them.

There were three girls of the group who seemed to be a little older than the rest. They were most interesting. One from Galicia; one from Madrid; the other a native of this town. The local girl told me of the battle between the priests who were barricaded in one of the nunneries with machine guns and killing everyone who came in range of the guns. They were finally subdued and the Assault Guards started a search for any of them who might have been hiding in the building. They found a door leading to an underground passage. They followed this passage which led to a large room in which were the dead bodies of several women who had been missing from the town for weeks. In the mouth of each of these victims was a large iron ball. These balls, according to the explanation given me by one of the guards whom I questioned, were thrust into the victims mouths as a means of killing them. You can only imagine what must be the torture of an iron ball in a person's mouth. Their hands were all tied behind them. There were also the bodies of many babies.

The little Galician told me that she was an orphan, that her mother and father were killed in Fascist territory. In an air raid? I asked her. No. Not in an air raid. Then how? I insisted. Though it seemed as if she did not particularly care to discuss the matter. Well....Then she sighed. "They blew the siren. We ran for the air raid shelter, my father, mother, my other sister, and everybody in the neighborhood. We thought the government planes were going to bomb our town. Then they sounded the all-clear signal. Everybody started out. As soon as I got to the foot of the steps I heard the machine gun and I ran back into the shelter. My father and mother, and many of the neighbors, ran up to see what was happening. When I finally got to the top of the stairs I saw them lying in pools of blood." But who killed them? And for what? She shook her head and looked down on the ground. "I don't know. The Fascists were standing there with the machine guns and calling us all kinds of names. They said: 'We'll teach you dogs a lesson.'" Then, how did you get here? "My uncle brought us across the line at night. He's now at the front, fighting."

Tales like this could be dismissed as the imaginations of a child, but for the fact that similar stories are told by responsible men and women, all over loyalist Spain, who have been fortunate enough to escape from the Fascist territory. They are cruel. They are gruesome. They are incredible. But they are, nevertheless, true.

The little Madrileña was the most interesting of the three. Not only because she had a different side of the picture, but because she really was a better story-teller. She was so much more animated. And every so often she would stop to tell us how she'd like to return to her Madrid. I asked her if she wasn't afraid of the shells which were constantly fired upon Madrid. She said she was quite accustomed to them. She told of the time, when the Fascists were at the very gates of Madrid, how her mother and even her grandmother, heated kettles of water and stood at the balcony of their house waiting. But waiting for what? I asked her. For the Fascists, of course. They would pour the

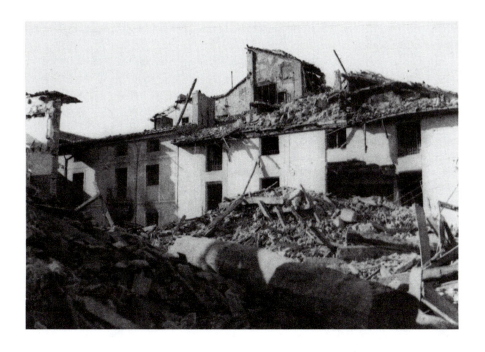

Typical damage after a fascist air raid in a town on the Madrid front (1937).

hot water down on them if they came. But what did you do? Hide under the bed, I suppose. When I asked her this she was quite insulted. And did not hesitate to tell me so. "Well," she said with great pride, "they wouldn't give me any hot water, so I got me a bottle and waited, too, on the balcony. But they never did come." Nor ever will, I don't think. The gestures she made and her general attitude were convincing enough even for the most skeptical.

The moon was by this time shining beautifully. There was not the slightest trace of clouds in the skies. Everything seemed so peaceful and wholesome with the presence of these little fellows. They felt so warm about me. Knowing that their little hearts were free from the black poison of race hatred meant so much to me. One had an arm around my neck. Another sat on the sidewalk between my legs. While others were on my knees or cuddled up near me on the narrow stone steps. When the time comes for me to leave these children, I thought, I know that I will not be happy. Where will I find children of another race so affectionate, so friendly to one of this disfranchised race of mine?

Then the thought of what I must return to, and of Fascist barbarism, crept through my thoughts like a slimy snake. What a task ahead of us! When will we ever find rest? We may not have time to rest, but we surely will be leaving a rich heritage for these lovely Spanish children. Those little fellows must some day enjoy a world of love, something like that love of which Christ spoke, instead of machine guns and bombs. It is such a high reward to know that we had come across the seas to help in this struggle, to free such as these from the dreadful menace of Fascist barbarous rule.

The Fascist bombers come everyday to Barcelona but have been unable to do much damage for the past few. This is because some more efficient anti-aircraft batteries have been installed and there is a constant air patrol in action.

I do hope that everyone of you who love liberty and democracy has done, and is doing, everything to help our cause here. By all means you must understand, by this time, the importance of the role we play here, and its relation with the international struggle for the liberation of the human race, and how closely connected it is with the liberation of our people. You must understand, by now, that our fight is inseparable from the struggle of the progressives of the world who fight to put an end to tyranny. And that we can never think of freedom for our oppressed race until a realm of freedom and democracy is established for the whole people. And that it is our duty to take a very active part in this struggle for freedom if we intend to merit the rights of free men.

My most earnest desire is that you have understood, and agreed with the reason so far advanced for my having come here. I trust that you are now an active force on the side of progress. I hope you have understood that our struggle here, in Spain, is an inseparable part of the fight to liberate Ethiopia from the yoke of Italian Fascism. Why? Because, every battle won here weakens the Fascist oppressors of the Italian people and strengthens the brave Ethiopian people in their guerilla warfare against those Fascist invaders of their country. In the meantime giving new hope and greater courage to the progressive elements of Italy to strike the final death-blow at their degenerate rulers.

Looking out beyond the hardships and the sacrifices one cannot help seeing the

beginning of the end of these war-crazed morons who slaughter Spain's and China's women and children. Every act of their's reflects their desperation. But what is particularly important, is the part each of us play in the crushing of these diseased-brained butchers—the part *you* are playing.

I'm sitting in the sand on the beach of this beautiful, blue Mediterranean. So much has been written about this great inland sea. So many crimes have been committed against the people on its waters and within its peaceful shores. And it is from under its blue surface that submarines come up to torpedo ships which bring food and medicine for the unfortunate victims of Fascist barbarism. While its water extends to the horizon in such seeming innocence. Some day, however, these waters will not contain mines, warships nor submarines for destruction. The mission of the vessels which will pass this very shore will be as peaceful as the water is today. Give my love to the folks.

SALUD.
Canute

• •

from CANUTE FRANKSON

Segaro, Spain
May 10, 1938.

My dear:

One year ago, today, I crossed the frontier into this country of extremes. Since then, I've seen and learned a great deal. On the one hand I saw a love and devotion which is nothing short of being sacred. On the other I saw rabid hate. Here I saw a village of century-old hovels where the workers live. There, on the outskirts of the village, the villas of the rich who had ruled and oppressed the people until the rebellion broke out. These mansions are today either occupied by hospitals, by institutions of the people, or by the people who work on the farms and in the shops, as homes.

There, I saw the antique donkey-carts crawling like tired snails along the winding highway. Here, a modern macadam highway over which speed modern trucks and streamlined autos at express speeds. And overhead the latest in airplanes, capable of flying hundreds of miles per hour. Then I saw the friendly smiles, the hospitality and the love of these people contrasting the barbarous fascist fiends who fly over the peaceful cities of Spain on beautiful moonlit nights and drop high-explosive bombs on her sleeping population.

And in the midst of it all these people wage their determined fight against the fiercest enemy of mankind, Fascism. We are now in the midst of the defense against one of the severest attacks of the war. At one time we thought it would have been impossible to stop the enemy from reaching Barcelona. But the remarkable thing about the whole thing is the fact that during this most trying period there was not the slightest trace of despair. The incredible resistance of these people, their willingness to sacrifice, their courage and confidence go far beyond anything recorded in history.

At times, the odds seemed to have been all against us. The losses are lamentable. But this last Fascist drive has done one great thing: it has forged the final link in the chain of unity which is of such vital importance in this struggle. The call of the government for one hundred thousand volunteers has been answered beyond our wildest

dreams. A permanent line of resistance is established. It is now definitely believed that the Fascists will not reach Barcelona.

I'm perched upon a granite rock overlooking a precipice about thirty feet from the surface of the sea. The water beneath seems to be at least another thirty feet deep. And it is crystal clear. As far as I can see along the shore there's one continuous hill of granite. Along high walls built up from this rock-formation are the villas of the ex-rulers of the land and some of the moneyed barons of other European countries. Down the ravines to small piers either cut out of the rock or made of concrete are steps which are also either cut out of the rocks or made of concrete. These were the landing places of the yachts of the leisure-class. This summer resort, this former resting place of the idle-rich, occupies one of the most beautiful spots of all Spain. On the terraced grounds there are cedars, pines, eucalyptus and the very rarest of flowers. There is a great variety of the choicest roses I have ever seen. And they are all in bloom at this time of the year. The atmosphere is filled with the sweet smell of these flowers. The villas—or may I call them mansions—are of the most modern architecture, and equipped with ultra-modern fixtures and furniture.

During the reign of these kings only workmen and servants were allowed within these grounds. And then, the servants were not permitted to sleep here. There are no quarters for them. They had to sleep in the village.

It is away from the horrors of war, from the sickening thud and whine of bombs, and the ra-ta-tat of machine guns. We are here to rest among the luxuries which only society's parasites were heretofore permitted to enjoy. We are workers, all, who have done our part and are enjoying the reward of our labor. This is how our fellow-workers reward us for the sacrifices we have made. This is how workers reward their heroes. Here we get the best that the people of Spain can offer us under a war condition. I wonder where are those parasites who bled the poor that they may live here in luxury? Will they ever return to these villas?

Well, here we are. Within a few more days we'll be on our way home. We're going from a war-torn Spain to more peaceful countries????? I wonder? But I'm wondering if we'll all be happy when we reach the frontier? We who have seen so much suffering and needless slaughter here. I wonder will we ever be contented in thoughts while Fascism continues its vicious slaughter of Spain's women and children? I wonder will we ever forget the tears of Spain? The pictures of the dead mothers with the little hands of their children wounded, and dead, clinging to their breasts. I doubt it very much. Such pictures can never be forgotten.

Some of us are pretty badly broken up. Many of us must be brought back to mental, moral and physical fitness. But after the wounds are healed and the minds repaired there will be many of us who will want to return to Spain. Because we love the Spanish people. We have learned to love them. And we know that the fight is not yet finished. Yes. I believe many of us will want to return.

To be away from the noise of war is quite a relief. To be on my way home is not such a bad idea. But I'm wondering with all these happenings of the past years, what's ahead. Is there peace and tranquility beyond these peaceful villas? Or are the vultures of Fascism awaiting us? We are not afraid of them. Because we have taken on new courage, we have learned new ways, and we will not be trampled under the heels of

repression. We are not confused on issues or factors, because we are veterans of a bitter struggle. We know that they have traps for us. But we are prepared for them. Often we feel the influence of the spying work within our ranks. But we know how to handle them.

Within a few days we'll be leaving this beautiful spot. Perhaps the Fascists are planning to bomb our trains. We have no way of knowing. They will try their best to demoralize us. Because they know the tremendous part we can, and will, play for their defeat. But we are prepared.

The sun is going down, slowly, a bright red ball beyond these granite hills. The sky beyond the horizon reveals every color of the rainbow, and their varied shades. And on the other side of this Fascist bombs are destroying cities and their arts and inhabitants. The women and children whom they slaughter have done them no wrong. They kill for the lust of blood. But the tide of this war will soon turn. We're on our way home. But not to retirement. We will be active agents for these people who fight so courageously against so formidable an enemy. They are deciding a very important question in history. We will help them to the finish. And the end will be victory for them—for us.

This may be my last letter to you from this beautiful country which is being ravaged by Italian and German Fascism. I feel relieved to know that I'm finally on my way home to the medical treatment I need. But I'm not glad to leave. Because there's so much to be done yet. Spain needs me, needs us. And if the way is open for my return after I'm again well, I'll be only too glad to return. Because my work is not yet done.

I gave all I could to the Spanish people under the circumstances. But I'm not entirely satisfied. Because I'm leaving the job unfinished. Fascism is still here. As a Negro who knows oppression under the iron heels of the ruling masters, I cannot again find real happiness and peace of mind while these Fascist madmen are still killing the Spanish people.

I love them. They are the loveliest people I know. Their country is invaded by these Fascist vultures. They know no hate but that which they have for Fascism and all it represents. They love our people. Their feelings towards us are very sympathetic and tender. We must—all of us—do all we can to help them. It is our duty. My sworn duty is to do all I ever can to help them. And in doing so win others for the cause.

Within a few weeks we will perhaps see each other. Give my warmest regards to the folks. And tell them I'm on my way home. Hoping to see you real soon, I'm as always:

<div style="text-align:right">

Your friend.

SALUD Y BUENA SUERTE.

Canute

</div>

. .

from DAVE GORDON

<div style="text-align:right">

June 16, 1938.

</div>

Dearest Lottie [Gordon],

Yesterday I visited the *Sanidad,* the Brigade sanitary or hospital service. I dropped into the midst of a farewell for the Chief of the service, Captain Dr. Mark Strauss.

Official but comradely words of good-bye were exchanged. A number of photographs of the officers and men were taken and handshakes went around. Just before

breaking up Dr. Strauss wanted us all to pay a visit to a spot a short distance away from the infirmary. He particularly wanted the new chief, Doc Pike, of the early Jarama and Abraham Lincoln Battalion days, to visit and give his opinion on what was located at that spot.

It was the *Sanidad* latrine.

Now a latrine is an extremely common phenomenon in an army. (In one form or another its popularity is universal.)

But his was a model latrine. It was the type of a latrine that an army doctor should be proud of. It was dug well and covered well. This is particularly important for warm weather because of flies, mosquitos, insects, and a clear air. This latrine provided the hygienic qualities which the overwhelming number of latrines do not provide.

What is more it is surrounded by trellises which should hide us from the scornful, contemptuous, curious gaze of the normal run of passersby. And here lies its chief fault:

The very position and entrance to the latrine is such that the sitter is posed perfectly in a setting of trellises which sharply bring him to the attention of the casual men, women, and children who walk up and down the little country road facing it.

Regardless of this, the latrine is still a model of cleanliness and an inspired work. Nor will this fact be forgotten by future generations, because in the pursuit of exact science as applied to army needs several photographs of the latrine were taken.

In view of this can one maintain correctly that a latrine is a lowly object?

- - -

To-day, and yesterday as well, thousands of lice and their more dangerous eggs were destroyed.

They were destroyed by hot showers. *Sanidad* provided the shower tent.

Old clothes were cast aside for washing and repair, and fresh, new clothes distributed. The *Intendencia,* the name for the quartermaster's store, supplied the clothes.

It was a happy, swearing, singing gang of guys. Soap was falling all over the boards and some of us had a helluva time getting it out from under them. Some of the too ambitious fellows soaped themselves too much and got stuck with suds because their time was up. But they managed to squeeze out a few more drops of water to get the soap out of their hair, and dried the rest of it in the sun or rubbed it off with a towel.

I met a friend, a lieutenant, entering the tent as I was leaving it. I forgot to salute him; mentioned the fact to him (you see, he didn't notice it either) and I asked what the rules were when such a situation arose where those who must salute each other are stark naked and entering and leaving a bath. This isn't merely a matter of etiquette. Saluting is the outward symbol of discipline. And discipline must be maintained at any cost.

And now to a more serious matter. Did you ever get my letter requesting clothes to be sent to me? If you didn't well and good. But if you have I want you to know that I don't need them. I already have more than enough to carry me through the summer and am even provided well for the autumn and winter. Perhaps some time in September you might send me another pair of boots. In the last month or so I bought a good leather jacket, a pair of trousers, and a few shirts. That plus what I had before will keep me amply supplied.

But I would appreciate having a tin of cigarettes sent me weekly.
I'll continue with this letter to-morrow.

<div align="right">

Your
Davie

</div>

• •

from SANDOR VOROS

<div align="right">

Aug 31, 1938
In a castle, Spain

</div>

Sweetheart,

Life is sweet, life is beautiful. Yesterday I was dodging shells and today I am sitting in an easy chair, listening to the radio under a palm tree in a beautiful garden, the European castle of some South-American nabob. All around me are exotic flowers—plants with white gardenia-like flowers with the scent of vanilla—potted plants lining the leaf covered walls—a lover's paradise, alas, without any women.

This morning and afternoon I took a swim in the pool and washed—my second wash in seven weeks. I soaped and soaped myself, using up a whole bar of soap in the process. Sweetheart, you have no idea how good it feels to be naked and clean, fresh clothes without any lice—it is an absolute sensation that stays with you—you are happy because you feel being clean as acutely as you would feel sticky and dirty if you fell into a pool of oil or mud. And I took a nap in a huge bed with an enormous mattress among clean sheets—what a pleasure. (What if the sheets will have to be changed tonight—you shared my bed even if in my dream.)

I came here to make a preliminary selection of pictures for a photo album for our Brigade which we intend to publish and will stay here for about two more days before going back to the lines. I feel so happy that I am absolutely ashamed to be here while the rest of the Brigade has such a tough time of it.

<div align="right">

Sanyi

</div>

• •

from ARCHIE BROWN

<div align="right">

Oct. 18, 1938

</div>

Dear Sweetheart:

At the present moment I'm living practically in the lap of luxury. I say practically. You see, after travelling for several hours on the way to our new camping ground, we stopped off in one of the classiest hotels in Spain. The doorman saluted the stripes & the obsequious clerk filled out our forms, the beautiful gal pressed the button for the elevator, the elevator had plush seats for the tiresome journey to the fourth floor. We were ushered into a room you & I couldn't rent for $40 a month in Frisco with double beds. There are mirrors & lights all over the joint & heavy draperies cover the balcony window.

But you can't get a damn thing to eat. People sit around the tables but there is not food. The people are on rations, which is the best thing for winning the war—but we got in too late to get ours. I'm sent out as part of the advance guard to prepare the ground. My job is to get acquainted with the townspeople, work out a program & have

everything ready when the Brigade comes in. I'm a sort of Brigade Commissar "accidental" as they call it here in Spain. Anyway I marched into this hotel with two captains & a commissar of the 11th Brigade (going to a different place). They were uniformed, clean shaven and had their stripes on. Me, I had ordinary soldier's clothes, a red sweater in lieu of a coat and hobnailed shoes, that go clunk, clunk on marble floors. Once in a while I slip & the sound sends chills up the nice customers' backs. So I'm practically in the lap of luxury, what with bed sheets & fine linen covers.

There are plenty of drawers, but I have nothing to go into them. The furniture is black walnut but the drawers are lined with old newspapers. Such is life.

No one knows how long we'll stay in our new place. The Commission from the League of Nations is on the border. The Gov't tried to get them to come down where we were, but the boys were afraid to dirty their hands. Since the new place is closer to the border, maybe we can lure them down. If not they will have to take our word for it. I believe we will get civilian clothes at the new place & start getting lined up for the necessary papers. Maybe it won't be too long.

I'm very anxious to see you again. This is the second stage of our journey—I'm getting closer all the time. Soon we'll be together. I love you. Keep writing.

Salud—Archie

Plaza Altazona—Base Postal Militar No 6. Spain
P.S. Howard Goddard is *mi capitán* on this junket.

Toby Jensky, an American nurse.

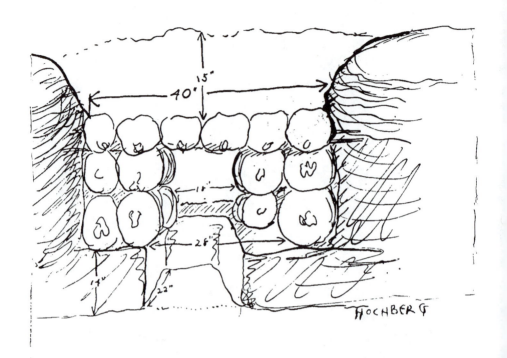

15"
40"
1"
28"
1'4"
22"

HOCHBERG

DIAGRAM SHOWING
MACHINE GUN POST CONSTRUCTION.

Instructional drawing used in training the American volunteers.
International Brigades Archives (Moscow).

IN TRAINING AND IN RESERVE
Morale and the Arts of War

· ·

INTRODUCTION

The combination of the fall of Malaga on February 8 and the bloodletting at Jarama on February 27 made people aware that courage alone could not win battles. Even the flamboyant militias that defended University City in Madrid in 1936 were strengthened by experienced World War I veterans in the International Brigades who were scattered amongst them. Military training, some general, some specialized, would be necessary if the Republic was to build a versatile army and survive.

In March of 1937 some Americans were sent off to officers' school. Others were organized into an anti-tank squadron and an artillery unit. Some, like Jack Freeman, were trained in the special skills of mapping and observing. Machine gunners practiced dismounting and assembling their vintage weapons until they could do so by second nature.

Unlike the Lincolns at Jarama, the new George Washington Battalion was receiving this training at Tarazona de la Mancha, a small town near Albacete, *before* they went into action. Meanwhile, the political commissariat recognized the importance of maintaining contact with the villagers and local farmers themselves as a way of strengthening morale and keeping the reasons for being in Spain firmly in view. Special amateur shows were performed to entertain the Americans and the townspeople together. Parties for children were held, and Americans were encouraged to meet Spanish families.

When added to a political awareness grounded in universal antifascism, the training and the social events combined to give the Internationals a special edge in morale. It was that morale that often enabled recent volunteers to perform in battle like seasoned veterans and what led the Republic repeatedly to use the International Brigades as shock troops.

Almost everything in camp life contributed toward this end. Even irreverent self-expression helped build the special group spirit needed for a volunteer unit. Thus the men—among them Harry Meloff and Ernie Arion of the "Convulsionaries"— made up satiric songs and put up bulletin boards called wall newspapers that were sometimes equally irreverent. One early *periodico* mural was dubbed "The Morning *Churro*," after the Spanish breakfast doughnut. Another was called "Red Dawn." They included news articles, drawings, photos, notices, and letters from home that the men wanted to share. As examples of that irreverent spirit, we include here some of Harry Meloff's (Harold Malofsky's) remarkable "kibitzing" letters, a witty and unstable mix of reportage and comedy. Readers will find the line between them easy to miss. Before leaving for Spain,

Meloff was a key figure in the New York Comedy group the "Convulsionaries." He played the piano, wrote satirical political skits, composed songs, and wrote a musical, "Let's Get Together." In Spain he wrote new songs and put together entertainment for both the townspeople and the Americans.

• •

from MILTON WOLFF

Saturday
March, 1937, Spain

Herbie—

I know it's Saturday and it must be March—tho it's May here—warm and sunny and cool, cool at night.

I stood guard last nite, shrouded in a warm Moorish coat-robe, and watched a misty moon melt away—watched the stars from hard pin points, become large and soft, luminous, phosphorous globes before departing. It was a beautiful nite—for an air raid—but the enemy hasn't as much freedom as once they had. We have the planes to keep them down and down they stay.

And I meditated on the peculiar color of Spain—for a country whose land and buildings are so old—whose land is so rich....whose people are so dark and vivid....and the life of which is so passionate—the velvety, soft pastel colors that predominate are unbelievable—and the children—smooth and olive—soft and large luminous eyes....small of bone and graceful....The poor however grow old too soon—and then their beauty is evident only in their suffering and strength.

And revolutionary—to an extreme—the raised fist is a salute that greets one everywhere....And everyone gives it from 3 years old to 90 years old. It's inspiring—the revolutionary songs—the cheers—salute! salute! Red Front! International! Long live the republic! *No Pasaran!* And they shall not pass—they cannot—It will take a hundred fascists to a square inch to take Madrid! They shall not pass!

And so youse guys and gals can get together and send me as much American tobacco and cigarettes as the customs will allow....because you cannot buy American tobacco here—no how!—If I don't ever get to use it—there are more here who can—The dough is here—6 pesetas a day—(you can buy a lot with a peseta). In America a peseta has little value—So....It doesn't pay to send money home.

I wonder, while we fight on this front, if our comrades on the other fronts (in the States) are battling on with as much courage, patience and passion! Always on the advance—digging in—and on again—in the face of anything.

Come along with us in this defeat of fascism—don't fall behind.

Well back on guard duty—

Don't forget to share this with Vivian.

Love, comrade,
Milton

● ●

from HAROLD SMITH

<div align="right">

Still somewhere in Spain
May 16th, 1937—7:51 PM

</div>

Dear Jeanette,

Have just made myself comfortable and settled down to write a letter to you. I should also write a letter to Clara, Phil, the Union and other people—but we shall see.

First: We still are in training and being held in reserve. As I have said in every other previous letter our marching orders may come at any time. But now we realize why we have been trained so long and intensively and I know that I speak for most of the fellows when I say that we're damned glad of the training we're getting. We, that is the I.B. boys as well as the thousands of fresh Spanish troops have a big job ahead of us.

The first major phase of the war is over. The Fascists have been stopped and stopped dead. They were stopped by sheer guts and self-sacrifice. They were stopped by troops (at some times you couldn't even call them troops—but groups of men and *women*—who weren't afraid to die for something bigger than themselves.) I've spoken to some of the chaps who were in the first units of the I.B. who fought at Madrid and the fight for the Valencia road. They had no time to train, Jeanette. They had no time to learn the things we are learning—how to take cover under machine-gun fire, how to dig in while lying on your stomach when the automatic rifles let go across an open field. They had no time to learn these things and let me tell you Jeanette the best way to learn the importance of these defensive measures is to go out and handle that delicate little toy called an automatic rifle or light machine gun. You lay on your stomach and sight for a half-moment and gently, very gently, squeeze the trigger—and then *Brrrppp Brrpp*—100 meters away a target the size of a man's head is torn to pieces. Dick, for example, can do this 3 bursts out of 3. After my first experience handling this baby, I conceived a very healthy respect for our modern weapons of warfare. And since then in practice maneuvers our instructors (incidentally some of the most competent military men, dyed in the wool antifascists all, are acting as our instructors) well even these instructors can find no fault with the speed with which I take cover. But as I've said before most of those who went before us, Spaniards as well as International Volunteers had no time to practice these things. The Fascists were driving against Madrid and they had to be stopped—well they're stopped.

But stopping is not enough. They've got to get out of Spain, and they'll need more or less gentle urging to convince them that perhaps it's easier to fight against their own bosses than against a people determined to keep their freedom.

So there you have it—we're building a Peoples' Army here second to none. A trained army, a unified army, able to coordinate every branch of the service. An army able to let loose an offensive and keep it going. In my opinion, when we go into action The Big Push will be on. And once we crack the Fascist lines the reverberations will be felt in Berlin and Rome as well as Seville and Granada. Jesus Christ, Goebbels will have a hell of a time explaining that away to the German people—and I got an idea the sweat will be down the crack of his can when he does. I don't think I would want to be in any Fascist officer's pants when we come thru—I think he would be safer as our prisoner than with his own men.

But I'd better pull myself in. I'm jumping way ahead. But the thing in Spain is the main link today. Wallop hell out of Fascism here, and we'll see a World People's Front that opens up possibilities that make me thankful that I can play some little part in bringing it about.

It is now 9:05 PM and taps are blown at 9:30 PM. That's right, you want our daily schedule—OK: Reveille 5:30 AM—Wash roll mattresses—drink coffee and swallow a few churros or bread & butter, clean quarters—fall in at 6:50 AM. Maneuvers until 11:30 AM—Lunch—and siesta till 2:30—Instruction until 5:30—Dinner at 6 PM—Free time till 9:30 PM—and usually you're quite ready to go to sleep. Today, for example, we started from scratch and laid out a complete trench system for a complete company—machine-gun posts, rifle pits, communication trenches, etc. Right now I'm trying to nurse a honey of a blister on my left hand, write a letter to you, watch a double pinochle game, and carry on a conversation with two guys all at the same time.

How are you, honey! I wish you were here so I could talk to you. It's so much easier than writing. Writing is so damned stilted. If you were here I could tell you all the things I want to tell you. The little things you would like to hear. How swell the guys are. How we kid around and every once in a while when you're marching or sitting in barracks or lying in a little hole in the woods during practice, watching for the word to advance, you get that warm feeling of companionship even if you're not saying anything. Or you begin thinking of home (and what Jeanette is doing and whether she is thinking of you) or how the Branch is doing and the Union. We'll have lots of fun talking about these things Jeanette, but I'm so tired now. I can't keep my eyes open—and I have to see whether the urine cans are out because I'm in charge of sanitation (for the time being) for our battalion, which is a new American battalion and will probably be called the Tom Mooney Battalion. But good nite now, Jeanette. I'll finish tomorrow—pleasant Dreams.

Five days later—I couldn't finish the letter the next day, or the day after as a matter of fact. I can't write much now—mess will blow soon and I have a job to do tonite. Will write in other letter—as soon as I can. Am in the best of health—The reason for the interruption was a move to another town—No—not the front yet. Will continue to jot down flashes 'til the bugle blows. Practiced throwing hand grenades today. Yesterday I made 3 hits out of 5 with our new rifles (marvelous weapons). If Dick continues as accurate as he is, he probably will be one of our snipers when we move up. The ambulance sent by the Artists' Union will be attached to our battalion—A swell job it arrived yesterday. This is a beautiful town—with beautiful country around it—too beautiful in fact because I think of the fun we could have if you were here.

But I think of you a lot all the time.

So Love & more Love
Harold

from **HARRY MELOFF**

"In a little Spanish Town."
May 6, 1937.

Miss Mim Sigel
135 Waverly Place
New York, N.Y.

Dear Mim,[1]

You know, pal, sometimes I get a letter, and before reading the first sentence through, I get chock full of gulps in my throat, as hard-hearted a slob as I think I am. It's things like what you said—"I figure that I have more to read here than you there—so I may as well send you more letters than I receive—" that makes me realize my real friends think of me not only when they get mail. So when swell guys like yourself undertake to write regularly (some comrades have written to me without having seen me for weeks before I left—they took it upon themselves to find out my address. This doesn't apply to any of the Youth Theatre bunch. I haven't heard from any of them.), I just turn my head so that Ernie can't see my eyes while I read. Shit! Enough of sentiment and let's get on to some "kibitzing."

No, I haven't forgotten how to write English. The truth is I still don't even know a word of Spanish. The real fact is that there are so many Americanos here, that the Spaniards learn our language faster than we learn theirs. And the stationery supply is more than plentiful. The reason you don't hear from me too often (incidentally I write to you and Peozner more than to anyone else) is that I have to write to dozens of people, and besides it takes time for the military censors to maul through mail. Outgoing mail is much slower than the incoming.

We moved to a larger town last week, and the three of us (E. & B.) are bunked in the same room. It has a fireplace and yesterday our whole section bought oodles of food, after chipping in 10 pesetas apiece. An hour before we went to bed we had a real feast, like the night snacks in Camp Kinderland. There was salami, and peaches, and apricots, and cherries, and cheese, and bread, and delicious coffee and chocolates, and cookies. So of course I couldn't get up next morning and Ernie talked all night long and during the night nearly murdered me.

I'll give you the low down. I weigh eighty and a half kilograms. Figure it out for yourself—I can't. Yes, I think I've lost some weight—not enough though. I can't promise any pictures, as there isn't a photographer in town. And you can forget about one with a *señorita* on my lap.

Don't let anyone give you the impression that we spend our free time whorin' around. Not that we wouldn't like to, but the truth is that small town "backward" Spain, won't tolerate it. Approaching a girl is like going near dynamite. Marriage is the only solution. So we choose to remain continent. The only time you'll receive a picture of me with a *señorita* on my knee, is if her mother is seated on the other one. It was an embarrassing request and you caught me with my pants down. Please, please don't underes-

[1] "Mim" was the nickname Meloff and Paul Sigel used for Miriam Sigel, Paul's sister.

timate me. But Lord, it's been so long now, I'm afraid I'll never get the wrinkles out. (Don't I get vulgar in the nicest manner? You know how aesthetic I am.) It's really heartbreaking, after the "supplies" the doctor handed out when we first arrived. Most of the boys however, are economical, and are using them for tobacco pouches. We still have hopes of going on leave in a big city like Valencia or Barcelona, and there find out if we still are men or not.

The major problem though is how to keep from going "fruit" altogether. Already the boys are beginning to ogle eyes at each other, and sometimes Ernie frightens me. (The big lug, he took a short hair clip, and now everybody calls him "bullhead" Arion.) You should see us washing our clothes, and yes, even sewing buttons on our underwear. That was the last straw. Rather than do that, I threw them away, and go around without. Incidentally, if you really regret not sewing my shorts before I left, I promise to give you ample opportunity when? I get back (Hold that chair!)

I hope you enjoyed that dinner with Mike, and the next time you see him, tell him if I don't hear from home soon, I'd very much like to avail myself of that floor on 51 1/2 Horatio St. Tell him too, that at this writing Ernie didn't get mail from him in weeks and is worried. By the way, he's very busy being a group sergeant these days, after a reorganization in our section. The respect and love that the comrades have for him, commanded that. As for me, I'm a flounderer and don't know where I am. In theory I'm the Battalion Singing Master and have the complete Battalion to worry about in that respect. Actually, I'm thus far the section light machine gunner and am just a private who hopes to be permitted to use that gun at the front. So where am I? You know, there are so many officers (mainly non-commissioned), that it's considered almost an honor to be a private. No jokes though, every man has such training that he can immediately fill his superior officer's shoes, should something happen to the latter.

No, we haven't the slightest idea when we go to the front. I've given up guessing. The best thing is to have it sprung on us—Surprise! Things are so slow now, that the boys, who are here from Jarama, for a few days rest, say that their front now is like a Camp. They dug a swimming hole, play ping pong, and eat plenty of the finest food available. Both sides are firmly entrenched, and wait for either one to start something. They are still waiting. After the bloody February days, one can't blame them.

The new government here has tightened things up tremendously for the better. They call themselves the Government of Victory, and will carry it out by first immediately purging the rear of any pro-fascists elements. They are strenuously investigating what is now known truthfully as the "betrayal of Malaga." The same thing could have happened to that city as to Madrid, and it will be too bad for the traitors responsible. This should have happened a long time ago, and the stand of the new government thus far has heartened us tremendously. Enough for politics! Now for the actual battle!

Don't worry about Ernie's not writing. Every now and then he gets into a non-writing rut, and refuses to take up a pen for days. But he is busy, and writes as often as he can. Bernie has been back from officers' school quite some time, and feels badly about the very few letters received from the Youth Theatre comrades. He has written many.

I'm glad that your horse behaved May Day. The burros here don't.

If you go to Unity this summer, be a good girl. If you can't be good—be careful. Anyway, try to sleep some of the nights. I'd hate to see rings on your eyes when you

get back. Not that I'd be able to see them from here, but the Youth Theatre developed a pretty fair imagination for me, so I can picture you any time. How about returning your request and sending some pictures over? But please, please, not the passport kind. Send the kind like in the movies, where the dying hero says to the comrade holding his bleeding head, "Tell her I died bravely, with a smile on my lips." Do you think you could doctor the picture enough to fit? (Ouch!) I'm only kiddin, toots! If you have some new pictures of the Youth Theatre, send them also.

I heard about "Bury the Dead!" Well, let's bury it and forget. I could hardly believe what you said about Al Richman's improvement. Give that "sleepin Jesus my love," and don't forget - - - - - - - - - - This is the best method of sending regards to all without fear of forgetting to mention a name.

> Salud, Baby.
> As ever
>
> Hersh.

P.S. Do me a favor, will you, kid? Go over to that little store off Sixth Ave. and drink one of those luscious chocolate malted milks for me. Then write in great detail what it really tastes like.

••

from HARRY MELOFF

> "In a little Spanish Town"
> May 16, 1937

Dear Mim,

So you're starting up again, eh? Well, you know, if you want to begin a kibitzing combat, I can hold my own any time. "No—honestly you don't have to stand on your head to read it." I know that. In fact I don't even need a head. Honestly, though, I've enjoyed your letters very much and am more than grateful for them.

I'm sorry you mentioned Esmeralda. I hoped you wouldn't. But since you mentioned her, I better settle the question once and for all. Comrade, she played me a mean trick, very mean, one from which the wounds are just now beginning to heal. Let me start from the beginning.

You remember how I touted Esmeralda to the skies, how I told of the many joyous hours we spent together every day, how she solaced me in my empty loneliness? Well, one fine day, Esmy didn't show up. I figured she was probably busy or something. The next day again she didn't appear. And the fourth, and also the fifth went by without her. I was going crazy. My heart was beating furiously with anxiety. Was she ill? Was she dead? Did someone eat her? Oh, Mother Mary, how frantic I became!

On the sixth day, I decided to find the sad answer, or perish in the attempt. Immediately after maneuvers, I set out to search for her. Hours went by (I even missed my supper); every nook and corner of the town was scrutinized, and finally I found her. In a barn of grain, on the far west side of town, snuggled up peacefully with a litter of seven baby goats, sucking furiously at her teats. It was like a clap of thunder splitting my head. Such brazen treachery! Such callous faithlessness! And all the kids had red hair! The hussy didn't even care to recognize me. She just lied there, bleating happily!

I rushed out furiously and walked for miles in the cool air before I finally returned to my barracks. Such is the price one must pay for platonic friendship! Thus ended my once so beautiful romance, and I hope you will never mention her again.

No we didn't march to the front on May 1st. Instead we marched into the theatre to rehearse the show for the night. I still haven't the slightest idea as to when we'll see and experience the fright of being under fire. Maybe never. You see, we expect to do all the firing from now on. And how! Both Ernie and Myself are now handling automatic rifles (light machine guns) and we haven't the least bit of pity for any mercenary Moor who gets within 800 meters of that beautiful piece of steel. Are we anxious for the great day or are we anxious? You should see our battalion! We are the most and without a doubt the best trained troops in the People's Army. The "Tom Mooney" Battalion we feel will play a decisive role in this great crusade to end fascism, and we most certainly expect to hold our banner flying as gloriously as the "Abraham Lincoln" boys are [holding] theirs. Confidence grows stronger day by day, discipline improves, and nothing in the world can make us feel sorry that we are here. Oh, for that glorious moment when we sight our first fascist! Can anything in history be greater than just that second?

So you're still dabbing about with paints and sticks and signs. I sympathize with you and I sincerely hope the horse behaved. You know, this is the first May Day in New York that I didn't mind missing. It all appeared so small because of what is happening here, and yet is it so great, because we realize what that marvelous united demonstration meant and its significance to Spain. If the parade didn't put the Youth Theatre on the map after all that fanfare, I can't imagine what will. I get reports in my mail that you're getting along pretty slow and hard. What's wrong? Certainly with a guy like Saxe you people should be glad to work and work hard. Look at us here! Training hard all day, and despite the fact that we must be in barracks to go to bed at nine thirty, we spend all our spare time rehearsing, & put on a show every two weeks. We realize that military activity isn't enough. Education must be combined with it. I'm the battalion singing master, I lead the glee club, direct the dramatics, have meetings, all on our own free time, and yet I never think of quitting one of these activities.

Don't you dare fold up! Spain and antifascism needs you too much. The Youth Theatre is too important an organization to desert us now. I speak desperate because I know what another summer can do to a drama group. Keep working hard and build up. That contribution would still be small compared to what the Spanish people are sacrificing. In your next letter I expect you to tell of the performance of "Bury the Dead." 'Nuff said!

Does Helen Sable still come around? If so, tell her that Harold Smith and Rico Ruciano from Corona sleep on either side of me. They both know her as well as her friend Sophie and Irving Burns and Val Colburn. They send regards to her and to Milton White's girlfriend. (I haven't seen Milty any more. Rumor has it that he is with a Red Cross Unit in Madrid.)

That $25 from the I.W.O. was a·good start. Keep after them. I just met Abe Harris today. He walked in while the glee club was singing the "Internationale," and began to cry. He's doing important political work so far.

Well kid, outside of reporting the good health of Ernie, Bernie, and myself, there's

nothing else I can think of right now. And besides, I want to take advantage of Sunday to hike down to the creek and take a bath. What a place! There I can splash around and bask in the sun, and make remarks about certain portions of Ernie's body and have a real hell of a time at least once a week! What a war! So far it has been more like a vacation at Kinderland! So long, baby, take care of thou and regards to all my sweet pals. Salud!

Harry

P.S. Remember Joseph Azar, the original "third general," who disappeared so suddenly? Well—now you know where he disappeared to. The Youth Theater is well.

• •

from HARRY MELOFF

"In a litle Spanish town"
May 26, 1937

Your "tremendous" letter just arrived, so I guess you can disregard my first paragraph. Try to make your next one at least a little longer, huh?

Dear Julie,

Well Bulle, it's now quite some time (two months I believe) since I last wrote you from here, and as yet no answer is forthcoming. I'd hate to think that you wouldn't take it on yourself to answer what was an important letter for me, so I rather choose to conclude that because of the war situation, the mail was lost, and that hence, you did not receive it. I know you'd answer, even if you would have to wait for old man Finn to leave the shop before doing so.

I'm O.K. pal! Healthy as a pig (and sometimes quite as dirty), and hard as nails. This is a marvelous experience for a Bolshevik, and though I have not been to the front as yet I know damn well that my many weeks of training, will bear its fruit. My military behavior is still a surprise to me. I hold up as well as anybody else, and my handling of arms is 100%. In fact, I, together with my cousin Bernie [Abramofsky], have been appointed to work together as a unit on a light machine gun.[2] With my four eyes, and his previous army experience, the fascisti will do well to stay far out of range of that automatic baby.

Speaking of babes, will next May 1st be another occasion of celebration for you? From comrades who have written to me, I understand that you actually finished what you started this time. Good luck boy! Tell Rose, I'm sorry I couldn't remain to collect the bride's kiss, but not to worry. I have many hopes of returning. If I don't, you collect it for me. You know, there are lots of babes here; not only the small ones. Grab wise, Boy, are they beautiful! Exotic? M-m-m! No, I won't tell you any bullshit! I've practically forgotten what a woman feels like, you lucky son of a bitch! (You notice how I'm beginning to warm up?) The orders are hands off! We don't want to antagonize the

[2] For information about the death of Bernard Abramofsky (Leonard Aibel) see Peter Carroll's *The Odyssey of the Abraham Lincoln Brigade* (pp. 184–87) and Milton Wolff's autobiographical novel *Another Hill*.

population by chasing their virgins, and on the other hand, a "sick" soldier is not a good soldier (Got itch?) So therefore the twin slogan to "No Pasaran" is "No Fuckeron!" (Hey, I hope your mother doesn't open this letter before you get it!) It's been so long now, I'm afraid I'll never get the wrinkles out any more.

Yep, life so far is wonderful. Last week we moved to a new town, and our barracks is a beautiful old fashioned hacienda that once belonged to a fat farting fascist. For some unknown reason, he had to leave sudden like. I wonder what it could be? Anyway, after scouting around, Bernie, myself, and three other comrades picked out a room that previously was a kitchen. Were we smart? There's a fireplace there and a cupboard full of dishes. We buy eggs, potatoes, cans of marmalade and coffee, and at night just before "taps" we cook ourselves a little good night "snack." Nice? This room is connected also to a patio, with a big water fountain, with goldfish swimming in its base. There are two big peacocks that strut around all day like Julie Blickstein on a Sunday afternoon.

Some of the boys decided to give Spain a taste of American culture, so they washed their clothes in the base of the fountain (nearly killing the goldfish) and hung it to dry on the nude statue that compromises the top. (Americans you know, are shocked at nudity.) But I'm an aesthetic guy who loves beauty, and some fine morning, the guys will wake up and find their clothes strewn all over the ground.

I've just returned from a twenty-four kilometer hike, and I'm sitting on a chair with my feet in a basin of nice cool well water. I certainly am a soldier. I can peel potatoes and dig a shit house latrine with the best of them. Now, let's see how well I can slaughter fascists.

Spain is a beautiful land, Bulle. Nobody must be permitted to destroy it. The people are too good, too hard working, the children are too smart, the women are too beautiful for that to happen. There are too many orange trees and olive trees and nut trees. Too many Roman built roads, and too much beautiful Moorish architecture. The people are united and love liberty. That's why it's absolutely essential to get rid of the bastard Trotskyites who tried to disrupt this unity, and therefore consciously knew that they were playing Franco's game.

You know pal, sometimes I wish all this had happened a year ago, when you didn't have all those responsibilities. I know damn well where you'd be—right here with me. Just the same I'm glad you finally settled down with a good gal. It ought to straighten you out. What I've done ought to "straighten" me out too, one way or another.

I'm worried about Jack Goldstein. You probably know that he left for here a month before I did. Nobody I meet has heard of him, and from letters I receive, I find out that he hasn't written to the States. I'm trying to trace him at Brigade Headquarters. I hope he's still OK.

Julie, it would be swell if you and Rose would take it on you some night to visit my parents: If you can't manage that, try hopping over during your lunch hour for a few minutes. The address is 1022 Stebbins Ave., Apt 4. I made clear to them what I was doing before I left and they didn't try to hinder me in any way whatsoever. I know that they are hurt, but from the mail they send me, they keep their chin up pretty well. My Mom says she is following the events in Spain very carefully and Pop wrote in a real antifascist manner. I want you to check up on their attitudes. Do that little thing for me, will you? Thanks.

Give my love to your parents; and tell your mother I apologize for the dirty words if they offend her. I imagine she uses worse Jewish words when speaking of the Francos and Hitlers. Love too to Yetty and Marty, and naturally Rose. My best to Pearl and the Inlaws. Please write soon.

<div align="right">Salud</div>
<div align="right">Harry</div>

WRITE TO HAROLD (I almost forgot my birth name) MALOFSKY.

P.S. Will you tell Julie Wilin I'm sorry I couldn't.
P.P.S. Bernie sends his regards and asks if you remember the "three French girls?"

• •

from HAROLD SMITH

<div align="right">Somewhere in Spain</div>
<div align="right">June 11th, 1937</div>

Dear Jeanette:

Just got back from one big maneuver with full equipment so we have an extra hour so I've plenty of time to write.

So where shall I begin? First, I think about you a little bit too much to be comfortable, especially after 3 months absence—but you know all about that—I've said it before and will probably keep on saying it for a very long time. That is as long as I am able. Second, we still are in reserve, despite numerous alarms and excursions. Our last and biggest alarm was about 5 days ago. Received orders to fall out with full packs— great excitement, much scurrying back and forth, assembly in the square, the complete battalion all keyed up, 4 days tension and then back to the regular training routine. But we're all on our toes. Ready to go whenever the General Staff decides the time is ripe. When we do, I'll try to live up to the slogan "Keep Astoria ahead."

All kidding aside, I'm damned glad proud and happy every time I get more news about our branch. Everybody who comes over from Queens comments on Astoria. Everybody here knows I come from the Astoria branch, especially after I gave a few solo renditions of the song you sent. Dick gets absolutely green with envy every time Astoria is mentioned. When I heard about the role the branch took in the strike in Queens, I was almost sorry I was here. To think that I had to miss the Astoria gang in action on a real tough picket line. I'll pass on some instruction that we received here from some excellent military instructors. "Don't strike until you're ready, but when you hit—hit with everything you got and don't stop until the enemy is annihilated." Tell Phil I appreciate the letter he sent and I'm absolutely going to write him a letter as soon as I can. Until then tell him that the way things are going on back home—he and all the rest will be getting more & more chance to translate their theory into practice. Really, it looks as if the movement only had to get rid of us to sprint ahead. Especially Astoria—Jesus—you hardly waited a decent interval after I had gone before showing your heels to the rest of Queens. You can tell the rest of the Branch that I wouldn't mind an occasional letter from some of them—the more news the better. Tell Bernie the galoop that even if he can't join us, he can write. Tell him I heard about his exploits on the Epco line—more power to him. (Incidentally, tell Norman Retkin to write me a

letter. I want to get some news of the Union. He'll probably be sore as hell that I haven't written to him but give him my best—and tell him I'll write a letter to the Union from the front.)

I'll be damned if I can ever finish one letter in one sitting. I've been interrupted constantly. First when Moe got his letters from home—(There goes the whistle. More later.)

4 hours later:

The rest of the boys are down in the mess hall eating (it used to be a theater), so it's very quiet here. I think I'll write a real long letter this time. I bought some bread and tomatoes and cheese and ate in—the change in diet is pleasant.

To resume: my first interruption was Moe's letters, then we were paid, then the whistle blew and we fell in for afternoon drill. Instead of drill we had a lecture on military tactics. We get a great deal of theoretical instruction here, damned good stuff. Our instructor today was the American who took the Lincoln Boys to the front [Merriman]. He was wounded in one of the assaults that they took part in. He's OK now and will probably be back in action soon. His topic was "Defense Against Aerial Attack." How to take cover. How to concentrate fire against planes when discovered. How to recognize different types of planes. How to organize [illeg.] with our own planes, etc., and etc. One thing stood out in his talk as well as all others who have spoken on the same matter and who have had experience in battle. That is the absolute confidence and pride we have in our aviation. When our planes go up the fascists get out of the air unless they are overwhelmingly superior in numbers. When our planes go up they fight as a unit, never leaving unless they are forced down or the whole unit leaves. The fascist aviators are a bit different. If the going gets rough, and it usually does, the bozos on the fringe of the fight skedaddle by themselves and devil take the hindmost and the devil quite often does. Our planes and aviators have the fascists licked a mile in everything including spirit. I've seen some of our planes maneuvering and they can do things in the air that one would think impossible. Incidentally, when I stop to think of it, if I were a guy in a fascist army I would probably think first, last, and always about myself. It must be terribly demoralizing to have to risk your life for something which you didn't believe in. That is one of the big reasons why we stopped those guys and now will run them first out of Spain and later out of the rest of the world. Including Astoria, my pet.

Lillian's letter mentions that you took Mother up to see Mrs. Fishman—splendid, dear. If you can activise my mother and sisters in organizational work of one type or another, you will be doing them and me a great service. Mother you know has quite a bit of influence among a number of Astoria & Flushing women. Clara also is quite influential. They can do really good work and you'll never have a better opportunity. So strut your stuff and remember that the pride and joy of the Smiths is rooting for you in far-off Spain. You know it won't be half bad if and when we have to take a crack at our own fat boys. Just think I'll be able to see you quite often—Glory be—Get thee behind me Satan. Learn mending and how to organize Jeanette—it's going to come in handy for all female Y-C-Lers. But no more raving. The next part of our letter will be devoted to personal news from here.

First: We, that is Dick, Fred, Moe, Gus, Ruby, and myself are members of the Second American Battalion, The George Washington Battalion. The First American is the Abe Lincoln Battalion. Dave is with them, also Manny B, not Manny M. I'm glad to say that the report we received about Dave's being wounded was later corrected. He is safe, sound, and unscathed. And you can tell Queens County C.P., the W.A., and especially Sylvia that they can be very, very proud of him. I've spoken to boys who come back to the base. He is one of the best-liked and most respected men in the line. He is political commissar of the Machine-Gun Company and is doing a swell job. Tell Sylvia that we just received a letter from the front and he is in the best of health.

To go on: Hy G. and Manny M. have also arrived, also a couple of boys from Jamaica. They are in the newly formed 3rd American Battalion. We'll probably move up ahead of them.

Now for some details. First, we're all in tip-top condition. Hy is losing weight and I'm gaining weight—18 lbs honey—so you had better build yourself up. But no fat, mind you. Rico is as dark as a Moor and Freddy can still break me over his knee. Manny M. has a baldy, and so has Moe and so have I.

Here's more: Ruby is our battalion clerk. This kind of clerk doesn't stay behind the lines tho. He goes wherever the battalion commander goes and in this army that's right up with the rest of us. Rico is in my group, Freddy is in our section, Moe is in our company, and Gus is in our battalion, so you see we're pretty close together. I've been promoted to group military leader and Rico is group political leader. The group is the basic unit in the army and the position would correspond to a sergeant. I hold no rank tho, as this is only in our training period. Tell Freida that I saw her boyfriend again recently and he's all OK. Tell the Levys that a guy by the name of Skippy is here and sends his love. Say, you know those pictures went over big. The fellows flocked around like bees around honey. Tell the girls that now they should know what it feels like to be a maid among a million men. I was beginning to think I was exaggerating your charms but the picture proved that my imagination was if anything a bit too cautious.

What is this stuff about Harvey? It didn't make much sense. But so many other surprising things have happened that even his arrival wouldn't faze me. His girlfriend's letter was a honey. She's an OK kid tho. Kiss her for me, and get her to join up with the rest of the gang and tell Barney we got his picture of Linda. Rico & Fred had a big fight over which one was too keep the picture. It really is a cute kid. I almost detected a slight stirring of paternal feeling deep down in my dark secret self. Mickie looks real good too and I'll be damned if Barney isn't getting a settled down look on his face. Say, listen, tell that mug that we would appreciate some detailed reports of what's happening in Queens. What happened to that idea that Rico broached of having each branch send us letters of their activities? I think it would have an excellent effect on the branches. Just finished another interruption—Rico & I changed our sleeping quarters, much running and carrying. Right now Rico is trying to find excuses for not writing and I am setting the good example. Really, Jeanette my beloved, I'm an alright guy once you get to know me.

You know I just realized that, when you get this letter, you'll already have been graduated. Do try and get a job in the line that you have been trained for and keep up your studies in the same direction. And no matter what kind of a job you get or don't get—

keep your chin up and give 'em hell.

Will you mention to Bill Haas that all the boys and especially our artists think that his little essay into the field of self-portraiture shows great promise, much more than anything else they've seen of the surrealist field?

The song, tho, is hot stuff. If it reflects the tone and trend of the branch, and from all indicators it does, I really think that's one of the reasons the branch is going ahead so well. Keep it up and let's have some more. I'm sending a copy of the sort of stuff we sing here. Harry [Melofsky] of the Convulsionaries made it up. It's only a sample but will serve to indicate why they call our section (Section 1) the "cracked section." Incidentally, we are also the Crack Section, I hope. The song really is not exaggeration. Everyone has his fist in the air and you'll probably "Salud" 100 times a day to 100 different people from kids of two up, especially the kids. Tell Lillian I introduced "Hi Ho Sorum" here, and it swept the battalion. We made up our own words to it describing different guys—like this:

"And another one's name was Harold Smithium."

The last line has to do with my activities as emergency sanitation director, so draw your own conclusions. I can't send any verses because they're not fit for the delicate ears of a Y.C.Ler.

I've got to stop, because if I keep on writing I won't be able to use my hand tomorrow.

Love to you and to all, regards to the two Bills—Charley—Phil—Alice—Sarah— Rae— Gladys—Vivian—Sonny—Ulisse—Ben—Lillian—Shirley—Eve and Jean— Bernie— Eddie—Lou—Norman—(Both) Sophie—Jack—(I hope to see him soon) Leon—Terry Jack Green—your Mother & Father. Tell your sisters—Flotzie & Rosie— not to fight over me. Abbie isn't bad either, and one Culler is all I can handle. Who says my memory is bad?

So Long & Pleasant Dreams

Harold

• •

from HARRY MELOFF

"With the George Washington
Battalion (not the Tom
Mooney)"
June 19th, 1937.

Dear Mim,

Every time I receive an oft-written answer to my oft-written letters, I scratch my head and say "Now, which the hell letter is she replying to?" What's the difference, as long as we sit down and knock it out? It's the symbol of a comrade's outstretched hand across the water saying "Hello, how are you? Well s'long; take care of yourself—see you next week."

I was pretty much excited last time, what with "stand by" orders and all that, figuring that the great day had come at last. Now you know it didn't. But this time we are far from disappointed. In fact we are very much pleased. When we are encamped now at a place where we can actually hear the rifle and machine-gun shots very distinctly,

and can hear the cannon's "boom," and see the smoke and dirt and stones fly in the air, where the shell landed on top of the hill; then we already know that "it won't be long now," is finally coming through. We are in the first line reserves, though we may never see action at this particular front. [Censored]

I dare say this place is very much like Camp Unity itself. Our tents are placed under large olive trees; we bathe in a long narrow river down the road, and there is a cavalry base, with beautiful stallions grazing right adjoining. Great big hills surround our valley, and at night the moon just fills it full of light. The food here is of a fine combination of vegetables, meat and wine punch. This morning we even had cereal. Butter, so far, is never lacking. Even a fine cultural program is arranged. Last night they sent us a sound truck with a loud speaker, and until "taps," they played revolutionary songs, symphonies, waltzes, and ended with a variety of jazz selections. It was really funny! The record was playing "Button up your overcoat"; we were sitting around smoking "Lucky Strikes," tapping our feet in rhythm to the music (Ernie was even dancing with some little feller), and on the other side of the hill, firing was going on like all hell.

This afternoon (Sunday) a truck is taking us to play a baseball game with the Lincoln Boys at their rest camp (shades of Unity vs. Kinderland). Tonight a vaudeville group from Madrid is coming to entertain us. Tomorrow a lecture by Ralph Bates. Tuesday a new Soviet movie. Right now there is very little difference between what you and I do. I'm even teaching the guys some of the folk dances. Of course, at 3 AM, I am fast asleep.

Yes, we are taking in as much fun as we can now. Very serious business awaits us, and we are prepared. The fascists are trying hard to get Bilbao, and though the situation is grave, I'm sure the same fate awaits them as at Madrid. If they fail at Bilbao, then their last glimmer of hope is gone. They have no other front to attack.

Meanwhile we rest, clean our rifles, and try to figure out which machine guns, on whose side are the cannons firing? Once after supper, the Moors started singing one of their weird, mystic chants, and I could almost picture you going into one of your improvisations. Don't imply from this that I think you either weird or mystic. I'm referring to the Moors only. (Heh, heh. I'm one up again.)

Kid, I'm sure glad that you made such an impression on the Unity management. If anybody can sit that Camp on its ass it's you. Just don't give them the benefit of you doing everything. You'll probably buck up against things with the management, that will get your angry blush up, and make you explode, like I know very well you can. But if you remember to grit your teeth, smile sweetly, and then do what you want; you'll have them eating out of your hand soon enough. I know that Camp will make you, and Miss Miriam Sigel should be a mighty popular person from now on. By the way, do you know if Al Richman got the job there or not? Say, with a team like Sonia and Beadie Bogurad, you all ought to be stupendous. Now that I think of it, words fail me! Take good care of Sonny;—for Beadie—I've given up hope. It's because I know you'll show her this letter, that I say this. If anybody can take it, that Red Head can. (I wonder—can she dish it out?) Now then, all three, (this is a new dance I just made up) form in a circle, and hug each other hard for me. As for the kisses, I've decided to attend to those, personally, later. (Boy, is that artillery bombarding again). I'll write the kids in a few days. (Hey, this is getting serious. The shells are coming uncomfortably near. I better

get my helmet handy. Aha, our own cannon is beginning to answer theirs. Last night we also shelled the shit out of those bastards.)

Bob Steck paid us a visit the other day, and the little guy is doing all right by himself. He is political commissar of a squadron of trucks. They gave him a little car to himself, and he rides around all day long. Tell S. & B. that Murph is still driving that truck. Bernie has been transferred to another company of our battalion, and Ernie in his short-fitting uniform, looks funny as hell. Except for once in April, I never saw Milton White again. If you remember (Beadie should) Nils, the tall blonde Swede who worked in Kinderland the last two years; I'm sorry to report, that he had his fingers shot off.

Paul will probably be sent into the 3rd American Battalion (tentatively titled the Tom Mooney, as ours was. It might be changed to Tom Jefferson or Tom Paine) of which Abe Harris is quartermaster. I will however try to communicate with him. He has always been a swell lad. In five minutes I go on guard again, so

Hasta la Vista and Salud.

Harry (Hersh to you)

P.S. Did you get my letter in time to send off that song to "New Masses?"
Harold Malofsky

...

from WILLIAM SENNETT

June 12, 1937
In Spain

My Darling Gussie:

While we're on this business of pride, I must say that with every letter you send I feel that the content is an expression of your development. It is a joy to be able to read that your own wife appreciates the upsurge in the labor movement and activizes herself accordingly. I received two letters from you—May 26th & 27th—also the Chgo 'Daily' supplement. I read them with the feeling that at last you had broken the shell of passive acquiescence to Political developments. You appreciate full well the significance of the steel strike. Its effects will be tremendous.

I read in the news bulletin we receive that 5 workers were killed at Republic steel and 100 wounded. What has been the effect? This callous brutality should be given a fitting answer.

When I hear of you speaking before this meeting, it opens me up to the failure on my part of pushing you forward sooner. How can you contradict yourself so in letters by saying in one that your Political development is nil (that means nothing!) and on the other hand you have written some of the swellest letters from a Political point of view? Don't hide facts with an absurd inferiority complex. Why, I received letters from Marv. T. & Ben Marshak in particular that are a lot of empty agitational crap. From you I have really received information and the trend of Political development back home. I say this with all honesty and sincerity because I feel that Politically you have come of your own.

It hurts me to know you are still so much in debt. Since we have been married debt has constantly harangued us. It is actually ridiculous for you to say that now that the League car was wrecked you'll have to pay for it yourself. Where is the logic? I don't

even know why you were paying half. They had the use of the car and could well have paid the full amount and the expense to repair it and still got a bargain. For Heaven's sake *don't* pay for the car because Claude wrecked it.

It is getting too dark to write now. I will enlarge on things tomorrow. I had a ring made of the better picture you sent me.——Please get more rest——Plan your work——Write when rested——With all the Love that is in me *(Muchos besos para tí)* [Many kisses for you],

Bill

●●●

from CARL GEISER

June 3, 1937

Dear Impy:

My first really rainy day in Spain, and it is quite a relief. The crops were badly in need of water, and this means much for the harvest in this region. Just now the comrades in my gun crew are kidding about what they would do on a rainy day at the front, about how much they would be willing to pay for a taxi to take them home from the gun pit, etc.

Here it means we have a little extra time for lectures and indoor classes. This morning was devoted to a lecture on gas warfare. Although the fascists have not used gas yet, perhaps because they are not supplied with masks for their own men, we are preparing ourselves if they do use it. All of us have masks, and are fairly well prepared to meet a gas attack. We know how to recognize the different types and how to deal with them.

Yesterday we had a lecture on defense against tanks. And we are quite prepared to stop them. Our whole defense is built against tanks. Besides this we have pits or traps, hand grenades, and special ammunition.

There has been a marked change among us here. At first we were hoping we would get some training before going to the front, though we would have gone without any if need be. Then after a few days training and we appreciated how much we did not know, we were still more anxious for training. But now we feel we are prepared to go to the front, and are anxious to get our baptism of fire. In addition, these few weeks have given us complete confidence in our officers, and they certainly are quite capable. My section leader spent 4 years in the German Army in 1914-18, wounded 4 times. Our Company Commander has had plenty of experience on the front. Others have had quite a bit of experience in the army of the U.S.A. And with the modern tactics that are being developed here, we are all set.

Just now our discussion is raging about the subject of digging dugouts, trenches, making tea, etc., how to dig in sand and timber, etc. And now it's on tobacco and making charcoal for smokeless fires, which reminds me that yesterday we received a piece of chocolate from the Friends of the Lincoln Battalion. It was good.

By the way, I haven't received a letter from you yet, although fellows have gotten letters dated on the 19th of May. But I am still waiting patiently.

Incidentally, I am No. 5 man in my crew, which is the next most responsible part to that of Corporal, and am also being trained in signalling.

You, of course, have read of the bombardment of Almería by the Nazis. It seems to me this ought to be about the last straw. Do the Catholic teachers still refuse to see why they must support the Spanish government? People must realize that if the Nazis are permitted to do this with impunity, they will go still farther, that nothing will be too low for them. The role of fascism certainly is made clear by this action.

You must be near the end of the school year when you get this. And getting ready for the summer vacation. I hope you are not entertaining any idea of coming here, for it is impossible to enter Spain. And even more impossible for me to leave. And don't let anyone tell you different, for I know. Anyway, I'll probably be quite busy this summer.

Just now the subject is unmentionable, but quite hilarious.

Did I write you I thought I had scabies (a trotskyite itch) but it turned out to be flea bites? They are under control now. But don't worry about me, for I am feeling fine.

Give my regards to all.

P.S. My address is always the same regardless of the particular place I am at.

<div align="right">With my love,
Carl</div>

..

from CARL GEISER

<div align="right">June 5, 1937</div>

Dear Impy,

A few minutes after I mailed my last letter, I received yours, and certainly was happy to hear from you. And 2 hours later, I met Irving W. & Pretty. You could have knocked me out when I saw Pretty. Both of them arrived here without difficulty, and are well. But they just came in time for I think our company is leaving this place today, although one never knows until one is on the way.

I am glad you didn't write until you were certain. And you addressed it quite perfectly. Now to answer some of your questions.

Yesterday they took out about a third of the men from my company because a higher standard is demanded of us than of the infantry. For if one man in a crew doesn't do his duty, it may have very serious results. Each machine-gun crew is made of 5 or 6 men. There is the Corporal, the first & second gunners who are responsible for the gun, and then 2 or 3 more ammunition carriers who are responsible for supplying the gun with water and ammunition. I am the last man, responsible to see that no one ever leaves any ammunition behind, for keeping in touch with the ammunition dump, to see that everyone in my crew keeps in line, and for communications between my crew and the section leader. (There are 3 or 4 crews to a section, and 10 to 12 to a company.)

Probably you are worried because the machine-gun crews were called "suicide squads." But actually, you are relatively safe, if you properly camouflage your position and know your gun & work hard, which means use that pick & shovel every night.

Am glad to hear you plan to go to Cornell for the summer. I hope you'll go through with it. Let me know your new address. And am glad to hear you are all set as far as the furniture, etc., is concerned, though I am almost tempted to remind you of some remarks I made when you bought it.

I am writing to my branch to tell them I heard they are doing good work. It certainly

is nice to hear they are going ahead. It means much to me here.

By the way, the name of our Battalion is the George Washington. I think the next battalion will adopt the name of Mooney. But the name Washington is much better for us, for it signifies our own struggle for national freedom and brings to mind the support we received at that time and it certainly should help the American people understand why we are here.

How did the elections come out in your union? How large is it by this time? And how many in your club from your place?

You can write to Maria, for I have written her as well as Bennet. By the way, open all my mail & answer it for me.

Must close if I want to get this into the mail before we leave.

<div style="text-align: right">

With all my love

Carl

</div>

. .

from JOE DALLET

<div style="text-align: right">

June 30, 1937

</div>

Dearest darling:

Things are going swell. We have really got the socialist competition going between companies and today awarded the battalion banner climaxing the first week of the competition. Company I won it this time but it was close and the chances are that they will lose it next week. On the 10th we are holding a big affair jointly with the unified Socialist Youth League. Edwin Rolfe is writing a mass chant which someone will translate into Spanish and it will be chanted by a mass chorus of 50/50 Spaniards and us. There will be several skits, based on local and battalion events and mainly in pantomime, which goes over best with the Spaniards and our own people too, for you can't keep 2,000 kids out, and they make too much noise when the dialogue is in English for anybody to hear it, even the actors. The companies are developing some swell initiative as to methods of work in political work—spelling bees in which instead of spelling the guys gather in a circle and answer questions like how many men in a group and why and what is their function; what parts in a rifle; why this or that kind of formation, etc. They all kick in a peseta in a pot before they start and the last one left takes the pot. They also play sticking the tail on the donkey, but they are not blindfolded and instead of a tail they have paper pieces that fit into a large cross-section drawing of a rifle, and they have to stick the piece in the right place. They do lots more things, all during their free time, which keeps them out of trouble and at the same time makes them better soldiers.

Wars are funny things and especially wars in Spain and there's a million interesting things that some day I'll be able to tell you. Met Ludwig Renn yesterday, a gauntish man with eyes who speaks quite good English though with an accent and whom, they say, the men absolutely adore and would do anything for.

Our battalion now has a four-cylinder Ford with a V-8 chassis and we chug along in great style.

Yesterday was in Albacete to get a picture taken for you and even had a shave first to look my best for you. But there is no film available for the minute, so you will have

to wait. For awhile I had a beautiful 44 side-cannon, but the guy remembered where he'd left it, so I lost the gun for which you can't buy ammunition anywhere in Spain— only you don't need ammunition for the other guy sees it pointing at him and runs.

I'm going to sleep. When I'm this tired I snore and if you were around you'd quietly say, "Joe," and I'd stop but you're not around. Much much love,

JOE

..

from JACK FREEMAN

July 19, 1937

Dear Pop & Mom,

Altho I received your June 30 letter two days ago and your June 9 letter a few days before that, I did not have an opportunity to answer them before as our battalion was out on a four day maneuver, during which I had absolutely no chance to write letters, even if the blisters on my hands from trench-digging had permitted me to hold a pencil.

The tremendous delay in receiving your letter of June 9 was caused by the fact that you addressed it care of the Lincoln Battalion's number, and so the letter travelled twice thru Spain before it reached me. As you probably know, the Lincoln is up at the front again after a short rest, after having set what is a record unprecedented in the history of warfare by remaining at the front without relief longer than any other unit has ever done.

As you have gathered from my first paragraph, I am still in training camp. The day after tomorrow will make seven weeks that I've been in camp. However, our battalion has already been given stand-by orders, our training is well-nigh complete and the heavy activity along the center front (where the other American battalions are at present) all make it probable that we will be moved up at any moment now. We have been definitely told that we may go up within an hour, a day, or a week; but it is almost certain that by the time you receive this letter we will be in the lines. I say "almost certain," because of course, in an army nothing is known for certain until it has actually happened.

In my last letter I told you I had received your letter on the Paris address, but it was not until the last few days that I received some really complete letters from you for the first time, and boy, they read good. Best of all, I got the package of socks thru the mail. The boys around here were walking around in circles, it is such a rare occasion to get a package thru all the way from the States. I don't expect to get the razor, but I'm well satisfied.

The news of your re-election was good and aroused quite a bit of interest, because there are a number of people here and in Albacete who had come in contact with you back home. Let's hope I dispatch my opponents as efficiently as you did yours.

You will also please convey to your office personnel that I have received his of the first and will reply at the earliest possible convenience. Give the kid my regards (also his mom and Louie & Arnie). Tell him he's got a big job ahead if he wants to fill my shoes. (Don't snicker when you tell him.)

Jack writes me that Herbie has gone to Camp Kinderland. He deserves it. From what you write it appears that my coming here will also make a better Communist of

him. Since it is quite late now I won't be able to write to him until tomorrow.

Your news about Mom was not quite so good. I know that you've already done so, but explain again to her why I'm here, and why, no matter what happens, she has no right to mourn. After all, you've known me all my life. You know that I'm not the kind of guy who flies off the handle easily or who is swayed into foolish actions by his emotions. I've tried to be level-headed, and what I decided I think I could not help deciding. Even now, when I realize more completely than I could have before all that my decision implied, when even before going to the front I've already had a fascist torpedo show me what death means at close quarters. I still believe that altho I've let myself in for some pretty tough going, still I did only what conditions and conviction led me to do. All crap aside, I'm not one for Boy Scout sentiments, and altho I've felt pretty uncomfortable at times and will probably feel more so soon, I think I was right in coming. I'm experiencing things I never could have otherwise and I'm doing work that was otherwise impossible for me. Those are sufficient reasons.

Mom has been in the movement long enough to realize these things. After all, how long could I have remained her "sonny"? Read this to her. I think she'll understand. Maybe soon I'll have a chance to explain personally to her.

You ask about my French. Well, as I wrote in Jack's letter, I was in France for more than three weeks. During this time my knowledge of the language increased as much as it had during the five years I studied it in school. Not only did my French make my stay in the country more enjoyable and profitable, since I could discuss quite readily with the people, but it came in damned handy for interpreting work both in France and on the trip to Spain. As a matter of fact, since I could speak some French and enough German to make myself readily understood, the political commissar of Americans in Spain offered me a job at the base of the International Brigades, where these two languages are most used. However, what I came here for can't be done that way. You can't translate ideas into concrete actions in an office.

The reason I haven't been writing more frequently is, to be very frank, that the schedule here is so tough that even when I have spare time I haven't energy enough to concentrate on writing letters. You can probably see even in this letter that I've made many mistakes in such things as grammar, etc., that I would previously never have allowed.

I'm now regular mapper for the first section of company one. In practical terms this means that I'm in the scouting section, which in our advances (and the IB expects to do a lot of advancing soon) marches several kilometers ahead of the rest of the battalion. My job is to scout and to map the territory thru which we are travelling. Because of our being way ahead of the rest of the battalion these maps are really an important part in determining the tactics which the staff will decide upon. It's a damned tough job because I have to map on the march. It's quite a responsible position and not quite as safe as discussing Trotskyism in the corridors of City College. In the trenches, where the terrain is already well mapped, I work the same as any other soldier.

My knowledge of math comes in very handy in this work. To back this up I've become a surprisingly (that is, for me) good shot, and I'm at least up to average in all other phases of this job of soldiering. I've gotten callouses on my hands, can eat almost anything, sleep anyplace and march full pack without collapsing. Considering my

original condition, that's giving some.

Well, this letter pretty well exhausts me for a while. Up to the present my health has been pretty good except for some diarrhea brought on for a while by the change of water and diet. Give my regards to everybody in the family and the union and my job and everybody else that I don't have to list here.

Don't bother sending me anymore packages. The Spanish post office is not as efficient as the one in the States and I don't want you to make any unnecessary waste of money & energy.

<div align="right">Yours
Jack</div>

P.S. Tell everybody you see to write me.

••

from JOE DALLET

<div align="right">July 25th, 1937</div>

Dearest,

Training a battalion is very much like training a football team in some ways. You know you have a certain minimum period in which to prepare the men. Into that period you must pack the maximum possible. At the end of that period, if you have worked as we have, you are set to go, and what is more; the boys are set to go. That period ended with the ending of our four-day maneuver. Now the boys are set, they are waiting for the word, and the danger exists that, lacking the word, with the suspense naturally accumulating, they will go stale. We are alert to the danger, and are taking a whole series of steps to avoid it. But it requires plenty of work, though of a somewhat different character. We are cutting down somewhat on the heavy work, although giving enough to continue hardening up and to keep trim. Especially are we cutting down on the heavy work during the blazing heat of midday and afternoon, and packing most work now into the early morning up to 11, and in the night, with night maneuvers most nights.

Simultaneously we are trying not only to introduce new things into the training (and there are plenty of new things we can well afford to spend time on, if we have the time) but also to make it more interesting by means of introducing more competitions, etc. For example, on night maneuvers we are pitting one company directly against another, in mimic warfare. The winning companies in the first nights meet for the final competition. This week we are starting volley ball, soccer and soft ball tournaments, with each section entering teams. Tomorrow we are taking the whole battalion out on a long stiff march (combined with scouting, etc.) which ends up at the river bank where the boys can swim. We'll spend most of the day out there, have a lecture right there on the river bank, and march back in the cool of evening. Our field kitchen will be sent in advance to prepare a good meal right on the river bank, which gives the cook staff practice at that sort of thing, and the boys will have both a good workout and a good time.

All this, my sweet, is part of political work in the battalion. It was the political department which raised this question sharply in the battalion military staff, but the singular joy of working in this battalion is that the staff agreed completely on the whole question. Indeed, frankness necessitates my saying that, hard though I work, the best

political work in the battalion is still done by Bob Merriman, even though he is in a military position. He has a political approach to every military question and it is that, together with the fact that as a human being he is a swell guy, which makes the working relationship with him so pleasant. I have learned plenty about political as well as military work from him, and am continuing to do so.

Marion promises to do everything possible for you if and when she sees you. I assume that you got my last letter in which I said that the answer finally is "yes" and enclosed a note to Jack. I am overjoyed, even though I did not go into details about that in the last letter, and I can't wait to hear your plans. Bill was also swell and said that he will do anything he can to help.

Ralph Bates was here this week and made one of the finest speeches I have ever heard to the battalion—on the development of the Spanish People's Army from its beginning to now. It was packed with facts, many of which were new (in their details) to me, and was so high-powered that many of the guys had tears in their eyes when he recounted some of the tales of the heroism of the Spanish people, of how the entire Executive Committee of the Madrid C.P. went over the top on the famous night of Nov. 7 when Franco was checked at Madrid; about how 200 women of Madrid laundered all the clothes of the defenders of Madrid from Nov. to Feb. without a cent of pay, plus countless other anecdotes and stories with which he illustrated some of the most dramatic political history of all time.

Got a swell new automatic this week, a Belgian Browning 9 mm. The clip holds 8 and you can put another in the breech. I shot it today for the first time; it balances fine in the hand and is very accurate. Sometimes very nice-looking guns are not too accurate, so I was well pleased when I found I could plink the target with ease. Now the problem is getting ammunition for it. 9mm. short is not a common calibre in Spain. There is no ammunition sold in stores, all must be gotten through the army channels, and while they have plenty for the 7.65s, they are very chary about dishing out the 9s. Incidentally, a good friend of mine (so good a friend he was wearing my boots when it happened) shot himself through the foot the other day while cleaning his automatic. He is a veteran from the Lincoln Battalion, a seasoned soldier, and still he did that. It was a good lesson for all of us and I assure you that we are extra careful now as a result of it.

More good reports about Johnny Gates—some officers from his battalion say that not only is he now a Brigade Commissar (the highest post held by an American here) but further they think he is in line for the job of Division Commander. Strange, eh? But Spain is a funny place. Some of the best people at home crack up badly here and some of the least significant ones from home come through with flying colors. You can see men changing before your eyes, and they say that up front the changes sometimes come so fast you can't even see them—they just have happened, that's all. It's a bloody interesting country, a bloody interesting war and the most bloody interesting job of all the bloody interesting jobs I've ever had, to give the fascists a real bloody licking.

JOE

Tarazona, España
July 27, 1937
Tuesday

Dear Audrey,

You would be interested in the army. It is altogether a different type than you have ever known. There is little formal discipline. There are no dress parades, no punctilious saluting of each rank. The discipline is nevertheless here, greater even than in other armies. It is because the majority of men are politically conscious. "Goldbricking" or shirking is looked down upon by the men themselves. Of course, I don't mean to imply that all are perfect.

This is not a Communist army, but very much a general "antifascist" army with many who are merely adventurers. Some of these hit the "vino front" and are put in the brig. Some have the long standing habit of going on drunks whenever they have a chance. Such will finally end up in the labor battalion. This group is sent to the front to dig trenches and other similar tasks under cover of night. They are unarmed and their sentences may be from one month to duration. To emphasize the democratic nature of this army, I need mention only that one company commander was found drunk and is now a buck private. Another conviction will send him to the labor battalion. Best of all he admits freely that his demotion was just in the interests of our common purpose.

Salud!
Hank

August 1, 1937

Dearest,

I just got your letter of the 25th. This is being written on what I gather to be a German Royal so all mistakes are due to it. Anyway our having it is a marvel. It is the first decent machine we have been able to acquire for ourselves, and our getting it is due to some first-rate wrangling which Bob and I did at the General Staff plus over half an hour of swearing in Spanish and French simultaneously at the store-keeper at the International Brigade warehouse, who first swore he had no machines to fill the order we had from G.H.Q. and then, after much swearing, threats, etc., tried to palm off on us all kinds of old broken-down specimens. We finally got this new one, but I have far from solved the mysteries of its keyboard as you will very well see.

I do hope that you will continue the splendid practice of sending me snaps each week, only you are not sufficiently religious about keeping it strictly once a week— sometimes two weeks go by without one. I have all the snaps mounted in a little pock- et photo album which I carry in my shirt pocket in my union card case all the time. I need less than no excuse at all to demonstrate you to all and sundry if they are good guys.

I can't tell you what division I'll be in or what army corps. There is a certain reor- ganization going on in connection with strengthening the whole Spanish Republican

Army which makes some of this unpredictable. However, we will surely be in the 15th Brigade in which will also be all other English-speaking units including the British and American battalions. Incidentally, the tone of most of the American press toward our boys here is remarkably respectful.

This last week-end was a sports week-end for the battalion. Our battalion staff team reached the semi-finals in mushball and horseshoe pitching. However, we lost to Company I, the winners in both events. I played first base and was with Bob on our horseshoe team. In the latter, after going great guns for a while, we ran up against a couple of Iowa farmers who took our pants down in full view of the whole battalion in spite of our efforts to convince them that it was bad for the prestige of the leadership for them to beat us so unmercifully. Those guys could make the horseshoes not only talk but also throw ringers which would settle down around the stake, lie there for a minute, and then rise unassisted and fly right back into their hands. You should have seen it.

Last night the boys put on the best show the battalion has had, including several very good skits, one serious wrestling match between the ex-champion of Finland and the ex-champion of the U.S. Navy, and a burlesque between two guys who were great acrobats, excellent wrestlers and better actors. They threw each other all around the ring with proper grunts, groans, and facial contortions and, finally, as they were rending each other limb from limb and were in the death throes of their agony—or vice versa—your hero, the referee, dove in head first to separate them so they could each die separately in peace, and all the seconds, coaches, managers, handlers, masseurs, etc., dove in on top of all of us and the curtain rang down amidst scenes of wildest hilarity.

I'm terribly worried about your appendix, dearest. Why in god's name does it have to pop now? Please have it fixed up immediately so you can start your trip here.

<div align="right">JOE</div>

• •

from **LEON ROSENTHAL**

<div align="right">August 2, 1937

Monday, 11:30 A.M.</div>

Lee sweetheart,

Your letter of July 13 just got here—and the other nite I got the one of the 15th—so I guess all your letters reached me so far except perhaps one between June 8-21? Also the July 4th delegation has not reached us yet—altho one of the boys says he saw Phil Bard in town 2 days ago—so that the letters etc. ought to reach us any day now.

The news I have to write is negligible—in a few days now the stuff I ordered in Barcelona ought to be here & then we can complete our truck and be ready for the front—which is the place where we belong & where we can do something useful. Meanwhile, as long as we are here we entertain the boys here with daily programs of recordings and patter. Last Thursday nite we had a show here & our truck played the leading role—we used our canteen (which is on a circular raised platform in the center of our circular grounds) as a stage—as a proscenium we had a red arch containing a slogan in Spanish "culture is also a parapet from which to attack the enemy." Our

microphone I fixed up on a wooden stand with red bunting. The comrades of each nationality had a chance to sing, speak, or recite & in between we played recordings. Our repertoire of records so far are all the revolutionary songs we could get—American jazz records—Spanish songs and dances & of course the other day I purchased the "Dance of the Hours" from *La Gioconda*—remember?

Yesterday we went swimming near a small waterfall. I have a real nice tan now—a homogenous brown color—except where my shorts go.

I asked Sam to go to Valencia the other day to get a ventilator that we need for the amplifier—he didn't get the fan but brought back some nice drawings & cartoons—3 folders or books—I'll send them on today—let me know if you receive all of them.

Yes, it was surprising to hear of Bill Downey's betrayal of the boys at Ansleys—he was always frightened to death at being fired—he needed the work so badly—a nice chap—but economic conditions made a rat out of him.

As for Gershon—I wish I had the poster I would like to send him—it shows the super-leftist—with two arms on the right shoulder raised in 2 fists and one left one—and a fist for a nose, etc., etc., and inside his belly is a fat bourgeois sitting on a soft chair & smoking a cigar—of course Gershon is a Trotskyite—which other road is open to a theoretical super-revolutionary such as he?

A cat—no! Cat-raising is a purely peace-time occupation—I haven't the opportunity or inclination for taking care of a cat—altho some boys do have pets—dogs, foxes, "runt chickens," parrots, etc.

Your letter of the 15th is pretty gloomy—I hope the picture is brighter now. You do need a rest and since you have saved some money—by all means get at least a week's vacation. Let me know how the campaign is going—is it really hopeless? $5,000 is a very small sum for all of Rockaway to give—but those damn petty-bourgeoisie have little interest in anything that doesn't show immediate returns. Well—we'll see how your dance makes out.

(I can't seem to make much progress with this letter. You see—Sam received 4 letters this morning all at once and included were some pictures he had taken before we left. He is now in a very loud voice advertising the merits of his marvelous $9.00 camera to all within sight and keeps tossing over photos for my approval and amazement—so that it's hard to write, but the letter must go on.)

Your letter of the 13th is more cheerful & as a result more informative. You ask about my 1st letter from Spain—from Valencia on about May 29th or so—well, you never got it—forget about it. It was a 20 page letter and full of detail—but that is ancient history now & I'll write much more interesting news from the front. When you get a later letter—never worry about the ones that didn't come—nothing can be done about it—but I assure you—no mail will be lost either way—they are doing a marvelous job with the mail considering the conditions and the vast number of transfers, etc. etc. (Time out for lunch)

12:45 I have written to Jimmy, Eddie Wolff and Morris Bailey. Joe asked Wolff to come to Spain and Bailey to join the YCL.

Also—I got the ticket to the drawing at the dance—If I win—I want you to take a vacation with the money—to Bermuda—or to the mountains. And that settles it!

You ask me to fashion my letters after the ones that Sam writes. How is that

possible? He is an *artist!* Don't forget most of his stuff is for publication—but I only write about events as they occur or as I see them—if there is nothing to write or if I am in a certain mood—I don't attempt to impress you with it 3 weeks later—nor do I send trivial gossip when there is so much important work to be done and such a fine purpose to be fulfilled. I've asked Sam about some of the untrue junk he wrote about me and he denies writing it. Above all—he is very young & naive and nervous—but I am able to handle him. He is my problem because I am in charge of the truck. There are two ways with him—either he is excitedly elated—or morosely depressed. But as I wrote you—he changed since I had a talk with him and he is anxious to get along with his comrade. So please do not include any more of the quotations from Alice's letters, nor should you take for granted everything you hear—you can fully depend on the veracity of my letters, I assure you. Alice is not very clever—and if she and Sam have nothing else to write but such nonsense—good luck to them—but as for me—I shall be content to write of the way we comrades are helping the Spanish people conquer fascism and of our experiences in the army. And I in return want news of you—not 3rd hand quotations from Sam's letters.

The latest *Daily Worker* we have now is July 18th—and the London *Daily Worker* of July 23—but a lot of later ones are due any day now. I have seen June & July *Esquire* & there are plenty of French & Spanish & German papers & magazines.

I am not going to make any prophecies about the duration of the war—except that I am sure that we shall break them on one of the fronts in a matter of weeks. At Brunete—Franco lost 20,000 dead according to British broadcasts and Franco admits 12,000—now that's a nice few fascists—no? And the Americans were right in the thick of that attack. One of the truck drivers was at the rear of the Garibaldi & Dombrowski lines yesterday—some of the boys were back of the lines for a much needed rest—he told how they were so happy & so full of spirits that they played a game of chasing down rabbits until they'd drop exhausted—can you imagine running a rabbit down to exhaustion—and then they'd cook them!

Beatrice will receive a separate answer to her letter as is fitting for a comrade doing her bit for Spain.

Lee—if I've been a little severe in parts of this letter—don't misunderstand—I merely want to impress on you not to take stock in Sam's letters—if you saw how he dashes off a letter at breakneck speed (the same way he does everything else) you would realize that he merely jots down anything that comes to his mind without thinking. Don't feel gypped if I don't write what I eat, drink, wear, how often I shower and poetic stuff written for future publications—I never wrote that way—nor do I intend to start now. So far I have kept you fully informed as to my work, health, interesting events and the progress of the war in general and our relations with the civilians—I believe that is more interesting to you than gossipy trivialities.

I hope that by this time, you have gotten at least a week's vacation—don't wait for a nervous crisis. Your health is a prime requisite for any work you want to do to help the cause.

In last Sunday's letter I included full directions for hooking up the converter. Also, separately, I sent 8 colored post-cards—did you get them?

Flash—Sam dashed in 10 minutes ago—and attacked some stationery with a pen—

now he finished his letter and asks me—"are you writing a book again?"—excuse me—
he just asked for 2 envelopes—so he wrote 2 letters in 10 minutes. Now—I ask you—
do you want me to be like that?

Sometimes, in the evening, we listen to Moscow on the radio—in English and
German.

There are good reproductions of Goyas etc. available in book form—in Valencia and
I think here, too. So—if I don't send some—I'll surely bring some back with me.

I'm waiting for news of Jack—whether he is in the mountains or not. I wrote him last
Sunday & also a page in Jewish to my mother. Tell my mother the same story—I'm
busy, working hard—in good health and I don't write definitely when I'll be home—but
keep her enthused about my success in France and that our work in France is for an
ideal.

You ask whether anything in your letters has been censored—no—not a word so far.

Well—I guess that covers the general lack of news. So you can imagine how much
I'll write when there is news!

Give my warmest regards to your father and mother. Tell your father that he is right
in wanting to give all funds to the medical bureau. I have seen plenty of ambulances
here—and all those from the states are sent by the Medical Bureau of the N.A.
Committee except a few sent by associated Spanish societies. But I have yet to see an
ambulance sent by the Socialists, Trotskyites or anything else. Also tell your father that
I am witnessing with my own eyes the growing unity of the Socialists & Communists
here into one revolutionary party—like in Catalonia and that locally in Albacete the
fusion has been accomplished—and the platform for unity excludes the POUM—all of
this despite Gershon's theories! Yes—the revolution will not be directed from
Brookhaven Ave!

And so, darling—we part until the next letter. Be sweet, honey, don't worry about
me—and be patient—when you have your citizenship and if the war is not over by
then—we'll see what can be done to bring you here—but you must wait until then.

Please take a vacation and get the other comrades to assist in the Spain campaign.
Is Mrs. Jaffe helping you? And how about Ezra & all the young YCLers—can you put
them to work?

Above all—don't worry about me—for the first time I'm able to get in a whack at the
oppressors—don't diminish my pleasure by worrying over me.

So long sweet toots—don't lose any more weight, skinny! Regards to Goldbergs &
all the young folks.

Salud, Leo

· ·

from PAUL SIGEL

Aug 13, 1937

Salud, Mus [Hannah Lipman Sigel],[3]

Received your letter—swell, gal, and swell again. Letters that long, and that inter-
esting are twice as good at second reading, and so on. I want all the news about the

[3] "Mus" was Sigel's nickname for his mother.

people I know, about events—We get the *Daily* and Sunday *Workers* here about two weeks late, but our *New Masses* and other magazines are lagging way behind. Send me that literature—simply, it's more likely to get to me and keep 'em coming all the time, it keeps me so much more in contact with what's going on in America. I also received the *Mother Bloor Birthday Souvenir Book*. When you see her again give her my (and all the fellows' here) sincere greetings, I know she'll have many more birthdays. Tell her, her work has always been an inspiration to all the fellows here, and we deeply appreciate what she has done in the campaign to help us carry on here in our fight to defend democracy in Spain and the rest of the world by wiping Fascism out of Spain. We pledge ourselves to carry on the fight here with as much energy and enthusiasm as she does back home.

Incidentally, in the magazines you send, you might, include a pair of rawhide shoelaces in one and a scout knife in another. That's about all I need. Possibly some chewing gum in each package, but don't make 'em big.

I had already heard something of Miriam's success at Camp Unity and this article confirms it. It's really swell, and I'm sure she'll go on to greater things.

I haven't seen Mac, but I have an idea he's driving a truck—one of the fellows who was in Madrid was asked by a fellow (answering Mac's description) if he knew me. I'll probably see him soon—I'm glad he got here anyway. I was glad to get that letter from Charley (also a bunch of other former Commonwealthers here), and I'll try and write soon.

I want to give you an idea of some of the things we do here in town, things that by now are second nature to us. Well—up at 5:30 in the morning, wash in some cold water pulled up from a well, using the Palmolive soap (and that's some luxury) and toothbrushes that's come in from the States. Then fall in, and off to the mess-hall on the other side of the town for coffee and bread (and usually goat's butter or marmalade or both). Then out on maneuvers, and back in time for dinner at 12. This is the hottest part of the day till 2:30, and during this time the whole town digs a hole somewhere, crawls in and pulls the hole in after them for siesta, and we do likewise in our barracks. Of course, right after dinner, we visit Maria at the doughnut shop, and Josephina at the cookie and candy shop—we can amply supply ourselves with the six pesetas a day that we receive here (this pay was even more of a surprise to us when we first came than it will probably be to you). Also, there are stalls laid out in the main square that have hundreds of useful knickknacks, a regular 5 & 10 ct. store. They have beautiful cigarette lighters. The cord is so made that a spark from the flint will make it glow. The harder the wind blows, the more efficient it is and the harder it glows; and it's very easy to light. (It very nicely takes the place of the lighter Mim gave me that I left in Béziers, France, though I was sorry to lose it.) Incidentally, I still have the Wittnauer watch and it's going great. Also the shoes & wool socks I bought in New York are swell and that's very good. Feet, stomach & brains are the most important part of an army, and they all need good food.

To continue: siesta is spent in sleeping, writing letters, reading, discussions, etc. Then at 2:30, off to afternoon maneuvers, which end in time for washing up before supper at 7:00. After supper we're free till 10:00 when we have to be in barracks, and this evening is the best part of the day.

First we have our own canteen, well stocked with cookies, fruits, drinks (all kinds, even to lemonade)—makes a swell meeting place for the fellows. And the wine in this town is really good if it's gotten in the right place. For instance, I was in the house of one of the townspeople here, and we had some wine, red wine, and really delicious. Then there are the many combined centers and cafes usually run by one of the organizations—the Left Republicans have one, the Anarchists, the Communists, etc. The Communist café has a radio, around which a group of fellows gather almost every evening. We can hear France, England, Germany, Italy, etc.,—the symphonies are the best, though we also hear jazz, speeches, etc. Sometimes we pass the evening with Maria (lives opposite our barracks) and the family. Her father, brother and sweetheart are all at the front, but the work is still continued by the rest of the family—as brave and courageous a family as there has ever been. There's where we learn most of our Spanish with our *"Como se llama,"* "How do you say," and then pointing to the thing. When we'll be with our Spanish comrades at the front, our Spanish will proceed much faster.

In the evening the whole town turns out and strolls up and down the main street and then the town square, and we of course, now a real part of the town life stroll up and down with them. I have already described the beauty of the night, the stars, the moon, the cool evening breezes, etc. But I couldn't possibly describe it too much or overstate it. There's been just 2 light showers during the entire time we've been here, though I know that along about November it's going to start raining every day and I know we'll regret our rainless, beautiful evenings.

Well, that's about the gist of it, and I'll sure be sorry to leave our little Spanish town.

I'm doing fine, getting along swell. My best to everybody, especially to your office people.

Salud
Paul

Say Mus, I've written you about Harry Fellman. Well I feel he deserves a real mother, something like you, so say Hello (better still, Salud) to your new son. He's a swell fellow—will make a real son & comrade, and I'm sure you'll be a real mother & comrade. We'll really discuss a family relationship when we see you.

• •

from LEONARD LEVENSON

Monday, August 30th, 1937
S.R.I. 271—Plaza del Altozano

Dear Herb, Julie, & Dad,

I received Herb's letter a few minutes ago. Of course there's little need for me to describe how welcome it was. Besides giving me news for which I have been terribly anxious, it opened the way for me to write to you.

Although there is material enough here for me to write volumes, I still feel myself confined by the deep urge to explain, at least to Dad, my act. I know that deep in your thoughts you believe it wrong. Yet even that judgment is predicated solely on the fact that had I remained in Washington I would have been able to make mother's last days

happier. This is undeniable and constitutes the lone regret, a profound one too, that I have. Opposed to this is the circumstance that I'm fighting for a cause which concerns the entire world. It's not a dedication to abstract ideals either, it's a gruesome fight for all your lives and future.

Although I've not seen action yet, I've encountered enough of fascism indisputably to demonstrate this. What we're doing here is inextricably connected with your routine existence. Spain must be the sepulchre of Hitler and Mussolini. It must also provide the first *final* crushing blow against the system which has made our lives such a poignant struggle against odds.

Where I differ from you is that I refuse to shrug away from the truths which blare forth from every wrong I encounter. Here I'm face to face with them and they foretell one thing—unless we conquer, you will soon be facing the same fanged monster as the people of Spain and perhaps will not as valiantly oppose it.

Of Dad I ask one thing. If he wishes to exonerate me by his own standards, I beg him to go to Rabbi Wise and tell him my story. The good doctor will not, judging from the fight which he is waging, say that I have not done right.

I will keep writing to Mother until I hear the sad news that her long struggle has ended. The time for me to go to the front is still weeks away, so nothing can impede my discharging that heartfelt obligation.

My Battalion, the Mackenzie-Papineau, is still in training. We're quartered in a little Spanish town in the south. Physically our village is centuries old. Its buildings, customs, and mores have not changed their aspect since the Moors were driven away in the 15th century. To this of course there is the marvelous exception attributable to the war and its causes. There is a political awareness and a lust for freedom in the people that will never permit the return of the oppressors. Their methods of agriculture are biblical in character but in defense of their liberty they are wielding the ultra-modern weapons of solidarity and class consciousness.

Since I left home I have run the gamut of the trials and tribulations which we members of the International Brigades have to encounter in getting to Spain and becoming acclimated to the country and military life. The tortuous twelve-hour trek that finally landed me here left me with a case of flu. That put me out for ten days. Having gotten over it, I since have become a lean, hard, brown soldier quite able to withstand the vicissitudes of army life.

Our outfit will move into the lines as the best trained and equipped battalion ever turned out by the I.B. It is composed of Canadians and Americans of every origin and from every walk of life. Not the least backward are those comrades who were most oppressed at home. The Negroes in particular here demonstrate their ability to learn and lead with the best of all other races. Our early training was under the leadership of a grand young ex-college professor who lead the Lincoln Battalion in the great days of February when the Italians were routed at Guadalajara. He has since been promoted to the Brigade Staff and his place taken by a slim tall guy of the Lindbergh type who came here in the early days of the war and rose from the ranks.

For myself—I'm doing rather well having shown particular aptitude in shooting and observing. These will probably enable me to go into action as chief sniper of the outfit.

This is all I have to write at present, but you will hear from me as regularly as

possible. Please write often. Don't bother about more cigs and chocolate until I let you know that the others have gotten through. Due to the efforts of the Friends of the Abraham Lincoln Battalion we get about two packs of Luckies a week—hardly enough but awfully welcome. You might drop a nickel in their box every so often.

My regards and greetings to all the Benders.

Warmest love to each and every one of you, including Mickey of course.

Leonard

··

from BEN GARDNER

Sept. 13, 1937

Dearest Elky:

It's getting dark already & I doubt if I'll be able to write much. At least I'll get started. Am sitting on the stone bridge which crosses the river from this Spanish town or village. Hundreds of soldiers are sitting around & the town is full. Our brigade is in reserve & at rest temporarily. We might be called to the front any day & at the same time we might stay awhile if we're not needed. After some interruption from comrades, I am continuing in my abode by candle light. A good straw bed with a blanket over it is like a heaven after the front line trenches. You may wonder how I am taking it. Somehow we get toughened up & can stand sleeping out, not washing & not changing clothes. Of course as soon as we get out of action we get a complete change in clothes. Last time I wrote we were close to the town, we took & slept outside. Now we're inside houses & among civilians. The town is like every other Spanish town. It lies in a valley. Streets are so narrow that a truck can hardly pass thru. You can almost reach across the street from balcony to balcony. The houses are rather tall, 3 to 5 stories & they look like fortresses. Then comes the eternal churches. At least two or three in every little town. They not only look but actually are used by the fascists as fortresses. Even heavy artillery does not have full effect to dislodge the machine gunners & snipers. To get back to this town. You can't buy a drink in the whole town. A drug store, a few stores that sell sandals & other junk. So you can imagine what I can do here with my pay. I guess we'll have to wait until we get to some city. Last night the division propaganda truck showed "We are from Kronstadt" & I saw it for the 4th time I believe. Somehow the picture had a different meaning to me this time. Certain scenes looked like the ones we went thru. Watching our Russian comrades in the picture we felt we were participating in the picture. Believe it or not Alice, but your letter came into my hands on Sept. 10th my birthday & I was the happiest man & it was my happiest birthday. More so, since your letter was a cheerful one & you didn't bawl me out. The pictures, I got 4 of them, are very nice. In fact, after not seeing a mirror for some 10 to 15 days I got a good look at myself & realized I'm still a young fellow. You, in plain language, look swell, but somebody said that Mary Loman spread her legs too much. Gee, I hope you don't tell her that. Kelly looks like a millionaire hombre in the picture. Now, to repeat, on the criticism you gave me for writing dry stuff. I remarked in most letters that it's war & many things cannot be written. Nevertheless, during the training period there isn't a thing to write. Only after one goes to the front, things begin to hum. You live thru actions, episodes, etc., some of which I'll never forget. I think that the letters I wrote

from the train & after are not dry any more. I hope to continue to write interesting ones in the future. Please send me clippings from the *Times* especially on the activity of the Lincoln-Washington Battalion & other interesting stuff. When I come back I'll please you in going even to the Y. to speak to some club or to a dance, since they all know about it already. Now, listen kid, stop praising me or I'll get a swelled head. So far I got all your mail, four of them & remember that I sent at least 4 times as much & if some don't arrive remember it's war. As to the token, if you're in N.Y. get it from Helen Schiff. I'm in a hurry to get my supper or somebody else will get my share. It smells good too. So, remember that I haven't seen Joe & a few other Philadelphians for 4 weeks. They remained behind & I'll have Franco's head first & leave the rest to the others. Got letters from Pat, your father & will answer soon. Love Always, Yours,

<div style="text-align:center">Salud,</div>
<div style="text-align:center">Ben</div>

• •

from JACK FRIEDMAN

<div style="text-align:center">Oct. 8, 1937</div>

My dearest Esther,

In the past few days I have received mail from you, Mims, George, Ruth, Trudy and perhaps other members of the family. Yet my reply to all of them will be as usual through this letter to you. I would like very much to have the more worthy contents of this letter reach them all with the explanation that I do not find it possible to answer each of them and have selected you because of seniority, at least you can tell them that. Certainly I do not want to invite their wrath and least of all a boycott.

First, Mim in her letter stated that there seems to be some local opinion around those parts that maintains that I came here for reasons of adventure. I don't feel a bit hurt, it merely provokes a bit of humor. I just want to say this, when I left Accord I was firmly convinced that I saw my dear and loved ones for the last time. I was satisfied that it should be so. The fact that I am alive today is only a matter of having more luck than my comrades. There is still no guarantee that I will live to get back. I could have left this country months ago and can do so any time I choose but I am not yet ready. Those people who raise that cry are just a pack of hypocrites and cowards. But let me remove myself from the scene and give you a picture of another "adventurer". You know him, or at least of him. His name is Roger [Hargreave], George's friend. Roger was a first aid man during the Brunete offensive. His comrades on the battlefield needed to have their wounds dressed and bandaged, so when a fascist bombing plane came over he refused to flop on his belly for some degree of safety and was hit by shrapnel from an exploding bomb. The result was a hole ripped through his thigh, about five inches of bone torn out of his right forearm, both legs badly hurt. I came back from the front about a week ago and went to see him. This former welter weight champion of the state of Iowa looks today about the same as Papa did before he died, and that mind you is an improvement over what he did look like. He is laying in a hospital where he is the only English speaking person and has been on his back in bad pain now for over two and a half months. I asked him how he was getting along and he beamed and said, "Swell, I will only be here for another *two or three months* and what's more they are not going to

take off that right arm. My hand will be a little stiff but I am sure I will be able to do first aid work." If there are more "adventurers" back there like Roger I wish they were here.

I wish you would make a special effort to write to George and tell him that the letter that he wrote me from Iowa I read to Roger who was overjoyed at it. Tell him to write to Roger along those lines.

Events here in the last week or so have been reminding me most pleasantly of former days up at Kripplebush when Joe and those many interesting people used to drop in. Of late I have run across such guys as Langston Hughes, the famous negro poet, Bruce Minton, Hemingway, Matthews of the *Times* and the like. I drag these fellows out to our camp and get them to tell us what is going on back home and in the rest of the world. I tried to get Langston Hughes to join the CP of Spain, of which I am a member, but he explained that he was not staying long enough to make it practical but at the same time promised that he would do so at once when he returned.

Roosevelt's Chicago speech, which looks very definitely like a break away from the former policy of isolation, was received with great optimism by the entire Spanish Press. They consider it a favorable reply to Litvinof's recent Geneva speech. The press also knows however that the Roosevelt policy is the result of Japan stepping on the financial toes of US, but that does not matter.

At present we are more or less at rest, kind of recuperating from the last big drive and getting ready I suppose for future ones. One of the greatest obstacles to greater success has been the lack of complete unity among the various political parties. However, I am sure I can say without fear of contradiction that that unity which is necessary for winning the war quickly is rapidly becoming a reality. The various parties are dropping their petty differences and uniting around the central idea of winning the war, quickly.

I am very sorry to hear about Iz and Ruth not being smiled upon too often by our good lady fortune. Somehow I have the idea that the best bet for security lies in settling down in earnest on the farm. Of course I understand that little can be expected from the agricultural end but I am certain that a couple of young people would be able to make the boarding end of it go very nicely. I don't mean on the present basis but rather modernized to cater to a different clientele.

I would like to have you call Fred Breal and give him and Edna my deepest and most sincere wishes, together with apologies for my complete criminal failure to write him. Tell him that many are the times that I think of him, think of him when the going gets tough, think of him spending twenty-two months in a lonesome hell of a dungeon, in defense of an ideal. He did not have comrades to cheer him when his spirits were heavy or comrades to sing his praise as he fought courageously. Yes, I salute him.

I am enclosing a copy of our Regiment paper. On page three is a satirical article by Dave Thompson, nephew of Kathleen Norris. Dave is a swell guy with plenty of wit. You will notice that even the Political Commissar does not escape from being soundly ribbed. His dad by the way is a banker on the west coast.

Am also enclosing some pictures I took with Eddie Rolfe, they were taken during the closing days of the Brunete offensive. I assure you that I look much more tidy today.

Let me wish you all a belated happy new year. My love to Mom and urge her to take care of herself and if at all possible, and I am sure it is, she should try to get down to N.Y. for a long stay with one of the kids. Remember me to Joe if he is still up at Kripplebush and distribute my greetings to all the members of the clan.

<div align="right">
Love & Salud

Jack
</div>

We expect a large shipment from the Friends of the Lincoln Brigade very shortly, no doubt all the stuff you kids have been sending will be among the shipment.

• •

from DEWITT PARKER

<div align="right">
Albacete, 270

October 26, 1937
</div>

Dearest Funny,

Last night I came down from the front with a few comrades. We had a long, dark ride and after being away from the school for a while I hoped to find a letter from you and sure enough, there it was. It was dated September 28 and therefore was a bit slower in reaching here than has been the case with previous letters. Was disappointed to hear that you had not received either the two fans or the handkerchief. In fact yesterday, with my pockets full of pesetas I decided not to send you anything else until you wrote of receiving those. So I bought a new pair of trousers, two shirts, necktie, 6 handkerchiefs, socks and watch chain, chess men, two protractors for mapping, and some party literature. So for a few more weeks the clothing problem is solved. Had a pair of beautiful black boots made and can now splash around in the Spanish winter months. Believe me, if the Spanish summers are hot, the winters are colder. Tonight in our room we have for the first time gotten together a charcoal fire in the typical Spanish custom.

Our present session of the O.T. School will be over soon and the comrades will be sent out to new posts. We are working very hard to see that everyone has learned the most possible and are busy drawing the lessons of some of our successes and failures at the front. Also there are last minute details of questions that need special study before we close. I personally expect to go back to the front again as soon as the school is over. This officers' training school is a very interesting institution. We bring together in the school those who have proven their capabilities both at the front and rear. Here they are given very thorough training in rifle, light and heavy machine gun, mapping, observation, tactics, fortification, engineering, scouting. We have had forty comrades in this school and it is a pleasure to see how they have grown into fellows with some skill and appreciation for these things. We are very careful in the training of officers for the I.B., knowing how great the responsibility of such a person is. In war mistakes cost lives and we must select to train as leaders only the best from among our people.

Your concern over whiskers, I am afraid is either founded on slanderous rumor (over here known as "shit house rumors") or a very poor estimation of your very respectable husband, for I shave once every other day with clock-like regularity. As for

the boots, there are two pair under the bed. One bought in Paris, low shoes recently re-soled and one pair of medium high boots made for me here at the Base of the XV Brigade. Beautifully made, believe me as remarked in an early letter, the Spanish are excellent workmen. Then we all have woolen socks, ponchos, coats, many of which have been sent from Mexico. It is as hard to keep warm here in the winter as it is to keep cool in the summer. However we have a charcoal fire in our room and manage to keep comfortable. My roommate is Norman Dorland, whom I first met when he was arrested in Toulouse. He was leader of his group of 29 and spent 40 days in the can. Over here he was a machine gunner in the Washington Battalion, was wounded at Brunete and is now Commander at our school. We have a number of excellent instructors with many years of military experience.

I too am sorry you are not here. You would be very valuable in your profession. Spoke to some people about your coming over but couldn't get much response. We could get permission for you to come into the country and once in could find a place for you here. But if you want badly to, I am afraid we must bring you over under our own steam. Have been given military rank of Lieutenant and so have 173 pesetas every ten days which is doubled at the front. You can use your own judgment on the question. It is a hard one to settle and, while I miss you terribly, perhaps we would only create complications for ourselves if you came. While we are on the subject or close to it, I want that $100 paid to you and am enclosing a note to Norwood to that effect. You should visit him and ask him to do me the favor of making the arrangements to pay the money to you. There may be technical difficulties but a way must be found to put that money in your hands. Use it to help pay for your car which I am very happy to know you have.

Some time ago in one of my letters, I spoke of the party comrades in Connecticut writing news of the party work and of the development of the labor movement there. This is really important and I think would be done if they knew how important it was to help keep our perspective here a little broader than cold and wet and beans and bombs, and to help us relate some of these things to affairs at home. Please raise this question very sharply with the Party. We want to know what is going on at home and the only way we can find out is thru the letters we receive. Recently saw Teddy Praeger. He is in the artillery and reports practically no one writing him except Sarah Wiseman. What the hell is wrong with New Haven, don't they know Teddy is here? The comrades should let Teddy know what is going on in the C.L.U. of which he was a member. Karl Gustafson was wounded slightly at Quinto. He gets a few letters from personal friends. Has the Party forgotten him? Tony de Maio has become a leader here but never hears from the District. Nick Stamatakos' address: Albacete 1 R.T. ought to get a note from the comrades. Nick did outstanding work for the *Daily Worker* drive and has been doing splendid work here. While we're on the subject how about myself! A section organizer and district committee member, away for 8 months as yet no letter from anyone but yourself. Do they think we've gone to the moon to stay? I'm raising hell about this question here and if all the Connecticut and Western Mass. comrades don't receive a letter from the Party before Christmas I shall raise more hell thru official channels. It's a scandal! A hell of a big scandal! And must be corrected immediately. I raise this very sharply for there isn't time to fool around. Please see that the leading

comrades understand this problem. If they don't know the address of all the Connecticut people here send the mail to me and it will reach them as I am making it my business to contact all the boys by mail.

Also how about sending over a few more people? People like Don Wiley, one of our best machine gunners. I wonder if the comrades have written to Don about farm work in Eastern Connecticut.

We are sending home thru Minor, all the material on our Wall Paper for a period of two months. Get hold of it thru Wofsy and have it displayed about the District. It will give you the best insight into the political life of one of the units here.

The shipment of things for the guys here from the "Friends" will be in within a day or so and we are looking forward to a new wave of prosperity of chocolate, tobacco, etc. It's a fact, but a cigarette becomes a very important political instrument sometimes.

I saw "Jack" the comrade with whom I worked in Paris. He is in Valencia doing work for us and the Spanish C.P. It was good to have a talk with him after all the battles we fought together in on the "Paris front". My belief is that we both came out a little better for it. He is one of the guys here who has become a real good friend, also a very capable and energetic person.

We lost a friend also. One of the comrades (Joe Dallet) who came over in March and led the group who were jailed in Perpignan. Funny how many friends I first met coming out of jails. Did a lot of work with him here and thought very highly of him. He was killed in the attack on Fuentes de Ebro which you have probably read of.

There are a million things to tell you and you won't get a wink of sleep for listening to them someday.

Tell me something of Bar and Alex and tell Alex to drop me a line one of these days.

Take good care of yourself sweetheart and don't get tired and worried. I shall try to write you more often and more fully meanwhile you are always close to everything I do here. Tell me a lot about all the things you do in your next letter. How is the work, where you go and how our friends and family are.

All my love, with peaches and cream to make it better.

D.

from MILTON WOLFF

December 4, 1937 Spain

Ann Lenore,

I'm getting to be a real letter writer of late…just time on my hands. I consistently think of you when I want to write a letter with no point to it, I wonder why. Can it be the desire of a negative to find a positive-pole? Or what….

Maybe I'm thinking that you will save all this and some day I'll be able to remember. Some clear, cold, golden day such as this…when you can stand on the hill and allow the wind to bring the skin alive with a glow. When you can see so far you dare not estimate the distance…and all that you can see is vivid with color, shimmering, changing chartreuse and russets and gold. Look! Today there isn't a cloud in the sky, not one flaw in all this vast expanse of blue…but wait and you will see the backdrops come up…just wait.

I was out putting the men through their paces this afternoon...teaching them how to kill. Most of them are new men and must learn the art. And every man I taught to aim a gun stirred within me the actual picture. I could see that gun explode, throw orange flame in the grey of the day, I could smell the acrid powder and I could see the human target disappear...a hit or not?

And then to crawl, crawl when you hear the snap of the angry explosives overhead...the bastard is gunning for you, keep down, for Christ's sake, keep low...you are no good rotting in the sun. Now the attack, speed is the theme...speed is the mad music...up, down, hurry, hurry...you must get there and alive! What madness is this that we must exert ourselves in...where are the gods?

And now siesta is done with, back to the stage, for we must rehearse until we are perfect at the play...for if we succeed we end all this stupid drama. Goodbye, my patient listener...I'll be back later....

Salud Milton

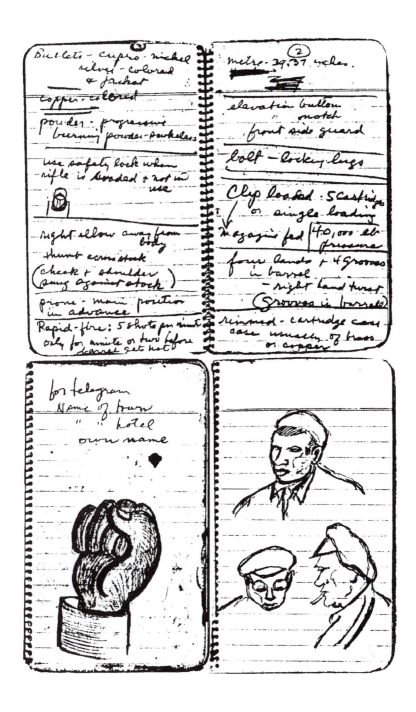

Selected pages from the diary Edwin Rolfe kept when he was in training at Tarazona de la Mancha in June of 1937.

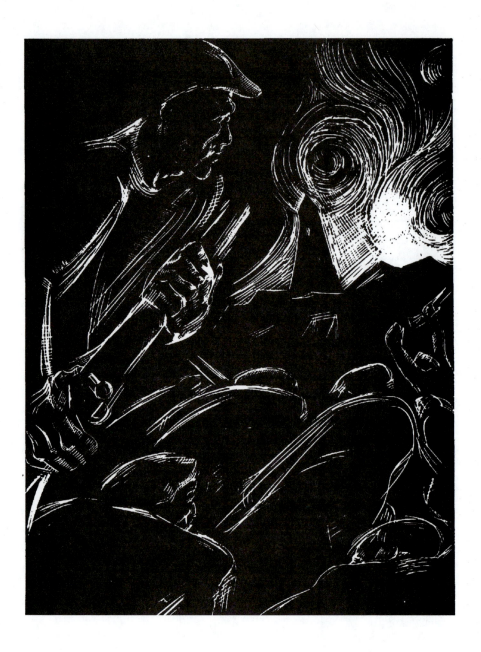

Oveido en llamas será la antorcha que illumine el desperatar del Mundo, y la sangre de sus hijos sur-
tirá de savia al árbol de la Liberatad. (Oveido in flames will be the lamp that lights the world's
awakening. The blood of its sons will supply sap to the tree of liberty.) *Frente Libertario* (Madrid),
October 17, 1936.

IN BATTLE
From the Plains of Brunete to Fuentes de Ebro

••

INTRODUCTION

Here are two postals I picked up on the road, trod over as you can see by hundreds of soldiers' hobnailed boots. Well, here we are finally, lying in close reserve. Five miles ahead of us lie the trenches which we shall enter for a brief period for our first baptism of fire. Over the hill during the night we hear occasional rifle shots, a brief machine-gun burst and then zap-boom-zap-boom-zap-boom. After the authoritative voice of the light artillery speaks the barking of the machine-guns, and the baying of the rifles respectfully ceases. Sometimes too we hear a noise like dynamiting. That comes when the big babies are letting loose their miniature earthquakes. The attacks take place only at nite because the machine-gun nests are so placed and the trenches so built, that to attack them when visible would be to commit suicide under a withering machine-gun cross fire. In fact almost everywhere both sides are so well entrenched that frontal attacks have become impossible. Wide flank movements by foot under the terrific sun, or sweeping movements by tanks attacking from the sides and rear, seem the only way to break the deadlock. Our new offensive will be to the end run of modern football as the flying wedge was to the old time football. Soon we expect to quit the trenches and try our luck.

> Much love.
> Gene [Wolman]

This letter was written in June of 1937, after the Jarama front had largely stabilized. Stray explosive bullets could still do damage, as could artillery, but deep trenches in the rocky hilltops made direct assaults difficult or impossible. Some of the Republican trenches were so well-constructed that on at least one hill they were still substantially intact in the 1990s. As late as April both sides mounted attacks, but thereafter the front settled into a holding pattern.

Among those who arrived at Jarama after the devastating February battles were over was New York native Harry Fisher, born in 1911. A labor activist and member of Local 1250 of the Department Store Employees Union, Fisher had several times helped evicted depression-era families move their belongings back into their apartments. Done quickly, before the police could arrive, it meant that lengthy eviction proceedings had to be started all over again. In the fall of 1932 he enrolled in Commonwealth College in the Ozark mountains in Arkansas, but he was expelled after joining a protest against racial

discrimination on campus. He rode a freight train to Chicago to look for employment, but there were no jobs to be had. Back in New York he joined the labor movement. In 1937 he was in Spain. As he wrote home on May 29, there were even moments of humor at Jarama once it was stabilized:

> It was an extremely hot day. The hour came to change shifts in the trench. Slim was going into the trench with his rifle and wearing only his underwear and shoes. Mike, his group leader, became very indignant and asked Slim to put on his pants before going in the trench. Slim refused to do so on the grounds that it was too hot and he wanted to be comfortable. Mike threatened to arrest him if he went into the trench without his pants. Slim dared Mike to arrest him. Mike became very sore and placed Slim under arrest. He asked another comrade in his group to get his rifle and help bring Slim to headquarters. So there they were walking to headquarters, first Mike, then Slim in his underwear, and then the other comrade. Suddenly Mike remembered his own rifle was unloaded and asked the other comrade about his rifle. His too was unloaded. Only Slim's the prisoner's was loaded. Anyways they continued to march to headquarters.

> All the officers were surprised to see the three come in with the prisoner in his underwear. They heard both sides of the story. They then asked Mike why he objected to Slim going into the trench without pants. Mike looked at them as though he were a teacher looking on schoolboys. "Suppose the fascists were to attack and come over to find our comrades in their underwear, what would they think of us?" Mike won his point. We wear pants in the trenches now.

Fisher was with the Lincoln Battalion in the trenches. Wolman was with a second American battalion, the George Washington. His letter was written after the Washingtons were trucked up to Morata de Tajuña, just behind the lines, in June. The offensive he anticipated did not materialize. Indeed, at that point all the Americans were taken out of the lines; their long and sometimes pulverizing 120-day vigil at Jarama was over.

A few days later, on June 20th, the Basque capital of Bilbao fell to Franco's troops. The isolated segment of Republican territory in the north, surrounded by land and blockaded by sea, was in danger of being overrun. With no way to help the north directly, the Republic decided instead to strike on the Madrid front. That might simultaneously relieve Madrid, cutting off supply routes to the Nationalist troops at the city's edge, and take pressure off the north by forcing Franco to move troops toward the new battle zones. A major, carefully planned, assault was prepared. Uncharacteristically, the element of surprise was preserved. The ensuing battles west of Madrid would become known as the Brunete offensive.

On July 2nd the Americans were on the move. Two days later, near Valdemorillo, they celebrated July 4th with a special dinner prepared by their popular cook, Japanese-American volunteer Jack Shirai. That night they marched again. Oliver Law, an African

American volunteer from Chicago, now commanded the Lincolns. It was the first time in American history that a black officer would command an integrated group of his countrymen.

On the morning of July 6th, the Americans were on a ridge overlooking the Rebel-held town of Villanueva de la Cañada, some 13 kilometers from Brunete. They looked down into a saucer-shaped valley alive with thousands of troops, tanks, trucks, artillery pieces, machine guns, and ambulances. At its center lay Villanueva de la Cañada; it was astride the logical supply route for the rest of the offensive and would need to be taken at some point. Nevertheless, speed was essential if the overall plan for the campaign were to succeed. Thus it would probably have been better to bypass the town and lay siege to it later. But that was not to be. The Lincolns were about to enter into seven days of relentless combat in the unforgiving heat of the Sierra sun. After they took the heavily fortified town, they were assigned a still more difficult task—to storm the fascist positions on Mosquito Ridge, the high point overlooking the valley. By that time a counter-attack was under way. The valley was an inferno of burning villages; the sky was criss-crossed with fascist planes on bombing and strafing runs. Dehydrated and exhausted, the Americans were withdrawn on July 15th. Their ranks depleted by the dead and wounded, the Lincolns and Washingtons were combined into one battalion. They were due for an extended rest, but weaknesses in the government lines brought them into action again until July 25th.

As is typical in modern war, it was against regulations to give details of a battle still under way. Thus the men often waited until an action was over before writing home about it. We have generally arranged the letters not in the sequence in which they were written but rather in the sequence of the events they describe. When place names were blacked out by the censors, we have restored them [in brackets] whenever possible. In two cases (Fred Lutz's letter and Harry Fisher's October 18 letter), we added dates and place names not in the original to clarify the letter. Here is their story in their own words.

· ·

from WILLIAM SENNETT

July 10, 1937

Dearest Gussie:

After days of whirl-wind action I have finally secured a breathing spell which affords me the opportunity of writing to you.

Just let me say that I have received your letters of June 12th & June 20th together with a package of literature and 3 bars of chocolate. All of this was waiting for me at my old place after I had come there for a rest.

Now to the big thing which for 3 days I was a participant in. It is going on strong still, but I was forced out for only a few days because of a slight flesh wound from a fascist bullet. It is so trivial that I didn't even have to go to the hospital. Just for one day it numbed my leg so that I couldn't keep up with our advancing troops.

On July 5th the Lincoln and Washington Battalions moved with thousands of the

best Spanish troops up to the [Brunete] sector. The objective is to once and for all lift the siege of Madrid by clearing out the Fascists all around and remove them from positions where their artillery can reach Madrid. Our American Battalions were in the second line of offense. We moved up through [Valdemorillo] (consult map of Spain) and marched about 10 kilometers (6 miles). On July 6th we moved up on the left flank to the Fascist held town of [Villanueva de la Cañada]. The Fascist troops were driven back to within about 400 yards from the town. The Lincoln Battalion went over the top and advanced on the Fascists thru no man's land. We were successful in diverting fire from the main body to the left of us altho we caught some hell. After hours out in the field with no possibility of advance on our flank, the Washington Battalion relieved our boys (as they were directly in back and had yet not gone over the top) we retired from one position for a little rest while fresher troops continued the attack. Moe, Sammy G., & I along with others found a few soft spots in between some rocks and went to sleep.

On awaking at 5 A.M. we were told to reassemble past the town of [Villanueva de la Cañada] which had been taken by us during the night! The Fascists had kept us away by a steady stream of machine gun and artillery fire but our airplanes had bombed the town to hell and our artillery had pounded their entrenchments. It was only with that type of support that our forces advancing with hand grenades marched into the town. At the same time our troops on the right flank took the town of Brunete 5 kilometers away. There our tanks gave splendid support.

Moe, Sammy, & I took a tour through [Villanueva de la Cañada] and what a wreck the town is. We went through the houses and saw all the fascist dead. We started picking up souvenirs, fascist helmets, gas masks, insignias, etc. I picked up a membership book from the Spanish Falangist (fascist) organization. I intended to send some stuff back home but lost the stuff in the next few days' battle.

The Fascist losses were tremendous. Hundreds of prisoners were taken. Many Italians and Moors. We saw hundreds of dead. It was a tremendous victory. Usually in an offensive even though an objective is achieved the losses are greater on the side of the advancing forces. But let me tell you the casualties on our side were very small compared to that of the enemy.

We reassembled near [Villanueva de la Cañada] and started (July 7th) the [second] day's advance. We kept marching over hills and out of ravines against the retreating fascists. Then the enemy planes came over and for 4 hours we had to find holes and what little cover an open field afforded.—Wow—What a helpless feeling you have with the planes overhead. They drop bombs—you hear them release it, then the whistle thru space and you just hope for the best. You sort of have a little sigh of relief when the bombs drop on the other side of you. They kept coming and dropping bombs and we had to lay down and take it. After all the bombs were dropped the most horrible thing is the strafing by machine guns. The planes swooped down right over us and let loose with machine-gun fire—then more planes and more bombs—those hours seemed like days—but it had to end some time and considering the amount of bombs dropped and strafing done the casualties on our side were very few.

After the planes we got a little artillery barrage but our artillery got busy and silenced them pretty quick. We proceeded to march and our troops in advance of us were successful in keeping the enemy on the move.

At nite we stopped for a little rest and set up guards while the others slept. On the shift of guard I had around 3:30 A.M. bullets started whizzing by—machine guns started rattling and grenades were exploding. The Dimitrov Battalion had met the enemy about a KM. away. The Fascists were quickly driven back.

On July 8th at about 5 A.M. we started the day's movement. An advance detail was sent out to contact the enemy. At around 8 A.M. we started a wide sweep against the enemy and they took to running. Our tanks moved up and gave chase. Our Battalion was right on the side of the tanks. Boy what a deafening roar. I thought my ear drums would burst. We ran after the enemy and they ran away so fast we couldn't keep up to them for a while. Then they stopped to consolidate their position. The bullets were flying fast and thick, over you, to the side, and in front of you. I felt (not having been under such a heavy fire before) that any minute one would hit. The explosive bullets would give a "pop" and the others whistled on all sides. Then I felt a sting and the guy next to me got the same bullet through his toes. We both dropped down and had to stay behind as our forces then continued to push ahead.

After going back to the first aid station we heard of the terrific battle that was taking place up ahead of us. Again Fascist planes and artillery.

We had on the other flank cut the road to [Romanillas] and captured some more towns.

That nite I was taken down to the town of [censored] for a rest and met one of the trucks from my transport outfit. They told me there were others nearby and took me back with them where I met Morrie & the others I knew.

After a good nite's sleep I went up with the trucks to pick up cargo in Brunete. Fascist planes came to bombard the town. We had to run for the fields and were bombed for over an hour. Then the trucks were taken out, and right on the road shells from the fascist artillery started popping. We quickly moved out of range.

I was taken back to the auto camp for a few days rest and here I am.

This afternoon I have to see the Commissar of Transport in connection with my particular position. It so happens that officially my transfer did not come to the Lincoln Battalion although I was considered attached. Also I was (and still am) an inexperienced infantryman having had no previous military training here. It may be that I will be kept back in transport. I personally feel that I wish I could get some training before getting up to the front again. I'll straighten out things by tomorrow.

Moe T. & Sammy are still OK and they are probably wondering where in the hell I am. I'll see them tho. Izz. Tivin was a stretcher bearer and Sam Fuller is a cook's assistant.

Yes sir—the big offensive is on and stories from Spain will be much different now. Let me hear what the American papers say about it.

Enclosed you will find the bulletin issued to us before the drive started. It was really an inspiring thing to read and started everybody off in the right spirit.

Meanwhile write again to the 2 R.T. address and there will be many big developments before this letter gets to you. When the siege of Madrid is lifted we will be well on our way to the final victory.

You asked me a question which I repeat in every letter—Do I *still* love you! *TREMENDOUSLY!* Why even when we were being bombed and strafed I looked at my

watch and thought of where you were at that hour. Regards to Jack K. and all others. I'll see you yet!

Bill

. .

from PAUL SIGEL

Spain—July 7, 1937

Salud folks,

Well, and life rolls on, rich and easy and fascinating. As I gradually cram myself with knowledge, I am gradually becoming attuned to the tremendous difference between conditions in the old country and here. And the difference is tremendous, without even considering the change in the usual eating and living habits. Actions or performances, that would keep our American daily newspapers singing for months, are here the very usual thing.

I have in mind especially at the present time, one fellow who is now in my group in the signal corps. Harry came here in late January, and along with the rest of the American boys he was immediately sent to the front. That was at Jarama. Harry seems like a typical 23 yr. old American. But would an average person be over here at all in the first place, would he be among the first Americans at the Jarama Front? He was wounded by a bullet that passed right thru his stomach, but he didn't bother to go behind the lines to the first aid station, and it wasn't until 24 hours later when he became delirious that he was finally removed from the front and sent to hospital. There he stayed for a month and a half, and there, after he came out, he drove ambulances for 2 months. Now he is in the signal corps here.

While he was in the hospital, he received first-hand knowledge of the battles on all fronts, and therefore has a fairly complete picture of what this war is all about and how it's being fought.

Now, usually in story books the hero who had had all these experiences would be called modest, and strong, with a twinkle in his eye. It would be said that he had not changed a bit except to become a great deal more mature in his attitudes. Well, I would never believe the story books, but here it is in real life. That is just the way Harry is— a swell fellow—a fellow that has had marvelous experiences, that is living on borrowed time, but who doesn't show it in the slightest.

I've been trying to put my impression of this comrade on paper, but I realize that I'm not capable of really expressing my feelings. How can I tell of my tremendous love for the comrade, of my admiration for him. Well, let what I have said suffice. I think you will get what I mean.

Vic Tishup is here. He is doing very well. He has acclimated himself very well to the life here, and is bearing out all my hopes for him. He sure has changed in the last year. You know he has only been in the league a few months. Incidentally, Bert, Ed Mroczkowski (or something), and a mess of other students came in with him.

Well, I'm corporal of the guard, so I've got work to do. I'm doing O.K.—in good health and wonderful spirits.

I'll be seein ya. Keep asending those letters gang.

Paul

· ·

from HARRY FISHER

July 29, 1937

Dear Sal, Hy, & Louise:[1]

I slept for ten hours last night. After a breakfast of ham, coffee, bread and jam and chocolate, I went deep into the woods to be alone so as to write you a letter. Instead, I fell asleep and had all kinds of dreams, of planes, of being captured, of singing the "Internationale" in front of Hitler—all in all, it was kind of nightmarish. I got back in time for lunch and this letter.

I see Ralph Bates just a little way off. He's been with us for two days now. During one of our worst battles, he was with us at the front. He's one fellow I have plenty of respect for.

What I want to do in this letter is to write some incidents about some of our comrades. It is the thought of these comrades that makes you willing to face again the hell you have already faced.

First about Comrade Oliver Law. When I first came to Jarama, he was commander of the Tom Mooney machine-gun company. He was a good-looking, well-built negro. Later he was promoted to adjutant of the battalion, and about a month ago he became commander. Now a battalion commander is not supposed to lead his men over the top—he should be a few hundred yards behind. But on July 6th, when we went over the last hill and charged under heavy machine-gun fire, Law was right up in the front, urging us on. When we were forced to drop, he was still up, looking around to see that we were all down. Then he dropped. How he missed being hit that day, I'll never understand.

On July 9, we went over again. It so happened that the fascists had attacked too. We were about a thousand meters apart, each on a high hill, with a valley between us. The Gods must have laughed when they saw us charge each other at the same time. Once again Law was up in front urging us on. Then the fascists started running back. They were retreating. Law would not drop for cover. True, he was exhausted as we all were. We had no food or water that day and it was hot. He wanted to keep the fascists on the run and take the high hill. "Come on, comrades, they are running," he shouted. "Let's keep them running." All this time he was under machine-gun fire. Finally he was hit. Two comrades brought him in in spite of the machine guns. His wound was dressed. As he was being carried on a stretcher to the ambulance, he clenched his fist and said, "Carry on boys." Then he died.

I was in battalion headquarters that morning before the attack. Law was there too. Everyone seemed sentimental. They were talking about home. Law spoke about his wife, how he missed her, how some day he would see her again. Later, the subject was changed. We began telling jokes.

Then there was company commander [Paul] Burns, an Irish comrade from Boston. I was his runner at the time. While out in front on the same day, he received a thigh wound. He was in awful pain while being dragged in, but he wouldn't utter a sound. While his wound was being dressed, he insisted on loading machine-gun bullets.

[1] Sal was Fisher's sister, Hy her husband, and Louise their daughter.

Comrade D. [John Deck] was a German American.[2] He had an easy job behind the lines, but refused to stay there. He insisted on being with the boys in the front. He joined the same section I was in while still in Jarama. I used to listen to his stories for hours. He loved to talk, but he was one fellow I never got sick of listening to.

On July 7 our battalion was maneuvering around, looking for the fascists. He was the lead scout, always in advance of the battalion, and in the most danger. That night we slept on the slope of a hill. Bullets were whizzing over the hill. The observer notified headquarters that there was a house about 800 meters away, where the bullets were coming from. D. volunteered to go out with bombs and blow up the house. Just as he was ready to go, we got word that we were to go some other place in the morning, so Law refused to let D. go. He was shot in the head at about the same time Law got hit. He was way out in front, a grenade in his hand, ready to throw. He died instantly.

But enough—I am thinking of Louise now. Her birthday is tomorrow or the next day—I'm not sure what date today is. If it is possible, I want to write her a letter.

And about mom. I really don't think it is necessary to let mom know I am in Spain yet. I'm afraid she'll be too worried. Everything seems to be going along smoothly as it is—I hate to spoil it. Unless I hear from you in the meantime, I'll continue to be in France.

During the beginning of these battles, I was unable to write to you for over a week. I hope I didn't cause you too much worry. Just remember, that as long as you don't get any official message from the battalion you have nothing to worry about. At the time it was impossible to write to you.

Remember me to all as usual.

> Salud, Love
> "Bozzy"

..

from HARRY FISHER

July 19, 1937

Dear Sal, Hy, & Louise—

Today is the first chance I have to myself since about July 4. Practically every day has seen heavy fighting. It is only 8:00 AM now, so there still may be much fighting. Our comrades are now fortifying these positions which we recently captured from the fascists. Twice already, the fascists have counter-attacked, but were slaughtered both times. Among the dead are hundreds of Moors. Our positions are very good. I hope the fascists attack again. It will mean that many less fascists.

Up to two days ago, I never really had any fear for airplanes. But now the sight of them makes me sick. Here is what happened. The Lincoln-Washington Battalions were in the second lines, or reserves. At about six o'clock in the evening, the fascists evidently discovered our positions and began shelling us with their artillery. Only one comrade was wounded, a slight cut in the head, not bad enough to remove him from

[2] Actually, Deck was a Canadian, but he had served in the U.S. Cavalry, which accounts for Fisher's understanding of his citizenship.

the lines. Then came the fascist planes, about 20 bombers and 30 protecting planes. They were flying low and coming straight for us. We all hugged the earth. The roar of the motors was deafening. But how can I explain the noise of the exploding bombs? They almost broke our ear-drums. I was positive that these were my last moments on this earth. At least 150 bombs were dropped. I expected every one to hit me. The earth trembled like it never did before. Our bodies actually bounced. We held on to the grass to stop us from bouncing. One comrade was thrown about ten feet and was unconscious for half an hour. When the bombers left, we discovered that one comrade was killed and six wounded. This is amazing as we were sure the casualty list was higher. But this was not the end. No sooner had the bombs left, but the other 30 planes came and strafed us for 15 minutes with machine guns. They didn't get even one of us. Then again came their artillery. Meanwhile the fascists attacked. We were rushed to the front lines. The Spaniards were happy when they saw us. They clenched their fists and welcomed us with hearty "saluds". We answered with *"No Pasaran"* and we were right.

When the battle was over, about a hundred fascists tried to desert to us. They made a mistake by coming in a bunch and with their guns. Most of them were killed and only eight reached us. We found out through them that their soldiers are scared and demoralized. They are afraid of us.

While writing this letter, I stopped to watch an air fight. At least fifty planes were mixing. How they can dive and whirl around. Finally their planes ran as they usually do. At least three or four times a day we witness dog fights in the air. We like to watch them because we usually get the best of it. Yesterday morning our planes brought down a fascist plane a few hundred yards in front of us, in fascist territory. We saw the plane crash. The pilot bailed out in a parachute. Our comrades were shooting at him. He landed behind his own lines. When the plane crashed, we all cheered like at a football game.

I've seen at least ten fascist planes crash already. I've also seen two of ours come down.

Sitting next to me now is a young Spanish comrade, 17 years old, 9 months in action. We are very good friends. Yesterday one of our American comrades was killed while observing. This Spanish comrade refused to let us dig his grave. He insisted on doing it himself. He explained that we traveled so many thousand miles to help, that the least he could do is dig the grave. He cried when we buried the body.

Except for the anti-aircraft guns booming away at planes and a bit of artillery everything is quiet. A good chance to rest. It's surprising how calm my nerves are. I'm so accustomed to the fighting, that it doesn't excite me any more. I suppose I'm a real veteran now. Last night I slept soundly, being awakened only once by a battle. It didn't last long.

Now—the roar of motors. All day long we hear them. I just looked up. Our planes. Fine.

Soon I shall continue digging my dugout for Comrade Steve Nelson (our political leader) and myself. We bunk together. What a fine comrade! My Spanish friend insists on helping me dig. He's always with me, except when he's on guard.

Just a word! I know I haven't described one-hundredth of what has happened. I haven't given a picture of the events as I would like to. I haven't described my feelings.

But how can I do so now! I'm tired and it's hot. The things that have happened during the past two weeks I will never forget. They were the most eventful of my whole life. The death of my comrades moved me more than I can describe. The running of the fascists gave me joy. The falling fascist planes gave me joy. The deserters gave me joy. The victories gave me joy. I've been in two of the captured towns. They gave me joy. Above all, the spirit and courage of our American comrades gives me joy. I thought that such courage existed only in books. But I've seen acts of bravery I'll never forget. I've seen comrades killed protecting others. I've seen comrades die charging over the top. I've seen our wounded smile confidence into our comrades still fighting. It's these things that give you confidence in a final victory. It's these things that make you fight on in spite of the horror and brutality. It's these things that give you courage.

When the chance comes, I'll have plenty to write. But again, please write often. During these battles, I look forward to your letters. I'll write as often as possible.

Regards to Ben, Jack, Nat, Clare, Paul, Hickey & everyone else. Also Joe—Love to Louise—

> Salud & Love
> Bozzy

· ·

from EUGENE WOLMAN

July 15th, 1937

Dear Family:

On July 4th, the day on which we celebrate our country's independence, we set out to seriously gain independence for Spain. On Bastille Day we were finally pulled out of our first line action. During that time we have been shot at, shelled, machine-gunned, bombed from the sky, peppered with rifle shot & grenades, cut apart with trench mortars, and knocked off by snipers. The fighting spirit of the boys has been swell, although everyone of us was more than glad to be partially retired. We have been an important part of the big offensive which has been highly successful, although naturally costly. It is almost all open warfare with us attacking, and the attacks always 4 or 5 times as dangerous as defense. What it means here, is taking strongly fortified positions by means of charging out in the open and means of flanking movements, and much guts. Finally, wresting them from the enemy. To make matters more difficult, the Moors, the best shots in the world, are set up in beautifully camouflaged nests with high-powered rifles, explosive bullets, and telescopic sights, where they pick us off with great precision until our machine guns or a rifleman finds them. Judging from the amount of dead and wounded, I feel good to be alive and in fine health. Those you know are also doing fine.

Harry E., Manuel, Charlie (the stout boy whom I brought to dinner and with whom I am now pairing up) in my company are all doing fine. Two other L.A. boys, Frankey F. and Nat T. (Emma's husband), have been wounded. The danger and the shells didn't bother me, but laying in a fox hole under fire with the sun beating down all day until you're slipping in your own sweat nearly drained my strength. Nearly, I say, because I have held up better than the average. We have them on the defensive and I hope to the successful conclusion of this war. When it's over I will really begin to appreciate life.

Home Sweet Home for me and there to stay. Naturally, under the bombardments it has not always been possible to get us food and drink. One of the pictures I most often see, is our nice white frigidaire with the tall cut glass pitcher inside, filled with punch, ice cubes, and splits of banana floating on top.

Yes, I received a letter from Uncle Will, one from Elmer, but none that I can remember from Harvey. Aunt Rose sent me an extremely sweet letter for which I am grateful.

If by chance I am knocked off, it is just all over, and there will be no me to have regrets. The only ones who will suffer will be you who love me, and in case of this eventuality, I apologize in advance. Better still, of course, I hope to drive through to victory and come back to our happy home, there to enjoy life more than ever.

> Very best love.
> Gene

P.S. It's tough about Elmer, but I hope by now he's tops again.

. .

from HARRY FISHER

Oct. 18, 1937

Dear Sal, Hy & Louise:

Spending most of my time in the library. I just remembered that I promised to write of some experiences, so I'll try.

We had spent two days in reserve [July 14–15] after days and nights of continuous fighting at Mosquito Hill. We were beginning to feel normal again. Most of us washed and shaved for the first time in ten days. The two American battalions were made into one—the Lincoln-Washington battalion. During these two days, we heard the continuous whistle of fascist shells over our heads.

Now I was with Butch, Pat, Norman, Morty, Johnny Rody. We spent hours telling stories of our battalions. We were happy to be together.

Then came the "stand to" order. We must move into action again. Where? Who knows! We pack up, rested and happy. Two days ago, I thought I'd never want to fight again. But now, after a full stomach and plenty of sleep, I was raring to go.

Just at dark, we start the march [toward Villanuevo del Pardillo]. There was very little resting that night. We had to make a good distance by dawn. We couldn't take a chance marching on the road. Too dangerous! We marched in a river-bed, the sand getting into our shoes, making us curse under our breath.

It's tedious walking in the dark, following only the back in front of you. So conversations start:

> "Jesus, wait till I get back to New York,—I'm gonna spend my life at Child's drinking coffee."

> "Oh, hell, I'll be satisfied with just sleeping in a bed."

> "I'll bet the kitchen surprises us with something new tomorrow after all this walking—apple pie or something."

> "Sure, they'll surprise us—beans—that's what you'll get."

"Boy—what those beans are doing to me. I'm beginning to sound like the fascist artillery."

"That's not saying what you smell like."

"Say why don't you fellows talk about something intelligent?"

"O.K. Shall I tell you about the fat dame I had in Madrid last week?"

"Aw—baloney."

"Naw—beans."

And so it goes on till we're too sleepy to talk anymore. Every hour or so, we sit down for a five minute rest. Now when we sit, our heads sag and our eyes close. Suddenly someone is shaking you—I fell asleep. I slap myself on the face, and continue—seeing only the dull back in front of me. My eyes want to close, but I force them open. Once in a while I close them for a few seconds, continuing the walk, getting a bit of satisfaction. Then I think of beds, sheets, luxuries, home. That's a different world. It's hard for me to believe that people are sleeping in beds in the rest of the world.

Then I think of the war. What will happen tomorrow? Now I'm scared! Hell, only a few hours ago I wasn't scared—I was raring to go. But it was light then. Comrades were talking. Now it's quiet—just the swish of shoes on sand. And it's dark! I'm scared! What will happen tomorrow?

The night finally ends. We are in a valley, not far from the fascists, as we can hear machine-gun fire. As the light comes, I get over my feeling of being scared. Now I'm happy. I'll be able to stretch out and sleep. Just think of it—sleep!

I drink the coffee, which always nauseates me. Sometimes I think it's made of dried horse-manure. But I drink it every morning—thinking of your coffee Sal. Then I slept. Most of the day. Only up to eat.

Late in the afternoon shells begin falling around us. We all hug the sides of the hills. One comrade gets a cut over his eye, but refuses to go to the hospital. Evidently we've been discovered by the fascists.

Supper comes and we eat it to the music of shells. During the supper, we hear the distant roar of airplanes. *"Avion—Abajo"* and everyone gets down, not wanting to be seen by the planes. I see the planes coming in our direction. About 25 bombers and 50 scouts. The bombers are low—coming straight for us. My insides feel like mush. Dennis is lying next to me. He looks at me. We grin stupidly at each other. I see the first bombs dropping from the planes, silvery in the sun. I dig my head into the hard dry earth. I close my eyes and my body stiffens—waiting. Crash—boom—how can I explain the noises? Like a million cats screeching at night! I can hear and almost feel the shrapnel passing over me, shrapnel that can cut off my head like a butcher's knife can slice a banana. My body is bouncing up and down. Bomb after bomb is falling. I grab hold of the weeds to stop me from bouncing. The lower I am, the less chance of getting hit. But, I am sure I will be hit. "So this is the way it will all end," I think. Nothing else enters my mind. The bombing and my bouncing continued for over three minutes—long minutes—the most awful in all my life.

The bombers had dropped their load and disappeared. It was still daylight, but there

was so much dust raised by the bombs, that nothing could be seen. Planes could still be heard overhead, so we kept low. In ten minutes, the dust cleared. Then came the scouts in single file, machine-gunning us. This kept up for fifteen minutes and they left. We took count of ourselves and found one dead and six wounded, one of whom died the next day.

But this was only the beginning. The companies were ordered to fall in and march towards the trenches. The shelling continued and stray bullets fell around us. The fascists were attacking. We must hurry. In fifteen minutes, we found ourselves at the bottom of a hill looking up at young Spaniards on the top firing away. Our companies were spread out and given positions among the Spanish. The young Spaniards, their faces sweaty, grinned and shouted *"Viva los Americanos."* Comrades answered, *"Viva los Espanoles."* For the first time I heard the Internationale sung in a battle outside of a movie. As we passed, every Spanish soldier clenched his fist and cried, "Salud." Then they continued firing.

All night long, fighting continued. Some of it was comic opera stuff. A company of Moors were trapped in no-man's land. They couldn't move forward or backward without being hit. One Moor waved a white handkerchief and came forward. He asked us if we wanted to surrender. That Moor sure had nerve. Every once in a while, he'd come forward and start a conversation halting the war. Later, these Moors were picked off one at a time and killed.

More in a day or two. Have a meeting now—

<div align="center">Salud
Bozzy</div>

Regards to all.

. .

from EUGENE WOLMAN

<div align="right">July 21st, 1937</div>

Dear Family:

A month or so previously I suppose you read those letters from "our boys in Spain" appearing in the *Daily*. Many of them, especially those starting from the first line trenches, were a source of merriment among us. Not only did some of them sound phoney, but others were actually written by men who had never been under fire.

This letter can actually be headed from the "front line trenches" and we have been under fire for 16 days. The Spanish are still not quite as seasoned as they should be, prone to run in the wrong direction and it falls upon the International Brigade still to fill the gaps. Charlie W., the fat boy who was with you for dinner, and I had been buddying up for the past week. We have been sharing poncho and blanket, fox holes and food. Yesterday evening the shells began falling fast and furious. Charlie ran to a little fox hole and I started following. He yelled, "there's not enough room for two here" so I dropped into a hole ahead. The next moment there was a thunder clap, a black cloud of smoke overhead. "Oooh, ooh," moaned Charlie, "my leg is broken." I caromed down the hill to our stretcher bearers, whom, when I told them what was up, rolled off another man from my group, dead, and came for Charlie. His is a thigh wound and he will recover. This narrow escape is just one of many I have had so far.

For the past week the Lincoln and Washington boys have amalgamated into one Battalion. During this time I have been Group and Section leader, and as stripes and responsibility are not my desire, but I do step in when the situation requires. You people at home have the right formula for happiness. Stress on family life and love, a close circle of good friends and active participation for the collective good. For me anyway, I know an unbalance either way cannot mean happiness.

Although our offensive is proceeding, the war will be a slow terrible process unless we get the outside help we require and are entitled to. Incidentally, it might interest some of your friends to know that among Fascist ammunition we captured were many United States Army bullets. American boys are being killed and maimed by American munitions sold by American Capitalists to Franco, Hitler, and Mussolini. An arms embargo on Germany and Italy would be of some aid. You would be doing us a favor if you would get your friends to write their Senators and Congressmen to apply an arms embargo on the belligerents Germany and Italy.

> Much Love
> Gene

• •

from HERBERT HUTNER

My Dear Mr. & Mrs. Wolman:

I had the pleasure of meeting Mr. Wolman the day I came off the ship, Berengaria, in the offices of the Friends of the Lincoln Brigade. But, unfortunately, it was only for a few brief moments that I spoke to him. What is more, at that time I was unable to recollect or collect my thoughts. I was sick and tired and it seems that it takes a lot of hard thinking for me to recall details. But now I'm rested and can recall a lot of things and incidents concerning Gene, myself, and other friends of his. Since I was obliged to rush right down here to see my own mother and father and try somewhat to lessen for them the pain of my brother's death, I did not have the opportunity of seeing you folks further.

Gene and myself met of course by circumstances beyond our control. We were assigned to the same group. By this time, I suppose, you know that a group is the fundamental set up of the military organization of the International Brigades. There are three groups to a section, three sections to a company, three companies to a battalion. The men in a group are consciously trained to "stick together" and get to know one another, so when they go into action, it will be one will operating and not several.

I do not recollect the first time I consciously saw Gene or spoke to him as a personality, but, I do know, that it was after we left Tarazona and went into "reserve" in Jarama that I knew Gene best—we became fast friends—and he spoke to me of his mother and father. We were camping on a slope behind Morata which was about four kilometers behind the front lines. We could hear the machine guns fire from the front and see the artillery bombard the valley we were in, trying to churn the wheat. Aeroplanes overhead—not to drop bombs but leaflets telling us to go over to the Fascists. You don't know how many laughs Gene and Van de Ross and I had over these "Paper Bombings."

Van de Ross was the company clerk and the closest friend Gene had. We three formed a triangle with myself just a little bit on the outside. Van de Ross was the best company clerk in all of Spain and worked unstintingly for our company. You can't imagine how important a job is a company clerk. Van de Ross was a big, lanky chap, one of the swellest men I ever met in my life. I am telling you all this because Van de Ross was killed on the second day of action by an aerial bombardment and Gene received the hardest blow of his life.

I think that the time we spent in that little valley was the most formative period of our lives. We had erected little tents and saw no one but ourselves, excepting when we went to town for a bath and it was a starving little town. Gene and Van de Ross used to squeeze into one of our little pygmy tents and you should have seen what a tight squeeze three big men like ourselves made. We spent all our time laughing at each other and at everything under the sun. It was a time for laughter indeed—there was soon to be little enough laughter. But it was the laughter of men—men who were not afraid to die, but who loved life. And it was on this gentle slope that men showed their true colors. It was here that any selfishness—any bad traits of character—came out, and Gene proved what a man he was even previous to our seeing action. We took on ourselves the job of getting and distributing the food of our section. Gene was chief. We used to work ourselves to the bone running after the food when the cook-wagon came, then seeing that there were no squawks.

There was a night which stands out, only the stars weren't shining on this night. A storm blew up and washed out our camp to the roar of the biggest attack the Fascists made at Jarama. We were given orders to stand by and our company had the honor of standing guard. Gene and I covered the bridge, we lay grimly silent in three inches of water—chattering and shivering for hours. Then we became "runners" and ran errands bringing messages back and forth in that clayey mud that sticks like glue.

That night brought us closer together and proved another thing—that Gene was a boy no longer, but a man.

Gene not only knew how to take orders but to give them—he had a streak of organizational genius which he demonstrated at those times when he was assigned as leader of the group during maneuvers. He made me feel the sting and lash of his sharp, biting tongue when I laid down on the job or did something wrong. He knew his onions and did a man-size job.

One day Gene and I went to Madrid to help buy stuff for the battalion canteen. We met two Spaniards in Madrid who took us places and then tried to abduct us. But we wouldn't go. When we rode in the subway they stood up and made long speeches about us and all the people crowded around Gene and me and shook our hands. Babies were placed in our laps and what not. I forgot to tell you we were all a trifle drunk, just enough to make it a very enjoyable event. The next morning I was sick as a dog and Gene had to make the report to our section on just what had taken place in Madrid to every little detail. Were we heroes, for Gene and I had been to Madrid.

Another time Gene and I went out to steal food. We wore pants on the style of ski-pants. When we had the opportunity we would slip the food down our pants and there it would stick at the bottom. Well, that day we managed to organize a nice big ham and a big bag of candy—Gene was the carrier this day. There he walked along with the stuff

at his ankles, everyone in the street staring at him. We laughed our heads off. Gene wallowing like an old scow in a stormy sea. But, we ate good that night and the rest of the guys too.

That night Gene volunteered to carry ammunition for the machine-gun company. I couldn't as my feet were all sore and it was torture for me to make a step. It was the important night before we saw action, at Villanueva de la Cañada. He carried that ammunition all night without a whimper and we had been marching for four nights steadily. I was marching behind Gene that night and he nearly bayonetted me four times. We were all tramping along more asleep than awake and his rifle slipped. The point of his bayonet fell into the palm of my hand. It happened four times and we laughed each time, silly, tired little laughs. Then I fell and Gene stopped with his load to pick me up. He gave me some of his invaluable water and we staggered on. At five-thirty our artillery boomed and the attack was on. I looked around me and saw everyone's faces go ghastly white. We were given orders to move up. We were all silent. Then little by little our spirits picked up and Gene started to joke and kid and that started the rest of us off. That day was the worst of our lives. No water. Terrible heat. Crawling on our bellies. Some of us started to cry it hurt so. That night some of us, still crying, took the town and baptized our offensive. We staggered into the town late at night and I went to see what food I could find. I filled a sack with a great big ham and some cans of tomatoes. I found Gene, Van de Ross, and my brother Danny and we ate. I remember Van de Ross especially. How he enjoyed those tomatoes. Then it came to the carrying of the food. Again Gene volunteered. He carried that big ham for kilometers that night. Gene suddenly said something to me. I don't remember what it was. I lost my head and started to yell at him. He didn't say a word until I had blown my top, then he took me around the shoulders and laughed and I started to laugh with him. The next minute, unknown to Gene, I dropped at the side of the road exhausted. I couldn't get up. An hour later Gene was at my side. He had come back for me. He found me and helped me to the camp where he bandaged my feet; they were full of blood; but we ate that ham the next morning, got plenty of water and started out again.

Then it was that Gene got the shock of his life. Aeroplanes suddenly zoomed over us as we marched across the fertile land. We dropped and they were off, only to circle around and come back again behind us. We dropped but somehow Van de Ross didn't. Van de Ross always refused to wear a helmet. A piece of shrapnel got him in the head. The same bomb lifted me from the ground, and Gene, lying a few feet from me, told me later that he'd been picked up and set down in the same way. We received orders to run into a gully a little way down. I ran blindly and fell on my stomach, breathing and gasping. Finally I looked around for Gene. He was nowhere in sight. I poked my head over the rim of the gully and saw Gene stumbling towards me. I called to him and he came over and slid down. I saw he was crying. They got Van; they got Van; he said repeating through his tears. I didn't say anything. Just sat there until we were given orders to move.

It was a few days later that I was wounded and saw the last of Gene. We were given orders to go over the top on Mosquito Hill. As we went up, Harry Hynes was killed, Ernie Arion was killed, I was wounded. We were laying a barrage and it was a trifle low. Gene went flying down the hill with Fascist bullets nipping at him—he showed me the

marks later—to give orders to lift the barrage higher, just in time. I couldn't, with my leg broken. Gene saved my life; then he came back with water, wet my lips and bandaged my leg and stopped the flow of blood. He went around that day while I lay wounded there for eight hours tending the wounded men, hourly risking his life for us by going for water—standing out in full heroic contour—then my brother came and they carried me off in a blanket, Gene on one end and my brother on the other, both gone now. During that day we had received notice from below that we were being surrounded, but that band of men refused to leave us and fought the Fascists off.

Gene is a hero—not the only one—there were others; they stand out like a beacon of light for me, men who were big: Gene Wolman—my brother Danny—Harry Hynes—Sammy Stone—Burton—Ernie Arion. They will always be with me forever.

That was the last I saw of Gene. His picture is engraved in my memory. I want to be the friend to you folks that Gene was to me. When I come back to New York, which won't be for some time, I'll come to see you and tell you all these things over again.

My deepest love to me and please write to me.

<div style="text-align:right">

Salud
Herbert Hutner.

</div>

Miami Beach Fla.
Dec. 9th, 1937.

. .

from PAUL SIGEL

<div style="text-align:right">

July 12, 1937

</div>

Salud, Mus,

Bang, and we're on the offensive finally. As our beginning we're going to push those bastards back from Madrid. And incidentally notice the beautiful little maneuvers by which we've started cleaning Madrid of the smell of the fascists. They're not shelling Madrid now, they're too much taken up in finding the easiest way to retreat, and that's the direction their going to continue traveling. We've got the equipment, the men, and the morale to make them do it.

Here's a sequel to the story I wrote Miriam about one of the fellows here in my group. This fellow Harry has a brother, Sol, who came to Spain at the same time Harry did. The were on the same sector at Jarama, but saw each other twice for only 5 minutes at a time. They were then separated when Harry was wounded, and for three months, each didn't know where the other was. Yesterday a fellow walks up to Harry and says, "Don't I know you from somewhere," it was Sol. I've described a little what Harry is like. Well Sol is just about the same type of fellow, though a bit older. He used to be a chemical engineer (had a good job). However, Harry points out that he was always a very timid fellow, nervous at the sight of blood, etc. But in spite of his saying that he is still timid, the stories he tells about his life and actions at the front greatly belie his words, even though he tells them in the same simple, straightforward manner that Harry does. The two of them make a great pair—swapping stories of the front and giving us an idea of what life is like there. But, we'll be up there ourselves pretty soon, and find out.

July 14—I've been so damn busy I haven't had a chance to finish this letter, but I'll try now.

I'm sort of settled now doing telephone work in the signal corp. It's important work, and I feel that I'm doing all I can to help defeat the fascists. Life here is terrifically busy, what with a tremendous pile of cultural work on top of our intensive training.

It's been the custom for some time now, for the entire battalion to go out every Sunday morning and assist the local popular front committee and the farmers around here in the fields. We have quite a bit of contact with the townspeople here. We roam thru the stores with our English-Spanish dictionaries, incoherently mumbling to the storekeeper for awhile, and then, of course, assist each other by pointing. We're great friends with the kids here—the cutest you ever saw—with very many and not just a few. They are also very clean, as is practically everything about the town. Incidentally, today we threw a party for all the kids in town, cake & candy, etc. Every one of the 2,389,473 kids in this town were there and they sure enjoyed the blowout. And we enjoyed our blowout today, of good cigarettes (for a change) and *good American* chocolate. That is some treat around here.

And there are some new *Daily Workers* around (new means only 2 weeks old). I used to think that the "Daily" meant a lot to me, reading it as I did thoroughly every day. But in N. Y. at least I could complement it with some other papers or news channels. However every new issue that comes out here is a new breath of life in our entire bunch. It injects a new spirit into the fellows, containing as it does the life of not only the working class movement in America but also internationally. Keep those "Dailies" coming—also the cigarettes & chocolate.

I haven't received any letters yet, and you can bet I'm anxiously awaiting them—and when they do start, keep them coming. That includes you, Miriam, Bert, Laurie, etc.

I remember when I saw Rachel, Laurie, & Naomi last, the delicious meal we had. That supper has to be repeated. Don't forget to give my regards to them. I really don't have time to write many letters now, but I still promise to answer every one I receive, so tell them to write to me.

Well, we'll probably be at the front soon, and we'll give 'em hell.

Paul

* *

from CARL GEISER

July 14th, 1937

Dear Impy:

Your letter of the 24th of June came at a most opportune time when I was dead-weary after 7 days of steady fighting, usually in the front line. Imp, you must write me every two or three days this summer, for your letters lighten me very much.

I haven't written you since the 4th because we have been at battle in the big offensive since then and I have been much too weary, tired and dirty, not to say lacking in paper and equipment to write to you.

As you know, our offensive has been victorious and is still continuing. But, believe me, Imp, war means suffering, horrible and nerve wracking. I have never been so

exhausted in all my life. Our machine-gun company lost 3 commanders and 4 section political leaders, all wounded. As you know, this kind of fighting means much greater casualties than ordinary trench warfare.

Just now we are in a reserve position, which means we are ready to move into the trenches on to the front lines, in a few minute's notice. But it gives us a chance to sleep, to rest and my first shave and bath since the 4th. And just now it looks like we are going up again after eight hours here.

You read about 700 soldiers deserting *en masse* to us three days ago. This is the kind of action that helps us very much and we hope it will increase during the next few weeks. Opening of the French border will help us greatly for while we have great sources of arms, there are many things we could use, such as field glasses. The fascists use them to spot our positions, while we try to locate them with our naked eye.

You ought to see how brave our boys are when they lie shot on the stretchers. As long as they are conscious, they speak firmly and think only of the battle. By the way, Paul is well, but Andy is dead. A sniper must have got him when he sat down to rest for a moment. Anyway, he was found sitting down with his head nodding forward a bit. He did very well here. Pretty and Irv are in the 3rd American Battalion which did not take part in the offensive yet.

As you probably read, our Battalion was in the thick of it from the beginning and we took part in the taking of Villanueva de la Cañada and now are about Mosquito Hill, the highest point between here and Madrid. As soon as it is taken the going should be much easier.

But, Imp, I hope to get back to tell you many more things of our fighting here. As for myself, it is doing much to steel me physically and mentally. Only one thing, write me every two or three days, for when one is out in that terrifyingly hot sun, oft times without food and water, with bullets flying all about, and you are exhausted to the bone, a letter from you means very much to me.

> With all my love,
> Carl

• •

from HARRY MELOFF

> "With the George Washington
> Battalion on a Spanish Front."
> July 16, 1937.

Dear Mim,

Your last three letters reached me during the past ten days, and when one is busy chasing fascists, without time even to sleep, you just can't sit down in the face of a hail of machine-gun bullets to answer mail. Now, when for two days our battalion is at "rest" behind the lines, to regain strength and reorganization, the past events, seems like nothing but a continuous nightmare. Only the fact that many of the familiar faces of the comrades whom we loved, are not with us any more makes me realize the reality of those seven horrible days.

You ask me, what does it feel like? I'll tell you as simply as I can. I never tried to be silly romantic about the heroic fight we were going into and I'm glad of that. I knew

what to expect and so instead of filling my letters with political slogans, as many of the other fellows did, I minimized that part of it, and wrote mainly of our daily personal life, scattering anecdotes and kibitzes here and there as much as possible. I hated fascism, and with a cool head. I gradually prepared for the task I came to do.

Ten days ago, we left for the front, and were initiated into some of the fiercest fighting imaginable in this type of warfare. There are practically no trenches—mainly open warfare, because from now on we are doing the attacking, and the fascists have to retreat. Remember those many war books we read, and how it used to turn our stomachs, due to the hand of a skilled craftsman? Well, multiply their descriptions a hundred fold, and you still can't capture it.

Who can describe that feeling, when you're lying flat on your belly, and black fascist planes drop eggs all around you; when artillery shells explode so close, that dirt and rocks fall all over your clothes, and you run but 10 yards before the next bomb explodes, because the gunner has an exact range on you? Oh, those shells! One would gladly run into a storm of explosive bullets any time, rather than face the fear of being blown to bits. Then there's the sun. The goddamn gosh awful Spanish sun that burns and burns for hours and hours, that pours the sweat into your eyes and burns them so that you can't see but five feet in front of you.

Yes, we're taking it—and taking it like we're supposed to, like antifascist fighters. We lost weight and strength, because our food truck was bombed and our mules were shot. For days we lived on nothing but marmalade and water. But our spirit kept on— no one cracked up and we took our objectives. And through this all we are satisfied— satisfied because the fascisti are going through even worse than that.

How do they feel like, when our cannon bombs them, when our planes strafe them, when our machine guns mow them down, when their planes are continuously brought down in flames, and though the aviator jumps out in a parachute, he usually commits suicide, rather than be caught? How do they feel like, when they are forced to retreat in the sun, giving up position after position? They are desperate, and at night they yell across to us and curse us, and their planes fly about blindly in the moonlight, dropping incendiary bombs on dried up wheat fields, lighting them up so that in the distance it almost looks like Luna Park.

Oh, you bloody bastards! You know that your end is fast approaching and you are swinging out wildly like an enraged boxer eh?

I hate you fascists, for you are responsible for this war, you are responsible for the death of my closest comrade, for the murder of so many thousands of innocents, for blood and destruction and the return of barbarism. I hate you with the most intense fever possible. What matter, sun and sweat, bombs and shells, explosive bullets; nothing but dead muscles can get me out of this fight now. Our victory means too much, and victory is now very near.

Mim, I'm sorry for that last outburst. I didn't believe I had that much emotion left any more. But I hate blood and death. If I ever get back, I'll be a much harder, much more determined young man, but with more love and heart for my American comrades than ever before. They are doing a wonderful, brave job here—and at home they have never been as active as now.

I've been getting loads of mail these days, and though I haven't much time any

more, and can't keep up with answers,—because you are so swell and write so often (*I know* how busy your work now can be) I'll always write you first whenever I can now.

Kid, pay no attention to rumors. My arm is in perfect condition, and haven't suffered a scratch as yet. So far I'm an expert bullet dodger. If you listen to rumors, I'll probably be dead and buried a hundred times, before this war ends.

Give my love to Sonia and Beadie. I haven't written them as I promised because I just haven't the time. They at least get one day off a week, and to Sonia I've already written twice, without an answer as yet (shame!). I never remember telling her that I was already at the front at that time. Where did she pick it up? So far I've done but seven days of fighting (and what fighting—enough for seven years), and in a couple of days we go up again to break the back bone of the fascist forces at this particular front. It may take another week or so to complete this battle; then a few days of "zowie" in Madrid (Boy, have I been waiting for that). If I'm sober, I'll write from there. After that—up to the front again to chase the sons of bitches in all directions.

<div style="text-align:center">

Salud

Harry

</div>

P.S. [blacked out line] is the best news I've received from you as yet. Hold the fort, baby.

P.P.S.Got a long letter from Jules Garfield, very nice one too.[3] Got a couple from Rozzi Kean in California. She seems to be pretty lonely out there. Also a long gossipy letter from Izzy Singer.

•••

from JOHN COOKSON

<div style="text-align:center">

July 29, 1937

Villanueva de la Cañada

</div>

Dear Dad:

Everything seems to have its opposite. The dust thrown by bombs thousands of feet into the air drifts over the mountains and plains and the glorious, golden Spanish sunsets are supplemented by an unrivaled red and purple against the craggy mountains. The Spanish word for mountain chain is "*Sierra*," which is also the word for a saw.

<div style="text-align:center">

Love,

John

</div>

[3] Jules Garfield is the actor, John Garfield.

The Aragón Offensive

Quinto & Belchite

After a brief rest, the Americans were called into action again. This time it was the Aragón offensive, its ultimate aim to isolate and recapture Zaragoza, a fascist-held city considered largely sympathetic to the Republic. On the way were a series of towns about to earn a place in the history of the war—Quinto, Belchite, and Fuentes de Ebro.

Aragón was also a politically significant offensive. Generally quiet since the fall of 1936, while fighting focused on Madrid, the Aragón front was controlled by the Spanish anarchist and POUMist militias. The countryside was the site of a series of peasant agricultural collectives under the overall authority of the dominantly anarchist Consejo de Aragón. With the offensive under way, the region would finally be brought under the control of the central government. Once again, as with Brunete, the attack would divert fascist resources from the north as well. More sparsely defended than the fronts available as alternatives, it seemed a realistic choice.

News of the new action came without warning. In fact, nearly two hundred Americans were on leave in Madrid. Most were rounded up on August 19th and driven to Valencia by truck. From there the next step in the journey was by train, heading north across the eastern half of Spain, through Caspe to the impoverished village of Hijar. After that the route was on foot, across the bleak, dusty, windswept Aragonese plateau. Their goal was the fertile valley of the River Ebro, ten miles wide at some points, along whose walls the towns of Aragón were scattered. By the night of August 23rd, the attack was under way. As the campaign opened, key shock troops, including the Americans, who were expected to bypass Quinto and Belchite, were instead ordered to take the towns. The Lincolns went into action against Quinto on the morning of August 24th. The battle would last three days and be immediately followed by a twenty-mile march to Belchite.

This section ends with a unique narrative of what it was like to work in a Republican entertainment and propaganda sound truck at the front and behind the lines, followed by a letter about a friend's death. So far as we know, the letters about the sound truck provide the first such account to be published. Those letters are from Leon Rosenthal, a New Yorker who was a member of the United Electrical Workers Union and an amateur astronomer at the time he left for Spain. He planned to become a scientist when he returned from Spain.

from SIDNEY KAUFMAN

August 28, 1937

Dear Folks,

I write these lines from a hospital bed in Barcelona–nothing serious–be out in 2 or 3 days. Even if one has a bruised trigger finger he is sent to a hospital, inasmuch as a fellow must be all there in the infantry. Oh you want to know what happened to me. I could have stayed home to get it–a pretty badly wrenched ankle. The ironic part of it is that I came thru my first action at the front with flying colors. On two occasions bullets came so close as to splatter rocks & dirt from my parapet into my eyes & face. Another time a runner was needed to carry a message to battalion headquarters. I was chosen from the volunteers. My appearance on the semi-open terrain between company & battalion staffs was greeted with a shower of bullets. I know now what is meant when a novelist speaks of a "hail of bullets whistling past his ear." They whine, rumble, whistle, & play all sorts of tunes. At training camp I was told that it takes a sniper 4 seconds to get a "bead" on a man running. I remembered this—also remembered to run zig-zag with the result that the 250 yards over rough terrain was done in almost 4 seconds flat. Another thing I experienced is the feeling of having a rifle in your hand get so hot as to almost blister your fingers—this comes about when it is necessary to give rapid cover fire. By the way I'm on the company staff—(Co. clerk). It's usually referred to in this man's army as the "company jerk." It means nothing except that you have more grief.

The action I referred to took place in the town of Quinto (Aragon front) and the heights surrounding it. The *N.Y. Times* may refer to the battle as the siege of Quinto or something like that. We took hundreds of prisoners—our artillery was so accurate & deadly as to cause such demoralization amongst the enemy that they began to pour out of the hills *en masse* to surrender after about 6 hours of a barrage. This in spite of the fact that for the past year their only activity has been to fortify themselves. They had done such a good job as to be almost invincible. Their dugouts had electric lights— writing tables—honest to Christ mattresses & pillows. (By the way this is the first I've been in a bed since leaving home—even on the ship coming across I had only a narrow bunk—most of the time my bunk has been terra firma with some weeds for a pillow & a blanket of stars) also tremendous casks for water in case of a siege.

With the surrender of the fascists came the end of the battle and the need for a moving of our wounded to places behind the lines. Little Sidney, a veritable bundle of energy, offers to assist stretcher bearers. Takes hold of stretcher containing 200 pounder. Starts up the hill—stretcher comes down with 200 pounder on Sidney's ankle—net result—little Sidney takes his place in another stretcher. It pays to mind your own business in this country also. Ennyhoo, I expect to join my outfit in a short time & go on. Can't tell you of our objectives—Perhaps the *Daily, New Masses,* & *Times* are carrying stuff on it. We've seen some clippings in the *Times* with a by-line for Herbert Matthews—it is pretty good and quite accurate. He's sympathetic & a good fellow besides. It's pretty hard getting out a letter from the front lines—we throw away about everything we have except our rifle, water bottle, & ammunition—no packs, hence no writing paper, no facilities for writing. Please explain this to Ed, Eleanor, Izzy, & others

who expect word from me. As before, I write this letter not knowing when or where I'll be able to mail it. Here comes the chow so I'll quit, for nothing interests me more, as it would you too if you got by with a jar of jam, some bread, & cold coffee for three days.

<div align="center">

Love

Sid

</div>

P.S. The short stay at the hospital turned out to be over 10 days—hence delay in mailing.

· ·

from HARRY MELOFF

<div align="center">

"With the Lincoln-Washington Battalion"

Aug. 28th, 1937

(In answer to yours of the 4th)

</div>

Dear Mims,

It's kinda funny receiving a letter which is a reply to my first trip to the front. Especially when it comes to me in the midst of my second battle. It brought back memories of those first fearful days, days of desperation, high tension and hate—of Ernie and that look of surprise in his eyes, as the bullet penetrated;—firing at the Moors, he never thought of the bullets that whizzed by him in great numbers. Your letter with its warmth & simple understanding of what we felt like during those "rookie" times, made me realize that it all occurred only last month and not last year.

And yet, things to me now are so different. I don't know why, but the planes no longer bother me, and dodging bullets seems such an ordinary thing. Only a few minutes ago, a fleet of fascist bombers flew overhead, and somehow the old quick heartbeat was no longer there. Instead of lying on my belly, thinking "Well, goodbye Harry old kid," I lie on my back, looking up at their deadly beauty and grace as they flew low and ominous above, and tried to figure out just about where the bombs should land. I never found out how good my calculations were, because our anti-aircraft guns went to work on them, forcing them to climb up very high and fly away very fast. Then our own planes came along and for five minutes gave an aerial demonstration for the boys, that was marvelous to watch. I can imagine what the fascist troops felt like. You know, admiring them like this—quite naturally, the old song keeps humming through my brain:

> Our planes are set,
> we're ready for the battle.
> High in the air
> Our engines loudly roar:
>
> _____
>
> And every propeller is roaring—

You get what I mean?

Yesterday, we got through mopping up the town of Quinto. Took over 1200 prisoners and as many chickens. Executed 32 officers and a Russian white guard and a Nazi officer committed suicide. Capturing the town was done very quickly considering the

marvelous fortifications they had. Our own losses were very, very light. There now remains but one town between here and our main objective, Zaragoza. The famous Lister Brigade is already working on it. Tomorrow we will probably go in and give them a hand.

Aug. 29th

We're moving up in a couple of hours. And when we take Zaragoza, the rebel siege will be lifted and then—who knows? I may even drink a toast with you New Year's eve—but don't be too optimistic. The fascists are fighting like all hell; they have plenty of guts—and if they get more men shipped in—this war will stretch out.

So, s'long and if my good luck still keeps up, I'll write you soon again, and if not—well, remember war "delays" mail, so you can always say—"It's held up, a letter's on the way."

Paul's battalion hasn't been put to action yet. I imagine he feels pretty bad about it, as I did once upon a time. I wrote him a note and told him to make the most of his training; he'll need it.

I guess the Unity season is over by now, so I'm sending this to your Mom's house. Mail from the States is taking over three weeks to reach us these days; I don't know why.

Hey, I took some photos in a Madrid "5 & 10," which didn't come out so bad, though the jerk cameraman put my face too near the lens. I'll enclose one, in case you forgot what my mug looks like; though Lord knows you don't deserve such punishment.

If you see Mike again, ask him to write me, huh? I've torn up about ten letters to him that I started so far. I just can't do it. It chokes me up, and I don't know how to begin. He's a swell guy and I don't want to lose contact with him.

Regards to everybody, with a "Hip, Hip, Salud" and love to you,

Hershel

from CARL GEISER

Aug 31, 1937

My dear Impy—

This makes my fourth letter to you since I received your last one. Of course, at present we are in a position where mail doesn't reach us very regularly, but nevertheless, I expect one soon. I am especially anxious to hear about your visit in Orrville, if you were able to stop there.

You ought to see the excellent first-aid facilities here. In the first place large numbers of ambulances. Then besides this there is an 8 car hospital train following us only several miles behind, with a well-equipped operating room. And on top of that, there is an oil-electric streamlined car, which takes especially critical cases back to a hospital immediately. And this improved organization of medical service is only a reflection of the greatly improved organization of the army in every field. I can notice a great advance in the present army over that of 2 months ago. By the end of the war, Spain will be a military power to be reckoned with in Europe.

An interesting sidelight here is the difference between the cultivation of the fields

Memorial Meeting

TO THE MEMORY OF
a member of the
INTERNATIONAL WORKERS ORDER

Harry Meloff

WHO DIED FIGHTING FOR A
FREE SPAIN

●

THURS. NOVEMBER 11th.
8:P.M.
AT GRAND PLAZA
821 • E. 161 STREET
PROSPECT AVE. STA.

• PROGRAM •

1. MAX BEDACHT - General Sec. of the I.W.O.
2. DAVE ENGELS - Just returned from Spain
3. THE CONVULSIONAIRES
4. "THE SONG OF SPAIN" - By Langston Hughes
5. EXCERPTS from HARRY MELOFF'S OPERETTA "LET'S GET TOGETHER"
6. JULES GARFIELD-Group Theatre

ADM. FREE

SPONSORED BY

National and City Youth Committee of the I.W.O.
Harry Meloff Branch - Y-1
Medas Youth Club - Y-39
Lincoln Friendship Lodge-536

in fascist and loyalist territory. We are now some 12 to 15 miles in fascist territory, and the inferior cultivation of the land is quite striking. There are many more fields of weeds, especially thistle, many more uncultivated fields, and in general, the aspect is one of lack of attention. But there is one nice crop here, and that is alfalfa.

By the way, I am much disappointed in the way a group of 12 to 15 seamen we recently added to our company are turning out. They have such a powerful hangover from their days of fighting against the shipowners, that they insist it is necessary to kick about the food even when it is good so it will stay that way. They find it very hard to act on the principle that this is a peoples' army, our own army, and that we fight to overcome shortcomings by doing what we can ourselves to remedy it, rather than by protest delegations, etc. And also a number of them who pretend to be so tough, show even a subnormal amount of courage in the face of fire. But perhaps a better acquaintance with bullets will help them overcome this. I wish there were more Harry Hynes among the seamen, or Paul Andersons. But these new seamen haven't had a real test yet, for in this offensive the fighting we participated in has not been as bitter as in the last, or as severe on us physically. So far we have never lacked either food or water, which means a great deal, and our casualties for the first week are about 10% of those in the Brunette campaign.

What I miss here is news of the world. And of the U.S. The latest paper we have here is the *D.W.* of Aug 6, 3 weeks old, and because of the limited means of transport, we don't receive any Spanish papers. For instance, I am still wondering what happened to the 3 Soviet fliers forced down in the Arctic, and what is going on in China.

Say, isn't your birthday due soon? It's the 14th, if I remember correctly. I am very sorry I am not there to pull your ears, but if I have any luck at all, you'll remember this one.

But I have a real surprise in store for you. Wait until you see me smoke my pipe. I am even getting to enjoy it! And I am smoking American tobacco to boot! And that isn't all. 3 days ago I found the first louse, and yesterday I found 2 lice and 2 fleas. So you see I am getting to be quite a soldier.

A few of our "Moscas" are flying overhead at the moment, our fast pursuit planes. They certainly are lovely to watch. Their speed is terrific, and often when they come over in squadrons of 9, they fly all about twisting and turning and maneuvering about in a delightful manner. And always when our planes are about, we need have no fear of the fascist planes. It is plain that aircraft will play an increasing role in war. A squadron of 9 heavy bombers flying close formation and dropping their bombs together can practically wipe out everything in a given area, leaving behind them only columns of dust and smoke 40 to 50 feet high.

Haven't received any news from Pretty as yet about the seriousness of his wound. And as far as I know Irving is still in training. And Paul went for treatment for stomach troubles to a hospital. I doubt whether he will be back, for a number of members of the I.B. after serving four to six months are transferred to other tasks than fighting on the front line. Which reminds me, I will have been here 4 months tomorrow. I hope to take part in at least one more offensive after this one, and let us hope it will be the one that will break the back of fascism.

I believe you said you sent a box of chocolates. Anyway, I am waiting patiently for it.

Just now it would suit me especially fine for we have had little sweets. Yesterday we received our first chocolate ration for about 10 days, and it was only 1 oz.

> Must close & await your letter:
> With all my love
> Carl

..

from CARL GEISER

Sept 8, 1937

Dear Brother Bennet,

Your letter was certainly very welcome, and reached me just in the middle of another offensive, as we were attacking Belchite. I am feeling fine now, and so far after two weeks more of battle, I haven't received a scratch.

I was much interested to hear what John and Bill and the others think of my fighting here for the Spanish government. Tell them not to worry, for that can't help me, but to try to get accurate information about what is happening here. Tell Bill that while there is not the concentration of artillery fire there was in the World War, the aerial bombardment and battles far exceed anything seen in the World War. One day, 250-300 planes passed over head, and on another we were bombed 9 times. I measured a hole made by a Fascist bomb—7 feet deep and 28 feet across. I believe Bill was in the medical service there. Our medical service here is excellent. Very few are ill, and quick and competent attention is given to the wounded. I believe there are over 50 ambulances already here from the States.

This offensive has been even much more powerful, and much better organized than the first one. And the American boys have earned themselves a swell reputation again. The Spanish soldiers are always very happy to see us coming.

Up to the present, in the first 15 days, we have taken over 3000 prisoners. And hundreds more have deserted to us, in spite of the measures used by the fascists to keep their soldiers from deserting. In Quinto, the fascist soldiers told us that the parents of any soldier who deserted were shot. Here in Belchite they made some of the soldiers fight in their bare feet so they wouldn't desert. And officers would come around to check up on where the men were firing. Several were shot because they were shooting over the heads of our soldiers.

Belchite is a very important city. Do you know what the 2 main fortifications were? A seminary and a church. Many of our comrades were killed and wounded by snipers from the church steeple. The fascists also held us up a while by forcing the civilian population to withdraw to several buildings along with them so that we wouldn't blow those buildings to pieces. And civilians who tried to escape to us were shot. I myself saw the fascists firing on a crowd of old men, women and children who were trying to get out of town into our ranks.

And a further experience to show what "brave" men the fascist leaders are. After most of the soldiers had surrendered, we had to search the houses for those who were left, particularly officers. Three of us were searching one house. I was in the lead when I looked into the attic, of which the sloping roof on one side had been blown off, and I saw a sniper sitting on a box with a rifle across his knee. The moment he saw me he

stood up, raised his left hand shouting *"Viva la Republica"* (one of our slogans), but keeping the rifle in his right hand. Then he began to beg me not to shoot him, that he had been fighting for the Republic for 40 years and could prove it, etc. By that time the others came up. But when we felt the barrel of his rifle it was warm, there were empty cartridges lying about, and his rifle was loaded. So we took him down to the proper authorities, he all of the time insisting he was against the fascists and for us.

Last night I learned that he had been identified as a leading fascist organizer, and was the vice-president of the *Falangistes*, a fascist organization, of Zaragoza. And a friend of mine who had the job of executing him, told me he went to his death crying without any sign of courage. It is these kind of men that execute the parents of deserters, order the bombing of towns like Guernica, and are the dregs of humanity.

By the way, we are quite well supplied with equipment now, mostly German, which we captured from the fascists. And I have the sniper's rifle, which is a beauty.

But enough of the war. What I'd like now is a quart of Smith's Butter Ice Cream, or even a quart of Smith's Milk.

Thanks for Maria's letter. I should write her too. And by the way are Bill and Lola going to Europe? Let me know exactly where they are going & when, if they do. You can never tell, I might meet them.

I haven't heard from Sylvia yet whether she was able to stop in Orrville on her way back or not. Hope she was.

Write me regularly. My regards to all.

<div align="right">Carl</div>

● ●

from HARRY FISHER

<div align="right">Sept 9, 1937</div>

Dear kids:

I can see Belchite from where I am sitting, with its three church towers high above the rest of the town. The fascists boasted that we'd never be able to take it. Well, they boasted too quickly.

Our brigade, the fifteenth, took part in the capture of both Quinto and Belchite. Quinto was considered about the best fortified position in all of Spain. Just before getting into the town there is a very high hill facing the road, with barbed wire around it and deep trenches on top of it. The fascists had plenty of troops to hold it, yet after two days they surrendered. The soldiers were happy in coming over to us. If this is an example of the morale of Franco's soldiers, it does not look any too good for his chances of conquering Spain.

Then came Belchite. Here is a city with a history. Hundreds of years ago, the Moors failed to take it. Later Napoleon failed. This whole territory is surrounded by high hills which gives the town natural fortifications. Besides, there were plenty of barbed wire and machine-gun nests all around. Here it took six days to take the city, but we took it.

I spent most of my time with the anti-tank guns, a battery of three guns. The crews are made up of Englishmen and Spaniards. They were about 300 yards outside the town. They had telephone connections with each battalion, in this way finding out the enemy machine-gun positions. An anti-tank gun is also used against machine guns. I

have never seen a more efficient working crew than this. Everything was orderly. "Number one gun–do this—No. 2–do this—No. 3–this." I never saw them get excited. It seemed more as though they were on maneuvers.

On the third day we took the first houses on the edge of the town, including a church. Then began three days of ugly fighting, street by street, house by house. Hand grenades were constantly going off. Naturally there were quite a few wounded–fortunately not many dead.

The day after Steve Nelson was wounded, I visited him in a hospital. Here I want to say a bit of doctors and nurses. Not enough has been written about them. Not enough can be written about them.

This was a base hospital, a few miles behind the front, where the wounded are treated before being sent to regular hospitals. There were four nurses and two doctors in the clean large room of about forty beds, most of them occupied. The four nurses were Spanish. One of the nurses was on one of the beds–half asleep–half unconscious. She had been working day and night until now she was practically a patient herself. The other three nurses were dressing wounds, feeding the wounded, taking care of their needs–always trying to be pleasant. There were rings under their eyes–from lack of sleep. But they couldn't sleep. Ambulances were still coming in with wounded.

The two doctors were working in their shorts. Their faces were expressionless, as only the faces of fatigued men could be. The day was hot. The doctors' bodies shone with perspiration. The drone of airplanes was heard. One of the doctors hesitated and continued with his work. Even the threat of bombs couldn't stop them.

In front of Steve, a nurse and a doctor were bandaging the stump near the shoelaces of a Spanish comrade who just had his arm amputated. The comrade showed no pain. His face was sad—so sad that something seemed to be tearing at my heart. I couldn't talk to Steve. I just sat by his bed—my head pounding—my eyes wet—my insides sore and gripping. Later a nurse brought him food. She tried to feed him, but he shook his head. He looked at his stump, then his eyes wandered to his other hand. The nurse was sensible enough to leave him to his thoughts.

Steve is out of the hospital, but not here yet. He showed up the other night with Bob Minor and Joe North, but had to leave on some business. I spoke to Joe North about Clarina. He promised to look around for Butch. I'm worried about him as I haven't heard from him yet. Pat ought to be with us soon. Irv and Hy are still recuperating and coming along nicely. Monty and Norman, two more union members, were wounded in the Belchite action, but very slightly. Jack Small and I are still going strong. Irv Ch. is doing some work in the rear. Leon is still driving an ambulance. Anyway, get the union members to write to their wounded comrades, at their same address, in order to cheer them up. Clarina especially should write. They are Pat, Irv, Hy, Butch, Norman, and Monty.

Here is how Belchite was finally captured. On the sixth day we had most of the city. The fascists still controlled the main square and a few surrounding streets. Barricades were being put up at our newly won positions. The American comrades were tired— sleepy. They struggled to keep their eyes open. At about 10:00 o'clock we are told that the sound truck is outside the town and will appeal to the fascists to surrender. Sure enough—the words are loud, clear, simple—even we Americans can understand such

Spanish. The fascists are quiet, listening. They are told that tonight is their last chance to surrender. If they surrender, they will live. Otherwise—death. For a few minutes, dead silence. Suddenly grenades—noise—a crash—confusion. The officers were trying to escape—but were captured by a different battalion. Later, one fascist came over, his hands high, surrendering. After a lot of talking, he was convinced to go back and get the rest. They came out, one by one, shouting revolutionary slogans, and quite relieved. They might have thought we were Russians, because they kept shouting "*Viva Russia.*" They were practically all young fellows, and looked like peasants.

The civilians were the most relieved of all. They were taken out of the city, because of possible fascist bombings, to a safer place. Their homes and belongings will be protected till they can return. There was one middle-aged woman, so happy at the fascist defeat, that she kissed every soldier she could. And yet there was something sad and pathetic about it all. It's tragic seeing elderly people moving away from their homes, where they have lived all their lives. Belchite was the whole world to them. I had a lump in my throat watching the Spanish soldiers comfort the elderly people.

We are resting now. The morale of our troops is exceptionally high which is only natural after victories.

I have been showing everybody mom's letter to me. I'm real proud of it. The usual remark is, "you lucky stiff."

Give my regards to all—Now that school is here for Louise, I hope she continues her dancing. I hope Hy slows down a bit on his work. When I come home, I'm gonna make Hy quit for a week. It won't be long now. Oh yes, I knew the Stone bros. very well. They used to be in the B.H.O.A. Hy was my group leader at Jarama. He's returning home. Since he's from Williamsburg, I hope you get to see him. He was considered one of the best soldiers here.

As for Syd M. he is a motorcycle courier with brigade. He is the same naive, pleasant fellow as usual. Can you picture him after a bomb explodes nearby saying "Jeez—those fascists are serious—they really mean it."

<div style="text-align:right">Salud—Pasaremos
Bozzy</div>

· ·

from SIDNEY KAUFMAN

<div style="text-align:right">September 8, 1937</div>

Dear Eth,

This letter is in line with the promise I made in a letter not so long ago that if I got a leave I'd write twice—all in one week. From the foregoing don't get the impression that I'm considering it a task—that's farthest from the truth—it's a pleasure—both to have the opportunity and the actual writing.

There's a phrase from one of your letters that keeps ringing in my ear—you were speaking of should I ever go home could I picture myself falling into the old way of living—you said "when it's all over you won't want to go back—but neither will you want to go on." I've had a couple of days to think of just such things as you wrote about.

I'm inclined to believe that those of us who return won't have a typical World War veteran approach to war—I've no doubt that many things will have lost their savor—

the things once considered important will have become trivial matters and material things will have lost their former value as well as emotional affairs. As to death—I've developed a sort of semi-fatalistic attitude. I guess it's a result of a number of "close calls" that I, as well as anyone else with any length of time at all in the lines, can't help but arrive at. The first time I experienced a bombing, while lying flat on the ground and hearing the whistle of the descending bombs, I felt that they would land in the small of my back. Now, when *"avión"* appear, I seek the best cover possible near at hand in a ditch, a hole of any sort & say to myself, well, if the bastard can make a hit directly in this hole or ditch with so great an area about me, he's entitled to have my life. I imagine though, with a new environment I'd gradually adjust myself—get a goal once more & start aiming for it. However, I will never cease to be awed by the great historical movement taking place here before my eyes and how I've been honored to be able to take part in it. The courage of the Spanish people—the maturity of the Spanish C.P.—the ability of once illiterate peasants to weld themselves together with all other sections of society in Spain in order to build an army which is taking all Germany & Italy can offer and still say "No compromise"—the war isn't over until every invader is driven into the sea—such accomplishments can compare favorably with the building of the Soviet Union.

I've mentioned Vince in my letters to you quite often—you've never acknowledged it—a few times I wrote you to read a letter he had written to a friend of his and the said friend sent it to the *Sunday Worker* for publication. It was featured in the issue of Nov. 28, 1937. Let me know if you read it—anyway Vince & I have grown very close to each other here—read each other's mail—discuss our most intimate problems together, etc. We have a sort of mutual agreement that we won't go back to the States unless we can go together. He's kind of scared about returning and wants to lean on me. He probably feels that life in the home town of Rochester is too complicated for him to be able to adjust himself to it. Here he's second in command of the battery—liked & respected by everyone—brave and a damn good soldier—here he's gaining lots of technical knowledge. Food & clothing is provided—it's all comparatively simple—No?

I tell you all this so you can get an idea of how we get affected.

If you can send me some envelopes about the same size as the one in which this letter is enclosed it would be ideal—only it must be a better grade (stronger).

In a letter not so long ago I spoke of a new ruling with regard to tobacco—no more than 200 grams—I'm now told that the net weight of the tobacco in a whole carton is just about that, so you may send a carton.

Would also appreciate some soap—say a small parcel of 3 cakes of Lifebuoy.

Should you get the picture I enclosed in the last letter enlarged, send me one.

I've now got photos of Charley, Joanne, Esther—how about a recent one of yourself, one with Penny if available also? Love

<div style="text-align:center">

Salud

Sid

</div>

Plaza del Altozano #85a
Base Turia
Valencia

• •

from FREDERICK LUTZ

September, 1937

Dear Louise:[4]

First of all overlook whatever errors you may find here because the machine I'm using is a very ancient Spanish one and the letters are not arranged in the usual order.

Once more I have to say that I don't seem to be hearing from you as often as I expect or would like: maybe it's me. I just looked through my papers and the last letter from you seems to be the one dated July *18*th, which I think that I answered–did you receive it? Also, did you receive some photos of me and Johnny Tisso?

Well, I've moved many kilometers and had some exciting times since last you heard from me. You've no doubt read all about our latest accomplishments by now; Matthews of the *Times* was up the other day to look things over; he had Hemingway with him.

We now have an English-speaking Brigade; mostly American, it's composed of an American, an English, a Canadian, a Spanish, and a Slavic battalion (this last will leave us when reorganization is complete). I now hold the august post of Brigade Commissar of Justice, and during this particular offensive I have the additional job of Co-ordinator of services related to foods and supplies.

As to this campaign, as I've said you have read all about our taking of two towns [Quinto and Belchite] of importance. The one town is said to have stopped Napoleon in his heyday; of course with the Internationals it's another story: In connection with the larger town [Belchite] I have two tales to tell:

Before the town was taken and we lay surrounding it, I went up at night to see the American Battalion; when we were ready to return (another comrade was with me), we followed the directions given for getting out to the road. After going along for quite a while we were challenged by someone in a ditch; I answered and went over to ask directions and there in the ditch were a number of fellows with rifles dressed in civilian clothes. The question was—ours or theirs? After some palavering they gave directions, so we set off again; finally the road took a dip into some olive trees and just then we heard some stones rattle and we quickly and quietly sat down in the road. In a little while some more stones rattled and a chain clinked and then someone coughed and then we saw two heads moving against the sky behind some mounds on the other side of the road. Nearer and nearer they came and they finally stopped just opposite and apparently studied our dim outlines; we just stayed stone-still. After what seemed like a very long time footsteps sounded in the direction from which we had come, possibly they were some comrades headed for the road. In a little while two men appeared; when they got quite close I called out *"Camaradas."* They had their pistols drawn and asked *"Internacionales?"* There was nothing else to do but say yes and explain that we were in search of the road. So without putting away their pistols, they said come along they would show us. We went some distance and then they told us to go on and we would come to the road after some twisting and turning: were they going to shoot us in the back? After a little hesitation we said that we were still not sure of the way and asked them to show us further. They did and we soon came out to sight of the road and

[4] Louise Lutz, Fred Lutz's sister.

one of our tanks. The uncertainty was over.

The second story: after we had taken a considerable portion of the town but while the fascists were still fighting back, I went to town with a number of men and a mule team to establish headquarters for collecting materials of war left or taken from the fascists. Seeing a large building which, aside from its capacity, had a cellar (not many houses in Spain have cellars) which would come in handy if the fascists decided to bomb the town, I picked on it. It was getting late in the afternoon and before settling down for the night it was necessary to investigate the house to see that it was clear of any hiding enemy. The cellar was heaped with mattresses, showing that it had been utilized as a hideaway during our shelling. A little further search showed a tunnel leading out of the cellar; it was most necessary to look into that, so with a flashlight before me and two guards with rifles behind me we started in; the place was just carpeted with mattresses and quite a few cans of condensed milk. It was a low tunnel and we had to progress in a squatting posture. The Spaniards called out every little while but no one answered; then just around a turn in the tunnel a head appeared in the beam among the mattresses. Naturally I and the Spanish got quite excited; they cocked their rifles and called on the head to surrender and I drew the very formidable 45 I carry and exhibited it in the beam of the flash. The head quickly came out followed by a body and then a second head and body. We backed out of the tunnel. When we got the men out in the street and turned them over to the troops they said that there were women behind. So, taking the younger man, we went back. Since it is an old fascist trick to ambush us thru stories of women and children and by actually using women and children, we made our friend go a considerable distance ahead and call out. He called out "Matilde"; after a time a faint woman's voice answered and around another bend in a higher chamber of the tunnel came a very fat woman with a crutch, a little middle-aged women with a large child on her back, and a very old woman leaning on an old broom and leading another child. Fearing the trick we made them come forward one at a time. After quite a struggle we got them onto the street. By a struggle I mean that it was very difficult for the women burdened as they were to crawl along the tunnel, and when we got into the cellar we had an awful time getting the fat cripple to her feet and up the stairs. After this we again went back with the same fellow and explored the tunnel to its end in the cellar of a house quite some distance away.

The same day, in the morning when I was investigating the section of the city we held, an officer of some other Brigade stopped me and asked me if I could see that some wounded fascists were fed. Getting one of the Spanish as a guide I went to see them. They were in a large dark room and the odor was terrible (the Divisional doctor told me that almost all of their wounds were gangrened). They were being cared for by two nuns and two fascist first aid men. The nuns were dressed in white with black veils–possibly you can identify the variety. I asked as to the number of men and as to whether they needed anything immediately. They told me that they had no water all day so I took the two fascists and a guard and went to a factory we held that had a well. The nuns were apparently taking it all quite calmly. I wonder tho what they were thinking. Everyone on the fascist side has been fed terrible tales about us, so possibly they were prepared to be martyrs.

It's awful the desolation of war and the misery that it brings on the civil population,

but it's a necessary price that a people must pay to win their freedom. I've certainly seen some heartbreaking sights.

Are you getting the *Volunteer for Liberty* regularly? I've had your name put on the mailing list as I think I've already told you; did you get the collection of watercolors?

I enclose the insignia of the *Falangists España*, a particularly wicked set of fascist robbers; also the photo of a set of fascists taken from one of the prisoners. Let me know, and soon please, that you received them; also all the latest scandal. Tell Henry I received the Workers' School catalog, it's quite impressive.

Well, once more,

> Salud!
> Freddy

P.S. My address is now 5E instead of 17.1
 ALSO find three fascist postage stamps.

from LEON ROSENTHAL

> Wednesday, August 25
> Somewhere on the Zaragoza
> front.

Lee darling,

The afternoon is hot—that dry, sultry, lazy heat that makes everything stop during the afternoon in Spain. I would prefer to be out in the sun—but the absence of any place to swim or shower makes the shade—any shade preferable. So here I am—in an old, abandoned barn—built of stone of course—Sam is lying in the hay reading and I am sitting at a crude table & spending my siesta with you.

The last letter I wrote you was Sunday—Aug. 22—if you got that you know that we were standing by with the sound-truck, awaiting orders. Sunday evening we left. With frequent stops we slowly made our way thru a good portion of the Spanish map—thru all sorts of country—some parts are just like New York state—I felt almost at home— all night & all day we rode—about 700 kilometers. Monday nite we stopped at a little town right on the front—the barricades are right at the edge of the town. I slept on a soft chair in headquarters—Sam slept in the car and our chauffeur (his name is Joe— from now on I'll use his name) the Belgian slept in the fields. In the morning we were wakened by the big guns beginning to lay down a barrage—then our machine guns & rifles began their tattoo—this continued for about an hour or more—then came our planes—they are beautiful to watch in action. They are so swift and operate so effi- ciently. We watched the battle for a while and then ate some very good cheese, bread & melon & then we were off again to seek our destination. Finally at noon yesterday we reached a village where the International Brigade were & an officer accompanied us—to take us to Division headquarters to report. We rode up to the front—and I mere- ly want to say this—from what I observed on the way up—that our morale is of the highest—you see solidarity, victory and revolution in each smiling face and clenched fist.

We were up at the front for a few hours and received our orders. While there I was watching an artillery duel. From the hill where I stood I could see our shells striking

their objectives and I am sure we were getting the best of that duel.

As one looks into fascist territory one cannot help feeling along with hate—a mixed feeling of pity and hope for those poor devils—the workers on the other side who are forced by the terrorism to take up arms against their class brothers. But of course many of them risk their lives & desert to our lines and others revolt in Franco's rear.

We returned to a nearby village & are here waiting for further orders. We eat at the Garibaldi Brigade kitchen—and the food is very tasty. Yesterday I scouted around the village & found this abandoned barn—with lots of hay in it. I brought Sam here last nite to sleep—rather proud of such a good find—such a nice barn—all to ourselves. But soon we saw why—scratch, scratch—scurry, scurry—ssst—sst—rats, mice,—big and little—but they didn't bother us—we were tired. However, we have found a bunch of traps and tonite we'll go hunting.

This morning we heard the big guns in action again—and we heard that things went very bad for the fascists yesterday—but I suppose you follow these things in the paper and there's no sense my giving you general news.

Now it is siesta—all is quiet from the direction of the front—I can look out the barn door and see the fascist hills—but I don't think they'll be fascist much longer. This morning we looked over some of the houses destroyed by fascist assassins from the air—"culture"—and how!

At present I don't know just what brigade we will be attached to or if we stay in the division or what, but will let you know our new number for mail as soon as we are settled. Also I will notify the Auto Park in Albacete and they'll forward our mail to us. Meanwhile—until you have the new one continue writing to the same number—(1T). My letters, of course, no matter where I mail them—are taken care of—so I guess you'll keep hearing from me without interruption. I'll have a little delay getting your letters but once I have an address—they'll reach me O.K.

I am glad to be at the front—altho I don't know if there will be the time or opportunity for us to talk to the fascists on this front—but maybe we'll print some leaflets—I'd like to get started on the propaganda work & help deliver in the coup de grace to Franco—the time is ripe—we're going to win—and soon, too!

Well, honey, that's about all the news for now. (Except that I'm letting my beard grow temporarily)—I'm having a socialist competition on beards with Joe the chauffeur—Sam being out of the running because his Abe Lincoln whiskers grow too slowly.

Keep up the work on the home front & above all—don't worry about me—the only thing I lack right now is a shower, a piece of pineapple cheese pie and *you*. We are working nicely now as a team of 3 and after all these months we have a chance to do real useful work. I'll keep you well posted on everything new and you keep writing to me—your letters will reach me—whether a few days more or less doesn't matter so much.

So here's a kiss & a hug from your grizzly husband—I think of you day & nite and love you always. Wait for me patiently—there is much work to be done. My revolutionary greetings to your family and all our friends. Keep looking as sweet as you do in your pictures.

Salud, your Leo

from LEON ROSENTHAL

Sunday, 4 P.M.
Aug. 29, 1937.
Zaragoza front.

Lee honey,

Really, I should wait another day before writing you because I haven't the return address yet, but I feel lonesome for you this afternoon & must have a little chat with you.

The last I wrote you was Wednesday, the 25th. If you got that letter you know we are now working on the front with our sound truck. Mainly—so far—we have been printing leaflets on our machine—but tonite we probably will talk to the fascists. No doubt you have been following the brilliant successes we are having on this front—and I suppose the news will be even better when this reaches you.

As I'm writing this, I'm sitting in our truck—Sam is sleeping underneath, Joe (the chauffeur) is in the truck and one of the political staff is typing a stencil. The sound of cannon & machine guns is so commonplace now that I only notice the silence when they cease.

There are very many things to write about but you'll understand, I'm sure, if my letter does lack detail. I do however want to mention one of the many thrilling sights of the past few days—one for which we had a real grand-stand seat. The fascist bombers & pursuit planes had come over to attempt to bomb & strafe our lines. Before they could get a real start—out of nowhere appeared a large number of our "chatos" pursuit planes—they attacked the fascists in their skillful formation. The battle was on—zooming—rat-tat-tat of machine guns—maneuvering for position—meanwhile spreading higher and wider over the sky—suddenly—one of the fascists' planes went down—the pilot jumped out in his parachute & the plane crashed—a flaming heap on a fascist hillside. The pilot, wounded, landed in our lines & was captured by our boys—he turned out to be an Italian major—the leader of the *espadrille*. This is only an isolated incident—we have seen, in our short time at the front, much to warm the heart of an antifascist. Some day—soon I hope—we'll discuss these things over a quiet cup of tea.

In a separate envelope I'm sending a few samples of our work and also some leaflets dropped by our planes. As soon as I know what number our postal address is now—I'll let you know. Meanwhile—write to 1T and I'll also send our new number there—to have your letters forwarded. You see our truck is attached not to any particular battalion or brigade—but to the 45th division. So the mail has to be sent to the division—in order to follow us wherever we are. However—don't worry about the mail. My letters will go out—wherever I am & yours will reach me.

(Time out—the stencil is ready & I'm going to run it off)

4:30—O.K.—I have a little time until the other stencil is finished.

The days are getting shorter now. The nights are chilly, but the afternoon sun is still pretty hot. I have a week-old beard (with red hairs) and more to come. Of course there is no place to bathe, but the drinking water is brought up to the front in tank trucks. But despite anything & everything, there is only one main need that I have—and that

is you—all day long no matter what I'm doing—in the back of my mind is you and between us stands the victory over fascism. My hopes are high, for the situation on the fascist side is desperate. A deserter told me yesterday that they get 25 centimos a day (1/4 peseta—less than 1¢ at current exchange) in the fascist army—no drinking water—little food. They are for the most part waiting for their chance to desert. On the other hand is the unheard of courage of our forces, their unity & their tremendous reserve in the rear. In the International Brigade in particular the feats of bravery and superior strategy have got the fascists real scared.

(Time out—another leaflet to run off)

6:30 O.K. I am thru now—am sitting alone in the truck—the shadows are lengthening—it is growing cooler—the artillery is quiet now & the scene is peaceful—Sam finally got up & is sitting outside writing.

Lee, I must apologize for writing on such shabby paper—but it is the last of the paper you gave me to take along & I've sent it all back to you & have not thrown out any. I've plenty of paper here—the fact is we threw out hundreds upon hundreds of sheets of paper that was no good for our machine. So you'll pardon the unkempt appearance of this letter—it's only for sentimental reasons—now I have none of this paper left.

There are so many things I want to know—news about you, about my mother & Jack—the Ansley shop, etc., etc. But all I can do is wait for your next letter—it takes so long for mail back & forth that I won't ask any specific questions—usually I ask about something & the next few days a letter comes bearing the information I asked for—so all I can ask is that you continue sending me the nice long letters you have been writing—and again apologize for the short ones & scanty ones I've sent you. But I try to tell you everything of importance in the odd moments I can find when I am alone & can write in peace.

I am well in health. Whenever I have time I stay out in the sun & usually wear only trousers & shoes all day. At present—as you can see by the leaflets—we are with the Dombrowski Brigade—but we may move around from one front to another. However, as I say—we are connected to the Division & when I'll send you the number & you write there—the mail will reach me—wherever we are. And when you write also put in the corner of the envelope "*Coche de Propaganda*" (sound truck) to make sure the mail is sent to me—for as you remember there is another comrade who bears my name & if letters were forwarded to him it would mean more delay.

Really, Lee—there is very little I can write now—it is as if we were in the Maine woods for months & saw nobody & heard nothing. There are very few comrades here who speak English & then only a few words & so we know little else but what we see & hear in our own vicinity. All I can tell you is how much I love you & how very badly I miss you—but I hope it doesn't make you feel badly to have me say that—I happen to be very lonesome for lack of *companionship* these last few days & so I have more time to think of you. But by the time this reaches you—I may be near the American battalions & in different circumstances. Keep after your citizenship papers—in case conditions warrant your coming here & it is possible—but I still hope & hope some more that I'll be home real soon. The People's Army is on the go now & let's hope we'll be in

Burgos in a short time. I can't think of anything else to write now—because all I see in my mind is you & that's all I can write about—not that you're not a pleasant subject for thought—but I'd rather be near enough to you to hear you, see you & kiss you.

Dream of me every nite, as I do of you all day. Be very patient, my darling, this war will do all of us a lot of good & perhaps another will not be necessary.

Give my love & sincerest regards to all your folks. Do your best to keep my mother at ease about me. Tell Jack I'll write him again soon.

And now—my dearest, sweetest wife—it is time to part again—until next letter. Sleep tonite close to me & dream of happier days.

> Yours always,
> Leo

•••

from LEON ROSENTHAL

> Wednesday, Sept. 2
> 11:30 A.M.

Lee darling,

Good morning, honey, did you sleep well? It was pretty warm last nite & I slept soundly (from 3 to 8), however—I feel rested & am writing to you before doing any work today.

The last letter I wrote you was Sunday Aug. 29. If you got that one or the one before (Wed. Aug. 25) you know that we are here on the Zaragoza front with our sound truck. Before I go any further I'll give you my new address and address all mail as follows:

> L_____ R_____
> Socorro Rojo International
> 12 E———Plaza del Altozana
> Albacete, Spain
> *(Coche de Propaganda)*

Notice the new number (12E) and also put *Coche de Propaganda* on the envelope so it will be sure to reach me fast. This mail number is the Division & it means our mail will be forwarded wherever we are.

The scene is peaceful—I am sitting in the middle of a field that was once a quiet farm (the bundles of last year's wheat crop still on the ground). On all sides are hills & more hills—our truck is about 15 yards off—Sam is resting near the truck & the chauffeur is doing some work on the truck & I moved to get away from the sound of his hammer, etc. The sun caresses my body (stripped to the waist)—distant artillery from a different sector & infrequent traffic on the nearby roads disturb the silence gently—a cool breeze from the east makes it just nice & comfortable & so I can write.

We have already spoken to the fascists twice and with very good results. But first let me add some further explanation of how we function. Our truck (and that means us & all our belongings) are stationed in the hills near headquarters during the day. Our food is brought to us here—we do the printing of leaflets & whatever repairs & other things there are to be done during the day. Living with us we also have one of the propaganda staff (a young Spanish poet) and a deserter from the fascists who came over

last week. Towards nite we leave here & go to a point where we can reach the fascists with our speakers. We leave the truck in a sheltered spot and there we divide the work. Sam stays with the amplifier & handles the controls & phonograph—I lay our line up into the 1st line trenches and take the speaker up & rest it over the parapet facing the fascists. Then we begin—first the *Himno de Riego* (Spanish National Anthem)—and when it ends you hear our boys cheering "*Viva*" all up and down the front. Then the "master of ceremonies" (the poet) takes the mike & gives the latest news & tells the fascist soldiers how futile it is to resist—& analyzes the political meaning of the war. Then he introduces the deserter or some other one—who makes the main speech. He gives the facts on conditions on our side & their side contrasting pay, food, water, the nature of the discipline here & there, the plans of the 3 monstrosities—Hitler, Franco & Mussolini—he urges his friends, his buddies from his former company to kill their officers & desert to our lines with their arms. His talk is very informal, very friendly but with simple yet powerful logic. He tells how well he is treated here—water to drink & even to wash, 10 pesetas a day instead of 25 centimos, Spanish officers, not German or Italian; he tells how we (Sam & I) keep urging him to eat more & more, whereas in the fascist army there is very little food (except for officers). He talks on & soon the deserters—his own friends begin to come over guided by the sound of the loudspeakers. They embrace at the microphone & tell how whole companies & battalions are anxious to pass over to us. Meanwhile the fascist machine guns & rifles are going full blast—at the order of the officers who are pretty shaky. It avails them nothing—they waste loads of ammunition & altho they do not drown out or locate our equipment—it does make it easier for men to leave their lines during the noise. Soon the speaker ends with "*Viva la Republica, Viva todos obreros del mundo, Viva el Frente Popular*"[5] & the boys in the lines echo it from all sides—Then comes another plea to pass over to us from the 1st comrade (the poet) and then the "*Internacionale*."

The 1st nite 20 deserters came over in the great confusion we caused in the fascist camp. But last nite they saved their ammunition & listened to every word. Before we packed up & left 2 deserters had already reached us—how many more so far I haven't been informed yet.

By the time we get back it is 2 o'clock or so & then we camouflage the truck & go to sleep wrapped in blankets & lying on a big bunch of straw we spread on the field. I watch a few meteorites, listen to the gnawing and scurrying of the field mice & the next thing I know the sun kisses me "good morning" & soon the food truck comes with coffee (this morning we also got lady fingers).

Today the barber came around & I let him mow off my ferocious 10 day beard.

The heat is still great during the day & we are always on the alert for ways to get water, but so far we always have had water to drink. And when there is a chance we also wash our hands & face. As for a bath—we may have to go to a nearby town to pick up paper for our machine soon so when we do we'll have a swim in the river.

It is going very well on this front & we expect to drink beer in Zaragoza soon. And I can imagine the effect on world opinion when we march into Zaragoza! What will Eden say?

[5] Long live the Republic, long live all the workers of the world, long live the Popular Front.

And that's about all the news at present. I have sent our new address to Albacete & we should get some mail in a few days. Time is going pretty fast now. The summer will soon be over & then the fall & then perhaps we'll be together again. My ambition is to help win the war & be home by New Year's Day. Then you'll give me a new kiss & we'll start a brand new romance together—nice, eh? Honey I hope you are trying hard to be patient—we are doing important work now & the better we work the sooner will the fascist camp crumble—the hardship of being separated from each other is part of the sacrifice we all must make in this gigantic, decisive battle of the "final conflict." Keep thinking of our victory, of what it will mean to everybody and continue your splendid work for Spain. I am *really* proud of you, darling & the thought of the work you are doing back home is a great inspiration to me here. Every now & then I take your pictures & go off alone to dream of you—my sweet Lee!

I am awfully conscience-stricken about not writing to my mother & also I didn't write to Jack since leaving Albacete—so please, honey, visit them & convey all sorts of good news to my mother & explain that I'm extremely busy & will write to her first chance. I've been at this letter a long time it seems and I'm too lazy now for more writing, besides there is work to do & besides I don't like to repeat the same thing in several letters. But as soon as I feel inspired to write again (perhaps today) & have the chance I'll write to Jack & my mother.

And now I have to see what's what about lunch & then there is some work—not much, tho. So again, honey, we come to the hardest part of our little talks together—parting once more. Send me all the news & make it good news. Don't worry about me & tell my mother not to. Keep the love fires burning & wait patiently for me—time is flying & so will the fascists.

Again give my love to the folks & my comradely greetings to all our friends. Watch the papers & keep doing your bit for Spain.

I love you, dream of you, wish for you, desire you, need you & by the red star—soon I'll have you! Sweet kisses darling, bear hugs, honey—tender love, sweet wife and Salud, *camarada*

—————Your Leo

• •

from PAUL SIGEL

Oct. 3, 1937

Dear Mim,

Still in reserve, but expect to start pushing, pronto. [Censored lines]. He [Harry Malofsky] was doing great, Mim. I always just missed seeing him—he left just before I came to training camp & we joined the brigade just after he was hit. But I've been speaking to fellows who were with him in the burning heat & soul tiring work of Brunete, in the fierce street fighting at Belchite—and thru it all, he kept pushing the same untiring way that gained him the respect & love of all the comrades around him.

But more than his brave actions under fire. Back in the training camp he continued the swell work of the Convulsionaries that we knew so well—gave performances for the townspeople, who loved it & called for *mas, mas* [more, more].

With Ernie, he wrote songs that are the theme-songs of our I.B., songs that are sung

by the children in the training camp town—songs that will be carried back and heard thruout America & Canada & Europe as typifying the spirit & the courage of our I.B. And in the lines too, he continued to make up songs and sonnets, keeping up the spirits of the boys, emphasizing the spirit of comradeship that brought them together & causing the fascists many a headache when our boys "went over."

I don't have to write much to you about this, Mim,—You know how I feel—we'll make doubly sure our sacrifice was worthwhile—and you & the Youth Theatre can utilize your own methods on your front to do what you can.

I think we'll close this letter!

Salud Folks
Paul

At Fuentes de Ebro

INTRODUCTION

While the Lincolns were fighting at Quinto and Belchite, another substantially American battalion, the Mackenzie-Papineau (or Mac-Paps) was undergoing a thorough training program. They joined up with the Lincolns in September. With other brigades fighting on after their withdrawal, the Americans were soon recalled to the front. On October 10th they were trucked back to Quinto and from there to the scene of their next engagement, Fuentes de Ebro. The Americans went into the ill-fated action on October 13th. Preparation for the complex plan of battle was seriously inadequate. A key portion of the plan was a coordinated tank and infantry attack designed to overrun the enemy, but some of the tanks made a wrong turn and became stalled in ditches, while others, with infantry clinging to their sides, became exposed when they outdistanced the additional infantry on foot. The American battalions managed to withdraw at night, but both suffered significant losses. The survivors spent another ten days in the lines, taking further casualties. Overall, nearly 150 Americans were wounded, while 80 lost their lives. Among those who died were Milton Herndon, Angelo Herndon's brother. Among the wounded were Lincoln commissar Carl Geiser, hit by a mortar shell.

from CECIL COLE

España—Oct. 22, 1937
The Front.
[Fuentes de Ebro]

Well hello everybody—

The weather isn't bad, but I've seen worse.

We've been here at the front for almost five weeks. It's not so healthy here. Too much "lead-poisoning" going on to be exactly comfortable.

Since I last wrote I've been advanced again. I was as you remember Chief of Battalion Scouts & Observers. Now I am Chief of Brigade Scouts. That in itself is making life less sure. So far I've been beyond the Fascist lines twice and up to them six times. All at night of course. In fact we do most all of our work at night. Lately, however, the nights have been so clear and the moon so bright it was like day. We have to move very slowly to avoid being seen. Three times now I have been seen & shot at.

The first time I was about twenty meters from their line. They opened up on me with a machine gun & six or eight rifles. Believe me, I hugged the ground. They hit the heel of my left shoe at the seam several times and actually blew my shoe apart there. Five of the "slugs" passed thru the seat of my pants, one just burning my "fanny," but none closer. However my "fanny" is a little sore still to sit on. Needless to say, I was plenty scared.

The second time they caught two of us, myself and one of my sergeants about 50

meters from one of their outposts. It was pretty gruesome, as we hid behind two dead comrades who had gotten "it" in the attack a couple of days before. We lay there for three hours. Every time we moved, this damn sniper would put a shot alongside of us. Finally, after the moon went down we got back. I had 3 holes in my coat to show for that patrol.

The last time I went up alone to scout a path for our tanks to take down barbed wire immediately in front of their trenches. I found the way, but on the way back they saw me and put one thru the shoulder of my coat and one thru my hat. I led the tanks back—inside the tanks. We were successful.

I have been commended for doing good work and am to be made Lieutenant soon.

We have had several barrages of artillery here in our location. The last one killed seven men. We also have had an aerial bombing which killed four & wounded seventeen. The total casualties here at the Brigade H.D.Q. is somewhere in the forties.

Well, I can begin to think about coming home now. At least about leaving Spain. There is, of course, no definite information, but a great number of men have left after seven months here. However, I still may stay longer, tho I do think I have strained my luck so far. Then too I might try to see more of Europe while I am here. I can be in the open now, whereas before we kept pretty well out of things.

I don't know just where or how I'll get the money, but I believe I can earn my living doing something as I go. However, if there's any possibility of doing work at home for the boys here, I'll come home immediately. My strongest instinct is naturally to come straight home, but it seems to me pretty foolish to be here and not take advantage of it if I can.

This is a big "I" letter, but conditions here make it necessary. I'm not sure just how much I can write & if I write too much this will never go thru. However, I have loads saved up in memory. As my letters are so few, I would appreciate your giving this to Dian Jeffries after you have finished with it in the family.

Now I must close and go out on patrol again. I have to see if the Fascists have any new outposts. So until later, salud!

> Much love to you all
> Cec.

New address to the Brigade Staff
(ie) S.R.I. Plaza Altozano
 E5 (B.S.) Albacete
 España.

· ·

from JACK FREEMAN

October 22, 1937

Dear Mom, Pop, and Herbie,

I promised to write at least once a week, but since that time we've been shifted around quite a lot and seen some action, and it's difficult to write on trucks scouting around the country or in trenches where there's so much else to occupy you.

Anyway, six months after leaving home and almost five months after arriving in Spain, I've finally gotten to see some actual warfare. This morning marks my tenth day

in the front line trenches and, altho this front is technically speaking pretty quiet at present, still we've managed to squeeze in quite a lot since we came up.

We moved into the trenches one morning before light and, as soon as dawn came, the crap began to fly. Then started my education. Some of the old-timers explained the various sounds to me. At first anytime anything whizzed, whistled, or buzzed, I would duck. Then I found out that any bullet which passes anywhere near you will whistle. Ricochets, that is, bullets which have already hit the ground or a rock or something and bounce off in a different direction, buzz when they go by. When bullets come very close they sound more like a whine than a whistle.

But the most important thing of all about these bullet sounds is never to worry about any bullet you hear. Bullets travel much faster than sound, strange as that may seem, and the bullet is way past you by the time you hear it. As it's put out here, "You'll never hear the slug that gets you."

Of course, it's pretty hard to control your instinctive tendency to duck when you hear a loud noise, but the only time it really pays to duck is when you hear a burst of machine-gun fire and hear them come over you. You can't, of course, duck the first few if they're coming at you, but you can get out of the way of the rest of the burst.

The same thing goes for artillery too, except for trench mortars and very heavy stuff.

A trench mortar gun looks like a fat can between two wheels. The barrel points almost straight up and the shells go all the way up into the air and then almost drop. You can judge after a while if they're going to your right or left, but if they're coming in your general direction there's nothing to do but hope. Heavy artillery goes very slow and you can hear them coming, but they usually head for the rear lines anyway.

Well, the first morning I'm keeping low in the trench and not too much interested in the intricacies of military education, when these trench mortars start coming over. They whistle for a long time before they hit and that just increases the agony, waiting for them to land. When these things start coming the battle commander shouts "Everybody down in the trench." So I stick my nose six inches below the level of my heels and then the commander finishes his sentence, "That doesn't go for the observational staff. Locate that gun."

So I found out what observing under fire meant. Poor me has got to spend my time sticking my nose thru peep holes when it's much more comfortable two feet below, and my head and shoulders over the parapet half the night, and when the big bastards come over instead of dropping we've got to watch. It was pretty tough the first morning but I soon got used to it.

You see, after a while you get the feeling that what's going to happen to you, if anything, will happen pretty much in spite of anything you do. That doesn't mean we become dauntless heroes and walk out of our way to take risks because we like to watch the patterns the bullets kick up in the dust, but it does mean that we don't become nervous wrecks bobbing up and down every time a mosquito buzzes around your left ear. It's the only kind of defense mechanism you can adopt.

Shortly after noon that first day we went over the top. For about three quarters of an hour after the beginning of the attack I didn't think I'd get a chance to climb over that hump. I was stationed next to the commander in a pretty exposed observation post

keeping wise to how our boys were going, so that the attack could be properly direct-ed. The commander, you understand, does not move up until the troops have taken up a position, even a temporary one, in advance of the original lines. But if you think that's safe, you're cock-eyed. He's got to keep calm and see everything that's going on when every instinct is pulling him down to a covered position.

Communication with the men out front is maintained by runners. Pretty soon we ran out of runners, so I got my chance. But the company I had been sent out to contact had had some tough going and was pretty well scattered and difficult to find. I went out, couldn't find the company commander nor anyone else who knew where he was. So I was in a fix. I didn't want to return until I had contacted them and I couldn't find them. I roamed around that god-damned no-man's land, sometimes running, sometimes crawling, sometimes snake-bellying, and holy cow, was that a time. I didn't of course know where in hell my men were and one time I crawled up to within fifty meters of the fascist lines before a sniper reminded me where I was.

The hardest thing out there is not keeping going once you're on the move, but start-ing once you've stopped. When you get down in between two furrows in a plowed field or behind a little ledge where you know you're about as safe as you will be, it sure is tough to get up and start going thru the air again, especially since you know there's plenty more stuff in that air besides you.

Another thing. This time they used trench-mortars against the attacking men. The thing to do when you hear them whistling at you is to drop so that you'll be out of the way of any shrapnel or flying bits of shell. Most of the time I could hear them whistling at me and then the sound would reach a high point, and from then on it was whistling away from me. That scares you, but once the whistle is behind you you know you're safe a little longer.

But of the six hours I spent out in between those lines the worst moments were three times when the whistle of the mortars approached, came overhead, and then, instead of receding, kept coming louder. There's very little time involved, but you think fast out there. Here's that damned shell falling at you, no place to move to, nothing to do. In that brief instant you get a horrible feeling—not of excitement or fear, but just resignation. You are a dead man aware of the fact—a body which is lifeless except that its mind knows it is lifeless. I don't know if you get that. And then, three separate times, those damn shells land within ten feet of me, and were duds! This isn't literary exag-geration, I'm not writing a phony adventure story. I could *see* where the shells hit and dropped dirt over me and failed to explode.

Get my point. We are in danger continually and it is not pleasant. But there is a gam-ble, a risk, a probability. However when there is *no* probability, when it's a certainty—it's coming at you and you know it—then you've got something. Try thinking what you'd think about if you had two seconds to think it in.

Well, I couldn't find the company and it was starting to get dark, so I decided to go back. But I found that wasn't so simple either. Dusk is always a dangerous time, so everybody is especially watchful. This day there had been an attack, so the fascists were especially jittery and there was a hell of a lot of fire. I waited for it to quiet and started back. This time I attracted fire from both sides because neither side knew what I was. It's a funny feeling to be fired on by your own men. I had a couple of more scary

moments, but I finally got in.

It sounds pretty pale on paper. Perhaps later on I'll be able to try to do it more justice.

Most of the rest of my experiences are the same way. They are, on the whole, material that has at some time or other been described by some of the best post-war novelists. I can just record the facts barely so that their true meaning doesn't really get across, but at present I am in no condition to attempt to write of them so that their significance becomes more than merely grammatical.

Except for one more particularly outstanding incident, the rest of the time has been ordinary trench life. "Ordinary" trench life is just a series of miracles coming so fast one after another that your mind refuses to recognize them as miracles anymore. You've heard of the sort of stuff I mean. You take your head away from a peep hole to talk to someone and a bullet comes thru the hole. You have an argument with a guy; he walks off in a huff straight into a bomb. Hundreds of incidents just like that.

The other big thing was an *avion* bombardment. Anyone who has had experience with them knows that airplanes are not very useful in bombarding a target like a trench. The trench is too narrow, the planes too high. Only once in a thousand times do they score direct hits. If you keep your head and body down you'll be scared but safe. That is true, and all the experiences of the American battalions in this war bear it out. But we came along right on the even thousand. Our fourth day in the lines at eight minutes past two (I know the exact time because of the broken watches) a fascist squadron came over and dropped three dozen bombs of which two dozen landed either in the trench itself or within a strip of ten meters on each side. This was along a strip of trench about fifty meters long—marvelously accurate bombing. This strip of trench contained the staff and part of the machine-gun company. The ground in this part of the country was sandy and the trenches along here just collapsed. Everyone lying down was buried by sand, most, fortunately, not too heavily. I got sand and dirt all over me. One of my observers was killed by shrapnel. Several others were killed by concussion or suffocation. I'm not even trying to describe this one. This experience of the entire earth rumbling, bouncing you off the ground, earth falling over you, then digging out buried comrades with trench parapets destroyed exposing you to enemy fire while you're working like mad to get the poor bastards out while there's still time— well, it's unbeatable. Let's leave it at that.

In one or two days we'll be relieved and I'll write some more. I am still bodily and mentally unhurt.

<div style="text-align: right">Jack</div>

P.S. I'm enclosing a picture taken in our observation post.

•••

from LEON ROSENTHAL

Thursday 11 A.M.
Dec. 16, 1937
Huesca Front

Lee darling,

Outside the wind, rain & snow play a frosty melody, but here in the sound truck we are warm & snug & we survey the snow-covered mountains in wonderment & awe. It is bitter cold up here in the hills, especially at nite. But first I'll give you all the news about myself.

The last letter I wrote was on the 10th—in it I told you we were to leave for the front the next day—well, we did but our truck broke down—we had to be towed back for quick repairs & finally we came here Monday (13th).

Tuesday nite we were up in the lines & spoke to the fascists. We had seven comrades speak—farmers, workers, youth, etc.—they compared conditions in Popular Front territory and army with that of the traitor, Franco. We started off with a dance tune—then the speeches—finally the *Himno de Riego*. It rained some & there was quite a wind & it was 1 1/2 kilometers to the fascist lines—so we are rather doubtful about the value of our truck under these winter conditions. With more powerful loudspeakers—it might be a different story. I wish the comrades in the States could send over some high power public address units.

It is pretty quiet here—rarely a shot to be heard. The weather drives everyone into the dugouts & the fascists with all their equipment & mechanization can do no more than freeze in the trenches. This part of Spain is very bleak—no trees—only little spiny shrubs that hug the cold ground—plains & hills & mountains—cold, foreboding—when you climb up on a high point it looks like there's no life anywhere—like the war has already destroyed civilization. We can see pretty plainly in the distance—a strategic town held by the fascists—but I hope not for long.

Although our sound truck is attached to the Division—at present we are working for the Dombrowski Brigade—& its battalions. Yesterday we were trying to drive the truck to a sheltered spot and got stuck in the mud—it took us 5 1/2 hours to dig out—Sam went down to the village for a tractor but by the time it came—we had already come out—boy, what a workout—a few weeks of that and I'll be able to hold down a WPA job digging ditches when I come back.

The wind is roaring like hell outside—the tent cloth camouflaging our hood & cab is flapping noisily—but here in the truck all is warm & homelike. It is unbelievable to see what comfort hammocks, which Sam & I sleep on—Joe has a mattress which I brought him, there is a big upholstered seat from a car in one corner, & a single seater in another corner—the hammocks, blankets, mattress all strap up to the ceiling during the day—the stove burns merrily & when our chimney is mounted outside—we look like a railroad caboose (is that the word for the last car on a freight?) Sometimes we make toast on the stove & if you were to walk in a few days ago & see the fire going & us eating toast, Baker's chocolate, (chewing) Chiclets, Sam smoking "half & half" in his pipe, Joe smoking Luckies & I reading a radio magazine—you would not think we were so far from home. But now the chocolate, etc. is gone—only Sam is still smoking the

"half & half"—the fragrance fills the truck & I just tossed off a few tunes on the harmonica.

Our truck is now strictly a sound truck—we have left our multigraphing machine & typewriter with the Division office in the rear & our only work now is to propagandize the fascists at nite—our days are free. But as I said, with these speakers we can't do much against wind & rain—& the weather won't change until spring, so I don't know what our immediate prospects are. However, I'll keep you in touch as usual and I have your request still foremost in my mind.

We are out of touch with things here, so I don't know what's new with the non-Intervention business—or what's new in Albacete. The latest letter I got was of Nov. 16th—there is no doubt more mail somewhere around—but there is always a delay when you move around to different outfits. Sam has a letter of the 22nd, I think, telling of Bill Lawrence's answer to your question. He says it will be about 7 months. Well, I don't know, because things happen rapidly here & the rule might have changed several times since he left Spain. In case we are put out of active service for the winter (which is the only prospect I see—because of the weather) I will get in touch with Albacete again & try to get definite word from Johnny Gates. Until you hear from me, don't lose hope or get to worrying.

You must be wondering if we are clothed warmly enough for being on the front in such bitter cold. Well, between us we have enough sweaters, etc. to be warm. Joe gave me a leather jacket & I have a scarf & gloves & if we can locate any trees, we'll get warm enough chopping firewood. Just think, including today there are just 8 more shopping days to Christmas! It looks like you'll have to ring in the New Year without me, honey—I'm so sorry—no more promising definite dates until I know. The best of all would be to win this war soon & we'd all come home satisfied—but you realize as well as we do that there's a long road ahead. We are at the mercy of England and only greater & stronger efforts by the international working class can take our future out of her semi-fascist hands.

This morning we had bread & honey & coffee—pity the poor soldiers, eh? The government sees to it that we never lack for food & get the best there is. We are still wondering whether there will be an offensive (theirs or ours) before the winter is over. They tell me the aviation was pretty active here last week—the fascists trying to break up our concentration & make theirs. But since Monday, the weather has been bad for flying & we haven't seen a plane in the sky.

Don't be angry with me for writing so infrequently—I haven't had a chance to write more. And if there is a lapse between letters—please don't worry—I'll try to write every few days now, as usual and just be sure that there's nothing to worry about.

For the present, there's nothing else worth mentioning. I'm going over to headquarters to mail this and ask if there's anything for me—maybe there's some letters from my darling to keep me warm today.

Please wish Nachman, Rijkeli, Rosie, Eadie, Minnie, Betty & Beatrice a very happy & healthy New Year for me. I'm so sorry I can't be with all of them, but I hope my being here this New Year's Day will help make next one a real happy one for the working class & its friends.

My best wishes & revolutionary greetings to all our friends & comrades. Tell Jack

I'll write him in a few days & above all, don't let my mother start worrying about me again.

And for you, my sweetest, honiest wife—here's a kiss to mark 5 years since we first kissed—I love you more than ever & promise never to be away on New Year's eve again—hug me my chubby darling—here's the kiss x & now—so long, happy New Year & sweet reminiscing until next time.

<div style="text-align:center">

Salud—
Your
Leo.

</div>

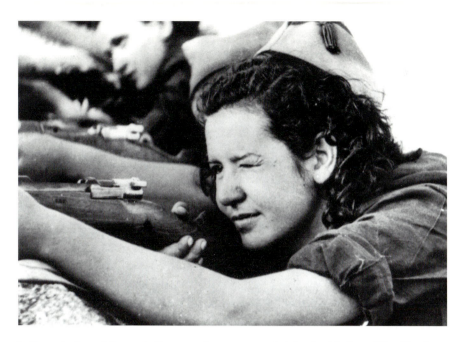

In the early days of the war both men and women served at the front in the militias. The fierce battle at Somosierra north of Madrid in the summer of 1936 was one of the first conflicts of the war. This is a photograph of a Loyalist firing line at Somosierra.

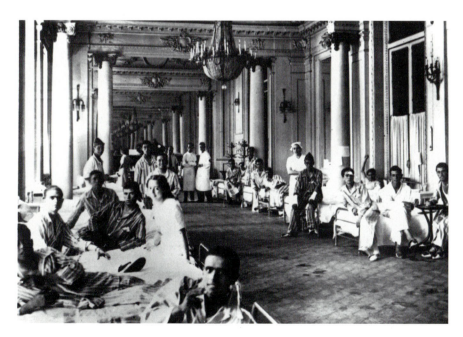

One of the most beautiful salons of the *Casino de Madrid,* converted into a hospital for wounded soldiers of the Republic, August 7, 1936.

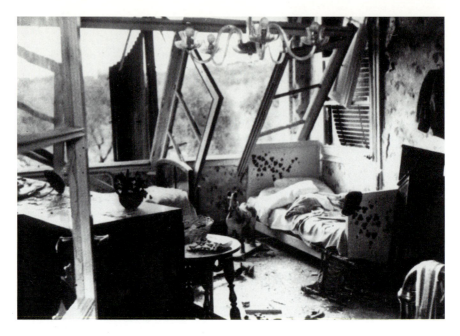

A child's bedroom in Madrid, March 20, 1937, after the family's home was damaged in an air raid. The sight of an apartment building with all its rooms open to view was fairly common when a bomb sheared off the outer wall.

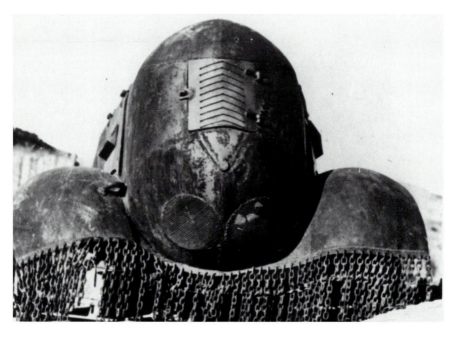

A Soviet armored car, captured by the rebel forces in their drive toward the Mediterranean. April 13, 1938.

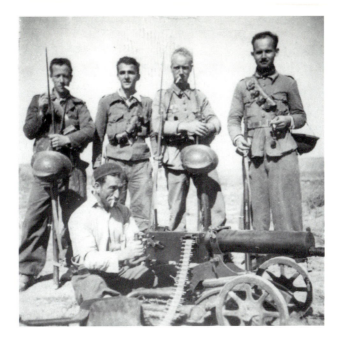

An American machine gun company. Neal Wesson and Sam Walters
are on the left. Second from the right is an American nicknamed
"Whitey." The man in front behind the machine gun is a Spaniard.

An Italian flier fallen from his plane, brought down in a dog fight in the Aragón campaign.

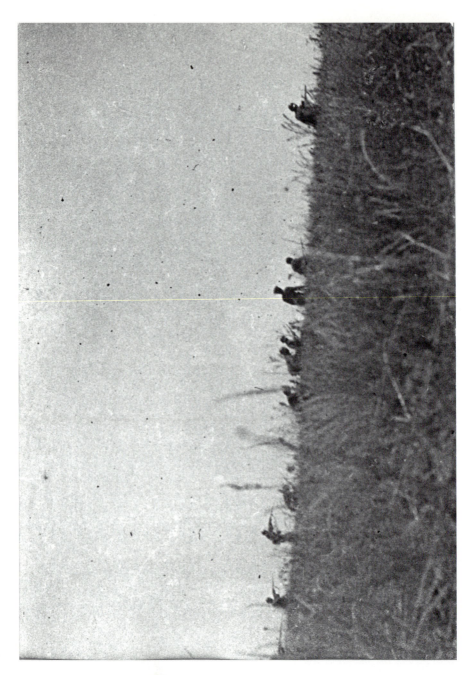

Oliver Law (third from the right, wearing a military cap) in action at Villaneuva de la Cañada in July of 1937. The Americans are attacking the town across a field. Law, an African American volunteer from Chicago, commanded the Lincoln Battalion until his death in the assault on Mosquito Ridge. Photograph by Sam Walters.

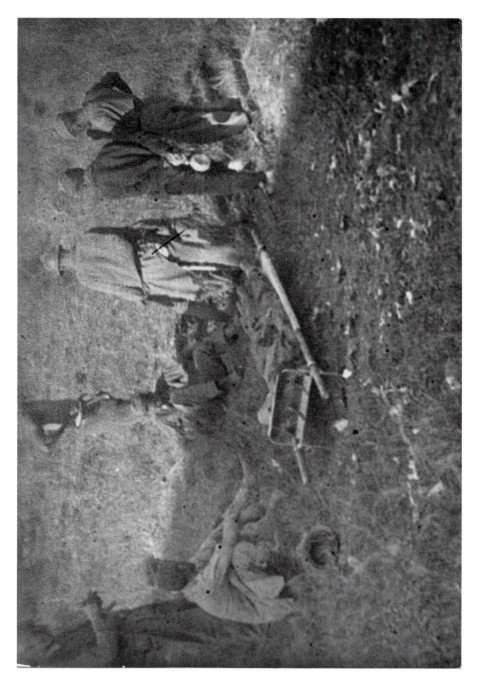

Burial of Jack Shirai, popular Japanese-American cook for the Lincolns, who requested a combat assignment and became a machine gunner. Shirai's body lies face down on the stretcher in the foreground, surrounded by other American soldiers. The photograph was taken by Sam Walters on July 11, 1937, immediately behind the lines.

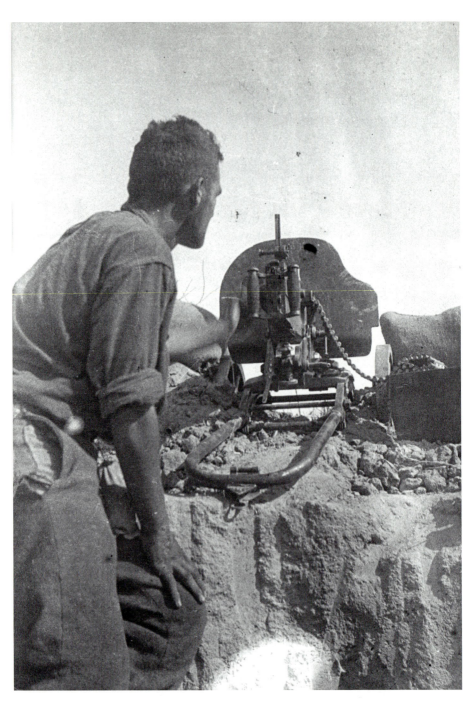

Sam Walters at the front during the Brunete campaign. The machine gun is a Maxim.

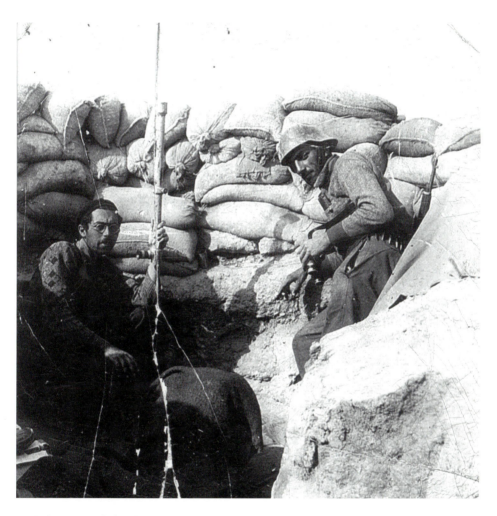

Jack Freeman (left) at his observation post in a trench.

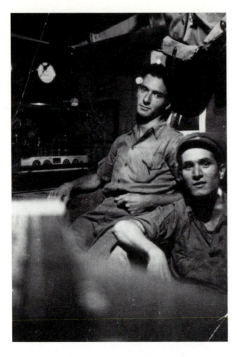

Leon Rosenthal (left) and his assistant Sam inside their sound truck (1937).

Len Levenson in Madrid in December of 1937.

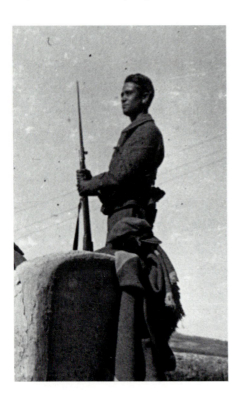

Harry Fisher standing (at left) and in a close-up (above), both photographs taken in 1937 after Brunete.

The second page of a December 22, 1937, letter from George Watt to his sister Mae. The sentence at the top, in its entirety, reads "Tell them all not to worry about my wound anymore I'm quite allright & as healthy as ever—just some nice scars to show my grandchildren."

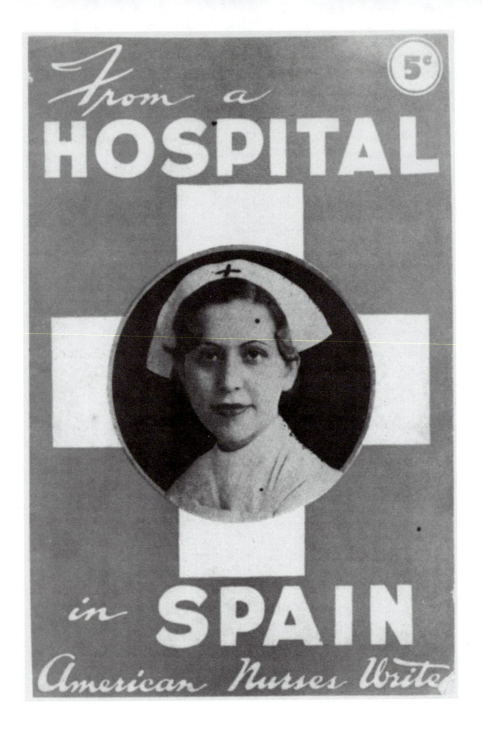

Front cover of a pamphlet issued by the Medical Bureau to Aid Spanish Democracy in 1937. It includes condensed versions of nurses' letters and an interview with Edward Barsky.

THE MEDICAL SERVICES
Making History and Saving Lives

INTRODUCTION

The volunteer Medical Services in Spain present a story of often selfless dedication under fire and with limited resources. Some of the doctors and nurses who went to Spain lost their lives in front-line service; others were wounded. All worked long hours under the most difficult conditions imaginable. Like the other volunteers, they were motivated by antifascism, leaving their jobs, their families, and their homes to place themselves at risk on the eve of a worldwide struggle. Because their motivation was not only humanitarian but also political, their story represents the founding moment of modern medical activism both here and abroad. Thus in America, the Medical Services in Spain provided the inspiration for the medical activism of the civil rights era and for the gift of ambulances to Nicaragua decades later. They leave us a special legacy about the social meaning and political responsibility not only of the medical profession but also of the professions in general.

As Peter Carroll tells the story in *The Odyssey of the Abraham Lincoln Brigade* (1994), a group of physicians met in a private home in New York to found the American Medical Bureau to Aid Spanish Democracy in October of 1936. With endorsements from physicians throughout the country, they embarked on a major fund-raising campaign to send ambulances and medical supplies to loyalist Spain. Within a few months, there were chapters in other cities and several hundred thousand dollars with which to purchase supplies. That effort would continue throughout the war and would prove an important rallying point for popular support for the Republic, but it soon became clear that there was a need for a still greater commitment—to provide medical personnel and to organize a wartime hospital in Spain.

The first group of medical volunteers, led by Edward Barsky, a surgeon at Beth Israel Hospital in New York, sailed from New York on January 16, 1937, just three weeks after ninety-six future members of the Lincoln Battalion made a similar journey. Fredericka Martin, night supervisor at the Crotona Park Hospital in New York and now scheduled to be head nurse at the first American hospital, was also in the group, as were nurses Anne Taft and Lini Fuhr, laboratory technician Rose Freed, and painter, interpreter, and soon-to-be administrator Mildred Rackley. In all, there were seventeen in the group, the first of about 150 medical volunteers who would eventually serve in Spain. Barsky was to be director of American hospitals in Spain, succeeded by Irving Busch when Barsky made a return trip to the United States. In Spain they would be joined by physicians and nurses from elsewhere in the country as well. Among them was Leo Eloesser, born in San

Francisco in 1881, a 1900 graduate of the University of California and a 1907 gradu-
ate of the University of Heidelberg. He was a clinical professor of surgery at Stanford
when he left for Spain. Before long, Toby Jensky, also a nurse at Beth Israel in New York,
would join several of her colleagues.

When the first group left, they expected to assist at an established hospital. By the time
they made it to the Madrid area in February, the Jarama battles were under way, and
there was no appropriately positioned hospital to receive the wounded. Almost overnight,
they had to create one. That was to be the American hospital at Romeral de Toledo, just
south of the town of Ocaña on the Aranjuez-Albacete road and near the Jarama front.
It was the first of several hospitals strung out roughly along the Madrid-Valencia high-
way. The second hospital was actually a group of three set up at Tarancón, two in the
town itself and one on the Valencia highway. The Tarancón area hospitals were bombed
twice in March, with severe civilian casualties. Early in April the American base hospital
was moved again, to the estates of the Bourbons at Villa-Paz, next to the castle of
Castillejo, near the village of Saelices.

A year later the American hospital would be moved to Catalonia. In the meantime,
as they were needed, American nurses and physicians would be transferred to a series
of new hospitals, including Murcia, Cordoba, Benicasim, and Denia on the
Mediterranean. But all these were only the major hospitals capable of handling long-term
cases. There also had to be first-aid stations at the fronts, along with emergency surgery
and evacuation stations. John Simon, portions of whose diary are published in Chapter
Three, served first at the Jarama front. These front-line units had to follow the shifting lines
of battle, and it was there that medical workers lost their lives. Also of some fame was
the mobile auto-chir, a front-line operating hospital on wheels.

•••

from EDWARD BARSKY

[early-March, 1938]

Dear Jesse [Tolmach, M.D.]:

Just a few impressions that I feel the urge to set on paper. I've had a good sleep—a
cup of good American coffee and there's a lull in the work. When I think back on the
last 6 weeks, there are so many unusual occurrences and experiences. However, just
at this moment, two things come quickly to my mind—two very different and extreme-
ly contrasting occurrences.

When we first arrived at the little town where our first front hospital was to be set
up—at night, in a shell-torn village—dark, cold, gloomy—a surgical team we formed—
just 5 of us—the rest we had left to set up an evacuation hospital. Well, we rushed
around and managed to get two rooms, each with a bed. There was no wood—and it
was cold—just a damp uncomfortable cold—and we wanted some coffee. We had some
and just walked into the kitchen of one of the houses—and started to make a fire. We
prayed and nursed a fire, started with paper, wooden dishes, and anxiously watched
and held our breath as the fire grew. And then, hunted about for water—a pot, etc., and
finally had our coffee. Gee, it was good—lifted our feelings—we sat and smoked, and

almost cheerfully tried to keep warm around a dying fire. Since then, I often think of that evening—our persistence with that fire—charging about for water—and how hard we struggled so that we each could get a cup (tin mug) of hot coffee. The coffee seemed so important—the inconveniences, the petty annoyances seemed not to matter—we wanted coffee and we got it. I suppose it sounds as though we are making too much of a little thing—but, honestly, I'll never forget that night!

And now for the other—the contrast is almost laughable. The town where we had our first front hospital was bombed every day—and such bombing I had never seen. One day, from 10 A.M. to 4 in the afternoon, planes were overhead all the time. At one time I counted 47 planes—going through all maneuvers—and dropping bombs all about us—and diving down to machine-gun us. When we weren't working, we stood about—ready to dive into the trench—trying to measure whether we were just beyond bomb-range, or not. Every passing plane was a threat—and they kept passing from all directions—groups—2-6-12-24—all bombers and some strafers. What a day!—Later, while I was operating, I could hear the rapidly increasing drone of the planes, swooping lower and then the rat-tat-tat of the machine gun—of course, being busy and engrossed in operating is a great help.

These planes were out to ruin this village—and the hospital—and for the past few days kept coming over in increasing numbers. We'd watch most of the night—crawl into a cold room and a colder bed (the sleeping bag certainly came in handy) and try to sleep—at times too fatigued to fall asleep and knowing that the next morning would bring the planes! And then sleeping is almost impossible. It's bad enough to be bombed—but it's a little easier if you can see the planes, and decide that this one is a little to the right or to the left or better jump into the trench or get alongside a wall or rock.

One night we were swamped with work. The wounded came in—ambulance load after ambulance load—terrifically sick, most of them in severe shock. This hospital was so close to the front, that we got many patients who would have died on the way to a front hospital a little further back. The horror—the misery—the feeling of impotence that we had—the sense of resignation and acceptance—all these would make a terrible tale. How we tried to keep the place warm—fought to heat water—struggled with gasoline stoves that wouldn't work—This night we worked over apparently hopeless cases—operating—operating—treating shock—groans of the wounded—the transfusionist running from one operating room to another—and we kept going all the time. I don't know where we got the strength and the endurance to keep going—but we did. The sky was gray when we stopped and I for one, hoped that it would pour—rain and rain—so that the planes wouldn't come and so that we could sleep—I got to bed—really too tired to sleep—finally dozed off. And was suddenly awakened. That morning the planes came over early and bombs were dropping about us. There was one terrific explosion and the dust and pebbles flew in the room through the window. I rolled out of bed to get a little further away from the wall and waited—waited for the next bomb and wishing it would fall—so I could hear it and know that it had missed. It's a terrible sensation to wait like that—inside—and wait for the next bomb. Will it strike—won't it? What to do—stay in this place—rush out—Well, it's better to stay—one place is as safe as the next—none of them safe at all. A bomb had landed just about 8–10 yards in front

of the house we were all sleeping in—what a lucky escape. I dressed in a hurry and rushed over to the hospital to see whether any damage had been done there. All the windows were out—all shelves down and the patients (and others) more than somewhat frightened. The next few hours were spent anxiously watching the sky and at times diving into the trench. We, of the *autochirs*, standing just next to the hospital received a few machine-gun slugs—the bastards came that close.

Well, at this moment, these two contrasting events pop into my mind—this air raid—and trying to get the coffee made.

Even at this second, Oscar Weissman is struggling with a gasoline stove—and when it gets going, we'll have some coffee. The food is fair—not too much nor of a great variety—and, luckily, some of the gang still have a bit of coffee (U.S.A.)—a few tins of sardines—kippered herring—or even a bit of candy. Can you imagine—this morning—also after a night's work, Anne Taft gave me a bit of tomato juice—can you beat that?

After that last bombing, the patients and also the others were in a bad way. An attack was being planned—and the town we were in was certainly not safe. The next morning would bring more planes—and the town, including the hospital would be ruined. I have seen front towns without a single untouched building. Luckily, the general gave orders for us to move—and we had to evacuate all the patients. Some had been operated on just a few hours previously. I had done a few head cases—one interesting case with a slug in the splenic end of transverse colon—just stuck in the wall of the gut and acting like a plug. Phil Detro, Captain of Lincoln-Washington Battalion came in with explosive bullet wound of thigh and fractured femur—these and many others—and they all had to be moved—to one hospital—to another—to a third—one after the other, because there was no room.

We emptied out the place—packed up and moved about 4 AM the next morning. Arrived at this town, confronted with the necessity of getting a hospital started as soon as possible. The fighting kept going on and we had to get ready—and also get a place where we could sleep—and a mattress to throw on the floor. So far we had been up for 36 hours—and all this had to be done. Well, we worked and weren't ready at all, when wounded began to arrive in great numbers. Our electricians were wiring up the place—and we couldn't get the dynamo going—no lights and we had to operate—cold as the deuce and we had to treat the wounded.

By the aid of flashlights, automobile lights, candles—I started—and the first case was an extremely sick English fellow—about 25 years old—a good-looking chap. He was sick—a shrapnel wound through upper left abdomen. He needed a transfusion—all our bottled blood was gone. Our personnel so busy and so necessary—and this fellow should have about a thousand c.c. transfusion. I had to operate anyway—he had a tremendous tear of the splenic flexure and a marked spleen. With the aid of poor and wavering lights that would often go out—I had to do a splenectomy and a resection and anastomosis of the splenic flexure. Dr. D., Head of the other surgical team, offered to be a donor, but after 200 c.c. he passed out (fainted). He had been on the go all this time, and working like hell to get the lights going. We finally got through and had a very sick patient for the nurses to care for. D. had to quit and I kept going. There wasn't very much but enough to keep us until….(stop of a hair-cut and shave—by the guy who does the patients and a cup of American coffee!) about 5 AM—and then I hit the

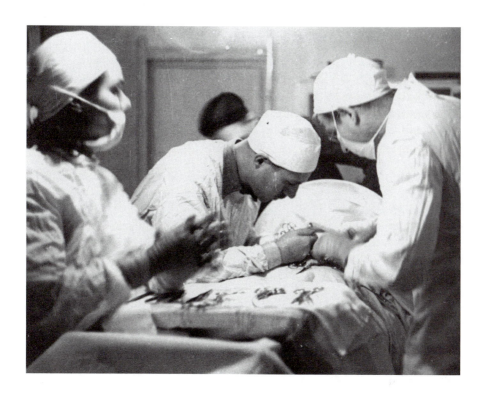

Nurse Anne Taft assists at surgery.

hay and no planes until late in the afternoon. So I slept about 8 hours. And now I feel okay.

So that's that—and maybe I'll mail this and I hope it gets there.

Since the last, a great deal has happened—a move to Val...and then a move again and we set up a hospital in a series of barns—and did a good job of it, too.

Feb. 4—expecting to get orders to leave—half-packed—work cleared up and we're all anxious to get to Valencia—especially for a hot bath and do I need it—and a complete change of clothes.

We have been on the go since December 10th.

A lot more has happened—and two days ago, we pulled out. I went to Barcelona for something. Found the mobile hospital, etc., but can't write any more, but to say that I just received orders to pull out again at once. So I gathered up the American Mobile Outfit by phone orders and am leaving at once. Will write again, and in detail, etc.

Love to all. Hope you can use some of the above notes for publicity—save them for me.

Regards from Busch.

Eddie Barsky

• •

from MILDRED RACKLEY

March 8, 1937
[Romeral]

Medical Bureau
American Friends of Spanish Democracy
20 Vesey Street
New York City

Dear Friends:

Since our last report submitted from Valencia, we have been working constantly, first getting the hospital installed, and then getting from one to fifty patients a day.

From Valencia we went down to Albacete, a central distributing point for medical supplies, and from there we received instructions as to our location, which is about eighty-five kilometers, or fifty miles, from Madrid. We are about thirty miles from the front. Dr. Barsky and Miss Martin with a representative of the military authorities spent two days looking for a location, and before it was found I got orders to move the entire personnel and equipment to the town where we were supposed to settle, but it was impossible because there was no building. When we arrived, Dr. Barsky and Miss Martin almost collapsed, because there was still no place, and they had not been able to look further because their car had broken down. It was then imperative for them to find a place, which they did, in the next village. About a week later, this village was bombed for no reason whatsoever.

We are now settled in a new school house, with no sanitary facilities (we all wonder how the Spaniards manage), a very feeble electric line, no telephone, no water, and a pretty awful road. We went immediately to the *alcalde* (mayor), head of the Popular Front asking him for the full cooperation of the village in the installation and operation

of the hospital. They did absolutely everything for us. We had dozens and dozens of men carrying out school desks and tables, the electricians were wiring the building for lights, the telephone service were installing two telephones, all the masons in the village were working the entire night knocking through a wall to connect the upper and lower floors. Another crew were unloading trucks, still another opening crates, and an army of women were sweeping and washing the floors. There was no place to eat, and no kitchen in the building.

We had orders to open the hospital for work in forty-eight hours, and we were giving everything we had—every one of us—to have the hospital ready.

On the third day, the patients began to pour in. We got forty the first day.

Twelve of our boxes were lost in transit—among them, the big autoclave, with rubber sheeting and mimeograph machine. We carried on the first few days using the small autoclave and boiling the rest of the instruments in pans. Later we got a broken autoclave from another hospital near here, and a second one, without stove, from Madrid.

The roads for six kilometers on either side of us were so bad that it would have killed a patient to take him over them in the ambulances. We spoke to the *alcalde*, and the next day all the peasants were forbidden to go to the fields, and literally thousands of men—all those not fighting at the front—were working on the road, carrying baskets of stones and filling in the holes, then baskets of earth to put around the stones. I can't tell you the feeling it gave me when we took the first bus over the road and all along the way, Salud! Salud! from every one of them.

Practically all of the soldiers we got were badly wounded, and all had to have operations. Many of them were shot through the skull, others through the chest, and numbers of them had nasty abdominal perforations. Every operation that Dr. Barsky performed was really a work of art. And every member of the staff has helped whenever possible, and in every way with all kinds of work. One night in the middle of an operation, the battery went dead. All of us ran for our flashlights, and with the feeble glimmer of eight flashlights, Dr. Barsky finished removing a shattered kidney.

Last week we had about sixty coming in in a few hours, the doctors and nurses were working forty hours without stopping, going from one major operation to the next.

• • •

You will be able to see from this the pressing need for able surgeons in all fields. We have not handled any civil patients, and won't unless the village is bombed, which it quite well may be any day, since other hospitals have been systematically bombed. Malaga and Madrid are the principle spots where there have been any number of civil patients.

Besides the initial seventeen in our American personnel we have about fifty people working for us, including eight chauffeurs, nine cooks, ten assistant nurses, ten washwomen, scrubwomen, seamstresses, stretcher carriers, etc.

As soon as patients are able to be moved, we evacuate them by train to base hospitals, keeping as many free beds as possible.

When we arrived in Port Bou, two of the cases were missing, and I have put in a claim for damages on these two boxes. Number 12, containing hospital and ward

supplies, 293 lbs, red and blue, mimeograph machine, office supplies, rubber sheeting, needles, etc., valued at $400. Number 2 containing Operating Room Supplies, weight 226 lbs, yellow, anestex pkgs, luer needles, silk ligatures, syringes, catgut, etc., valued at $1000.

The other ten boxes we have tried to locate, without success. There has been a shortage of needles, catgut, and all the things in the lost cases. I made several trips to Madrid and Albacete to get supplies—rubber sheeting, needles, X-ray, sterilizer, etc. The other supplies should be duplicated as soon as possible.

The description of the boxes:

Case #17	Color red and blue	weight	40 lbs
" " 1	blue	"	370 "
" 25	blue	"	73 "
" 101	yellow	"	650 "
" 103	yellow	"	145 "
" 302	no color	"	115 "
" 303	no color	"	112 "
" no number marked crinoline gauze			177 "
" no number " gauze bandages			185 "
" no number " gauze bandages			152 "

The small sterilizer is of little or no use, because it is too slow, too small, and the instrument sterilizer is made of inferior metal causing the instruments to rust. The only good part about it is the water sterilizer.

The heating apparatus in the ambulances is worthless, and does not function. The tubes are all bent. In this cold weather, we need good heaters. The steering gear was loose, and there were no tools.

Please try to arrange with various papers and magazines to send us literature. We are supposed to have a service here, but it is spasmodic and irregular.

Our mailing address is Socorro Rojo, Plaza Altozano 4 a m, Albacete, Spain. Our cable address is the same until further notice. I am told it is very difficult to get cables through. The only cables we have received from you are: one to Valencia re. sending out a pediatric unit, and one from Health and Hygiene.

We sent you a cable from Madrid when Dr. Barsky, Miss Martin, and I were there. When I was in Madrid Feb. 12 and March 4, cables were sent, but we have received no answer to them. I dropped in to see Matthews of the *Times* each time to give him and the other correspondents stories.

Did you hear the broadcast Monday evening March 1st from Madrid? Dr. Barsky and I wrote out the script for it, and intended getting in to Madrid to talk to you over radio, but there was such a rush of work that it was impossible to leave.

We hope that the unit which has sailed is another complete surgical unit with supplies to set up another emergency hospital. This should include everything—X-ray, complete electricity (portable) generator, wire splints of all kinds, complete list of instruments for brain operations, electro-magnet for removal of foreign bodies, all sorts of surgical needles, needles for local anaesthesia, suture material, two operation

tables, airway for anaesthesia, knife blades. The X-ray should have enough supplies to last six months. There are practically no supplies here.

We need badly a first rate housekeeper who can cook well, to supervise the local cooks, cleaning women, food supplies, and orders.

Good mechanics and drivers are in great demand. Every chauffeur must be able to do all kinds of repair work on the cars. We had thought at first that we could get local drivers and mechanics, but it was impossible. The language difficulty was a great obstacle at first. It was not so easy to teach untrained Spanish women to do technical work without being able to speak a word of Spanish.

Wilks needs for the pharmacy: 5000 capsules #1, powder paper not waxed, ointment slab—tile, 4 oz codeine.

Among things of lesser importance professionally, but sometimes of great importance personally, there is a need for: cigarettes, matches, lighters, kleenex, radio, phonograph and records, flashlights, and masses of batteries, butter and Washington coffee. We had no difficulty whatever getting our cigarettes across France.

* * *

We are all greatly disappointed that we have had neither letter nor cable from you about the second group. When we left New York we were told that another group would sail in about three weeks. In Valencia we got the cable about the sailing of a pediatric unit about the first of March, and since then not a word. We wasted a lot of good time in Paris and en route here getting splendid publicity for the American group, and everybody in France and Spain has been waiting for the second group to arrive. Where is it? What has happened to your pledges for a continuous flow of supplies and personnel to Spain?

We have to have more surgeons, nurses, ambulances and supplies, and we have to have confidence in you that you will send them. But when will they get here? You simply can't understand the pressing need for them.

Fraternally,
Mildred Rackley

from LINI FUHR

March 15, 1937
[Tarancón]

Dear Ida:

The light streams across my shoulder from a small window in the high wall. I am awaiting patients to be evacuated. Just came to this hospital last night at 12 P.M. (very tired). This evidently was an old convent at one time. Now it is a pretty cold place. I have on winter underwear—sweater and my cape—still I am cold. Hated to have to leave our other hospital. It was running so well. Our house that we lived in was just rigged up with a shower and a radio the day I moved. I came last of all—now our whole medical unit is here in charge of three hospitals. Very shortly we hope to have this like our other place. Much nearer the scene of action now—a little too near for comfort— *c'est la guerre—*

next day—10 A.M., same room

Can't get accustomed to this—in our other hospital—I worked much—here I supervise the whole hospital and have others to do the work—supervision is much more difficult—but it's fun—with a dictionary in one hand and the other hand for sign language I manage. Feel good today—got a whole night's sleep from 8 P.M. till 6:30 this A.M.—what to someone else is a bottle of champagne may be a night's sleep and an American cigarette to us, and when we get a letter—ah—that's the height of pleasure! By the way—when are you going to write me? Haven't heard from you yet—least you could do—son of a gun.

Got 2 letters this A.M.—one from Sadie and one from another, S.W. [illeg.], who tells me I got an A on [a] term paper—who cares—T.C.[1] seems so unimportant now—Kate gave me the impression in her letter that things did not go so well in Spain—that must be the doings of the capitalist press—we are so firmly entrenched, *they will never conquer Spain.*

And the Spanish people—words can't describe them—there they are in a society semi-feudalistic—yet so much higher on the thinking political level than the American proletariat—alert, sensitive, and intelligent. I love them! My nurse Modesta came yesterday P.M. with one of our ambulances and I was glad to see her—nothing is too much for her—4 weeks ago she was a peasant girl—today she gives hypos.

Max writes come home—*das geht nicht so leicht* [that's not so easy]. Just now a Negro, a Frenchman, and a few Germans, Spanish, and others walked in waiting for dressings. When I speak German—anyway what I want to tell you is this—that my vocabulary is one international jumble. To go back to my original opening sentence. How can I get away? We are so needed here—you can not imagine—even if I wanted to come home—doubt if I could—am part of Spanish army and getting my 6 pesetas a day (60¢). And, Ida, I don't want to leave—I know Mary Lee is well, so is Max—and I have the opportunity—the rare one—of working and feeling of value—Everything I have ever learned I can use here—except some T. C. [Teacher's College] crap. Imagine—working and knowing every step one takes is helping these men who are fighting our fight against fascism. It no longer is work—it is—to repeat—a rare opportunity—discomforts matter not—as when one has comfort for a night or a few hours—one enjoys it more intensely. (Just gave out my last lousy Spanish cigarette) share and share alike—comrades all.

So you are thinking—what an incoherent letter—no continuity—wish you could see me here—first the kitchen girls ask something then someone else—so on and on. *But damn it I don't get thinner*—a little firmer perhaps—that's all—look swell, cheeks red—5 years younger (could use a bath though).

Today at 2 we have a gas mask drill and get our helmets—1/2 block away bombs demolished place—bloody fascists are trying to get road my hospital is on—*they will never succeed*—We have four hospitals here.

My patients are singing near me—the French Front *Populaire* song—now the Int.

[1] Teacher's College, Columbia University, where Fuhr was in the midst of taking courses when she left for Spain.

in many languages. They are always asking me to sing. Don't need to join the New Singers' Chorus to express my desire to sing.

One morning from 4 A.M. till 5 A.M. I stood with a Dutchman while he was going out. His last words were *No Pasaran.* He asked me to sing to him—with tears streaming I sang the Int. One Doctor accused me of being sentimental, staying with him instead of sleeping—I had been up since 6 the day before. If that's sentiment—let's have more of it—these are not ordinary soldiers dying for the imperialists—but going out in the struggle against fascism for you and me, for the Spanish people and the whole world proletariat—I could weep when any of them go out before my eyes.

One thing I hope that back home you are and the whole party is recruiting more and more to take the place of these comrades. I have seen the results of dum dum bullets—I know what beasts the fascists are—the struggle is not 4,000 miles away—but affects the world proletariat closely. Everyone.

Give my love to my friends. Please go to 20 Vesey St. or call Mrs. Felterstein at 144 East 24 St. and ask them about paying for M.L.[2] after May 1, so I can work in comfort.

Write soon.

Lini Fuhr

* *

from ROSE FREED

March 21, 1937.

Dear Lou [Freed],

I received several letters a few days ago. One from you, Helen, Esther, Millie, Mathilda and Professor Hart of Columbia. If you continue to criticize my letters, because I describe the country of Spain and give you little or no details, I shall discontinue writing. I'm in no mood for any nonsense. I'll write as I please and if you don't like it tell me so and I'll stop.

We left Romeral a little over a week ago. We are in Tarancón now. In another week or so we shall move again. In Romeral we put in what I thought was a sanitorium, but I read too that it was a school house. It certainly was a modern, beautiful building. The efficiency of the hospital was like that of one in peace and not war. When I did not work 40 hours at one stretch, I was night charge nurse. In fact, that's what I'm doing just now. It is 5:30 a.m. and I've just finished making the rounds of our three hospitals—giving medications and hypos and dressing wounds and circulating in the operating room.

I worked all day and night, then went to Romeral to pick up my laboratory (I do laboratory work too) and back to work again. Driving for 7 hours at 120 kilometers an hour upset my nervous system a bit.

I was very glad to hear that Dr. Beller is doing such good work for Spain. The money you collected could best be used in buying a small generator. We need one badly. A few days ago Tarancón was bombarded. I explained that there are three hospitals here that we are in charge of. Hospital #3 is on the Valencia Road, and that of course was the target. One grape fell about 5 yards from the hospital, crashing all the windows and breaking the water main. For four days there was no water for the

[2] Mary Lee Fuhr, Lini Fuhr's daughter.

Rose Freed and Langston Hughes in front of an ambulance donated by
students, faculty, and employees of Harvard University.

patients. When a bombardment is expected all the lights are put out. If the surgeon happens to be operating they must continue with only the dim rays of the flashlight. If we had our generator we could supply our own electricity and would not have to depend on a central plant.

We need 1,000 more beds, 14,000 more sheets, 3,000 more pillow cases, 7,000 blankets and 2,000 mattresses. A hospital that has 120 beds and all beds occupied may receive 400 more patients in one evening. The boys suffer so much—there is no reason why we cannot have a bed for each one instead of using the floor or a narrow stretcher when they are in excruciating pain.

I need not mention the fact that nurses and surgeons are in great demand. The money raised for Spain should help our plight very much. There is little food here and if possible send us at least 500 pounds of good chocolate bars, as much sugar as possible and as many cigarettes as money can buy. I cannot say much about the political situation, but I will tell you just how I feel about certain things.

The Popular Front must be maintained at all costs and the Communists who created it must see that it gets stronger every day. Only with unity of all antifascist forces in Spain will we be able to win in the end…sooner or later. Our forces, our brave troops, workers of Spain, are winning at all fronts. We inflicted such a blow to the Italian invaders at Guadalajara that it is almost unbelievable if you are not here to witness it. The control of the coast of Spain and the frontiers by the world powers is the sister of the Non-Intervention Pact! We no longer trust or believe the democracies of the world, who are leaving us here to fight for our democracy and theirs. They have given us no help—instead a lot of trouble. We are only interested in the union of the Workers of Spain and of the world. We must win this war! We are not interested in any Non-Intervention Pact, Control Plan, or X Pact created by democracies who sit back and offer no help. And by the way, I wish you'd write to me and let me know how things are progressing in Spain. The only news one gets is of their immediate environment, and nothing more. We are in complete darkness of so many things.

It is three days now that I started to write this letter. It is March 23 now at 12 noon. We have just evacuated many patients to the base hospitals and the doctors and nurses have collected in my room. I cannot sleep. They are dancing and singing and their conversation is only of home.

It is March 27th now, at 11 a.m. I just got off duty and was told to go to the post office to get your registered letter. It made my morning pleasant.

Last night it was Dr. Goland's birthday. We made a party at the American *Casa*. I made rounds and came to see how things were going at the party. We were drinking champagne and had just given Dr. Goland his birthday present, which consisted of one dozen toothbrushes each in the center of a cupcake with bristles exposed and blue ribbon bows tied to each, when at twelve midnight the lights went out. We heard the roar of planes. There was a long silence in the room. I spoke. I said I was going to the hospital. Dr. Bloom shouted, "If you think anything of your life don't go." Dr. Barsky said he was going to the hospital. I ran to hospital #3 on the Valencia Road, Dr. Barsky to hospital #1, and Dr. Odio to Hospital #2. I stayed outside the door of the hospital searching the brilliantly studded starry sky for a sight of the planes, but they were too high and had no lights. They circled over head many times, they came lower and lower and

the sound of the motors became louder and louder. I ran into the hospital only to find some of the Spanish *enfermos* [patients] in hysterics. They could not be blamed, they who so many times have been terrorized by the lousy tactics of the fascists, and whose minds reflected the fatalities of such terrorism, and whose fathers, brothers, sweethearts and husbands died on the battlefield singing the "Internationale" as their last strength and life ebbed out for the cause of democracy and love for humanity—could they be blamed for hysteria when they realized what was coming? What right had I to be frightened? I who have just tasted what they have long lived through? With my heart pounding almost as loudly as the roar of the motors above, I spoke to them. I told them they must be brave. I told them that they must comfort brothers of Spain who are lying in bed helpless, most of them unable to move. I felt strong and stern—what did it matter our lives to be sacrificed for so many that they may continue to live in peace. They clung to me with an almost deadly grip, kissed me and dried their tears. The crash you cannot—never can anyone realize the horror of what seems like the earth opening beneath you. The light of the magnesium flare bomb to see if they struck right—and then eight more crashes—then silence, too long, and shrapnel flying in all directions. I ran to hospital #1, then to hospital #2, then back to my post where I found all crying silently. I made them all go to sleep and stayed on alone. Later in the morning Dr. Sarrel took the post with me.

I couldn't sleep the next morning, so I took the ambulance and went to Colmenar. It was a beautiful drive. Percy Mac and I took pictures. We stayed with Dr. Dumont and Dr. Langer until late in the afternoon and then Dr. Langer drove me back to Tarancón.

You ask me to write of the Spanish people. All I can say is that they are the most simple, most grateful, and most lovable people in the world. They are first starting to realize conditions in Spain and the world, but I am isolated from them. I am with the soldiers—how can I write more about them?

I judge the spirit by the soldiers. An ambulance came in with 30 wounded. We started to take care of the wounds and bandage them before we put them into bed. A young Spaniard (he must have been 16 years old at the most) became impatient. He took out his penknife, cut open the palm of his hand and removed the superficial inflicted bullet (all this without our knowledge). Then he held up his wounded right hand in a salute, and holding the penknife in the other with the bloody bullet shouted *"No Pasaran!"* In Spanish *"No Pasaran"* means that Franco shall not pass. The bullet you see, did not pass through the palm of his hand. It was in, but not deeply imbedded. How's that for spirit!

I should love to have newspapers, the *Daily Workers* and the *Times*. Also literature. Answer soon and I shall look for time to write more often. Tell ma not to worry and that I have received a medal—a star and stripe.

<div align="right">
Love to all

Rose
</div>

P.S. My address is:
> Rose Freed
> Socorro Rojo
> Plaza Altozano – 4 A.M.
> Albacete, Spain

...

from TOBY JENSKY

June 21, 1937

My Dears—

I've been meaning to write the last few days—but I've been so disgruntled—I just couldn't get down to it. My being disgruntled was about nothing important—just some petty things that occur all over—somehow I didn't expect it here. Enough of that—tonite we had our first dance. We invited the boys of the Lincoln Battalion and a good time was had by all. I'm still on night duty, but I was relieved for a few hours so I did my bit of dancing. The dance was also successful in keeping the patients awake and now at 3 A.M. they're just about popping off. But what the hell. Among the boys were a few I knew from the Village, so we talked & talked about New York and I really feel much better now.

Our visit to the Lincoln Battalion was more of a visit with generals. We made three stops on the way—first we had lunch (with many speeches & champagne) with one, lemonade & speeches with another, just speeches with the third. By the time we got to the boys it was time for supper and after that we scrammed. The generals are very nice but the ones we met don't speak English. Anyway the champagne was good; just a few sips made me horribly sleepy. But riding in the back of an ambulance over dirt roads awoke me. The part of the country we passed thru was grand, mostly farm land with a few towns in between. The soil is a brick red and all the green grass & vegetables make a swell contrast. They also have swell moonlit nights here. During the full moon, you can sit outside and read it's so light. The only trouble is that it's also light for the fascist planes.

A little girl was brought in here yesterday—all shot full of holes—both her eyes blown out. It seems that she and a few others found a hand grenade and decided to play with it. Her brother died soon after he was brought in. 3 other kids were slightly hurt and she, if she makes it, will be blind and all scarred. It's a pretty horrible thing—she's got plenty of guts and certainly can take it—you never hear a whimper out of her. She's about 10 years old. It's the same sort of thing you see in places that have been bombed, only more of it. It's a stinking business. We still get very little news of what's doing. Occasionally we get a *Daily Worker* about 3 weeks old. I still don't read Spanish, so there you are. I can speak a few more words. I wish I could make myself sit down for an hour a day and study, but there's always something more pleasant to do. Maybe some day soon—

I haven't written home for a while, so will you give them my love? I'll write soon. Did you get my letter asking for a grocery store? I hope you can do something about it. Dr. Busch was here Thursday. I saw him for a few minutes.

Jack still does his share of writing, but never any news—mostly poetry—and mush—the poor censor! But it's war, comrades.

Here's hoping we beat the hell out of the fascists soon, so I can get back. From the little I've seen of Europe, I know that I like America—

Keep on writing—
Saluda Comarado (the one & only salutation around here).
Till.

There is still plenty of romance in the air here—now it's an English sculptor. More about him later.

Please don't show or read my letters to Jack S. I might & have written things I don't want him to see. I hope he falls in love with a blonde soon.

I have not seen or heard what you asked about, but I'm making inquiries.

• •

from ANNE TAFT

July 15, 1937

Dear T.—

Just received your letter dated June 18, and was glad you sent the newspaper clippings. As yet the new groups have not arrived and we have not received the packages, but we hear that they are on the way, and have many things for us.

At present I am in the midst of setting up my fourth operating room, and T., each one presents new problems, and difficulties; but I guess the first 100 will be the hardest and then I'll be able to set up with my eyes closed. Do not think I'm discouraged because I'm not. It has been a grand experience, and is worth five years of my life.

My first operating room was set up in Romeral, and what a problem! No running water; water had to be carried in the house after we had pulled it up from a well, and then was placed in tanks for scrubbing. Water had to be carried in for the autoclaves, etc. Our autoclaves are heated by prima stoves which run on kerosene, and you can't imagine how much work there is attached to sterilizing and keeping things clean. We spend hours trying to figure out a way in which to sterilize our goods so that things come out dry. We have not given up trying although we have been at it five months. The sterilizer was very cheap and the water was very hard, and so when instruments were boiled, they were coated with lime and muck and what not. Soda bicarb and other chemicals would not soften this water. It would take me an hour or so to wipe the muck off the instruments every day. Finally I decided that if I boiled the instruments in something else, they might be cleaner, and that I would have more time for other work. So I hied me off to the kitchen and appropriated three dish pans for boiling and three frying pans for covers. What fun! The Primus stoves did their damndest but it used to take three hours to get water to boil; then the instruments would rust and stick, and all the greasing in the world was more or less ineffective. Wounded kept arriving day and night. It was so cold that while assisting at operations, I used to hop first on one foot, and then on the other to keep warm. The instruments were so cold they stuck to my hands and poor H. used to run her feet off carrying sterile hot water, circulating for me, and three or four small operations at the same time. We had no material for lap sponges, so we used muslin and gauze. We had no jars for catgut, so again we raided the kitchen, and every pot with a cover took up residence in the operating room. Some were red enamel and had two ears, and some had one ear, and no two pots were alike. Imagine! We even have glove covers made up by the peasant women. Every empty can that had a cover and every cookie box was appropriated so that I could keep up a good supply of sterile gauze for the operating room and the rest of the hospital. We cut up some rubber sheeting, dug up the back yard, and made sand bags. We made masks from unbleached muslin; and when I scrubbed I always had on a pair of woolen socks,

three sweaters and a jacket, besides the regulation uniform of the Medical Bureau. I'd fold up all my sleeves and commence to scrub in ice cold water, and then struggle into a gown. It was so cold, that you could see clouds of vapor rising from our patients' abdomens, and other wounds. Blankets were placed on the patients' chests and legs, and hot water bags were placed under their shoulders, buttocks, and feet; and in spite of everything we did, we could not keep our patients warm during operations. If we plugged in the electric heaters, the lights grew dim, and we could hardly see to operate; so we had to sacrifice heat for light. It is surprising that in spite of all the difficulties, our mortality rate was very low, and we are astounded at the unexpected recovery of some of our most serious cases. But the will to live is great, and all are fighting for a better world. After about a month of working day and night, we were told that we would have to move because the fronts we were serving were quiet, and we were needed elsewhere. Freddie Martin came to wake me one afternoon, and said, "Anne, pack the Operating Room; we are moving." She has said this so many times, it seems that some day when I'm old and grey, and death comes and taps me on the shoulder, I'll jump up thinking it's Freddie saying, "Anne, pack the Operating Room." The day we moved was March 17th and what a day it was. Cold, raining, bitter! We landed in the new town, knee deep in mud, and commenced to try to set up. And all the time wounded were brought in, cold, in shock, bleeding, dying. T., it was—I can't tell you what it was. Words cannot describe the horror of it! Things were so difficult. Not enough beds, instruments, linen or other equipment. Freddie has been marvelous. If she hadn't been with us, we never would have survived.

After we had been in this town a few days I went to bed with rheumatic fever, and had to remain in bed all the time we were at this hospital. Poor Rae Harris! Besides being night supervisor, and the only American nurse on nights, she had to work in the operating room day and night. Of course none of the nurses got more than four hours sleep at any time, and many a day, no one saw a chair or bed for 72 or more hours. We were so overcompensated, that when we finally went to bed we could not relax. Every time I tried to get out of bed, and go to work, Freddie would come along and sit on me. But everyone was working so hard, and I could not rest knowing that my being ill made it so much more difficult for everyone else.

After a month in this town, things sort of quieted down and we moved to the two *casas* that at one time belonged to the royal family. They must have expected us, because they left us the most beautiful parks and estates. The place is large and spacious, and we've been able to establish a really beautiful and efficient hospital. As a matter of fact, we've been told the Americans have the best hospitals in Spain, and that they realize that it is due to the efficiency of the nurses and doctors. I may sound very conceited, but I am proud and happy to be here helping the brave Spanish people wipe fascism off the face of the earth.

Now to get back to the operating room at our base hospital near Madrid. Four rooms make up our operating room; one room, where we do all our ambulatory patient dressings. We have regular dressing teams. Rounds are made at 8:30 A.M., and immediately after all dressings and treatments are taken care of. One team does dressings on the wards, and one in the dressing room triage. One of the rooms is used for clean operations only, and we have another for infected cases. We have had many cases of

Gas Gangrene; but in most cases we have been able to clear them up with the use of Sorum, Daikins and azochloramid. Of course, some of the more virulent cases had to have amputations; but, again, we have been very fortunate, and very few were done in comparison to the amount of definite infection.

I wish you could see the operating room. I am so proud of it. Again, I had no catgut jars, and so Lini told me about the royal preserve jars. I've been told that the operating room compares very favorably with any of the better operating rooms in New York. We have running water and electric lights, but the sterilization of instruments is still a problem. You see, we must keep everything sterile at all times, because during an attack, we have no time to stop and boil instruments. We autoclave our instruments in small drums and boxes and royal preserve jars. Everything that we can possibly autoclave is sterilized in this fashion. The whole department is quite complete, except that we never have enough instruments, suture needles and needles for intravenous use. Up until the new groups began to arrive we had to use clysis needles for local anaesthesia and intravenous use. The doctors would like needles varying in length.

The wards run smoothly, and when the patients have to leave, they are very sad and say, "*Mucho contento con los Americanos*" [We were very happy with the Americans]. That is all we want to know, and we feel that we are doing good work.

T., dear, don't think that I'm bragging, and if I am, I can't help it. Again I repeat, I'm so proud and happy to be here, and I won't come home until it's all over and we are victorious. There is work to be done and we must do it.

July 4th, four of us nurses were sent back to one of the towns to set up the operating room and be a surgical team. Between setting up and making surgical supplies, we spend every spare moment killing flies. We've managed to rid our base hospital of flies, and we will soon have this place cleaned up. My head is reeling, the flies are biting, and I must get some more work done. In a situation like this, we are never through until everything is cleaned up and sterilized down to the last pin.

Tell B.A. that I received both her letters and thank her and B. for sending the packages. Regards to Dr. E. and Dr. H.L. and all the others. Congratulations to R. and H. My love to all the girls and tell them to write. Remember me to Boss and Z.

Helen went to Cordoba because I was ill, and I hear that she is doing a swell job in the hospital on wheels, and is very happy. One of these days when things quiet down, I may be able to visit her and we will be able to know just what we each have been doing.

I will let you know when the packages arrive, and thanks loads for everything. Tell my friends to write.

Love to everyone.

<div style="text-align: right">

Lovingly
Taftie

</div>

..

from TOBY JENSKY

<div style="text-align: right">

July 23, 1937

</div>

Dear Jenks & Mac—

Here I am back on night duty and quite busy—and I'm afraid this world must be

going to lose me soon—cause—did you ever know me to be happy when working before in my life? I'm a changed woman. I don't know what's come over me—I even asked to be put on night duty.

I haven't seen a paper in some time but I suppose you have and therefore must know of the swell work our side is doing—In the last few days they've done a hell of a lot of advancing—taken quite a few villages and are still going strong.

2 days ago I got my first package, the food stuff—it was magnificent—we all pounced upon it and had a glorious time—especially with the Salami. Everything else in it is just what the doctor ordered. The only trouble is that with all the hungry dames around it ain't going to last very long—but we're having a good time while it does.

In fact we seem to be having a pretty good time always—even when we're so tired we can hardly move—we all lie in our beds and somebody starts wise cracking and before long we're all practically hysterical and throwing everything and anything. This evening I tried to get some sleep knowing that I would have a busy nite—Annie Taft barged into the room with a bottle of witch hazel she had swiped and decided I looked too warm to be comfortable—she started to give me a sponge—using all her force and when I protested she became quite hurt—I told her what I thought of her and told her that the only way she could atone for her sin was to make me some cold cocoa—she did and all was forgiven. This sort of infantile behavior takes care of our lighter moods—The other day I decided to clean my room and swept all the dirt under Annie's bed—when she discovered it she immediately started to beat up Sana—I watched and smiled—somehow she discovered later on that I was the dirty dog—P.S. I didn't sleep in my room that nite. The funniest thing was one of the girls was invited into someone's room for a drink—was he surprised when he couldn't find the bottle—she had already swiped it.

These little stupidities go on all the time but what the hell—it's the only fun we have—and we do have enough work and are certainly doing a good job—our hospital is considered one of the most sanitary & best organized around here. As a matter of fact the two big hopes the boys have are beating fascism and if & when they get wound-ed to be sent to the American hospital.

The new group arrived a few days ago and only 4 girls got to this place—the rest went to the other hospitals—They seem like a nice bunch and like the place. The freight they brought is being carried up in trucks—that's why I got only one package—I expect the other tomorrow—if there are no cigarettes—when I get back I'll beat the hell out of you—

I've been spending some of my spare time these last few days in making culottes—they are swell—and practically the only things I have to wear besides uniforms. I already wrote you about the sandals I bought and my swell vacation in the city—I was there for 2 days and had a nice time. By this time you also must know that Dr. Pitts has left and Dr. Busch an old pal of mine is here in charge, and things are running much smoother than they ever have. As for when I'm coming home—I really can't say —I'm happy here and want to stay and besides there is no surplus of nurses here—We have just enough to keep going and not work 12 or more hours a day—

I'm afraid I'll have to quit writing, I've got a lot of work to do—so, my pets, thanks a lot for the grub, etc. Please thank the rest of the contributors for me—tell Jack I'm sore

at him—he might take a few minutes off from his Packard and write to me—I intend to write to Charles as soon as I get ambitious plus some time.

Don't worry about me—if anything the fronts are moving farther away from me—on account of the advancing our side is doing. So take care of my end of Montville for me and I'll be there as soon as I can—

<div align="right">
Salud, eh —

Till.
</div>

My love to mom and the rest of the gang. How's Agnes doing? Just got a letter from Phil—He goes to different cities—repairing rifles—Says he writes to you frequently—I've met some people he worked with—when I was on leave—and he's very well liked—I'm going to keep in touch with him & will keep you posted.

<div align="right">
So long, Till.
</div>

I haven't written to Rose yet—but will very soon—Does she know about Phil's where-abouts?

•••

from MOE FISHMAN

<div align="right">
August 14, 1937
</div>

Dear Howard [Lederer],

Your letter finally caught up with me. I've been leading it a merry chase over Spain. It caught me in a hospital in Madrid. Yes, the fascists managed to put a bullet in my leg, but they have only put me out of commission temporarily.[3] I'll be back to get even soon. A Moorish sniper hit me & the comrades caught him that night. He committed suicide. No question of the bravery of these misled & duped people. The rest of Franco's troops surrender at the slightest opportunity.

This attack was my first taste of the front lines & it hasn't left too good a taste in my mouth. War is hell & no mistake. You fellows back home aren't missing anything by not being here. Keep up the fight against war back home & you're doing a good deal.

The Loyalist army has finally been welded into a strong fighting unit with organization & morale. The government has assumed the offensive. We expect to end this war despite the maneuvers of the Non-Intervention Committee.

Joe Lash was here a few minutes ago. He dropped in to say hello to the boys in the hospital. First time I ever saw him. He's regular [illeg.]. I showed your letter.

By the time this arrives in the States, the "Y" will be open again. Wish I were back to get into action again. I will be soon.

The International Brigade is playing a role of tremendous significance here in Spain. Not only as an explosion of solidarity of the peoples of the world with the liberty loving people of Spain. But even more as an example of well disciplined antifascists. This was forcefully brought home to me in the recent battles & here in the hospital. On

[3] In the battle for Villanueva de la Cañada, as Arthur Landis describes it, "Moe Fishman of the Washington's No. 1 Company miraculously survived a smashed leg bone, plus twelve hours of exposure beneath the blazing sun without water, food, or medication."

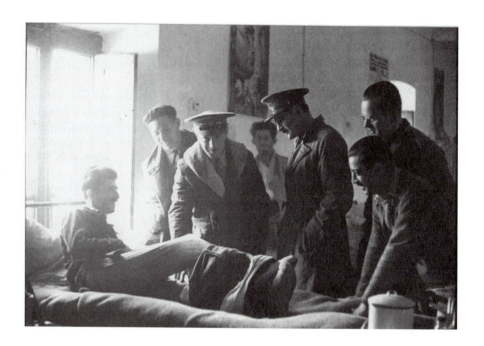

Above: Moe Fishman in bed in an International Brigades hospital in Spain. In the foreground are Dr. Irving Busch, Dr. Edward Barsky, and Jack Klein, D.D.S. Two chauffeurs and another patient are in the background.

Left: Moe Fishman with his crutches, beside an *enfermera* (Spanish nurse in training) some months later.

the battlefield, the Int. Brigades are the shock troops going where the fighting is toughest & by their example giving added courage to some of the new Spanish troops. In one attack, the Spanish troops started to retreat. Our battalion was instrumental in holding the line & keeping the Spanish comrades at their posts.

Here in the hospital, the doctors had to perform minor operations in the ward. The first one to be operated on was a Cuban comrade from the Lincoln Battalion. He shut his mouth & never let out a peep. The next one was a Spanish comrade & his yells were terrific. The Doc told him he was a baby & hadn't the guts of a worm. Also pointed out that the Cuban hadn't uttered a word. He shut up after that & so did the others when their turn came.

I would like to know what steps the A.Y.C. is taking to set up local Congresses in N.Y. Come to think of it, suppose you run a Model Youth Congress in the "Y" & you deliver the main report a la Hinckley. Say, I think a Congress would go over big with the clubs. Senator so & so from the x club & Congressman so & so from the Z club. Think it over. How is the Bulletin shaping up this season? I wrote Bill Schneider of the "Y." Ask him to write an answer.

I am enclosing a copy of a speech by Pres. Azaña of Spain. I think you'll appreciate its significance. Till I hear from you again give my regards to the gang, tell them to write, and—

<div style="text-align:center">

Salud,
Moe

</div>

- -

from THANE SUMMERS

August 26, 1937

Dear Sophie & Art [Krause],

It was especially swell getting your last letters, because they followed a period of about 2 weeks without mail due to the overwork of the Spanish transportation. Furthermore, it was a special treat to get a letter from Art—a letter, for a change, which neither called for a polemical reply nor was answering one of my polemics. It was a letter which touched on the many things we have in common & it did my soul good.

Sophie's letter has given me & my comrades many a hearty laugh. "*Escuchame*" (listen to me) my beloved Sophie, I do not deny the basis for your kidding me about my descriptions of Spain which, as you say, simply repeat what everyone knows anyway, but if you are going to inform me of platitudes, don't do it in the same letter in which you inform me of dysentery. For dysentery, as you politely call her, is one of my constant companions. We know each other inside & out in every little variation & mood, from the subtle, unexpected moods (the slight sputterings) to the more virile, forceful, firehose type of moods. Many nights have I kept vigil with this strange friend in strange places, waiting, watching, inducing her response, never knowing what to expect. At times I spend hours awaiting, only to be disappointed, then again in the most embarrassing places, when I have hardly noticed her, she will pour forth her whole self on me. She has the habit of totally abstaining for two or three days, & then throwing herself upon me like a bomb & clinging to me for a week, then again abstaining. However, such extremes are consuming of one's energy, & we are gradually striking the happy

medium between her fiery temperament & my more impersonal approach.

Well, so much for that—I am still in training, but I hope we will see action in this new offensive starting on the Aragón front. And when the war is over, I hope against hope you will still be in Europe & we can meet there.

<div style="text-align: center">Love,
Thane.</div>

• •

from SANDOR VOROS

<div style="text-align: right">10-P, Socorro Rojo, Albacete
Spain, October 11, 1937</div>

Honey, This is a copy of a letter I sent to Handelman.
Thought you would like to read it. Send it on afterwards
to my sister Gladys.

Dear Sam [Handelman],

What a pleasant and genuine surprise to hear from you. The information you sent is the kind of news we are so anxious to hear. Let me congratulate you on your new functions both as CIO attorney and husband. I suppose you approached the former with more experience than the latter. How are you making out?

Speaking seriously, Sally is a very fine kid, a girl I always respected for her serious approach, for her maturity despite her youth and for her dependability. I am sure you made a good choice. Wish you both lots of luck.

I suppose you are more interested in what we are doing here than in comments on your activities over there. Still I can't help stating how well pleased we are with the successful way you are carrying on activities back home.

I have to leave town in about two hours, so I'd best repay you by giving some extracts from my notebook. These notes were taken on my last trip to the front to study hospital set-ups under moving warfare. They will be very sketchy but will give you an idea. Much of it has to be omitted for obvious military reasons. I'll start with an entry dated Sept. 29, for I lost the count of days from then on:

Sun rises late—dull yellow bowl suspended over a drab damp hill. Desolate landscape—the war machine has passed it by—a few days ago it was still fascist territory. There is something sinister about the hills—a feeling of enemy routed but still lurking behind the barren rocks in the not very far distance.

The triage—men sleeping in their clothes on stretchers—women, too—all near the last stage of exhaustion—live corpses stretched out in the drab semi-darkness.

The front line hospital camp slowly coming to life—the low penetrating moan of the head case—a damp mattress lying isolated way out in the plowed field of sticky brown clay—broken bottles, cans, refuse heap.

A Spanish nurse carrying a bed pan, her face lined with the night spent on duty—armed patrols in the distance, their frames bent. Your teeth chatter as you can feel them shivering in the damp grey dawn even from this distance—crackling of rifles—machine-gun bursts.

The night before—supper in the dark, the glow of embers under the huge pot

casting indistinct, disintegrating shadows—the dim wards—nurses packing getting the hospital ready to move—patients feverish, worried, restless.

Suspense of stand by, conflicting rumors. Waiting for orders to move any minute. No time for breakfast again—no cognac—no smoke—if only the gloves could be found again—come on, sun, hurry up.

We move on.

Dusty roads choked with troops—long stretches of desert without any trace of water—winding dirt roads, mountain trails built for burros, hair pin bends.

Roads, paths, trails, troops, ambulances, supply trucks, troops, troops—Salud, Salud—villagers in black clothes.

Soldiers in open trucks, singing, mostly Spanish but also Internationals, caked with dust, baked by the sun, even hair full of dust like wigs—cheerful, singing, joking, laughing, flying red flags and anarchist emblems, the tricolor of the Republic, a People's Army going into action.

More roads—white alkali dust rising in clouds over the road—must move with the column.

Driving on and on—it's getting late afternoon—might as well eat that piece of bread I am carrying in my pocket for three days now. A peasant woman giving us a melon and some grapes, refuses to accept money for it—can't eat fruit, diarrhea still with me—let's go to sleep.

A hospital camp in the new sector—we stop to await further orders—no supper—field kitchen somewhere in the moving column left behind—there is the front—those hills behind the trees, oh, about five kilometers....

Pitch dark, no lights. Battery all exhausted. A Danish ambulance driver—slightly drunk—former seaman—travelled in States. You're from Cleveland? Have a drink. Have another one. I got another bottle. Have some more. I shouldn't. I haven't eaten all day. That's nothing. Will make you forget it.

Met Dr. [Chrome]; chief of the division *Service Sanitaire*. He was very busy. Had a talk with him. Hardly talked for five minutes when cognac suddenly began to work. Getting more and more drunk by the minute. Had difficult time to speak distinctly, to formulate questions clearly to prevent him from discovering he was spending his precious time on a man in advanced stage of intoxication. My mind works clearly, but have hard time moving tongue and I notice I am drooling slightly, have difficult time standing straight. Terminated the interview quickly before he had time to notice something wrong. Quite an experience to walk up to a man sober and then get rapidly dead drunk under his very eyes without any liquor in evidence anywhere.

Slept on the ground. Two on a blanket, one blanket for cover. Fellow shared his cigarette. Swell guy.

Spent morning interviewing personnel. Nurses, doctors, stretcher bearers, ambulance drivers, what a swell bunch.

Fascist scouting planes. Three more. No bombing.

Artillery fire in distance.

Moved up to Battalion First Aid post. Rest moved up to set up front line hospital.

Battalion First Aid Post 100-500 yards behind line. Classification Post 2-3 kilometers away. Small ambulances transfer wounded to classification post. Big ambulances rush

them from there to front line hospitals to be taken care of and evacuated.

Saw small Cleveland ambulance. It's liked very much because it's small and can approach front line very closely. Doesn't need too high cover—six feet is enough.

Met [Walter] Dicks, slept in his ambulance. Great guy, Dicks. So long Voros, meet you in Chicago.

Tropical rain. Sheets of water. Rain, rain, rain. Pitch dark. The road has become a riverbed. The trail leads up higher and higher—there is no road. We skid and slip. A foot more and we're through. The ambulance gets stuck. We're in mud up to the axle. Soaking wet. Voices all around, can't see anybody. If the Moors slipped through now....The gun in the ambulance feels good and comforting...Lightning. It's 1:35. This is 7:35 in Cleveland. Comrades are going to meetings now. I wonder what.... What's the matter, can't you sleep? No, I am cold. So am I. Wish I had a piece of cheese. Boy, could I go for a nice hot roast beef sandwich. What about a hamburger? Or some hot dogs with beans? How would you like a nice fat cigar? I'd settle for a butt. Me too. But a juicy steak....Aw, let's cut it out. I wish we could lie down. Let's sleep.

Morning. It is still raining. The ambulance is stranded. I leave it there. Mud. The post must be somewhere to the north. You slip and fall and slip and slip and regain your balance and then fall anyway. Boots are waterproof but can't keep out the water and mud coming in on top. Another half a kilometer, maybe they'll have coffee.

The coffee is warm. It warms your hands while you hold it and warms you when you drink it. Got to be careful, for the jagged edge of the tin may cut your lips. Sure, have another cup. You feel brisk and chipper and warm and contented. The straw in the sheep stall smells heavy and warm. But who wants to sleep? Let's go on.

The observation post. It is still raining but not so heavily. Two lines of thin bluish smoke. The first is ours, the other is the fascist line. Intermittent fire. Our artillery starts. You see the shells burst clearly. Wish they'd let you direct fire. You should have stayed in the artillery. If they'd only let you direct three rounds.

The front line. Where is your pass? Suspicious guards. The Spanish captain. We're soon friends. Talks. Interviews. Pictures. How about taking a couple of potshots at the fascists? Swell time firing away. Just like a shooting gallery with the exception that here they shoot right back at you.

The Spaniards are a fine bunch. Genuine comradeship—real international solidarity. *Nord-Americano*.

The Anglo-American Brigade in reserve on way back. The brigade staff. Happy reunion with boys you know. Louis Eider in a poncho—scarce beard half an inch long—five hairs to every square inch of chin. He looks swell. News from Cleveland, Kate, Johnny Fromholz, and the rest of the boys. Exchange of news, experiences.

The battalion camping out in the field deep in mud. Joe Dallet. No smokes. I thought you fellows had some. We thought you had some. The comrade I recruited some seven years ago "organizing" out of nowhere a piece of cheese and even a cigarette for me. Recruiting paying "dividends" in a most unexpected way.

Well, comrade, this is all for the present. Wish I had more time to enlarge upon them. But this will do to give you a faint picture. More next time.

My best regards to all of you. By the way, every time you have a little loose change invest it in a tin of cigarettes and mail it first class in a heavy manilla envelope. These

tins are very convenient to carry around and mailed first class, as I stated above, reach here quite regularly. Or pass the hat around when you fellows have a drink together. I was hesitating whether to put in this request but what the hell. If we are not ashamed to beg one inch or even smaller butts from each other, why should I feel embarrassed bumming cigarettes from you, provided you can afford it occasionally?

As ever

Voros

• •

from FREDERICKA MARTIN

[early November, 1937]

Evelyn Dear:

I hope that you can bear with some weird punctuation, for this is our Spanish machine, and I can hardly ever remember to reverse my period and commas. And not to mention the rest of the mistakes, There goes the first comma.

Tonight I am going to essay my first dinner of sparrows. Well, if I adore snails and shrimps and oysters, I do not see why I should turn up my nose at a harmless little sparrow. One of the patients who acts as my errand boy, a Spaniard, caught them today and I believe he also found some mushrooms, so it ought to be a swell feed. It will be some sort of a change from burro meat, though we have been having quite a tender one lately. Still, I think that is accountable for my hives, which have come swarming back, and succeed in making life pretty miserable.

The life of an Administrator is such a hectic one with billions of petty trifles and really is not quite human. I do not know how many times in the last few days I have started letters to you at my desk which wandered away into a state of incoherence due to interruptions and had to be discarded. Terrific waste since paper is getting more precious than gold. None in any of the surrounding towns and I proved to my own satisfaction that there is none in Madrid and everyone whom I have sent to Valencia reports the same. I guard every scrap. I suppose you will have to be sending us paper before long.

We cabled for warm clothes and scads of other articles and then last week came a cabled request from the Com. for information about clothing. By that time I was going haywire trying to buy woolen gloves and socks for patients who have to lie or sit in our cold wards and have inactive limbs and extremities. So we asked not only for the personnel but also for patients. The clothing situation is really acute for patients, who are huddling about these rainy days in several summer uniform jackets and bathrobes. Thank heavens for the bales of bathrobes you have sent. They are practically the only overcoats in the place. But they are not enough and it will be even colder. The worry I have from your request for information is that you did not receive the other cable from us and have no list of foods, such as cereals to be cooked, cocoa, jams, coffee, sugar, etc.

This winter is going to be even more difficult than last. During the summer we really had a luxurious existence and it will be hard for our gang to go back to beans and lentils and chick peas. They have been spoiled.

I am hoping that the new group will be here in a couple of weeks and I shall have a

longer letter from you. Not that I deserve it. Except that maybe I do despite my silence. But if you find little time for personal life perhaps you can imagine how it is to live in a glass bowl all the twenty-four hours and be roused for information or help at least three times a night and such brief nights, from one to five thirty or two to six.

We had two weeks of rain with a shortage of linen so that the personnel had no clean linen for three weeks and then just as a few nice days came our way, the laundry opened!

I did not intend to taper off so dramatically but I was talking to someone and went haywire. But I really think that fireworks are in order. It happened to be pouring the night the first load came home and to actually behold a pile of pressed sheets, still a bit damp and clammy but that cannot be avoided at such seasons, but white and square and neat being carried into the linen room. The little Spanish girl who is responsible for the linen room and I danced a jig and were very dignified. No wonder after days of denying clean sheets to the wards, doing them out in tens instead of the really necessary fifties. What a miracle it is. Now I have the problem of easing out the women who used to come from the village three or four times a week. Unfortunately, they have families and cannot move to the other town and work in the laundry and I have no more use for their services and as a matter of fact am under constant fire from headquarters for the large personnel that we have here. But it cannot be avoided and have an eight hour day which we try to maintain.

Nov. seventh we are going to have a fiesta of grandiose proportions. Just before the government edict came out against exchanging foodstuffs, I had secured over a hundred chickens of various ages for chick peas. Some of them went to feed our Congressmen and the others have been waiting for this day. So the celebration starts with a grand dinner at noon. Speeches and singing in the afternoon. Coffee at four with or without cake. Supper at six and dancing in the evening. A long program and we shall be breaking our necks until we're too tired to enjoy it. But we have a large number of walking patients just now and they will appreciate it.

We have a tremendous shortage of eggs just now. I have had a car scouring the countryside for two afternoons to buy eggs even at the speculative price of a peseta a piece but no luck. People will not sell them but they will exchange for other staple goods but that is strictly forbidden. And we have four patients of Dr. Donowa's that need them so, badly! It is heartbreaking.

These few crisp days that are being sandwiched in between the days of downpour make me a bit homesick. Just a bit. Because I am too occupied to think much of my personal feelings. I often wonder if I shall ever be an individual again. But when I am washing in the morning and gazing out of my window at the sunrise and smell the snappy air, I get a little pang. Five minutes later it is gone until the next day. Amusing to be such a machine and yet to have some people credit me with such terrible misdoings and such quantities of romances.

Well, I have been limping along with this all afternoon and I have to go check up on the day's work of the carpenters and masons and visit the wards and the kitchen. So, *au revoir* until I get another fairly easy afternoon.

I might add as a desperate postscript that the girls are entirely out of sanitary napkins and kleenex and the latter is terrible just when the hunting season for bigger and

better colds is on. I am preparing a list of female needs but am being delayed until I collect sizes from all over Spain so if you get a chance, urge them to send these without delay.

Much love to Milt and yourself. Do you see Charlie? My love to Lini also.

Salud, Freddie

..

from TOBY JENSKY

Jan. 8, 1938

My dears—

After waiting for almost a month—and doing nothing—we were suddenly pushed into a rush. We have plenty to do and, besides taking care of the boys, we have to invent ways and means of keeping them and ourselves warm. It's pretty cold—and plenty of snow. Travelling around here is just getting into one snow bank after another, or running into ditches. Haven't been getting any mail and don't expect to—while I'm up here. Your last letter was the one with the letter in Spanish, at the same time I got a letter from Gert, telling me of Morry's marriage to someone I don't know. I hope she isn't a blonde—in either case—I'm glad he's taken care of. I have become quite flirtatious. I hope I leave it behind here when I leave—cause I don't like flirts—but when there is no work—there really is nothing else to do—and I refuse to have my mind improved.

I hope you had a better time on New Year's than we did. We were planning a dance—but were given our marching orders that morning. We travelled all day and night and then each and every car got stuck on a mountain road—talk about snow and storms. We sat in the car for a while—tried pushing and pulling—and then decided to hike to the nearest town. We all got there—thawed out and stayed for 2 days—and then plunged right into this. We work all hours and grab a few hours sleep when we can. After all those months in the woods—this is a good tonic. It's fun taking these shacks— (Montville shacks are mansions in comparison) with no water or toilets & turning em into hospitals—with operating room and all, I almost feel like Florence Nightingale walking around with a flashlight or candle in my hand. We heat the place with kerosene stoves—carry water from the center of town—and empty bed pans in a ditch dug specially for us. We manage to get the guys comfortable—plenty of blankets, hot water bags, & hot drinks. I don't take my clothes off very often these days—because it's too cold—just take my boots off and dive under the blankets—but I ain't lousy yet.

About Phil—there is a guy back home—he got there recently—Walter Garland— get in touch with him—either thru the C. P. or Friends of L. Battalion. Tell him I wrote you to look him up— so you could get news of Phil. He was Phil's chief here—he can give you all the news—also give him my love. I didn't know he was leaving or I'd have asked him to call you. We didn't go with the outfit we expected to, don't see many Americans.

Sorry I couldn't make it by Christmas—but will as soon as I can.

Love
Till

Mailed Harry's letter to Joe. Will probably take some time to get there.

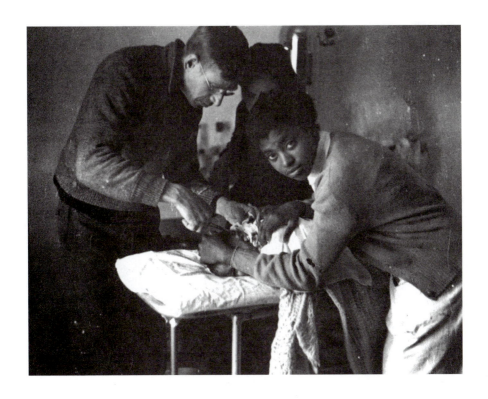

There were over eighty African American volunteers in Spain, but only one—Salaria Kee—was a nurse.

· ·

from ROSE FREED

Villa Paz [Hospital]
January 19th, 1938

Dear Lou,

I think the saddest experience I suffered in the year I've been in Spain, was the death of Abe Schwartz. Abe died of Typhoid malignant malaria, miliary tuberculosis, and Lobar pneumonia. He was very sick. He was a brave soldier attached to the Washington Battalion. I was at his bedside when he died. His mind was clear and burning with thoughts of the Working Class and his family unto the very end. The night before he died he spoke to me about you and the work you are doing. From your letter I was able to tell him news. The discussion had to end there for he was weakening steadily. That was the night before Yom Kippur. On Yom Kippur day he died. He was buried the next day in Salacies.

I went to his funeral as most others did. Many Spanish villagers were present too, for Abe had endeared himself to all who had met him. He had those human qualities that only an Antifascist from the teeming slums of Brownsville could have given expression to. He was real! Before the coffin was lowered, the Political Commissar spoke touchingly of his Antifascist work. As the coffin was lowered the Spaniards sang the "Internationale" as I have never heard it sung before. Don't ask me to describe the feeling with which they sang it, for I feel weepy when it comes back to me. As we turned away it started to rain. But it was hard leaving even though it was raining. It was an Antifascist fighter, who had left his family and future 3000 miles behind to fight a battle *here* for Democracy that he might spare America the terrors and misery of the battle tomorrow. It rained heavier, and at last the few of us left were forced to go. Even the elements knew of our loss and sorrowed with us. It rained heavily all that day.[4]

Rose

· ·

from LEO ELOESSER

January 22, 1938

Medical Bureau to Aid Spanish Democracy
New York

Gentlemen:

Some time between Xmas and New Year I sat up most of the night, as I am doing now, writing you a detailed account of our work at the Teruel front, accompanying it with a few furbelows which I thought you might use for campaign purposes. I hope that you have the letter by this time. We were in Barcelona but a few days when we were recalled to the front, leaving here January 2. In the interval, a number of cables accumulated here which I did not receive until my return on the 18th instant. They were dated Jan. 3, 7, 12, 18, and 22. You doubtless have copies so that it is unnecessary to

[4] This passage is all that survives of a longer letter to her brother.

quote them. I answered you on the 19th. "Just back from Teruel, ambulances and sup-plies desperately necessary. Transportation difficulties expose wounded to shock and freezing but can't break indomitable spirit. Should advise McNamarra not coming but urgently need nurses." Your cable of today announcing the departure of Tom Hayes and three nurses would indicate that you received this message. I advised McNamarra not to come because I think that his main idea in coming was to gain surgical experi-ence, and I am sure that if my surmise is correct that he would be disappointed, just as the Purviances have been. I shall write him; if I am wrong, and if his idea is to help Spain, quite aside from anything that may accrue incidentally to his advantage, then he may still be useful here. It is unwise, as a rule I should say, to have a man and wife come over; either would be better alone.

[Dr. Carlton] Purviance wasn't happy during our first expedition to the front, so that when we left the second time I asked him to stay here with his wife [Katherine, labo-ratory technician] and take charge of the Pavilion at the Military Hospital here for me during my absence. On my return here I was dismayed to find that he had left for Paris on January 5th, without saying anything about his plans to me, having made arrange-ments to do so directly through the American embassy. I hope and trust that he may do nothing to hurt the antifascist cause. My hope rests upon a statement he made in a note he left behind for me, "I think I can do more in a material way in the States than in a personal way in Spain," which he explained more concretely in a note to Weisfield in which he stated that he hoped to be able to collect money for Spain in the States. If he can and will do this, he may really be more useful in the States than he would have been here. After this experience I hesitate to have anyone come over unless his sole and main desire is to help, and not to further his own education or interests. Should this letter reach you before the Purviances arrive in N.Y., it might be well to have some tactful person meet him at the steamer and sound him out before newspaper reporters get hold of him. I don't know with what steamer he is sailing, and I have no address for him except c/o American embassy, Paris, an address he left with Weisfield, but I sup-pose it would not be too difficult to get the French and English passenger lists during the next few months. If he is still to be reached in Paris and I can find out with what boat he sails in time to be of use I shall wire you.

Another disagreeable bit of news, in order to get it all over with, is that Michel, in charge of the *Central Sanitaria Internacional* here left for Paris during December with some funds, not much, and failed to put in an appearance at the Paris office. The office is being run *ad interim* by Dr. Buco here. I am told that a new man is to come from Paris, but I don't know who he is to be. I don't remember whether I told you about this in my last letter. Michel's defalcation led to considerable confusion in regard to orders that had been put in through him to the Paris office and similar matters. It also made us very short of money. Fortunately I cashed $100 and got 3200 pesetas before leaving Paris and was able to buy more here. This made it possible to defray the units' expens-es, either by lending the members money or by paying for them myself. Our pay from the Spanish we only got yesterday; from now on we should get along on what we receive. The Central is still far from perfect. If a man of tact, who speaks a few lan-guages, preferably Spanish among others, and who has an ordinary American knowl-edge of business could be found for this office the whole service could be immensely

benefitted. Mr. Frederick Thompson of San Francisco would be an ideal man for the job in every way—provided he could be persuaded to take it.

Having got these details off my chest, I shall proceed to give you an outline of our doings since the first of the year. As I wrote you before, we returned from Teruel front on December 26. There had been but few wounded toward the last and the expected counter-attack had not materialized. However, scarcely had we returned to Barcelona when fighting began, and we got orders to return to the front on New Year's Day. Our equipment was no better than when we left the first time—somewhat worse in fact, for we had expended some material and the intervening holidays had interrupted our replacements. However, there was nothing to do but to leave. On getting to the hotel late on the night of the first, I found a note saying that our chauffeur, an A1 man, was in the hospital and could not go; he had been wounded by shell fragments while in the street here, in an air raid that took place on the evening of January 1. So the next day I scouted around, got the necessary papers and picked up a little moron of about 18, who had been assigned us as chauffeur, but who turned out to be absolutely useless except in the matter of attending to his own stomach and sleeping quarters. Our party was small, comprising Weisfield, Ave Bruzzechezi, myself and little Andres. We left Barcelona in the snow; the Valencia orange groves were snowy and frozen and as we got into the mountains it was very cold and the snow from one to three feet deep. The road was crowded with all kinds of traffic; truckloads of men, victuals and ammunition; artillery, tanks and cars all made an inextricable mess in a one car lane. At each village ingoing and outgoing traffic would be jammed in the narrow street, neither willing to back out, so that Weisfield and I would get out, act as traffic officers and curse our way through. We spent two nights en route; the temperature was 16 - 18 below 0 centigrade. At the railhead we reported to the chief surgeon of our mobile units and got orders to proceed to the same place we had left a week before. We were a bit disappointed, at first, for we had expected to go to the southern sector. However, we got under way, and the next day began to run hot on Barsky's trail. The trail got hotter and hotter, until that afternoon we found his outfit, ambulances, trucks and all, huddled in the snow and mud in a little town, occupied in setting up their hospital. We were delighted to see him, and envious at the completeness and ship-shapeness of his outfit. We spent a few hours together, but then left, as I had an uneasy feeling that we might be needed. We were. We got to our destination, where the changes we had begun in the hospital had stuck midway, exactly as we had left them, and began to unpack our things and set up. No sooner had we done so than the wounded began to come in, so that for the first two days we worked right through, both we and the Spanish outfit who worked with us. Work was difficult. There was no heat, except for one small stove in the receiving and classification room. Crowded as this room was with incoming stretchers and men off the ambulance we laid mattresses on the floors near the stove and put the worst shocked patients there to get over their shock and to warm them, a little at least. The wards were freezing, what with no heat, stone floors and no glass in the windows, it having been knocked out in bombing raids. There was no light. The line from a neighboring town had been put out of commission, so that we had to work with candles and pocket flash lamps. I have one little pocket lamp with detachable light that straps on the forehead; I did laparotomies with that, but it wasn't very satisfactory as you can

imagine. In spite of being very careful with it, two sets of batteries that I had extra burnt out, so that finally we had only candles. After about a week the line was strung and we rejoiced in light for one night; an air raid the next day did for that.

Sterilization presented much hardship. We had an autoclave that burnt alcohol. There were a few quarts of alcohol when we reached the hospital, but they gave out and we were several days without any. So we tried sterilizing on a kitchen stove that we had set up in the operating room. During our absence the chimney had become plugged, the stove wouldn't draw and almost smoked us out, and it took a very long time to get any heat from it anyway. Coal gave out and we had to use what wood we could get.

The roads were snowed under, and it was extremely difficult to get patients in or out; a number of them were frozen. Ambulances were far too few. Of our own we had none; everyone was clamoring for them at once, and it was very hard to commandeer those that were passing or unloading. Both as a consequence of the lack of ambulances and of fire along the road we got our patients only at night and after a sometimes fatal delay. In promptness of ambulance service we compared very unfavorably with the International Unit manned by Dumont, Broggie, and Barsky, which set itself up in a town some 10 miles up the road a few days after our arrival, and whose work was in every way better than ours.

Of cots and beds we had about half the necessary number, so that we had to put many of the wounded on the floor on mattresses. This wouldn't have been so bad had the floors not been of stone-tiling, and as I said freezing cold. Sheets we had none, pillows perhaps a half dozen for fifty, blankets and coverings all too few.

Of strictly surgical material there was no lack; we have a very complete set of instruments, and the Spanish pharmacies are adequately equipped with all necessary drugs, sera, anaesthetics, dressings, etc.

Ordinary hospital furnishings were sadly lacking; there were two enamel wash bowls, and four buckets. This completed the inventory of enamel ware—no, I forgot four bed-pans which we brought up with us from Valencia the first time. Cups, plates, saucers, etc. amounted to 0. The patients drank from condensed milk-tins.

It may be hard to picture such a hospital to one who hasn't seen one working. Two or three big mud-stained ambulances are drawn up in the frozen mud if it's a cold night, or in the slush and snow if it's a thaw; they stand in the dark, before the dark stone portal of an old stone house in a village street. Teams of four stretcher bearers are carrying wounded up a flight of stone steps by the light of a flickering candle. Perhaps it's as well there is no more light so that you may not see the blood soaked and mud-encrusted clothes and overcoats that cover them. They take them into a big room, perhaps 15 or 20 feet wide and twice as long. Near one end of the room is a little round stove; not much heat around it, for when the door is opened an icy blast blows through it and out of the paneless window. At the end of the room where the stove is, are an old marble topped dining-room buffet, used as a surgical supply closet and a dressing table, an old sofa, an old arm-chair and a few other chairs, and a surgical table. This end of the room is lit by some candles stuck around onto the furniture in various places, dimly lit, so that if you're very careful where you step you needn't stumble over wounded who lie on mattresses and stretchers placed on the floor near the stove. As near as

possible, for those wounded who can sit, those shot through the arm and some shot through the head, are sitting on the sofa and the chairs, and they too are huddled over the stove waiting to thaw out their frozen bodies. A surgeon in uniform and a medical student are on their knees beside one of the wounded; by the light of a candle stuck onto the floor they are trying to give him a transfusion of blood. It isn't going very well, and they are in the way of stretcher-bearers bringing in more wounded. In the utter blackness of the far end of the big room another surgeon and a sanitary officer with him are moving about, from one stretcher to another of the rows laid out there in the dark. The sanitary officer has a candle in one hand, in the other a pair of bandage scissors and a paper and pencil. The pair are sorting out the wounded, examining their tags, uncovering and examining wounds, deciding who needs operation, who is so shocked that he can't be operated upon, who can be sent on to another, better and safer hospital farther from the front—and who is beyond all help. The stretcher-bearers wait impatiently for their stretchers in the flickering candle-light. They need them in order to take their ambulance out again.

Up a stone step and through an arched stone portal is another room. It was perhaps a study or a lady's sitting room, and the big room was the drawing room of this old converted villa. God, it's cold in there. There's no heat at all, and here too the panes have been blown out of the windows. The room is full of cots in which wounded are lying; some are asleep, after an injection of morphine, exhausted, some are groaning, some are crying out loudly at the top of their voices; "*Sanitario! Sanitario!*" (Orderly, orderly!). The mattresses are wet with fresh red blood, or crusted with old dark blood, most of them. The men are fully clothed, except where their clothes have been cut off to make room for bandages. Most of them still have their muddy boots on. Some of them are covered with a blanket; some with only their clothes and overcoats.

Opposite the wall with the stone portal is a door, leading out onto a stone staircase. It's a narrow staircase, about three feet wide. Look out you don't fall onto the floor below. The banister has been chopped away to give the stretcher-bearers room enough to bring down their stretchers. There is a stone landing with a glass door on the other side, and light, not much light, but still light, after the blackness of the ward, shines through the panes of frosted glass. Some of these panes are out, and their place has been taken by pieces of pasteboard held in place with adhesive plaster. The room into which this door leads is warm. Warm and suffocating. The air is a mixture of smoke from a poor stove-pipe, the fumes of burnt alcohol, steam and unpleasant surgical smells, mainly iodine and fresh blood. The room was evidently a big dining room. A French window, closed and shuttered now, so that the light can't be seen, leads out onto a little tiled balcony overlooking the broad valley that leads onto Teruel and the clear cut range of hills beyond the valley. Both of red earth, from which the little town gets its name. A brook flows below, just at the foot of the balcony. Tomorrow morning early, before the planes start bombing you can go out and look at these things. The view is very lovely. The people who used to own the villa, a Valencia doctor fond of shooting and fishing, probably used to sit out here and have their dinner and look at it. The walls of this old dining room are painted with these scenes, but someone has painted little tanks and airships into them, and one wall is spattered with red where blood from a pressure transfusion tube squirted onto it. In one corner of the room stands a

little black kitchen stove; there is a bucket of water on it and a nurse is bending over it, rubbing her eyes and trying to get it to burn. Black smoke pours from the chinks of the stove and from the ill-fitting stove pipe which has been mended with adhesive plaster. Next to the stove, on the floor of black and white checkered tile is a small pile of wood, among which one recognizes the rungs of a chair and other bits of furniture. Along the wall is a tall wooden china-cupboard; the glass is missing from one of its windows. It is filled with surgical instruments and supplies. In the other corner of the room is a barrel containing tubes of salt solution wrapped in pink wax paper; there is a big pile of similar tubes alongside the barrel. On the next wall is a rack with hats, coats, uniforms and dingy white gowns hanging from it. Opposite is a little table on which sits, supported by a perilous contraption of condensed milk cans, a sterilizer of bright nickel; a sardine tin under the sterilizer contains some cotton with alcohol poured over it and the sterilizer is boiling. On the table are also some shiny nickel surgical drums, somewhat battered, some gauze, some partly folded dressings and about half a loaf of bread. In the middle of the room is a surgical table covered with a black rubber poncho; a man lies on the table. He has been shot through the forearm, the arm is shattered, both bones are sticking out of it, surrounded by dirty shreds of bloody brown muscles and whitish tendons; the wrist and hand dangle by a strip of skin. At the side of this table is another little high three-legged round one. It is hard to imagine what it might have been used for, if not as a pedestal for a piece of statuary. The little high table is covered with a cloth and surgical instruments are laid out on it. Two surgeons, clad in ridiculous ill-fitting smocks which they have put on wrong side fore-most, so that they may button in the back, are busy with the wounded man. He has had a local anaesthetic, but is quite conscious and is talking to them. They are cutting his arm off; cutting through the strip of skin that it dangles from, and cutting off the dirty shreds of flesh and the dirty ends of the bones. There is a single electric light bulb hanging from the ceiling of this room which emits a faint glow. It is helped out by candles held by an orderly. Each candle gives about twice as much light as the electric bulb. In one wall of this big room is another glass door, with light shining through it. It leads into a little room, about 8 x 10 feet. An autoclave is in one corner, and a sterilizer is in a cupboard. In another corner is a nickel container with a gallon of sterile water in it. There is a little tap at the bottom of this container; by turning it on you can have sterile water run over your hands drop by drop and wash in it. The water runs into a Spanish wash-bowl with a hole in the bottom. The bowl stands on a rickety wooden stand and the water runs into a bucket below which is decently shielded from view by gauze, as befits a decent Spanish household. In this room too is an operating table with a wounded man on it, and along one wall a cloth-covered table on which instruments have been laid out. A Spanish nurse is deftly tending the instruments, two surgeons, with their sleeves rolled up and white aprons on, are operating on the wounded man, and pressed against the wall of the little room, trying to keep out of each other's way, are five other young Spaniards, medical students, the surgeons' helpers. There is a single bulb in this room too, which gives a little better light than the one on the big room. When you put this one out, the one in the big room is a little brighter, but not enough current reaches them for them both to burn together.

That's about the lay-out.

Jack Freeman in hospital. Ernie Amatniek is on the right.
The toy monkey is a group mascot.

The self-evident question is, of course, "Why do you put up with this, and why don't you get what is needed?" And the answer to that is: To have what is needed takes time and money and means of transportation. Money can be got, sooner or later, some way or other. Time can't, and when wounded begin to pour in, one has to take things as they are and make the best of them and leave improvements until later. And as for transportation: you may understand why I am clamoring so loud, long and insistently for a Ford carry-all and a light delivery truck. I'd sooner have these two *now* than a fleet of Mack trucks in six months. All the things in the world won't help unless you can take them with you and have them where you want them.

The situation as regards equipment has improved. In the first place, before we left the hospital the town council had given me help with masons and carpenters and the place was quite ready to make a nice little hospital of by the time we moved out. That, however, will not help the next one. Enamel ware, etc., I provided myself with. I flooded Spain with requisitions for about six weeks; but these beseeching papers brought forth nothing but promises. So I went into Teruel one day in a fog that protected the road, and I found a nice shell-struck pharmacy and next to it a nice shell-struck bazaar with all sorts of things in it; brushes, pitchers, bowls, buckets, pots and pans; a real Aladdin's cave the cellar of that bazaar was; so I loaded up the little Ford. Tomorrow and the next few days I'm going to look around here for a small light-generating plant; I am told they can be had for from 3 to 600 pesetas, i.e., about $1200, and I'm going to get one. That should solve the light problem. And I do beg you to send the transportation I asked for promptly. [Major Oscar] Tellge, chief of the International Sanitary Service, promised me an ambulance and Barsky also said he'd do what he could. I'll be stuck without them if I get any more supplies when I go out again. We got back here on the 18th inst. I hope we'll stay here long enough to outfit properly.

I've sent a sort of diary of my adventures and doings back to San Francisco, which will be sent to the Medburo there. You might send a copy of this letter there and ask them to forward the other to you. By patching them together you should have quite enough, more than enough, publicity material.

With kind regards.

> Very sincerely,
> L. Eloesser

P.S. Weisfield had an upset in his intestinal tract while at the front, so that I had him at Benicasim in hospital for a few days on the way back here. He's here now and alright. He wants to work with the Brigades, so I'll send him to Strauss and have Larsen take his place as soon as I can affect the change.

I hope that the unit that left on the 22nd inst. is bringing the supplies I asked for. Will you also please send at the earliest opportunity: 20 Luer syringes 2 CC., 10 Luer syringes 5 CC., 10 Luer syringes 10 CC., 10 Luer syringes 20 CC. These could go forward as first class mail direct to me care of the CSI, Barcelona. They need not be of the best quality. Those that can be had here and in France will not fit the American needles. If you can get 1/2 dozen adapters from a Record tip to an American size Luer they will help us to use Spanish and French syringes.

Furthermore: Three Winchester 5-cell batteries, usable as headlights with 60

Eveready batteries to fit for extras. The Eveready makes a similar 3-cell light, which is the one I have, and which has proved a life-saver. The Winchester is larger and better, unless the Eveready also make a 5-cell size.

Should you send this via Paris please notify the Paris CSI.

• •

from LEO ELOESSER

With the Army of Maneuvre
April 2, 1938

Medical Bureau to Aid Spanish Democracy
New York

Gentlemen:

A sunny spring day. I have escaped from the hospital and gone up the hillsides, like southern California hillsides—rocky, covered with thorny chaparral and cut with rocky dry water-courses and cliffs of gray stone. I've gone up here and am sitting alone under a tree, so as to be able to write. It's two weeks since I wrote other than a post card that an officer who went to Barcelona yesterday took with him.

I sent Maury a letter long before you collected for the stuff—never heard from him, I certainly expected he would write.

How do you like my typing—I'm getting so good I can now use 2 fingers. This typewriter doesn't always spell correctly—maybe because it's Spanish, and while my Spanish isn't exactly the worst around here—it isn't so hot.

I was chafing in Barcelona at my inactivity, for the hospital pavilion that I had scarcely kept me occupied, and there seemed so much to be done. So last month I got an appointment as consulting surgeon to the Army of Maneuvres, which in time of activity should keep me in the thick of things and which might have been a very interesting job. Anyway, after concocting some paper plans of organization for front line surgical equipment, I got a request from the Brigades to go down and help them out at a big evacuation hospital they had set up and where they expected many wounded. We left on March 15th, quite a string of us, in a small ambulance and a mobile operating unit set up in two larger vans. Eleven of us. Dr. [Leonard] Larsen of Point Reyes, myself, four nurses, the one I originally had with me from New York, a very nice Italian girl, three San Francisco and Rose Valley girls, three chauffeurs and two "*sanitarios*," medical orderlies, students of medicine. We left in the evening and got down to our destination late at night about 2:00 a.m.

The town stood in the moonlight, apparently deserted. Houses shuttered up fast, walls gleaming white in the ghostly light. We knocked and banged at half a dozen doors, but were able to arouse no one. Finally, in response to our calls a man got up from a flat terraced roof and told us where the hospital was. In an enormous old Jesuit convent, a very rich one, most luxuriously equipped; beds and fine linen sheets and blankets. The convent had been converted into a municipal hospital, but just before we got there the municipal hospital and the doctor in charge began to move out, across the river, and left us to look the place over. A number of large dormitories, used for wards, and big rooms down on the main floor for classification. A big room lined with oak

wardrobes around the walls, where the church vestments had been kept, filled with women sewing and sorting linen. All kinds of little cells and cubicles occupied by old people—dodderers, mostly old nuns and church pensioners. They looked on us with uneasiness and misgivings when we first came, fearing, I suppose, that they were to be put out of their old haunts or that dire things would happen to them. But we left them in their little cubicles and attics, and they'd flit about the hospital, coming suddenly on one unawares like some little dark bat. They were very grateful when they found that no harm was to come to them.

A big olive orchard surrounded the place, the gardens with a windmill that didn't work, irrigating ditches, stone walls and little out-houses, also full of pensioners. In the center of the convent was a big church, filled with all kinds of material—electric motors, pumps, a quantity of iron pipe and tools for threading and cutting it. We started to get installed and set up during the day. That night of bright moonlight the nightly bombardment came, as usual. Within half an hour the place was full of the most horrible injuries, people screaming and groaning with pain and terror, little children looking blankly at the wall, people with their arms and legs blown off; women, old people, children—forty of them. We worked all night attending to their wounds and injuries. Almost nightly the same scenes. No soldiers, but only the civilian population. We stayed there four days and then got orders to move on to this place to join the Maneuvre Army.

We left under the grateful cover of a light morning fog soon after dawn on the 20th and arrived here that afternoon. This hospital lies in a valley almost alone, without a surrounding town. It is housed in a wayside shrine where the Virgin is supposed to have had a miraculous spring gush forth. There are several springs piped into the church and the adjoining pilgrims' inn. The one in the sacristy of the church used to be very costly to drink from. In the inn adjoining the church are many small dormitories and rooms and little suites of bedrooms, dining rooms and kitchens where families of pilgrims used to live when they made excursions to this place to drink the water and worship at the shrine. Opposite are some houses, a forester's house and an old inn where the carters and muleteers coming down from the hills to the coast put up. The inn is inhabited by refugees: we, the hospital, occupy the other buildings. When we got here we found one surgical team on the grounds and a young Spanish commanding officer getting the place ready for occupancy, setting up beds, kitchens, etc. That night the wounded began to pour in. The other team and we worked turn and turn about. Three to four hundred wounded a day. Very bad. Artillery mostly. We worked 28 hours operating as fast as we could go. Pretty tiring. Within the last few days two other teams have arrived, so that things are much easier, and the influx of wounded today and yesterday less.

What a horrible thing to see them come in all night, groaning and crying out, legs and arms shattered and shot off, bellies, heads shot through, laid out on the floor on stretchers in the light of an automobile headlamp fastened to a storage battery for the current in the house keeps going off and blowing out fuses.

Some thirty or so of medical officers; all kinds of men, but all brave and smiling and uncomplaining. And truckloads of soldiers going past on the way to the front, singing and laughing. Nothing of desperation or panic. One wonders what they feel in their

hearts.

It all seems so impossible, sitting in this little sunny rocky canyon with ants crawling around busily and a couple of partridges whirring out of the bush and butterflies flying futilely about, that so close to here men are killing each other and making life unbearable for each other. One wishes it would end.

April 5, 1938

It's only three days since I was sitting on the hillside writing this, but so much has happened that I can no longer keep count of the days. The next day, April 3rd, half of our surgical teams that were busy at the hospital left for the new hospital they had established down nearer the coast; the stragglers down the road increased, poor tired, dusty men, refugees in two-wheeled carts high off the ground, piled with precarious mountains of bedding and pots and pans and household belongings, tired men and women following them down the dusty road one or two dusty donkeys dragging them slowly along. Opposite the hospital was an inn, an old Spanish roadside inn, much like the one Quixote stayed at. The lower story was occupied by a huge room, on the left a stable where the muleteers put up their animals and wagons; on the right a dining room and in the middle, next to the staircase that led upstairs, a little counter and a little dark stone taproom, where a bleary old lady sold eggs, when she had any, and cheese and *aquardiente* and a few such things. On the morning of the 4th I went over to buy a cheese. "We have no more," the old lady said. Then she led me upstairs and undid an old shawl in which were tied up her few precious belongings and brought out a cheese. "This is the last we have," she said. "Well, I don't want to buy it," I said, "Perhaps you'll need it, and cheese is worth more than pesetas here." "Take it," she said. "We're evacuating. We can't serve the guests in our inn any longer and we're moving to a farm we have near here. We'll find something to eat there." So I bought. 35 pesetas. Normally it cost 2.

April 10th

Each place one goes the main job is to try to establish some sort of order out of the hellish chaos. You come into some sort of a place and try to set it up as a hospital, or try to get your operating room and surgery going if it is already set up. You stumble about by candle among wounded lying on the ground on stretchers or grope about among dirty cots, men groaning, dying, everything full of blood, of dirt, of pieces of clothing cast aside or cut off, of partly eaten victuals, hunks of half-devoured bread.... You get the place half straight in a few days, everyone working like Trojans, the stretcher-bearers carrying and hauling cots up and down old curved staircases, giving their men food and drink with gentle, patient, blood-stained hands; exhausted they are overcome by sleep, so that you find them asleep on chairs and in all kinds of unaccountable crannies, under stairs and in deserted attics. On the road, in the night, trucks and convoys go rattling by, and always you keep one eye and one ear half-cocked for aviation, wondering what you'd do if they hit the teeming place you're in. You keep going until two, three, four o'clock; until dawn, until bright daylight. You get up frowzy, wash if you can, shave occasionally, and start off again. Tired blinking staff officers drive up, usually in the middle of the night, in cars that should have long since

been junked; Fords that have gone 100,000 miles without an overhaul, and Grahams and all sorts of things that can be made to run. Cars that are always getting stalled and breaking down. They go into a huddle with you about evacuation and problems of food and beds, and they drive off again, if the car will go. Out in the dusty, sunny or moon-lit road in front of the hospital the stream of carts and refugees goes down the valley, plodding on to safety, women with little children hanging onto their skirts; they stand about the hospital and the men water their mules at the trough; the women wash their faces and their babies; the children hang about the door and the auto-ambulances and try to beg for a little food. In the distance over the clear, rocky hills, comes the can-nonading, and now and then a heavy boom that means a bombardment, and you look, and slowly over the ridge you see a column of thick smoke mount into the sky.

I'm writing this in the mobile operating unit, sitting in back of the hospital. It's a Sunday, I think the 10th. I began it in Barcelona after we had come up, but couldn't finish it, for I was too sleepy after driving all night.

I came back to Barcelona with some misgiving. There were orders to evacuate the hospital where we were stationed. Two of the surgical teams had been sent down near-er the coast a couple of days before. We and another outfit and the Commanding Officer remained. The other outfit was headed by a nervous little fellow. So after the others had gone I went down the line to speak to the chief surgeon of the Maneuvre Army, a fine fellow from Madrid. I told him that the responsibility of my keeping my team of Americans in the southern sector was great. I told him that if he wanted me to stay, he should say so, but if we could be spared, I thought we should go North. He had three other teams working in the hospital, the new one, and I didn't feel as though I were leaving him in the lurch. I told him we'd leave him any material he stood in need of, and asked him what his orders were. "That's for you to say," he said, "the hospital is to be evacuated."

So we waited until it was evacuated, got all our things out in safety, loaded them onto the big mobile unit, brought them down to the newly established hospital where the other teams were working, and that night set out for Barcelona.

A night of April, partly drizzly, partly clear, with the stars out. An endless procession of tired men, soldiers, refugees, carts, cannon, all going down that single road. Men asleep on foot behind their carts and donkeys. Their donkeys asleep ahead of them. An endless procession of fatigue, winding along the road by the sea. We came through with no trouble at all. Tortosa heavily punished, all the buildings around the bridge bombed, but the bridge still standing, and we over it to the other side in the little ambu-lance and the bigger operating truck emptied of all its appliances. The other one, with autoclaves, sterilizers, light generators, and all the useful appliances we left behind.

Some fifty or sixty kilometers from Tortosa we waited, having lost the other truck from sight. We waited and waited but it didn't come. We turned back, a bit nervous. Pretty soon a car came up and Pelegrin, one of our little *sanitarios*, got out of it and flagged me. The other car had had a crackup. Only that, thank goodness! We went back farther and found them. They had hit a cart and done some damage, but had hurt no one except Dr. Larsen, who had some minor cuts and bruises that kept him laid up a few days at a hospital, but who is with us again.

Well, we got into Barcelona and found Barsky. He looks like a wreck, so tired that

he can scarcely drag himself about, and with all his old spirit gone out of him, but sticking on and helping like the brave scout that he is.

I spent the day with him and he begged me to come up here; said that they were putting in a new International Hospital with 1000 to 1200 beds and that they had no surgeon. So we came up here and started in to work. Again no supplies, none of this and none of that and not enough of the other. But the wounded came in, so many and so many urgent ones that it was the same thing over again. Not front line this time but mostly wounded of four to ten days; everything floating, not in blood but pus. We worked eighteen to twenty hours a day, so that the girls went asleep on their feet and today I struck; attended to two patients this morning and then gave them all a holiday. Another team got in two days ago and I let them do the work today.

We're about 30 kilometers from Barcelona, again in a convent school, a big building with a church in the center. A big courtyard flanked by galleries and schoolrooms each side of the church. I'll stay here, I suppose, for a time, until they get things properly going.

Leo Eloesser

· ·

from BARNEY MALBIN

July 21, 1938

Dear Morris [Malbin, M.D.],

The conclusion of the second year of the second Spanish war for independence was celebrated most appropriately; the soldiers in the trenches and the rear at work; Barcelona completely decked-out in the colors of the Republic and of Catalonia.

I suppose it is a thing of amazement to find that the people here are so confident of the future, are so little deterred by the murderous bombardments of children and women. In fact, the reaction to this criminal activity generally is to create closer unity between all forces, to improve efficiency and output even more.

I was in the bombing at Granollers—a little town somewhat more modern than most Catalan villages—at nine in the morning. The men were out in the fields working, the women with their kids lined up in various "*colas*" (queues) to get their rations of bread, milk, meat, etc. We had an excellent view of the procedures. The Italian planes came in from the opposite side to that we approached. Ten of them were floating about 5 thousand feet up, six in a diamond and four in a wedge a little behind and above the first group. The only possible military objectives in that town were a small air field about eight kilometers away and a small barracks located about 1 kilometer out of town. The planes headed straight for their objectives: the center of the town and the markets crowded with women and children, and laid their eggs—big ones at that. They dropped their stuff so close together that even if they failed to score a direct hit, the concussion was enough to shake down strong houses.

When the earth stopped heaving and dropping away from us, when all the glass and brick that was flying about seemed to have quit, we decided to continue on, although the planes were still overhead. However we had to duck for shelter again; the bastards weren't content—they came down to machine gun what was left of the pathetic queues formed so expectantly that bright spring day. I think that the impersonal tac-tac-tac of

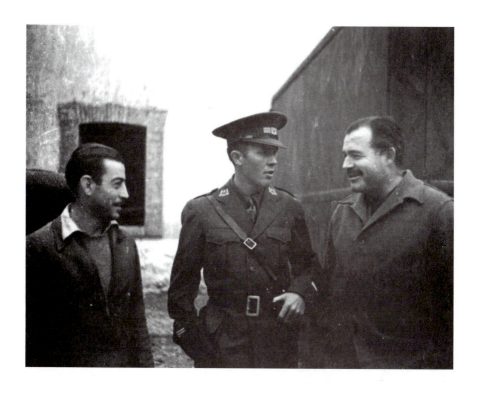

Ernest Hemingway talks with Dr. Oscar Weissman and Lieutenant Rollin Dart at an International Brigades Hospital.

strafing planes are much more terrifying than the sound of the bombs in their rush through the air or the fury of their explosion. One by one the planes broke formation, wheeled on their right wing tip and at the same time swooped down on the town, let go long bursts of machine-gun fire, finally zooming with a terrific screech to join each other, and finally away.

Immediately after the strafing we rode through the streets of the town which we had to traverse to get where we were going. Already the rescue and medical squads were working. Here the bodies of four old women and six kids dragged out from the building that had collapsed on them. There the mangled flesh that was all that was left of a line of housewives and their children; everywhere bright red blood, hunks of flesh plastered up against the walls of buildings; and corpses, corpses old and young but no soldiers or even able-bodied men just subdued weeping of women and those carrying the wounded to the ambulances. They carried them in anything they could find—stretchers, doors, modern chrome tubular chairs; and everything covered with blood. That's what our "neutrality" law is doing for the women and children of Spain.

So it is no wonder that with this going on and with the great example of the Spanish people, we are all stepped up and working the best and hardest we know how.

I've been going pretty hard ever since we moved up north in April. First it was getting the new hospital [Vich] in order and running. Then an outbreak of a typhoid epidemic, localized fortunately. I was put in charge of organizing the typhoid work and ward. In as much as the beginning was particularly malignant we devoted all our resources to that work. The best American, English and European nurses were concentrated there. I wasn't out of my clothes for at least a month and never had more than four or five hours sleep out of the twenty-four. But within ten days we had organized practically out of nothing a strict isolation ward, private isolated kitchen, disinfection chambers for excreta, for linens, etc. Thanks to the complete cooperation and the hard work of the nurses we had a ward hard to beat anywhere.

It was a very peculiar epidemic. It started off with a bang: four comrades dead before we even really established the fact that there was an epidemic; and all variations because most of the people had vaccinations so that classical cases were the exceptions. The rash was present in about 80% and of all types from a few small rose spots on the back or abdomen to a profuse, coalescent, blotchy, measly rash covering the entire body, all the extremities and the face. The latter rash usually came rapidly, lasted two or three days, then started fading and in a week or so was gone. In one guy it was so marked that we wondered whether perhaps we didn't have a case of typhus, but the cultures and Widal[5] all came back positive for typhoid. I missed fame and glory by a hair. I almost had a new disease licked. He came into typhoid as such but he didn't look it and was more of a meningo-encephalic type. I did a spinal tap and all was normal grossly, microscopically it appeared negative, except that on the centrifuged smear we found a gram-negative fat ovoid rod that everybody has agreed was not typhoid. I did another tap shortly before the patient died and again found the same bug but unfortunately the culture I inoculated with the spinal fluid went astray and we never succeeded in getting a report on it. It was not a meningeal form of typhoid that is certain

[5] The Widal Test is a blood test used to detect typhoid fever.

for the Widal; cultures of blood urine and stools were consistently negative. Well, such is fame—missed it by a hair, but what is worse is that we may have been on the verge of discovering something useful.

Just as we got the epidemic ward and the epidemic under control I was called to Barcelona to serve on a commission which would finish its work in time for me to go on leave and meet Virginia in Paris.[6] But the character of the commission changed as we worked on it and when the work was only half through all leaves abroad from Spain were cancelled. Fortunately I absorbed a lot in the early days of the commission for no sooner than I began to feel that I had mastered the technique of that particular work than I was pulled out and put into the present job—that of evacuations of the wounded internationals who no longer can serve at the front. It is mostly a question of organizing, organizing of file systems and routinization of forms, because in a war there is considerable movement of personnel and unless an airtight system is devised, people get lost, papers get lost, and all in all there is a mess. Now we are all set and can put our finger on practically every comrade under our jurisdiction at any time we want him. The guys really appreciate a smooth system where they know at all times where they are at.

<div align="center">Barney</div>

[6] Malbin was to meet his wife Virginia, on her way to Spain to do volunteer social work for the Republic. The letter was addressed to his brother.

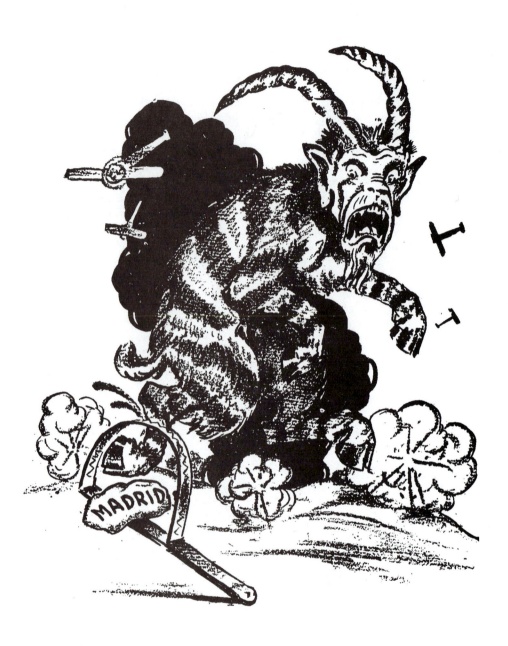

Con lo que no contaba la bestia fascista (What the fascist beast was not counting on). *Frente Libertario* (Madrid), November 12, 1936. The rebel attack on the capital had started less than a week earlier. Here the fascist armies are imaged as a diabolical beast that will find its cloven hoof trapped by the city's defenses.

MADRID
The Heart of the World

. .

INTRODUCTION

It is impossible to think about the Spanish Civil War without thinking of Madrid. It is equally impossible—for those with a sense of history—to think of Madrid without thinking of the war. Not only was the Spanish capital the focus of the military conflict for the long months between November of 1936 and March of 1937, it was also the crucible in which much of the international meaning of the war was forged. Each of the slogans that echoed through the industrialized nations was either first spoken there or inseparably connected with the struggle for the city. It was in the attack on the capital that German and Italian aid to Franco first became internationally visible, and it was the attack on Madrid that led people to see the war as the stage on which the international struggle between democracy and fascism was being waged. "Madrid shall be the tomb of fascism" was, for the first phase of the war, one of the rallying cries that galvanized world opinion. Similarly, when people worldwide called out "No Pasaran!"—They Shall Not Pass!—it was at Madrid that people understood the line against fascism was being drawn.

It was in Madrid as well that the International Brigades made their first major appearance, marching through the city's center singing revolutionary songs on November 8, making tangible international support for the Republic, and immeasurably boosting the morale and expertise of the city's untrained but passionate defenders. And it was in Madrid that the Left as a whole recognized and, for a time, partly supported and reinforced the role of the masses in resisting fascism. For when the international media declared the capital lost, when the government abandoned the capital and moved to Valencia, it was the people who rallied and formed popular militias to save their city. Thus, while there was no lack of intrigue in Madrid politics, and while it is perhaps excessively simplifying to say so, there is nonetheless some cultural warrant for the following claim: it was in Madrid where the fragile alliances of the Left cohered, and in Barcelona where they disintegrated. It was also in Madrid, ironically, that centralized authority, at first overturned, was reconstituted, whereas it was in Barcelona that anarchism was a major force and where the militias had more independent power. Madrid was thus at once a place and a symbol, a site of daily struggle and a living myth. It was proclaimed by some the capital of Europe and by others "the heart of the world."

Not all the American volunteers got to Madrid and fewer still were able to spend substantial time there. We thus feature here some of the letters Edwin Rolfe wrote from Madrid while he was editing *Volunteer for Liberty,* the English-language magazine of the

International Brigades, and serving periodically as political commissar for the Americans in the area. From June of 1937 to February of 1938, Rolfe lived and worked at International Brigades headquarters at 63 Velasquez, where many of his letters were written. Other Americans who came to Madrid regularly included members of the transport regiment stationed north of the city at Fuencarral and people on extended duty at Albacete, the administrative center of the International Brigades. For many volunteers, however, a trip to Madrid was a special treat only possible when on leave in the area. There they discovered a city—situated in the center of the country on a 2,120-foot-high plateau encircled by the Guadarrama mountains to the north—under bombardment from the fascist artillery on Mount Garabitas in the Casa de Campo, the hilly, wooded park at the city's edge. The front, on the city's western border, literally bisected the now heavily entrenched campus of the University of Madrid; it was but a subway ride away from the city center.

••

from MILDRED RACKLEY

Wednesday, Feb. 8th, 1937

Precious, darling Bobbie:

We got your letters in Barcelona, and they were terribly comforting. So many things have been happening that our heads are in a whirl.

Since Barcelona, where we met Luis Companys, President of Catalonia, and other officials, and I got our freight across the border, we were convoyed down to Valencia. There we were again besieged by countless official receptions. Eddie [Dr. Barsky] says this is a boring war! Because we haven't done anything yet. Eddie, Miss Martin, and I left Valencia four days ago with a representative of the Health Dept., a chauffeur and a guard with a machine gun in a Rolls Royce, for Madrid, where we made a tour of the front line trenches.

While looking over to the enemy line a couple of hundred yards away, a bullet sang past Eddie's right ear. We both ducked. There was not much shooting that day. We were being conducted by Lieut. Col. Ortega who is the commanding officer in the sector of University City.

We were quartered in the Hotel Florida, which is only three blocks away from the telephone building, which despite newspaper reports, is whole and has only a few cannon holes in the top part. We, E. and I, went over to give [Herbert] Matthews and the other correspondents a story, and everything is functioning normally.

At night in the hotel and in the streets, which are completely unlighted, we could hear the reports of guns and mortars only a mile and less away. It was a peculiar sensation. Everything in the city still and sleeping, an occasional car darting through the dark streets, stars twinkling overhead, and the rumbling of guns not very far away. In the daytime, the streets are absolutely filled with people. There was no air raid while we were there. The morale of the population is superb—invincible, triumphant.

Even though they are rationed—bread, meat, and cigarettes—life goes on as if no war existed. The government is having a hard time trying to evacuate the civil population which is greater in Madrid than usual because suburbs in the fighting areas have

Inside University City on the outskirts of Madrid a group of Loyalist sharpshooters take aim at Franco's outposts, February 18, 1937.

moved into the city and a food shortage resulted.

We also visited numbers of hospitals, first aid stations, and classification stations in order to get a perspective of the hospitalization in Madrid. They have plenty of hospitals and have even consolidated some for efficiency's sake.

On other fronts the need for assistance is much greater, and we expect to open a hospital on a front where we are needed more badly.

The officials of Madrid were more than cordial and hospitable to us. We had dinner one evening in the Ministry of Finance—where we were the guests of honor, and we met all the generals in the fighting around Madrid—Ortega—a Basque defending the University sector, Galan, Fanjul, Sabio, Romero, besides the administrator of the Min. of Health & Finance and the Pres. of the Spanish Red Cross.

The main road from Madrid to Valencia was threatened by cannon and tanks, so we had to return by a wretched by-road down here, where we spent the night and visited a base hospital—where we are sitting now. This hospital is established in a palace belonging formerly to one of the wealthy landlords of Spain. It is a gorgeous place.

We are leaving for Albacete in a few minutes—tomorrow we will return to Valencia. Have to stop—finish later.

<div align="center">Valencia: two days later</div>

Leaving now for Albacete. Eddie spoke of you last night. All love to you and Joe and the children.

<div align="right">Mildred</div>

· ·

from MILTON WOLFF

<div align="right">August 14th, 1937
Spain</div>

Ann Lenore,

Once again I visited the city....the most wonderful city in the world...the miracle city. The buildings were only a little more pock-marked from shelling, the streets were wet, the boulevards black and gleaming and the avenues and side streets and alleys were teaming with people. (I just changed typewriters.) Later on I saw the sun come out and in a little while Madrid heard the all too familiar bark of anti-aircraft batteries. A flurry of powder puffs appeared in the blue marking the path of its target....the planes were too high for us to see.

Planes carry tons of explosives, death, that falling anywhere in a crowded city is certain to wreak cruel punishment. Huge aerial bombs rip through six floors of a modern building with ease.....delayed fuses. They detonate with terrific force, shock hangs for an age suspended and all originality is drowned in the roar of sound and flames. Can you visualize thousands of people scurrying like so many panicked sheep....tripping, jostling, pushing their way to safety? Madly dashing for holes, basements, and *refugios,* frantically seeking escape from the ripping bombs? Not the Madrileños! No, not they.....They are spectators, they are the same thrilled audience that watch the bullfights, they exclaim with delight, with disgust, they jabber excitedly....It's a duel and no matter that their lives are at stake. They rush to the roof tops for better views, they

throng the streets....They are a people that cannot imagine terror, fear for them must have an immediate connection....The planes were chased off.

You know that in the quiet of the night you can hear the death rattle from the front? The chattering machine guns, the rifles coughing, the dull sound of a grenade and a trench mortar? Madrid, a beautiful, modern city carrying on right at the front lines! Cafes, wine, and many lovely women, no music and dimmed lights, no tobacco, and food in minute quantities....Madrid lives its lie of gaiety.

I spend much of my time with Hemingway, Matthews, and one or two other literary names. They pleased me for they are part of the fight and are very close. They are working hard and know why. They did not impress me, as names do you....I could very easily become annoyed with them for some of their very human, irritating qualities. (I did.) Ernest is quite childish in many respects. He wants very much to be a martyr. Matthews is in love with a Martha Something who writes for *Colliers* and is peeved by her seeming coldness, and she lays it on pretty thick. Just finished talking to Levin of *Esquire* and he is a damned nice guy. So much for writers...I'd much rather read their works than be with them.

I think that I shall leave this now for I have nothing more to write....That is, nothing that won't require effort to write. Give my love to El, I think he will now begin to understand more basically the meaning of economic suffering for the masses. I don't intend this in the way of a "I told you so." Honest El, I am pulling for you and your happiness all the time....But for Christ's sake, kid, get up and fight!

<div style="text-align:right">

Salud.........Sincerely

Milton

</div>

• •

from **MILTON WOLFF**

<div style="text-align:right">

August——14th 1937, Spain

</div>

Mom dearest—

You first of all...I'm about to write many letters...but you first!

I've delayed answering a letter I received from you (of the 21st). Why? —Madrid! Yeah! I just returned from that beautiful city...after spending several days.

Madrid must have had all European cities beat at one time—for even now...torn by war and with the enemy at her gates...she has plenty to offer.

The war has taken from Madrid its many, many well-lighted places of entertainment, its music, its exorbitant meals, its gay traffic, much of its population has left—its beautiful statues and monuments have been made bomb proof and so hidden and etc.—

Yet despite that and more...one can get hot baths—clean beds—gorgeous women—heavenly wines—decent meals—friendly people—candy, cake, ices, and beer!!! All within hearing of the big guns at the front—and I almost forgot the American movies and American whiskey.

And there I sat in the club "Chicote" sipping a whiskey and soda when what floated into my vision? The most beautiful face I've ever seen...so what does Milty do? He grabs paper and pencil and starts sketching...This is what I sketched...a copper-colored face, gracefully long, with sweeping lines joining jaw and neck—slanting eyes,

black and sparkling—a small nose, tilted so you could see the tiny nostrils—full, sensuous, and voluptuous lips, slightly negroid—naturally arched eyebrows and black-blue-black waving hair. She was tall, yet small boned and she didn't touch the ground when she walked—she floated. Time went on and I found she was a Moroccan and very interesting—but enough of that!

Madrid is far away now—I hope the next time I go back—I will find it in its full glory.

Well—if you received Letter No. 1. you have most of my recent news. Let me know at once if you received my letter marked No. 1.

Picture me smoking a pipeful of "Union Leader"—nibbling Hershey's Kisses and listening to American swing music via our portable vic;—so what!

> Love to all
> Salud
> Milton

P.S. Still your favorite son, Mom?
Enclosed find five postcards.

· ·

from HARRY FISHER

June 29, 1937

Dear Sal, Hy & Louise:

First, I haven't received your package yet, not even your first one. Since they take a little time to get here, I still may receive them. As soon as I do, I will let you know. But until then, don't send any more. I hope I do get the stuff.

I spent three days in Madrid. If ever I have loved a city, it is this one. Not only is it a beautiful city, but it has a population with a beautiful spirit.

I spent my three nights in one of the hotels that has received its share of shells. The hotel is so strongly built, that the shells have done surprisingly little damage to it. The windows are all shattered and a few rooms have been destroyed, but the greater part of the hotel is in good shape. As far as my room was concerned, except for the windows, it was in perfect shape. I could just as well have been in any hotel in New York.

As for the bed—how can I describe it? For the first time in many months, I took off my clothes and slept in the nude between two clean white sheets. I spent many hours those three nights doing everything in my power to keep awake, so that I could appreciate the luxury of a bed. One night I went to bed at 9:00 P.M and didn't get up till 11:00 A.M the next morning—Oh, how fresh I felt the next morning—as though all the fatigue had left my body during the night.

Right after going to bed the third night, I heard an explosion that sounded like heavy thunder. The fascists had begun shelling Madrid again. Now listen to this! There had been singing for a while in the street just before the shelling began. I was listening to it from my bed. Just as soon as the shelling began, instead of the singing coming to an end, it became more spirited, louder—an answer to the fascists' shelling. Exactly the same thing that had happened in the trenches. I almost felt that again I was in a trench right after a fascist barrage listening to our soldiers sing their answer.

And yet I experienced an awful feeling. Every time I heard an explosion, I wondered how many more innocent women and children were blown to bits. Can you understand

the feeling? Can you imagine shells falling continuously in New York? All the time you know that each one means death.

I fell asleep to the terrifying sound of the explosions, and awoke at dawn to the same terrible sounds. Trucks were passing with singing soldiers. If ever I got a thrill listening to the "Internationale," it was then.

I went one afternoon in a section of the town not very far from the front. I was told that occasional stray bullets land in the streets there. At night, when it is quiet, the sound of rifle fire could be heard. All the streets were barricaded with thick brick walls and firing holes. If the fascists succeeded in getting through one street, they would be faced with another barricade and then plenty more. So if the fascists ever succeed in getting into Madrid, they will be slaughtered. If they have any sense, they will not try to get in. This isn't July, 1936. Madrid is ready!

In between these barricades, I watched a bunch of children play soccer. Out of one of the windows, hung a pair of winter underwear. Here were the fascists banging away at the gates of Madrid! The underwear in the window made me feel that Madrid turned its behind at the fascists and left a fart.

Understand this—the people of Madrid are not excited. They are as nonchalant as the people of any large city, and certainly they seem calmer than New Yorkers. Spirit and enthusiasm—plenty of it. I have heard more singing in Madrid than in any city I have been in. All this in the face of terror. The people of Madrid know that the eyes of the world are on it. They are very conscious of this. They know that the outcome of the war does not only affect them, but the entire world. They are proud of the fact that they have carried out the slogan *"No Pasaran"*. All of Spain is now preparing to carry out the slogan *"Pasaremos"* (We shall Pass). Madrid has shown the world that Fascism can be stopped! Guadalajara has shown the world that fascism can be pushed back. All Spain will soon show the world that fascism can be defeated. What a glorious day that will be. Not only for the entire world, but for me personally because I will be able to come home and be with you again.

We are all glad that we are preparing for an offensive, because we know that this is the only way to win the war. You'll be reading about it soon.

I know I didn't answer fully your last letter about the situation in the union, Sal, but I guess you know how I feel about it. You were justified in doing what you did.

I carry Louise's picture everywhere with me and all the comrades ask if she is my girl friend. I'm waiting for pictures of Sal, Hy, Ben, and any others you send. I'd like to look at your mugs again.

Since I'm in training now, I don't know if I'll have much time to write other letters. I will try to write to Claire, Jack, Nat and Hickey and others, but if I can't give them all my regards. Sooner or later, I will write. Anyways, I shall write to you at least twice a week, so that you will know how I am. And please continue to write to me—many— many letters.

Get Ben to write again—

Salud & Love
Bozzy

I will send pictures as soon as I get them.

from CARL GEISER

Aug 13, 1937

My Dear Impy—

Received a letter from you last night when I returned from Madrid, and again one this morning, and that certainly is nice. Your decision to write every day is tops with me. And I'll try to do at least half as good on our courage.

By the way, while I was in Madrid, I saw something I thought you'd like, and then besides I remembered your birthday is on the 14th, or is it the 17th of next month. I hope it will reach you by then.

Yesterday Ben (my best pal here) and I visited a number of interesting things in Madrid. Our hotel was on the main street, only 3 blocks from Puerto del Sol, the main square, and only about 400 yds from our hotel there is an excellent barricade, 5 feet thick of concrete and cement blocks right across the street. We went on a little further, and convinced ourselves there really is an iron ring of fortifications around Madrid that will never be broken.

A little further along, in territory where no one is permitted except the soldiers on duty, although we didn't know this, we saw the Imperial Palace, and from a parade ground balcony, we were able to see the Casa de Campo battlefield. We could hear rifle and machine-gun fire, though no bullets were whizzing by us. We were able to see some trenches, though they were no longer occupied.

Just as we were to leave, an officer approaches us and takes us to the captain of the guard to whom we show our papers and who nicely explains to us we are in a front line position, and could not remain there. So we were escorted out. Generally speaking, the buildings close to the front are not destroyed, but are damaged, especially with broken windows and holes in the walls. But I can imagine that shortly after the fascists are driven out of artillery range, the city will soon appear quite normal again. Life now goes on as if nothing were happening, with street cars and subways and stores crowded, and people wandering about everywhere.

Do you remember Robbie, waterfront organizer? Well, he is our Battalion political leader now. I think he will do quite well. Steve Nelson is now our Brigade political leader, and is receiving praise from all sides. The new men who joined us are being assimilated into our Battalion. There are a couple of tough guys in it. Chances are that the front will reveal the softness they are protecting by their pseudo-hardness. But on the whole, they are a good bunch.

Yesterday I started to break in my pipe. The biggest trouble is getting pipe tobacco. At present we use Spanish cigarette tobacco, which works after a fashion.

But more tomorrow.

With all my love-
Carl

• •

from EDWIN ROLFE

S.R.I. Plaza del Altozano
63 E
Albacete, Spain
July 26, 1937
[Madrid]

Darling [Mary Rolfe]:

It's very difficult to write of complete and definite things when everything is con-tinually in the process of change, when one's duties shift imperceptibly at times from one to another field. It is for this reason, as well as a number of others, that my letters to you are so vague, insofar as detailed information is concerned. But you'll have to bear with this for a while. I'm still—although I have learned much since I arrived—pretty much of a stranger in this land.

Yesterday, just after dusk, after a long and dusty auto ride during which we *drank* our chocolates (so great was the heat), I reached the one place which I have wanted, more than any other, to see, both before and since I reached Spain. It is a grand, beau-tiful city, with imposing and graceful buildings, wide thoroughfares, numerous parks. But its face is sadly scarred, where the fascist bombs and shells have torn great holes in buildings. It is a curious experience to walk up to a white, stone hotel, of the swank-iness of the Barbizon-Plaza or the Sherry-Netherland, and have to enter the main gate through a pile of sand and a mass of sandbags. I slept in one of these hotels last night, a hotel on the Gran Via which had been struck by fascist shells only three days ago. Together with the five companions of my dusty auto-ride, I walked up numerous flights of stairs (the elevators were either docked for the night or on the blink). We were shown to our rooms. Mine was only three doors away from one whose wall had been completely demolished in the recent bombardment. But I took comfort in the thought that no shell would hit the same spot twice, and attempted to convince another com-rade that the laws of probability were surely operating in his favor. Nevertheless, when I finally put out the light, chucked the pillows and light coverlet away, and stretched out on my bed, I lay awake for about twenty minutes, listening to the dull explosions in the distance, far outside the city. But I was so tired that I could not remain awake longer. When I awoke the next morning (that is, this morning), I was greeted with "A pretty peaceful night, huh?" The always expected shell or two or five or more had, I am happy to report, not materialized. You and all my friends and comrades may take comfort in the thought that tonight, and for the duration of my stay here, I shall be quartered in a neighborhood which has never yet been hit by the fascist bastards.

This is a short letter, I know; but there's work to do, and I must get busy on it. Incidentally, I bumped into Bob St. just an hour ago. He's a bit thinner, but looks swell, and he sends his best to you and Leo [Hurwitz] and Jane [Dudley] and Dave Crystal and everybody. His love he sends to Josephine. Tell Leo—he'll know who Josephine is.

My best to Vera and the others, and to the comrades in the branch, etc. My love to you. *Auf wieder schreiben* [until I write again],

Ed

P.S. I've put a number of people, you included, on the subscription list of *The Volunteer for Liberty.* You'll get five copies regularly, I hope, and so will Vera. Save a couple of copies of each number. Also, I'll soon send you a complete set of the *Volunteers,* from the moment it was initiated. Take good care of them, till I return. The others should be distributed where they'll do most good.

• • •

July 28, 1937

The ending of my letter of the 26th (enclosed in this envelope) is probably unclear. What I mean is that I shall send you a complete file of *The Volunteer,* which you should save. In addition you'll receive five copies per issue of each new number as it appears. Spread them among people and places where they'll do the most good, but be sure to save at least one or two copies of each issue to keep the files in good order.

The Jews have a fasting day, once a year. I don't recall when it falls, but you can remind me, sometime in 1938 or 39, that July 28, 1937 was my first complete fasting day in a long long time: whereby hangs a tale. Last night I was invited to the sumptuous one-room and many-privileges home of G. Marion, the *D.W.* correspondent in Madrid. The date was for 10 p.m., which is considered early here (although I have not gone to bed later than 12:30 since I wrote to you). I remembered the date—and at nine p.m. I went up to my own dining room, where all the people attached to my "residence" eat. There I had a large meal of soup, meat, potatoes, bread, grapes, and coffee. Not long after I finished my meal, I went down to get R.B. and with him we went to Marion's. There we were surprised to find a complete meal ready for us: canned ham (which had probably been in the can for many many years—but it was delicious nevertheless); some sort of vegetable pastiche; grapes, chocolates, tea and coffee, cheese and pate de foie gras of a kind fairly common in France. Well, although I had just had a swell large meal, I went to with vigor upon the second. At the end of the evening I felt pretty much bloated, but went to bed and after 10 minutes of reading, was asleep.

I don't know whether it was the sound of shells bursting or artillery booming or anti-aircraft guns crackling—or whether it was my belly-ache; at any rate I woke up in the middle of the night with my whole belly a mass of pain. After that I didn't sleep except intermittently, trying to lie on my belly, tossing around and falling into short dreams from time to time. The one recurrent dream—the one that was hardest to bear, unfolded something like this:

My battalion was moving up to the front. Its orders were to advance. And there was I, with a bad belly-ache, unable to go but unwilling to admit that I was sick—such a slight illness at that. I tried and tried and tried, but couldn't go. And I saw the battalion march off without me, and it created an anguish of a very real kind in me. I would wake up, hear the booms in the distance, fall asleep again, and dream again the same dream. I woke finally, at 8:30, with the bellyache still with me, and immediately decided that there would be no eating at all for me today. I did have some coffee at 9 a.m., some more coffee later at 2 p.m., and in a few hours I'll have some coffee again (it is now 6:30 p.m.).

Incidentally, I was busy at work yesterday when who should walk into the room but Connie K., looking swell and sunburned and happy. He has grown much, much

thinner; there's little belly left on him and even less ass (comparatively speaking of course); and his face shows some marks of the tremendous battle in which the Washington Battalion (of which he is quartermaster) has recently participated in near Madrid. He's very well liked by everybody and has evidently shown that he has plenty of guts on the battlefield. While he attempted to take food out to the boys on the front lines, seven mules were killed by bullets, machine guns, shrapnel, etc. His water kegs were shot through—but he did get water and food through to the boys. It's not heroics—nobody here believes much in that because the fight is too tough and real, but it's a quality of high calibre for any man to have. And Connie seems to have it.

● ● ●

July 29, 1937

Sweetheart, here it is a day later and I have not yet mailed this letter. But no sooner than it takes to write a few more words, I'll post this immediately. Time is growing short, the next issue of the *Volunteer* must be sped to the press, and there are a number of men who have to be listened to, understood, and dealt with.

I'm enclosing one of the leaflets which Franco's fascist airmen dropped over the lines held by the International Brigades. Needless to say, it had no effect except to make the men laugh and grit their teeth and vow they would get the whole bloody fascist set-up on the run.

Incidentally, remember me to Nancy and Roberto and Eve, to Hazel and Bob and young Herman, as well as to the others.

Connie sends his best to you.

So long, baby. I love you.

Ed

from EDWIN ROLFE

August 3, 1937
[Madrid]

Dearest—

I've just completed a good day's work and I feel tired, physically, and ready to sleep. But otherwise I'm wide awake. It's 11:15, and there's no *New York Times* to expect at midnight; even if there was, I'd say to hell with it, if only you were there, near me. I've sent off the last of the copy for the August 9th issue. And in the evening, after supper, and before my loquacious little Italian friend and interpreter, Albertini, interrupted me with his chatter, I wrote four pages of a long poem on Madrid. What I've written is merely tentative; I'm still feeling around for a core for the poem. The completed four pages describe a bombardment of Madrid which occurred last night, beginning at 12:15. Most of us went to the roof of our building where we watched the flashes on the horizon and, closer by, the answering fire of our own artillery. Two German comrades, both officers, were standing next to me on the roof; and they had a very heated argument about the number of enemy cannon in operation. One said six: the other insisted, seven. I still am not certain how many heavy artillery pieces participated. All I know is that the shells fell in the city for more than 2 1/2 hours. After a while I got tired of the

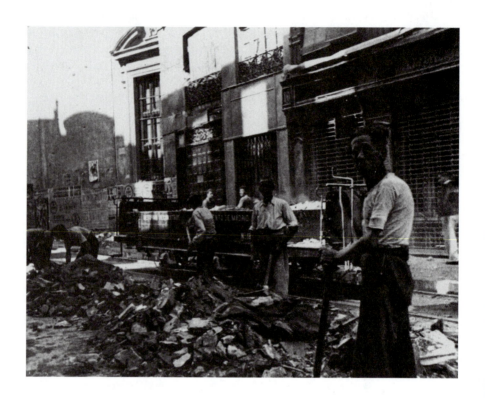

Cleaning up after a bombardment in Madrid (1937).

roof (as did most of us), and Albertini brought his tea kettle down to my room, and I opened a package of swell tea that belongs to Ralph B., and we had cake and tea while the artillery kept up the noise. This morning I was informed that the auto of a very good friend of mine was splattered with shrapnel just a few minutes after he had left it. Needless to tell, my friend's unscratched.

Well, as I said before, for the first time since I got to my new post, I'm satisfied with my day's work, I love you, and I'm sleepy. If I were with you I would not be sleepy, because it would now be (it now is, to be sure) only 6:30. And secondly, I wouldn't be sleepy anyway.

Sweet dreams, darling, to you and the C.I.O.

<div style="text-align:center">Ed</div>

Forgive me for writing a purely personal letter like this once in a while. Even back home, you know, comrades have a night or two purely and completely to themselves. Also, pay up my unemployed Guild dues; I want to keep my membership in good standing.

<div style="text-align:center">E.</div>

Soon you'll be getting that letter and the little pendant from Phil.

••

from EDWIN ROLFE

<div style="text-align:center">August 11, 1937
[Madrid]</div>

Darling—

I'm beginning, suddenly, to feel that I've regained contact with the world I lived in until a few months ago. The reasons? Well, yesterday I received TWO letters: one from you and one from Meyer. Your letter told me that you're still in love with me, albeit via long-distance, by its very tone; if I were at home now, we would have had a bit of a spat and then cooled off and warmed up. Or maybe—and I'm pretty sure of this—there would have been no trouble at all. I left just after our third anniversary, and when we get together again I have a feeling that everything's going to be beautifully clear sailing, as it has been, all in all, in the past. But I'm getting away from my reasons for feeling in touch with America. Second of the letters was Meyer's, as I said, which told me of the improvement in Stanley's health, and of some very swell things about Bernie. Which was not at all strange, or unusual, because I expect only swell things from Bernie. It's an unusual thing for a brother to grow and grow on you, but Bernie has done that and still is doing it. Please get him to write; I know the letter will be matter-of-fact, extremely uninformative about what he's feeling, modest about his actions; but I can read between his lines by now. Then, miracle of miracles: this morning I received another letter—from Joe Freeman. Which made three letters in two days—fancy that!

After a day of work, during which I drove out to the American Squadron of the First Transport Regiment (and was repaid for the trip by a sumptuous meal—chicken, with turkey for desert) I returned to Madrid to find a message for me from Langston Hughes, who is here to do a series of articles for the Baltimore Afro-American, the Associated Negro Press, etc. I got him permission to have dinner in our dining room,

and we had a bit of a talk, and now he's gone until tomorrow, when we'll discuss ways and means of getting him on the radio.

The chicken and turkey we ate were very old, very tough. It is possible that they died of old age, or else were so decrepit that they were unable to dodge the autos on the road. But the meal was a rarity—the best I've had in Spain—and I understand it was the first time that the Squadron had ever had such a magnificent luncheon layout. When you add, as you must, the salad and the sweet yellow corn, you can understand why I ate very little this evening. Firstly, I was too full-up, and secondly, goat-meat after chicken and turkey would have been an awful let-down. But I'll have to forget about the grand meal because goat-meat, mule-meat, etc., is what we most frequently get.

I have a little assistant here—a bald-headed middleaged guy who speaks many languages and is both very useful at times and fairly irritating at others. When he's useful I nurse him along, listen to his stories, let him chatter. When he gets on my nerves, as he occasionally does, I merely give him a hard job to do, shoo him away for a day or two; but I never let him see that I'm bothered, just that I suddenly become unusually firm. One has to be calm at all times here, especially in the work I'm doing. If you lose your self-control, you're kaput. At any rate, among his other numerous hobbies, my little assistant is bugs about photography. He has bought a small camera, and whenever he has the film he scoots about taking what he calls "candid snapshots." The other day he took a few of me, while I was working, as well as a few for which I and a friend, Jack F[riedman], posed. I'm enclosing a couple (3, to be exact) for you, darling, in the hope that it will spur you to have a good photo made of yourself. When you get the photo taken, send me a copy.

Keep your chin up, sweetheart, work hard and get to know more and more about people and things, regain the old touch on the piano and buy some of the good books that, I hear, are coming out; especially some of the books you think I'd want to read when I return: poetry, biography, criticism, and the pick of the novels. Some day, when the bloody fascists (whose shells I hear falling as I write this) have been beaten into the pulp they deserve to be, I'll want to pick up all threads where I left off. And you've got to keep most of these threads together for me.

I love you,

E.

P.S. — 1. Tell Johnnie Meldon I wore his socks again today.

2. Say hello to Paul Strand.

3. Kiss Leo and give Jane some milk and cake.

4. Tell Vera to keep her weight down.

5. Get my father to write to me.

from EDWIN ROLFE

Tuesday, August 17, 1937
[Madrid]

Dearest,

I've just completed work on another issue, and there's nothing to do now for three quarters of an hour; nothing, that is, that once begun would not take much longer. The

Lean Man [Ralph Bates], who is always pleasant (that's the least) to have around, is sitting in an old armchair at my right and disgustedly, with only intermittent interest, flipping the pages of an unusually bad *Anthology of Modern English Verse.* As a matter of fact, the Lean Man is always good to have about: he knows more about Spain than any Englishman or Canadian or American in the country; more, I am sure, than most of the Spaniards themselves. He's a mine of information, of good humour and humor, of amazing energy and of equally amazing lassitude. He always knows when he's had enough, whether it be liquor, guava jelly, food, sleep, excitement or whatnot. It's too bad—for me—that's he's going to leave soon. There will be a real void here. But the people in America and England will gain by his leaving; they'll have him for some time. He himself is pretty sore about the fact that, out of respect to his great value as a writer, as a speaker, etc., etc., they have yanked him out of the danger spots where he most wants to be. But, since he's a fairly wise man, in addition to everything else, he quit fighting against the decision as soon as he was convinced that the fight would from then on be a losing one. Had it been a fight for an important principle he would probably still be handing 'em out as well as receiving them, but it's not that kind of debate. In every case but this, he's in thorough agreement with his opposing debaters, who outvoted him several times against his solitary one. In other words—he hates to do important work that involves no danger when there is, at the same time, important work that *does* involve danger to be done. The man is thoroughly human, robust, earthy, a good man among men; at the same time he's one of the most sensitive creative artists writing today. Pick up a number of his books—as many as you can get— and check on this for yourself. He'll probably insist that this or that book is no good; but he really does set extremely high standards for himself. He's disappointed in his writing only when he feels he might have done better, or when he feels that the writing has violated that sense of form and order which to him is indispensable to great or good art. But at the same time he is tremendously sure of himself and of his work. Like Malraux, who can say about his work in progress that it's "like *Man's Fate,* only set in Spain" or, as he told the Lean Man, "It's the best book I've ever written," the Lean Man has an enormous faith in himself as an artist, and a parallel conviction that every new thing he does is the best yet. When a new work of his does not measure up to expectation (his own, not others') he very simply tears it up. This last statement needs some elaboration. When it measures up ideologically but not artistically, he will continue, painfully or easily, to work ahead on it, bringing it up to the high level he seeks. But when the new work's ideological basis seems to him to be false, then he will tear it up— despite the fact that he may feel it is artistically impregnable. Which, after all, it could not be, unless it were merely a sort of pleasing piano exercise, without unusual significance, merely good practice or training.

There, darling, I've gone and written an incipient essay on something literary when really I wanted to write of other things. The fault was of course (and I'm glad of it) the L.M.'s presence in the room, his silence and the fact that I've been thinking much in the past few days of many of the things he has told me; things that he has said and which have been, whether he intended it or not, self-revealing. About himself—yet in the process of conversation with him I have been able to check on my own statements, to discover how much of myself I give away in real conversation. Or how much there

is to give away. But then, the forms of self-revelation are different in different kinds of people; and I'm as different from the Lean Man in most ways as two people can be. Our points of agreement are of course political, intellectual, craft, etc. Then too, we both are writers, and I feel that very soon I'm going to hit the very high and honest level that my past sporadic work has aimed for but never achieved.

The other day—more than that, last Sunday—I rode for a long way in one of the bad trucks that is used for transportation of melons and humans around this area. My destination was the brigade, and I hoped to reach it the very same night. But that was not to be. The drive over extremely high hills and in valleys, over dusty, narrow, twisting mountainside roads at night, ended in a little valley at about 10 p.m. I got out of the back of the truck, which I had shared with four Spanish soldiers—all young men, almost boys—and asked both the lieutenant-commissar and the driver whether we couldn't go on to brigade, which was only about 10 or 12 kilometers away. With gesture and a few words he made me understand that everyone was hungry, that if I wanted to stay I would be given supper, a place to sleep in, and tomorrow at 6 a.m. he personally, the chauffeur said, he himself personally on his word of honor as a man, a comrade and an anti-fascist, would drive me over to brigade. I really didn't want to delay the journey until the next day, but they had been so good about everything—about the drive, about their offers for the evening, about the singing on the way up and the general feeling of companionship they exhibited (saying the few words they knew of English, the shorter versions of fornication and defecation) that I decided it would be best to stay. Firstly, my Spanish was not equal to a good, stiff, winning argument. Secondly, I was attracted by what I could see of the valley-village in the extreme darkness, and I wanted to taste of its special brand of hospitality. It was the first time I had stopped in a village in Madrid province. The last one was far away, in the province which gave Cervantes to the world.

The commissar, treating me with extreme but earthy courtesy—that special kind of companionship and camaraderie and perfect taste which I have found, in rare combination, only among the Spanish peasants, led me to one of the modest-looking homes on the main road. We entered just as a young woman, dressed in black, not pretty but swell-looking, was placing the knives and forks and plates on the table. We gathered around her, the Spaniards kidding her, she taking it all in tolerantly but very gravely, with the kind of sorrowful dignity one expects of a woman who, as I afterward was told, had lost her husband only a month ago. Then she brought in a large chunk of yellow cheese, very fresh and tempting to look at after the long dusty ride, and two loaves of bread. We sat down—commissar, driver, a couple of lieutenants and myself—and helped ourselves out of a large dish of sheep-meat, green peppers and tomatoes, all stewed in olive oil. I had two helpings, and could have gone another, but didn't. All of us filled and refilled our glasses with excellent white wine (and when I say glasses I do not mean the small wine glasses of America but the large glasses which *we* use for milk); when the stew was gone, we passed the cheese around and each of us cut off large chunks, which we ate with bread and wine and small purple grapes freshly-picked from the nearby vines. At this point a middle-aged civilian, tall and thin and half-deaf, with the kind of face that Hollywood would grab for the heavy villain role entered the room, and offered all of us some Spanish cigarettes out of a big carton. They were the

kind that are wrapped in paper, but they have to be opened and re-wrapped in other paper to really stay together in the process of smoking. I'm not very good at rolling my own yet, and seeing my difficulties, the tall, thin sardonic-looking guy offered to roll mine; which he did, and I smoked it just as an old woman, probably the young woman's mother or mother-in-law, also dressed in black, entered with the coffee. Then tall gaunt-face opened the cupboard and took out a bottle of cognac, which we drank with our coffee, and a bottle of anise, which we sipped afterward. Then for a long time, while three other officers joined us, we sat around the table, the goodnatured skinnypuss spinning yarns. After a while I got the gist of the stories, and the main outlines, both from the look on the others' faces, from the very special quality of their laughter, and from the fact that one of the men closed the door so that the women should not hear. While the story-telling was in full swing, I dug my precious single pack of Raleighs out of my pocket and passed the cigarettes around; they were tremendously pleased with the slight gift. Throughout the evening, till 12 when we hit the hay, they kept trying to interpret the nuances of the stories to me. One of them spoke French, and he got a few points across, but on the whole their efforts were useless. After a while I got very sleepy, and so did the others. Everyone said good night and left the house except the commissar, the tall thin man, and the three women (another old one, also in black, had appeared as the party was breaking up). We lighted our last cigarettes, and then the tall guy began to show us his new lighter, which had both a rope-lighter (good for trenches because it has only a dull glow, no flare) and a gasoline lighter. He proudly explained how it worked in combination and announced that it cost only two pesetas. Which was my turn to brag. I pulled out my own black-enameled lighter with my initials, and showed it to them, how easily it worked, showed them the initials. Immediately I saw the thin man's face acquire that "I'll trade you" look. But I explained carefully that it had been given to me by *mi mujer* (my woman, or, my wife) before I had left for Spain. He didn't get the meaning, but the young woman looked at me very warmly and shouted in his ear that it was not the lighter itself that I valued but the *sentimiento*. He asked how much it cost. I explained with difficulty that I didn't know, since I hadn't bought it, but I guessed about four dollars. Which astounded him, since one dollar is worth from 12 to 15 pesetas here—I don't know how much because I have only my single silver dollar and I've never thought of exchanging it. He examined it again and then pulled the sour-grapes act on me: "Well, it's no damn good in the trenches," he said.

Afterward, in the room upstairs to which the old lady led us with a lighted candle, the commissar pointed to three beds: one was very large, with beautiful, real white linens; another was single (which corresponds to our three-quarter size), with a coverlet but no sheets; the third was just a cot, which had merely a blanket on it. He pointed to the very large bed and told me I was to sleep there; he himself used the small, bare cot. After I blew out the candle we talked for a while, which was good practice because I couldn't use or see gestures in the dark. We didn't get very much said, but it was understood that at 6 a.m. the truck would be waiting outside to take me to the brigade.

The next morning I awoke promptly at six. *El Commissario* was still asleep, snoring musically from the dark corner where his cot was placed. I dressed, washed as quietly

as possible, only woke the Com. once, and that only for a moment. Then I groped my way through the house, downstairs, and into the dirt-road street, where most of the soldiers in the local battalion, mostly Spanish youths, were already awake, getting their coffee out of a large vat a way up the road, breaking their bread into small chunks, which they dumped (not dunked) into their tin bowls, allowing it to soak in the coffee. I had left my mess kit behind, and so I approached a young soldier and asked him to lend me his. He did, and I filled it, drank the coffee (all the while thinking, crazily enough, of one of the things the doctors had told us: "Syphilis and the clap are transmitted more frequently through dirty germ-ridden drinking cups than from any other….") But the tin bowl was clean, the young fellow looked okay, and in a short while I forgot about it, as I should, and I felt good, with the coffee in me and the sun coming up behind the high hills. But the car and the driver were nowhere to be seen. I looked around for a while, then gave it up as a bad job, and decided to investigate the town, which didn't need much looking around; it was so small that you could take it in, church-tower and all, at a single glance. Tiny, one street dug into the side of a hill, with the houses rising from it on one side, and sinking off, sloping downward, on the other. Chickens here and there, a few rabbits in cages. Then, low, beyond the houses, a slow-moving clear stream, dammed at one spot. There I dipped my head into the water, freshening myself, in company with at least a hundred other men dotting the banks for a hundred yards. Up past the gully through which the stream ran, was a steep hill, and as I washed I saw two shepherds steering a large flock of white sheep down the hill, a single solitary black one among them. I don't know whether you've ever seen a large group of sheep going down a hill: it's almost as if they were flowing, not running, downward….Well, it was 9:30, actually before I found the car and the chauffeur and got going on my way to the brigade, where I found the comrades I'd been looking for, settled the few matters which had caused the trip to be made, ate, spoke to some friends, and finally got a car back to town after tracking down a German colonel of the I.B. He was very (that is, the colonel) polite all the way back, kept whistling Bach all the way, offered me melons and grapes but withheld the one thing I wanted: a swig of his canteen, which had been filled with delicious lemonade at the brigade.

From the length of this letter you probably have guessed that it's no longer the 17th of August, but the 18th. I've been back for some time, busy at work, off and on, with long periods of work and short ones of rest. I've seen many people from home and heard from others. A letter from Joe Freeman, one from Herb Kline (who should be here by now), one apiece from Lou and Bernie, one from Meyer and 4 from you. Nothing from Stan or Mother, neither from my father. Then too Leo Gallagher has been here (still is, I think) and Langston Hughes.

I've acquired a book, in much the usual way that things are, among the foreigners, acquired here. It's one of the Lean Man's books, and it originally belonged to Doctor Bethune, of the Blood Transfusion Service; then evidently, when Bethune left, he inscribed it to Ted, who is Ted Allan, the FP correspondent here, so that the flyleaf reads: Bethune (in a large scrawl) Madrid, January; then "To Ted," and Bethune's initials. The book was left at the Institute when Allan departed, and G. Marion's wife picked it up there, read it and then gave it to me, since most English-speaking people had gone elsewhere. I brought the book up to my room, where the Lean Man inscribed

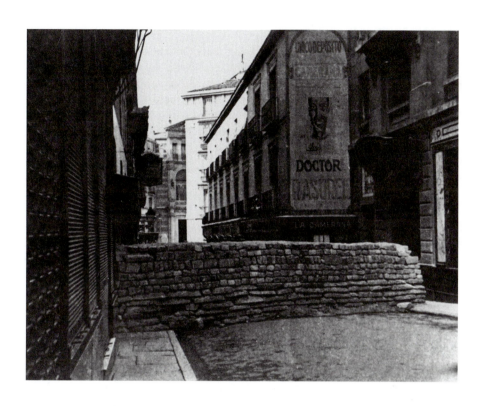

A defensive barrier in a Madrid street (fall 1937).

it by crossing out the byline and writing his in, then putting down "To (my name), Madrid, August 1937"—then he had to turn to the blank page before chapter one, where, quoting from the ending of the book, he wrote the following:

"To E..........., of the International Brigade—

"In his imagination he was already going about the solemn olivars beneath the tiger hills of Jabalon, beneath the splendor of a sky that flamed with scarlet and gold. Among the trees of his imagination a voice was singing and he saw himself moving deliberately around the trunk of an olive. It was a lovely zorzaleno in the full pride of maturity, its great mother branches holding themselves nobly, the leaves and fruit shining purely in the golden light." Page 470

"It is still the same with me, E....., and more keenly now because we have first to reconquer the South before we can visit The Olive Field again. — R........, of the International Brigade – Madrid, August. 1937."

We have done many things together, the two of us; gone driving, visiting, swimming, on lectures; have taken long walks in the evening when Madrid is more beautiful than ever, especially in the amazingly clear moonlit nights of the past week; have talked, of war and books and music; have stopped at one of our walks to listen to music (old native Spanish music) blaring out of a window into the street. And many others, out for the evening stroll, stopped alongside us, listening. You don't have that back home—not in the same form, nor the same music, nor the same quality of tense listening, complete concentration. And I have listened to him play music—Bach and old Spanish melodies, Andalusian, Malagan, etc. He's an almost perfect "amateur pianist," as he calls himself. But what I am most grateful for are his long, rambling informative talks; he knows more about Spain, as I said, than anyone I've had a chance to speak with. And the whole country and its people and its problems are clearer and closer to me now that I've listened to him. And in the pleasure of having learned so much, I am deliberately overlooking for the moment many of the not-so-good qualities of the man—the other side of the picture, present in all of us except angels—which do nothing more than make him completely and utterly human. I'm not hero-worshipping, understand; I'm too old for that. Clay feet, etc., you know. That's for the moon-calf. But the great debt I owe him for what he's given to me is as important, in this situation, as the one I owe to Joe Freeman for the more basic influence he exerted for so many years, formative and decisive years. Or the kind I owe to Leo, in a thoroughly different and more important way. Or the kind, dearest, that I owe to you, for yourself and what you've meant and still mean and will continue to mean for me. They are all parts of the same picture, equally essential to the whole—each adding its own special quality of knowledge, understanding, goodness, skill, to the entirety. And I'm grateful for all of it.

It's past one now, here. Where you are it's only eight o'clock in the evening, and you're probably finishing your dinner and preparing for an evening of meeting, or movie, or visit, or whatnot; perhaps work, or study, or piano. I still have to remain awake for several hours, even though I'm very tired; I've given my interpreter and assistant the job of dummying the *Volunteer* this week, but I have still to write the

captions for the pictures and photos. Which I'll proceed to do in a few minutes.

Goddamit, kid, I wish you could be with me, only for a day or two, once in a while. But don't go grabbing any boats: stay where you are. I can easily stick it out to the finish, and you're better off and more useful where you are. However much I'd like us to be together, I don't want you here now. Sometime, when we've "reconquered the South" and the north and all of Spain, we'll come here together in peacetime and I'll show you everything I've seen, and the places and people I've grown to love. Meanwhile, sweet dreams and I love you.

<div style="text-align:center">E.</div>

••

from EDWIN ROLFE

<div style="text-align:right">Aug 24, 1937—Tuesday.
[Madrid]</div>

Darling,

It is very early in the morning—just 3 minutes past 12 (or late at night, as you will) and I'm sitting in Station EAR waiting for 12:30, a broadcast, and then an interview with the man scheduled to speak tonight—H.V. Kaltenborn of the National Broadcasting Company; here on a short visit. After that's all over, probably by 2:30 A.M., I'll go home for a long sleep—that is, if the mice don't get into my bed, as they did two nights ago. I remedied this disturbing state of affairs last night by dipping candy and bread in rat-poison and spreading the stuff around the floor. It worked. I hope it works again tonight. I don't mind the little critters playing around on the floor—J. Hawthorne calls 'em "ducky"—but it's a queer feeling to have them running over one's thigh, as one little mouse did two nights ago.

On Sunday I visited El Campesino ("The Peasant") one of the most famous of all the Loyalist commanders in Spain. I ate with him, drank beer with him, joked (through interpreters) and then we went to a soccer game between two battalion teams in his division. Two other Americans & I sat in the same box with El Campesino (or Barbos—the bearded one) and watched the teams, each led by a pretty señorita carrying the Battalion banner, parade up to the box, where the captain stepped out & made a short speech, while Campesino looked on, fist raised in the Loyalist salute, smiling through his beard. All the time the band played flamencos & malagenas, typical ancient, beautifully rhythmic Spanish music. But suddenly we heard a very strange sound. It wasn't music (and that was all the more evident in contrast to the songs which had preceded it). The band was playing a number in special honor of the three American visitors—believe it or not, the piece was John Philip Sousa's "Stars & Stripes Forever!" Of course we all rose & saluted, as did most of the Spanish soldiers, while Campesino stood there, smiling like a kid. It was swell. And the band-leader (who incidentally is one of the best hot coronetists I've ever heard) sweated and swung the old baton.

Well, I hear the people coming.

<div style="text-align:center">X X X</div>

I'm home again and it's 2:30 and I'm sleepy & I'm going to bed.

<div style="text-align:right">Goodnight, darling
Ed</div>

P.S. I have just sent you 7 photos in an envelope which will be mailed in Paris by Leland Stowe. 5 are for R.B. c/o Random House, or when he (RB) comes to America—& 2 are for you to do with as you will.

* * * * ED

Send me your footprint, traced on a sheet of paper, and I'll get you some swell native shoes.

..

from WILLIAM SENNETT

June 9, 1937

Darling Gussie:

It is very pleasant to wake up in the morning after a few days grind and receive a letter from you. It starts the day off right.

When I read in your letters and in the *Daily Worker* of the things that have been and will be sent to us I am forced to smile and wonder. The honest effort that is made back home to supply a few luxuries often goes for naught because of certain conditions. So far of all the cigarettes sent to the boys here not one pack has been received by our boys. Only small packs have been received by individuals of stuff sent directly to them. That is why I say that for the present have things sent directly to individuals. Small packages can be sent first class mail.

Every letter that is received back home is probably expected to contain some valuable information on Spain. From what you wrote in one of your previous letters it seems as tho you expect the general propaganda type as written in the *D.W.* I must repeat again that basically those are good in their place but not as a regular feature for transmission of thoughts and experiences.

I have just finished reading the abridged text of Gil Green's report to the YCL convention. Its crystal clearness should point the way for every YCL Branch. When he speaks of our YCLers leading a normal fruitful life it's time to start examining our Branches. Much remains to be changed in Chicago as a result of the Nat'l Convention decisions. Its effect should be felt immediately.

In a previous letter I wrote to you of the conditions and attitude of the peasantry. You might be interested in knowing of the reaction and changes amongst the urban population. Madrid has afforded me the opportunity of seeing things for myself.

The Trade Union movement is still not unified due mainly to the differences that exist not amongst the membership, but the leadership. An example of this is in the attitude towards the formation of the new Government. The C.N.T. *(Confederacion Nacional Trabajadores)* anarchist led Union and membership refused (previously) to support the Negrin Cabinet. The U.G.T. *(Union General Trabajadores)* though composed of Socialists and Communists also refused to support the Negrin Cabinet. This might seem contradictory to the policy of the Communist and Socialist Parties, but it shows that the leadership is still part of the old Trade Union officialdom (not Communist) and does not reflect the recent growth nor opinion of its membership. (It is having its first convention since 1932 this month—watch the change.)

The two unions have realized the necessity of unity with the government and both

have issued statements since, that they will work with the government towards victory.

It seems funny, yet ironic, to walk into barber shops, clothing stores, etc. and see that the shops are union and, to emphasize it, belong to both unions—C.N.T. & U.G.T. Some workers I have met have shown me membership cards in both unions. How simple unification would make things. How much clearer things would be for all the workers. How much impetus it would give for a greater unification in other fields and in the general struggle. We hope to see this while we are here.

In Madrid on the Gran Via there is a big department store resembling the Woolworth store in downtown Chicago. It has about 100 employees. I was curious to know how it was operated, so I hunted up the owner. The "owner" was in reality the manager of what I found out to be a store run on a collective basis. They had bought out the former owners and, together with some former employees, taken over the place on the co-operative idea, which is prevalent amongst many of the middle class. All of the workers were either C.G.T. or U.G.T. members. The hours of work are 10 A.M. to 1 P.M. (3 hours) then 4 P.M. to 7 P.M. (3 hours) from one to four P.M. is lunch and the usual Spanish siesta. Not bad!

I read a lot about queues (lines of people awaiting rations) back home but could never really appreciate their meaning as I do here. There are things that are not available in the open market (because of war) like soap, bread, and canned milk—even coffee. People start forming lines as early as 3 A.M. to wait all day if necessary for rations of precious supplies. What patience! Considering war conditions, the queues here are not as numerous as might be thought. I have seen them grow smaller since the last two months. Why even candy is available!

The situation in industry here is of making it more part of the war machinery. It has been functioning heretofore too individualistically and not adapted to the needs of the war. The nationalization of the war industry is an important step forward in a central command of both the front and rear. Its effect is already becoming obvious.

Not knowing the language is really a difficulty. I can appreciate the problem of the foreigner in the States. My Jewish comes in handy at times (speaking to Germans) but in Spanish I can hardly manage. I have picked up some words but haven't made a serious effort to study. We have Spanish classes now so I should benefit from them.

Just received your letter of May 22nd this evening. Your letter of May 24th I received this morning. I sent you photos and now I get jibed! Will get one in civilian clothes so that you can recognize me. Did you get the ring?

Got your union paper. Very explanatory. Taps now, time to turn in. A Good nite kiss. Write at leisure—Love—

<div align="right">Bill</div>

• •

from SANDOR VOROS

<div align="right">Madrid, December 17, 1937</div>

Sweetheart,

"The moon is very big tonight"—this sentence has been on my mind for days. It is a beautiful sentence, I can't stop rolling it off my lips. I came across it in a letter among my documents while searching for material for the book I am now working on.

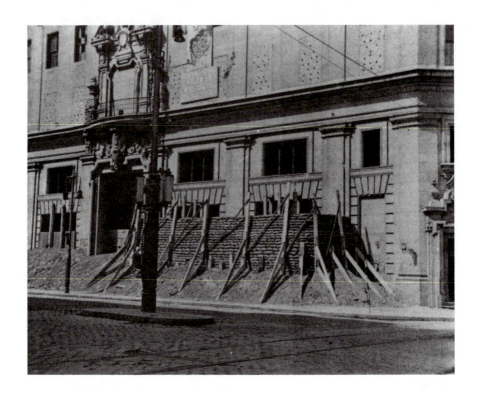

The first floor of the Telephonica building in Madrid, the highest point in the city. A favorite target of fascist artillery, it is sand-bagged for protection (fall 1937).

A girl in New York started her letter off to her boyfriend in Spain with that—on the very night her boyfriend was killed. He died very bravely under that very big moon and that very big moon lit up the whole landscape, throwing a ghostlike silvery flame on No Man's Land, silhouetting the rescuing parties against the sky, and the fascists opened fire, wounding many of the brave volunteers who were risking their lives trying to bring in the body of that boy who was lying dead out in the field under the very big moon his girl was writing about in New York. She was very lonesome for him and so she was looking at the moon in New York and the moon was very big; it reached all the way to Spain. He never received the letter. I was the one who received it and I read it ten months later, a few days after I finished my chapter, on the night of the very big moon, and I never heard till then about the girl. But ever since I read that letter my heart went out to that girl. I keep on wondering whether she still notices the moon and hope she is proud of the boy who died a death worthy of his principles and his class. I want to raise a monument for that boy and girl under that very big moon, a monument of love and class struggle and of heroism and self-negation and sacrifice that shall be at the same time a monument of the struggle against fascism in Spain.

The moon has been very big a number of times and I hope the time will be soon here when it will shine on a free Spain and we, two, will walk arm in arm under that very big moon, thinking about that other boy and girl...

Sanyi

from EVAN SHIPMAN

March 14 '38

Dear Ernest [Hemingway]:

This letter is a little late. Mine usually are. I was very glad to see you last December, and I had a good time with you. I am back in Madrid again now working on the radio, and have been here for the last month. I will give you my news and as much of the rest as I have been able to pick up.

When I got back to Murcia—Eli Beigelman and I had a hell of a trip with four breakdowns between here and Albacete—I came down with a real case of grippe, fever at 104 for ten days. They thought it was typhoid and kept me quarantined even after I got well. If Eli and I had not finished a quart of gin you left, on the road, I don't know what I'd have caught.

When I got well, they put me on a diet—four eggs a day, and a lot of other things. I guess I began putting on weight hour by hour. I'm fat now, and for the last six weeks I've never felt so good. My job at Murcia had pretty well petered out—all the French administration was fired, so I did not have any more translation to do. Ailmuth came down to see me, and I began to get eager to go back to Madrid. They wanted me to stay in Murcia to prepare a booklet for foreign propaganda, but I thought if I came up here I might get something on the *Volunteer.*

The Medical Bureau sent down for nurses to broadcast, and I fixed up the broadcasts and managed to wangle a leave to come up with them. When I got here, I found the *Volunteer* had moved to Barcelona and Eli was suffering the fate of all Polit. Commissars—on his way out. But I had luck. They had to have someone down here to

handle the English program: I stepped in, and they wrote to Barcelona and got my authorization. It is hard work and interesting work. I do seven articles a week—around 1500 words each. For instance, last week I wrote articles on: The French Invasion of 1808; Pablo Picasso; Ramon Sender's book; Malraux's book; The Children's Camp in Murcia; and condensed a number of articles on Spanish politics. I am much better off here than hanging around in Murcia, especially since I am well now.

I live at the Victoria. It is like a morgue and the food is terrible, but there is nowhere else to go. Notter is there, of course, and he's like an undertaker, except when he's drunk—then he'd do for a first gravedigger. Simone Terry was there (our Ophelia), but she's gone back to Paris. Marty Hourihan left for Albacete the day after I came. He wanted to go back to the front, but he was still limping bad. I hear that they are sending him home. Chicago was here, and he did leave for the front. Also they use the hotel for all the delegations. I could tell you a lot about the delegations, but you'd think I was getting to be a defeatist or counter-revolutionary or something. But I have found out how to escape the delegations. In the middle of the pep talk—even in the middle of a sentence—just say, "Comrade, can I have a cigarette, please." If you say it often enough, they never bother you. And you never get more than one cigarette.

The last news I heard of John Sanakas, he was OK. We spent the day together before I left last time, and he went up to the brigade. Also Wolff and Keller were OK, but the last I heard was a month ago. I'm afraid a lot has been happening since then. Detro I guess you know got wounded early in Teruel. It was in the hip, and at first they were very worried. He was on the danger list at Benicasim, but they moved him to Murcia where we have a fine English bone doctor, and right away he began to pick up. Before I left, he was definitely off the danger list, was sitting up, eating good, and looking 100% better. I think that is all I know about your friends. Herbert [Matthews] is still away. Or if he is back, he is not in Madrid. Tom, too, is gone. I think they gave up on their apartment. I put your guns there the day I left last time. I hope you get them.

You probably know as much or more about what is going on here as I do. By the time you get this letter, we all will know a hell of a lot more. Things look pretty black right now, but when I think back to last year, and remember just before Guadalajara, I know that it is foolish to be discouraged. I am sure that we have the army now, and that industry is developing. It is just a question of how much the fascists are shipping in, or rather when France will come to her senses. Jesus I wish old Clemenceau was alive.

We have not had any first rate shellings since I got here (I knock on wood) but there was one the other night that hit the top floor of the Palace across the street. I think the top floor is empty. And another one the same afternoon banged the Ministry of the Interior a little way off from the hotel. They sent over quite a lot of little ones that afternoon, and all of them—maybe twenty—fell right within a hundred yards.

Ryan and Mickey were both at Velasquez until a couple of days ago. Now they have gone to Albacete. Ryan's Brigade book is out, and not such a good job. I know it was done under tough conditions, but just the same it should have been better. Ryan was very nice to me while he was here. I went out and had dinner and spent the night with him several times. His heart has not been too good, and the doctor said one drunk would kill him quicker than fascist bullets. So he's on the wagon. But he's just as good company.

The various phoneys that were here when you were are all gone. But there is a new crop.

Outside of my work—and it's a long day what with research and everything—I have no life here. Things did not work out between Ailmuth and me from the time I reached Madrid again. I have the Moorish record, and I play it once in a while. And I go to Chicote's, but there is nobody around that looks like Anita. I guess she's still in the hospital.

Madrid is very beautiful now. It is real Spring and all the fruit trees are in blossom. It's fun to walk on the Prado, or down where the book stalls are. I am learning to read Spanish, and I've picked up three books on Spanish horses, but I haven't had the time to read them. When I have the time to think of it, I'm homesick. I didn't put in for repatriation, because I knew pretty well how things were, and it would have been no use. Please write me. Just S.R.I. Plaza Altozano Albacete, reaches me. I know you hate to write letters—but you like to get them. So do I, and right now, more than you do probably.

My love to Pauline and the kids and you,

<div align="center">Evan[1]</div>

Give my best to Max. Tell him I mean to write to him soon. And to Sully. Did you write to, or see, Mary?

George is around and seems anxious to hear from you. I gave him your address.

[1] Hemingway had met Shipman—a wealthy American born but European educated poet and horse racing devotee—in Paris in 1924. Shipman drove one of Hemingway's ambulances into Spain, signed up with the Washington battalion, and was wounded at Brunete.

YOU CAN HELP STOP HITLER'S INVASION OF SPAIN!

PICKET THE GERMAN CONSULATE SAT. JUNE 12 11:00 A.M.

Women and children of Spain are being slaughtered! Hospitals are destroyed, flourishing cities reduced to ruins! Nazi warships bombarded the Loyalist port of Almeria, killing and wounding scores of civilians!

Hitler's troops have poured into Spain, to help Franco's fascists smash the democratic government! The Spanish people, fighting to preserve their liberty, are fighting for the peace and freedom of the world. Give them your support! Join the protest picketing of the German Consulate at 201 Sansome Street, Saturday, June 12. 11:00 A.M.

SPANISH AID WEEK — JUNE 12 TO JUNE 20

The children of war-racked Spain are being driven from their homes by the guns of international fascism. Orphaned by the bitter struggle, they cry out to humanity for food, clothing and shelter. In response to this urgent need, the North American Committee to Aid Spanish Democracy declares June 12 to June 20 to be Spanish Aid Week. The Communist Party actively supports this drive for the collection of medical aid, food and funds for the suffering Spanish children!

Thousands of real Americans are today fighting side by side with the Spanish government forces, in the Abraham Lincoln Battalion. Many have already given their lives that democracy may be preserved! YOU CAN DO YOUR PART! Join in the activities of Spanish Aid Week! Give that the children of Spain may live.

DEMAND U. S. EMBARGO AGAINST FASCIST INVADERS!

The American people, with a long tradition of freedom and liberty, cannot fail the people of Spain in this crucial hour. The U. S. government has established an embargo against the legal and recognized Spanish government. Demand that this embargo be placed against Germany and Italy, who insolently march their troops into Spanish territory! Give every support to the Spanish defenders of life, liberty and peace!

Join the Communist Party, foremost in the struggle against reaction!

Read the Western Worker, People's Champion of Liberty, Progress and Peace!

Issued by: S. F. County Committee, Communist Party, 121 Haight St. Dist. Permit No. 300

To Aid the Children of Spain
GALA SPANISH EVENING
Dancing — Program
Speakers
Buffet Supper
121 Haight Street
Sunday, June 20, 6:00 P.M.

An illustrated flier distributed in San Francisco.

POLITICS
Reading the 1930s

..

INTRODUCTION

The politics of the American volunteers is one of the most vexed subjects at stake in describing their role in the war. After an early stage when volunteers came without organizational support, the Comintern in the fall of 1936 became actively involved in recruiting volunteers and aiding their travel to Spain. About 65 percent of the American volunteers were either Communist Party members or members of its youth organization, the Young Communist League. There is no question that being politically aware in this way helped alert them to the dangers of worldwide fascism, and almost all the American volunteers were first and foremost antifascists. Many Americans who did not think much about international politics, on the other hand, thought fascism was Europe's problem, not ours. In that they were wrong, more wrong than anyone could have known at the time, given that Hitler had secret plans for mass exterminations across Europe and America. The Party's antifascism and its support for the Spanish Republic—like its defense of the Scottsboro boys in the States, or its advocacy for Depression-era relief for the unemployed—are among the things in which it can take pride. Yet postwar anticommunism has led many either to exaggerate or to de-emphasize the Party's role in the life of the American volunteers. Some, to be sure, were long-term activists and Party members. Others, like many Americans in the Depression who believed capitalism had collapsed and the Party was the only real advocate working people had, joined the Party only for a few years. Many resigned their membership in 1939. Others resigned in the 1950s. Unlike the German and Italian troops in Spain, however, the Americans in Spain were volunteers. Once they volunteered, some Party functionaries were assigned political responsibilities in the International Brigades, but no one was compelled to volunteer. Indeed, there were usually more volunteers than there was transport available.

Part of the necessary cultural work in Spain involved keeping the Americans current on major developments there and elsewhere. Those who trained at Tarazona de la Mancha heard lectures not only on how to dig trenches but also on Spanish politics. There were also political essays in the magazine *Volunteer for Liberty* and in the daily mimeographed newsletter *Boletin de Informacion de las Brigadas Internacionales del Ejercito Popular Espanol,* issued in several languages. The newsletter in particular included not only updates on the war in Spain but also brief articles on other countries. It is, for example, a likely additional source for some of the views on Palestine expressed in one of the letters here, a letter that will surprise some readers in view of its similarity to left rhetoric now. Palestine at the time was, of course, under British military control.

By far the overwhelming amount of political information provided to the troops focused on Spain. Keeping political awareness about the civil war high was an essential part of maintaining morale. One only has to stand at the base of, say, Mosquito Ridge near Brunete or Hill 481 across the Ebro river, look up the hillside or gully through which the Internationals charged, and imagine what machine-gun fire would have done to them, to realize how much political commitment mattered to morale and the whole military effort. The volunteers were asked to take terrible risks and perform impossible feats. Only a deep sense of commitment to a cause of great importance made that possible.

from THEODORE VELTFORT

> Aragon Front
> Oct. 16, 1937
> 22 AM
> First letter

Dear Mom and Dad and Mary Jean:

Just received your letter—Bill Lawrence forwarded it. Rather surprised me; I really expected to keep you in the dark. Thought it would make less worry for you than knowing I was here. You know now why I was so subversive before I left!

Sorry couldn't cable you—would probably take longer than this letter.

'Tis a long story. First of all, I am in best of health (have gained almost 10 pounds!) and am in no immediate danger from Franco.

At the time Joe L. met me, I had been driving various cars and a refrigerator truck. Soon afterwards I was sent out from Albacete to a town west of Madrid as an ambulance driver—my occupation since that time. A month near Madrid and I came up to this front with a large evacuation ambulance. A few days ago I was given a small new Chevy ambulance and I now drive for a Greek battalion.

I will write more in detail of my impressions here; I want you to get this letter as soon as possible, so I will only outline the things I have learned about Spain.

Historical and Political (much of which you already know): Spain has suffered for centuries under extremely despotic rule. The lands and more recently the factories were held by a few and for the sole purpose of squeezing the last centimo of work-value out of the peasants and workers. This rule of a few culminated shortly after the last war in the Fascist dictatorship of Primo de Rivera. Behind the scenes, pulling the strings, in the Fascist camp, then as now, was the big Spanish industrialist and ex-smuggler-racketeer, Juan March. After the abduction of Alfonso and the founding of the Republic in 1931, March used his wealth (see *Fortune*) to obtain power for the clerical-fascist, Gil Robles. Robles became effective dictator late in 1933. The desperate measures of the political Right only put off the inevitable. A little over a year ago the people elected a Popular Front government which started, in a very mild way, to fulfill the promises given to the people for years. Allotments for schools were increased, taxes were imposed on the wealthy clericals and taxes on the big landowners were increased. Meanwhile Juan March had been busy organizing military supplies and negotiating with Italian and German representatives for assistance to be given to a fascist revolt.

The rest you know; Spain appeared on the map internationally when Italy, Germany, and Portugal sent forces for a foreign invasion. The present Spanish government is composed of representatives of the Left and the Center. The present representatives in the *Cortes* (Parliament) were elected by 5,000,000 votes against the 3,000,000 which went to the Right.

Next, the Popular Army: In the first days of the outbreak the Spanish people had tremendous odds to overcome. In addition to 80% of the old Spanish mercenary army and control of military stores, the Fascists had the military advantage of foreign equipment and personnel; whereas foreign democracy was very slow in giving any aid whatsoever to the Republic. However, the workers dropped their tools (not to sit down!) and men, boys, and even girls grabbed any weapons handy and rushed to the lines. Out of the Loyal Republican Guard and the other groups of militia that so ably defended Madrid in the early days, the Popular Army was formed. This is a truly democratic army; officers' stripes denote increased responsibility but not increased privilege.

The International Brigades became a part of this army just a year ago. When it became apparent that Spain was the scene of a Fascist invasion, antifascists from all over the world asked to help overthrow the one present menace to world peace. Internal difficulties in a Fascist economy make invasion necessary (for the Fascists!) for economic support; but when the expenses of invasion outweigh the resulting advantages, further invasion is necessary. Manchuria, Ethiopia, Spain (and now China again) prove this thesis. Hence it was recognized by thoughtful democrats that if the world is to have peace, Fascism must be halted. Frenchmen, Austrians, Czechoslovaks, Scandinavians, saw their countries "next on the list." Even Americans and Australians saw that oceans are no longer impregnable barriers. This is why there is now an international section of the Peoples' Army. I have seen men here of practically every nationality. One exception, however. Because of diplomatic reasons, the only Russians here are in technical positions. Anything that would offer the enemy the slightest excuse for comparing the International Republican volunteers with the Italian conscripts is scrupulously avoided. Of course, the Fascists need no excuse!

My personal estimate as to relative numbers of nationalities in the Int. Brigade would be as follows (1st) French & Belgian, (2nd) Germans and Scandinavians, (3rd) English-speaking, (4th) Italians, (5th) Slavs. The Americans I have met come from all sorts of occupations. One chap here is a farmer who has a family back in Dennison, Iowa. He is quite proud of his fine kids and writes letters home almost every other day. There are many seamen as well as other workers from all kinds of industry. There are students, writers, artists, and (attention, Papa!) even a few businessmen.

There are many Spanish who are working in the International Brigade and, of course, we operate in close contact with the purely Spanish brigades. The Spanish people are often ignorant and lack proper sense of organization—this of course is the natural result of lack of mass education. However, they are very quick at learning. At the beginning of the war there were very few Spanish drivers. Now there are many, and quite a few very good ones. The Spanish are wonderfully generous and hospitable. When I was in Valencia once to get a load of meat the Spanish *"responsable"* invited me to his home to have supper and stay for the night. It was the very modest quarters of a worker's family. It seemed a small place, in spite of the usual Spanish broad hallway;

however, it was a large family. The kitchen was half in the back yard, also usual in Spain. Good food is scarce in Spain; but they dug up a real meal in honor of the visiting *Norteamericano*. From somewhere they obtained a rabbit (it *was* a rabbit!) and made a very delicious stew with vegetables and rice. By sign language and very few Spanish words I managed to understand most of their questions. They wanted to know about the skyscrapers (the children thought that all Americans lived in them) and the movie stars. They wanted to know, too, if more help was coming from America. "They must surely have heard of the air raids," they said.

The bombings—the snarl of descending planes and the crash of exploding bombs and falling walls—one almost gets used to these sounds. In the country (where I am!) one has ditches and dugouts, and is quite safe; but the bombing of the cities is horrible. The Fascists pass up definite military objectives to bomb civilians in the cities. This seems senseless to us; but the evident object is terrorization and the frightening of the populace into submission. A method much older than the Inquisition, and practiced recently with some success in Ethiopia. The results of the air raids are everywhere. I saw a six story building in Tortosa that had been split wide open. In the exposed rooms the furniture and clothes were lying just as they had been when the bomb hit. I drove a tearful family into Murcia once. The man of the family had been killed and their home was destroyed by a bomb. They were going to see some relatives.

But even in spite of the war, all is not frightful here by any means. On the one hand the people are throwing back the invasion, but on the other they are repairing and rebuilding and constructing a whole new Spain. They have crews that get to work on a ruined building almost immediately after its destruction; clearing away the debris and then laying foundations for a new building. The big cities resound with pneumatic drills and riveting hammers as modern new buildings go up. This astonished me, that architects should be so busy and whole public works projects should be planned right in the middle of a terrific war. They are not merely planning for winning the war (although this is nationally considered most important) but also for the Spain after the conclusion of the war. I think they are quite right. This is still a very backward country, and a lot of development will be needed to raise the standard of living even to that of northern Europe.

Nearly all of the movie houses are open and play to full houses. I am sorry to say that most of the pictures are rather bad Hollywood productions with dubbed-in Spanish sound. Jimmy Cagney sounds very silly in Spanish!

I see that my "brief account" has become rather lengthy. There is really loads more to tell—I will send it on later.

We are quite well clothed and are fed off the fat of the land—so have no worries on that score. Advise you not to send any large packages—and if you send any small ones address them care of Bill Lawrence and mark "Hold in Albacete." The package service to the country is extremely doubtful to say the least. I can pick up, or get someone to pick up for me, anything in Albacete. Most valued items here are cigarettes and real soap. Cigarettes can reach me if sent flat in a letter that is backed with cardboard. Don't send anything valuable!

Sorry that the mail has to be so slow, and that you will have been quite anxious, knowing where I am. My best to everyone—keep sending me the news.

Teddy

P.S. We are coming home when Mussolini pulls out—but I shall get leave in Paris any-
way next Spring.

• •

from WILLIAM SENNETT

June 3, 1937

In Spain

My Dearest Gussie:

Again, time on my hands, you in my mind. The result–letters formed into words to
transmit thoughts to my loved one across a great body of water. Sentiment from me!

Summer is almost here, the days grow hotter, the flies more numerous and the war
goes on. This summer you had better take advantage of the things you like to do. Go
swimming regularly. Become a frequent visitor to the concerts at Grant Park. See that
more YCLers indulge in an organized program of activity that is healthful, beneficial,
and interesting. This is where Cicero in particular could attract the youth. Make the
interests of our comrades the activity of the League.

From what I see in the *Daily Worker* the New York YCL has a baseball tournament
in progress. They have a sports director, baseball teams, give prizes, etc. How does
Chicago line up in this sense?

Lately I have had an opportunity of grasping some of the political developments in
Spain more clearly than when I first arrived. It is wonderful to be in the midst of a social
change. The minds of the Spanish people have undergone many progressive changes
during the process of this war.

The survivals of Feudalism are definitely being broken up in Loyalist territory,
while in Fascist sections of Spain it exists in an even more brutal stage. I never realized
the extent of the importance of the peasant question as I see most clearly now. Even in
Madrid we see the mules and ox carts of the Spanish peasants. Their entire existence
is based on the soil. The majority of the Spanish people (58%) depend on the develop-
ment of the land for their livelihood.

Previous to the Popular Front government most of the land belonged to rich dukes
and lords who hired peasant labor at exorbitantly low wages, from 1 1/2 to 5 pesetas a
day (about [blacked out]). The vast lands, covering tens of thousands of acres, were in
the main uncultivated due to primitive methods. The peasants were kept in ignorance,
could neither read nor write.

The development of the Popular Front movement shows the leading role of the
workers in the class struggle. While Spain is in the main a peasant country, it was the
workers who formed their trade union organizations and political parties who suc-
ceeded in bringing about popular reforms that even bettered the position of the peas-
antry. A concrete example can be taken from the problem of literacy.

It was only after the republic was formed in April of 1931 that the question of mak-
ing the people literate was being tackled. Previous to 1931 the domination of the
Catholic Church over education showed their true role. 55% of the population of Spain
was illiterate and among the peasantry the proportion was even greater. In certain
regions it ran as high as 90%! Right after the formation of the republic a system of

public education was instituted. 9,000 new schools were developed in the first two years. The sway of Catholicism over education was definitely broken. When that happened the people of Spain were sweeping away feudal survivals.

The workers made strides forward and were winning the peasantry as allies. The present war against fascism is proof. The Spanish peasantry, though more backward than the workers, in the main are fighting together with them against fascism.

The Popular Front Government in existence since February 1936 has given the land to the peasants. It is true the type of distribution is varied but in one form or another the land is in the hands of the people who till the soil. There are collective farms. Land is controlled by organizations. Individual peasants have plots of land. There are no more dukes and lords controlling vast estates. Poor as agriculture is in Spain today (due to war conditions) the prerequisites of a rich tomorrow have been laid. When you meet a Spanish peasant you will hear from him the confidence he has in the future. He is making sacrifices today so that the war may be won. He shows you why the workers must have them as allies. If Fascism had succeeded (as they did in Germany) in duping the peasantry the scene in Spain today would be much different. It sure has been brought home to me.

I don't think that some of our own comrades back home realize the seriousness of the struggle here as an International one. The fact that not only fascism in Spain but particularly Italy and Germany will be dealt a blow cannot be considered merely a general statement or a superficial observation.

The other day five German warships shelled Almería. That day the German delegate was absent from the Committee on Non-Intervention. Does that seem consistent with the thought that Germany is backing down on her support to Franco? If something positive doesn't come from England and France, it looks more like Germany is prepared to go further.

Things look pretty serious at this moment because Fascism feels it cannot afford a defeat in Spain. Why even now the Spanish people (who by the way are very Internationally minded) are saying Spain now, Italy and Germany next! Within these fascist countries tremendous impetus will be given to the antifascist struggle with a defeat in Spain. Back home our democratic forces will gather courage and inspiration. The victory here, yes, will help to develop the Farmer Labor Party, will build the Party and the Youth Movement. Its concrete expression will surprise some of our "concealed doubting Thomases" on the benefits for America of a Popular victory in Spain.

The development of the Youth movement here can well be held up as an example to ours back home. Here as a result of the fusion of the YCL and YPSL a vital national force has taken shape. The Socialist youth organization (J.S.U) has recently declared working relations with the Young Socialist International for purposes of helping to unify the International youth movement. It still retains sympathetic affiliation to the Y.C.I.

Now close to 400,000 youth belong to the J.S.U. with the entire organization working at the front and rear for victory. It has come out openly against Trotskyism and its paper *Ahora* is carrying on a consistent campaign for the extermination of this evil force. I wish that it would be possible to have closer connections with the J.S.U. and to learn more about its appeal, program, and leadership. At present this is out of my range

Bill Sennett (standing), on the outskirts of Madrid,
April 1937.

because of the circumstances under which we function.

May 30th Memorial Day, United Youth Day for us, just passed. Chicago U.Y.D. was narrow and had a small turnout. If that is so then valuable lessons and methods that should be understood by now are not applied there. I know personally that for quite a while I was in a rut back home and that didn't help the west side any. My outlook was narrow, my contacts almost nil, my organizational work and political development were in a static (and therefore retrogressive) state. The understanding of a person towards things right under him is sometimes brought forward more clearly when there is a beneficial change of scenery. How much better I feel I could work now. The thing I miss most is an opportunity to do some basic studying.

This week being International Aid Spain Week gave me an idea which can be put into effect even though by the time you get this letter that particular campaign will be over.

Every fellow who went to Spain has a list of friends, many of whom are not connected with the movement or who up till now have seemed to feel that Spain does not concern them. We want to reach them, get help for Spain and make them part of the youth movement or at least members of the F.A.L.B. Why not on a personal basis, branches of the YCL who have members in Spain, call special gatherings with invitations to these people? What young person would not respond to such a gathering? Let me give you an example. Cicero is almost dead. Rudy and I were in the branch and we did know some people in Cicero, particularly Rudy who was raised there. He has friends, Slim & Wes know them, he played ball with them, grew up with them but they never were interested in the YCL. Now if they received a letter telling them that their friend Rudy was in Spain and a gathering (or beach party) was being held in his honor to help him get cig's, chocolates, etc. I'm sure they would respond to such a call. You might even be surprised to find some of these friends joining the YCL. In Cicero this could be done for Frankie C. too. Get his sister Betty to help. In the Barron Branch for Moe, Iggy, Sammy, what a host of friends—outsiders—could be gathered. Why not try it? For myself I know of fellows like Ben Libkin who could bring my whole old gang down. His address is 1538 S. Kolin Ave.

Every newspaper writer who has been to Spain seems to have formed conclusions as to the duration of this war. If you will notice, however, all are based on if's and possibilities. Hemingway with his one year if Bilbao is saved, two if lost. The *N.Y. Times* correspondent who says two years with an if attached to everything. This whole war is a problem of International if's. Its duration therefore cannot be accurately forecast. Things looked so rosy when I first came that we all thought it was a matter of 3 or 4 months. Now things look like they can be drawn out even if localized. But, the longer the war the greater the danger of it becoming world wide.

Personally I feel that the summer months will be crucial ones. We may not see an end to the war but its future character may be decided by the end of summer. What I wouldn't give to see it ended! I would still like to be in the prime of my youth when I return to the States for active work in the Youth Movement.

I still don't have an address to write to Johnny M. & Irv. If you care to you can let them read this letter (propaganda, eh!). Let them write back to me though. I want to hear about the work of the League in Chicago in every detail. (Though I hope to settle in L.A.)—

I will end this lengthiest of letters that I have ever written to you with a request. Have your F.A.L.B. send us indoor baseballs and boxing gloves. Send them direct to our 2 R.T. address. For those boys who are at the front chambre 17.1—15th Brigade. Imagine our Army. Ping Pong, radio, baseball, boxing, swimming. Relaxation helps morale.

May I also request a letter in return with as many words as I have written? Give the YCL my heartiest greetings and good wishes. Tell them I look forward to the day when I can again be with them.

Regards from Rudy, Charlie, Morrie, Frankie, etc. May we all have a speedy reunion in Chicago. As for that wife of mine, tell her that I miss her, wish that both of us were together, feel it would be better so, hope she still loves me

> As I love Her
> Bill
> 2 R.T. Albacete

P.S. – Eat a brick of strawberry ice cream for me. Then wash it down with a cherry malted. Boy that tasted good!

··

from PAUL SIGEL

Aug 29, 1937—Spain

Salud Mim, Bert, & Gang,

I'm almost startled to think of how things have changed for me since my last birthday. It's a swell feeling, though—it means that all of me, all of my actions, are keeping in step with the progress of the world towards a new civilization, towards a decent social order, and my one aim is to keep constantly in step until (and long after) that end has been attained. Anyway, a trip out here (and what I'm working at now) is as swell a birthday present as I could ask for—and so—my birthday greetings from me to you (all, and Mus, of course).

We're still here in town (impatient as hell to get going, though we have every faith in our I.B. leadership and Spanish Republican Army generalship) but some interesting things are happening. Of course you've been reading about our advances on the Aragón Front. This action is even more important than the one at Brunete. For almost a year the *Consejo De Aragón* controlled Catalonia. Soldiers went out to fight in the morning, fought for their usual number of trade union hours, and then went back home in the evening. Disunity—no organization, no discipline at all. Trotskyites, certain Anarchists, and people who used their name, filled storehouses with arms, munitions (even tanks) that were sorely needed at the front. Armed bands took over towns in & near the war zones, "stuck-up" gasoline trucks, gasoline that was sorely needed for ambulances to take wounded soldiers to the hospitals. Trotskyites played football with the Fascists in "no man's land." And all this was allowed under Largo Caballero. When popular protest & action forced him out & put in the Negrín Gov't, things changed quickly—*Consejo de Aragón* was dissolved, General Pozas was sent from Madrid to organize the Aragón army—and here is the result. Here is a releasing of the tremendous, untapped force & energy that exists in Catalonia. With this force released in an

organized form (as a distinct part of the Spanish Rep. Army)—*just watch our smoke.*

One of the reasons for the disunity that exists in the fascist army is the leaflets being distributed to the fascists by our planes—very effective "ammunition." I'm enclosing some of them. The one entitled "*Soldado de Franco,*" for instance, tells concretely just how the fascist deserters to our lines are treated, and has had a very great effect. Incidentally, pitched battles (lasting for hours) between fascist factions have been actually witnessed by our army. If you guys can't translate these leaflets, I remember Gil Green saying at the Convention that he was learning Spanish.

Here's something swell—we're working with Spanish comrades now—really getting an excellent chance to learn the language, to understand Spain—to learn from and teach our Spanish comrades. I've been waiting for this for some time.

Here's an interesting incident: Towards the end of the World War there was much fraternization between the soldiers of both sides. An American and German found themselves in the same shell hole and instead of extending bayonets, extended hands, in comradeship. They saw each other for but a few minutes then, and did not see each other again for 20 years till they both found themselves members of the I.B. here in Spain.

Listen gal, if I'd just answer your letters mine would seem (& would be) very few. That's the way yours are to me—I've received (just) two from you and two from Mama. Camp Unity is soon closing—& then what—and what address? Lemme know.

I'm giving my hand a rest from that last letter I wrote Mus—so, Be seein' ya! Feeling swell & doing fine.

> Salud,
> Paul

..

from LEONARD LEVENSON

> November 15, 1937
> Madrid

Herb, Guy,

I just received the box of cigarettes and your letter of the 15th. The former had a marvelous effect as they're the first I've tasted in long weeks. They were delivered here at a rest home where I'm getting over a slight attack of grippe which interrupted my short leave.

Your letter contained only one portion that saddened me. That was your condemnation of Roosevelt for "flaunting" the Neutrality Act in his Chicago speech. You wouldn't write or believe that way if you knew how that Act has kept peace out of the world and caused the slaughter of Spanish women and children by fascist bombs. Give us the arms which that act denies us and the forces of Hitler and Mussolini would be mowed down in a few week's time. It is precisely through the enactment of such hypocritical laws and foreign policies that the imperialists are defeating collective security and loosing war on the world. Do away with Britain's vacillation toward the fascists, the U.S. Neutrality Act, and let France open her borders—then the crimes against China and Spain will cease. The fascists will have a resistance to their excesses which they could not overcome. Technical equipment is the sine qua non of modern warfare. Give it to

the people of Spain and China who want peace and you will have peace. Herb, the way to peace is to see that Roosevelt lives up to his high words, not to censure him for speaking as he did.

I can't help scoffing at your turning to religion. Aren't you really using it as a nice sandy place in which to hide your head? (Altho I must say it will take some very honest thinking before you label the magnificent Temple Emanuel as such.) If you could have spent your birthday with me you would have been more concerned with the real deviltries conceived by men than with their pleasant Gods. That day we went over the top. Nine hundred meters we traveled thru a blazing machine-gun fire and were finally stopped at the top of a ridge. There I was stuck in a lousy crossfire. A Spanish comrade just ahead of me got one between the eyes. A blond college kid from Chicago, right beside me caught an explosive in the gut and passed away shrieking his own dirge. By dint of frantic digging with my bolo I got by with a crease that just broke the skin of my shoulder. While I lay waiting for the blessed night to come, maybe I didn't wonder how your birthday was being celebrated at home.

A couple of little incidents like this and you really get to hate war. You get to hate it so much that you even get damn mad at your brother for falling into the Utopian idea of American neutrality and isolation. Man, I don't want America in a war—I know what it means. But I know just as surely that the only way out for her is to join with the Soviet Union in an *active* fight for peace. Don't let it merely be the same old story of the Morgans and the Mellons deciding when, where, and with whom.

Tell George Aranow salud for his letter—regards to him and the family. Also—American dollars don't do me much good. Our pay is quite adequate to cover whatever we can buy. After a month or two in the lines with no opportunity to spend a centimo, we all come out with enough pesetas for as much steam-letting as we wish. The cigarettes are, of course, another matter and now that they've started to come through I wouldn't be bumped off for any darn reason.

Enclosed are a couple of snapshots taken on the sidewalks of Madrid. The uniform cost me a month's pay—it may not look like much, but it has one-millionth the number of cooties that the old possessed.

Oh, yeah—I spent an evening "b.s.'ing" with Ernest Hemingway and Herb Matthews of the *Times*. These are real guys by any standards. Both of them are as straight from the shoulder in the flesh as in print. If a lot of the press flunkies were like them, so many people would not be getting the wrong slant on things.

Give Dad a big bear hug for me and tell him I'll try not to make him a red-star father.
Love to you all.

Leonard

. .

from DAVE GORDON

Nov. 19, 1937.

Dearest Lottie—

This is radio station DG-IB. (For the sake of clarity—*DAVE GORDON—INTERNATIONAL—BRIGADES*. It's not a code.)

Today I read most of Uribe's report to the Plenum of the C.P.S. and took notes on it.

I also read his entire report to the Feb. Plenum. I will soon have enough material for a decent outline on the agricultural situation.

I was asked to draw up a sort of manual for political commissars. There is abundant material in Spanish. But the specific application to our Brigade, the XVth, will have to be what is generally called "original" because for the specific Anglo-American condition there exists no material.

One of the comrades who went to Madrid and who promised to bring me material returned with a volume called *Historia de la Civilización Ibérica*, by one J. Oliveira Martins. I was very glad to get the book until I saw that most of its almost 400 pages deals with history up to the beginning of the 19th century. It's just with the 19th century that I want to begin my study. I'm anxious to do an outline on class struggles in Spain. It would be useful all around. If I were in Albacete I'd know where to get the stuff—I know all the book shops there.

In the meantime I have the outline on agriculture and an idea for an outline on the military progress of the war, and a couple of others, to work on.

Because of working on the outlines and taking notes on various topics I find little time to work out a systematic educational program of a "permanent" nature for the Brigade. However, I've made a few notes towards the formulation of a program and a couple—not more—ideas are rattling in my brain. I hope there'll be enough time to work it out.

Last night some after supper gossip in the courtyard hindered my learning of an Elks' [Russians'] bull-session. I really would like to have been there. However I had some good tea, toasted rice—

Tonight I sent lots of propaganda for Spain back home—to you, to Ken Eggert, to Hymie, to Ken Cole, to my mother, to Traski, Peters, and Gus Scholle.

I even sent a few postcards to Williamson with a promise to write soon. I'll close now, do a little work and then go to sleep.

> Love
> Daviexxxxx

* *

from WILLIAM SENNETT

> January 30, 1938
> 2 R.T. Albacete, Spain

Dear Augusta:

It made me very happy to receive your recent letter and to know that you are still working and in good health. From what you write about the immense amount of lay-offs back home, I feel somewhat economically secure here from a purely selfish point of view.

Christmas and New Year's was, for me, very much unlike the festivity of the celebrations of a year ago when I was in Chicago. True, we observed the holidays here with the Spanish people of a little village nearby; a fiesta that provided an excellent meal, sufficient drinks and an evening of wholesome entertainment, yet one cannot celebrate and forget what is around us. The Spanish people are a really remarkable lot, when in the course of all the suffering that the war has brought, they pledge on occasions such

as Christmas and New Year's that they will continue to fight and sacrifice so that the year 1938 will see the foreign invader driven out of their country.

The fact that I am in the transport service enables me to see many things that other boys in the trenches cannot. I can safely say that I have been in almost every part of Loyalist Spain and can appreciate at its true worth this country and its people. At the present time I have made frequent trips to the recently captured city, Teruel, and can assure you that the headline in the "Trib" you spoke of regarding the assertion by fascist sources that they had retaken the city is so much poppycock.

In regard to your question on the alleged atrocities against religion, priests, Nuns, etc., I can recount to you some of my own observations in addition to that which is an established policy here in regard to the Church. The Catholic Church previous to the war was an organic part of the state apparatus. It owned 1/3 of the land in Spain, controlled all education, and was the dominating influence in reactionary political life which kept Spain from taking her place with the advanced countries of the world. When the coalition of progressive forces established the Republic, similar to our own in America, it decreed the separation of Church from the state and took practical measures to give land to the peasantry. Thus the Church was to continue as an institution, with the right to religious worship not solely confined to those of the Catholic faith. This is as we have it at home, but this is not as the upper hierarchy of the Church would have it. It is from this lust for economic and political power that *certain* officials of the church conspired and gave their blessings to an armed uprising to overthrow a government legally constituted, which in the previous election had obtained a majority vote. Hitler, who is particularly vicious against the Catholic Church in Germany, peculiarly found it easy to collaborate with the Italian fascist dictator, Mussolini, in sending in whole armies of men and materials in the name of Christianity! What hypocrisy and brazen mockery.

Yes, priests who fought with the fascist murderers are treated as enemies of the people but you must also remember that there are many priests who have remained loyal (and I have seen them) and are fighting with gun in hand against those who betrayed the faith. There are hundreds of Nuns who are working with might and main amongst loyalist soldiers helping to relieve the sufferings at the front. I have visited churches in Madrid, Valencia, and Barcelona and have spoken with the heroic priests who administer the services under bomb and shell. They hope and pray for a Loyalist victory.

I saw the Nuns that were taken out of Teruel when the city was captured. Contrary to fascist reports, they were treated with the utmost care and consideration and were safely evacuated to Valencia.

I had occasion to spend a number of days in the Escorial, world famous Monastery. There countless pieces of art were being vigilantly watched and added protection was taken against air raids. Here, where the most sacred treasures of the Catholic Church are safe-guarded, the self styled "Christian Liberators" attempted a bombardment twice, but were driven away by the extra concentration of anti-aircraft guns we have placed there. "Lord, what is done in Thy Name." German and Italian planes bomb towns behind the lines daily and it is only recently that the Spanish government was forced to retaliate by bombing Salamanca. The fascists wiped out a whole town of 3,000, the holy Basque village of Guernica, which was far behind the lines in the North.

Fascist propaganda is widespread and subtle. Many an honest person back home has fallen a victim to their pack of lies and has failed to examine the evidence. One need only to reflect on a few examples. How do the Loyalists treat prisoners as compared to the fascists? Who concentrates on behind the line bombings and that of hospitals? And the greatest question of all is who started the war against the wishes of the majority of the Spanish people?

I hope you will better be able to understand my feelings from what I have written above. To those of us who have come here from other lands the war is not a question of adventure. Being profoundly antifascist we feel that a Loyalist victory will not only relieve the suffering of the Spanish people but will be a great blow to the Fascist nations who would spread the war over all the world.

It's about time to conclude and I hope I haven't bored you with the serious side of me. Thanks for the *Daily News* subscription. I should be getting it soon.

Regards from the other boys and continue to write.

<div style="text-align:right">

As Ever,
Bill

</div>

from CARL GEISER

<div style="text-align:right">

Monday Morning.
Feb. 21, 1938

</div>

Dear Impy:

This is a bright splendid Spanish morning, with the sun streaming into the patio this first day of spring as if to give a warning that in summertime it's going to be hot. But the sunshine, the invigorating freshness of the air, and the noisiness of the sparrows, make me want to put my packs on the shoulders and hit the trail. Imp, I doubt whether I shall ever really be satisfied in my work unless it is connected with the great out-of-doors, and with the wild-life. But I don't see any chance of really doing such work.

But these nights here remind me very much of our hike through [illeg.] to West Mountain one Easter vacation, especially of that one cold night we slept in a lean-to. Sleeping is like that here, for at night it gets very cold, and the only advantage of being inside is that you escape any air that might be about, and you don't collect as much frost. But by 10 in the morning you can take a delightful sunbath.

Have I written you about Prieto's decree abolishing the rank and pay of Company Commissar? No explanation has been forthcoming from any source of why such a decree. The company commissars will continue to function as political leaders, but of course this does not make their work any easier. Previously they held same rank & pay as the Military Commander. This new move makes training the company political leaders more imperative than ever before.

It was interesting to see that the day before the decree was made public, the press carried an article by Jose Diaz, giving three tasks as fundamental for winning the war in the shortest possible time. 1—Creation of more reserves of men: 2—Organization of war industry: and 3—Intensification of political work in the Army and in the rear.

All this has raised in my mind what is the proper role of the commissar today. The role of commissar originated in the Paris Commune, where the commune assigned

trusted political workers to each military leader or commander who was trained in the old order, to control and guide his actions. It was necessary to use these military men because the new class did not have able and well-trained military leaders. The same was true in Russia in 1917, and also here in Spain where the political parties and trade unions appointed special delegates responsible politically, for the work of the early columns.

Today the commissars are responsible directly to the Peoples' Front Governments, thru the Minister of National Defense. They are not representatives of the soldiers, but representatives of the government.

I am informed that in the Red Army today there are only commissars where the Military Commander is not a Party member. Where he is a Party member, there exists a Political Dept. but no one called a commissar. I do not know for certain whether this is true, nor have I been able to find a detailed account of the work of the commissars and political depts. in the Red Army.

In the past the commissars, company as well as battalion, have been responsible for the functioning of the services, such as *Intendencia*, Kitchen, Armory, First-Aid, etc. But I should not be surprised if this becomes an ever lesser part of their work, and their work becomes more that of a political dept. You might put it this way, they will work to develop and maintain a good morale less by what they put in the stomach and more by what they put in the mind.

The work of the company political leader, it seems to me, will be concerned with the mental & cultural and recreational needs of the men. As for example, news about what is happening in Spain and abroad, translating whenever necessary. Supplying such material as will aid the men to develop and maintain their antifascist consciousness, providing them with cultural facilities, and organizing recreation. But the problem of improving discipline, or creating a desire for better mastery of military science, of developing a high fighting morale, seems to me to be one of developing a strong antifascist consciousness, and of showing the relation between discipline, military training, etc., and the fight against fascism. In other words again, the work of company political leader will have to be much more of an educator than in the past. Now I suppose you'll have the idea you could make a good company political leader. And come to think of it, you probably would.

One weakness I have noted in the work of company political leader, including my own, is the failure to always know what the men are thinking about, what is bothering them, what they want. And this is more than just a matter of living among them, for often, at least occasionally, the political leader is amazed and surprised by some development in his company because he did not enjoy the confidence of the men, nor know what they were thinking about. For when he came around, they promptly discussed something else.

The rumor of the morning is that the British Cabinet met 3 times last night. No one knows. When I read it in the paper I'll believe it. But of course these things make you feel maybe something big is happening, such as Hitler marching into Austria, and that may mean a little more spine in England's and France's attitude towards the war in Spain.

There has been a particularly strong turn during the past 2 or 3 months, towards

fortifications on the front line. Trenches are now much deeper, much more zigg-zagged (for protection against aerial strafing, tanks, machine guns, shrapnel from artillery & mortars), much better firing pits are built, and now the drive is for deep underground dugouts for protection against bombing and heavy artillery. In fact, this need for solid defenses to protect the soldiers from artillery barrages & aerial bombing may lead to the establishment of a series of camouflaged fortified posts rather than a continuous system of trenches. As it is now, if the enemy wants to dislodge you from a trench, it can do so by laying down an artillery barrage on it which will destroy every living thing in it. And then they march up and occupy it. Of course, that requires a lot of artillery, but the fascists have a lot of artillery.

Well, Imp, this letter is long enough so I'll close it. Just one word, don't let our separation get you down. The less you think about my returning & the more about what I am doing here, the happier you'll be and the better work you'll do.

<div style="text-align: right">

With all my love

Carl

</div>

from CARL GEISER

<div style="text-align: right">

March 5, 1938

</div>

Dear little Impy:

Today was red letter day with two letters from you, one from Bennet, and one from Phil Reising, which has been on its way here since October 16. I am enclosing two envelopes. One is a curiosity, the one from Phil, which travelled all over Spain until someone finally recognized the name, and forwarded it to me. The second is proof why you must mark all letters to me "Via France" in order to avoid their passing through countries like Greece, and their possible censorship.

Your letters are dated Jan. 30 and Feb. 11 And I am relieved to know that you received the calendars, postcards, etc. But I didn't mean to suggest you should start knitting. I couldn't imagine you doing that. It would look very funny.

Your quotation from Marx on the Civil War in the United States makes me anxious to see the new book containing his writings, which I understand has now come out. It hasn't reached here yet, but perhaps it will before long. Though actually we are woefully short of good books of that nature, and long on fiction and romances of all kind, some of which we had to burn for its anti-democratic and anti-peoples' sentiment. Time is too valuable here to waste on that sort of trash.

You must answer Ben's letters as regularly as mine. By the way, he is one of the very few, perhaps two or three, that have been with the Washington ever since it was formed, without being wounded or ill or away for some other reason. I saw him a good deal when I was in Teruel. And it will be extremely pleasant if some day after we are through here, the three of us can reminisce around a fine meal (notice how my mind runs to food) about how fascism was defeated in Spain.

Your letter indicates you are really quite busy, studying, preparing reports and programs, and even don't have enough time to sleep. Probably you shall have changed as much as I have during the past year, and both for the better I hope. And it's not so bad if you wish me to come home, as long as you don't wish too hard.

Yes I knew Amlie quite well. I first knew him one afternoon when he took us out to drill in close order formation last May, and then he has been with the battalion ever since except when he was in hospital. His articles should be read by all readers of the *Post*, for they are well done.

Everything here is going along well, except that the students for the school have not arrived yet, and time is passing. Of course in the meantime, we are improving the lesson plans, gathering together more material, doing a good deal of translating. Monday morning we begin instruction of the political workers here at the base. I am responsible for the organization and content of this instruction as well.

Today I spoke with two English comrades, who were among a group of 39 Englishmen taken prisoner on Feb. 13, 1937, held in Franco's jails for three and one-half months, then sent back to England, and are now back here to fight fascism again.

The account of their experiences in Franco land is ghastly. Shortly after they were taken prisoner, one asked for permission to roll a cigarette, but when he reached to his pocket, they shot him, the same bullet killing the man behind him as well. Then they executed one of their number, a Communist, in front of them. He died with a proletarian salute and "Salud, Comrades." The young fellow who was telling me this said that previous to this (he was not a Communist) he would have been afraid to die, but after witnessing this, he could have borne up under anything. And the executioner's pit, 90 feet by 30 feet, ten feet deep, two of them, one filled with dead bodies and the other partially filled.

They were taken out several times to be shot. They saw girls being taken out to be executed, and can tell horrible tales about the fascist prison regime.

Franco finally decided to release them several weeks after as fake a trial as ever occurred, in which they were condemned to death. He gave them each a private room, clean clothes, a good meal and called in the movie photographers. And most of these men are now back in the Republican Army, fighting against fascism, and an inspiration to all of us.

Very interesting material is being unearthed by the trials in the Soviet Union, bringing many things to light. To think that Lenin, Gorki, and others might still be alive if it were not for those filthy deeds. It must teach us to be careful, particularly with those who at critical moments oppose us. Incidentally, it would be very unwise for Mr. Norman Thomas to show his face around the front anywhere. He has no followers here.

Which reminds me of your question about my lice. They are neither big nor small, in fact they aren't at all. At present, I believe there are very few lice in the base, a steady battle against them with disinfecting and hot showers, etc, has put them on the run.

As I wrote you before, I have received all the packages you sent me, plus the *Imprecorrs*, for which I thank you very much.

<div style="text-align: right">
With all my love—

Carl
</div>

P.S. The cook's difficulties here: the water is so hard it won't soften the rice or garbanzos regardless of the hours soaking. It's so hard they start cooking the garbanzos at 3 in the morning. And they are still hard at noon, 9 hours later. So we are looking forward for some soft water, so we don't have to eat hard rice and garbanzos.

The problem is, is this a soluble or insoluble problem?

Nada mas

Carl

· ·

from WILLIAM SENNETT

April 16, 1938

Aragon Front, Spain

Dearest Gussie:

Two of your letters reached me this week. According to the reports of the Chicago newspapers you would hardly think that there would be such a thing as a mail service at this time, let alone a Loyalist Government. It serves to emphasize the falsity of recent reports.

The newspaper headlines and stories relevant to Spain may make interesting reading for Franco's well-wishers but they do not give an actual picture of the recent developments here. Just as in the crucial days of November 1936 at Madrid when the Chicago *Trib* carried the story of Franco's triumphal entry into the city, so at this time do the papers announce as "news" that the Government has fled, the war is over, etc., etc.

It is surprising to me that people at home still refer to the war here as a civil war. Especially at this time should it be clear that this is a war of intervention on the part of Germany and Italy against Spain. Their purpose is to destroy the national independence of the country, set up a puppet "Nationalistic" regime and make of Spain a colony for their fascist purposes.

The dangerous military position that has been created is due to dangerous (to peace) political policies of the other Democracies. While the policy of "Non-Intervention" was (and is) in effect, Germany and Italy poured in troops and materials. While discussions were going on about the withdrawal of the so-called Italian volunteers, Mussolini kept sending thousands more to Spain. Germany and Italy sent huge quantities of war materiel while Britain and France still *discussed* the maintenance of the policy of Non-Intervention!

Don't think tho that Non-Intervention wasn't applied at all—it was when it came to the Republic. Germany, Italy, and Portugal bought war materials for Franco, but the Spanish public was denied the right to buy arms in accordance with the Non-Intervention agreement!

Is it any wonder then that the bloc of Fascist powers was able to achieve such military successes in Spain? The big fascist advance here was planned and directed by German and Italian general staffs. The troops in the van were an estimated 100,000 Italians, 40,000 Moors, 10,000 Portuguese and a sprinkling of Spaniards. The planes in the air, German and Italian. Artillery and tanks, German and Italian. Technicians in auxiliary services, 10,000 Germans. With this superiority of material (mainly) the enemy was able to advance.

We've learned to distinguish the type of planes used here. A few weeks ago we heard the roar of the German "Junkers" (big bombers). We counted 24 bombers and an escort of 50 chasers, "Meisserscmidt" and "Fiat." The town of Gandesa was their

objective. This town was then a good sized place with a population of about 10,000. They began to bomb, circling around and around, destroying civilians and homes. Then the chasers came down over the rooftops to strafe the helpless women and children. This was kept up for about an hour until they left. A few minutes later some Italian 'Fiats' returned and dropped handbills over the ruins of the town. We picked some up and read the following "People of Spain, Our glorious army advances to save civilization. You are spilling your brothers' blood, lay down your arms and help us to reconstruct our dear country. *Viva* Franco!" Were we filled with revulsion and indignation? Then you can imagine the kind of reception the Spanish people give to such appeals.

The people here are an admirable lot. All their suffering and anguish has made them more determined to prevent fascism from winning in Spain. They know what it means and a common expression one hears is "We would rather die fighting on our feet than live the rest of our lives on bended knees." That characterizes the spirit during these critical days. As an expression of the Popular Front movement in which is fused the common desire of all the people, a new cabinet was constituted which is more representative and enjoys the greatest prestige. New divisions of volunteers are being formed and more materiel (tho not enough) is made available. The slogan seen everywhere is "Resist Today to Win Tomorrow." And to that end all possible resources are being put into motion.

More and more developments here and in the world hit closer home to America. How the false policy of Neutrality can continue under present conditions is beyond me. If Hitler and Mussolini win here they will go after bigger game which will bring a new world war in its wake. Economically and politically America is definitely a leading factor in world affairs and only the naive would think that she can stay out of a new world war. The present isolationist policy benefits Germany, Italy, and Japan. If the powers that believe in the Democratic form of government were to band together now and undertake economic action against the bandit nations, they would check their war schemes and give impetus to the further development of Democracy.

The President has given the lead in his Chicago speech on the use of isolation. He told the Democratic nations that the aggressors, bandits, should be quarantined. He said in effect that economic sanctions would place them in a position where they would be put in a helpless state to continue aggression. However, despite the President's views the contrary policy is still in effect.

I spent some days in Barcelona and saw the damage caused by the bombings. Somehow it made me feel just as tho the bombs had dropped on Chicago. That's just what people back home can't understand.

I'll have to conclude this letter to attend to certain matters and will write when time permits.

Regards to all at home,

<div style="text-align:center">Love,
Bill</div>

● ●

from DAVE GORDON

June 25, 1938

Dearest Lottie—

To-morrow will mark the beginning of my second year in Spain.

It has been a year of significant events for Spain. Soon shall end its second year of continued resistance against the invaders. What a wonderful page in history it has written.

I did not have the fortune of witnessing or taking part in the struggles of the early days. Yet in this one year how much I have seen.

I arrived at a time when the process of transforming the militias into a regular army under a unified command was taking place. It was a struggle. It was a struggle complicated by the disruptive work of the Trotskyists, uncontrollables and other fascist agents whose putsch in Barcelona had been put down only a short time before. An army had to be built. There had to be officers, technicians, commissars, trained soldiers who had to learn the technique of a regular army. Events, the continued, increased and relentless attacks of the fascist armies of invasion hindered this process. The Republican Command had to improvise on the basis of the needs of the movement. It was due to the strengthening of the Popular Front right along the line that enabled even the improvisation.

I have seen the Army, through our own Brigade, work hard to master the technique of war. I have seen our Brigade steadily improve militarily and politically. One learns unforgettable lessons in such a situation. Especially is this true when one has been through actions with the Army for some four solid months at the front.

Here it is June 26th—with this letter unfinished. A combination of work and conversations (all morning with Murray Gould) prevented me from writing all I wanted.

These days there is much discussion regarding the non-intervention committee's latest decision. A strong stand had to be taken in order to remind all that neither does the decision benefit Loyal Spain, nor can we have any illusions that Hitler and Mussolini will voluntarily withdraw from Spain. It is dangerous and disruptive to subject the great issue of the independence of Spain to the individual eagerness of a few cowards and weaklings who consider the committee's agreements as an escape for themselves from the difficulties we must yet overcome to achieve the victory.

It is important to note how, despite the constant exposure of fascist promises, some people who should know better still fall victims to these promises. And when this happens you can be sure that it becomes serious unless immediately checked and exposed.

I'm enclosing a few special stamps—one of the Euzkadi Government, one to aid Madrid and one S.R.I. stamp. I'm also enclosing a negative of myself and my "brother." How about developing it and sending five prints of it here.

By the way, send *everything* to me as before. The item in the *Daily Worker* about mailing via France seems to be a mistake—and a tragic one. Again there are packages not coming through. I hope you began writing as before when I wrote you to do so last week.

I'll try to write you soon.

Best wishes from Murray.

<div align="right">
Your

Daviexxx
</div>

..

from THANE SUMMERS

<div align="right">
Socorro Rojo Internacional

Plaza del Altazona, 270

Albacete, Spain

Nov 28, 1937
</div>

Beloved Sophie & Art,

Again you raise the question of the difference, which you doubt exists, between fascism & communism. Even a most superficial reading of the official positions of each, written by each, will show a most tremendous difference, but we have gone over these points many times, and while in conversation I might be able to bring out some new points, in the short space of a letter I probably would just be repeating myself. All I can say is that I have been going through many most interesting experiences which reinforce the points I previously made. I see the way the people's gov't of Spain is operating as an expression of the people & fulfilling the needs of the people in the most inevitable way, from the fundamental necessities of food up to the needs of education, culture, & art. I cannot help but see the tremendous contrast between the spontaneity, initiative, & brotherliness of the whole society here in Spain, as contrasted with the class distinctions & hatreds in the U.S., in spite of their greater wealth. And I have seen how the communist party functions here. I have gotten to know men of leadership here, & I know their ideals & their abilities.

Such things will take a book to describe, but my point is this: our party is not one to build an *a priori* theoretical plan for the progress of society out of pure air. We cannot pretend to give deductive Kantian proofs of our views. We can only offer inductive reasoning based on experience to convince one of our views. Our theory of the various forces in society can only be understood by working in society with these forces.

Why is it that you have isolated yourselves from the problems of society? It is in my mind because your ideals & desires are not consistent. They are contradictory. Some are on one side, some on another. Now the burden of the proof lies with you. What are your social ideals? Write them to me unambiguously. (Remember in all of this argument I love you.)

I hate to think of you in Italy, because if my letters are opened by their censors, they won't pass. You are helping fascism by being there.

I have fought side by side with Italians in the International Brigades and have come to love and admire them. I have also met Italian prisoners from the fascist side who were forced to fight & who hated fascism as much as their more heroic brothers in the International Brigades. I have smelled fascism.

From Italy each day come Caproni bombers to bomb our lines & our civilian population. You may see some passing overhead some day when you are in Italy. They may be carrying a load for me. One bomb can easily kill one person, & the taxes on your expenditures in Italy can easily buy one bomb. So you may donate the bomb that may get me. Or if it doesn't get me it may get one of the many heroic Jewish lads who is

here fighting anti-semitism, which you have felt in the background of your life.

Knowing you are behind the enemy lines makes me feel like crying, but I love you as much as ever.

Thane

••

from PAUL SIGEL

July 18, 1937
Spain

Salud, Mus,

Exactly one year ago today, the fascists started their little game here in Spain. As Comrade Witt put it, the fascist monster opened its bloody jaws again and tried to consume another democratic country. But the carefully laid plans of Hitler, Mussolini and Franco are not going so well. Their small minds could not take into consideration the tremendous power of the international popular front against fascism; they could not see that the people of the world will not submit to their terror and hatred any longer. And here in Spain we are gathering together the international might of the people and with it, and with the fighting Spanish people, we will destroy fascism here in Spain and then proceed to wipe it off the map of the world. We are too strong to allow such a foul system to exist any longer in this world, and in spite of the fascist coalition, in spite of their maneuvers, they will soon be defeated.

There are a couple of fellows here who have just come from Palestine. They have been giving me some first-hand information about the place that I'm sure will interest both you and some of our relatives in the Siegel family.

These fellows have been in Palestine since the beginning of the Jewish colonization there. They were just expelled from the country because of their political convictions, namely being communists. They report that Palestine is in its greatest economic crisis in its history, and that within a year it should collapse entirely.

Chauvinism towards the Arabs is even greater than that of Hitler Germany toward the Jews. No Arabs are allowed in Jewish cities—there is not a single Arab in Tel Aviv. No Arabs are permitted to work for Jews. If a Jew & an Arab are seen walking together, both are punished, tho the Arab is punished much more severely than the Jew.

No Arabs are allowed in the Jewish Trade Unions.

Say Mus, let me talk to Laurie.

Hi ya gal. I'm sorry I can't write you an individual letter, but we have so little time to write that I'll have to leave it up to my mother to get my letters to you. However, what I said before still stands—I'll answer all the letters I receive.

But to get back to the subject we were discussing. From what those fellows said it is evident that the alliance of the immigrant Jews in Palestine with British imperialism is splitting any front that both the Jewish and Arab workers might form against British imperialism. It seems inconceivable to me that the Jews who are experiencing such terrific chauvinism in Germany, Poland, etc., should not see how such actions split and disrupt the power of the working class, especially when fighting such a powerful enemy as fascism or British imperialism. I remember you saying that most of the Arabs who were fighting the British-Jewish alliance were just mercenaries sent in by Muftis

& Effendis from bordering countries. But here is a reason that sounds a little more like the real one. Those fellows told me that the situation is quite the contrary. The Arabs are politically and economically conscious. They realize who and why they are fighting. This is proven by the fact that the Communist Party is very strong among the Arabs, and of those that are not in it, there is a very great sympathy for the U.C.P. by a tremendous majority of the Arabs. You, Laurie, may or may not agree with the C.P. political philosophy, but I think you'll agree that members or sympathizers of the C.P. do not engage in political or economic actions as mercenaries, notwithstanding the myth of "Moscow Gold."

Among the Jews, the C.P. is practically extinct, because of the brutal suppression by the English—also the imprisoning & exiling of party members and leaders.

Jews are continually leaving Palestine, especially the younger ones. The only reason the membership is as great as it is, is because of the influx from Germany & Poland.

Well, consider it Laurie.

How are you doing otherwise? I'm sorry I had to leave so suddenly but it was unavoidable. When I get back, we have a date for another meal in that Chinese restaurant. Don't forget it.

Time presses, and so do my eyelids, soooo, I'll be seein ya.

Paul

I'm still anxiously waiting for my first letter. Still same address.
I'm doing fine, mentally & physically.

• •

from SIDNEY KAUFMAN

September 12, [1938]

Dear Ida & Tommy,

Letter of Aug. 3 just came in—will be looking forward to the textbooks you mentioned—I've already received 4 and the I.C.S. Courses—now in a position to use them too—thanx lots. Had to put off the writing of this for a few hours while I listened to Hitler over the radio—he was up to his usual demagogic standards playing up to basest racial and political prejudices the German people have had instilled in them. The situation at present looks to me like an unknown quantity. Believe Hitler is bluffing, wants to see if there's any weaknesses in the democratic front—sufficient vacillation on England's part and any sign of internal differences in France and he'll strike in Czechoslovakia. I realize of course what I write now, by the time you receive it might turn out as a result of change in actual events, to be all wet and I'm "short suited" in this political analyzation business—anyway I'll chance it. If you're wondering how I could get anything out of Hitler's speech—besides being able to get by in *Español*, my German has improved considerably as a result of much usage here. There are so many German speaking comrades here that hardly a day passes without a conversation in the lingo of the Teutons.

There's a popular misconception on the Czech situation—wonder if it's in existence to any great degree in your circles—it goes something like this—well, let Hitler step into Czechoslovakia, it'll be the last stepping he'll do—we will be able to smash him &

Fascism once & for all—it smacks too much of a "holy" war like the stirring up of the peoples of many countries during the last war on the basis of smashing German militarism, which even the American Socialists like Sinclair, Dell et al fell for. We want peace—that's part of our job here. Spain is the place to smash Fascism. Should the Fascists be victorious, we knew before we came here, it would only be a short time before France, England, or possibly the U.S. would be the next victim of aggression. In all wars the proletariat suffers the greatest losses—they supply the largest part of the army, living standards go down, working class organizations are destroyed by patriotic pleas to aid the government in her hour of need, and the labor movement most always gets set back for a while. This in addition to the terrific loss of life & havoc wreaked in general by modern warfare.

In my past few letters I've been asking that you send me some stationery because of the growing shortage—you might be surprised at the paper this is being written on—came upon it by accident in a small out of way town. I'll have enough for a while—you can send some in a few months, especially some good-sized envelopes.

I don't think you need write Mike any more. I've been getting the little envelopes (separate) with the smokes pretty consistently of late and perfectly intact, keep it up. Haven't heard of or seen Charlie Harper as yet—he's probably on the other side—Haven't heard from Hilda either in months—I'd expect that she'd write me from Paris.

Thought you'd know from my address that I couldn't have been anywhere near Gandesa, or perhaps you don't see an up-to-date map of the fronts and therefore don't know exactly where the offensive took place in relation to the other fronts in Spain. How about sending over some of the literature you have around the office where you do the voluntary work—The sort of stuff that can give us information on China that the *Masses & Worker* don't carry—I can use it as a basis for political discussions on China.

Love
Sid

Plaza del Altozano #85a
Base Turia
Valencia, Spain

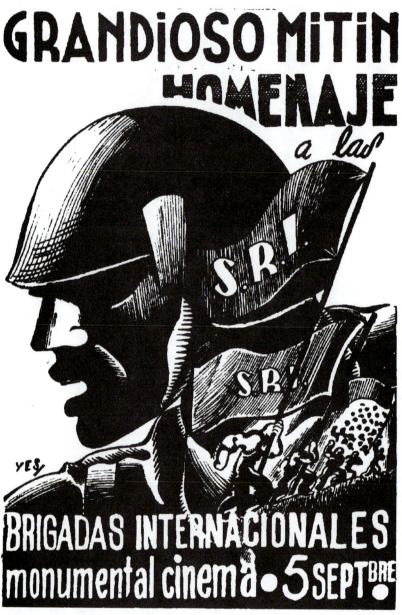

One of several different posters advertising a "Grand Meeting—Tribute to the International Brigades" held at the Monumental Cinema in Madrid in 1937.

X

THE REGIMENT DE TREN
Transportation Under Fire

∙∙

INTRODUCTION

In March of 1937 a sizeable group of Americans was gathered near the French border at the massive medieval fortress of Figueras. It was the standard transit point for volunteers who had just hiked across the Pyrenees into Spain. A call went out for men to drive a long line of new trucks to Albacete, the headquarters of the International Brigades. As it happened, Spanish drivers were few indeed, and even those who could drive had little experience with anything like the large trucks lined up for departure. American and French volunteers proved the nearest thing to professional truck drivers. About sixty-five Americans were happy to offer their services; it seemed the fastest way to get to Albacete and the front.

In a few days the line of over a hundred trucks made it to Albacete safely. The men thought that would be the end of their responsibility, but on arrival the drivers were ordered to take up paint brushes and camouflage the trucks. Soon two squadrons of drivers—one mostly American and one mostly French—were formally organized. They began to drill, training against aerial attack, practicing equipment checks. At this point most of the men still thought the assignment temporary; they expected to join the other volunteers in the infantry shortly. But it was not to be. These men had a vital skill, one necessary to any modern army that had to transport troops, along with the food and munitions they required, but a skill especially vital to the Republic, for Madrid was a city under siege and could only be provisioned by truck.

It was not long before drivers and mechanics were under Spanish command and assigned to the Fifth Army Corps. The Regiment de Tren, the transport division, was now a reality. Yet being part of a military command structure did not altogether blunt the Americans' independence. They organized their own social activities, published their own newsletter, and—most notably—elected their own officers, choosing a Socialist, Durward Clark, as their commander. Meanwhile, they soon found that driving trucks was a risky business in wartime. Not only were convoys vulnerable to bombing and strafing by air; roads also offered good fixed reference points for ambushes and artillery bombardment. A number of drivers lost their lives as a result. And there were other dangers. On the night-time route from Valencia to Madrid all lights had to be turned off when they reached Alcalá. They drove in darkness whenever planes were heard as well. And even in relative safety headlights were masked to minimize the targets they offered. Long shifts of twenty hours or more were common, and falling asleep on winding mountain roads could easily prove fatal.

MOBILE

BI-MONTHLY ENGLISH
voice of the English-spe

Vol. One Number Four AUTO-PARK,

STRONG REAR
 INDICATES A
 STEEL FRONT

PARK ACTIVITIES
 OPENED WITH
 CONTESTS

RUN CHESS MATCH

WE came to Spain to war a-
gainst international fascism.
Many of us find it necessary
to remain behind the lines and
render service to assure an or-
ganized and efficient rearguard
Work behind the lines is as im-
portant for victory in Spain
as work at the front lines. As
sincere antifascists, it is our
suty to help build and consol-
idate this rearguard.

GOOD ANTIFASCISTS

What does it mean we are
good antifascist fighters? It
means we know how to handle our
trucks, that we be particularly
concerned with cultural, gym-
nastic, and hygienic questions
to improve ourselves generally
Every comrade must be act-
in those fields which in-
st him most--already org-
d or being planned--not
his own welfare but
 help his comrades to
 rd.

 ZE CHORUS

ALMERIA---A LESSON IN NON-INTERVENT

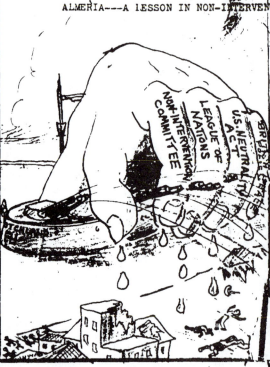

IN MEMORIAM TO OUR · FOUR COMRADES
 KILLED IN ALMERIA--ROLL ALONG
 PEACE; WE. SHALL EVER R

Comrades Louis Beregezozy centive for al
Al Alexander, Jack Greenstein comrades who w
and Robert Chartier--four the last to c
more names that will live for for a better /
 world.

The top half of the first page of a Regiment de Tren mimeographed newsletter. Note the
announcement of Canute Frankson's class in mechanics.

FRONT

-PAPER FOR ALL
nrades of

CETE, SPAIN

June 17, 1937

AMERICANS IN SPAIN BOOST ACTIVITIES AND MORALE IN STATES THROUGH FINE WORK

YANKS LEARN FUNCTION OF MOTOR PARTS

"Dual intake manifold", "Crankshaft counterbalance", "Camshaft", and so on, and so on. The mechanics class is on with a bang under the super- vision and instruction of Com- rade Frankson.

Every afternoon save Sun- day at 2:00, a class in mech- anics takes place in the inner circle. All comrades are o- bliged to attend.

TRUCKS, OUR WEAPON

The infantry fights fascism with rifles; we fight it with our trucks. And just as an in- fantry man must know his weap- on thoroughly, so must the chauffeur know his.

The class to date has cov- ered: ignition, distribution, carbaration, and gear make-up

ROAD GUIDES

Besides making it possible

CONEY ISLANDERS HONOR THEIR HEROES

MASS RALLY HELD

Spurred on by the departure of their personal friends, thou- sands of Americans are flinging themselves into the breach made by the heroic volunteers to Spain. Activities in support of Loyal Spain is increasing with each pass- ing day.

TRANSPORT BOYS LAUDED

Comrades Goff, Chesler, Gollomb, Yellin--all part of the transport service--have been honored by a giant neighborhood mass meeting organized in Coney Island from where they came. Other Comrades have been the subject of memorial meetings and mass rallies. Milton Pekow, David Schapiro and many more othernames that are becoming familar to America.

RANKS STRENGTHENED

Friends of the Americans now fighting in Spain have been inspir- ed to increase their work two-

To give a sense of this often neglected element of the war, an area where Americans made an important contribution, we have included not only letters from members of the Regiment de Tren (Foucek, MacLeod, Frankson, Friedman) but also letters from American volunteers being transported by truck. Finally, we have added one letter from an American describing his experience of motorcycle transport.

··

from GEORGE FOUCEK

Albacete Spain
Aug. 8, 1937

Dear Folks,

Yesterday was a very hard day for me, as I had to drive all day till 12:30 in the morning, then sleep till 5:30, then get up and drive till four o'clock this afternoon and so I am very sleepy from it all. I had to pick up some men of the International Brigade and take them to a rest camp about 40 kilos. from this city. I had to go up and down many hills, as this is a very mountainous country. After I write this letter I am going to drive a rolling library to Madrid on Aug. 10. I will also cover small towns between here and there on the road, visiting hospitals mostly. The books I carry are mostly for the wounded soldiers in the hospitals and I am glad to be of service to them. I told my commander that this was too safe of a job, and he said it may be safe but it's one of the most important. Anyway, if I was in a hospital I know I would like to read a couple of books, wouldn't you? I will write you a letter from Madrid if I can, so please wait for it in a couple of days.

Love,
George

P.S. I know you like to receive letters from me, so I am writing all I can. Also, Albert came here today with another boy from Omaha (you remember him because he was in the Communist Party and came to our house a lot, he's Bohemian). We went to his father's farm and got a lot of tomatoes a long time ago. Al and he will stay at my camp tonight and go back tomorrow. We are having a lot of fun, I wish you were here to see us in our uniforms.

··

from GEORGE FOUCEK

Aug. 9, 1937

Dear Folks,

Well, I'm keeping my word. Here's another letter, and if you want more just tell me and I'll send three a day (if I don't run out of paper). Here in Spain I find it hard to get soap but easy to get wine, so I just keep looking for the soap. We do get soap as an issue in the army, but it's not very good and I have to work like hell to get lather from it. But there's one good thing and that is nobody cares to wash more than once a day and any way I will be getting some American soap in a few days from the Friends of the Lincoln Battalion so I'm not worried. It won't be long now and I will be in Madrid with my rolling library visiting the hospital there. Driving my truck around Spain will be a lot of

fun. Where a man in the infantry sees only one part of Spain day in and day out, I will see all the parts and know what's going on. Albert was here yesterday, and we had a lot of fun running around Albacete buying watermelons, lemonade, and salted pecans. We said it felt funny to be running around here so far from home. They say there's a war here, but the way the people all act you'd think they were celebrating New Year's. Every place I go the people ask me who I am. I point at myself and say "Americano." When they hear that, they look at me up and down sideways and backwards, smile, offer me wine or cognac (if they have any, it's very cheap), and start rattling off questions. All I do is shake my head and say "si, si," and they think I'm smart to understand them. If I get one word out of a 100 I'm good.

Love,
George

P.S. Albert told me of those letters you wrote him. It makes him feel good.

•••

from DONALD MACLEOD

June 8, 1937
Socorro Rojo Inter.
Chamber 2RT
Albacete, Spain

Dear Stuart [MacLeod]:[1]
Your letter and Freida's reached me at the same time. Yours were the first letters I received since leaving the States and believe me I was never so happy to get anything before in my life.

I'm much relieved to know that you all know where I am now. The reason why you didn't hear from me sooner was that there is always a long delay in getting letters out of Spain. That is true of any country at war. I did write to Edna and to Red, though, while I was still in France. Those letters should have been received at least two weeks before you got the one I sent from Albacete. By this time Edna will no doubt have received the other letter I wrote her from Albacete and you all will have gotten my post cards. You must be sure to write to me again right away.

I am still stationed outside of Madrid. We live in a pleasant camp near a river. We are now a part of the regular Spanish Army, our job being to transport troops, supplies, munitions etc. Chauffeurs are very scarce in Spain. Less than 1% of the Spaniards know how to drive trucks and for that reason Americans are usually at a premium. We have the status of a Corporal in the Spanish Army and receive Corporal's pay, which amounts to 130 pesetas every 10 days.

We get a town leave in Madrid once in every 10 days. In Madrid you are always sure of a good time. The morale in Madrid, as I have said before, is extremely good in spite of the shelling which comes almost every day. The shells actually kill very few people. I have heard that so far no soldiers have been killed by the shells, probably because there are very few soldiers in Madrid, but that about two or three civilians are knocked

[1] Don MacLeod's brother.

off daily. Unfortunately these civilians are too often children and women. The fascists, by continuing to shell Madrid, obviously hope to provoke us into attacking them in their strongly fortified positions in the hills above Madrid. On my last town leave I was talking with a machine gunner who was back from the Jarama front on a short furlough. He told me that on certain fronts both the loyalists and the fascists are so strongly fortified that a direct attack by either side is suicide. "You don't think then," I said, "that we shall attack the fascists directly on such a front as the one near Madrid." "No," he said, "I don't think so." Then I asked him how he thought the loyalists would win the war. "The loyalists will win," he said, "by cutting the fascists' sources of supply from the rear."

You asked for information about the actual military situation and for that reason I have written this much. I, of course, know very little about the actual developments, so I cannot write with any degree of accuracy.

I can tell you with great accuracy, however, why Franco's ambitions are bound to end in a dismal failure from a political standpoint. One good reason I can give you, & I say this not egotistically, is that I am here fighting so that Franco shall not win. Hundreds, yes thousands of Americans are here, Germans are here, Italians, French, Chinese, Japanese, men from all ends of the earth are here fighting so that Franco shall not win the war. In short the working people of the world are marching to defeat Franco and subsequently international fascism as well.

The People's Army has a tremendous advantage because it is waging a war with a purpose, while the rank & file of the fascist army has no real purpose in fighting and is held together by fear and terror. Such an army of course lacks morale and spontaneity. It is utterly incapable of any brilliant or heroic military activity. Consider for yourself what your attitude would be as a soldier in Franco's army, assuming that you were politically unconscious. For years you have worked on the estate of the Duke of Alba receiving 2 pesetas a day, enough to keep you and your family on a malnutrition, but not quite a starvation level. You do not know how to read or write, the church has seen to that. Your formal education consisted of a few months in school where you learned maybe to spell your name, JESUS CHRIST, THE VIRGIN MARY, and to learn by rote history of the Saints to the tune of little jingles. With education in the hands of the church until the time of the 1933 revolution, a survey showed that almost 75% of the population was illiterate. Finding yourself now in the Fascist Army and feeling the injustice of your past existence and at the same time knowing that your fellow countrymen are fighting to establish a better & more just mode of living, you can understand why there are still, in spite of increased vigilance by the fascists, over one hundred deserters a week to our lines. And why, furthermore, we gain, after taking a town, almost as many men as we lose in taking it.

So much for that. I could explain in greater detail the political significance of the war but this letter will be too big for one envelope if I continue much longer.

Ralph Bates, a well known writer and now political commissar for the Americans in Spain comes down to talk to us about once a week to explain current developments of the war. There is much that one can't write about in a letter because of the war-time censorship, so I'll have to save many interesting things to tell you when I get home. Here is a good story he told us at the last meeting which will give you an idea of the

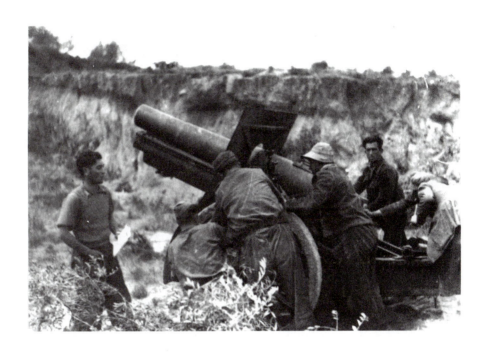

Members of the Regiment de Tren delivering ammo to a cannon at the front.

ignorance & superstition which is still apparent in some parts of Spain.

One of the inland towns in the northern part of Spain decided to buy a statue of the Virgin for their church. The Virgin had to be shipped from Italy and on the way to Spain the ship which was bringing the statue was caught in a bad storm. The sailors were badly frightened and when the storm continued to grow worse the sailors ran to the statue of the Virgin and began to pray. Their prayers were of no avail. The storm continued to rage. Then one of the sailors noted that the Virgin was lying on her back and as a last resort he turned her over on her belly. Almost immediately, according to the mariners' story, the seas quieted and the miracle was completed. The moral of the story, of course, is that the Virgin had been lying in the wrong posture for a virgin, and Jupiter was displeased!

In reading over my letter I see that I have failed to mention two things which you are probably curious about. The first is the part that Russia is playing in this war. I should have said before that the very existence of the strong & powerful working class government of the U.S.S.R. is the greatest assurance we have that the Spanish loyalists will be victorious. It is impossible to understand to what extent the U.S.S.R. is helping. There are practically no Russian soldiers here, and yet we all know that without Russia we would not be in the advantageous position we hold today.

The other thing I forgot is the composition of our camp. There are 70 fellows in our *esquadrone,* all English speaking & hailing from all parts of the U.S.A. and Canada and including three fellows from England. They're a hell of a swell bunch.

My Spanish is coming along fairly well but not as fast as it would if I were with the Spaniards.

No, Jerry and Ham are not with me. None of my Berkeley friends are with me. They all went into military training after we arrived in Albacete & I have heard nothing from them since, although I have written several times. I'm sure I shall hear soon though. It often happens that one receives letters from the States before he gets a letter from Spain. I don't know why that is.

Yesterday I went on a delightful one-day convoy up in the mountains. The roads were very good. There are many good roads in Spain made of stone bricks and covered with tar. There are many quaint little towns in these mountains and there are green meadows that smell sweet & fragrant with clover where cows are munching grass and everything seems completely oblivious to the existence of the war.

Our convoy rolled higher into the mountains and we came to a scene that looked like an illustration in my old book of *Grimm's Fairy Tales.* Here was a well-preserved Spanish castle overlooking a blue lake. The sun was going down and its rays struck the landscape in a strange manner. It was not a real experience.

Just before we reached our destination we passed a company of soldiers in full gear. They all had steel helmets on and some had their bayonets fixed.

This was my first trip into the mountains. Usually we go in a different direction, often with a cargo of troops. The roads are not so good when we go this way. Some of the best roads are under artillery fire so we often have to take back roads. I get a hell of a wallop out of these convoys though. Coming into a pueblo we have to travel close together so we won't lose the convoy in the narrow streets. I shall never forget some of these trips with the pueblos of white adobe glistening in the sun and the dust rolling

up from the *camións* in huge clouds, and you have to have your horn going most of the time because you can't see very well and you don't want to hit anybody. The people on the side of the streets are cheering and most of them have their fists raised in a red salute. The soldiers are cheering in the back of your *camión* too, and many of them are singing *"Acabar con Los Traidores"* [Destroy the Traitors]. You go wheeling out of the pueblo and up a hill and as you make a turn you can look back and see the people still cheering and waving.

Since I began this letter Grandma's letter arrived. It seems so good that mail has at last begun to come. Tell her that I have made arrangements for identification and all that so there is nothing to worry about. I was glad to hear about the rapid pace at which labor is organizing in Nausau.

I'll close now and get this letter off. We get no American cigarettes here and I should like you to send four "Kools" in each letter. Don't send any packages because the chances are I shall not receive them.

> Much love,
> Don

P.S. A *camión* is a truck

• •

from CANUTE FRANKSON

> Albacete, Spain
> July 19, 1937

My dear:

It seems like so many years since I last saw you. And how I wish it were possible to see you, to be near you and to be able to talk to you, instead of having to write to you. Letters are such impossible things for conveying one's thoughts, especially when one feels as I do right now.

I thought of you quite often today. This I attribute to the physical and mental strain of the past few days. Seemingly, after these hard days and sleepless nights I get a child-like longing for home and those who are dear to me. Fortunately, however, after I get a bath and some rest I get back to normal. There's a lot to do here. And I soon get involved in work.

I have just returned from one of the fronts, where I got my initiation, my first real baptism of Fascist bombs and machine-gun fire. They taught us in Sunday School that whatever came from above was a blessing. But what rained from Fascist airplanes the day before yesterday could hardly be called a blessing. There must be exception to the rule—even the Biblical rule.

Colmenar Viejo is a town about thirty-five miles to the north of Madrid. As we drove along the winding dirt highway up the mountain we did not see the faintest sign of life. Nor was there anything to show that there was a sign of life beyond. There were no farms along this lonely road. Though this was not the reason for the absence of human beings. Because here the farmers do not live on their farms along the highways as they do in America. Everyone lives in the villages. And a fifteen-mile walk to and from the farms is not at all unusual here. This road was an emergency road for military purposes only.

As we reached the summit we saw the village about two miles down the side of the mountain. I wondered why they chose such a place to build a town.

Within about half a mile from the town the military commander who was ahead of us stopped his car and was looking up through field glasses. Instinctively we piled out and made it for the fields in double time. The planes passed very low above us. But certainly the Fascists did not see us. They circled the town and flew away. The longest seconds I have ever lived through were those which dragged by while those beastly things passed overhead.

We stopped in the town for gasoline and oil. As each vehicle got filled up it was sent out to the outskirts of the town and the drivers instructed to spread them far apart along the highway. The bus I was riding in was the last one to reach the city limit. The men were all scattered along the road and in the fields. I got out and walked over to one of the threshing circles. I call them threshing circles for want of a better name. The grain is spread upon a large circular surface, which sometimes is hardened earth, and at other times made of concrete. Horses or mules hauling odd-looking instruments around, in some instances this is simply a heavy wooden slab, and other times a number of narrow wheels mounted on a shaft, to thresh the grain.

I stood there for about five minutes watching the primitive method, wondering how old it might be, and talking to the women and children at work, when we heard the roar of airplanes. Someone yelled *"Fascistas!"* This to a soldier means to lie flat to the ground, and still. The civilians ran and huddled together. I did all I could to get them to lie down. But it was useless. They were too frightened to understand. This was the Fascists' first visit to Colmenar Viejo on one of their bombing sprees.

Within a few seconds the planes were making a straight line for the town, and coming down lower and lower. Before we realized what was about to happen there was the most terrific succession of explosions I had ever heard in my life before. So violent were these explosions they seemed to have lifted me from the ground. The women and children were still huddled together crying and screaming.

We're instructed to always lie flat to the ground with face down, but my curiosity got the best of me. So I looked up. I saw one of the planes coming toward the spot where I was lying. At first it seemed as though the devilish thing was coming on top of us. And as it came down it was belching fire. The poor frightened women and children ran and were caught in the direct line of fire. The plane dived down to about thirty or forty feet off the ground. And as it passed to about fifteen or twenty feet to my right I could see the face of the man at the controls. He was laughing.

Those seconds stretched out in my mind like long years of waiting, expecting, hoping, trembling. The terror on the faces of those women and children isn't something that one can forget easily. I don't think I'll ever be able to forget it. The earth rocked beneath me like a strong man with the ague as I wondered during those explosions if one of those bombs would drop where I was. Those seconds seemed an eternity of torture to me. But the flash second in which that machine gun was spitting fire, and bullets were kicking up dust around me, is really beyond description.

The screams of the women, which was like a nightmare to me, rose above the thunderous roar of the propellers as the ship was pulled up out of the dive. Within a few seconds he came down again, and for the second time sprayed death in front of him. They

did not hit any of our men. I'm sure they did not see any of us. But the women and children running were a perfect target. After the dust had settled there were three children and four women killed. The brave Fascists had done their job. They flew away.

The laugh on the face of that beast who killed those innocent children and their mothers reminded me so much of the snarl of a hungry tiger. He had his fun. There were the children with their little hands still clinging to their mothers' dresses. They were lying in pools of blood. Those mothers with calloused hands and sweated faces would never smile again. Those expressionless faces described the horror of Hitler's and Mussolini's contribution to society, and painted on my mind an indescribable hate for Fascism; a resolution to ever give my all to the aid of these people who so heroically are defending their land and world democracy against these Fascist beasts. Then I'll better justify my leaving home, you and all that means so much to me to stake my life against so vicious an enemy.

I sighed and walked away from the blood-soaked wheat and those sad, dead faces; away from those frozen lips which were expressing such beautiful and sympathetic smiles only a few short minutes before. Those women and children are dead, but the last groans from their dying throats are heard and will be answered by all of us who still represent and appreciate democracy and decency. Their dying silence must inevitably forge another link in the chain of unity among those who represent progress. Their blood will not have been shed in vain. Fascism must be, and will be, crushed.

It was then getting dark, so we piled into our cars and moved on. It is very unfortunate that the enemy should use such horrid methods, but our tears or our staying there could not have helped those unfortunate victims. So we moved on. Our jobs are ahead. We must avenge these brutal acts, this Fascist barbarism. Such loathsome deeds against a people so wholesome, so sympathetic, so noble, can never go unavenged. They died and many more will die, but as they die they write a glorious page in world history. Because there is no living human who dares say less than these people are of the bravest. They shall not have died in vain.

The following morning as we passed through the town we saw the result of the bombardment, and, incidentally, of Fascist sadism. The public square and nearly every building in its vicinity was destroyed. And it is very important to note that at this particular time of evening the squares and promenades are always crowded. A check, after the last raid (2 a.m.) showed forty dead and sixty wounded. And among them there was not a soldier. Because in Colmenar Viejo there were no soldiers.

We loaded as many of the homeless as we could, on our trucks, and took them to Madrid. The grief on the faces of some of those mothers who had to leave the dead bodies of their little children to be buried would burn into the heart of the most cynical person. Their gestures, their appeals, their agonized tears were like red-hot pokers being thrust into my heart. It can't be described. It's too vast, too cruel, too gruesome. Within a moment cities are destroyed, smiling children at play are torn into small pieces. Yes, this is the kind of war Fascist Germany and Italy are waging against these peaceful people. What had these little children done to these mad-dogs of Fascism that their little bodies should be blown all over the streets where they were playing? Why should the blood from their little bodies stain the streets of their beloved cities? Why should their little hands be clinging to the dresses of their dead mothers, lying in pools

of blood, with their faces to the skies as if looking for help from the very skies which rained death down and sapped the life-blood from them?

Those innocent victims lay last Friday night on the streets of Colmenar Viejo as a grim example of Fascist savagery. Their blood was necessary to quench the thirst of a class gone mad in their lust for power, grown desperate and determined to destroy every trace of human freedom and decency, of civilization itself. But the death-gasps, and the agonized faces of those little children will never be forgotten. They are gone. But we are here.

We came because we are convinced of the cause for which they fight. We remain here because we could not help learning to love them. We fight with them because we know that they are representatives and defenders of freedom. We see that they represent the best in human beings: love, sympathy, tolerance, sacrifice, determination and bravery. We expect to stick it out until these mad-dogs are driven out or chained where they can no longer do harm to the human race. They must be put where they cannot spill any more innocent blood. Yes, we are here and our job is not by any means a small one. Some of us have sacrificed much to come here. Some of us will not live to return. But there is one thing certain: each one will have done his part in ridding the earth of the parasites who must quench their thirst with the blood of women and children.

These beasts who live by hate and the ruthless slaughter of a civil population must not rule the earth. They must not be given a chance to suppress and enslave a people so courageous. A people so heroic cannot be enslaved. For them there's no such thing as defeat.

With best wishes for your health and happiness, and hope to see you soon, and that you may share with me the celebration of our final victory I close. The road is long and painful, but victory is assured.

> Write soon.
> As ever,
> With love.
> Canute

..

from CANUTE FRANKSON

> Albacete, Spain
> July 30, 1937

Dearest:

One of the greatest advantages we have is the change which transport offers us. Being here at the Base is something quite boring, but the change seems to put new life in us. We have a big job keeping these cars and trucks in running order. Organizing our work so that it may function at the greatest degree of efficiency is quite a problem. And this must be done at all cost. Because transport is a most vital unit of a modern army. Seemingly this is where the enemy's agents are busiest.

The change which I refer to is the periodic trip with convoys of troops and materials to the different fronts. We do not only get a change, but we also get our heads full of experience. We get a close-up of Fascist brutality and sometimes—especially after it's all over—a real thrill from ducking from the enemy's bombardments.

I've just returned from one of those trips. For five days we had gone without a decent meal, very little sleep and not much water. And believe me thirst during these days is no joke. The socks were sticking to the soles of my feet this morning when I tried to get them off. They didn't smell exactly like perfume, but you see we get used to that.

During this trip I saw Madrid under bombardment. It resulted in a dogfight with the Fascists losing two planes. One fell within our lines. The other fell on the other side in flames. It is quite exciting to watch the small chasers racing up and down and around the large bombers. And to see one of those devilish things go down in flames is enough to pay up for the danger of exposing oneself in the open after the siren blows.

We had gone to one of the fronts, delivered our material, and returning, had stopped for gasoline and oil. I was sitting on the running board of one of the trucks, surrounded by about fourteen youngsters, ranging from about six to ten years old. They were telling me, in amazing details, of some of the Fascists' bombardments of their beloved city. Some were sitting beside me, some on the curb, while others were on the fender of the truck. After we were there a while a little fellow of about three years walked towards us. He stopped within about four feet of me and looked up at me. I smiled. He smiled. I beckoned to him to come to me. He looked back at his mother who was sitting a few doors from us. Then he watched me, and made another step cautiously forward. I held out my hand and called him. He turned as though he was going to run. He looked back, and we both smiled. I said "Salud." He held his clenched fist above his head and said "Salud." This word "salud" is derived from the verb *"saludar"* which in English is "to greet." But here it seems to mean very much more. It is used as a means of returning thanks and saying goodby. The word really seems to adopt an historical meaning here in Spain.

As the little fellow would not come any closer to me I made an attempt to hold him. But he ran to his mother. We followed him. And with the assistance of his mother and little sister I was able to gain his confidence. I took him up into my arms, and we returned to the truck. He then told me that he had a rifle at home. I asked him what he wanted a rifle for, and he told me he was going to shoot Franco with it. But why should you want to shoot Franco, I asked him. Because—as seriously as though he were a man of thirty—he is a traitor general. Then he called him some names which would not look very good in writing.

This, however, was not just a child's simple statement. It was the result of the lesson which Fascist barbarism taught Madrid. It was the people's answer to the foreign invaders of their country, of which Madrid is a symbol. It was their answer to the lying boast of those Fascist mad-dogs who bragged that they would have had coffee in one of Madrid's cafes before last Christmas. As things look right now, despite the systematic destruction of the buildings and art treasures, and the killing of its women and children, they'll never drink coffee in a cafe in Madrid. At least, I'm quite sure that it is now quite evident to them. If it isn't then they are really dumber than I give them credit of being.

The little group was just about to be broken up. I had reached into the cab for my flask when we heard the siren. Instead of scattering in terror or running for the shelters as one would normally expect, the little fellows ran out into the street and were

looking up for the planes.

Strange, although I knew that those airplanes over my head carried hundred of pounds of high explosive bombs, and that any minute they may be let loose upon us, I was not at all frightened. It may have been because of the children's attitude. At least I was there with them looking up. The "Moscas" were up there with them. And within less than a minute one of the bombers was roaring down in flames. Within another half minute another was down. A thunderous roar went up from the people.

Now, tell me, do you think I did the right thing by coming here to help in this struggle? Can you see now that a Fascist defeat here will discourage our would-be Fascists at home and give courage to the progressive people in their fight against the enemy? I wonder do you realize how close to us is the cause of these people? And you can, even where you are in the South, do something to help the cause for which they fight? There's no use in our burying our heads in the sand as the proverbial ostrich. Nor can we ever be afraid. The facts are cold and naked. They are barbarous and inhuman. So since they will eventually wipe out all the gains we have made, if they go unchecked, then we must get down to business now. And not wait until those of our America make a Germany out of it for us. Our job is to unite our forces and fight.

But we Negroes, as individuals or groups, cannot sit back at ease and expect others to fight our battles for us. We must unite our forces with all the progressive forces and build a united front of action which will not only fight on the economic field, but will represent us, and fight for us, on the political field. We must use our unity to crush the Ku Klux Klans, Black Legions, Liberty League and all other reactionary groupings. We must educate the people, tell them about these organizations and what they represent.

We, Negroes, are victims of the worst kinds of oppression and abuse. But we must not be confused by the lying propaganda of our enemies. We must use our heads. We must start to do a little thinking of our own. This race consciousness and race loyalty is the bunk. It's enemy propaganda. Our isolation is our defeat and their victory. There's no better time than now to understand that we are not victimized simply because we are Negroes, but because of a system of exploitation. It is the bosses' scheme of separation. Can't you see how cruelly anyone who attempts to unite the people in the South is dealt with? Can you live long enough to see the bosses ever forgiving a man, be he white or black, for talking unity of the Negroes with the whites? Don't you see how they say nice things about the men of our race who preach race solidarity? These are some little simple facts we must open our eyes to.

So long as we can be kept from forming a united front with the common people of the white race, so long will they be used by the masters to lynch our loved ones. So long will they have jim-crow cars for us. The people who work for a living and the small business people who have a mind to preserve human rights are organizing themselves into powerful organizations. It is our duty to join with them. Remember, it will be us, the common people, who will save democracy, if ever it is saved.

As we work in our churches, instead of wasting our time discussing trifles, we should discuss, and especially take active part in, the program of action for peace. We should contribute very liberally to anti-war organizations. We must call upon our ministers for action on the question of peace. No one can be neutral during such trying times. And ministers must take an active part in the progressive movement. In our

social clubs we must discuss world events, and keep a close eye on national problems. We must draw up resolutions on important questions and send them to our representatives in Congress. We must get all Negroes and our white sympathizers to send in demands for the passing of the Anti-lynching bill now before the Congress. And above all, we must get our organizations and churches to support the program of the National Negro Congress. Unity is on the tongue of all progressives of the world. Unity must be our slogan. Unity, as proposed by the National Negro Congress at its convention last year. We must fight for the affiliation of our organizations with the Congress. These are our tasks, as members of an oppressed race, and oppressed class, and as representatives of progress. To this, my dear, each one of us should, and must, dedicate ourselves.

For some reason or other I'm feeling a little depressed. Perhaps it's because of hearing of the death of some of my friends in the recent battles. Or it may be because of seeing so much slaughter. Then it could be the thoughts of home and my friends all through this afternoon. Regardless of what it may be—and I'm about convinced that it's a combination of all three—there's nothing else for me to do but try to forget. There's a long, hard battle ahead. There are many days of hardships and sacrifice ahead. But beyond, or rather, at the end of this trail of bitter sufferings we always see the perspective—victory. We have the courage to continue against this barbarous enemy because of our convictions; because of our intimate relationship with, and our love for these people, and because we know that the responsibility of saving the treasures of this earth rests on our shoulders. And then we cannot help but be inspired by the bravery of these people. We all find—even as I do now—our hearts somewhat depressed at times. Because, my dear, we see some real brutality here. We see Fascism at its worst. But we dare not look back. Sometimes we get awfully tired, even discouraged. But because of our conviction and knowledge of the situation at hand, we soon get ourselves together and keep on going ahead.

I'm tired and terribly sleepy. There's always a hard day ahead after a convoy. The trucks have to be all gone over. I must get some sleep. Goodnight. Do all you can to help our people to understand. Make them understand how to choose their friends only on the basis of what they have done and are doing. Don't fail to acquaint friends and associates with the National Negro Congress and its program of unity. Remember that the Congress is only opposed by those privileged men and women of our race, and their white masters, who do not want us to see the way to social, economic and political freedom. We must be kept in ignorance so that these parasites may keep on living in their beds of ease, on the bleeding bodies of our people. They talk against segregation and the jim-crow system, but do everything possible against building unity to destroy them. The way they want us to practice race loyalty can only be a chain to keep us continually down. We must break it. Their loyalty is not to our people, but to the system which gives them the chance to accumulate wealth from the suffering masses of our people who live in want and poverty while every nickel is taken from them. Our loyalty is to the cause of freedom from disfranchisement, discrimination and lynching.

Be on guard. Think of me. Have your friends write to me. Send me some snapshots. Somehow they seem to mean a great deal here to us. Regards to all. So long.

<div style="text-align:center">As ever.</div>

<div style="text-align:center">Canute</div>

•••

from DONALD MACLEOD

> September 13, 1937
> Plaza del Altozaño
> Ch. 2 R.T.
> Albacete Spain

Dear Stuart:

Well, laddie, it seems to be fall already and I'm still here in Spain. The war moves along slowly. We made some good gains on the Madrid sector during July relieving the pressure on Madrid considerably. Now we are up on another front in the province of Aragón. In the last week and a half our forces have advanced approximately 38 kilometers toward the city of Saragosa and the fighting is still going on every day. We are still advancing but more slowly during the last few days. I've been up to the front only once so far during this offensive. I hauled barrels of water up to a kitchen situated right on the front, but off to one side behind a hill which gave the kitchen protection. For the two days I was there our artillery guns were firing at a rate of about one big one every five seconds. We must have been blowing the hell out of some place but I never did find out just where. The machine guns were going at a terrific rate too. The firing gives you a nervous feeling at first but after a while you can tell by the sound the shells make whether they are going away or coming and, if they are coming, just about how close they are going to land.

War is much different from what I pictured it while coming over on the boat. Guess I must have taken the movie versions for granted with everything from the aerial bombs to the *pistolas* all going off at once like a glorified 4th of July celebration. Not like that at all. It takes a long time to prepare for an offensive and during that time things are pretty quiet. Remember about the time we were together in Chicago the loyalist forces were beginning the famous counter-attack on the Jarama front? I landed in Albacete the middle of April and from then until the 5th of July the only evidence of war I ever saw was an occasional shell which happened to land in Madrid on my day off. It is only during the time of the actual attacks, and these last for comparatively short periods, that war becomes hell in the concrete. Even during these times the truck drivers see little of the actual business because the unloading is done behind the lines.

The aerial attacks are bad but there is usually plenty of time to stop your truck and take cover. During the July offensive I was in a few bombardments while hauling supplies up from the supply stations. It happens like this. You are driving along watching the people who are working in the field. Every time you see anyone along the road you never fail to take a good look at him because if he is looking up you can be damn sure that he is watching an airplane. It is practically the only way you have of telling when you have run into danger. You get out of your truck then and take a look for yourself. It is almost impossible to distinguish the fascist planes from ours unless they are flying so low that the markings are visible on the wings. In the early days before any of us had seen much of the war some of the boys in camp claimed to be able to tell their planes from ours by the sound of the motor and every time any plane came in sight the "detectors" would enlighten us with their decision whenever they could agree. As time went on and we all acquired more skill in the pastime we were able to formulate one concise

rule as a guide for the detection of airplanes. It is stated thus: "If they drop bombs they are theirs."

The thing to do in a bombardment is to get below the level of the ground and then you are fairly safe. You can see the bombs when they are coming down. They look like big drops of milk. They make a hell of a racket but they don't do as much damage as one would expect. I'm not trying to lessen the horrors of war, though, because it is horrible. We all hate it and would like to be back home again and the only reason we don't leave is because we hate the thought of fascism getting a stronger foothold even more.

One of the boys here in camp got a letter from his mother in which she enclosed a clipping from the Santa Barbara *Morning Press* about a former State College student fighting in Spain, which of course was me. Most of the article was an excerpt from one of my first letters. The article seemed naively optimistic as I read it. Not that I am not still optimistic. I am certain that we shall eventually defeat the fascists but it will be a damn tough fight. Just recently we captured one of the biggest fascist towns in this vicinity and found it to be fortified in an amazing manner. Trenches made of steel and cement and running in an irregular line covered the whole front of the town. Captured papers and documents proved that these ultra-modern fortifications were designed by German engineers. As you can imagine it took plenty of hard fighting to make this capture and there will no doubt have to be many more such battles before fascism is finally destroyed. Spain has plenty of men now. What we need is political pressure and for that we must rely on the working people. Do what you can over there, Stu, but don't come to Spain. Tell Bug I got her letter. Also Kenneth Engler's. I'll write to him soon.

Much love,
Don.

. .

from JACK FRIEDMAN

Spain May 13, 1937
With the International Brigade
(and giving the fascists hell)

Dear Joe [Freeman]:

I think you are a bastard for not having written to me yet. Here I am writing my second letter to you while I am most anxious to get the first one. You have no idea how happy it makes us boys to get mail from back home. Then on the other hand to be removed from your teaching and guidance is more than I can stand. So hurry and write and lay down the logic.

The more I see of Spain, its people, its struggle, the more happy I am for being alive and here. With each passing day *ne sus non insperatus* and clarification. There is nothing like a few good bombardments to clear up issues for me. Things here change from the theoretical to the reality. For example in one of our truck convoys we had to guard ourselves with guns, not against the fascists—but against the Trotskyites. You see Trotskyism is no longer a theoretical question to us, it is real, and any bastard that tries to discuss and uphold the theory of it is quite apt to get the butt of my gun over his fucking head as a most convincing argument. And when you are in the midst of a

bombardment of Madrid, that too becomes real and you do not have to spend months in an effort to convince yourself what to do about it, if at all.

No, Joe, it does not require a lot of thinking here. When you see the bravery, loyalty, sincerity, and kindness of the Spanish people, you just wipe away a tear that is bound to creep thru and pledge to yourself to go till the end to help them, at the same time your heart is bursting with inspiration. Then you see the bombs falling on the women and children of Madrid. You are filled with such a hate for the Fascist bastards that you will not rest till the last rat is dead. To us here it is as simple as that.

I saw one of the most dramatic incidents the other day, and I wished and wished that you could have been here. Me and my comrades saw it but it must remain our secret because we lack words with which to describe it properly. You could have told the world about it. Here is what happened: We were moving a hospital unit up to the front. We arrived in the small peasant village where it was to be set up. The town was two or three times the size of Accord. It was to be established in the schoolhouse. Joe, there were the kids, some of them no bigger than my little niece Toots, carrying out their own desks and books from their own school. They were lugging them to a nearby barnyard where the new school was to be held. While the kids were taking out the desks the women, their mothers, were sweeping and washing the floors, upstairs old men, their fathers and grandfathers, were busy tearing down partitions to make larger rooms of small ones, while the younger boys, their brothers, who are not at the front were carrying down the old bricks and mortar. Incidentally there were no men in the town who were old enough or young enough to carry a gun. The work was going on in a wildfire pace and with utmost efficiency in spite of the fact that it was spontaneous and without leadership. It took but a jiffy for the place to be vacated and cleared. Then came the job of carrying in the beds etc. and setting them up. Here again was this desire to help. Old women, older than my mother, almost fought with each other for a chance to carry in beds. Children stood by and wept when they were not permitted to do more. In went the beds, they were arranged, the linen spread, the kitchen set up etc. The whole job took about as long as it does in the movies. Joe, then came the last scene and climax of this greatest of all dramas. The same kids who had removed their desks from the building were carrying in the wounded on stretchers. Four kids carried out one desk, four kids carried in one stretcher.

Joe I know that you have devoted your life in the interest of humanity. I appeal to you to do more. If you have been working 15 hours a day in the interest of the Spanish cause, do not be content, increase it to 20 hours a day. You and I must help these people win their fight. They are writing the most glorious page in the history of the working class, you must hold the candle for them.

I have been having a couple of days of rest, for the first time in a month. During that time I have been living in my truck. When we get going we drive on the average of 20 hours in 24. We eat in the truck and sleep in it when possible. We drive day and night and at great speed. At night we drive without lights. I have discovered a way how to take a piss while driving at 50 miles an hour. I have revealed this method to my comrades and they are most grateful. We Americans are the most efficient in the transport outfit. I am the political leader of a group of my comrades. When I take care of their needs, both material and political, everything is O.K. If I fail I catch plenty of hell. We

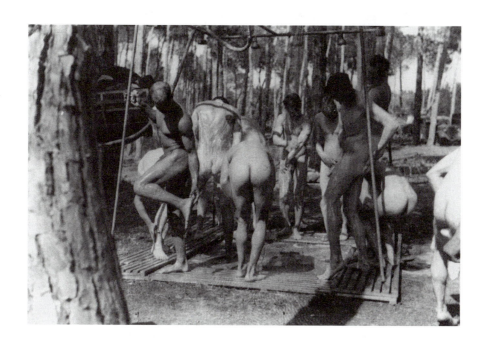

Delousing for the Regiment de Tren.

make people toe the mark out here, and that goes for officers as well as comrades in the ranks. We had a political commissar who seemed to have lead in his pants, so last night we held a meeting and we slung him out. We now have a comrade in his place who we feel will do a better job of it. But we do not give him a blank check either, if he fails to do the work properly he will follow his predecessor. We believe that we came to serve the Revolution and not to have the Revolution serve us.

The women in Spain I believe to be the most beautiful in the world. When you walk through Madrid you keep gasping for breath at the sight of so many lovely creatures. How they behave in bed is something I am completely ignorant of. But I assure you that before long I shall check up on that angle of it.

I received a letter from my little niece Mildred in Accord. I was so proud of it that I showed it to all the boys in my outfit to marvel at, and believe me they did. I think the little darling is going to be capable of big things before long. I want you to keep an eye on her and help her as you did me. I am enclosing the letter.

Since I wrote the above we have received orders to move. At the moment I am writing in my truck while we are awaiting further orders to move up to some front. Just where we are going I don't know, even if I did know I wouldn't tell you see. We are off—

May 15. We arrived safely at the front with our troops. Sitting beside me was a captain in the Spanish army, he was an anarchist and whenever we passed through the cities and villages he would give the anarchist salute, in reply to the raised hand clenched fist that he received. Out of courtesy to him I also wanted to give the anarchist salute, but as you know it is not possible while driving.

May 16. Yesterday I had my first day's leave since I have been in Spain. I went to Madrid and spent a very interesting day, and did some shopping. Spoke to Matthews of the *N.Y. Times* and discussed the Spanish Government crisis which had just arisen with Ralph Bates.

Joe, I am sending this letter to you, but will you see to it that George Willner reads it? The fact is that there is a fixed amount of news and time to write is most scarce. In view of that I am going to make a strange request. I am going to ask you to make several copies of this letter and send them to the following people (of course you may edit it.) Please do this for me since I have not written to them in a long time and will have devoted most of my spare time to this.

If it would be possible for you to arrange for a 3 mos. sub. to the *N.Y. Times* for me, that would be swell. Let me ask you again to write often and urge my friends to do the same, especially George and Tiba, to whom I send my love and greetings. You can tell Tiba Garlin that even way over here I have found people who do not like her, but let her not feel badly—I still love her, and she is aces with me.

My best to Charmion [Freeman], and I would appreciate a note from her too.

Salud my comrade and friend,

 NOSOTROS PASAREMOS

 JACK

· ·

from JACK FREEMAN

 Sept 26, 1937

Dear Folks,

If you get this note you will probably be astonished at receiving three letters from me in one week. However, the explanation of this present letter is that I'm in a place where I've got to look busy and so I'm writing a letter since I've nothing official to write.

How I got where I am now is a funny story. As you know, I was transferred about a week ago into the Lincoln Battalion. You also know that I've been doing mapping and observing work: Yesterday morning I was supposed to attend an observing class at Battalion headquarters. Instead, I was asleep in my hole in the ground, which has been my headquarters for the last ten days. At mealtime, when I came down to the staff I was greeted with the news that the chief observer had been transferred to Brigade and that a fellow named Jack Freeman was now in charge of all observing and mapping. I got pretty sore at this sloppy manner of doing things and even sorer when I learned that all the equipment that had been left me consisted of one ruler and 3 pairs of binoculars—one blind in one eye, one a pair of opera glasses so poor that all you can see through them is rainbows, and the other night-glasses of only 3 power—practically useless.

I decided to go up to Brigade. As I came into the office of the Chief of Information he turns to me and asks, "Who are you?"

"Observer of the Lincoln," I answered.

"Good," he says, "We need an observer to send to the Thaelmann Brigade (which is also in our Division). Report back here in an hour."

So I reported, hooked a pair of decent glasses from the big shot, and was put onto a motorcycle with instructions to report to the headquarters of the Thaelmann, which is at the front.

That motorcycle ride was a honey. I had only been on a motorcycle for about 5 minutes in my whole life. The roads around here are not smooth but of the macadam type, that is, they are made of crushed rock, only the rock isn't very crushed. In addition Spanish roads were not planned to carry 10-ton trucks, so they are full of ruts caused by the continual passage of these big trucks.

Well to shorten this, for 40 kilometers I bounced my guts around in my mouth and did trapeze tricks on the back seat of that cycle. I almost went on my head about 50 times and risked being put out of this war in a very ignoble manner. The continual bouncing actually made me sick, and I had to stop the driver twice to give me a chance to rest and have my insides settle down to their normal positions.

During the last part of the trip we also had the worry of making sure that we found our destination before we passed into enemy territory. There are so many trenches and lines of barbed wire that it was hard to be sure which was actually the front line and which the reserve trenches.

On the way we stopped at Belchite, which as you read in the *Daily* was captured by street fighting several weeks ago with the help of some of our American boys. I walked thru part of the town and what a mass of wreckage some of it is. In one place I saw one wall standing, mostly whole. Right inside the hole and surrounded by piles of debris were two militiamen playing a piano. Another carrying an open Parcheesi board stood by. Telephone and electricity wires dangled from the roofs and I almost tripped on one lying across the street. I went into the church which the fascists had fortified and used

as a machine gun and sniping post. Standing under the central dome which had been blasted by our anti-tank guns you could still see the sandbags in the upper rooms or belfries. On the floor was a big flag whose significance I could not make out. There was a big red cross in the center and around it were two skull and crossbones and two other insignia with crossed torches, crossed scythes, and a smaller cross in the center. The militiamen on guard ask us if we were *"Russes"* and smiled skeptically when we told them we were *Americanos.*

Now I'm at the headquarters of this Brigade waiting around for information. I thought I was going up to the actual front, but it seems I was mistaken for we are still several kilometers from the final line of trenches.

Just now, to make things very dramatic, we observed a number of planes zooming over the front and there seems to be quite a bombardment going on. I don't know whose they are but they haven't come over here yet, so I guess they must be ours.

I expect that my brigade will move up any hour now, but as has happened so many times before, I may be completely mistaken. We may even move in the opposite direction and go into rest.

I'll let you know as soon as anything happens, providing I can.

Love and Regards to all.

Jack

P.S. I wrote this letter 3 days ago, but I didn't have a chance to mail it before. 9/29

· ·

from CECIL COLE

España
Jan. 29th, 1938

Dear Jeff—

Perhaps I'll find some mail waiting for me when I return to the Brigade today. Anyway, it's been a long time since your last letter. In it you mentioned you were to be on the receiving committee for Ralph Bates. How was he? Did he still have my note or remember me?

Since I wrote last at New Year's time, I've been to the front—Teruel—and to the hospital twice. First with my stomach, for which they can do nothing; & second immediately after my return, with a high fever. I've been here seven days now and am returning this evening.

Believe me this is a terrific struggle here now. The fascists are putting everything they have into their attempt to retake Teruel. Thus far, they have suffered huge, simply huge, losses and advanced very little. We, of course, are having many casualties, but they are far from the tremendous losses we have inflicted upon them. However, they are fighting with all they have, air bombardments all day long, shelling so continuously it is impossible to hear individual explosions—just one long roar—tanks, trench mortars, strafing by planes, everything imaginable all day long.

I was strafed one morning, when I was returning to the brigade, in a truck. There was the driver, three comrades against the cab, and myself against the back of the truck. The driver evidently saw them first and started to stop, turning off his motor and

heading toward the bank. This was the first I noticed, then came the staccato crack of heavy machine guns, and there was the 1st plane, not over 40 feet above us. It killed the driver instantly, taking off most of his face. The truck was then stopped against a high bank to the right of the road. I shouted something to the other three and jumped out. The only place I could see that offered any cover was between the motor and the bank. The planes were not coming head on, but from the side of the truck away from the bank. They dove three times, one after the other, all seven of them, and finally went away. I was never so terrified in my life. You see, there was time between each plane's dive, to think, and the continual tightening up and letting down was horrible. The enclosed is a fairly good idea of how I acted and felt. It's not a very heroic nor pretty picture, but it's true. The fact is, I haven't yet gotten back on my feet—mentally—yet. It was the first time I had time to be afraid. The other times I was doing something and moving, but that helpless feeling of no place to go and just waiting—waiting, really got me.

As usual, I rode thru the storm on my "luck" and tho all the others were hit, I escaped with only a terrific jolt to my nerves. Incidentally, they also dropped hand bombs, but they all hit on the far side of the truck. If one had landed any place on my side, I'd be so full of lead they wouldn't have to dig me a grave, I'd just naturally sink into the ground.

Well, we're sure we can "take" all they throw at us, and soon we shall push them again, but this time so far they won't have a chance to retake any ground. Our Spanish troops are improving steadily, and can now give the fascists more than they can take. They and we are all just waiting for the order to advance! We'll soon push, and push them clear off the map, at least of Spain. I guess it will be time then to go ahead and completely smash them.

I'd like very much to come home by next summer. I've, to be honest, just about had a belly-full of fighting—at least for quite some time. I've been here nine months & and had 4 months front service—including the time we were in reserve a few klm. from the actual front. Then too, the doctors all say I need a long rest and a diet of milk, eggs, and other foods equally impossible to obtain here. My gut is in an uproar all the time and I run around with paper in one hand and the other unbuttoning my pants. Not very soldierly of me, I'm afraid. Oh well—I'll git along fairly well I guess.

Now I must close and go back to the front in Teruel. So hoping I get some mail when I reach there, I'll just say, do write soon.

As ever, Red Front
Cec

P.S. If there's no mail I say—Write you S.B., write!

* *

from CLYDE _____

Spain, [undated]

Dear S—

A few days ago I received your letter. I was very glad to hear from you after so long a time. I attempted to answer, but was called for a round trip of 1000 kilometers.

On this trip, I successfully out-maneuvered a lone plane which attempted to strafe

me and my truck. I entered a village and was suddenly in the midst of an air raid of 4 Capronies which bombed the houses and strafed the streets for over an hour. Then the following day I was entering the place where our hospital corps has a large convalescent home, and again the fascists were having an air raid.

The building I was in had the roof strafed several times, and all around, the same thing. Our two trucks had 4000 liters of olive oil on them. Two tanks on the other truck and one on mine were punctured by machine-gun bullets. The other truck had a headlight broken and one tire hit, and my truck also had several bullets through the body, one tire hit and one bullet through the head and into the middle of the generator. I don't know the number of casualties.

My friend, who was wounded and in bed, unable to move, kept on writing his letter, and when the pellets of death peppered the roof, he mentioned the fact in the letter and kept on writing. This shows the unbreakable morale of the International Brigade.

The cigarettes which are sent are a wonderful aid to the spirit of all, but are not sufficient. Tobacco, too, is scarce here. I do not ask for anything personally, but do what you can to get the amounts increased.

S——, you have work where you are, so don't worry about not being able to come over, but continue your job as before.

Don't jump at conclusions because the letters are not so fast in coming to you. Good luck and answer soon.

Clyde

· ·

from DONALD MACLEOD

April 24, 1938
Socorro Rojo Internacional
Chamber 2 R T
Barcelona,
Spain.

Dear Stuart,

This will just be a note to let you know I'm OK. Things have quieted down a little and our company is at rest.

I'm doing my resting in a hospital. After driving for a solid week with practically no rest and only an occasional meal, I was pretty well worn out. There is nothing else wrong with me though. Now that I'm sleeping in a bed and getting good food again I feel much better. I'll only be here for a few days more.

I hardly know what to say in this letter, Stu. We see Hemingway and Matthews every once in a while. They seem to be all over the Front so if you watch the periodicals you will get some pretty straight dope from their articles. They are great fellows; always right up there where the news is being made. They are always good for an American cigarette and usually a shot of Scotch whenever you meet them on the road.

Last summer during the Brunete offensive some of us were talking to a truck driver who drove during the World War. He told us that the worst experience he ever had in his life was moving troops to the Front during a retreat. During the last three weeks the Regiment got a chance to appreciate the full meaning of what this guy said.

One night I was taking up a truckload of supplies along a narrow road in the mountains above Tortosa while the retreat was at its peak. The scene in front of my truck headlights that night is something I dream about. Tanks, trucks, artillery pieces, armored cars, cavalry, soldiers white with dust from hours of walking on the highway, jammed the road and slowed traffic down until it was one gigantic procession moving patiently along. The machinery could move only a little faster than the pedestrians and over the whole mass the dust rolled up so thick that you could only guess at the clearage by the sound of the approaching object.

Filtering down thru all this came the refugees from evacuated towns. I was going to have to face the pleading hands and faces of these people begging for a ride when I came back, and I hated the thought of it. I came back several hours later. The road was cleared of most of the machinery now but the refugees were still streaming down by the hundreds. Some families had carts drawn by a mule and on these were loaded that part of their household goods which could be loaded in a hurry. The small children rode on the carts along with the chickens, sheep, mattresses, etc. The rest of the family walked, the father leading the mule.

These were the fortunate people. Most families were entirely on foot, the mother and father carrying the babies and the other children trailing along. Though these people had been hours on the road I only passed one crying child all night. Maybe they were too tired to cry. These poor kids plodding along were so covered with dust they looked like little spooks. Usually the mother would turn to face the headlights to plead for a ride and sometimes the children would join her in hollering *"Para!"* (Stop). I couldn't stop—my orders were to rush the material thru and besides I had a Spanish lieutenant with me who was more hard-boiled than I was. However, I did stop once. Near Cherta a woman was standing in the center of the road holding up her baby in front of her. She was crying and so was the baby. When I pulled up and stopped the woman was choking back sobs and trying to explain that she had walked since before sun up that morning and was so exhausted she could go no further. I took her across the Ebro River to a town about 20 kilometers on the other side.

I was just talking to an American here in the hospital. He was telling how he had escaped being captured by swimming the Ebro. There are about 16 Americans here and an equal number of Scotch, English, and Canadians.

I don't know how this thing is going to turn out, Stu. The Non-Intervention, designed to turn Spain over to Franco hog-tied, has made the going awful tough. However, we can still win if the democratic countries will only come thru for us. It takes a hell of a lot to defeat a country fighting for its liberty.

The nurse just came in to close the shutters so the light in the room won't be visible from the outside. One of the Spanish patients told her not to bother because the airplanes wouldn't come in through the window. She said, "I know, but we must be careful." He said, "we have nothing to fear here—this is the Lord's house" (the hospital was formerly a monastery). The nurse thought that was a good joke and went out laughing.

 Write immediately,
 Don.

RESISTIR ES VENCER

The VOLUNTEER FOR LIBERTY
organ of the international brigades

Vol. II - SPECIAL No. 10 Barcelona, March 21 - 1938

¡ATRÁS LOS INVASORES DE ESPAÑA!

DRIVE OUT THE INVADERS OF SPAIN!

Make Aragon a second Guadalajara for the Italians!

Reinforcements of arms and men are on their way.

These new weapons, with your courage and heroism, can be used to halt and destroy the enemy.

All of Spain is with you.

The whole nation is mobilizing in a feverish war tempo against the fascists.

Fling your whole strength against the invaders!

TO DEFEND SPAIN'S FREEDOM IS TO DEFEND YOUR OWN HOMELAND!

Una sola preocupación política en todo el país y en todos los antifascistas:

¡Unidad contra el enemigo común!

"Cada metro de tierra española tiene ahora un valor de kilómetros para nuestro destino y el de la humanidad civilizada."

(Del discurso del Ministro de Instrucción Pública, camarada Jesús Hernández.)

¡Aragón será para los Italianos un segundo Guadalajara!

¡Soldados! ¡Combatientes todos! Nuevos hermanos vuestros. Nuevos medios de lucha van a ayudaros, y con ellos y con vuestro heroísmo y vuestro patriotismo hay que aplastar a los extranjeros que asaltan la patria. Todo el pueblo está a vuestro lado. Toda la patria se moviliza en un mismo latido de guerra contra los invasores.

DESCARGAD COMO HURACÁN INCONTENIBLE TODA LA FUERZA DE VUESTRO DESPRECIO, DE VUESTRO ODIO SAGRADO CONTRA LAS HORDAS SEDIENTAS DE VUESTRA LIBERTAD.

In the midst of the Great Retreats the *Volunteer for Liberty,* usually consisting of 8–16 pages of detailed articles and photographs, was issued as a dramatic two-page broadside.

XI

IN BATTLE
From the Snows of Teruel to the Great Retreats

· ·

INTRODUCTION

After the pitched battles of Aragón—from the house-to-house combat in Quinto to the tank attack at Fuentes—the Americans retired to the Madrid area for a period of rest. Shortly before Christmas 1937 the word arrived that Spanish troops had captured the fascist-held town of Teruel in a surprise attack.

The Teruel campaign was partly defensive and preemptive. The Nationalists were assembling troops and equipment for what they hoped would be the decisive attack on Madrid. Once again, capturing the capital seemed the swiftest way to end the war. Word leaked that Franco planned to launch his Madrid offensive on December 18th. Three days earlier the Republic attacked Teruel, which also seemed the possible point of a future fascist drive eastward, a drive that could cut the Republic in two. On the stone cliffs above the meeting point of two rivers, the walled city of 20,000 was also less heavily fortified than others and quite near the front.

News of the victory was particularly exciting because it suggested the Republic's forces were maturing rapidly. The American battalions had no role in the assault, but several Americans, among them Irving Goff and William Aalto, had worked behind fascist lines with a guerilla group to blow up a key bridge on the eve of the battle.

As expected, Franco counterattacked on December 29th. Meanwhile, Loyalist forces were still rooting out the last fascist defenders from fortified buildings. Under pressure from within and outside the city, the Republican troops momentarily panicked, and it was decided to call on the International Brigades again. The American battalions were among those rushed to the city and neighboring towns to open the New Year. Meanwhile, intense cold and heavy snows hampered all military activity. The winter 1938 battle for the heights around the nearby town of Celades earned them the name "the North pole." Trucks stalled, food froze, men were taken out of action with frostbite. By mid-January roughly 100,000 men were engaged on each side, but Franco had accumulated still more men and had massive superiority in artillery and absolute dominance in the air. It was to be one of many times that year when the huge imbalance in equipment would prove decisive, despite the exceptional courage of many Republican troops. Among the actions the Americans participated in was a diversionary attack on Segura de los Baños, designed to force Nationalist forces away from Teruel. But Franco's vastly superior forces at Teruel could not finally be stopped. On February 22nd the city was his.

••

from ALFRED AMERY

February 2, 1938

Dear George & Lawrence:

Plenty of water has gone under the bridge since I last wrote and plenty has happened to me. In the meantime I have received lots of letters and due to action have not been able to answer. As to packages I've given up hope of getting any, and would advise everyone at home not to bother sending them.

Your letters have been very interesting, and it is pleasing to me to see how both of you have proceeded to roll up your sleeves and participate in the rough hurly-burly of world-doings. George, I can see, has a tough job on his hands, but will be doing splendidly if he can make a start. And Lawrence—well, I can't imagine him as being anything but busy, anyway; so I guess he's just "busier" than he used to be.

Now follows a brief review of the latest in regard to myself.

About the day before New Year's the brigade went into action. The battalion, after a long and freezing ride, got off trucks in a blizzard, and took up a reserve position in what is said to be one of the coldest spots in Spain. There followed a week of near-zero weather; and this, with our clothes, was *mucho malo* to say the least. Then we shifted our position to a place in the mountains, still in reserve—and zero weather. But soon after that it began to warm up slightly, and one could feel that one was still alive. During this period all the toes on my right foot became frostbitten, so that now they are numb, without much feeling.

Then, our next move was into the trenches, perhaps you can guess where [Teruel]. With daylight we were greeted by a salvo of trench-mortar shells and a view of enemy trenches in places only fifty yards away.

Suffice it to say that during the thirteen days I was there we went through much worse than the usual "hell." The fascists had a tremendous amount of artillery and used it unsparingly. They attacked in hordes, but as long as our machine guns worked were slaughtered. After six days of intensive fighting they gained a little ground, but not enough to do much harm nor to do them any good. I got wounded—not badly—on the 25th, and though the last three days had been very quiet the men by that time were nearly exhausted.

I got wounded at noon when all was quiet, while carrying some of the noon-rations to my section. We had to leave the trenches and traverse about 40 yards of area exposed to the fire of a fascist sniper in order to get the food and bring it back. On my way down not a shot was fired, and coming back, rather heavily loaded, I thought that maybe the sniper was eating his own dinner and so I didn't run as fast as I might have. Anyway, when about 15 yards from safety I heard "crack!" and simultaneously my right knee felt as if struck by a hammer. Still running, I thought, "Christ! I'm hit—but maybe it's only a stone." You see, the bullet might have hit the ground and knocked a stone up to strike my knee. So I said to myself over and over—"Maybe it's only a stone." But the leg grew stiff, and as I reached safety I noticed an insistent pain. I dropped the food then, and yelled, "I got it in the leg!" And as I fell down the first-aid men came running to help me.

The pain grew worse but nothing to rave about; and as my pants were slit up I could

see the blood and was of course at once convinced it had been the bullet. It looked pretty bad at first, the bullet having gone through just below the knee, but by the way it felt I thought it had struck the bone and that permanent damage might have been done to the leg.

However, with a shot of morphine the pain was easily bearable—no worse than a toothache—and I was carried away at once.

Now, 8 days later, the wound has healed completely; there is no pain, and every day I find myself walking better. So I consider myself very lucky, and believe that in another couple weeks I shall lose the limp completely.

The bullet must have just cleared all bones, though to look at where it went in seems unbelievable.

As before, the hospital, with cleanliness, good food, and soft beds, is like a bit of heaven after the trenches, I am very glad to be here.

In about a month I expect to return to duty; and by now, with all my experience, I should do better work than ever the next time I go to the front. However, the battalion is badly shaken up this time, and I believe it will take a long time to reorganize.

Well, we are all hoping for an end to the war this year, and it seems possible, even probable, for Franco appears to be staking all on a last desperate attempt, sparing no expense; but he has gained nothing, and if our victories continue the end is inevitable.

Best wishes and comradely greetings to all,

Alfred

* * *

from LAWRENCE KLEIDMAN

January 23, 1938

TO FAMILY

West of Teruel

Greetings,

I know that you are angry because I have not written for such a long time, but I guess it is hard for you to understand how busy a guy can be here. I know that when I was back in the States I had an altogether different idea of what the war would be like. Believe me, it's no picnic.

We have been at the front since New Year's day and we have had some very cold weather in the mountains. Right now we are in a large valley and the days are getting warmer. We are eating very well, pork, lamb chops, and good wine, all captured from the fascists. We would have even more if the bastards hadn't shot all the livestock they saw as they retreated.

As usual, I am in the best of health, and my work seems to agree with me. A few days ago I received a citation from the Brigade for good work in a tight spot. I can't tell you about it now because military information won't go through the censor, but I will write about it after this campaign is over.

I lost all my belongings, including my diary about two weeks ago. At that time it was necessary to advance quickly over a rough mountain trail for about 14 kilometers in order to cut off a group of fascists. Naturally we had to travel light, so we left all our extra equipment behind. When we attacked, the fascists fell back and we kept driving

them further and further until we were about 20 kilometers from our original position. When we finally arranged to send a detail back to get our belongings, they were gone. However, I am starting all over again and as soon as we go back for a rest, I will try to rewrite from memory.

Hy Greenfield finally reached the front lines. He came to Spain with Harry Rubin but he became sick and had been hanging around Albacete for 4 or 5 months. Harry is almost better now, but he won't be fit for front line service anymore. Steve is in the Brigade machine-gun outfit so I don't see much of him anymore, but he is trying to transfer to my outfit.

I am learning a hell of a lot about practical engineering here and I even study the army manual to get the theoretical end down pat. I have a *camión* at my disposal and I get around quite a bit.

As time goes on the outlook becomes better and better. The morale of the fascist infantry is very low. It is quite noticeable that they have no heart in their work. When we meet them and open fire, they generally run back quite a way before they put up any resistance. Another indication of their low morale is the manner in which their night patrols and raiding parties function. They receive orders to raid a certain section of trenches. They will come out to about 150 meters from our lines—throw their grenades to about 100 meters from our lines where they couldn't possibly do any harm, and then go back and probably report to their officers that they had grenaded our positions.

Then again, every night deserters dribble into our lines and report unrest and disaffection among the troops. The fascists issue circulars among their own troops claiming that they still hold Teruel, but the deserters say that the men do not believe them. Besides all this, there are many differences amongst the fascists themselves. The Requettes want the monarchy restored, while the Falangists want a Franco dictatorship. They both dislike the Italians who were discredited at Guadalajara but are still very arrogant and impose their will upon the Spanish fascists. We don't seem to see many German troops, but a lot of the equipment we capture is German. The only reliable branches of service the fascists have are the artillery and the *avion* composed mostly of upper middle-class elements. However, you can't win a war without infantry, so Franco has one foot in the grave and the other on a banana peel—and we're about to give him a good boot in the can and bury him.

I hope everything is all right at home and everybody likes the new dugout. You had better get it ready for a welcome home soon. There are a good crew of sailors here whom I know from the strike and we're trying to get a big fishing boat from the government, which we can sail home in. So if you see a two-masted schooner coming down the bay flying the I.B. flag, I'll be on it. Give my regards to everybody as I cannot write often.

With love and courage,

Yours, Niche Nevo

from AVE BRUZZICHESI

c/o Central Sanitaria Internacional
Paseo de Gracia, 132,
Barcelona
Jan/8/38

Dearest Tommy:–

You should see me—or rather you shouldn't—unimaginably dirty—3 a.m., sitting in the at last deserted surgery, installed in an old house, formerly belonging to a Dr. This room was the dining room, for there are scenes from the country round painted on the walls, and someone has painted little tanks onto them and air-ships in the skies; some of them are spattered with blood which is squirted onto 'em from a pressure transfusion tube. There is a dumbwaiter leading down into the kitchen, but it has been nailed up. We got back to Barcelona from the front Dec/27. I wrote you from there. I felt that there was probably something stirring and made haste to get ready this time, but what with all the holidays time was short. Hemingway came through I heard, but I didn't see him.

Anyway, on the night of Jan 1st. I was at the HQ. of Sanitation (Surg. Gen'l's Office) and got orders to leave next a.m., Sunday. I got things packed and got hold of the chauffeur and the rest of the outfit leaving Purviance in Barcelona, and taking Weisfield and the nurse only. At HQ. I met the old rascal of a chauffeur, looking very thin and smelling strongly of liquor. I sent him to get the orderly who was to go with us, and went out to attend to things. When I got back to the hotel at midnight I found a note saying that Joaquin couldn't go, that he was wounded and in the hospital. The next morning early I went to the hospital and sure enough there he was, in bed. There had been an air raid that evening, and the poor fellow, who had spent his time hiding in refuges while at the front had been hit while in the street in Barcelona by fragments of a bomb. He wasn't badly hurt and will live, but badly enough to lay him up. So I went back to HQ., scouted around, got another chauffeur, a little moron of about 16 and got all the necessary papers and things attended to and finally got away at about 4 p.m. We drove along at about 20 miles p. hour for 3–4 hrs., until finally we stopped for supper. Weisfield and I took turns at driving after that and drove until about 1 a.m., when we hit a little town where there was a hospital I knew. We turned in and went on again in the A.M. It was cold and the Valencia orange groves were covered with snow. As we began to get up into the mountains it was very cold. Trucks, artillery, tanks moving up the road, truck loads of evacuated persons, prisoners, and troops moving down made an inextricable mess in the snowy road. The snow had been shoveled away far enough to leave a one-car lane, but at each town traffic would enter downward bound and upward bound and would jam in the narrow street, neither willing to back out and both unable to proceed, so that finally Weisfield and I got out and acted as military police and traffic directors. It took us about 12 hrs. to do 75 miles. At railhead we stopped for supper. Two long surgical trains were drawn up there; they were operating in what was a dining car converted into a surgery; we ate in another diner; alongside were a row of dead laid out in the snow and a force of men busy digging graves for them. We had orders for a town south, but the chief, D'Harcourt came in while we were eating, and to our great disappointment changed them to this place we had been at a week before. So we picked up and pulled out. We had only a little piece of chain left for the tires;

someone had stolen ours while the car was in the garage, so we kept on the look-out. I saw an old mill and thought where there is machinery there are chains, but there weren't. However we found an even greater treasure; stumbling through the snow I uncovered an old axe. So we took it along—"organized it." We went along and soon ran into a stalled truck with no one watching it, from which we "organized" two beautiful chains. Pretty soon we began to encounter British and American ambulances, and enquiring found that Barsky's division had just arrived and was in a town nearby. We were glad to see him again. Everything pretty much upside down, for he was just getting installed. We had a meal and scouted around and found the division surgeon, a good-looking,—too good-looking—Pole, in bed with frozen feet. Everyone rummaging about in the mud. Ambulances unpacking; an Australian nursing-sister in a high fur hat; people diving in and out of stone passages into dark old Spanish houses, setting up a hospital. Mud up to the knees. We didn't stay long. I had a feeling that we had better be getting on. I don't remember whether because of hearing the artillery fire at this place or not; anyway we got on. We drove in here in the afternoon and scarcely had we had time to look around and unpack when the wounded began coming in. We worked hard that day, Jan. 5th., and the next and since then there has been practically nothing. The first night a commissar came in, a German, his forearm was shot through, bleeding and dangling by a strip of skin. He looked at it and said "—— on it, it's got to come off!" I got to talking to him. Do you know who I am? he said. Yes, I know, you're the battalion commissar H.G. No, I'm not, said he. I'm a member of the Prussian Parliament *(Abgeordnetenhaus)*. I took his arm off and put his stump up in plaster and kept him here for a few days.

There had been nothing done toward putting the hospital in order since I left, so I began by raising a hellish row. All the work had stopped as I left it. No light. We operated by candlelight and with the little flash-lamp that fastens onto your head that I used to use on the old Flirt. Imagine doing laparotomies with that! No heat. It was very cold, 16–18° below 0 and I was so darn cold as I lay on the floor on a spring-wire mattress, wrapped up in my sleeping bag—a God-send—that I couldn't sleep. Several men brought in with frozen limbs. The wounded all lying in the big classification room on cotton-stuffed mattresses, close to the stove. I didn't dare move them into the icy wards until they had got over their shock at least. Very few cots, most of them broken; not enough mattresses, not enough blankets, vainly trying to sterilize on an old kitchen stove that wouldn't draw. The next morning I went into the office where the *administrador* (the business manager or the QM. of the hospital) was sitting with his men and disconnected their stove around which they were sitting and brought it into the operating room myself. That was the last straw! Stealing a hot stove! So I went rowing about for the next few days until the old outfit was about ready to cut my throat, but now we've got the hospital fairly clean.

The Spanish workingmen and peasants are the salt of the earth. I've never appealed to them in vain. Almost daily I plunge up through the mud and snow to the old house with the coat of arms painted on the whitewashed wall and the sun dial, minus the dial, and go into the office of the *"ayuntamiento"*—the Board of Aldermen. There is always a group of 3–4 men in peasant's clothes, corduroy trousers and a woolen sash and a *"boina"* (beret), and I put my wants before 'em; and they respond so quickly and

willingly. A wall to be built, or a door put in; the next a.m. 3 of them appear and with the simplest implements that an American mason would scorn, a piece of an old foot-rule, a string, a few trowels, they hunt around the bombed buildings for brick and stone and doors and hinges and things, and the next day the wall is up. Or I go down to the old blacksmith who lives next to the town well; at night, for by day his little rascal of a son is up in the hills hiding in the caves—and get him to make Thomas splints. Two days ago I went to the *ayuntamiento* and asked for stoves to heat the wards, and electric light bulbs. See here, they said, we have had soldiers in this little town for 18 months; and each group that goes, moves on and takes all their things with them. We are exhausted. I know, I said, it isn't for myself, but for the wounded. Look here, I lie on these stone floors and freeze at night and there's nothing wrong with me. But imagine lying there with your leg shot off. Suppose you look around the village and get one stove or two, and in the morning I'll give you my car and write you a letter, and you go to the neighboring villages where there haven't been so many soldiers and say "See, we've given two stoves, suppose you give one to the hospital." "That's a good idea," they said, "You write us a letter and we'll be around in the morning and go." So I wrote the letter that night, a very formal letter, and in the morning they came around and said—"The letter isn't necessary, we've brought 3 stoves." I wish the officials were like them, but they're not. They're still 1/2 of the old regime and it takes heaven and earth to move them.

Several times a week we go up to the graveyard and do autopsies. I wish I had a movie of it. A little cemetery on top of a hill, about 100 yds. square, a big wooden gate, locked with a huge iron lock and a key that weighs a pound. A plain stone wall a little over a man's height surrounds it. In the middle of the enclosure is a small stone house, in front of the house the gravedigger's cart, with wheels 6 feet high, and an old grey horse. A Collie dog lies in the sun beside it in the snow. The two gravediggers work in their trench, scanning the sky every little while for planes. In the graveyard are some wooden crosses and two iron ones, to two young aviators that fell. On one of them is a little iron flap that you can lift up and uncover a photograph in a frame. A nice-looking kid of 19. In one corner are vaults, and all along the wall are black slate tablets, about the height of a man's head above the ground. They are about an inch thick, but every one is shattered. It took me several visits before I realized what that meant.

So the last few days being comparatively quiet and today the 10th. Being my day off I took the opportunity to go up the line about 12 miles to a hospital of the International Brigades. They were very busy, for they had just got men in from an advance in that sector. Barsky and 2 other teams were there working hard. They have a very nice hospital with plenty of English and American nurses. As they were busy I went out with Tellge, the chief surgeon of the International Brigades; we visited the Brigade Commander; a lot of artillery fire, both 75's (ours) and big ones, 155, (theirs) going on the other side of the hill. We found the colonel, a big Dalmatian, under a stone bridge in a little hut constructed of sandbags, carefully peeling an orange, surrounded by officers and orderlies waiting outside the sandbag office. He told us encouraging things of the spirit and courage of our men, and how they had to hold 'em back by main force from running forward.

A Lincoln Battalion machine-gunner was with a machine-gun outfit that got up there with orders to dig in. The ground was so frozen and so rocky that they could only dig

8 inches that night, so they ensconced themselves in a farmhouse, and the next morning, when the fascists came on, started business. That one machine gun held back 2 attacks, but the stone windows of the farmhouse were in the way of a full sweep of the gun, so the gunner gets out in the open road and starts mowing them down. Weisfield saw him in the hospital at La Vega last night, whistling and having a great time, shot through the elbow. "What's so funny," he asked, "you there, shot through the elbow!" So the boy told him. "Gee, it's great," he said, "you'd have thought so too if you'd been there!"

To see them come into the hospital, frozen, bellies shot through, wrapped up in a dozen of shirts and clothes, trying to keep warm; to get off their frozen, blood-drenched, muddy clothes and see their mangled bodies, poor people, that's not so funny.

So we talked with the Fort Sandbag officer a little, and left again, caterpillar artillery getting under way and disappearing up the road, and fire getting heavier. Franco's territory is not yet allowed to know that Teruel is taken, we are told, although it's been in our hands for 2 weeks. We took a very large number of prisoners, including men, women and children imprisoned in the Seminary, and the Archbishop and his secretary, when the convent of Santa Clara surrendered, starving and begging for water.

The food cooked in oil has been hard on some of the outfit's stomachs, so little Weisfield went over to the house where the man from the other outfit who acts as cook holds forth. He wanted to broil some beef over the coals. When he came in, the woman who owns the kitchen went off into a hysterical shriek. She thought he was about to roast a human hand. A bad business what with our autopsies up on the hill.

Well, that will do up to date. It's 2 a.m. I have had a bad time finding a place to write. There are so many people coming in, and officers coming around to inspect and chew the rag. Good night, sweet Tommy. It's 2 a.m.

Are there places where one can turn on a faucet and have water come out of it, without going to get it from a well in a bucket? And places even, where hot water runs from a faucet? And hens that have laid an egg? Or where there are other things besides a condensed milk tin, a very precious thing, to drink out of? And streets that are paved with pavement? Even asphalt pavement? And lights? And rooms without milling hordes in 'em all day and 3/4 of the night? Are there such things? Where?

Jan/11. After I wrote this last night—or this morning—I got very brave, put a bucket of water on the little stove, locked the surgery door, took a pasteboard box and put it on the floor, stood in it and gave myself a good bath. As good as could be had under the circumstances. And this evening I went out. It had thawed and drizzled all day and I saw the Tommy star, so far away, cloudy sky, against the Spanish mountains.

Jan/15. I'll keep on writing, Tommy dear, until I get a chance to mail this back from Barcelona. On the 13th. I heard that there was a hospital in Teruel that wasn't guarded, so I thought I'd go in and see what I could get. We drove in over the main road, the one I've described before, with lots of trucks and cars hurrying up and down. It was a foggy day; quite a thick fog. About 6 km. from Teruel the traffic suddenly faded out, and as I drove on I realized that our car was the only vehicle on the road. There were some shell holes in it, and I hit one with a bump that broke the little stove (stolen) that we carried in back, but it didn't hurt anything else, and we got through into the town without a single shot. I had never seen the town by day. What a sight! What a wreck;

not all the buildings down, as they were after the San Francisco fire; in fact, very few of them down, but not a one that hadn't suffered from shell fire, and its walls battered in in places, or windows and doors in; soldiers everywhere, camping over little fires built between bricks placed on the floors of shops; mud everywhere, counters bashed in, goods strewn everywhere, blown about in the shops as though a volcano had broken out among 'em. An old town, built on a rock, at the fork of two rivers, a deep gorge at each side, a little city wall overlooking the gorge, with sentry boxes of brick and tile in it here and there. An arched aqueduct leading into the town, with one of the arches blown up and hanging in the air. In the center a famous old irregularly shaped oblong plaza with a column in the center, formerly surmounted by the "Torico," the little Bull of Teruel, only the little bull had been blown off and there was no top to the column. Round about the plaza old, tall, stone houses and cafes and shops, and narrow streets leading off from it, just wide enough to allow one car to squeeze through, also lined with shops. In these unassuming old stone houses and shops lay stored much wealth of the Aragónese capital. We went down one of the side streets after asking an old woman the way to the hospital. At the hospital I thought I might be able to pick up the enamel-ware, buckets, bed-pans, etc. etc. I'd been asking for weeks, and which I had strewn Spain with requisitions for. The street was blocked by the stones of a wall that had fallen into it. However 4-5 doors down from the plaza we found a pharmacy with its front blown out and all kinds of drugs strewn around the floor. That looked promising so we stopped looking for the hospital and began to explore the pharmacy. The back rooms were pretty good and contained a number of drugs and things such as glassware that looked good to me. One of the little back rooms had a flight of stairs that led down to a cellar. I went back to the plaza, got the kid to drive the car as far as the tumbled wall, which was just across from the door of the pharmacy, got a candle from the back of the car and went back. The steps led down into a cellar, evidently a store-room, with a lot of empty flagons and bottles and tins. It was small, carved in the solid rock and totally dark. Besides the empty flagons there wasn't much,—only a lot of empty Insulin phials, some of which also littered the kitchen in back of the pharmacy, where the old diabetic apothecary had lived. From the first cellar a stairway led still further down through the rock to another little dugout, and here a fresh opening had been broken through into the cellar of the house next door, which was similarly tunneled. A faint glimmer of light came through and we heard voices. We went through and found ourselves in a large underground storeroom of the bazaar next door. What a find! The short stub of a candle kept getting shorter and shorter. The voices came from soldiers who said they were looking for dead bodies and beat it. They were probably out for the same thing we were out for. What a find! The storeroom of a big bazaar. All kinds of toys, stockings, silk and linen thread, trinkets of all kinds, and most wonderful—stacks of enamel and aluminum ware, buckets, trays, coffee-pots, stew-pots, cauldrons, saucepans, enough for ten hospitals. The damn candle kept burning down and burning down. We went from one stack to another and loaded up what seemed most urgent. Wash bowls, buckets, pitchers, stew-pans, kitchen-ware, with a little thread and some looking glasses and a few odds and ends for the nurse. We came back through the narrow opening into the cellar of the pharmacy. I looked around. Still another staircase carved in the rock. I peered ahead and began to feel my way down. I heard a sort of a

distant hoarse barking. Look out, old boy, I said to myself; you have a light and it's dark below. The barking grew louder. I found myself in another cellar, a heap of cotton mattresses and linen, old bottles of mineral water, insulin sets. In the back of the dugout lay a little spitz dog, barking and snarling, his eyes gleaming green in the candlelight. Guarding the fort. The Last of the Teruel fascists! I climbed out again into the daylight. The candle was beginning to flicker out. We completed the day with a visit to a hardware shop next door, got some scissors, knives, stoves, a sulphur spray for grapevines, which I took for a gasoline stove—locks and keys and some Sterno cans, some oilcloth, and for good measure a handful of rosaries as a souvenir. Only my little addled chauffeur forgot the oil-cloth and the big box with the canned heat, the rosaries and much of the hardware. By this time a lot of soldiers had gathered, and officers—and a lot of non-com's came in to chase 'em away, looting being forbidden. So I thought we'd better call it a day, slammed the door of the little Ford and beat it back through the fog, which fortunately still lay thick on the road, for this place.

Jan/18. Back in Barcelona. Got orders to return on Jan/16 p.m., left y'day a.m. and here we are. A lot of aviation activity the last few days before we left. My—it feels good to sleep in a bed. Found your letter of Dec/8 here. Hope you get my long one of Dec/27 or thereabouts. Please acknowledge 'em and keep 'em, and type as much as you like of them for the Med. Bureau. So glad to get the letter. Only the 2d. one since I left. Look for Tommy star, and although clear skies mean much Aviation, the TS. makes it worth while. Lots of loving thoughts...

Jan/19. The annoyances at the slow gait of things and the bodily discomforts are more than made up for by the people one meets. Y'day we sat around after dinner at coffee. One tall chap who sometimes says he's French and again not. I think he's a Swede; wears a ring an inch and 1/2 long on his finger and looks and talks like it, so that there is a great temptation to sock him in the pants; a well-known writer, Joe North, for la labour papers: two girls, one American one French, an English petty naval officer, now lieut. on board of one of the Spanish destroyers. He was telling us how he got off a British merchantman into the Spanish Navy. He also related things about Spanish ships. At the outbreak of the revolution almost all the ships' crews remained loyal, although many of the officers didn't. The navy was small; a sort of private Yacht Club for the king. There were, however, three fair-sized cruisers or battleships. One of them, I forget which—I think the Almirante Cervera, was in dry dock when the Revolution broke out. The fascists surrounded the dock, so the only way for the men aboard to get out was to get the ship afloat. They couldn't get at the locks of the dock, for the Fascists had 'em. So they trained their guns on the gates from the after-deck and tried to batter them down, let the water into the dock and float the vessel up. The attempt was a failure; the water got in all right, but the stone and cement from the blasted gate barred the way out. So there was the ship caught in the dock with the crew aboard and the fascists firing on her. The men held out for 2 days, but it was hopeless. Food ran low. The fascists sent word aboard that if the men would surrender they'd be given their lives. So they surrendered. They put a gang-plank ashore and began to come down, and as they did, the fascists trained a machine gun on the gang-plank and mowed 'em down. Many such tales one hears.....

 Ave Bruzzichesi

from LEO GORDON

Feb. 18, 1938

Dear Gus,

Was unable to write to you for a while cause I lost your address along with everything else I had, some time ago. Getting your New Year's card, however, solved that problem. At that, it travelled around a coupla months before it reached me. Partly due to the fact that I was on the move all the time. Also my number has changed from S.R.I. 274 to S.R.I. 250.

I still haven't rec'd your package or Tauhma's letter.

Don't wait for me to answer your letters before writing again. There's too great an interval between the posting and receipt of mail. I intend to do the same.

Got a letter from Puny. Says she's drifting around. What's it all about?

As to my present circumstances. Spent a month in hospital on account of being wounded up around Teruel. A slight shrapnel wound near the temple. Nothing serious—since as I have pointed out time and time again—us Mendelowitzes are a very tough breed. I'll be rejoining my battalion in a coupla days.

It's quite a story—the defense of Teruel, I mean. Do you want to hear all the gory details?

As you probably know, hard-hitting Spanish troops led by the famous Lister & 25th Divisions smashed thru the city of Teruel and drove the fascists back into the hills which surround the town like a necklace. They were then relieved and the International Brigades called in to hold the line. A desperate series of counter-attacks were immediately initiated by the enemy. The Thaelmann Battalion bore the brunt of the initial advances. The phlegmatic Dutchmen held their fire until the fascists were within a coupla hundred meters—then methodically mowed 'em down. When my outfit took their positions over a few days later, the terrain in front of our trenches was covered with dead and decaying Moors.

In the next few days, the fascists attempted an encircling movement on our right. Our observers reported huge concentrations of troops, artillery, and munitions being moved in.

On Jan. 19th, an exceptionally heavy artillery barrage on our right flank confirmed my decision to take a look at a coupla guns we had stationed on a strategic hill. When I got there, the shells were landing close enough to make a guy feel kind of uncomfortable. In a while, direct hits made the place look like a shambles. A shell landed on one of our gun crews and wiped 'em out. Others tore down the walls of the trenches. Under this effective cover fire, they attacked. Came over in droves, shoulder to shoulder. A quick check-up disclosed just a handful holding the hill. No time to bandage the wounded. No time to mourn for the dead. The Maxim had to be shifted. Willing hands tossed the gun up to the top of the parapet. One burst—then another. But still they advanced. Our rifles popped away—but it looked hopeless. Then a guy yelled "They're down." Sure enough they had hit the dirt. Was fixing a jam when a terrific concussion bowled me over. Got up with my head spinning, the air full of dust, more guys pawing the ground. Clapped my hand to the side of my head, warm liquid trickled thru my fingers. Wondered if that one had my name written on it. But it was spelled wrong.

Sequel. In a hospital train on the way down, I spotted Lee, Brigade scout, arm in a sling. "Yeh. Mashed my arm. They're gonna take it off." "The hell with your arm. What's the dope?" "The British came up and so did the Carbineros. We held the line." Lay back smoking a cigarette. Felt pretty good. It's a good thing I'm thru writing 'cause I hear the dinner bell.

Yours, in haste
Leo

. .

from SIDNEY KAUFMAN

February 24, 1938

Dear Folks,

This letter will have to do for quite a while—don't know when the next one can go thru—in fact don't know if I can mail this one within a week. We are now back up in the lines—a front of which you have probably read. Can't name it, however can see no objection in telling you that the last two letters of the name of the front are the same as the first two letters of the name of a gal we know in New York who's a W.P.A. actress and wrote a play. The first 3 letters of the name of the front are the same as the 3rd, 5th, & 6th letters of my youngest sister's name. I'm writing from a dugout that I dug with my own no longer lily white hands but calloused, chapped, & dirty ones. It's cold as hell—no I mean as cold as a kiss given to a baby by a politician from Tammany Hall. My thoughts are continually being interrupted by the booming of our guns about a 100 metres or less away from here—they're 155's. Ask Penny how much noise they can make.

Sid

. .

from CECIL COLE

March, 1938

Dearest family—

I do hope you haven't been too worried about me. I am sorry I haven't written for such a long time, but circumstances have made it quite difficult until the last few days. I've waited these last few in order to receive your package which I knew was here, or rather at the front.

I guess I'm still one of the luckiest fellows over here. A shell landed about ten feet from me and all I got was a *very* small piece of shrapnel in my foot. However, my foot became infected and I had a very unpleasant 16 days in the hospital. I've been up and about with the aid of a cane for the past six days. My foot is improving daily and I should be ready for action within a very short time.

It doesn't look very favorable for my coming home soon, so for the present I'm forgetting about it. During the time I was in the hospital I was also on a very strict diet and my stomach seems to be behaving itself. As for my nervous system it seems to be completely unaffected by this stay here, so, except for a desire merely to be home again there is really no reason for it, (i.e.) my coming home.

I don't know how you could have made up a better package for me. I really don't

know which part of it I appreciated most. Everything in it was something I especially wanted. Of course the cards will give me the longest enjoyment, but I surely did want the smokes and candy a lot. The wrappings made a big hit with the Spanish comrades. Thanks a million, and any time you can, more smokes will be appreciated, Camels preferred.

The war here seems to be progressing in a direction favorable to us. During this Teruel episode, we gained a great advantage. The fascists lost terrifically both in men and supplies. I will try to give you an idea of how it all worked out.

As we all know, due to their own boasts, the fascists had saved or accumulated a great quantity of war material, as well as men, with which they planned to make a grand offensive. This offensive was, according to their statements, to be one which would sweep on to a final and definite victory. It was planned over a large front of some six or seven hundred kilometers. What happened, why has this great offensive never become a fact? The answer lies in Teruel.

By a surprise movement, our troops, all Spanish, took not only the city of Teruel, but a great deal of territory adjacent to the city. This was accomplished in six days with exceedingly few losses. Actually, the city itself, the prisoners, 1,000, and the materiels of war within, estimated at well over 10 million dollars, was incidental to the blow that was given. Political as well as financial repercussions made it essential for the fascists to retake Teruel.

Consequently, little by little, the fascists brought into play these huge reserves until finally they had a good 3/4 of this materiel concentrated within a very small sector directly opposite Teruel. A sector not more than 20 kilometers wide, at the outside. It took them, however, even with these enormous odds, two months to regain the city itself, and they have not yet regained 3/4 of the territory lost. During these two months of such heavy fighting they lost men like water. The slaughter of their forces during these daily attacks was truly horrible to witness.

Our positions were such that we mowed them down like grass as they swept on, many times losing well over a thousand men and gaining nothing. The only way they were able to advance as they did was thru superiority in artillery and aviation. They would concentrate guns and aviation upon some small hill and then literally blow the hill out of existence.

Naturally it was impossible to maintain positions which after such an attack did not exist. You may remember a few costs I have mentioned regarding artillery ammunition and bombs, and have an idea as to the amount of money it costs during such operations. Now they have retaken Teruel, but what actually have they gained? You may rest assured nothing of the least value remained in Teruel when we evacuated it. Also they took no prisoners nor materiels of war. We retreated scientifically and orderly, taking all our materiel with us. Our positions now are even better than before and can be held with fewer troops.

They have, it is true, partially re-established their prowess, but at what seems to me, too great a cost to make their assumed victory valid. Boiled into a nut shell, we have forced them to use a good half, if not more, of all their carefully saved materiels, not in gaining new ground or new victories, but in maintaining a foothold in a tiny sector of their own. I believe we have precluded any general large scale offensive on their part

for some time. Also I believe in actual costs, we captured enough materiels to more than pay for what we have expended in this area. As to the ratio in regards to the numerical numbers of our army and that of the fascists. It was greatly changed in our favor due to our comparatively few losses and their huge losses. When I say comparatively I do not mean compared to them, but in reference to the action which took place. However, either way, the proportion remains the same.

This is my idea of how the Teruel situation may be viewed. Our brigade is soon going into rest and reorganization so I may not be at the front for some time. However, we never know, & I may be at the front next week.

I really must stop now. Thanks a million for the package. I'll be sure to write again soon and tell you all I can. Much love to all the family.

<div style="text-align:center">Cec.</div>

P.S. Please show this letter to Dean, as I think he may be able to use the bit about Teruel in publication. I might suggest the heading to be The Situation at Teruel as Viewed by a Soldier in the Ranks (or some such thing).

<div style="text-align:center">Love, Cec.</div>

The Great Retreats

At the beginning of March the Lincolns were in and around the much damaged town of Belchite, attempting to gain some rest and absorbing new recruits into the battalion. The Mac-Paps were nearby in the little village of Letux. The Nationalists, meanwhile, decided to follow the Teruel victory with a major thrust toward Catalonia and the Mediterranean. They had at their disposal some 650 planes, nearly 200 tanks, and a more than ample supply of trucks, many of them of American make. On March 9th more than 100,000 of Franco's men launched an attack with these supplies. The following day the Americans found themselves confronted by an overwhelming force. Against tanks on the road and a sky full of German Heinkels and Messerschmidts, the Americans had little but small arms fire as defense. They did not yet realize that the entire Aragón front was collapsing, but it was clear retreat was their only option. Yet many Americans were dead or captured before a decision could be made. Repeatedly, over the next week, they withdrew on foot to regroup and make a stand, but each time the fascist tanks and motorized troops outflanked them. Soon any chance of an orderly retreat was lost. Nonetheless, the Americans repeatedly stood their ground, sometimes against mounted cavalry, sometimes against tanks blasting them at point-blank range, and always with airplanes bombing and strafing their positions. But the mechanized enemy pushed on, shattering Loyalist units and leaving many men lost among the myriad hills and valleys of Aragón.

from HARRY FISHER

May 3, 1938

Dear kids:

I've been writing quite regularly during the past week. I hope you've been getting all my letters. Let me know. Since there is nothing new to write about, I'll write of some old experiences.

We were just outside of Belchite on the morning of March 9, the morning the fascist offensive began. For many days before, we saw their planes bomb the surrounding towns, and we knew something was up. On the morning of March 9, the sky was continuously full of planes and we heard their artillery banging away. We knew the offensive had begun.

No news came to us. We didn't know if our lines had broken or if we held. We went to sleep that night a bit uneasy. The full moon gave plenty of light. A fascist scout plane spent hours overhead, looking for troop movements. At three in the morning, we were awakened. "Pack up and ready to move." The orders were to take up a certain position outside of Belchite. We started marching. Hundreds of civilians were leaving in a hurry—with their few belongings on their carts drawn by mules. Just as we are

reaching our destination, it is getting light so our commander decides to take us off the road. We go to the left. About a kilometer in front of us is a very high hill, dominating all the country around. We figure this is the hill we are supposed to take. But—on top of the hill, against the skyline, we see hundreds of soldiers. We were sure they were our troops. The commander decided to send out two scouts to contact them. Meanwhile, we would take up positions on the hills just behind us. One company started to go into these hills. Suddenly one bullet whistled over our heads. "What the hell," we wondered. Then two more bullets. Coming from the high hills in front. Must be a mistake. Everybody was ordered behind the hills. The sun was beginning to come up. No sooner had we started, but hundreds of bullets began to sing around us. I ducked and lay on my stomach. Bullets were landing nearby, but most of them were too high. Everybody running behind the hills. Too hot where I was. No protection. So I got up and ran the fifty yards and felt safer. Later I bumped into Leon T. We grinned and patted each other on the back. "Pretty close, huh? Not like the Ohrbach picket line." Then came a single plane. A scout plane—observing. Everybody down. Leon and I in the same ditch, with his section. For half an hour we were on our stomachs—talking to each other. Finally, I went to headquarters to help put in a phone. [CENSORED]

Now the sun was in all its glory. March 10 was a hot day. The day started off with a bang! The fascists were on the hill we were supposed to be on. Their hill was at least three times higher than ours. We had nothing on the right side of the road. It was flat. Impossible for troops to take up positions there. We were in a bad position. We were in for a hot day. And we all knew it.

Yet our breakfast came up—hot coffee, fritters, bread and jam. It tasted good. I didn't get another bite to eat until the next day at about noon. The food made me feel good. Things might not be so bad after all. Our fellows took up positions, but weren't dug in. The phone was placed in a good safe tunnel.

At about nine in the morning, the fascist artillery opened up. At the same time their bombers and strafers came. Now things were getting hot. Behind us lay Belchite—only 4 kilometers. We saw the town bombed—time and time again that morning. The nine strafing planes flew over our hills and opened up. I saw the bullets land outside our tunnel. Their hand bombs shook the tunnel and dirt fell on us. I felt sorry for the comrades in the open, with nothing to do, but be still and hold their positions, without any protection from the planes. We were never able to find out how many were hit by the planes.

"[Marty] Sullivan & Fisher, you'll have to fix the line to brigade." My heart felt funny. Shells landing all along the road where the line ran. Planes overhead. But out we went. One or two fellows gripped my hand and said, "Good luck." Sid [Rosenblatt] said, "Too bad, Harry." He looked miserable. He never expected to see me again.

There were many breaks in the line. We had to keep low. Too much shrapnel from shells landing nearby. Gosh but I felt shaky then. Meanwhile I still saw the planes strafing the hills. While the planes were keeping our comrades low, a bunch of their tanks got around the hill. In this way many of our comrades were killed and captured. They never had a chance.

It must have been about this time when the order came to retreat and take positions in Belchite. Meanwhile the fascists were coming up another road and were about to

enter Belchite—from the South. I was able to see this from where I was. So I decided to head for a fortified hill I noticed to the North of Belchite. It took me many hours to reach the hill.

There, I found about a hundred other comrades. Their guns were placed, and they were ready. We learned that the fascists were already in Belchite. Their bullets were flying over our hill, but we were safe. Then we noticed that they were trying to surround the hill. We decided to make our way out after dark and go East. We had no contact with brigade.

After dark we started in single file, quietly but quickly. We got out nicely. But we walked plenty. A good fifty kilometers. Reached our destination about noon next day and got coffee and bread. This was March 11. Next day my birthday. Would I make it? I felt jittery.

I'll continue soon again. Anyways, here it is, way after my birthday—and I'm still going.

But now I feel the need of a wash. So—as usual—regards to all. Love to Mom, Ben, Louise.

Again—Hy—write more often—Sal the same

<div style="text-align: right">Love
Bozzy</div>

<div style="text-align: center">• •</div>

from ALEX _____

<div style="text-align: right">May 11, 1938.</div>

Dear Magda and Milo:

I have torn up three letters trying to write down my feelings…feelings of death…feelings of sickness…feelings of rage and anger against the vicious fascist bastards that killed our DeWitt in Spain. As I sit here writing I look up from time to time and see the photograph of D. smiling his goodnatured smile, confident of the truth he fought for…confident of the new world he carried in his heart and head. I feel somehow as if a part of me has been removed under anaesthesia and the pain is increasing every day. De was a part of us, and his presence in Spain brought that bitter fight closer to us than any other single factor could, despite the fact that we all know that the life-and-death struggle going on there transcends the life of any given individual. We understand well enough that the fate of decent humanity and civilization hangs in the balance…yet we cannot quite make our emotions completely subservient to intellect. DeWitt [Parker] is dead, killed in Spain. Goddamn fascism! We must amplify and enrich his life and its meaning by carrying his fight to higher levels as our common cause. We must wipe fascism off the face of the earth. No life can have any dignity or decency until that has been accomplished.

<div style="text-align: right">Ever
Alex.</div>

• •

from HARRY FISHER

May 1, 1938

Dear kids:

At about this hour I imagine that the May Day parade is taking place in New York. This is the second one I'll be missing. I think this is as appropriate a time as any to write to you.

I know that next to hearing that I'm in good health, you'd like to hear of some of our experiences. Anyways I'll give you one. This experience took place in our last action.

The brigade was in reserve [near Batea, at the end of March] about 20 miles behind the front. For days, we could hear the distant fighting take place. It sounded like the distant thunder you'd hear on a hot day towards sundown in the country, as a storm was approaching. The fascists were continuously bombing and shelling our lines. They seemed to have all the ammunition they wanted. But we were far away—safe and sound. After all, we were so accustomed to being right under the bombs and shells, that being 20 miles away, was like being in New York.

One day, at dawn, the fighting seemed to be nearer. Sure enough, the boys got orders to be ready to move to the front. The fascists had again broken through our lines—broken through by sheer force. Hundreds of planes, tanks and cannons just banging away endlessly, until there was no line left. We began moving forward— Americans, Englishmen, Canadians, and Spaniards—with no lines in front of us. We were to keep going till we met the enemy. The British were the first to meet the enemy—that is, the enemy tanks. It's very seldom you meet the enemy's infantry. Their army seems to be made of iron and steel. The British put up a fight and destroyed one tank. Many of the British were taken prisoners.

Meanwhile the Lincoln-Washingtons took up positions in the hills. The battalion spread out over a space of about four kilometers—two kilometers on each side of the road. Slowly the fellows advanced, moving ahead hill by hill. Here and there we bumped into a fascist patrol and a little battle took place, and then forward again. We took some prisoners and an auto-water tank. Finally the fellows began to dig in. I was with the central about a kilometer behind.

All day long we heard heavy fighting on our left flank. Airplanes were in the sky all day long. But we kept digging in continuously.

At about 5:00 P.M. my adjutant calls up and says, "Pack up all the wire possible and report here (5 kilometers behind) within an hour with your central and phones." I knew what that meant. I noticed that the fighting on our left flank had moved behind us. In other words, once more the fascists had outflanked us, and had us surrounded. I knew all this, yet I wasn't scared. After all, this was the fifth or sixth time it happened and I was getting used to it. So we notified the battalion and began picking up the wire. We reached headquarters in an hour. Copic, commander of our Brigade, was still there. We all decided to get to the crossroads about ten kilometers behind us, before the fascists did. No sooner than we started, but two armored cars came back and reported the crossroads in the hands of the fascists. So once more we had to make for the hills. The armored cars and Copic's car took a bad dirt road. At this time it was getting dark. There was no moon that night.

After an hour or two, we stopped and took inventory. There were nine of us. In charge was our adjutant [John Cookson], an instructor in a Wisconsin university. All of us were telephone men. We each had either phones or wire. We decided to stick together—come what may. We had only one rifle—telephone men don't carry rifles. We were behind the fascists lines.

The night was dark—black. We had to stay close to each other—in single file. We tried to walk as quietly as cats. But we were always tripping over grape vines.

At about eleven, we hear footsteps coming towards us. We sit down. The footsteps come closer. All of us are anxious and we almost stop breathing. The soldiers got right up to us. They are surprised to see us and scared too. They walk faster. They don't know how many of us there are sitting down. It's too dark. They pass us without a challenge—without a word. We keep quiet too. Only one rifle. We don't know who they are. They don't know who we are. The black night helps us. As soon as they pass, we begin again—North by East. That's our direction. Boy—how we appreciate the North star. It's saved us many a time. It shows us where to go. Some night—look at that star—it's the one that has kept many alive. How we love it.

At about one in the morning we have to stop again. A battle is taking place 500 yards in front of us. Both sides are using tracer bullets—bullets that you can see at night. It's a beautiful sight watching bullets—like shooting stars—flying in all directions—but not so enjoyable as many are accidently landing near us. We stayed in that spot for an hour, while the battle lasted. I must have fallen asleep, as someone was shaking me and whispering, "Let's go." I was cold and shaking. I wrapped my blanket around me and the phone and kept going. The stars twinkled at us. I thought how much nicer it would be to have a girl in my hand—rather than the phone—which was by now getting heavy. Every minute we expected to meet a fascist patrol. I thought of home–of Louise-Sal-Hy-Mom-Ben & others. How far away you all seemed and how much I loved you all then. What were you all doing then, I wondered. Here it was the morning of April 2nd—about 2:00 A.M. I imagined it was about nine in the evening of April 1st in Brooklyn. I pictured you all in familiar scenes at Greene Ave. And all the time we kept going. I was only half conscious of where I was. Daydreaming at night—in fascist territory. Happy in my thoughts about home.

At about three in the morning, we hear something a few hundred yards away that sounds like carts. Our adjutant decided to catch up to the carts and follow them. We figured they were refugees and that they would know the way out. So we walk towards them.

In a little while, we find ourselves on a 3rd class road, and troops are marching towards Gandesa, in good order. We all stood on the side of the road and watched them go by. Soon, 3 pieces of mountain artillery, drawn by mules, pass. This is what sounded like carts. Officers on horseback passed. It dawned on us that these were fascists. The adjutant whispers in everyone's ears—"Don't speak English—they look like fascists." He tells me to see if I can see what kind of rifles they carry. I try, but it is too dark to see. The passing troops glance at us, and keep going. They notice our phones and wire, but it is too dark to make us out. An officer on horseback is looking at us, from a few feet away. We join at the end and march with the fascists. The officer figures after a while that we are their telephone men, so he goes ahead. We stayed with them

for 15 minutes, and gradually slowed up to allow a greater distance between us. Then we sat at the side of the road for 5 minutes and once again went into the mountains.

At dawn we looked down from the hills and saw that we passed Gandesa. Heavy machine-gun fire was coming from behind us. Evidently we had passed the fascists. We started for the road. We met some of our troops. The order is to meet at the Ebro to put up a line. So on we go. We got there and crossed before the bridge was blown up. This was at about two in the afternoon. Over 20 hours of walking. And after about three sleepless and active days and nights.

We got a good, hot dinner from our kitchen then and I fell asleep—for how long, I don't know. Since then, nothing much has happened as far as fighting is concerned for our brigade. We are holding a sector that is quiet.

For days after, fellows from our brigade kept showing up. Some had to swim the Ebro. Others came in row boats. They were days of rejoicing—seeing good comrades we thought were gone show up again. But some drowned because they couldn't finish the swim.

And now—I'm well-rested—tanned—in a good safe-dugout—and you are most likely parading. I know that at this time you are thinking of Spain. And I'm thinking of you.

The sun is shining—warmly—after 2 days of heavy rain. The trees are all green. The grapes on the vines are taking shape. The air smells good after the rain.

June 6 is Sal's birthday. How much before this date you will get this letter, I don't know. I'm sorry I can't send you something—but I hope you have a happy birthday.

Once more I must plead with you to send me more letters. Write about anything—everything. But I want to hear from you. I can't impress you with the need I have for your letters. They cheer me up more than anything. Ask my friends to write also. Let Hickey and Lois Zucher & Charles Cherubin know that I don't hear from them enough. Lou Zucker hasn't written for months. And Jack Macy too. I can't write to all of them—but certainly they can write to me. And although I hear from you quite regularly, I don't hear from you often enough. So get busy.

Greetings to the gang.

Love to Mom-Ben-& Louise.

> Love
> Bozzy

••

from SANDOR VOROS

Spain June 9, 1938

Sweetheart,

Your letter of May 24th arrived today and I want to state at the outset that you were absolutely in the right and Goldfrank was in the wrong. I myself was tremendously disturbed over the fact that you hadn't heard from me so long. I was about to send you a cable when your letter arrived with the welcome news that you received ten letters.

Today's letter lists five additional letters, including one dated March 29th. I am amazed to hear that you received that one. If my memory does not fail me, we were in a fierce battle that day—one lasting days—we were outnumbered, outclassed in arms, worn out tremendously after a month of heavy fighting, we were strafed, bombed,

shelled without a moment's let up. I was so fagged out that I would go to sleep every time I hit the ground to wake up only with another explosion nearby. Many other comrades had the same experience.

It was around this time that we made a last desperate stand. I remember the night when I emptied the armory and brought up every machine gun they had, only to find that we had more guns than men left to handle them. Henry Mace of Cincinnati did a good job that night—he held the hill with a handful of men and brought most of them back when we finally decided to withdraw to the other side.

Then there were the tanks, firing from all directions, and worst of it all, you never knew how far the fascists succeeded in infiltrating, whether the hill on your right and left flank was still ours or in the hands of the enemy. Thinking back on it now I am amazed to find that I still found time and inclination to write personal letters of assurance when the chances of getting out, much less of getting out in one piece, were not exactly bright, to put it mildly. I went with Merriman to the "tropics," so nicknamed by Dave Doran because they were "turning the heat on" and Dave did not exaggerate. It was hot there. The letter you refer to must have been written just before my departure—as was my wont. But enough of reminiscing.

In your previous letter there was a postscript—"I'm still wondering, though, did you say I'm a 'true woman' and what prompted that, for goodness sake?"

I can't exactly recall ever writing that, but if I did, the reason for it is obvious and you yourself supplied the answer—"for *goodness* sake." Now that I think of it, I must have written something like that way back in Madrid—in the course of our discussion on "what to send me" when I listed why I was satisfied without getting or asking any parcels from you.

This brings me to that "painful" subject again you brought up in your letter. Let me tell you for the last time:

1) I don't want and don't expect anything from you.

2) Ninety percent of the time the cigarettes you mentioned in your letters as being sent arrived as per schedule. This leads me to the logical conclusions that you indicated in your letters whenever you sent something, as anybody would expect.

3) I am not corresponding with you because I hope you'll send me some cigarettes. I am corresponding with you for one simple reason—*I love you.* Neither is my affection alienated by all the cigarettes, candy, and worldly wishes that are being sent me from New York.

4) I extremely dislike the situation we're in due to this accursed subject. I don't want any favors from anybody—you included. Once, a long time ago, I made an exception and asked you to send a few things for me. I have regretted it ever since. As it turned out, it developed into a problem. The fault was mine because, not being in the habit of asking for favors or depending on others, I became sore when it didn't work out as I had expected.

5) So-o-oo—keep your filthy lucre, for gold and riches my love can never buy—I love you for your simplicity and the purity of your soul. And how I do love you honey!

Sanyi

•••

from SANDOR VOROS

Spain, April 4, 1938

Dear Myrtle—

This is the fifth day of battle. We are resisting all along the way despite the heavy bombardment, shelling, and uninterrupted fascist attacks. We have large troops of the regular Italian army opposing us, not to mention the enormous quantity of Nazi and Italian planes, tanks, artillery and other equipment. They are pressing on our flanks and the resistance of the International Brigades belongs to the brightest chapter of the history of the international working class.

I am well—last night I had my first sleep in I don't know how many days—I simply flopped down and slept till daybreak oblivious of everything. It is really interesting how lack of sleep affects one—I would fall asleep under shell-fire or bombing while pulling my head down for cover.

At the present moment I am kilometers behind the front to take care of some work of the Commissariat. Everything is peaceful and serene, it is a beautiful spring day and I am sitting in one of the loveliest orchards in the world. Not a sign of war except the planes passing ominously overhead. This night's sleep made all the difference in the world—I am already beginning to think of getting washed and turning over schemes whereby to obtain a shave. I have some blades, but no razor—a bit of soap, but no brush or mirror. (Don't go sending me some now—I'll get some as soon as we get to a town.) My face feels like the skin of a porcupine. I must look like a tramp.

My mind is crowded with impressions like a newsreel—picture after picture is racing through it. I wish I had time to jot them down but there are so many things to be done—neither am I exactly in a writing mood.

But just to give you a glimpse—

Tanks blocking roads where fascists may advance—position on hill tops—marching—heat—enemy infiltrating on our flanks through gullies—scream of shells—mortars—whistling of bullets, the staccato of machine guns—the drone of airplanes—the strafing—the worst bombardment I have ever experienced and the beautiful, comforting one yard deep, one yard long, newly dug pit originally intended for a latrine where I was perfectly safe from anything except a direct hit—

Well, this should give you a glimmer.

Met Hemingway and Matthews of the *N.Y. Times* on their way to our Brigade H. Q. for news. Well, there certainly is plenty of news around here—hope memory will be able to retain at least one hundredth part of it.

This is all for the present, Honey. If everything is alright with you do not worry if you only hear from me from time to time—this is not the time to write—nor can I be sure of the letter reaching you. Our incoming mail is still running smoothly—yesterday I received two letters from you, one dated March 1, the other one March 3. It cheered me up no end—keep on writing, Honey, even if you don't hear from me.

With much love

Sanyi

from HARRY FISHER

April 11, 1938

Dear kids:

Nothing new since my last letter of a few days ago. We are in the same positions and everything is quiet—too quiet. Trenches are being built—our positions look good.

Received your letter of Feb 24. Did Teitlebaum, Gibons, & Thurston come up for supper? These fellows are typical of the Lincoln fellows. They were all wounded here. I remember visiting Teitlebaum & Gibons at the hospital. How about Dennis Jordon? I hope you've seen him by now. Let him know I'm sore as hell for his not visiting you.

I know you would like to hear of some of the experiences of the last month. I find it hard to sit down and write now. Someday—I'll write in detail. There is plenty to write. Just imagine being surrounded six times and fighting your way out over mountains. And then watching a Moorish cavalry charge being mowed down. And then finding a fascist tank ten yards behind you. Also being bombed and strafed daily. And being in a barn that fascists are trying to hit with hand bombs from planes for half an hour. And seeing fascist planes brought down by rifle and machine-gun fire—three of them. And seeing terrorized refugees being strafed by planes and then have the planes drop them leaflets saying—"Franco is the savior of civilization."

Again—just as soon as I can, I'll write of some of these things in detail. I know how much you'd like to hear them—but I want to do a good job. As it is, I'm trying to write often just to let you know I'm O.K.

Please—write more often than you do. Every day—I look for letters from you. Also, explain to Mom that I have no stationery. Tell her I think of her often and miss her. Syd M. is still missing. Same for Leon T. Looks bad. Do you remember Norman Berkowitz—also of the union? He's still with me in transmissions. He sends his greetings to you.

Looks like I missed Passover & May Day again. Couldn't be helped. Anyways I'm not wasting my time.

Greetings to everybody.

Love to Louise—

Bozzy

Hey, Hy—Come on & write.

from HARRY FISHER

April 16, 1938

Dear kids:

I just received the letters from you of March 30. Evidently the mail is coming through in better shape than before, in spite of the critical situation in Spain.

I knew that my letters weren't very cheerful for a while. I was tired. In fact, the letter you received on March 30, was the one most likely written before our retreat, so you can imagine how tired I was later. Since I wrote very few letters during those days, I know how worried you must have been. But it couldn't be helped. There was continuous action for weeks. Every day I underwent two, three, and four bombings, and in

between strafings from their planes. Their planes were predominately German. At times, I spent 24 hours of continuous walking, with only a few minutes of rest now and then. Most of this walking was done over high mountains, very difficult walking. I'm writing all this in order to let you see how tired I must have been. There were times when I was lucky to get ten hours sleep in a week. And hardly any food. Naturally my letters must have sounded pretty dull.

To be honest, I still am tired—not physically as I've been resting for two weeks, even though we are still at a front. It's more mental than anything. My mind always goes back to some of the boys who "got it" or who are missing. Some of these fellows were very close to me. I can't cry anymore like I did at Brunete. My eyes are quite dry. But I wish I could cry and get the relief it gives you. Whenever I think of these fellows my heart grows heavy. You'll never know what fine fellows they were. [Names censored] are typical examples. And so many others like them. It's funny, even the last time I saw Sid, he still felt that Sal was sore at him for giving Hy so much work to do.

But how can I return home now? I wouldn't feel right leaving just when the fight gets hot. Now is the time we must fight. Every man is needed. I still believe we can defeat the fascists here, in spite of the serious defeats we are suffering. The fascists may reach the coast soon, possibly they have, but still the war won't be over. A fascist victory now would be an awful blow to the democratic forces of the world. I don't have to become theoretical and show you how even our States would suffer. It's all quite clear. I know that you will be much prouder of me for staying at a time like this. As soon as things clear up—when the danger is over, I will come home, for I know I can return home by asking for it. But things will have to stand for a while.

You say you have lots of dreams about me. I can assure you that I have plenty of dreams about Louise-Hy-Sal-Ben-Mom & others. Nearly every night I dream about you. Sometimes I dream you are in Spain, but usually I dream I'm home. The dreams are very pleasant—a contrast to the present day realities.

I'd like to get some more clippings about Spain & the boys who returned, like the ones you sent in the last letter. And remind Joe M. to send me the book of letters. I'd like to have one.

Let Anne Friedman know that Pat writes her plenty of letters. Evidently something wrong with the mail. Pat, of course, sends you his greetings.

Tell Sam Stockman I hope his health improves. Also thank Harry Sonnes for his letter. I hope I can answer it soon.

And Louise—you know how much I miss you—as much as you miss me. I still want to walk down 5th Ave. with you and be a show off. And ice-cream too. Oh, will I be happy when I can see you all.

Give my love to Mom & Ben—

<div align="center">

Love
Bozzy

</div>

Hy—write more. It's good to hear from you.

American volunteer John Cookson in Spain.

1° MAYO

Gloria a los heroes del Frente y del Trabajo

Los voluntarios internacionales saludan a todos los héroes del frente y del trabajo. En la lucha contra el enemigo extranjero, en la producción febril de la guerra, los mejores hijos del pueblo español, nuestros héroes han escrito y escriben páginas fundamentales para el porvenir de la humanidad.

Gloria a esos héroes, agradecimiento eterno de los pueblos de todos los países por la inmensa contribución que aportan al porvenir de todos los pueblos.

Ediciones del Comisariado de las Brigadas Internacionales

A 1938 May Day flier issued by the International Brigades. The text above reads, "The International Volunteers salute all the heroes of the front and of the working class. In the struggle against the foreign enemy, the best sons of the Spanish people, our heroes, have written and are writing essential pages for the future of humanity. Glory to these heroes, eternal thanks from the peoples of all countries for the immense contribution they are making to everyone's future." The artist Giandante did a great deal of work for the I.B. in 1938.

IN TRAINING AGAIN
Rebuilding a Battalion

···

INTRODUCTION

As the remnants of the Lincoln and MacKenzie-Papineau Battalions made their way back across the Ebro river, singly and in small groups, there was cause at once for repeated celebration and recurrent sorrow. Some men, thought lost, somehow made it through the enemy lines. Milt Wolff, alone for days, mostly without food, finally swam the river and rejoined his men in the second week of April. He was now commanding the Lincolns. But with every reunion the absences were also on everyone's mind. Many, like Merriman, were simply never heard from again. The Americans were now down to just over a hundred men.

Not only was Battalion strength below functioning level; morale, the only edge the International Brigades had, was also widely shattered. Even Harry Fisher, whose letter opens the chapter and who was consistently as level-headed as a front-line soldier could be, reveals the weight of the Great Retreats on his spirit. Paul Wendorf's letter, which follows, does not express universal sentiments, but it certainly represents the way many men felt. Once again, as with Jarama, confidence in the I.B. leadership was undermined, and some men doubted their immediate commanders as well. No matter how they argued with themselves, some of the volunteers could find no hope for the Republic unless non-intervention were overturned.

It was the lowest ebb for the Americans since Jarama. In this climate a new fighting force had to be created. Americans came from rest areas and from behind the lines. Edwin Rolfe, who had begun to lose heart in Barcelona, abandoned the *Volunteer for Liberty* and joined his comrades in the field. A few new volunteers, like James Lardner, arrived. And Spanish recruits once again took the place of Internationals killed or captured. Now their numbers were high enough—about 400 joined the Americans—that a general retraining would have to accompany their integration into the battalion. Relationships of trust and confidence had to be forged. Some Americans became teachers; others devised educational programs or worked on carefully planned social events. There were drills and contests, maneuvers and festivals. On some days the men practiced taking hills outside Marsa, ten miles from the Ebro. On other days there were speeches and athletic contests.

Men who needed to talk through the trauma of the great retreats meanwhile sought out those they could trust and confided in them. Three months of conversation, camaraderie, and training gave men like Rolfe renewed access to their political convictions. Writing about this period years later, Rolfe observed: "If there's any place in the world

where I could be dropped from an airplane, alone, blind-folded, in pitch darkness, and yet know from the very smell and feel and slope of the earth exactly where I was—that would be the hills and valleys just east of the Ebro, in Spain." Dave Gordon, periodically ill earlier in Spain, felt similarly strengthened. Gradually, from April through most of July of 1938, a committed and cohesive military force was recreated. Wendorf, too, whatever his doubts, fought when the time came and fought until the end. Meanwhile, plans for another crossing of the Ebro were under way.

* *

from HARRY FISHER

May 2, 1938

Dear Kids:

So many days have gone by now without a word from any of you. It seems as though you can't realize how much a letter from you means. I want to hear about what is happening, what you are doing, about all the small everyday personal things that are going on. I know that there are hundreds of things you can write about. Perhaps they won't interest you as you write them. You may think that they will bore me. No—all of your letters are interesting—but I get so few of them.

In the past few months, it is true, I have written seldom and monotonously. I couldn't help it. I wanted to write to you every day, but I couldn't. Sometimes it was the weather, sometimes the action, sometimes I just couldn't write. I can imagine how the people back home feel. You feel that so many exciting things are happening, that we can write millions of words. In a way it's true. Yet, after a while, nothing seems exciting. These last actions of ours, although they were the most adventuresome, were not half as thrilling as my first days in the safe Jarama trenches, listening to bullets whiz by. Then I'd think—only 1 foot over my head! How close to death! Yet recently, when there were no trenches to protect us from bullets and bullets would miss me by inches, I'd be scared—but that's all. It scared me—and bored me.

Even now, as I look back at all the fronts, it doesn't seem as though I've gone through anything unusual. In fact, it's hard for me to believe that there is any other kind of a life. I'm so accustomed to this that I can't imagine you living through a day without fear of a fleet of bombing planes visiting. At night I dream of holding a beautiful girl in my hands—but girls are only dreams, it's hard to imagine they exist. This life has become natural—everyday. Yet when I think of it—I know it isn't so. This life is cruel, not natural, stupid and boring. Certainly there is no romance in it. What lies our movies told. You know, the soldier and the beautiful girl—what rot! The only kind of love a soldier gets here, he pays for.

Yet, in spite of all this, I want to stay. I realize how necessary all of this is. If the fascists ever win here, there will be more wars. What's the use of being home, only to get into another war? If the fascists lose here and in China, there will be that much less of a chance for another war. What keeps us going, is that we know we are right. And still I have faith that we will win.

Have you ever seen new, young soldiers, just joining a battalion in the front? We

have them. Some haven't even started shaving. Some look like kids becoming fresh-men in high school. Many lied about their age, so that they could join. I admire these Spanish kids. Many have brothers, fathers, friends who have died. They certainly know what war is like. Their homes have been bombed. They haven't joined because of any romantic ideas that propaganda has pushed into their heads. They joined because of a justified hatred they have for fascism.

Their faces are so serious. Yet I can't see them as soldiers, as matured men. But what excellent soldiers they make. A soldier that wants to fight is better than a soldier who is forced to fight.

Yesterday, Matthews of the *Times* and Hemingway visited the battalion. Matthews gave me the impression of being sleepy and bashful. Yet he's the most wide-awake cor-respondent in Spain. I've seen him on many fronts—getting fresh, first-hand news. Hemingway looks like a bull. Send me some of their articles.

Which reminds me that Ed Rolfe is in the Lincoln-Washington Battalion. Perhaps you remember him as a writer in the *New Masses*. He's a short, thin, sickly-looking fel-low. He was doing journalistic work for many months. Then he became sick. When things looked bad, when the fascists were advancing, he joined the battalion, although he was still sick. He's a fine fellow.

By the way, I always intend to write of this, but I always forget. There is something you can do for me. Whenever you write a letter, which I hope will be often, put some cigarettes in. Somehow, I've become a smoker. And cigarettes are quite scarce here. Many comrades receive cigarettes in this way. Tell Hickey & the others to do the same.

Tell Vivienne that I read her round-robin letter to all the boys. [Censored] This Vivienne must be a good kid. She writes to the fellows regularly. I should write to her—some day I will.

How are mom and Ben? You seldom write anything about them. What are they doing? What do they say? How do they feel? And Louise? Why can't I know more about what she is doing? And Sal & Hy? There's a world of stuff you can write to me that will interest me.

My regards to all my friends—Hickey—Vivienne—Jack, Sam S., Harry, Nat, Ben, Joe, all in Hy's family, Joe M.—aw hell, everybody.

<div style="text-align:center">

Love
Bozzy

</div>

Regards from Pat [Jerry Cook].

..

from PAUL WENDORF

Socorro Rojo Internacional
Plaza del Altozano 171
Barcelona
(*Don't* use French address) June 16, [1938]

Dear Sylvia [Geiser]:

I got your letter of March 6 just a few days ago. So much happened since you wrote it; the moving of the I.B. back into Catalonia, and my own moving around from place to

place. I got back to the Battalion a month and a half ago, and my mail has just about caught up. The Battalion today has quite a different aspect. There is a minority of Americans who have been through a number of actions, most of them embittered by what has happened to them and their comrades, and a majority of young Spanish recruits, many of whom have little idea of what the war is about and still less of what they are going up against. The last 2 months have been spent training in reserve positions. The recruits have learned the rudiments of their job, and we hope they'll be all right.

News these days isn't so good. Castellan has just been evacuated and the 43rd Division, which had been defending the Pyrenees Border has just been forced to cross the frontier. Our chief hope right now is from France—but hell knows when they're going to really do something about the situation they know has been threatening them for a year and a half. Reality is such a senseless nightmare that sometimes a person must stop himself from thinking about things too much. Ever since I've been in Spain I've heard fellows say, "Well, I think something that nobody expects is going to happen to save Spain." You sometimes like to think like that—it is the reverse side of the gloomy picture of the immediate reality—reality which some political writers qualify by some word like "superficial" or "temporary," but which is very real in the front lines. We need a hell of a lot more than a trade union resolution to make up for the quick firing artillery which can uproot every inch of ground on the hill you're on within a few hours. I hear that some people are "inspired" by the stand that the men in the Republican army have put up against machines. We over here are quite uninterested in reading the fulsome praise showered on us. Human nerves are fragile, even the strongest of them. It hasn't been inspiring to us to go through these experiences and see a vista of more experiences like them. The only thing it brings to our minds is the consciousness of how few familiar faces are left around us. One of the saddest days of my life was last summer, after Brunete, when we received 250 reinforcements. That was for the already-merged Lincoln-Washington Battalion. I'd look around whenever we were gathered for meals, and turn all around, and all around me were strange faces. I felt that either they didn't belong to my outfit, or I didn't belong to theirs. Of course, the feeling was just sentimental—if I may be pardoned for using such a word about the feeling one has for comrades who are lost or wounded.

Maybe I'm getting sunk in a sea of gloom. What I am trying to say is that we, whether Internationals or Spaniards, can't be expected to keep carrying this burden forever. In a few days we will be going up to the lines again. Maybe it will be a move to relieve the seacoast south of the line. "Relieving another front" by an attack on a more distant front is a technical maneuver which means that troops are thrown in as a sacrifice to save the lines and the units of forces suffering a concentration of enemy forces. We don't know just where our point of attack may be—an attempt to slash through the fascist arm to the sea, or a stand to defend the French border area. Whatever it is, we know it will be a similar story—an attempt to make up for equipment by daring, quickness, and the capacity for men to face superior odds. We know that we've gotten new stuff in the last couple of months; the interesting question is how it compares with what the fascists have gotten.

I am not writing much about Carl [Geiser] in this letter—few people around here

remember him, so he returned to the Battalion just a couple of days before the affair on the Batea-Gandesa road. You have probably heard a more authoritative report than I could give you. My information is that he was captured without a struggle—a scouting party walked into a fascist nest and were taken before they realized what was happening. I last saw him on March 24th, when he left Tarazona for the brigade. He was quite recovered from his limp and seemed to be in good shape. A group of men were talking about going home. Carl remarked in his quiet way that he wouldn't be able to face his friends if he went home at such a time. It was said in the way that made me respect him so much when we were working together years ago—the statement of a personal will which had made up its own mind, in the sure way of a Communist.

Please continue to write me.

Paul

. .

from DAVE GORDON

April 30, 1938

Dearest Lottie,

It is about 10 P.M. Our *Estado Mayor* (General Head Quarters) is crowded with busy comrades. We are putting the final touches to our May Day preparations. The Spanish and English editions of our daily bulletin—*"Nuestra Combate"*—"Our Fight"—are almost ready. We have printed articles about May Day in Spain—free and fascist, about May Day in England, Canada, the U.S.A.

Two excellent wall-papers will be issued. One is completed. The other is being decorated by crayon drawings of a hand clasp, of factories and a power plant, by the well-known Mexican artist, Antonio Pujol.

Just now our *Enlases* (runners, or liaison men) and Cyclists showed us their little wall-paper composed chiefly of drawings made by the men themselves.

Typewriters are going, articles are being written, paper and paste are all around us, the mimeograph machine is being turned, arguments and opinions about what to cut, what to insert, and how best to do things are creating a good old-fashioned pre-May Day scene.

In the Battalions and other units scores of wall-papers and hundreds of plans have been made. After digging trenches the boys return and make their papers. In a few hours wall-papers are made that easily match the best ones at home.

And down a certain river on the other side of which are the fascists, a May Day raft will be set afloat—a new wrinkle in May Day work in Spain. Our military command is quite impressed with the spirit and work for May Day. But not for a second is there a slackening of our defense.

The men are in trenches, in rifle pits and machine-gun nests. They never take their eyes from the enemy lines and the occasional machine-gun fire attests to this fact.

For Spain May Day is work day—an extra hour in the factories to produce more for the front and extra efforts at the fronts to improve the fortifications.

May 1st

Four, six or more-than-two-page bulletins have to be held together—by glue or paste

Dave Gordon, Morris Miller, Edwin Rolfe, near Marsa, summer of 1938.

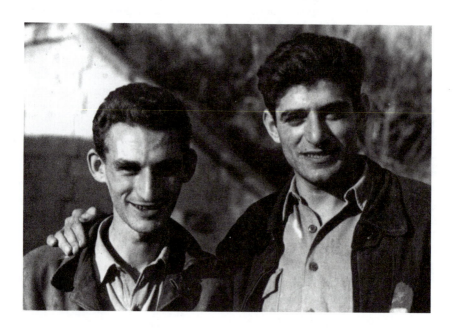

Edwin Rolfe and Milton Wolff, 1938.

or clips or by tearing the paper in a corner and bending it over. We compromised on the last and on until 4 A.M. we worked.

This morning it's dry and chilly. The sun is bright. That's our May Day.

This morning we got a special May Day ration of cigarettes—"Twenty Grand" and the French "Gauloise" (sometimes called "Go Lousy" or "Gallows" and some other thing I just heard and forgot). Two packages. And I had the good luck of again finding someone who preferred the strong French to the mild American tobacco, with whom I made a swap.

Soon a joint CNT-UGT delegation will visit us. The officers' "dining room" is being decked with our wall-newspapers and with the banners of the Republic, of Catalonia, and the Brigade. It will all look very well.

Right now I'm smoking a "Twenty Grand" and finishing nibbling on a liqueur candy "à la Palestine made" sent by my Mother and brother-in-law.

I think I'll keep this open until the mail dead-line in the event I want to put in more gossip.

The papers carried an extremely important government statement defining the aims of the Republic as of today and after the war. It should have an important effect on both sides as far as Spaniards are concerned. It is certainly an answer to the needs of the moment and should considerably encourage the further mobilization of the world democratic forces to aid Spain.

In the meantime, the war goes on until the invading armies are defeated.

Now for a nap before supper.

<div style="text-align: right;">

Your

Davie xxxxx

</div>

from EDWIN ROLFE

<div style="text-align: right;">

June 24, 1938—*España*

</div>

Dearest—

It's almost 7 p.m. (our time) but the sun is still high. I'm sitting outside of my hut waiting for the food to come, hoping that it will be something other than the usual stew-mess of beans, a few chunks of potatoes, and shreds of meat, all in a brown sauce whose flavor hasn't varied once in two months. I'm tired, but not sleepy, as I should be, after a stretch of work—a maneuver which began at 12:30 last night and lasted until noon today. Before that, we'd had a fairly full day yesterday.

After we returned to camp today, I fell asleep for an hour and a half—with a towel over my face keeping the flies, which are getting more numerous daily—away. At 1:30 lunch (stew) arrived. And at two-thirty, Murray and I set out on a narrow mountain path in search of a bath. After walking up and down-hill for 2 kilometers, we found a large, rectangular trough, about 3 feet deep, fed by a mountain stream—and which, in turn, feeds the primitive irrigation system of a miniature farm, owned by a lonely, 74-year-old man, hidden deep in the hills. We hollered "Salud" to the old man, picked a few garlics (which may give some lifting flavor to our evening meal), stripped, and bathed. Then, for an hour, we lounged about, naked, peeling the skin from our feet where,

before and during last night, blisters had been; going through our clothes for the inevitable lice, but finding only eggs; washing our socks and underwear, talking; lying in the sun. The farm is a beautiful one—small, lost among these great hills. Hazelnut trees (or bushes—they're very small) are all about, with the nuts still green, as are the almonds; there are crab-apple and pear trees, the fruit still unripe, rows of potatoes and onions and garlic—and the always-present vineyards, terraced down and across the mountainside. Finally, when our clothes had dried, we knocked on the old man's door, expecting that he would invite us in to talk over a sack of nuts and a carafe of wine (as he had done before); but he had trudged off somewhere, so we made our way back to camp.

Everyone in the Battalion is enthused over Joe Louis's K.O. of Nazi Schmeling, and we're waiting for the accounts of the fight, which should arrive soon. The *D.W.* reaches us more rapidly these days. Today, for example, we have the *Daily* for June 11.

Mail, on the other hand, is scarce and frequently delayed. My most recent word from the States comes from Joe Freeman dated June 5, in which he tells me about the death of his father. It affected him strongly, but did not (could not, I think) have overpowered him or put him out of commission for long—at least, not emotionally. He's still at Kripplebush—why don't you & Leo [Hurwitz] & Paul [Strand] try to get in touch with him?

I was glad you wrote about the time you spent "on location" with Frontier Films. I wish you would write more frequently about such things—and more. I wish you'd write on what you *talk about* (not only *do*) with such people as Leo, Jane [Dudley], etc. It would give me a better sense of what you are, a closer tie with home.

I hope you didn't misunderstand my reference to Dave Wolff—it's not directed against him (whom I like) but it simply means that I don't want anyone to read the stuff, outside of you & Leo, and perhaps certain others whom I specifically designate. Exhibiting an incomplete poem to people, unless it's for a very definite purpose, is distasteful, or more—sometimes even embarrassing. I know you'll understand why I feel as I do about this.

• • •

June 25—1:40 A.M.

I've just returned from a long talk with our old friend Saulie [Wellman], about whose profound development and growth and change I've written before. We talked of many things—of the situation in Spain primarily, of our own roles in it, and, finally, of home. About Spain—you know, if you read the papers, how desperately the fascists are trying to push on, trying to gain a quick victory without which the Anglo-Italian pact won't be worth a damn. But even fascist military experts (I read, in the *N.Y. Times* of Sunday, May 29) now realize and admit that the war will last at least another year. And time is still, as it has always been, on our side. When you send me clippings, I wish you would pick especially those which deal with dissension and inner conflict on Franco's side. Will you?

About our own role—well, you know that as well as we do. On this point the discussion was livelier, with more disagreements on small specific points. Yet we have an essential unanimity on this.

Of home—here Saulie and I speak not only of what we know—remembrance of things past—but we drift into fantasy, wishfulness, nostalgia, desire,—and always, invariably, snap back, out of it into reality. He's as lonely for Peggy as I am for you—and always, though we never talk of this to each other, in the back of our minds we calculate the percentages.

<div align="center">11:30 A.M.</div>

To continue: Everything, right now, seems good to me—hopeful, pretty much alive, expectant—even though the battles are likely to be tough and many. This, just as was my estimate that I'd be back before your next birthday, is just a hunch—but one that I believe in more firmly as time goes on. What I wrote you not long ago about everything here being, for me personally, anti-climax, does not hold. I've got my—well, call it my second political, literary wind. And I hope it stays.

Felicitations to Del & Fanya on their little tiny Lefty.

<div align="right">Love,
Ed</div>

· ·

from JACK FREEMAN

<div align="center">6/29/38</div>

Hi Herb,

Just got your letter of June 3. I see you're doing OK for yourself in school. That was a nice piece of maneuvering—getting yourself on the program committee. If Boys' High is anything like it used to be when I was there, the program committee is one of the best rackets in school. Good stuff. By the time you get this letter the term will be over & you can let me know how you did on your finals & also what you're going to do this summer.

In answer to your question about whether I'm writing to some unknown Bessie, the answer is no. It consumes all my mental energy to write to you & Mom & Pop even as infrequently as I do. I've written to practically none of my friends, because I simply can't concentrate on getting off a decent letter. And the summer isn't going to help much. Last winter we had the coldest winter in about twenty years and now, it seems, we're headed for the hottest summer in a long time. From eleven in the morning to 3 or 4 in the afternoon it is simply physically impossible to do anything. The slightest motion brings oceans of thick, stinking sweat rolling down your body. The civilians sleep their famous siesta, but for us, living in trenches or in open fields, even this is almost impossible. For along with the hot weather came the flies. Not flies like the delicate, frightened creatures we have in the states. Oh, no. Big, heavy, tough, persistent things that you can't shoo away. They swarm in thick clouds over every square inch of your body that's exposed, buzzing ferociously, creeping across your skin so heavily you can feel each individual footstep, biting so that you almost forget the lice. And when you swing at them, they don't scatter like properly civilized American flies. They merely fly off two or three inches and are back on you before your hand is at rest. If you lie uncovered they torment you to distraction and if you put even the most sheer piece of material

over you, you drown in your own sweat. And the lice, thriving on the rich sweat, grow fat & bloated like well-fed pigs and dig fortifications in your skin. "Now I'm School-girl Complexion All Over." Some fun.

Say kid, send me some pictures of yourself. I was speaking to Joe Gross & could hardly recognize you from his description. Also, write me if you could use some sort of a note from the half-dozen Boys' High men out here to help you on your ASU work next term.

The address you are using is unnecessary. The old 17.1 address is still good, except for packages you send via mail, which still need the Paris address. Please continue putting cigarettes in your letters.

Regards to Louis & Jack & to any of my friends you see.

> Salud
> Jack

from JACK FREEMAN

July 14, 1938

Dear Folks,

This is just a short note to let you know that I'm still OK.

I really haven't very much to write you because, since the last few letters I sent you, we've been lying around behind the line in a rest position and very little happens here.

We are training quite hard every day. We're teaching the new recruits all the tricks of the game and at the same time the veterans are learning new stuff that we hadn't known up till now.

For me the program means teaching topography & observation to the Spanish kids that have been assigned as observers. It's a tough job, because most of them have had very little schooling & have great difficulty understanding the mathematical concepts involved. Also, even though my Spanish is quite tolerable now, it's quite tough to explain technical matters in a foreign tongue. But we're getting there.

I've also been doing some advanced work on my own & I think I can say that I know my field just about as well as anyone in brigade, and that goes for those who've had previous military training too. It makes you feel pretty good, like a worker who knows his tools, I guess. A few days ago I even lectured to the company commanders.

Aside from the training, the weather is hot, the flies bite like bastards, smokes are tough for everyone except me, & we're all getting tired of the inactivity.

Write me what you're all doing this summer. My address is still 17.1. Regards to all.

> Jack

from DAVE GORDON

July 9, 1938

Dearest Lottie—

Who hasn't seen thousands of posters, whether for advertising or for propaganda? (Of course the advertising is only another type of propaganda itself.)

Has there ever been a poster which did not contain a rather more than less obvious

moral tailing along, either in the watchwords or catchwords or in the photograph, or drawing? It would be hard to find one which spoke for itself. It is extremely difficult to present the lesson desired without some concise wording or without plainly indicating the idea graphically.

Yet this is exactly what was done in a poster issued by the Generalitat of Catalonia. What is more, this particular poster deals with the principal pride of Catalonia, with what so strongly characterizes its special individuality and comprehends all of its cultural traits—the Catalan language.

Picture to yourself a photo-montage of two pages of a newspaper, one more and the other less obliquely reproduced on a huge poster sheet. Remember, too, that these newspaper pages are taken from a rebel fascist newspaper, impertinently bearing the name *Unidad*. The name "Catalonia" is printed in large letters, once at the head and once at the foot of the poster. Part of one of the newspapers is underscored in black. The underscored lines are only one sentence in a longer article. The paper is written in the Castillian tongue. The specially marked portion, translated, reads:

"José Juan Jubert (fined) 100 pesetas and Javier Gibert Porrero, 100 pesetas, for speaking in Catalan at the table in the dining room of a hotel."

The newspaper, published in San Sebastian, bears the date January 6th, 1938. The news item is a report of the court procedure of a day at the fascist tribunals.

The poster carries no more than what I have explained above. Yet it speaks worlds. It reflects a profound confidence in the understanding and pride of the Catalan. At the same time it reveals a grand contempt for the dogs of fascism who aim to crush the culture of the regions of Spain. It is a convincing call to all Catalonia to fight with Spain to defeat fascism if it wishes to retain its freedoms.

It is a simple poster, colored simply. I wish I had a copy to send you so that I need not have been compelled to describe it in words. It speaks most eloquently for itself. Yet I can't help writing about it for two reasons—it impressed me considerably and I could not get a copy of it.

> Your
> Daviex

from DAVE GORDON

July 15, 1938

Dearest Lottie—

Just a few words:—

I'm going bathing every day. Hope I can keep up doing it. I'm quite white. The sun is good and can help me. And it's better than sleeping during siesta. I am fighting the summer heat and its consequent weariness. Sleep's for the night and I'd like to have it that way.

I sleep out of doors lately. That shouldn't sound strange to one who knows army life. Soldiers generally sleep outdoors. But being with the Commissariat we generally find it more convenient typing and doing research inside.

It's great sleeping out—when it isn't too windy or cold. Last night a few drops of rain awoke us. I'm glad there were no more than a few drops—aren't you? (I expect an

answer to this question!)

Harry Dobson and I are having fun collecting the summaries of all sorts of bilateral and multilateral treaties signed in the last years. It's an excellent review and will be helpful for others as well.

<div align="center">

July 16 –
7:30 A.M.

</div>

Thunder got me up. The skies were overcast with most threatening clouds. With the first drops that fell Mark Alper and I were out of bed, we packed up our blankets and went inside.

Last night—on my way to see some elks [Russians]—I was detained a moment to be informed that in addition to putting out the "Front Line Organ" I am to take charge of the Activist movement for the Brigade. It's a very big job and it will mean cutting out most of my elk hunting.

It's a good switch but I faced it with undefined reactions or shall I say, with several reactions. The elk hunting was fine and it isn't easy to give up.

Harry Dobson and I went to visit some elks yesterday. He, Tom Loyd (Ohio boy) and I were in the back of the truck. We were admiring the sky and the mountains. Those were huge cliffs—but they were puny compared to the clouds which settled over their crests. The clouds seemed like colossal, billowy blankets—covering not merely one mountain but a whole long series of them.

One may suggest any shape, form, or combination of clouds or sky colors and be correct in describing it as a Spanish sky.

On the way back from seeing the elks it was another compelling view that attracted us—a moon beginning to appear between the dip separating two mountains.

The Spanish land and sky is an endless collection of beautiful pictures. It isn't possible to do verbal justice to such beauty. What's more, a painter must be really great to reproduce the color, the blacks and whites of these grand skies.

Ed Rolfe has been transferred from the Lincoln-Washington Battalion to the Brigade Commissariat. He is correspondent from Brigade to the *"Volunteer for Liberty."* Our "M.L." [Morris L. Miller] has been claimed by the British Battalion. But I'll be seeing "M.L." since he's to take charge of Activists and Cadres for the Battalion.

I'm reading *Spanish Testament* by Arthur Koestler. He's good. It's a book worth reading.

I'm due for congratulations—Have gone bathing four times in four days. Today was the fourth day. Hope it can keep up a little, that is if we don't go into action again soon.

Our boys have been discussing surrealism for a couple of days. Lots of fun and many good ideas. Best analysis came from Antonio Pujol Jimenez (I believe I wrote you about him, he's one of Mexico's outstanding artists). Antonio criticizes the surrealist move towards ivory-towerism but states that their method of representation, of keen analysis of the part of the whole, can well be used by the working class to give an understanding artistically of movement and progress.

I just missed being able to get this out. The mail came in and the mailman is gone.

The mail brought me a fine letter from my mother. Let me quote part of it—"We old timers can just marvel at the splendid unity of the Party leadership and membership,

at the growth of our Party. It is great to be one of the little screws of that great machine called the Communist Party....The Party grows fast and Browder is becoming the outstanding leader loved by all....I, personally, have nothing to live for besides the Party and to see you back home when democracy will triumph over fascism."

I wish some fellows could get letters like that from their parents. It would do a tremendous amount of good.

Now I'll close. You can be sure this will go out with the next mail.

<div style="text-align:right">

Love

Daviexxxx

</div>

the VOLUNTEER for LIBERTY

NUMBER OF THE XV INTERNATIONAL BRIGADE

Vol. II - No. 19 Barcelona, May 1 - 1938

ARMAS PARA ESPAÑA

1° mayo

FORTIFICAR · RESISTIR · VENCER

EL VOLUNTARIO DE LA LIBERTAD

NÚMERO DE LA XV BRIGADA INTERNACIONAL

XIII

THE LAST CAMPAIGN
Across the Ebro River

● ●

INTRODUCTION

In the spring of 1938 the French border with Spain was briefly opened and a limited amount of war materiel again reached the Republic, including 100 Soviet planes and roughly 200 artillery pieces. It hardly equalled Franco's resources, but it made a carefully chosen offensive possible. At the very least, such an offensive would prolong the war, leaving still more time for the Western powers to be pressured into reversing their policy, lifting the embargo, and allowing arms to flow to the Republic.

The area of the front chosen as the point of the attack was a stretch of the Ebro river about a day's motorized travel southwest of Barcelona. If nothing else, the attack would relieve pressure on Valencia and thus indirectly assist the Republic's severed southern half. The exceptionally hilly terrain would also somewhat counteract the fascist superiority in tanks, transport, and planes. At the same time, some areas were so unforgivingly rocky that digging trenches would be impossible. The Americans would soon discover what artillery shells did to men scattered atop the solid rock face of a mountainside. On the positive side, though, morale, perhaps the major weapon in the Internationals' arsenal, was finally up again. Meanwhile, every effort would be taken to maintain secrecy.

While the Americans trained with their young Spanish recruits, experienced platoons wandered the countryside in search of deserters or fascist spies; either could be a dangerous source of information for the enemy. As it happened, the Republic succeeded in obtaining complete surprise. Until massive fascist reinforcements arrived, the army of the Ebro moved forward with speed and effectiveness. It would eventually prove the largest battle of the war. At least for a time, the Americans, crossing near Ascó and heading toward Gandesa, would retake some of the very ground lost in the recent retreats.

● ●

from SANDOR VOROS

Spain, *Zona de Guerra*
July 22, 1938

Honey,

We're on the march again, at last. We have marched two nights now, resting during the day. At present we are resting in a gully, trying to get whatever shade we can under olive trees. The sun is beating down relentlessly as only a Spanish sun could and the tiny leaves of the olive trees offer scanty protection.

Water is scarce as usual but yesterday we discovered a small water hole in a dried-

up river bed and it was divine. The water barely reached up to our knees but lying down you were covered and it was a luxurious feeling. The march is over rocky mountains that try one's endurance, but there is comparatively little grumbling—the men accept it as part of the inevitable hardships of war.

I am assigned to the British battalion as representative of H. Q. for the present and will spend the next days with them. But my address is still the same, so keep writing as usual.

Enclosed find the latest pictures taken of me. Send one of them to my sister with a copy of this letter and give her my love. It is too difficult to write here and one letter must do for both.

This is all I can manage for the present. I must get some sleep, if I can—for there is plenty of hard work ahead.

With much love and all the happiness to you

Sanyi

Will try to write as often as I can. Do not worry even if you don't hear from me for a time.

from JAMES LARDNER

August 2, 1938

Darling Mother,

I don't know whether you are aware of the sad fact that I was wounded six days ago and am taking it easy at a popular Mediterranean hospital. I didn't have the money or facilities to cable. Anyway, it is nothing serious, just enough to keep me out of action for a couple of weeks.

It seems that after a couple of days of forced marching and patrolling on the far side of the Ebro River we encountered the enemy and rapidly took 200 prisoners. I was one of those sent back with them as a guard. We reached the river in the afternoon of the 29th very tired and hungry, and were ferried across.

I heard a rumor that there was an orchard 200 yards away and, not having eaten all day, got excused and headed for it. There were some unripe pears and apples and peaches, which were better than nothing, but my attention was soon distracted by one of the frequent duels between anti-aircraft guns and bombing planes. The small round white puffs of smoke where the shells explode keep appearing all around the bombers until either one of them lands and a plane comes down or, much more often, the planes fly away after dropping their loads.

This time the bombers were coming directly overhead. I began to wonder what were the chances of my being hit by one of the anti-aircraft shell fragments. It didn't occur to me that there was any danger of being bombed all by myself until a munitions truck 300 yards away burst into flames with the explosion of a bomb.

I was lying on my stomach when the planes passed over, but the bomb was a little too close. The explosion and concussion were terrific, but I didn't discover I was hit right away. In fact, I walked over to where my rifle, munitions belt and canteen of water were lying, picked them up and started back. Then I began to notice that my left calf

and the left side of my behind were hurting. I felt them and found my trousers were covered with blood. A little further on I found several soldiers waiting in a trench for all the planes to go. I joined them, and one, a Negro friend of mine, went for a stretcher. The stretcher-bearers dressed my wounds and took me to an ambulance. Since entering the trench I haven't been able to put my weight on my left leg. It seems the flying shrapnel hit me in the flesh and muscle, picking very soft and fortunate spots. It will be about ten days more, I think, before I shall be considered cured. I hope to get a few days in Barcelona before returning to the front.

This hospital is clean and sunny, but nothing to read. I am going to write a piece on my recent adventures, which I shall retail through Walter.

<div align="right">Love,

Jim</div>

• •

from JACK FREEMAN

906 DeKalb Ave
B'klyn, N.Y.

<div align="right">August 3, 1938</div>

Dear Folks,

I just received your two letters of July 19. Considering that we are right in the middle of an offensive that's pretty good time.

I'm glad you finally got one of my letters, but for Christ's sake, how can you think that I'm stupid or thoughtless enough not to have written for 4 months? I can't help admitting that I've been very lax in writing to you but not quite that bad. I wrote you several times at the end of April when I discovered I'd passed the danger of TB & was definitely recovering. I wrote again 4 letters at once early in May when I received 9 letters in one batch from you (the first since late January). I wrote when Joe Gordon & his group got here on May 29. I sent you pictures & a case history to prove I'd never been wounded when I found out you thought I had been. I wrote when I was about to rejoin the battalion & when I did, & I have written about once every ten days since I've been back again. I wish you'd believe me. If you write asking Saul Wellman he'll tell you I've been writing. I can't send cables like he can, but then he's a commissar & has that power, while I haven't.

About myself now. For over a week we've been in action. I guess you have been reading about it. We've been outstandingly successful. Crossing that river under artillery & *avion* fire was one of the most amazing experiences I've ever been thru. We caught them completely with their pants down. For the first time since I've been a soldier I had an enjoyable experience with the fascist *avion*. As they would swoop down low over us the whole damn battalion turned its rifles up & kept up such a fire that we chased them off, made them run like hell. Maybe you don't know what a feeling that is. These damn machines, so immense when they come down at you, so terrifyingly deadly in their effects—and this time we had them running from ordinary riflemen.

Since this began we've been marching or fighting every day & night up till today. My tiredness is impossible to describe. This terrain is one of the dullest in Spain & we

marched up & down every hill we could find, or so it felt to me. We (our battalion) captured several hundred prisoners, a town, and millions of hills. I worked my ass off, as a scout in the advance & observer during fighting.

I had a bunch of souvenirs I picked up in the town we took & from the prisoners, which I intended sending to you, but I lost them all in the subsequent fighting.

My luck has been positively amazing. With all sorts of crap flying around & casualties all about me I didn't get touched. I was even getting to feel ashamed of myself, everybody else walking around with bandages on except me. Finally two nights ago, on one of the toughest artillery shellings yet, a piece of shrapnel hit a tree & fell down on me. It burned me slightly & left such a tiny scratch that the doctor had trouble finding it the next day when I went down to see if anything had penetrated. Absolutely nada or nothing as the Spaniards say. I wasn't out of action for even two minutes. I still think that if they didn't get me with a whole torpedo they aren't going to get me with anything else.

We're resting now on a hillside. That's why I have time to write. The sound of the motors of their *avion* hasn't been out of the air one minute since daybreak. Same the day before & the day before that &....So far they haven't hurt us much & anyway I got a deep hole in the ground to retire into when they start unloading. I'm right in it now, taking no chances.

Joe Gordon is right with me & one swell soldier. There just isn't anything he can't take. A few hours ago I spoke to the Commissar of the Mac-Paps & he told me Abe Smorodin was all right.

I'll be twenty in a few days. I may still become old enough to be officially listed as an adult. Ain't that sumthin?

Thanks for the butts. Regards to Jackie Schwartz & Tante Ferge & Herbie's nurse & Butch the Baby Killer (what the hell is it?) & all the rest.

<div style="text-align: right">Yours
Jack</div>

..

from HARRY FISHER

<div style="text-align: right">August 5, 1938</div>

Dear Kids:

It must be more than a week now since I last wrote to you. I don't like to let such long periods go by without writing, but I just couldn't find any stationery.

This is the third day of more or less quiet. The fascists have their planes in the sky a good part of the day, and there are constant artillery duels—but when this is all that goes on, we consider it quiet. We did have 8 or 9 days of extremely heavy fighting, so that we can appreciate these days of peace.

We are leaving the lines for a rest in a day or two with fresh troops coming in to take our places. I'm looking forward to a change of clothes, and a good soapy bath in some swift running brook—or possibly in the good river Ebro—who knows?

The recent victory has raised the morale of the troops immensely. There's a new spirit in the army as a whole. You can imagine how we feel after crossing the river, and once again running after the enemy. And what makes us feel best is the recent war

news from the Levante front—where our troops have taken the initiative. There is no doubt that our main purpose has been achieved, the relief we have given Valencia. We can see this with all the planes they brought up and artillery.

It's hard for me to concentrate. There are about 30 large trimotor bombers roaring overhead and an artillery duel going on. I'm just about in the center of this duel, so that I hear a steady whistle of shells overhead. It makes me a bit nervous. I guess you never can get wholly accustomed to this. Especially the roar of bombers overhead. And they are still loaded. You can tell by the strain on the motors—their heavy sound. Yet I shouldn't feel nervous—I'm in a good dugout.

Pat and Jack are O.K. and send their regards to you. As usual, I feel fine—only more homesick than ever. After every battle, I get this feeling. Last night I dreamt I was home with you—how happy I was! I know you want me to tell you when I am coming home—but I still don't know. I hope I can make it very soon. As soon as I find out—I'll write.

Let Mom and Bing know I'm O.K. and give them my love. Tell Vivienne & Hickey I have no more paper—so I can't write to them yet. The same for the Ruckers if you see them. And also Charles Champion. I received a letter from Hy Rossman, from California this morning. How's Jack Macy? Ask him to write again. Why doesn't Joe Lieber or Nat write any more? I'd like to hear from them. I'm sorry I couldn't write to Louise on her birthday, but I was too busy ducking shells. No kidding! Remember me to Phil & Jean & Lou & his wife & Claire and everybody else.

<div align="right">Love, Bozzy.</div>

I'll try to write again soon.

..

from ARCHIE BROWN

<div align="right">Aug. 7, 1938</div>

Dearest Darling:

All I hope is that you receive this letter. I know that some letters are getting thru so perhaps by now you have heard from me.

Right now we are at rest, having but yesterday returned from the front lines. When Mussolini and Chamberlain signed their agreement they both took it for granted that Franco had won already. They were so certain that they organized a big push against Valencia, not expecting any action along the river. So on the morning of July 25th on several different points the Army of the Ebro crossed the Ebro by rowboats & proceeded to erect pontoon bridges. You have read the results—despite heavy bombings by planes, our troops, artillery & tanks crossed successfully with more coming. We have taken a large stretch of territory, stopped the attack on Valencia & in several places have the Fascists on the defensive.

We marched all night on the 24th & we laid down for a while. At daybreak the coffee wagon drew up, but there was scarcely any time. The order to fall in a march came through. On went our blankets, packs & guns. I grabbed a case of ammo & hoisted it on my shoulder. Almost in back of us the red sun tinted the clouds & even the reeds along the bank looked red. We marched briskly for a kilometer when the fascists opened up with their trench mortars, trying to hit the highway above us. We ran into a

thick group of trees & waited. We didn't wait long. A plane roared overhead, dived down & began strafing. About a dozen machine guns answered him & he quickly swooped up. He returned this time flying higher & dropped bombs, but they went wide of their mark.

We ran like hell until we reached some communication trenches, connected with the beach.

Quickly we ran down the beach. The sky was not red now, and it was becoming warm. Six men to a boat and we started across. The oarsman was good. He crossed the 200 meters in record time. Meanwhile we saw the pontoons, cement, & other materials for the bridge. On the other side we scrambled up the bank. We began hearing shots of the companies who had proceded us. We ran forward continually only to meet a stream of prisoners. We finally sighted a town & began an encircling movement. That night we took up positions on a height but did no firing. We had no water & ate our dry rations. In the morning we moved down. We could hear firing below spasmodically. Finally we received word that the town [Fatarella] had been taken.

We sent a couple of emissaries into the town who brought back some tobacco. We hadn't smoked for a long time. Later on the *"intendenda,"* or food headquarters, sent up some canned fish, meat, bread & cookies. Boy was that a relief. But we didn't sit still long. My squad was assigned to an infantry company who was attacking a town. We drew along a wall where our contact was to be made when ahead we saw men coming toward us. We didn't know who they were and the bullets were flying our way thick & fast. Our "cabo" (corporal) gave orders & the gun was set up. But we finally decided they were our men who had advanced too far. Later we circled and took up positions on a hill. With whatever we had we dug in and began firing. That night the infantry pulled a surprise attack, entered the cemetery and returned with eight machine guns & prisoners. During the attack the fascists threw everything at us except their guns. But we were well dug in.

I quickly lost track of the time after the first day but I believe on the 4th day we rejoined our company. We were lying in a *"barranco"* (gully) right behind the lines. We had received coffee that morning and were bumming smokes from each other. Overhead appeared about 30 bombers. Everyone hugged the ground. It took about 5 minutes for the tail end to get directly overhead, and with a signal from the head two of them swooped down & let go their bombs. The concussion shook the ground. There were shouts for *"practicante"* (first aid). Dirt & stones flew all over. I cursed them in English & Spanish. It turned out however that we had but few injuries and one of the planes had dropped its load in the fascist's lines, killing many I hope.

We stayed around in the position for several days. The fascists fired artillery & trench mortars at us. The mortars are tricky things. You can't hear it until it lands. A shell you can hear. The mortar has fins on it like a torpedo. It shoots straight up into the air & then straight down. Our company fared pretty well. J.E. is a runner & was keeping pretty busy.

Finally we withdrew a little way. Towards nite a message came for me, saying I was wanted at headquarters. I thought at first it was the carton of cigarettes you had sent me, but no such luck. George Watt told me that I was to be a company commissar. Now aside of the fact that being a commissar requires certain qualifications, this company

was an infantry company. I told Watt I had never gone over the top as such. So, he said, "You'll learn."

That nite I grabbed my stuff, transferred companies & we marched. When we reached the front, I was introduced to the various officers & we proceeded to follow another battalion into a *barranco* for the attack. It was hot that day & the fascists were shelling so that we could get very little of water thru. Towards evening we attacked and the fascists let go with everything they had. Shells, mortars, artillery, machine guns and what not. Finally we took up positions on the top of the hill & peppered at the fascists. I was supposed to help keep the company together, but in the scramble uphill I was lucky to keep myself in touch with the company. We finally did get all the squads together. Things quieted down a bit & after eating we tried to sleep. The fascists however are very jumpy. Every bush looks like a man & two bushes look like an attack. So several times for an hour at a time they let go a tremendous barrage. They threw tons of hand grenades, and you can throw a grenade only some 30 yds. While we were a couple of hundred yds. away.

After a couple days we came here for a rest. War is not without its humor. A former Calif. boy by the name of Cooper was captured along with 13 others. It turned out that the 200 fascists that captured them had lost contact with their main body. Cooper told them of the tremendous numbers of men we had, the large number of artillery & planes etc. Then they discussed with them the war & its issues & asked them why they wanted to die for German and Italian Fascism. The result was that 14 men brought the 200 marching into the brigade headquarters. Johnny Gates ran out & wanted to know what was coming off. But the men all laid down their guns.

I've been very lucky so far in dodging all the stuff flying around. I intend to keep up my record. So my sweet keep writing & send me smokes. Every time I get a chance I think of you. I love you my dear.

<div align="center">

Salud,
Archie

</div>

Send smokes in the envelope. 17.1 Plaza Altazona Barcelona Spain

••

from SANDOR VOROS

<div align="right">

With the British Battalion
Spain, July 31, 1938

</div>

Sweetheart,

It's a week now and the battle is still going on. We're continuing our pressure, attacking as much as six times on one day. We have made a great advance, gaining a lot of territory and we are still on the go.

These British are a great bunch. Morale is excellent. They take everything without grumbling and are tireless fighters, self-reliant and disciplined.

We have been through a great deal in this week—but all this is part of the game. If we only had enough artillery and aviation to match that sent in by Hitler and Mussolini this war would be over in two weeks.

I wish you could see me now to know what a week's fighting does to a man. I am

still in one piece, well and healthy—my luck still seems to hold. But I haven't shaved or washed for a week, slept very little, went without food for two days, subsiding on dry rations for the rest, marched and marched under the broiling sun, climbed mountains so steep I had to crawl up, was shelled and bombed and strafed and sniped at—we all look like wild prehistoric ape men. But as I said before, morale and discipline are good and we are convinced of victory.

Just before we went into battle I received a tin of Luckies from you mailed in new York—the first one in about two months. What a lucky stroke. Million thanks for it. Nothing in the world would have pleased me better. We have been without smokes for months and nothing like a smoke after a half hour of close bombing. In no time I had become one of the most popular men among the British—five-six comrades fighting for butts and swipes.

I am writing this on top of a very steep cliff overlooking our lines stretched in the valley below. There is a lull between the fighting, and the enemy artillery is devoting all its attention to us. So are the trench mortars, not to mention the aviation, which is almost ceaselessly overhead. There is no doubt that they have discovered our Headquarters, but we can't afford to move because this is the best observation post we have. Life is exciting.

It is rather difficult to concentrate when you have to duck and in a hurry every so often so you will forgive me the lack of cohesion.

Things are beginning to pop again, so goodbye sweetheart. Will try to write again soon. As it is I have no idea when I'll be able to send this letter out.

Hope for the best, honey, victory may be closer than you suspect.

<div align="right">

With much love

Sanyi

</div>

my address still is: 5-E, Socorro Rojo
Barcelona

from ARCHIE BROWN

<div align="right">

Aug. 10, 1938

</div>

My Darling:

The doctor is running around without his pants and saying "damn," which is quite radical and excessive for the doctor. It is equivalent to conservative members of the W.C.T.U. doing a strip tease on 5th & Market. The occasion is that some *"camión"* (truck) driver neglected to leave the blankets to be disinfected. The place is the very good beach here at the river where we've come to take a bath (what a luxury) & receive new clothes.

The boys are in a festive mood. They run thru the warm water laughing like children. The river is so shallow you can almost walk across. But the current is swift. I drop my soap and try to borrow someone else's. But they've had the same experience. The swift current carries it off. Finally the company commander commandeers a piece & we set to work. The screeches die down, the boys get into their clothes and the doctor runs around without his pants. The dirty clothes are all thrown into one truck and the boys try to avoid riding back on that one, for they might get loused up again. Finally

we start off. We go thru the town again. The moon has come out from behind the clouds & the bomb- & shell-torn town is revealed. Gaping holes thru both walls. Half rooms standing with chairs & dressers undisturbed. Only the mirror on the wall hangs a little crazily. There are also rows of houses all blown to bits. The truck just barely gets around a bomb hole in the center of the road. We make a turn, and come onto a real Hollywood scene. On both sides of the road the houses are in ruins. The houses immediately in front of us have their roofs blown off. Straight ahead is the remainder of the old bridge. The center has been blown clear out.

When we reach the highway, or rather the dirt road, the driver says he can't make it because he has no lights. So we walk, in our clean clothes, kicking up the dust. It's 2 o'clock when we arrive in camp, but I can't go to sleep because some 10 men have not received their clean clothes & will have to go down with their next batch. So I place myself in the center of the camp & call out *"limpia ropas"* (clean clothes) several times. This of course is done in my best Spanish, & I was greeted with "talk Spanish so we can understand you" (that from an American comrade—I asked him if he shaved himself). "No clothes today—besides, it's late—go to bed." "You clothes dealers are gyps anyway." The Spanish comrades all chorused back that they had clean clothes.

Finally we located about half of them. I called for the remainder until I was sore in the throat. Suddenly a muleteer brought his mule down the path, so, speaking my best Spanish & in a very persuasive voice, I offered the mule a pair of pants, a shirt, undershirt, drawers, socks, &, since he had 4 feet, 2 pairs of *alpargatas* (sandals). He didn't even deign to answer me. So the commandant says, "Commissar, it's time for you to go to bed." So I spread my blanket in my fox hole and prayed that too much dirt wouldn't come to sleep with me. About an hour later I awoke with urgent pains in my stomach. I ran as fast as I could, but I dirtied my clean drawers. Life is like that.

I ran into Howard Goddard the other day. I knew he was around but had been unable to see him. Finally here I tracked him down. He is Chief of Operations for the brigade & totes *tenniente* stripes. He is rather thin, but in good health & spirits. He says to say hello to everybody. Running into him afforded me the first apple & peach of the year. They were good. Now we get them regular. It helps me keep my stomach in order.

Before me I have your two latest letters—dated the 5th & 17th of July. Notice that— 12 days in between. Perhaps Hon gets tired of writing and not receiving letters. But you must not give up hope, and write often. I need your letters dear. Particularly when I don't receive letters from anyone else. I know that they haven't heard from me—but some of them know the address. Wait till I get a chance to tell them off! If you get a chance tell them to write, and send cigarettes in the envelope.

I have a number of things to do & I have a meeting in a few minutes so I'm closing. Don't forget my dear I love you and miss you terribly. In one of the actions I lost your pictures, would you mind sending me some more? I won't lose them again.

I love you.

<div align="center">Archie</div>

· ·

from DAVE GORDON

August 14th, 1938

Dearest Lottie—

Your letter of July 25th arrived today, as did a letter from my Mother, from Willie, a joint one from Isabel and Mac and the enclosure from Miriam. As usual, Willie's letter is a gem. It's more serious than his other letters and is excellently written. They are all quite upset about the death of Mikie's old friend Ruby Ryant, who died the death of a hero when he stuck to the last at Belchite last March, when he covered the retreat of other comrades by the fire he kept up. And it is miserable to think of those other fine comrades who have fallen in battle or have otherwise been killed at the hands of fascism.

It is now twenty days since we entered our last operation. There hasn't been a single day when we haven't seen planes five, ten and twenty times. The observers even fly during the night to see whether they can detect concentrations in order to bomb them the next day. Nor have they stopped at day bombings. There were a number of nights during which sleep was disturbed by the roar of the motors of the fascist bombers and the louder boom of their heavy explosives. They've wrecked villages and bridges—but the roads are cleared and the bridges put up again, with supplies continually coming across to the troops at the front and to those of us who are in support and reserve.

Yesterday and today were interesting days. Up until now the fascists were the masters of the air. Only our anti-craft batteries, of which we need greater quantities, would fire against the planes. But wave after wave of planes would come, bomb, and go—all day long—not one or two, but ten, twenty-five, fifty and sixty. Now and then a chaser would dive low into the hills and hurl a light five kilogram bomb in the hope that it would hit some hiding troops. But yesterday and today, or the day before yesterday, rather, they were challenged. They were challenged by our bird-men, by our Gloriosa.

There is a terrible beauty in watching a dog-fight. Planes screaming, spitting heavy machine-gun bullets at each other, weaving, diving, soaring, chasing, turning over and over backwards, forwards and sideways: our men with but one aim—to destroy these monsters who think they rule the skies, to punish them for their destructive work, to strike fear into their vicious hearts. And our birds strike fear in their hearts. The Savola's, Fiats, Messerschmidts, Junkers, the whole Italian and German band turn tail and try to run. Their chasers would also like to run but our own "chatos" compel them to fight while our other chasers head for the bombers. I saw the fights; I heard a heavy fascist bomber blown up; I saw three of the crew sailing in parachutes downwards into our territory. Day after day we had air circuses. Day after day the fascists would sail over us in beautiful formations; often they would maneuver weaving into one another very low over the hills. But there isn't much beauty in a five hundred kilo bomb; nor is there much beauty in planes diving low to strafe at our comrades and throw those nasty little bombs at our soldiers. Imagine the damage a five hundred kilo bomb can do in a city when it makes a cavity in the earth of 14 feet depth and 30 feet in diameter.

Aug. 15—

It's a sight worth studying, the series of cavities stretched for miles along the shores

of the Ebro, made by the bombs dropped by the fascist planes. It's worth studying the scores of villages with so many of their houses destroyed by fascist bombs. At first glance those homes of stones held together by clay and heavy beams appear strong. Yet how easily a bomb crushes one to the earth—making a heap of sand, stones and splinters. And they were such pretty, post-card pictures before—villages and towns out of the children's story books.

Still, when our chasers come their giant devastators hastily unload their cargo and flee for home.

Today, again, we witnessed aerial battles overhead. And the day is quieter as a result. Of course, the fascist planes will be back again but we've had a few hours of quiet.

I've been asked to ask you to spread the word around to everyone that they should enclose as many cigarettes as possible in each letter sent to the boys here. I've seen as high as a full pack of 20 sent loose in an envelope and arrive. Letters are sent more often than packages and a number of cigarettes in each letter can help tremendously.

Best wishes from Morris Stamm.

I'll write again soon. I'm enclosing a picture showing how badly I needed a shave when we left the lines.

<div style="text-align:center">Your
Daviexxxxx</div>

P.S. Am returning your letter of July 16th.

· ·

from SANDOR VOROS

<div style="text-align:right">Spain, Zona de Guerre
August, 1938</div>

Sweetheart,

We're back in the lines again much refreshed by a week's rest. At present I am perched on a big rock on the side of a mountain in a small aperture under an overhanging cliff. The jagged rocks are wearing a hole in my bottom, there isn't room to sit up or lie down and yet it is a most comfortable arrangement—for I am safe here from artillery or aerial bombardment.

The panorama is wonderful. We are in a bowl formed by high mountains all around and the road below curves like a white ribbon—or more like a runway in one of those Ten Million Dollar Hollywood musical settings. Early this dawn with the troops moving single file in opposing directions, along the edge of the road one had the impression of watching a Hollywood super special chorus going through its evolution on a gigantic scale, the tiny figures below accentuating the effect. But it didn't last long, the first shell dispersed the illusion.

When moving into action—used as one may be to it—there is always a momentary sinking feeling, a certain sort of apprehension which, try as you may to dismiss it, stays with you until the action begins. But once the first shell lands it evaporates completely and one settles down to the tasks ahead, coolly and levelheaded, never for a moment betraying any emotion, thus setting an example, even becoming a source of strength and inspiration to others. During combat life is a series of continuous tension and

relaxation, the frequency depending on the intensity of combat and the amount of shelling and bombing one is subjected to.

The mail caught up with us and I received your letter of July 30 and a tin of Camels postmarked August 2. Nothing like a supply of cigarettes to keep you relaxed during battle. I think this is the fourth or fifth tin I received from you in the past two or three weeks, which is a hundred percent batting average. So keep sending them, Honey, the chances of receiving cigarettes sent first [class] mail have always been very high, especially when sent one tin at a time.

Accept my belated congratulations for your birthday—let's hope your next birthday will be celebrated by us being together.

One phrase in your letter was very amusing, where you advised me to eat before going to sleep to induce dreaming. I solemnly promise to follow your advice whenever the possibilities exist. For your information, I should tell you that during action food can normally only come up at night—you may be awakened at 2 in the morning that supper is here—you eat it and go back to sleep, when very exhausted you may eat without ever being fully awake.

Your sending some of the snapshots to Johnny Williamson is perfectly O.K. It was my original intention anyway to have it shown around the Party.

This reminds me, just before we moved up I arranged three small series of photos taken during our last action to be sent to I.L. Kenen for publication in the Cleveland news, press, or what have you. I haven't any envelopes at present. I will try to send them as soon as I can get to it.

The first one is a series of six photos showing the crossing the river by boats. The second is a series of six showing the building of a pontoon bridge under fire.

The third one is a series of about 14 showing the assault of a mountain, capture of prisoners, etc.

I think I.L. could find some use for them.

Well this is all for the present.

> With much love
> Sanyi

from SANDOR VOROS

> With the Brigade
> Spain, Sept. 3, 1938

Dear Myrtle,

Came back to the Brigade night before last and it was a wild journey. We were caught in one of those night scares when one side believes the other is pulling a surprise attack and both open up with everything they have.

These scares usually start with a sentry who sees or imagines seeing some figures moving in the dark ahead of him and starts firing. The others, not knowing what happened, follow his example and all rifles start blazing away. The machine guns immediately chime in and start a rapid fire. By this time the other side is thoroughly aroused and not knowing what's going on plays safe and lays down a curtain of fire in front of its own position. This scares the first side more which now believes that an attack is

imminent and it lets loose with a barrage of hand grenades. By this time the entire sector is thoroughly aroused, trench mortars are put into play and finally artillery on both sides is brought into action.

The artillery promptly begins shelling the front lines, the communications, all fixed points on which the guns had been trained in advance and the big battle is on with all its fury.

The men in the lines are of course under cover and usually very little damage, if any, results outside of a great waste of ammunition and loss of sleep. The danger is for the outsiders, the "innocent passersby" so to speak, who happen to be caught in it, but as everything else the scare came to an end, too, and we were able to continue our journey without any further incidents. Being away four days I found an awful lot of work piled up and to top it all, an order requesting me to report to Barcelona to be put at disposal of the Commissariat of War of the Intern. Brigades. I have no idea what work they have in mind for me there and I am strongly averse to leaving the Brigade as long as we're in here. But orders are orders and they have to be complied with. As a matter of fact I should have left for Barcelona yesterday but I postponed it in order to clean up the accumulated work.

Going to Barcelona to work has its advantages that would be foolish to deny. Life in a city, no matter how difficult, is incomparably easier than the hardships of the field especially with the rainy season about to be due, not to mention the danger to life and limb.

As to the last I have a fatalistic attitude—if you're bound to get it you'll get it no matter where you are, so this part is easily discarded. My main consideration is that here I am doing useful and important work, I haven't missed an action ever since I joined the Brigade and I wouldn't want to work in the rear guard unless the job is more important and necessary than the one I am doing here. If I could get away for a while I'd infinitely prefer to work on the photo-album of our Brigade which is a pet project of mine.

To conclude, I have an agreement with the Chief of our Brigade and Johnny Gates that they'd back me up in my request to stay with the Brigade. Tonight I am going to leave for Barcelona and find out what's what. Will write you from there.

Keep writing me to my present address until notified otherwise. I have made arrangements to have my post forwarded if necessary.

Now to others. The cottage of your relatives, judged by your description of it, is an ideal spot. I am very glad that you took time to stay there for you did need a rest.

The cigarettes in your letters reach me in perfect state. Thanks awfully. Cigarettes are the greatest gifts here, especially a steady supply of them. Don't bother about the clippings any more. They are not at all worth the trouble.

A subscription to the *New York Times* would be a complete waste of money. They would never pass the censorship office to reach me. I once had a subscription and not a single copy ever reached me.

The first batch of our men left for foreign leave a couple of days ago. My turn may come sometime around the end of October or November. So have patience, Honey, it won't be very long before you can see my mug again.

<div align="right">

With much love
Sanyi
</div>

from **SANDOR VOROS**

Sept. 4, 1938
In the field, Spain

Dear Myrtle,

Two letters of yours reached me yesterday after I finished my letter to you and so I am answering them now.

Your complaints about my not writing systematically are justified. However, this is not due to neglect. Perhaps I had better attempt to give you a picture, inadequate as it may be, of the conditions and circumstances that make letter writing here somewhat more difficult than back at home.

For one, especially when in a campaign, as often as not we have no paper, or envelopes, or pencil, pen, or ink. You may have all of these in your knapsack but a curtain of fire might separate you from it. (I did once walk through a barrage because I wanted to write a letter—the stupidest thing I have done.)

You can't write at night because there is no light and very often you might be involved in continuous battle day after day when you have neither the time nor the possibility of writing.

There is also such a thing as exhaustion. It happened time and time again that I was on continuous duty for two-three days and nights. A thing like this plus the continuous banging away of artillery, aviation, trench mortars and what have you plus the strain of expected attacks that do not materialize plus the still greater strain of the expected attacks that do materialize—all of these are not very conducive to writing.

There is also the subjective factor involved that you don't want to write about danger while you are facing it and you are certainly in no mood to either minimize it or write bombastic phrases about it. In addition there is the censorship—you can't write about the immediate situation for fear of giving away military information.

And when we are on the move there are other difficulties—believe me, Honey, when I tell you that I doubt if there is anybody who writes more often than I do in the entire brigade.

To conclude this I want to state that time after time I have run considerable risks to finish and get a letter to you, risks that were absolutely stupid and uncalled for and that could have easily ended tragically. I shall give you only one example that happened quite recently.

I started a letter the day previous and was interrupted, couldn't continue. The next morning I started on it again only to be interrupted. The same thing happened at noon and early afternoon. Late in the afternoon I started on it again when a heavy shelling started. When the first shells began landing in our direction everybody naturally took to cover but I disregarded it—I was sore of all the interruptions and wanted to finish that goddamn letter. Well, that barrage was meant for us, because it soon developed into a real one and by that time I couldn't move from where I was. It was a pretty close shave, I am telling you. I don't want to go into details of it, but one shell landed close enough to impair my hearing for a couple of days.

Besides, as I have stated before, my job is such that I have to see a great many people at all times. This means a stream of people coming in and out at all times. For

instance I started this letter around 6 o'clock this morning and it is now a little over 12 o'clock. It took me that long to get this far. I hope I have written enough on that subject to convince you and if I only had preserved the countless letters I started but was unable to finish the proof would be overwhelming.

I decided not to go to Barcelona at present. The fascists are making heavy attacks on our sector and I want to stay until it is over. To leave now would be equivalent to deliberately running away, as you readily understand.

By the way, one of the clippings you sent continued a story by Matthews which was absolutely misleading. We're going to raise hell with him about it when he visits us again. It is not true that anybody can come and go as he pleases. No army could operate that way. Only the wounded and immobile (those who are physically disabled) can go back. The able-bodied are receiving foreign leaves, about thirty a week. My turn should come around the end of October or November unless something interferes.

<div style="text-align: right">

With love and kisses
Sanyi

</div>

. .

from JAMES LARDNER

<div style="text-align: right">

Sept. 19, 1938

</div>

Mother darling,

So many things have happened since I left Barcelona that it would take many pages to summarize them. And just now I haven't the energy to write that much. I'll tell you about it later. For the last week we have been pretty inactive and it is just as well, for I feel like doing nothing at all. I have a cold and a little trouble with my stomach but no temperature. This probably has some connection with the fact that I made a pig of myself yesterday out of other people's packages of food. In any case, as soon as we get out from under the planes and artillery shells, I expect to sport a distinct improvement.

Everywhere we go now it is necessary to dig trenches and/or individual refuges from the shells and bombs. Once dug in you are pretty safe from anything but a direct hit, which is very rare.

Recently our company took a position on a very exposed hill, almost enclosed by the Fascist lines. We arrived at night. Four of us worked hard with pick and shovel for seven hours in stony ground to make a trench for our protection. Soon after daybreak it was deep enough to sit in with our heads below the surface, and we got in just before the trench mortars began to land. They kept exploding around us all day. I never was so well paid for hard labor as by that feeling of comparative safety.

This is not a very cheerful letter, but I will do better next time.

<div style="text-align: right">

Love,
Jim

</div>

. .

from DAVE GORDON

<div style="text-align: right">

Sept. 28th, 1938 12:30 A.M.

</div>

Dearest Lottie–

It is quite dark. The little piece of candle helps just enough to be able to guide my

writing. A driving rain is falling—but we are in a house. I wanted to write you in the morning. However, I was awakened from the soundest sleep I had in weeks to answer the telephone because of someone's mistake in transporting Activists to a Divisional meeting. Now I can't fall asleep. Certainly there is nothing better to do at this time than to write you.

I wanted to write you before. I was both busy and extremely tired, both of which conspired against any attempt to write.

A few days ago, Sept. 25th, was my most exciting (!) day at the front since my entrance to the Brigade itself, Nov. 11th, 1937. On this day two other comrades and I were on a mission to reconnoiter several kilometers of hills and valleys to discover where the enemy was. At least that is how the mission ended. Well, we traversed those *"lomas," "cotas,"* and *"barrancos."*

(It is now 8:20 A.M. Everything is damp from the rain. The tops of the hills are hidden by the clouds of mist. I had to go to sleep before because the wick fell through the candle into the bottle and because I didn't have anything with which to light another bit of candle I had dug up. And now I don't feel much like writing. There are many things to straighten out; I've already done a little work and I'd like to get on and through with it. —Although there isn't really such a thing as getting through with work.)

Anyway, we met the enemy at a hundred yards distance one time and on one side later on, some five hundred yards distance, and we knew they were the enemy by the way they fired at us after we sent a couple of bullets over to find out exactly who they were. Of course, they had other signs of being the enemy which I can't explain here. Bullets were coming our way from three directions, but only very scatteringly, because we showed ourselves to the view of the fascists only twice in unnecessary fashion. However, even though we were caught in two heavy bombardments, we got back safely to make the report. It was on the basis of this report that our forces were sent in to establish positions in the furthest hills we scouted, thereby gaining about three or four square kilometers of precious territory.

You can't imagine how glad I am that I had that experience. By now, or long before now, you must have known that the International Volunteers are being sent to their respective countries. I can truthfully [say] that all things considered I could not work up any enthusiasm over the fact. It's not that I don't want to be in the States, for all that it signifies, you, the family, doing the things I am accustomed to, etc. It's not because I love war. Nor am I an adventurous lad who must be thrilled by war escapades, the roar of cannon, the crack of rifle fire or the thunder of aerial bombardments. It's none of that. But I have the feeling that something more could have been done for Spain.

On the other hand, who can question the value of this move by Spain? Spain for the Spaniards and a Spanish Army consisting of only Spaniards is a sharp rebuke to Chamberlain and to the hesitant democracies who have abandoned Spain.

It's about 9 now. I've just awakened the comrades. They're sleeping long enough. We've got a lot of cleaning and re-organizing to do. So now I'll close, write a short note home, and then get to work. (By the way, I received a letter from the Arnholt Clan yesterday.)

Love,
Davexxxxxx

. .

from DAVE GORDON

Nov. 19, 1938

Dearest Lottie,

If I don't take a few minutes off I never will get the opportunity to write you. And the intervals between my letters appear to be lengthening. That shouldn't be, should it? It's inevitable, though, on account of the great amount of work and the tremendous rush in which it must be completed.

Since my last letter came the news of our move back to the eastern bank of the Ebro. It was a great fight while it lasted—and it lasted beyond ordinary calculations. Fighting with our back to the river, with a few slender bridges for communications and, most important of all, without the material the fascists received right along, the maintaining of positions on the other side of the river is a military achievement equal to the crossing of the river itself. We crossed the river and gained a great amount of territory with rifles, machine guns and hand grenades. On the other hand, the fascists had to use hundreds of tons of bombs and shells, cannon by the dozens, hundreds of airplanes and had to sacrifice 80,000 in dead and wounded in order to retake what we had recaptured. More than that, what we accomplished in two days with so little, they had to achieve in four months of bitter struggle with such great expenditure of men and materials.

But we had to move back. This should be a starting point for a new drive to aid Spain. Now, more than ever, Spain needs help. Spain must have arms. This is the best answer to the fascists and to the capitulators. The Ebro, from beginning to end, is ample proof of who would win the war given equality of material on both sides. But there must be more than that: the Ebro must also be the signal for a new and more intensified struggle for the withdrawal of the German and Italian aviators, technicians and soldiers. A struggle among the Spaniards themselves would resolve itself quite rapidly, with a round victory for the people, for democracy.

I haven't read any more news about the elections in the States, except the figures on the losses of the Democrats in the House and Senate. It's by no means a decisive vote but it is an indication that some very stiff work is ahead to prevent a decisive swing to reaction in the presidential elections.

It appears as though I will have to stay on a little longer after the others leave. I don't know how long it will be; that depends on the work and other circumstances beyond my control.

I should like to be with you and see family and friends, but I guess it will all have to wait a little while longer. And now I'm sorrier than ever that I told you to stop writing me. But you might begin writing me again. You can write me care of Felisa Gonzalez, Calle Mallorca, No. 233 (Baja), Barcelona. If I am gone by the time your letters arrive, Felisa will mail them to me in the States; she is a most dependable comrade.

I will try to write again soon.

Your
Davie

HUELLAS DEL FASCISMO

Fascism's footprints. *Frente Libertario* (Madrid), October 17, 1936.

BARCELONA
Assault from the Air

．．．

INTRODUCTION

If Madrid, the Spanish capital, remains for many the enduring symbol of the historic resistance to fascism, Barcelona, alternatively, stands as the historic capital of the Spanish revolution. Throughout the century, in fact, Barcelona was not only Spain's major industrial center and its cosmopolitan port city on the Mediterranean but also a mecca for unconventional revolutionary groups. Elsewhere in Europe socialism and Marxism were significant influences and, in some cases, were represented by major political parties. In Spain, uniquely, the radical Left was represented most powerfully by anarchism, concentrated especially in the province of Catalonia. Catalonia's capital, Barcelona, had perhaps 350,000 anarchists when the war opened. Their ultimate aims included the complete overthrow of the modern, centralized state. It was that revolutionary change, in part, that the Catalonian anarchists sought to realize in the latter half of 1936. Appropriately then, our Barcelona chapter opens with letters by Carl Marzani, an American who served not in the International Brigades but in the anarchist Durruti column at Bujaraloz. For Marzani, it was a return trip to Europe; he was born in Rome in 1912 and came to the United States in 1924.

It was Barcelona, more so even than Madrid, that became a proletarian city in the opening response to the military rebellion of the right. As in Madrid, no one would be seen on the streets in middle-class clothes in those wild, violent, opening weeks. As in Madrid, the palaces of the rich, abandoned by wealthy owners who fled the city, were taken over by trade unions, antifascist groups, or by the government. In Barcelona, the government meant more the autonomous Catalonian government, the Generalitat, rather than the central government that moved from Madrid to Valencia in November of 1936. Not until a year later, in October of 1937, when Prime Minister Negrín moved the central government again—this time to Barcelona—was Catalonia's challenge to the national government's authority substantially undermined. In the meantime most of Barcelona's great industrial plant had fallen under control of the CNT (the anarchosyndicalist organization that became Spain's largest union), with workers' committees running most of the factories and businesses that remained open. In the countryside anarchist collectives—some of them abandoning money and private property—replaced the large feudal estates.

Much more than in Madrid, the numerous workers' militias in Barcelona were resistant to being integrated into the evolving army of the Republic. In both cities these militias sprang up and seized arms for themselves in an immediate response to the July 1936

rebellion. For the Spanish Republic essentially had no army; it was in the exceptional position of needing to defend itself against a rebellion of its own professional military. In Barcelona and Madrid it was largely these people's militias that blocked the military takeover in the opening days. Elsewhere, many soon recognized the need for a centrally organized military force. In mountainous terrain or in cities, militias often proved effective. On open terrain—where large troop movements coordinated with tanks, artillery, and aviation were required—it was another matter. But the anarchists of Barcelona were philosophically and viscerally opposed to centralized authority. Meanwhile, the communists in the national government were almost pathologically hostile toward a much smaller group that had some strength in Barcelona, the POUM, or anti-Stalinist Left. All these antagonisms boiled over into three days of street fighting in Barcelona in May of 1937. For those stirred by the remarkable anarchist romance, this was the point when the Spanish Revolution was suppressed.

This was the complex political world that the Americans who spent time in Barcelona had some occasion to experience. Their numbers increased when the International Brigades' Headquarters was moved from Madrid to Barcelona in February of 1938 and even more so when the military operations at Albacete were shifted there as well. Even the American hospitals relocated to Barcelona. And, of course, training for the great Ebro campaign put Americans in regular contact with Catalonia's towns and cities. The Americans whose letters are here include some in Barcelona on leave and others who were there regularly as part of their job. In one case Harold Smith, himself a Jew, criticizes a Barcelona restaurant run by Jewish exiles.

By 1938, Barcelona, unlike Madrid, was not quite a city nearly surrounded or under siege, but it was a city under murderous assault. In Barcelona's case it was not artillery bombardment but air raids that killed hundreds each day during the heaviest periods. In March of 1938 wave after wave of Mussolini's bombers dropped delayed-action bombs on the city. They would explode only after burrowing into a building, thereby maximizing deaths and structural damage.

Still, the city was beautiful. One could walk from the wide central Plaza de Cataluña, down the tree-lined Rambla with its cafes and flower stalls, all the way to the harbor's edge where Columbus's statue stands. On some days, however, the flower stalls were empty. Funerals for bombing victims had taken all the blossoms Catalonia had to offer.

· ·

from CARL MARZANI

December 1936

Dearest beloved,

I wish you were with me in this lovely city, although the twenty-hour journey from Paris I wouldn't want to wish on you. There is no danger here, so please don't worry, only darling I miss you very much and I do hope you or I will make a little money soon, a few hundred dollars, so you can come and stay with me—permanently. I just don't

relish life sufficiently without you, lover, and that is the truth. Also it seems such a waste to be travelling about to so many places and you not with me, so we could have time together—as we were in Atlantic City together—and you talking in the middle of the night—and telling me you felt alone—you darling dope—and me talking and talking to you—but most of all loving you—which made you feel all right and more in love with me than ever—and me more in love with you than ever.

I'm writing you from the hotel at Barcelona where I am staying—2 1/2 pesetas a night, which is 25 cents American money. There is a long table here and lots of men sitting at it, half of them are militiamen in ordinary clothes but with leather belts and insignia. I came down in a train with a bunch of French volunteers, about six hundred of them. I've written a few things down and sent them to Morley to see if the *New Masses* will have them. If not, Gene will get them back and give them to you. The spirit of the people is excellent, lover, and all solidly against Fascism. It does give one great feeling of belief in the future somehow. Even if the Fascists win, which I don't think, how can they hope to kill the memory of these days?

I know this is a miserly little letter, sweetest, but I can only make amends by telling you that I love you very much and that it is difficult to write when one is tired and I am, rather.

All my love to you, my best and dearest lover, my only love and closest to me—as I myself am close to me—

Dearest I want you—in every way—physically no end—and as a companion to share my life even more—

Good night lover—may my feelings bless you.

> Ever yours,
> Carlo

P.S. In case you should happen to be in touch with my mother, don't tell her I'm in Spain. I don't want her to worry. I'm sending her my letters from London. H's mailing them for me.

●●●

from CARL MARZANI

December, 1936

Dearest beloved lover,

Here I'm back in Barcelona after a couple of weeks at the front. Nothing very exciting—a bombardment once, but it was a few miles away and little damage. There was a skirmish elsewhere and I saw the wounded being operated on; I wrote a short article for the *New Leader* in England, and I'll send it to you as soon as I get back.

The war is going very well for the reds as you probably know from the papers. The fascists have been trying and trying to get into Madrid, and although they have literally destroyed half of the city—the most barbarous event in our times, I think—they haven't entered and they won't. I feel pretty sure that they'll be broken even though Germany is still sending men, and there is an even chance of a European war if Germany keeps it up—but I don't think there will be a big war—not just yet.

It is wonderful to see the spirit here in Catalonia (a province of Spain with Barcelona

as its capital). But there may be a real civil war here after the Fascists have been beaten, because I think there is a section of the government which thinks it is going to install a democratic middle-class government like France, U.S., or England; but the workers are armed and they are in no mood to be disarmed. They are the ones who have spontaneously risen against Fascism and they all feel that they haven't shed all this blood just to change from one master to another.

This is especially true of Catalonia, which is the industrial part of Spain, the most advanced and the most revolutionary. Spain will occupy the place in the eyes of the world for the next two years that Russia held in the last fifteen. The anarchists want a communism without a dictatorship—i.e., they are the antithesis of communism—they are against parties and politics. I think they are going to find that it won't work, but I really don't know because I am woefully ignorant both of their practical experiences in the past and of their theoretical ideas. But I have some books and I'm going to learn. I haven't heard from you in four weeks, since of course I didn't have my mail forwarded, but oh, lover, how I look forward to seeing a nice little pack of your letters. I think of you every day, dearest—truly and honestly—you are always in my thoughts and I think "I wish she were here to see this," or "I'll take her here sometime when she comes," etc.

Darling, I truly am going to work hard and see if I can't get a little money so you can come here, because I am not me without you. I am not happy, lover, not really happy. I am restless and dissatisfied—but I love you.

Edith, Edith—I can't wait to see you—next best to get your letters. Write to me, lover—write a lot and tell me you love me. I'll never tire of reading that.

I kiss you,
Carlo

• •

from LEON ROSENTHAL

Oct. 23, 1937
Saturday, 9 A.M.

Good morning darling,

Indian summer still lingers over Barcelona—the Mediterranean is so beautifully blue—just like your eyes—only I'd rather see your eyes. These days I have so much time to think & reminisce and I get so nostalgic—I can hardly wait for the weeks to pass.

The leaves are falling in the park; the children feed the animals peanuts; young couples stroll in the flowered walks; the low sun warms the body—but the air has the touch of autumn;—the subway is rickety & rudimentary but it gets there; the double-decked street cars are fun—but it's different to have the rolling contact sizzling on the cable right over your head; the people rush to & from work & life goes on as usual—or as much as usual as the war allows! All these details of city life make me think of New York, of home—of being back with you.

As I've written before—I don't know yet just how my application will be dealt with. Perhaps I'll be home by New Year's—perhaps later—but I believe it will interest Bill Lawrence to know that we may be able to build sound-trucks in New York to send to

Spain. We are planning to get relieved from our jobs with the Division first—then go to Albacete and see Lawrence.

But of course—first we want to return to the front and serve thru November. The truck will be finished in a few days. We are having new wooden horns built—the motor has been completely overhauled—the roof on the truck replaced—the truck will be painted and—2 hammocks are being made—so that Sam and I can sleep in the truck— and the loudspeaker units are being repaired & the amplifier will get tests with good instruments—and a dozen other minor improvements. Then we go back to the Division base—get our winter uniforms—and then to the front where we expect to make Franco very unhappy for another month. At the front—time passes very swift- ly—December is as good as here already!

Yesterday I sent you a parcel containing a folder of water-colors of the Revolution, a P.S.U.C. magazine and a map of Spain—so you can follow our offensives. The day before—I sent you a letter containing 3 pictures.

Today—I think there is a symphony concert—if so we're going—we've seen all the movies around town—every single day we've gone to the movies!

The anti-air defense of Barcelona is excellent. Every time the fascists try a bom- bardment—our lights & guns make it hot for them & they have to go back to Majorca & drink more beer! I suppose the American press is playing up the Asturian situa- tions—but the fascists have taken all the territory they can take—from now on they're going to be giving it up—our army has just begun to fight!

I'm anxious to get back to Aragón because there must be several of your letters wait- ing for me—then I'll write a longer letter. There isn't much to write about from here— good food, movies, lots of sleep, some cake & candy & lots of beer, snails, anchovies, clams, mussels, crabs & the best of fishes.

Sam & Joe have gone uptown to the truck—I stayed behind to write this letter and now I'm going to take a nice quiet walk in the zoo & feed all the animals peanuts & make believe you're with me & nobody will rush me. It's a date—meet you at the lion's cage—you cat!

So—until we meet in the zoo for real—have a nice, mushy kiss, a very close-cling- ing hug, a hair-tousling caress and a couple of spanks to bring you closer—hold it— tighter—I love you,

 Leo

•••

from LEON ROSENTHAL

 Barcelona—Tues. Oct. 27
 [1937]
 8:30 A.M.

Lee darling,

Good morning, honey—just finished my breakfast of bread & butter & will have a little chat while there is time. As you see—we are still in Barcelona—it is a rainy day— just the kind we could spend so pleasantly together indoors—I would make pop-corn & spaghetti—you might bake a cake—we'd listen to the radio, read, play & pass the day together. But, unfortunately I have to find other ways to fill my time.

Saturday morning I sent you the last letter. I've also sent one containing pictures and also a package of drawings. Saturday afternoon Sam & I went to a symphony concert—given by the Catalonian Symphony Orchestra. It was nice—and a very welcome novelty to us. They played Beethoven's 7th & 3rd overtures—admission is free—but we were surprised that the hall was not crowded. Sunday we had the choice of going to a symphonic band concert or hearing Luis Companys speak—so instead we took a trolley to the edge of town & then a cable car up to the top of Mt. Tibidabo—where there is an amusement place—high overlooking Barcelona. It is one of the most beautiful natural scenes I've seen—the coastline—the Mediterranean, the mountains—the beautiful city & harbor—really unusual. On the hill are amusement devices—an airplane flying on a girder, high & thrilling rides, penny arcades, etc., etc. There is a nice woods for picnicking & necking & families & couples overran the hills.

We are no longer staying in the hotel—but it was very good while it lasted. You see, our resources proved to be unresourceful, and so the last couple of nites—we've slept in our truck. Two excellent hammocks have been made & we have our place to sleep wherever we are. They are still working on the truck—fact is—I'm in the garage right now—writing this. We will be here a couple of days longer to complete everything. The sound truck has been altered until it is unrecognizable—every improvement we ever thought of has been incorporated—and more. Our experience will affect the construction of future sound trucks & we are glad of that.

As I've written—Joe, the chauffeur, has brought a new & very good camera. We've taken some pictures & as soon as we have them developed & printed—I'll send them.

This afternoon, we shall probably go to the Tivoli theatre—which is Barcelona's "Follies"—since we've covered all the movies. At present I don't know where we're going from here—because of new developments, but as usual I'll write as often as possible. No doubt there are letters waiting for me & I'll answer them as soon as we get to the division base—where the mail is. I hope you've gotten all my letters—this makes seven—two on the 15th—one on the 17th, 19th, 21st, 23rd, & this one—and a package—ain't I a good husband for writing so regularly? If we are here longer than 2 more days—I'll write more from here.

That's about all the news—darling. I'm feeling well—eating ice cream, drinking beer—going to shows—it's a nice vacation—but we've had enough & are anxious to get going. At the front—the weeks will pass faster & bring us together again. Be patient & wait for news about that—as soon as I know anything, I'll let you know, of course.

Yesterday—the children of Barcelona were avenged—two fascist bombers were brought down over the city by our pursuit planes—Salud! & more power to our "chatos"!

I'm watching the developments in the Non-Interventions committee closely—even tho odds & our experience are against it—something may come of the negotiations. But—will soon see!

Now—honey sweet, I've got to kiss your pouting lips good-bye again—I'm sorry we can't spend more of this rainy day together—but don't pout & cry—we'll be together for good soon & I'll never leave you for such a long time again.

So—now a kiss & tight bear hug & so long, my chubby—until next letter. Give my love to your folks & revolutionary greetings to all comrades.

So long, honey & Salud,
Your Leo

• •

from LEON ROSENTHAL

Barcelona
Friday, Nov. 5, 1937
10:30 A.M.

Lee honey,

Here we are at last—since last Saturday I haven't written you, expecting each day to leave here & return to the division but the truck had many things to repair and the days flew by. Today is 3 weeks that we are here and I think we will finally pull out of here this afternoon.

Winter is fast coming on us—the nights are cold now & the days too—unless you stay in the sun. I'm sitting in the sun now—on a rock up on top of a hill overlooking Barcelona—I have my first cold of the season and the warmth of the sun feels so good on my face. Below, down the gentle slope of the hillside, stretch the Exposition grounds (1929 Exposition)—I just came up thru the grounds to reach here. It is a world of magic & beauty—it must have been a real fairyland during the Exposition—the beautiful buildings, pylons, waterworks, flowers & trees & grass and the serene grandeur of Barcelona lying below & the mountains around—Lee, I wish you were here beside me now. Lack of companionship is what I feel most & I am glad of the few chances like this when I can be all alone—with you. 24 hours a day, 7 days a week I have to look at dear little Sammy's grim face & observe & stand for his "tough" & cocky behavior. Really, I have tried everything possible, but I cannot instill in him character that's been lacking all his life. As I wrote you last Saturday, I intended to leave the sound truck & go to Albacete & arrange for my leave—but it is too early—I don't think I could get it yet—so I'll simply exercise patience as in the past months & wait for the proper time. The main thing here is the struggle against fascism & comrades have made much greater sacrifices than that in this finish fight!

I've spoken to quite a few comrades passing thru here on their way home and it seems seven months is about the accepted minimum, except for special comrades who are sent home to do political work. So that means—if I wait & apply in the ordinary way—I'll still be home in January—but I'll probably be able to make it before then & still hope to keep that New Year's date with you. In my letter of Oct. 15th I also explained the situation to you—and as I know more about it—I'll keep you posted. Now I'm anxious to get back to the division, because in 3 weeks at least 5 of your letters must have accumulated for me. (I am anxious to know if you are well, if you are still working & if you are able to get along—because if not—I'll have to go to Albacete & take it up there—also I am anxious as to how my mother is—but tonite I guess I'll have all the news.) I hope you've gotten all my letters (this makes *nine* from here)—because I can imagine how you feel as the days drag on with no word—I've sent you some pictures & a package of drawings—I have more pictures & I'll send them thru the IB mail.

Lazily the delicate cirrus clouds float across the deep blue sky, the birds chirp gently and underneath is the deeper sound of drums, the recruits drilling below on the

Exposition mall—the distant sound of auto horns & street cars fading as the wind shifts—the sun so good, so warm—everything seems unreal far away—only your imaginary presence—sitting here with me as I exchange my thoughts & feelings with you—it is so quiet & peaceful—we could talk for hours.

Yes, darling, time is piling up between us—we never imagined we'd be apart for so long—but everything has its beginning, its middle and its end—when the time is up & we are together again, we can make up for lost time & both have the added satisfaction of having done our bit against the monster—fascism! I am glad that I came here—the tales of heroism & courage & sacrifice that I have heard here convince me that this is the place for all those who want to build a better society & a fuller life—of course it is regrettable that Sam has to be in the picture to leave such a rotten taste in my mouth— but it is my fault—I should have nipped that mistake in the bud—last May!

Well, honey, once again we have to part—but I'll write you tomorrow or Sunday— after I've read all your letters. In the meantime, keep your chin up—be patient & be assured that it won't be much longer now—I want you & need you as you me and we won't be apart one day more than necessary. So—here's the usual "paper & ink" kiss & hug, & wait quietly for the real thing. So long, my sweetest, darling wife.

<div style="text-align:right">

Your
Leo

</div>

from CANUTE FRANKSON

<div style="text-align:right">

General Military Hospital
Barcelona, Spain.
February 28, 1938.

</div>

My dear:

Since I last wrote to you, about a month ago, I received four letters from home; but, strangely, none from you. I cannot help wondering what is the matter, always hoping that nothing is seriously wrong with you. A thousand thoughts have gone through my mind, however. Though I'm always hoping for the best, there's ever that feeling that something is wrong. I still expect to hear from you soon. Sometimes I think you may possibly be ill and cannot write, sometimes that someone may be destroying your letters, then other times that my mail is being held up somewhere in this country.

I've been here about two weeks and am learning to like this city with its beautiful gardens, large, crowded promenades, artistic parks and gay life. One hardly feels the atmosphere of war. But for the heavy sprinkling of uniforms and the wrecked buildings one would think there's no war here. There's evidently no sign of struggle.

In, and near, the Madrid sector the people live in an atmosphere which advertises the struggle. They seem to express a real revolutionary attitude toward their fight for freedom. The profiteers are out of business. And exploitation is a thing of the past. Here all this is foreign, as business and entertainment, in fact, the general behavior of the people is like that of a nation not at war. Even the word "SALUD," which takes on such importance in these other sectors to which I referred, is not used. The raising of the fist, which is even common among the small children, is also not practiced here.

I was out yesterday to see some of the buildings which the Fascists destroyed last

month. It seems as though the wanton destruction of their homes would have a tendency to wake these people up, but it hasn't. Some of these buildings were six and seven stories high. This can be told by the remaining walls which stand like ghosts among the other partially destroyed buildings. In some instances large sections of these buildings remain standing with the parts cut away exposing furniture and other household objects which had not been taken away. This reminded me of some scenes in a comic strip. Only this thing here is no comedy photographed in miniature for entertainment, but traps in which hundreds of women and children had been killed while they slept, by the bombs from the planes of German and Italian Fascists. Then, there are three large holes on Catalunya Square where some of the bombs had fallen. And as this square, like all these places in this country, is always crowded with thousands of men, women and children—mostly children—sitting, strolling, and playing, one can imagine, and not be surprised at, the large number of victims during these air raids on Barcelona.

Fortunately, for the past three weeks there have been no raids. This gives the poor people a chance to clear up and do some emergency repairs. Most of the bombs during these raids fell in the section where the working people live. And of course this is the most congested area. But why should the Fascists choose to bomb these areas? You would only have to review the facts I have already presented to you in some of my former letters to understand why.

Their main reason is to terrorize the population. But they are meeting with failure. Because instead of terrorizing the people, as the Fascist butchers anticipated, the people are learning the value of unity. Each bombardment brings them closer together. Even those of the population here who have remained more or less unconcerned are beginning to take a decided stand against the invaders of their land.

These ghostlike walls; household furnishings perched on the edges of broken floors; kitchen utensils; tables set for meals which were never eaten; the blood which stains the walls from which human flesh had been scraped have brought the people of Catalunya to a consciousness which is growing more evident everyday, despite the outward appearance of things. And, incidentally, they are all nails in Fascism's coffin. Such barbarisms can never rule the earth. Even though democratic governments declare an arms embargo on Spain, while the rebels have a free hand at purchasing all the bombs and other war materials they need for the destruction of Spain; while the blood of its women and children run on the streets of Barcelona; these mad men will not rule the earth. Because these people are putting up a brave fight and will not be crushed. They are writing a marvelous page of heroism in history, and putting to everlasting shame some of the governments of these so-called democratic nations. They continually bow before the Fascist war-gods while the Spanish people fight courageously for the liberation and salvation of all of us.

Barcelona has been bombed and many of its homes have been destroyed. Hundreds of women and children have been needlessly slaughtered. Spain is being bathed in the blood of her children. But Spain will find laughter. She will win freedom and happiness. She will live joyously into the coming years; will build a wholesome society from this wreckage in honor of her dead, which will stand out as a living example to the future generations. This will survive the years and be beneficial to the human race centuries

after the carcasses of these vile butchers have rotted and their wretched names have been forgotten.

I hope that you are well and that you have received my letters. Above all, I hope that you are working for the cause of Spain, and for the forces of progress. I'm not at all well. Some days I have severe attacks of pains. These pains are taking a lot of my energy. I'm thinner now than I've been as far back as I can remember. The doctors here can do little for me. In the first place they are short of equipment. In the second place they're over-worked. Love and regards. Write to me. I'm dying to get a letter from you.

> Love and warmest regards.
> As ever.
> SALUD.
> Canute

• •

from EDWIN ROLFE

April 10—Leo-I've decided to send
this on after all—It's now about
3 1/2 weeks old. *Ed*

> S.R.I. Plaza del Altozano
> # 555 E
> Albacete, Spain
> [Barcelona] March 17, 1938

Dear Leo [Hurwitz]—

I haven't written to you for a long time, and I probably would not be writing to you now, but for the fact that it's impossible to work at the moment. Since 10 o'clock last night I've put in exactly five hours of fairly solid work (it's 7:35 p.m. now). I would have been able to work two or three times as many hours but for the frequent visits of the fascist aviation. If you were here, or I at home, this would be one of the occasions when I'd interrupt you in whatever you were doing to get a lot of things off my chest. Until the siren warning against aviation bombardment sounded through the city last night, the bastards hadn't been around for five full days. And the sense of security was strong in all of us, although we were speculating about the extraordinarily bright full moon and what use the fascist planes could make of it. Well, they came over at 10 p.m., and immediately all lights were switched off. We went down to the first floor and stood at the entrance of the house for a while, then walked over to a makeshift trench we had dug in the yard. It's pretty deep, about seven feet in spots but we all know damn well that if anything struck within 50 meters it would be no protection at all. We heard the bombs thudding in the distance—about a mile away—and then the sharper double explosion of anti-aircraft shells. The sky was so bright with the moon that we could even see the white puffs of smoke where the anti-air shells exploded. Soon the whole horizon behind the buildings was red with the glow of a fire—one of the bombs had landed not far away. Two of us, the fellow who works with me on the *Volunteer* and I, went to a house nearby where an English discussion was scheduled. We found about 20 comrades in the room, lights out, windows open. We talked for a while, then decided

we would go to the places where the bombs had hit and help with the rescuing. By this time both the bombers and the anti-aircraft were silent. We started walking, a group of about ten of us—four American, four Canadian, and the others Spanish—in the direction of the burning and smoking buildings. On the way there, the planes came over again, and the anti-air opened up. We walked single file hugging closely the sides of buildings, and making a dash across the street when we came to an intersection. The air is full of falling shrapnel when the anti-air guns are going, and it's best to get close to something that will break the direct fall of fragments. I forgot to mention that we had a minor casualty in our own house—a falling fragment, bright and hot, came down on our street, and the glow of it terrified one of the women who works in the kitchen. She picked up her four year old kid, and made a dash backward into the house, blindly, in the dark, and she crashed against a wall. Both she and the kid were hurt somewhat— it was a terrific crack. But all we did was console them with a few words. We kept going, single file, in the streets, until we reached a house that had been hit. There was a large crowd around it, and the guards kept cautioning us to watch out for fallen wires. We jumped over a few, ducked under others. We reached the entrance, after passing many guards by uttering the magic words, "Brigadas Internacionales," just in time to see a couple of women being led out. Both were walking, both as if in a dream; they were in a state of terrific shock—and I understand the bandages around their heads and ears were to prevent further blood-flowing in case of new bomb crashes and subsequent irritation of the original concussion. The steel-helmeted rescue workers were already on the job, and they let us in without delay. The hall and all the stairways were filled with broken glass which we crunched to smaller bits with our heels. We went from room to demolished room, but there was nothing for us to do; the rescue squads had got there way before, in cars. So we left, passing, a few feet from the house, a spot where another bomb had fallen. It must have been a small one, not over 100 kilos, because the crater in the street was no deeper than three feet and the circumference no more than six or seven feet. We decided to go on to the next place—a few blocks away, where another bomb had found its target. On the way the *avion* starting bombing again, and again the anti-air answered and we saw the green signal flares for the anti-*avion* guns in the sky not far from us. It reminded me of the fireworks display I saw at the Washington Monument on the Fourth of July two years ago. The other wrecked building was a low one, nobody had been hurt, only half of the long structure completely demolished. It was still burning inside. We stayed there a few minutes, offered to help in whatever way we could; were thanked for the offer but told that everything was under control. By this time it was about 11:30 and we decided the best thing to do was to go home and get some sleep. We started, and four times on the way back we had to stop and take cover against buildings. This isn't actual cover; if anything hits directly only a *refugio*—a bomb-proof shelter—is certain protection. But it makes you feel good, and a bit safer, when you're against something solid like a thick wall. Once we even stopped under a canvas awning, and all of us felt safe. And back at my quarters again, I ran into the house, also feeling safe. But the feeling vanishes in a minute, as soon as you begin to think. To enter a building is to expose yourself to falling brick and beams and mortar, to glass shattering under the concussion of the exploding bombs. In the United States the inside of one's home, or one's apartment, is equivalent

to complete safety. Here it's much better in an open field than in a large city. You can take cover by stretching flat on the earth, face downward; and there are many foxholes and other declivities around. And you only have to think for a little while to realize that you're not safe; you just wait, and greet each bomb-thud with mingled pain and relief and rage. And you stand and listen to the bomb whistling downward, and wait, and wait, and when you hear the explosion you know that you personally have escaped again. Then, if you consider the laws of averages and probability related to aerial attack, you can build up a sort of mental immunity. We went to bed when we got back, but the bombing wasn't over; it continued, at irregular intervals, all night long. We stayed in bed, although the impulse to jump up and run every time the siren sounded and the sound of bombs falling reached us was almost irresistible. A third occupant of the room, however, put on his heavy boots, and kept walking up and down, as he always does on nights like this, cursing under his breath, muttering "schweinerei, schweinerei!" On previous nights I had been a little sore at him for waking us, but now I found myself cursing too, wanting to pace up and down too. We were all on edge, starting and almost jumping at every sound…. It's a day later now (March 18) and I've just had my morning coffee and bread. The whole day yesterday, and the whole night too, were the same, only worse. The *avion* came over eight more times: at 7:30 a.m., just as we were rising; at 11 a.m., while we were working; at 2 p.m. while we were having lunch; at 7 p.m., just after dark; during the night at 10:15 p.m., 1:15 a.m., and 4 a.m. And it roused us this morning at 7 a.m. again. Each time, by a pre-arranged decision, everyone in the house dressed and went down to our little trench every time the siren went off. Most of us, I included, slept in our clothes, removing only our shoes. The moon was full again, and enabled us to see the planes, thousands of feet high, on one of the raids. Another time they descended so low that we could hear their motors. They hit a church, about a block and a half away from us, and we went over and saw them remove a dead body and two women, one with her foot amputated, the other with her thigh ending in a stump of blood at the knee. (That last sentence was begun at 9:20 and finished at 9:40. The alarm sounded again, and we had another short air raid.) They got many buildings in the crowded workers' section of the city. This morning's paper says 400 dead and 600 wounded; and that's only a partial, preliminary count. It's a fine, sunny morning, with just enough early mist over the city (it's almost always misty in the morning along the Mediterranean coast) to permit planes to come over at high altitude, unobserved till they're almost upon us….The sound of an explosion close by, or the sight of a man lying on the street covered with a blanket, blood slowly oozing away from him, or the whistle of a bomb descending, is horrible. And between times every sound sets your heart beating furiously and violently, and it continues to beat even when the sound is gone. There have been other bombings, but none as consistent and brutal as these last two days of steady pounding from the skies...Well, what I wanted to talk to you about was the nature of courage and cowardice, intermediate states, effects on human beings of different kinds of tortures. Instead I've only told you the introduction. I have work to do, and it's almost ten o'clock, and we must put in as much time as possible between bombardments. I'll have to let the real discussion go till I see you again.

<div align="center">Ed</div>

● ●

from CANUTE FRANKSON

Barcelona, Spain
March 18, 1938.

My dear:

I came here expecting an operation. But fortunately—or unfortunately—the doctor told me this morning that I would not need one. Fortunate, because I've had two operations already for the same thing. Unfortunate, because since I need not have the operation I must have some other treatment, and there are no instruments here for that kind of treatment. This means continuing with these terrible pains without knowing for how long.

Since this is the largest, most modern and best equipped hospital in this country it can only mean one thing. I will be sent out to some other country for treatment. Perhaps France. The sooner this happens the better for me. Not only because of the physical suffering, but I surely would not like to go through another three days and nights like these which I experienced since Wednesday night I think it was. I can hardly keep track of the days, but I think it was Wednesday.

We are enjoying a twenty-four hour rest from a series of air bombardments which may be an all-time record for Spain and perhaps for any other country. At least I hope no other city will ever have to suffer what we saw here.

My first experience in Colmenar Viejo was like a nightmare to me. I thought that the bombing of that town was too terrible for the human mind to conceive, and that I had seen man at his worst. Since then I saw Denia under bombardment. Though this was about six months ago, I've never been able to figure out just why they bombed that little peaceful seacoast town. Later, I experienced fifty-five minutes of shelling of Alicante. One feels ever so much helpless under bombardment in a city. One feels trapped. This was carried out by three battleships. I saw quite a few in Madrid and about three in Valencia. I have seen and been through many air attacks at, and near, several of the fronts where I'd gone on convoys. I considered myself quite a veteran. I was thoroughly convinced that I had seen Fascism at its worst. But these three days and nights in this city have completely changed my mind.

There was the destruction of Durango which headlined in every paper of importance. Then, there was the complete devastation of Guernica, the holy city. It is known throughout the world that this city had no military significance. But nevertheless the Fascists attacked and destroyed it. And of course killed hundreds of its women and children, as usual. Many were killed while on their knees praying to the heavens from which murderous bombs fell to snuff out their lives.

The first of the attacks here was four nights ago, about nine-thirty. They raided all through the night until about five-thirty. The following night they came about the same time. During these two nights it was bad enough, but not many people were killed. The anti-aircraft batteries kept them up so high they could not do any concentration. But they came back at about ten o'clock the morning of the sixteenth. That was the day before yesterday. And with better visibility they began to set their record of destruction. All through the day before yesterday, then through the night, and through the entire day, yesterday, until between four and five in the afternoon bombs rained down

on Barcelona's population. The day before yesterday I was in a large building at a meeting when a bomb fell within about a hundred feet of the room where I was. Many girls were badly wounded from broken glass and falling plaster. There were many wounded within the area, but fortunately, no deaths. This was because the bomb fell on the avenue which is very wide and was deserted. The fact is, there were very few people on the streets during those hours.

After the anti-aircraft guns ceased firing three of us followed the trail of one of the ambulances to one of the thickly populated sections known as the Bario Chino. When we reached near the wrecked buildings the guards stopped us. But we managed to induce a man living near to let us look from his balcony. He agreed, alright. But I'll say this much, that as long as I live I'll always regret having gone up those steps. Because what I saw from that balcony was never intended for my stomach.

The streets along this section are very narrow. The buildings are high and very large. Some of them have more than a hundred people in them. In every case there's only one entrance. And the staircase is generally poorly lighted. Because of these factors it is very difficult to evacuate these buildings when the siren gives the warning. So, you see how many of these people must naturally be trapped and slaughtered in these places. And when one of the large bombs strike in these congested areas every house within a radius of three hundred yards is damaged; some to the extent that they are unsafe to live in.

From the balcony we could see the rescue party at work. They were removing the debris as fast as they could, rescuing the wounded, giving them first-aid when and where possible, and piling them into the ambulances. As soon as the ambulance gets filled it drives off and another takes its place. The dead bodies were thrown into the trucks. But what got me was the grief and fright which registered on the faces of the dead and wounded and the heart-rending screams of the women when they came face to face with the mangled parts of their loved-ones. Several of the bodies were blown to bits. Here a leg; there an arm; a few feet away a head; and against one of the remaining walls the mangled trunk of what was a human being. I watched the men shovel the small pieces of human flesh into baskets then throw them into the truck. And as they scraped flesh from a broken door which was not far from the balcony I felt my stomach coming out of me. I staggered to go back into the house but it was too late. My feet went from under me. The men caught me under the arm and helped me up, but it was no use. I hurried back here to the hospital and went to bed.

Since the government planes came and are patrolling the air there has been a lull. These unfortunate people now have a chance to remove their dead and to bury them. While we were on our way up yesterday the planes came back, and of course dropped some bombs.

There may be words with which these scenes can be described, but I'm sure I don't know them. All I can say is that it is horrible. And all these people have been slaughtered because the democratic governments have chosen to refuse selling the government of Spain the airplanes she needs to protect her population from these Fascist butchers.

The blood literally flowed on the streets. Everywhere the marble slabs are stained with the blood of mostly women and children. These stains will remain for a long time

as evidence of Fascist degeneracy. But though time may remove them, it will never help those of us who saw what happened in Barcelona to forget. And you may be assured that we will try our best to teach as many people as we can the evils of the system which breeds such filth. So far as we are concerned money will never be permitted to accumulate in the hands of a chosen few. No human who saw the results of these bombardments could ever be a supporter of Fascism.

Between bombardments, the day before yesterday, the people staged a demonstration, which was very significant. To one who was not in Barcelona this may seem quite impossible. Nevertheless, this is a fact. Thousands of people marched out on the streets. I was on my way back to the hospital when I heard a loud singing. Stopping, I saw these same people whom the Fascists thought they could demoralize, marching with banners, and flags. Every slogan they carried was in support of the government and a pledge to support it until victory is won. Can you ever imagine such a people being beaten and enslaved?

Today, many thousands have deserted the subway and the outskirts and are returning to their homes. How can people be so courageous? By all indications I'll soon be on my way home. Then, I'll be able to describe these things better.

I hope you are well. Give my regards to all. With warmest affection and hope to see you real soon.

> As ever,
> From your old friend.
> Salud.
> Canute

· ·

from DAVE GORDON

May 15, 1938

Dearest Lottie—

I imagine food has been a problem as old as the history of living things. You'll grant that makes it a rather old subject. Yet with new conditions, in a new setting it becomes a new problem. Let me give you some facts and impressions about a food question here—and its partial solution——Barcelona had a food problem. Prohibitive prices prevented many from eating as they should.

The Department of Economy of the *"Generalitat"*—the Catalonian parliament— planned action to solve the problem of speculation and to provide economic eating establishments, or *"comedores,"* (a much simpler way of describing restaurants, etc.).

The *"Generalitat"* called in representatives of the food industry, hotel and restaurant owners, and Food Union chiefs. Within twelve days a solution was arrived at and had begun to be put into practice.

On May 12th, one hundred and seven *comedores* were established under the new rules. *Comedores* were divided into two classes—"A" and "B."

Class "A" *comedores* serve meals at ten pesetas and class "B" at five. There are eighty-nine of the "B" and eighteen of the "A" types, both serving substantial and well prepared meals. In addition to these, six special places were opened for foreigners.

These restaurants of economy are able to serve 40,000 meals daily. Add this to the

25,000 meals served daily by the popular restaurants and we have a formidable service rendered the people of Barcelona.

This is only a beginning. The plan for establishing *comedores* of an economizing variety proceeds, now, to be introduced in the urban and industrial centers of Catalonia.

Further, a canvas is being made of movie houses in the workers' quarters of Barcelona where special *comedores* will be established in order to provide free meals to children of widows and orphans of war. More than that, they will also provide at least one good meal each day to the children of Barcelona workers.

The aim in this last respect is the fulfillment of Point X in the Thirteen Point Declaration of Independence, made April 30th. This clause states—

"The cultural, physical and moral improvement of the race will be the prime and basic concern of the State."

The solution of the Barcelona public food problem and that of feeding the children is the cement with which the Spanish Republic is building its structure as a pure and durable democracy.

I hope the above facts interest you and others. It may not be the most picturesque of subjects but it is an important problem.

Today I finished the draft for our China number. The work in gathering the facts was very instructive. I haven't made as consecutive and as comprehensive a *study* of China—not just a simple keeping-up-with-the-facts—since 1927.

I think I'll close now and arrange some of my Elk Hunters Club material.

Love,
Daviexxxxx

••

from SANDOR VOROS

May 19, 1938

Dear Myrtle,

It's been a long time now since I've heard from you last, and I am beginning to worry about it. In your last letter you were still without news from me, which was addressed in your statements about your growing anxiety. I am afraid Steve Nelson couldn't give you much information for he, too, was begging for news in the letters he had sent to the boys here. Something must have gone wrong with the mail in our last actions, which might account for the delay in outgoing mail. Most of our comrades complain that their families haven't heard from them to the date of their last letter.

There is much to write and yet very little. Many things of interest would touch on the military and therefore they are not to be subjects of letters for obvious reasons. Our daily routine, always changing and yet the same, continues with regular monotony. Last Saturday afternoon I had the good fortune to travel around a very long stretch of the sector held by our division. It was a most enjoyable though nerve-wrecking trip. The hazards were not those contributed by the enemy but those of the terrain. Riding up steep mountains over muletrails that kept twisting and turning and backtracking every fifty yards or less—navigating curves where we had to back up a couple of times to make it with deep gullies stretching invitingly and menacingly below—soon one felt dizzier than riding the steeplechase. From time to time we passed stretches that were

under observation to add zest to the trip. Afterwards we wound up on the sea shore and was it a real thrill to see the good old sea again! The road from there to Barcelona was perfect—we spun along with the speedometer registering ninety and hundred kilometers per hour most of the time. It was a brand new Renault and it performed beautifully.

Spent two days in Barcelona, slept once more in a bed between sheets, naked, bathed, shaved, reading propped up on a pillow—what a luxury.

Barcelona presents a sight like Madrid—houses, big buildings destroyed everywhere, food rationed out, cabarets, bars closing at nine–war as reflected in the hinterland. But the spirit of the people needs nothing to be desired, volunteers are responding to the call of the country spiritedly, youth divisions are forming—everywhere optimism and full confidence in our final victory.

Had dinner with the secretary of the "Free Women" organization, a young handsome girl of twenty-one whom I met May 1 when she was a delegate to our Brigade. The organization of which she is regional secretary has over ten thousand members in the province, mostly women who had never gone outside of their home circle before the revolution. It is an anarchist organization (I am sending under separate covers copies of their publication with pictures and hope you won't be affected by their ideologies).

Contrary to my expectations she wasn't at all what the name of her organization implied. She laughed very much when I explained that "Mujeres Libres" can be translated also as "Women Gratis" and told me to stick to my original translation which settled that.

That's about all I can report for the present. I am disgracefully behind my correspondence. There are at least ten letters to be answered, including one to my sister. It is ten-thirty now and my candle is still good for another two letters, so goodbye sweetheart.

<div style="text-align: right">Sanyi</div>

· ·

from AVE BRUZZICHESI

<div style="text-align: right">

c/o Ayuda medica extranjera,
Rambla Catalunya, 126,
Barcelona
June/9/38

</div>

Dearest Tommy:

Your letter of May 23 came two days ago, in record time. The same day I was in Barcelona and mailed a letter to you. This one will likely be the last one from here, for I plan to leave in a week or so. I went to Barcelona to get my papers straightened out for leaving and I hope to get them back in a few days.

The last days have been hot and with clear moonlit nights, so that one can see out to the Mediterranean with the white houses of the town shining along the shore in the moonlight. That always means aviation, and we got what we expected;—not we, but Barcelona. We are some twenty miles away. Every night they'd begin, one would hear the bombs over the hills that divide us from them, and then the warning sirens would

blow, and looking over the hills you'd see the red flares, and the flash of the anti-aircraft guns, and the windows of the house would rattle and the walls shake, here, twenty miles off. Between the peals it would be still; except for the frightened noises of little creatures, almost more frightening and dreadful than the dreadful big explosions themselves: the frogs would croak wildly in a symphony like a witches' night from *Faust* or *Macbeth,* and dogs would howl and bark, and birds call and fly about. The people in the hospital, patients and personnel would get out half-dressed, and stand around in the moonlight, looking at the smoke and the flashes. For the last four nights heavy clouds of black smoke and sullen fires from burning oil tanks fill the sky, coming up like smoke from a volcano, in a thick black funnel from the base of one of the hills, and spreading, less black, but still smudgy, over the clear and moonlit sky, obscuring miles of it, but not obscuring it enough. They haven't come tonight as yet, although the moon is but a day from full, because the sky was covered with black clouds, and we had lightning and now it's raining. So that's a blessing for many poor people.

A few days ago, during an early evening alarm I was on the top of a little hill behind the hospital, among the rocks and pines, where I often go for a walk. A whole troop of little girls came running up through the wood, and grouped themselves over the stones like gnomes, chattering and calling to each other and looking over the hills, pointing out to each other where they thought the damage might be.

The hospital has been rather quiet. Today I went back to the place I was at before to see Larsen, who is up and around and fever-free, with a big appetite; also Tom Hayes, still somewhat peaked but also up and around.

Cleo Duncan, the anesthetist of our group, of the San Francisco Hospital, left a few days ago for Valencia by boat, to work with the Spanish Army Corps we were with before we came up North. Lots of courage that girl—never the bat of an eye—I didn't feel very happy about her leaving by boat on a moonlit night, but I think she made it alright, for she's been gone for four days now, and there have been no reports of damage to the vessel she was on.

Saw the T.S. yesterday night, shining out among the clouds, and then going out again, like a little Tommy bug. I hope we see him together soon. Lots of hugs.............

Your,
Ave Bruzzichesi

• •

from HAROLD SMITH

July 22, 1938
Barcelona

Dear Jeanette,

Had some business to attend to, so here I am in Barcelona on a flying visit. I presume that you have received my last letter in which I told you that I had rejoined Brigade. The mail travels so slowly these days, that one is never quite sure of what is happening back home. Being 2 weeks behind in the news isn't so bad but when it begins to stretch out into months—

But right now I'm sitting at a sidewalk table in front of the Restaurant Versailles. I've just finished eating a dish of snails and am wondering whether I should buy another.

No I won't, because I'll eat very shortly. I'll confine myself to finishing my glass of Malaga. The Restaurant Versailles is on the Plaza de la Universidad, almost in the center of the town near the Plaza Catalunya. The Plaza is quite a shopping center. Really well-appointed stores of all types. The way the crowd hurries back & forth makes me slightly homesick. If it weren't for the overwhelming preponderance of uniformed men & [censored] it would be too much like 14th St. to bear. Especially—(Now read this carefully)—Especially when in a few minutes I will leisurely arise, pay my bill, and saunter over a few blocks, walk up a few flights and in my best Yiddish order a complete Jewish meal from *"Vorspice* to *Kompott."*[1] Can you imagine that—here in Barcelona a real Jewish apartment restaurant? I succeeded in finding it a day or so ago when I arrived and since then I've been gorging myself there with all sorts of things that I had almost forgotten. It's like going into another world when one goes up there. It's run by a typical Jewish family and is exactly similar to a dozen attic apartment restaurants of the same type I've eaten in in New York. As a matter of fact there used to be one—1 flight up on Steinway—near Grand. The similarity indeed is too great and in one aspect not pleasingly. Part of the clientele of course are Jewish boys from the I.B., but the majority are Jewish civilians, refugees mostly from Germany, etc.—some of them are people I decidedly dislike. Spain had given them refuge before the war, a place where they can hold up their heads and live in peace. Now Spain is at war with exactly those people who have and are persecuting the Jews. But do you think these bastards would do what one would expect any man to do—join in the fight? Some of them did perhaps—but the majority of specimens that I've seen are too busy with their speculating, with their jewelry trading, with their black market transactions, to care. Not even productive work but trading—depending on turnover & shortage for their profit. I'm speaking about duty only as Jews, as nothing else. As Jews who can't see beyond the ends of their noses or, to put it better, who are more concerned with their little miserable immediate selves. It's good to know that we have others of a different type who have proven themselves in the I.B. If I had my way I'd run this whole kit & caboodle out—and if you did run them out they would probably squawk to high heaven that they were persecuted. They won't become Spanish citizens because that would make them liable to the draft, and some I know definitely are gypping the Associated Jewish Charities, which aids Refugees. The ones I see are doing all right for themselves—paying the very high prices that this restaurant charges, eating there day after day. A soldier can do it because we blow a couple of months pay on a 3 day leave—but very few honest civilians can. Bah! They're a disgusting lot. But their food is delicious, especially after the anything but appetizing menu of our daily life. I'll finish this when I get thru with lunch—until then *love*.

I'm up there now and I have to wait a few minutes so I'll continue—The reason this place made such an impression on me (that is besides the food) is that the atmosphere stirred so many old memories. I had almost forgotten that people of this type exist. It's true of course that there are numbers of them among the Spaniards—that is, people out to make a good thing even of war and disaster—but they were outside my contact. These are so like people back home I know—but of whom I had ceased to think. In a

[1] In other words, from appetizers to dessert.

way I'm glad of the reminder, because it brings back to me the difficulties of work back home, which one accustomed to the black and white realities of war forgets at times.

But enough of that. When I finish this meal, I'll go back to my hotel and take a siesta. At 4 I'll amble over to the Grand Metro near the Plaza Republica and begin waiting for the *camión*. I'll probably have to wait twice as long as I anticipate—this being Spain. However—by midnite—I should be back in my own little *"chebola"*—home-made hut to you—trying to pretend to myself that the Spanish earth is as comfortable as the Spanish beds. In the morning I'll get up and everybody will clamor around me "Did you get tobacco—tobacco—tobacco?" And I'll have to admit that all I could get was a pouchful, which will be just enough for Rico—myself—and some for Jack Boxer—We don't get any tobacco at all now—I've been smoking potato leaves along with everybody else—potato leaves are high class, much better than ordinary leaves. A pack of Luckies costs 60 pesetas in Barcelona—and are impossible to get—Spanish tobacco of the vilest type is at a premium. So when you write use a big manila envelope and put cigarettes in and—Just finished the meal—listen—chopped eggs & onions—*kartoffelsup*—*Weiner-schnitzel* with cucumbers—*Kompott*—Don't know how the bastard does it—He charges enough—but food is very difficult to obtain—you know—Are you interested? I've been rambling along in a fashion that's probably hard for you to follow.

Here's some news: Moe Fishman should be home by the time you receive this letter. He left the hospital for Paris about 2 weeks ago. When he gets home give him my regards and tell him to write to me. I remember a long time ago (ala Florence) you mentioned in one of your letters that Jean (the Buxom one and so young) asked about a fellow named Leo Markowitz. Well, we had known each other all along; indeed we came over on the same boat. The other day I'm sitting outside Rico's chebola, chewing the fat, and he rushes over and says "Are you Harold Smith?" So I said "Of course," and he said "Jeanette's Harold?" So I said "I don't know—I used to be." So he said, "Christ, imagine knowing you all this time—and not delivering all the regards that were sent to you in Jean's letter!" Then I remembered the mention of his name in one of your letters. So for the next hour we had a lot of fun, saying—"remember this and remember that."

In my last letter I also mentioned a kid by the nickname "Gabby." His real name is Hy Rosenstein—sends his regards to everyone, especially the Richmond Hill branch. Wants to know as we all do, whether we're letting the bozos who smash up headquarters have a free hand? (When are you people going to get on Harvey's turf and bring him down?) He's a good kid this Gabby. One of the few people here who doesn't seem to have changed much. When I'm with him it's like being with one of the Astoria Y.C.L. We call him our perennial Y.C.Ler. Rico also is well and so is Lee Holt.

Is there anything else to say? The war as you know goes on heavily, but is concentrated in the Levante sector where our fellows' resistance is giving the Fascists a headache and throwing their international plans out of gear. Our sector is very quiet. We're in reserve. Don't put any faith in non-intervention, because the Fascists' word isn't worth a damn, and they're still pouring men & materials into Spain. They still hope to end this war in a hurry but are due to receive [illeg.] a disappointment.

I feel very full now having had doubles of everything. I love you. Write to me often.

Harold

Regards of course to everyone.

Give my family my love and tell them I'm okay.

<center>(Over—Flash—Important)</center>

This is getting to be a habit! Left Barcelona & just caught up with our Brigade. We go into action to-nite or tomorrow. It looks like a big Push. Lying in a valley now. We'll probably march all nite then over we go. You'll probably read about "it" long before you receive this letter. If the Push goes thru it may mean the big turning point. Anyway, we'll give them everything we got. Haven't got time to write Mother or any more to you. You know how I feel about you. I love you. I know you wish me all the best. Give my love to all the folks. Regards to everyone. From Jack, Lee Holt, Gabby, & Rico also.

<div align="right">Love & Salud
Harold</div>

● ●

from JAMES LARDNER

<div align="right">Barcelona, Sept. 2, 1938</div>

Mother, darling,

For forty-eight hours I have been having a marvelous time. It was good to get back to a familiar big city after playing the sticks for so long. And even better was to see most of my best friends here again and to receive seven letters all at once. Two of the letters were from you and one each from Bill and David. Yours were dated June 9 and June 17, having been forwarded from the Sheeans' Paris address to Bloms, St. Margaret's Bay, Kent, Angleterre, and then apparently brought into Spain by someone and given to Leigh White. I should have received them sooner, but no one knew where I was as I moved from one hospital to another. In any case, I think the best place to address me now is S.R.I. 17.1, Barcelona. I believe there would be a good chance of my receiving a package now if you sent it to Mrs. Waverley Root, 3 rue La Bruyere, Paris. I am going to tell her to forward anything to me in care of Edwin Rolfe at the Hotel Majestic, Barcelona. Rolfe, who is a friend of mine, has just left the International Brigades to take Joe North's place as correspondent of the *Daily Worker,* and will be seeing me from time to time in the brigade.

This paragraph is confidential and possibly inaccurate. From a number of events and opinions and rumors I gather that a gradual and lengthy process of removing the I.B. from Spain has begun. Herbert Matthews, *N.Y. Times* correspondent, with whom I had my first whiskey and soda in many months yesterday, says he thinks it will take six months or so. I, of course, would be one of the last to be withdrawn. All this is unofficial and by no means certain, especially if we receive any serious setbacks at the front. At present, the situation is promising militarily but not so good among the civilians. Catalonia is way overpopulated now and there is a shortage of food. If we get through the winter all right I foresee victory next year.

I arrived three days ago at Las Planas, the I.B. base through which all convalescents pass on their way back to the front. Probably in a day or two I shall be sent to Mont Blanc, a training camp, for a few more days and then to the brigade, which is now at rest after two very hard-fought actions near Gandesa. Las Planas is an old sanitarium

situated on a very high hill among tall pines and overlooking Barcelona, which is a much more attractive city when viewed from above than I had ever realized.

Day before yesterday I got permission to come down here to the city, and I am to return tonight. The first thing I did was to go see Johnny Murra at the hospital. He was wounded the day after I was. The bullet entered his shoulder, traversed his left lung lengthwise, missed his heart and other organs and came out right next to the base of his spine. His lung was filled up with blood and other extraneous matter and his legs were temporarily paralyzed. He had to lie in No-man's-land within easy range of the enemy from 7 a.m. to 11 p.m., most of the time in the blazing sun, before he could be brought back. This is just to show you how hard it is to get killed. He is going to be sent home when he is a little better and will recover completely. My other closest friend in the company, Elman Service, also was wounded, but I haven't seen him since.

The next step was to come to the Majestic, where North had left four letters, a cable-gram and a carton of Camels for me. The cigarettes being from Walter at my request. Then I had a long talk with Matthews about the European situation in general. I had supper with five other I.B. members at a semi-private Jewish place. There was gefilte fish, an excellent vegetable soup, fried potatoes, a fried egg and some wonderful peach strudel. The price was 30 pesetas, which is way over the heads of the wage-earners, and, I think, only semi-legal. Then I went with two other comrades and rented a room with three beds for the night. This arranged for, I called on Leigh White, whom I must have mentioned to you some time. He is about a year younger than I, came to Spain to drive an ambulance and later became a foreign correspondent. He speaks beautiful Spanish and knows the country better than any of the other correspondents I have talked to. Recently, he was substituting for the correspondents of the *London Times,* the *London Daily Express,* The *London Daily Mail,* and the *London Telegraph and Post,* simultaneously, while they were taking vacations outside the country. He is about to marry an attractive, vivacious Asturian girl, whom I met early in May. We talked so late into the night that I spent the night in their spare room instead of returning to the other lodging. After breakfast in their apartment, I got into touch with Douglas Flood, American Consul, and as a result today was returned 450 francs which I had left with the Consulate in May. I sold the francs to Leigh for transportation to Paris when he leaves the country with his bride in about two weeks. He is going to try to get a job in Paris, with the *Herald* or elsewhere, and if unsuccessful go to Mexico for a while. He doesn't like the United States. I forgot to mention that before I left he gave me his old ambulance driver's uniform, which is the best I have had in a long time, three books that I have wanted to read and some detailed maps of Spain that I gave him when I entered the I.B. Also my wrist-watch, newly cleaned and repaired. Yesterday I had lunch at the Majestic and dinner at the White apartment, again staying the night. Now, since I have eaten Leigh and bride out of all their food, I am taking them to dinner at the Jewish place. I have done a lot of errands for myself and others and am at present trying to think of a good wedding present, being very rich. And I just had a hot bath and put on all new or clean clothes. Those are all the luxuries of city life I can think of offhand, except that Johnny Murra gave me six caramels and part of a bar of chocolate.

There are still some phases of war that I haven't seen, so that I am not sorry to be returning to the brigade, but for your comfort it is very unlikely that we shall see action

for some time. There is a lot of reorganization and remoralization to be done. One thing that makes me more satisfied with life than ever is that I have a very good idea of what I am going to do with my life. Some of the details may not work out, but I shall work hard toward a definite end, and I guess there is nothing better than that.

All my love,

Jim

· ·

from SANDOR VOROS

Barcelona, Sept. 18, 1938

Dear Myrtle,

Your letters of Sept. 1 and 6 arrived together today—and together gave me quite a jolt. The second letter dissipated somewhat the effect of the first but rereading it carefully it was easy to find in it the more or less suppressed or subconscious elaboration of thought so clearly expressed in your first letter. I think the problem is too serious to be ignored or treated lightly. Before I go into it, however, I must make clear to you for the n-th time something which you still don't seem to, or don't want to grasp: I am part of an army and no one in an army can come and go as he pleases. I am amazed over your ignorance of this, since you, in your position with the Medical Bureau, have had ample opportunity to speak with comrades returning from Spain who could and undoubtedly did explain this elementary fact to you.

Please, for the thousandth time, do not rely for your information on Matthews. All this irresponsible talk of Matthews' on the "break up" of the International Brigades is so much tommy-rot. This may be the wishful thinking of the *N.Y. Times,* but it is not the actual situation here. The I.B. is still here and doing an excellent job. It was first and foremost the IB that has brought to a sorry end the Ebro offensive of the Fascists inflicting terrific losses on them.

True, people are going home. But who are they, that's the question? We are sending home the unfit—the wounded comrades who are not fit for active service and the morally unfit, guys who have done everything in their power to evade the front, who turned yellow when the going was tough, the adventurers and misfits of all kinds—those who by their stay here would continue to eat off the sadly depleted stocks of Spain without giving anything in return. The Medical Bureau people fall into a different category. They came as non-combatants, and the army rules do not apply to them in the same way as they do to us.

You are feeling like breaking with me because I continue to stay here while others are going home. Since I was lucky enough not to get crippled in the action, the only way I could get home would be either by deserting or becoming totally demoralized. Well, Myrtle, take it or leave it, but I'd sooner die a thousand deaths than go home like that. And if this doesn't meet with your approval all I can say is that we have been mutually wrong about each other. Our policy is that we came here to do a job and put ourselves at the disposition of the government. When the government decides that our mission has been fulfilled, that we are not needed here any more and gives us permission to leave, we'll leave. The same applies to foreign leaves. When my application will be favorably acted upon and I receive my leave, I'll go immediately. But as I have

emphasized time and time again, until that time comes I have to stay here and I do so willingly, doing everything within the limits of my ability to contribute to the cause of the Republic. That settles that.

After making the above clear I feel free to tackle your problem which is not at all new to me for I have thought about it (and even written) more than once.

It is close to seventeen months now since we have last seen each other. It is a long long time, at times it seems more than eternity. Neither of us anticipated such a long separation. How much longer it will last nobody knows. I certainly don't, for it is outside of my control. As a matter of fact the possibility of my getting a leave is at present more doubtful than ever. The leaves have been suspended for the time being. Even if they were to open again my turn would not come for many, many months. This is the actual situation. If nothing else, I learned in Spain to face every situation squarely, without fear, and do the best in the circumstances regardless of consequences as far as my own fate and welfare is concerned. It is in the nature of war that life becomes very cheap and one's future is of very little consequence.

Your life has been bound up with mine to such an extent that I often feared the effect a serious accident involving me would have on you. I never read a letter addressed to a dead comrade by his sweetheart without associating these two with us and worrying how you would stand up under the shock. Whenever I was in a very tight spot where it looked extremely doubtful that I would ever get out, I always made my peace with the world by saying good-bye to you first. I have realized it all along that a situation like this should not be permitted to exist and threw a couple of hints your way from time to time. Now that you raised the question very sharply, we can face it soberly.

Yes darling, go on ahead, make your plans and arrange your life the best you can without considering me. I may be here for a very long time yet, I may stay here forever. The boy friend of your imagination may be a completely changed man by the time of his return. War is no health cure, it does not improve one physically nor does it sweeten one's disposition. It may bring out some of the best that is in you, but it also brings out all that is the worst. It may take a long nursing to get us back to the same level we had been on before we left, and many of us may not be worth the bother.

You are young, you are beautiful, charming—you have everything needed to go very far. It would be criminal to permit yourself to be tied to a ghost any longer. For that's all we are after this long absence, ghosts roaming about in a far away place, ghosts that return to haunt our beloved who remain tied to us. It is about time that you, too, cut loose and begin living a life of your own, a life peopled with flesh and blood characters.

Everything I have said above may be new to you. But it is not new to me. I have thought about it long and often for I have deeply felt my responsibility.

You are completely free, darling, to arrange your life in a way that will bring you most happiness and you have my unqualified well wishes. We'll face the situation when I return home, jointly and in a realistic manner. We'll face it with the understanding and sympathy our past relationship qualifies us, with that honesty and mutual concern for each other's welfare that was the characteristic of our unselfish love.

Nothing more need to be said on the subject. I have no fear or worry about the future. The future is remote. You are concerned with the present and I share your

concern. I want you to be happy. I want you to lead a normal life. I want you to love and to be loved—I don't want you to wither away like a flower without rain. You owe nothing to me. It is I who am indebted to you for all you have done for me since I am here. I deeply feel my responsibility about that, too, for permitting you to keep sending things to me was equal to permitting you to keep yourself attached to me so strongly in my absence.

Nothing said here can and should be construed by you that I have grown indifferent to you. On the contrary, I have never been closer to you, even when we were face to face, body to body together. But I have grown in understanding and have the courage to draw conclusions regardless of consequences.

I shall not refer to this subject again. I shall continue to write to you as always, as if I had neither received nor written anything on this subject. You, however, ought to inform me of any change that may occur. It will help me to put my mind at ease.

Goodbye, Honey, for the present. I will answer your other letter about your experiences with Busch and Barsky in another letter.

<div style="text-align: right">Sanyi</div>

from DAVID GORDON

<div style="text-align: right">Oct. 21, 1938</div>

Dearest—

I've been working in Barcelona for the last several days. A big city tires me very quickly. I've been walking a lot because it's easier than street-car riding. New York subways have nothing on Barcelona street-cars—or its Metro.

Since I've been here I've had the pleasure of seeing Pasionaria for the first time. We were in the same *refugio* with many others during an air raid. She looks very much like her photographs.

Then I met Europe's great photographer—Robert Capa. Very fine and plain fellow. I also met Jo Davidson, one of America's famous sculptors, who has lived very much of his life in France. Saw his head of Miaja and of Milton Wolff—the chief of the Lincoln-Washington Battalion. Miaja's head was fairly well struck, but Wolff's was bad. However, he had the head of a 74 year old Basque, which appeared as though it would speak at any moment.

I think that Barcelona has proportionately more beautiful girls and women than any other large city. They have excellent taste in dress and, in the main, they've mastered the art of Indian war-paint.

My work is rather confining and tiresome and even boring to some extent. But it has extremely interesting and important aspects as well.

I hope your parcels arrive before we leave for home and I hope some of your letters get to me soon. Because of the change I haven't received anything from home for ten days. These days that's a record for not receiving mail.

Soon the problem of what I'm to do will confront me. I hope my plans will be realized. I hope I can see you in New York when I arrive so that we could talk things over.

<div style="text-align: right">Your</div>

<div style="text-align: right">Davie xxxxxxxx</div>

D. Gordon
c/o *Volunteer for Liberty*—Ingles
Mendez Vigo 5
Barcelona

P.S. - I do not work on the *Volunteer.*

..

from DAVE GORDON

Nov. 5, 1938
[Barcelona]

Dearest Lottie—

I haven't kept my promise. I missed a day with regard to writing you daily. What I can't make up—and one can't make up the loss of a day—in writing with the frequency promised I will try to make up with souvenirs which I shall bring with me when I return. I think you'll like the things I'll bring. And in order not to make you wait so long, I may mail some of them ahead one of these days.

Yesterday there took place the Barcelona UGT *despedia.* I wasn't able to attend the lunch and meeting due to lack of foresight. But I did attend the entertainment. And what entertainment. For the first time in months I again heard Aragonese singing and for the first time saw Aragonese dancing. A young boy of about twelve performed. It was a superb performance. I haven't seen such fine gracefulness with most complicated twists and turns for a long, long time—and I date the beginning of that time from the day I left the United States in June of 1937. The kid has also mastered the art of utilizing his hands in the dance, and not only in the sense of co-ordinated movements with his body but also in the sense of playing the castanets, never missing a knock.

There was flamenco singing, the thirty-three *Seguridad* band playing, mandolin and guitar playing. Flamenco was sung by the most expressive voice I've had the pleasure of hearing in Spain. Done by a young woman. But the Arogonesa was even better. She sang those Aragonese folk songs like a bird. The Aragonese songs are somewhat like flamenco but they have a finer finish, an anticipated end. Flamenco gains most of its interest, it seems to me, from its ability to hold a note forever, to run the scale up and down and sideways a hundred times with one word or syllable of a song and to end most unexpectedly. The more unexpected the end of the song is the greater the pleasure of those who hear. How different from the reaction to the much-abused pun! Well, the whole shooting match tore the house down. I'm sorry I had to leave before it was all over.

A good friend here, who edited the *Volunteer for Liberty* for a long time, John Tisa, has collected all the back copies of the thing that he could. It will be the fourth best collection extant. Some copies are missing. But then I couldn't hope to have, beginning so late, as good an archive as the Commissariat of the I.B.'s or as that of Ed Rolfe. It's going to be bound, very inexpensively. So soon you will be able to add that to your collection.

I wish I could know right now what you think of my wanting to learn a trade. I believe I wrote you about it in a previous letter. I also wonder what you will say about

a lot of other things which I will tell you—especially about Paul. It won't be an easy story to tell.

> Your
> Daviexx

· ·

from MARY ROLFE

Friday, November 25, 1938

Dearest Leo [Hurwitz] and Janey [Dudley]:

The enclosed note was written after the first two bombings on Wednesday—and I thought when I started that I could overcome the reaction of the morning, but I had to stop.[2] Now, though still a little limp and sickish, I can write of the last two days with more or less ease.

You have by now read accounts of Mussolini's message to the Spanish people on the day when Chamberlain and Daladier were to begin their conversations. The first raid, at about 10:30 A.M., came while two American *soldados* and I were in a shop buying cigarette holders. The boys had come to Barcelona to buy some trinkets for their girls and I went along with them to help them choose. The shop we were in is some three or four blocks from the hotel and some six or seven blocks from where the first bombs fell. The siren sounded just as we were paying our bill. We saw the people hurrying along the Paseo de Gracia (our street) into sheltering doorways, or hugging the walls. We stepped into a doorway, going out to look up when the anti-aircraft started and I spotted three planes—enemy planes flying high, they looked minute. The guns were hot on their trail and the boys pulled me back into the doorway because very often the shrapnel casings of the aircraft shells fall and get you. As we got back to the doorway we heard the bombs falling—and the boys made me crouch down, close to them with my head buried in my arms. The sound of those bombs, and they sounded close (as we found later they were) is hard to describe—crashing through the air as if to break the very air itself, screeching and whining and then the contact as they hit their target—as if a thousand wrecking crews were tearing down buildings at the same time. I wasn't frightened then, my mind was blank—I was concerned only with crouching down in the doorway. We got up then and started walking to the hotel, the people in the streets came to life, continuing to walk to wherever they had been going when the alarm sounded; we reached the next corner to see a crowd of people pointing up at the sky and then a shout arose, and cheering as our guns got one plane—it came down hurtling through the air head over heels. We were excited, forgetting completely the bombs falling a minute before and we hurried to the hotel to find Ed. We found him there, worried but relieved to see us. Everyone talked about the downed plane—but soon life went on as usual. Soon we heard the siren blow three times, meaning all's well, the raid is over, and we went out again—Ed, the two boys, Capa and I. We went to

[2] Mary Rolfe left New York and joined her husband Edwin in Spain in October of 1938, after he was withdrawn from the lines to take over from Joe North as *Daily Worker* and *New Masses* correspondent. She worked in Barcelona writing English-language publicity for charities like homes for refugee children.

the Rambla—a long street in old Barcelona (Barcelona was once a small village—the Rambla was its main street with narrow, winding streets stretching on either side of it—and although the Rambla is one thoroughfare it has various names—like Rambla de Flores, because of the numerous flower vendors, etc.). We stepped in a shop where Ed and Capa bought some shirts, leaving them there while one of the boys and I went on. We walked leisurely, looking in the windows of the numerous shops in the twisting streets, stopping to buy some decorative combs and finally going to a little antique shop stuck away in one of the little streets where I had bought a locket some weeks ago. We found a necklace for his girl and again, just as we were paying the bill, the siren started. This time we knew we were in danger because this quarter had been often hit, the last time only a week and a half ago. We left the shop, the boy with me starting to run, and so I ran too. But as I ran I could feel the panic growing in me and I stopped him— "let's follow the people here—they know where the *refugios* are—we mustn't run," I said. Meanwhile thoughts raced furiously through my mind—"I mustn't get panicky, I mustn't be frightened. I've got to be calm—if we reach the *refugio* in time, good—if we don't there's nothing we can do about it—*but we must not run*—Ed will be worried about me—I wish I could somehow let him know that we'll be all right." We followed the others coming out on the Rambla de Flores where we found two Metro stations (these, of course, are used as *refugios*—although Barcelona is full of newly built, completely safe *refugios*). We followed the others down to the subway—and I was struck by the order and lack of hysteria. No one pushed or shoved—everyone was quiet, composed—we all helped to get the kids down first—and soon we ourselves went inside, going deep into the station and standing close to the wall. The people talked together, played with some dogs who had come down with us, the children romped—these people will never be crushed. Mussolini and Hitler, however much they bomb, will never break the morale of these wonderful, courageous people. We heard the guns, the sound reverberating in the tunnel, and again bombs falling. My friend and I talked in low tones—about anything—I can't remember now—we held each other's hand and we both tried hard not to tremble. Soon the lights were on—we could go out. As we came up the stairs of the Metro we saw the puffs of smoke from the guns directly above us and we knew the bombs had fallen close to us. (Three blocks from where we were—we found out later). We walked home, both of us talking fast, but we walked slowly.

We found Ed and the other *soldado* looking for us frantically and we all embraced in the street—it was like a reunion. "Sure, I feel fine—don't worry—I'll be all right." We went in to lunch—and I got through it somehow. It was when I went upstairs that the reaction began—that's when I had to stop the letter I began to you. I got a terrific stomachache—it doubled me up for ten minutes, and when it was over I was exhausted and shaking as if I had just dug a well or pounded rock. I was alone—Ed was writing his story at the Ministry. I tried to read—but the letters danced before my eyes and so I put my book aside and just sat in the chair—thinking—this is what the barbarians have been doing to the Spanish people for two years; I had witnessed the ruthless murder of an innocent people because fascism's voracious appetite must be satisfied—I saw what I had been reading about—the systematic terrorization of a people, by which the fascists hope to bring them to their knees—and I saw the people reiterate the words of

Pasionaria—which by now have become part of their lives—"Better to die on one's feet than to live on one's knees." Think what these murderous raids have done to the lives of these people—to their nervous mechanisms—to their sanity. And what a heritage for the kids! Here was I, coming from comparative freedom, well-fed, my nerves shattered by my experience—and then think of the Spanish people who have lived through this horror for two years.

But the bastards weren't through with us. At seven o'clock they came again—this time I watched from our window—saw the powerful lights cutting the sky trying to locate the planes, saw the puffs of smoke from the guns and the flares going up—and the welcome sound of our planes—our little chasers going after them. Nothing excites the people as much as to see or hear our planes—they go wild with excitement—shouting themselves hoarse—every single time they come. I was alone when the siren sounded at 11:00. I watched only a little while this time—I threw myself on the bed, too tired to undress, and just lay there, anger mounting—"the bastards—the bastards," saying it over and over again until I could think no longer. Ed came in a little after midnight, bringing the news that the Bank of Spain had been hit in the first bombing, with an incomplete count of 40 dead, 124 wounded, mostly women. We went to sleep finally—and then began the night—six times they came over—the sirens shrieking each time—the guns furiously shooting—six raids in the night—six times to create terror. Matthews came in to see us in the morning, telling us how each time he had awakened, jotted down the time, and then tried to go to sleep again. There was no panic in the hotel—but there was anger and hatred for the fascists. And then at 9:30 they came again—to be driven off quickly.

When the siren sounded again—this time meaning release—we went out, Matthews, Capa, Ed and I, to see the damage. We found one building which had been hit in the second bombing—twisted and mutilated—piles of broken glass and debris in front of it—a huge crater in front of the doorway where the bomb had fallen—a water main cracked. Everywhere around the building—all the houses had piles of glass and debris being swept out of them—the concussion often creates terrific damage—in all the little streets off that main street on which the building was had the little piles of broken glass and debris lining them—the gutters were covered with brick and mortar. We drove on past the Bank of Spain—the bomb had fallen right clean through it—we went down to the port where huge craters showed where bombs had fallen, breaking water pipes; crews were feverishly at work repairing the damage—there was no sign of panic or terror anywhere—people went about their daily tasks, walked in the very spots where bombs had fallen—sat in the cafes along the waterfront—sat on the benches along the streets. We talked to one man (Ed wrote about him in his dispatch)—he told us most of the people had spent the night in the *refugios*—thereby lessening the toll of lives. He was calm when he told us about his demolished house—a smile on his face when he told us he had been able to save his family and then the full proof of what these people are made of when he said to us in farewell "I would invite you to my house—but you see, it isn't there anymore."

When I first walked into the streets of Barcelona I was amazed at what I saw. When we read about Spain in the newspapers, articles, and books, we read of the front, of cities bombed, and I came expecting to find a war-like—or what I thought was war-

like—atmosphere over everything and everybody. Here in Barcelona, the city goes on living its life—shops do business, people work and sit in the cafes. When you are in the city for a while you begin to see the effects of war. You see that there aren't many young men in the streets—and if there are they are in uniform, home on leave or recovering from wounds. You see the wrecked buildings where bombs have fallen—and you see the women and the kids, tattered, ragged, and hungry. But you see too that every-where are a people who are fighting *for their lives, their country*—the raised fist which greets you in Salud is not just a gesture—it means life and liberty being fought for and a greeting of solidarity with the democratic peoples of the world. Barcelona is a beau-tiful city—surrounded by hills and mountains—an ever blue sky—palm trees lining the broad avenues—a city which in peacetime must have been a joy to live in. And the peo-ple—how can I tell you how wonderful they are—how truly a beautiful people the Spanish are. They are an intelligent people and an understanding people, and even now, in midst of their war, the education of its people goes on—schools for kids, girls from the Basque country and Andalucia who three months ago couldn't read, now holding down leading and important jobs in Government agencies.

And—in the midst of their war—the Spanish people have created innumerable pro-jects for the care of their children—colonies, canteens, restaurants which care for not only the children of Barcelona but the thousands of refugee children who have poured into this city for two years. The women's organizations which care for the workers in the war industries—and their children—and which are now in the midst of the winter campaign for food for the kids. And this, you must impress upon everyone, is the most important campaign outside of lifting the Embargo. This is the work that I am doing here—helping in getting to America and other countries the all-important message that all friends of Spain must help to keep the children of Spain alive and warm this winter. And the Spanish people have already done splendid work in this—they are not asking for food abstractly—they point with pride to their achievements—and incredible achievements they are—the creation of all these projects which will take care of the children. But—and it's a big but—they must have outside aid—they must have the material, the commodities with which to carry on their work. They must have food. The first American relief ship was only the beginning—food, food and more food must be sent—clothing—these kids have to be saved from starvation. I wish more Americans could come here to see what I have seen—kids covered with disease from malnutrition—kids lined up before a canteen two hours before opening clutching their little tin cups—babies of two and four—waiting two hours for their cup of milk or cocoa and their piece of bread, mopping up every speck and crumb from their cups—and their bigger sisters and brothers who themselves have not yet eaten—bigger did I say—yes, five and six and seven years old—helping the babies eat—yet never once attempting to take a bite or sip from them. Or refugee children, living—hundreds of them—in a church or convent—having to stay there for the time because enough colonies cannot be built in time to take care of them they come in so fast—starved lit-tle bodies—torn from their homes, some of them orphaned—and hungry and cold. This is the story—the story which everyone in America must know—and help to alleviate.

News about the people I've met—Herb Matthews first. He's a tall, thin man, his hair

growing thin—rather taciturn and always looks as if he had a grouch. But actually he's a real guy, sincere and honest—and a real friend of the Spanish people. He's liked greatly by the American internationals—they think he's a straight guy—which he is and they like his stuff. He has done much for them—is besieged by letters from the States asking for information of this American or that American—which he answers, every one of them—trying to get the information the mothers ask for. He follows closely every campaign in America—visited them more often than anyone at the front—and is now at their camp. His knowledge of Spanish politics and government is good—and he's completely straight on it—as he is on our traitor friends like Sam Baron and the others who came here to create trouble. We've had swell times with him—and both Ed and I like him completely.

Then there is Jimmy Sheean (no one, it seems, has ever called him Vincent) a tall husky fellow—the red hair gone gray, a straightforward man with whom I became friends immediately. He was here only a week—but we saw them (he and his wife, Dinah, a very beautiful English girl who has been working hard making speeches for Spain in England) every day—Dinah and I worked together while she was here on children's work—he's real too—no pretensions, and no more of the confusion evident in "Personal History"—he's right with us now. Hemingway was here for a few days—but once you meet him you're not likely to forget him. The day he came I had been slightly sickish, but Ed came up and got me up out of bed to meet him. When I came into the room where he was he was seated at a table and I wasn't prepared for the towering giant he is. I almost got on my toes to reach his outstretched hand—I didn't need to, but that was my first reaction. He's terrific—not only tall but big—in head, body, hands. "Hello", he said—looked at me and then at Ed and said "You're sure you two aren't brother and sister?" which meant—"what a pair of light-haired, pale, skinny kids!" He told us another time when we were driving back to the hotel from somewhere of his correspondence with Freddy Keller—how he told Freddy he's got good stuff, but he must study—must educate himself and above all study Marx. That was what he had done all winter in Key West, he told us—otherwise, he said, you're a sucker—you don't know a thing until you study Marx. All of this said in short jerky sentences—with no attempt at punctuation. Before he left he gave us the remainder of his provisions—not in a gesture, just gave them to us because he knew we needed them and because he wanted to give them to us. I'm still a little awed by the size of him—he's really an awfully big guy!

There are always several boys coming in from camp—and so our room is nearly always full of sprawling majors, captains and *soldados*. Milton Wolff, that 23 year old major is a dynamo of energy. He doesn't talk, he roars—he doesn't walk he lopes—a genuine kid who went up in the ranks and became a major some weeks before his twenty-third birthday. He's over six feet tall—and we've got his height marked on our wall—next to it written "M. Wolff, 23rd birthday, (stocking feet)." When he calls me "hey, Wolfe [her maiden name]" the walls shake—and when he laughs everyone laughs—it's so infectious. Then there's Captain Lennie Lamb—a boy whose death was announced at least ten times in the past year—Ed's friend and mate at the front—lovable and fine—and others I knew in the States before they went—tickled to death to see me (and that's a compliment, believe me)—all of them, those I knew before and

those I've learned to know fine boys—seasoned by their experience, but not hardened or disillusioned—real Communist fighters—of whom we are proud.

There are other things to write—about Ed and me which will take too long in a letter and which are better talked about. You Leo are an ever present friend with us—and you will know what adjustments we are both going through. You know Ed pretty thoroughly—and so you must know that it hasn't been easy—but this much I know that he must go home—as quickly as possible—for me it's easy to say I want to stay—and I do—there is work to be done—a job has been offered me (the work I am doing is entirely voluntary)—which would keep me here some three or four months—but I'm turning it down for only one reason—and that is—home and rest and good food for Ed—he longs for the States—and a good meal is something he never stops thinking of—and only when you've been here can you understand that.

And now—I'll say goodbye—I promise not to let so long a time go by the next time I write—I send my love to both of you and to all my friends at home. The same for Ed—Salud—and don't forget the kids of Spain.

<div align="center">Mary</div>

I forgot to tell you about Capa—who is best described by the name I've given him—"MadCap"—he's a very talented fellow, that one—slightly crazy, but a really good, lovable guy. We're trying to persuade him to go to the States.

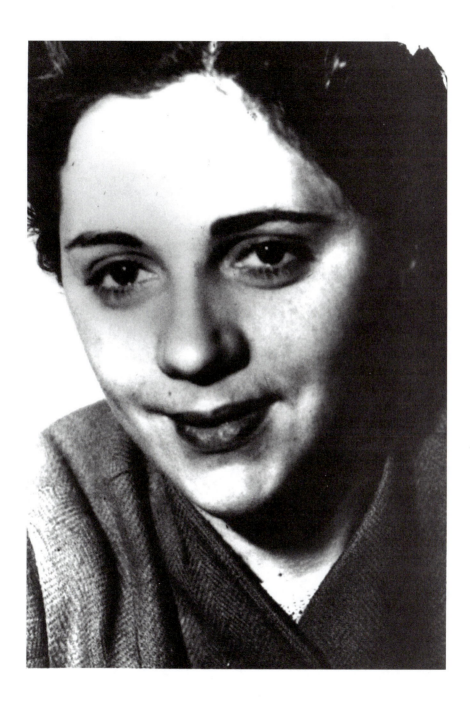

Ave Bruzzichesi, an American nurse.

ASI Defiende sus Libertades el Pueblo Vasco (This is how the Basque people defend their liberties).
Frente Libertario (Madrid), May 23, 1937.

ON THE WAY HOME
The Trials of a Legend-To-Be

∙∙

INTRODUCTION

On September 21, 1938, the Spanish Prime Minister, Juan Negrín, announced to the League of Nations in Geneva that the Republic would unilaterally withdraw all foreign military volunteers. With so few International Brigaders still fighting, Spain was taking no real military risk. There was hope, however, that this might pressure Franco into asking his substantial contingent of German and Italian troops to leave. Some, indeed, still imagined this additional moral pressure might get the embargo lifted. As for any immediate chance of an organized antifascism from the governments of the West, that was put to rest elsewhere—in Munich—the same month.

As it happened, the Americans were on their way into battle again that very day, heading to defend yet another unforgiving Spanish hill across the Ebro. Two days later they were relieved, but in the meantime several more Americans lost their lives. Among them were three of the volunteers whose letters are in this book—James Lardner, John Cookson, and Paul Wendorf. We first read John Cookson's letters to his relatives at the beginning of the book. Head of transmissions for the Lincolns at the time of his death, a hidden marker commemorating his service to Spain survives today; secretly tended by Republican sympathizers, it stands near a stream in a meadow near Marsa. Lardner's wonderful letter listing his reasons for going to Spain closes the book's opening chapter. Wendorf's letter, about the morale problems the battalions faced after the 1938 retreats, is one of the letters that open Chapter 12. Lardner, son of the famous American humorist Ring Lardner, went out on a patrol from which he never returned. Wendorf died in a bombing raid. He had fought at Jarama; since then he had survived more than a year of the war, but he did not make it through the final days. These were not the only Americans whose voices you have heard who lost their lives in the course of the Ebro campaign. Wilfred Mendelson, wounded on July 27 storming rebel positions on a hill, died before a doctor could reach him, shortly after being taken off the field. That same month Cecil Cole died near Gandesa. Jack Freeman, who survived the torpedoing of the ship "City of Barcelona," is buried west of the Ebro in an unmarked grave in an olive grove, killed in the Sierra Pandols on September 7 when a stray bullet penetrated his brain.

Earlier, a number of the other authors of these letters died as well. Gene Wolman was killed at Brunete in July of 1937. Harry Meloff, sobered by the death of his best friend and fellow performer and "Convulsionary" Ernie Arion in the first charge at Mosquito Ridge, went on himself to fight at Quinto; but he did not survive a stomach wound he

received going into battle at Belchite. Hy Katz also died at Belchite. Ten days after writing home about Meloff, Paul Sigel himself was dead, killed in his first action, Fuentes de Ebro, while laying telephone wire across a bullet-sprayed road on October 13, 1937. Joe Dallet, gravely wounded in October of 1937, was another Fuentes casualty; he was shot in the head as he led the Mac-Paps over the top. Waving the first-aid men away from his exposed position, he was shot again and died a moment later. Seaman Larry Kleidman was killed by an artillery shell at Teruel while he was supervising construction of defenses at the edge of the city on the grounds of the *Casa de Locos*. Leon Rosenthal died in February of 1938 when his sound truck was bombed by a fascist plane. Dewitt Parker, serving as Battalion Political Commissar, died at Belchite on March 9, 1938, the opening day of the Great Retreats, when a bomb exploded directly outside the tunnel housing Battalion Headquarters. Leo Gordon probably died two days later. He was in charge of two machine guns on a cliff where the Mac-Paps had retreated to and positioned themselves. Ordered to retreat again, the rest of the troops tried to reach Gordon, but could not do so in daylight. The position was exposed and under heavy fire. They shouted and fired pistols, but Gordon's men could not hear them over the artillery bombardment. Later the men could see shrapnel bursting against the cliff. Thane Summers, philosophy student, native of Seattle, was in Spain against the wishes of his conservative father; he was regularly out in front of the lines as a scout and he died at Caspe later that March. In the first days of April Robert Merriman was captured near Corbera and probably executed on the spot. There are thus none of their letters in this chapter because they were not alive to write them.

For those who survived, the last months in Spain mixed grief with celebratory public occasions. Quartered at first in Marsa, where they had trained before crossing the river, the Americans and their young Spanish comrades struggled to come to terms with leaving the war while it was still in progress. But public events to honor the Internationals gave at least some closure to their experience. The most extraordinary event was no doubt the October 29 march through Barcelona, here recounted in detail. It was, in effect, a defeated army treated to a huge outpouring of public affection. Most of the Americans then went north, past miles of terraced mountainsides, to the town of Ripoll, twenty-five miles from the border with France. Despite celebrations, Ripoll was bleak. It was cold with little to eat. Everywhere there was the odor of rancid olive oil, the only cooking oil left. A group of 327 Americans left in December; after being briefly delayed by a strike in Le Havre, they sailed for home. Yet two hundred Americans were still in or near Barcelona in January, while Franco's troops were moving toward the city. Among the Americans in Barcelona was David Gordon, helping to gather the records of the Internationals. They barely got out in time. By the time some of the Americans got to France, however, the government was placing refugees in crude oceanside concentration camps exposed to the winter weather. Those camps are described here in detail.

The trip home would prove still more difficult for those Americans captured by the fascists. Among them was Carl Geiser, born in 1910 and captured on April 1st, 1938,

during the Great Retreats. Through most of the war, Internationals who surrendered or were captured were often promptly killed. Of 287 Americans captured and taken alive, 173 were also killed. By the end, however, Franco modified his policy so that he would have some prisoners to exchange. Thus seventy-one Americans, including Geiser, were exchanged in April of 1939, and eleven more were freed that August. But when the end of the year arrived, a few Americans were still in Franco's prisons. By then mass murder was well under way in Spain. Franco intended to purge his country of Republican sympathizers. We offer no letters from Americans in fascist prisons because they were not permitted to write them. Indeed, to win the right to send home a one-sentence note on a Red Cross form was a major accomplishment; it was a way of letting people know you were alive. In February and March of 1940 the last eight Americans were let out of prison and allowed to come home.

There was thus a long period of time over which Americans left Spain for a variety of reasons. Some who were seriously wounded and incapacitated left early; some who were prisoners were held for months. Rather than print the letters in this chapter chronologically, we have arranged them topically to form a coherent narrative. Accordingly, the letters anticipating departure precede the letters written from Paris or from aboard ship on the way home, no matter when they were written. Dates of composition, however, are retained.

● ●

from JOE GORDON

Sept. 26, 1938
[Marsa]

Dear Gussie,

I'm taking time out to write you a letter while I'm still sober. We are now in a small town celebrating, and cousin, what a celebration, by now I guess you know why. The International Brigade is leaving Spain, what a surprise, at first we didn't believe the rumors, then when they took us out of the lines, they told us officially. These last 3 days of action were the toughest in the entire war. I won't go into details but I'm looking for grey hairs. So now everyone is stamping their feet, looking at clocks, etc. The route is Barcelona, Paris, and N.Y. Won't mind Paris, you know, I know that town better than I do N.Y. It's a beautiful joint, in short I'm mad about it, and then cold, starchy "London." But the beer is swell and the women are so "comradely cold" from there.

And dying to get a bath and a good meal under my belt, gee, good food. Well nothing more at least in this letter except thanks for the package. Everybody is kicking the gong, think they're going to break it soon. So long.

> *Hasta La Vista*
> Comradely yours
> Joe Gordon
> Happy regards to all

••

from **ARCHIE BROWN**

Oct. 1, 1938

Dearest darling:

We are still waiting to start on our journey. I should say the first stage. It's quite try-ing this waiting, as you can guess. The trouble is there will be more waiting at the sec-ond stage & probably at the third. I'm afraid I'll have trouble with my papers. Maybe not. But eventually I'll get home.

Last night I went to the *"baile"* or dance. There were 5,000 men & a half dozen girls. But the music was lovely. Soft spanish dance music. Young boys went thru the motions of dancing, or rather they danced by themselves with imaginary partners. I sat there & watched. Pretty soon I was dozing & the dance hall was painted, & people had civilian clothes on and I was dancing with someone I liked real well. But reality comes back with a jerk. So I watch some more. There is that lovely wisp of a girl named Maria. I made her acquaintance at the watering place. I simply said Salud—and she lowered her lashes and answered very softly & rather frightened. But I smiled every time we passed & so did she. Then I discovered she lives in a house just across the court from where we are staying & one of the Spanish boys introduced us—across the court-yard—semi-officially. It's never official until you meet the gal in the presence of her mother and father.

Well there she was, her raven black hair all done up like a lady & barely touching the floor as she danced. I could just see myself asking her for a dance, what combined with my wonderful dancing ability I had hobnailed shoes on. That seemed very funny, so I laughed and the boys next to me said *"Que pasa, comisario?"*

So I went back to dreaming & danced with someone who didn't mind how I danced. I've been doing a lot of dreaming lately & propose to do more, as long as it don't inter-fere with my work. We still have work to do you know. My adjutant got a leave to Barcelona so I have to take on all the work I had stuffed onto him.

I got a letter & package from Dave Lyon this a.m. It's the first time I heard from him. He's got a real fancy excuse for not having written sooner. He says he felt "embar-rassed," because we were doing such wonderful work over here, and he had nothing to report! How do you like that? But since he sent me 4 flats of 50 Camels, we'll forgive him. He wrote quite a lengthy letter & I answered this a.m. I hope he'll be able to send me some money.

I hope by the time you receive this letter I'll be on the way home. But unless you receive my wire (asking for money to be sent to American Railway Express, Paris), or know for sure we have left Spain, continue to write. It's hard enough waiting, imagine what would happen without letters from you.

We have a change of address, but I don't suppose it makes much difference.

One thing is sure, we'll see each other sooner than any of us even dreamt possible. I dream of the time when I shall see you again my dear. I never get tired imagining what it will be like. I love you.

Salud, Archie
Militar Numero 6. Spain

Oct. 22, 1938
[Ripoll]

Dearest Sweetheart:

I arrived at the new destination all safe and sound. I believe I wrote you that Goddard was sent up as commander & myself as commissar to the place that would be our base until we left. There are some boys here already & we are awaiting the arrival of the Brigade.

Today I received a letter from Schmidt. I think one of your letters must have gone down to the old base & it will be some time before I receive it. Henry writes that he was a delegate to the Latin American Labor Congress. That must have been some Congress. I read quite a bit about it in the *D.W.* & *P.W.* Henry's letter was short & he said that he was writing an article for the *Voice* on the Congress & that he would send me copies of the *Voice*. Also I could get the latest news about the waterfront from the *Voice*. Hot stuff.

Our stay here is going to be rather pleasant. We have fairly comfortable sleeping quarters. Of course I being a big shot, have a bed to sleep in, but all the men have mattresses and their quarters are clean & warm. The food is the best since I've been in Spain. And the townspeople! There isn't anything within their power that they won't do for us. Thru a joint committee we are arranging a big reception for the Brigade. There will be a 50-piece band, greetings by representatives of the Popular Front and a special meal. In the afternoon a football game, followed by a dance & a movie in the evening. We will also have something for the kids in the afternoon. Most likely we will donate some of our bread.

Our civil relations committee is arranging visits to the factories, organizations, children's homes & interchange of speakers. The educational committee has arranged for open forums on the history of Spain, the development of the People's Front, agrarian problems, etc. Our sports com. has organized a soccer team—the cultural committee has choruses practicing, opened up a cultural center, books for a library are being gathered & several tournaments will soon be in full swing. I think we will keep ourselves busy & comfortable while we wait.

For some reason or another the govt's of France & Britain are not very cooperative in helping the evacuation. And that from the gentlemen who have posed as angels of peace, & were supposedly trying to get the foreigners out of Spain. England has made an offer of a loan to evacuate the English if it's paid back within 7 days! They add insult to injury. Being afraid of favorable publicity, the reactionaries in France are trying to force the Intl's to come thru in small batches so that there can be no meetings or demonstrations. Furthermore they are sabotaging the Spanish govt's efforts to evacuate the comrades from fascist & semi-fascist countries. The Gov't is trying to get safe conduct for them in their own countries or asylum in other countries. Behind the scenes the English and French govts. are sabotaging the program. If the boys for whom it is easy to go home leave, then the publicity will die down & the other comrades will be in a hole. We're sticking around until the German, Austrian, Polish, etc. comrades are taken care of first. We're not so much in a hurry that we'll sacrifice the

interests of the other comrades.

I still have my hobnailed shoes so I can't go to the dances—damn it—there are so many good looking gals too. Nate Thorton & Leo Nitzberg are here, & several other Cal. boys that you don't know. I found another longshoreman by the name of Tom Reed—a member of the old '79. We didn't even know about it in Frisco. It rained yesterday, a chilly misty rain that reminded me so much of Calif. Particularly when I walk out on the road, along the trees, it could be Ontario—but isn't.

Say hello to the folks & all the comrades. Keep writing Hon—and don't forget I love you.

Salud—Archie

Plaza Altazona—Base Postal
Militar No 6. Spain

...

from ARCHIE BROWN

Oct. 31, 1937
[Ripoll]

Dearest Hon & Freudian interpreter Marie,

I received Marie's letter & the fags, also a form made out to be sworn to before a notary public. There is a space for C.B. Hampton—director & appraiser to sign, a space for the notary public, but no space for me to sign. Am filing same until further instructions.

I have not received a letter from you since before I left the last place, which is almost two weeks. I thought that perhaps the change in address was responsible, but first I received a letter from Schmidt, then a couple days ago one from Lolli (surprise) & one from Hook & Dillon of the machinists. Then today a deluge—nine letters! And a carton of Wings from Walter Lambert. When I saw the one from Ontario I felt relieved & kissed it. That was before I opened it. Marie will please take out her pocket edition of Freud and interpret that. (Note to Hon: after I found out it was Marie—I wiped off the kiss.) I suppose there is a letter floating around somewhere. I got letters from all classes of people, from all walks of life. Mae Wangamon & Margaret Eastman supplied the women's angle, Dick C. & Eddy Alexander (who whimpered a bit for my calling them down for lack of writing) gave me the lowdown on the League, Otto Kleinman utilized his space to declaim his disbelief in his union brothers, while C. Nelson gave me some union gossip. Jane Martin wants me to become a writer (she read the letter I sent her) and Bob Thompson sent me a note, two pages out of the Y.C.L. review & 4 Avalon cigarettes in return for which he demands a long letter. I received some 3 packs of smokes besides the carton in addition to a ration. What I need now is candy.

Most of my time has been taken up with preparing for the Brigade. Now they are here. Maybe I'll get a little rest now. One day I had to go to Barcelona for business. I got a ride down and started out looking for the different offices. Some I had addresses for, some only the names, and some of these names were incorrect. Sooo—in my best Spanish I started asking questions. It's not so bad when they answer in Castilian, but when I get Catalan thrown at me, I merely followed the direction of the finger and usually landed on the opposite side of town that I should have been in. The street cars run

when there is current (the addition of new factories cuts down on the current), but even then you have to know where they run, where they turn, etc. So I walked—and how.

Many times my director walked almost all the way with me. They are like that here, if you are an International. They will go out of their way to help you. Anyway I saw some of this beautiful town with its wide streets, the beautiful buildings, Squares (small parks) everywhere, Plaza de Catalunya is a marvel. It covers a dozen of our city blocks, trees and grass grow there—statues & stone works. Big buildings flank it on all sides. Paseo Gracia, the widest street in town with a promenade down its center, runs past it on one side—on another the Rambla begins. The Rambla is a story all in itself. It runs into a working class district & the waterfront. It also is the street for the girls. For 150 pesetas you can get one for all nite.

I was surprised not to find many more girls than what there was. Usually war produces a great many. But the people's moral fibre has been kept intact. I didn't have time to do much exploring however.

When I got back to the base, the brigade had just arrived. As a matter of fact, I came in with them on the train. We stayed up all night placing the men & trying to organize things. You have to find places to sleep (that we had previously arranged). You have to count noses, make out lists so that the men could eat. Next day we drilled, and tried to organize an apparatus. I got to bed about one, woke up at three, ran around seeing that everyone was fed and then we all marched down to the train. It's getting cold here now, will snow on the peaks. So we all carried blankets.

The train took us back to Barcelona, where we were met by trucks, taken to the barracks & fed. Then we lined up, got back into the trucks and were taken to the starting point. We got an idea of what was coming when we rode thru companies of *carbineros* and soldiers lined up on either side of the street. We were in a plaza I never saw before. It must be the grounds for the National Palace.

After a time the bugle sounded, we fell into ranks of nine abreast and proceeded to march. Overhead zoomed the airfleet. The little moscas, the nemesis of the fascist bombers, came down almost to the tree tops. The "chatos" and bombers performed higher up.

When we saw the "moscas" (flies) it reminded me. It was just daybreak that day, and one comrade said "look around behind us." Sure enough, hugging the contours of the land, in the dim light came our planes. They flew over the fascist lines, dropped their load & beat it before the enemy anti-aircraft could open up.

The people cheered. The bands were playing, but you could hardly hear them. The crowds kept getting thicker and thicker. Signs proclaimed "International brothers—we will never forget you!" "We will fight to the last man—so that all of us will be free from fascism" "Our adopted sons—Spain loves you." The people's salutation knew no bounds. They showered us with flowers. The *carbineros* had a very difficult time holding them back. Girls broke through the lines and showered us with kisses. One would run out with tears on her cheeks—she would grab the first man and pull him down. Then several others broke thru. I never felt so good since the time I first found out I loved Hon. The Negro comrades just couldn't march. They were actually besieged. After each attack we would bravely reform our ranks & plunge onwards only to find

that the enemy had pulled a *"golpe de mano"* (surprise attack) on us. This kept on for several kilometers. A million people had turned out, with hardly any mobilization. The government didn't dare announce the parade more than one day in advance for fear of a bombing. But our *"gloriosa"* was in the air.

Got [Goddard] was a bit confused at first, what with his capitan stripes & nice uniform. The gals liked his moustache. But after a while he was running competition with the best of them.

It was glorious—an ovation none of us shall forget.

The next day we got back to the base. Two days later (today) the townspeople here give us a reception. What people. They brought up a 50 piece band, arranged a program lasting from 9 a.m. to—it's now 12:30 & they're still at it. I gave up & came home. I believe they are at the movie now. For the first time in Spain I had a piece of cake. The officers were invited to dinner. They had some cake, cookies, salami, peppered snails, & excellent wine. I grabbed my cake & some wine & beat it to the football field where I became a pioneer director. We ran off some races for the kids & awarded prizes. You should see me trying to quiet several hundred kids, 50 of which were claiming that they came in first. So we ran it over again, with the first 50 being challenged by a second 50. So I closed my eyes & picked the winners. Then we had a soccer match, which we won. Then, boxing, sack & other races for the soldiers with tobacco as a prize.

Tomorrow a new stage begins. Things will be quite organized & we will await the Commission. I had hopes of being home by Thanksgiving—but I don't know. So keep writing please. And send some candy in the envelope.

I wouldn't mind waiting if you were here Hon. The people here are nice, the scenery is pleasant, the weather a little chill, but not too bad. I wouldn't mind sticking around except for you. So please, hurry up & come home—who the hell is coming home anyway? Oh yes I am. Well don't forget I love you.

> Salud
> Archie

..

from AVE BRUZZICHESI

> 126 Rambla Catalunya,
> Barcelona, Spain
> Oct. 29, 1938.

My Dear Dr. Eloesser,

Yesterday the Internationals got the most magnificent sendoff that I have ever seen. The Parade began at the Diagonal at its head and continued on to the Triumphal Arch. The entire Grand Via was jammed with people, as were all the balconies and windows that opened into that street.

The President's stand was filled with Military and Governmental officials. First, of course, President Azaña, then Negrín, Del Vayo, Companys, General Rojo Comorera, Pasionaria, Margaret Nelkin, etc. They were not all in the same stand but in a series of them, one next to the other. Planes swooped down almost touching the tree-tops and threw leaflets with greetings to the Internationals. They flew above us during the entire "Desfile." After we passed the officials' stands, the girls working in the factories

dressed in overalls, as well as all the women and children who were able to, broke through the guards and embraced us and kissed us. The few Nurses that are left I mean. The soldiers of course were given flowers. They carried no arms at all. Continuously a cry of *"Viva Los Internacionales"* rang through the clear, cool October air. The same cry persisted all along the Grand Via, only broken with our reply of *"Viva La Republica."* They would with all their soul shout *Viva!*

The street was filled with flowers and these leaflets thrown from the planes. I shall never forget it as long as I live, Dr. Eloesser. You should have been with us. I knew, however, that that greeting was meant for you too and so, in my poor attempt, I try to bring it to you. This is my first attempt at a typewriter, as you can readily see, so I shall say no more just now except that I miss you and the skill with which you treated the wounded and ill. I miss your encouragement, your kindness, I miss your consistency and persistency in my work, as do I miss the well planned and regulated organization of everything you did. Oh damn it, I guess I just miss you Dr. Eloesser!

I am still with D'Harcourt. He always asks of you and if you have written. All your friends from Valcarca have not forgotten you and many are the wounded who see me and ask me about you. I could fill this complete letter with names and, of course, there are many I do not know.

Do write to Dr. D'Harcourt if you have a spare moment. He too is busy as can be these days.

He operates three times a week. We often have 20 to 25 operations a day. He does a great deal of bone work and his assistants help him with extractions, etc.

I am with Cessie in your old room.

Dr. Bokow is in Paris; he was recalled. The C.S.I. is now functioning beautifully. Packages are coming through in record time and so are mail and telegrams. I received your package from France or London, for which I am terribly thankful.

Have you seen the girls and Dr. Larsen and Tom since they have returned? Please remember me to them all and tell them I miss them terribly. I should like to stay on until the Loyalists win the war if I can. Lately however my old ulcer is not behaving itself as it should. Sippy powders are swell but our "REGIMEN" is a bit tough on the old gastric walls. Anyhow, I shall stay on as long as I can, for I am happy in my work and Valcarca is not the same. It is improving in leaps and bounds. You would be happy to see it now.

Well, salud, Dr. Eloesser and please write me if in your busy day you find a spare moment. With all admiration and respect to one of the world's greatest men, I am yours,

Sincerely,
Ave Bruzzichesi

. .

from ARCHIE BROWN

Nov. 24, 1938

Dearest Sweetheart

Received your letter of Oct. 23 today. Must have been some mix up in the mail. You can imagine how happy I was to hear from you, particularly if you have received the

letters I've sent meanwhile. This is the first I've heard from you in about a month. I was a little afraid that the homecoming propaganda would keep you from writing. So now until you have read that we actually have left Spain—keep writing.

Today's papers carry the story that Roosevelt will propose the lifting of the embargo on Spain, to the next Congress. After the withdrawing of the Ambassador to Germany (for information) this is the most logical step. But—the people must respond with meetings, resolutions, demonstrations etc. in favor of the President's proposal or reaction will nip the plan in the bud.

Boy what the Spanish people couldn't do with a few artillery pieces & planes & of course food. It took the fascists four months to take back what we captured in 5 days in the Ebro offensive. We were forced back across the river thru superior artillery & airplane forces. But we took everything back with us—we did not lose a gun. The people of Spain need guns & food.

You may not know it, but I've become a producer. Yep, we put on the dangdest, whang-up production you've ever seen and not once but twice. The gods cast the dice & decided that I become the chairman of the social, cultural entertainment & miscellaneous committee. Among our activities was building Finnish steam baths & convincing guys it was necessary to register their books when they took them out of the library—and to say "now comrade also the one under your sweater—if you please!"

Then came the brainstorm—a brigade fiesta—to thank the people of the town for their hospitality & raise funds. Each company was asked to provide "turns" as the English call them. We had to negotiate for the theater—but the manager had to see the committee & the committee after one deliberation would not consent to taking up the seats for a dance & there was the problem of holding the program in one place & the dance in another. So we got another place, but then the com. decided to take up the seats. Then we asked to get signs made & the comrade in charge said there was no paint. So we sent another comrade to the cooperative & another to the popular front— still no paint so we sent a comrade to Barcelona. He came back & said no paint unless the union sent it up. So we decided no signs. So Monday the paint arrived from Barcelona, the cooperative sent paint, the mayor brought over his private supply. At 12:30 the comrade in charge came to me breathless & said "I forgot all about it—we had some paint left from last time." The signs look fairly good.

The English on Sat. said they had everything ready—the Ams. had four turns, the Cubans were not sure & the Canadians couldn't be found. Sunday everybody was ready. So we put in for a leaflet which was to be ready Monday, but came out Tues. at 3 p.m. The signs scheduled the dance for Tues. 8 p.m., the leaflet at 10 p.m. (the printer thought that the people of the town would not respond at 8). The announcement at mess was for 9. The commissar in charge also thought it would be too early.

At 8 the doors opened and in 15 min. the place was full—but the band leader also thought 8 was too early so he sent word he would come at 9 and arrived at 10.

Meanwhile we put on the turns. The English led off with their trio—followed by the Negro Chorus—& sundry numbers.

The only difficulty was that all the entertainers had brought their friends, particularly the Spanish comrades, & they would hold last minute conferences & rehearsals. So you didn't know whether the Rumba dancer was singing "Sewanee River" or telling

droll stories. I finally posted a guard at the door—but the door swung inward. So after he got smacked in the face a couple times he stepped to one side. The people would come thru the door, turn a questioning face at the guard's challenge, get indignant and keep on walking.

I said "Why don't you stop them." Said he, "—I could shoot them if you wish—." Not wanting blood on the floor we compromised—people came & went as they pleased.

Somehow the hours passed and I remarked to Harry Bottcher (a S.F. boy) "What a mess!" "If you would look out on the floor—or go out and dance you wouldn't think so."

I took his advice and had a dance & sure enough everybody was having a good time. All the notables expressed their satisfaction & we danced till 2 a.m.

Now I'm no longer in charge—I've been sent to the Mid-West-Pacific Coast Company. We have reorganized on a regional basis & I'm busy helping organize the activities of the company.

If you write real soon—I'll tell you more. I hope I'll be able to hold you in my arms when I tell you—but don't expect us very soon. There are many things to be ironed out. Meanwhile—don't forget I love you.

I'm writing to Ontario until I get another address.

<div style="text-align:center">

Salud
Archie

</div>

• •

from FRED KELLER

<div style="text-align:center">

Paris
Hotel Minerva
May 15, 1938

</div>

Dear Herbert [Matthews],

The Medical Commission very suddenly discovered a split kidney, a leaping heart, and a few dozen more things and said I could not go back for six months, and about two nights later I climbed over the mountains into France together with Marty H. [Hourihan]. It takes some people about six months to accomplish all this, but then they were never the subject of your nice, old capitalistic publicity and that is the real reason for my exile.[1]

I don't like the idea of leaving Spain at this time. I always wanted to stay till the end, but a lot of other people have different ideas and now we are going to Washington to lobby against non-intervention and make a few speeches. I don't trust the future, but if it is at all possible I will return in the fall. I learned a great deal in Spain, for me it has been a college education and a great inspiration for the future, and I think that it's very important to a successful life.

Paris has been good fun, we got two offers from ghost writers, a lot of interviews, and [were] the guests of a few more people, we are really seeing this place. In a few days we will work our way back to NYC. Money is very scarce, and they need it to send

[1] Keller's exploits during the Great Retreats—from escaping fascist capture to swimming the Ebro river three times—were the subject of a half-page *New York Times* story by Herbert Matthews.

back invalids, in this case we are setting the example.

If there is anything I can accomplish let me know and I hope we meet again soon and again, thanks for everything.

> Salud,
> Freddy Keller

from MARTIN HOURIHAN

> Paris, France
> Minerva Hotel
> May 19, 1938

Dear Herbert and Evan,

Hope one of you will receive this.

I have been in Paris since the 15th *(sin ropa)* [without clothes]. Had to walk across the mts and couldn't bring a goddamn thing with me.

Herbert, I hope you found things good down south and that you enjoyed seeing M. again—let us all hope we shall see it again like it was a few years ago.

I am stuck here without a passport, looks like I will be here for at least a month. The bastards are doing everything possible to make it hard for us.

Evan, ole boy, I hope you don't get to read this—I want to see you in Paris soon.

I went to see Robert who immediately wanted to give me 500 fr., but didn't take them and won't unless it is absolutely necessary.

My leg is in rather bad condition after the 10 mile walk, but hope to be okay in a week or so.[2]

Freddie is okay! You should see him in the bloody suit he bought in B.—looks like a pansie in the gay 90s—Christ, it is terrible when we walk down the street, we almost cause a panic.

Evan, I sent the letter to your mother, and remind me when I see you there is a long story connected.

However, I didn't copy the address, so if I get back to the States I may not be able to see her, however I don't imagine there is another Shipman living in Beekman Place. I will do my best.

If you have time drop me a line, either one of you.

> your friend & Comrade,
> Martin Hourihan

from EVAN SHIPMAN

> June 21, [1938]
> a bord, le
> French line

Dear Ernest [Hemingway]:

[2] In the battle for Villaneuva de la Cañada, Captain Hourihan, former teacher and ex-seaman, native of Towanda, Pennsylvania, was hit twice, one bullet smashing his thigh, the other his ankle.

I land tonight. I wish we had had a few days in Paris together. Marty [Hourihan] was still there when I got in. We had a week at the Montana, went to the races—Anteuil, The Jockey Club, and the Prix de President at Vincennes—and had a general good time together. We ate a lot of good food, drank some damned fine wine, and saw good horses. Paris was great all except the people. We could not take the same boat, as my ticket had to be bought in advance to clear me from jail. Marty gets in the end of the week. He will go up to Plainfield for a while with me. I am going to send a wire to Lana today to have her come down and meet him. You know they sent him out across the mountain. I don't know how he ever managed it with that leg.

The damn fools sent me across the mountain too. They knew I had been expelled from France but they told me it was perfectly safe. I no sooner left the *Carabineros* at the top than the *Guarde Mobile* spotted me—It was a bright night and they fired a couple of shots over my head. I lay low for an hour and then began again, changing my line to come out at another place on the road. Then when I got to the road I was so damned jollied up and excited that I made a mistake and started right back into Spain again. I got almost to the French Customs before I was able to get my bearings. The *Carabineros* had told me about a staircase going down the mountain to Cerbere from the road. I couldn't find it for the life of me, and I kept going back and forth and back and forth around those turns in the moonlight. If the *Guarde Mobile* were looking they must have thought the whole 43rd Division was on its way over. And they did think something like that, too, because finally I gave up looking for that staircase and followed the road right in and then I found the staircase—the bottom of it where it meets the road again—six *Guarde Mobile* were there. I couldn't dodge them. They wouldn't believe that I was the only man coming down the mountain. "Why we saw at least a dozen" they said. And two of them took me to the station and the rest went up the mountain to hunt. They hunted all night.

You know Port Bou—the way the whole town seems to be in the bottom of a cave. Well the Fascists bombed us twice the day I was there. There are good refuges but even then it's not a nice place to be bombed. When I got over and the *Guarde Mobile* had me I said, anyway, that's one thing I don't have to worry about anymore. There's a good big mountain between me and those planes. Can you believe it? I was not in that jail one hour—had no sooner gotten to sleep and I was tired—before there was the God damndest crash of bombs just up the street—not a hundred yards away from the jail. I was all alone and locked in of course and everybody was running up the street and women screaming. First I felt haunted as if they were following me, and then I felt glad that the French were getting a chance to run screaming through the streets for a change. I even thought they might let me go the next morning as a mark of solidarity or something.

That plane may have done it on purpose because Cerbere is all lit up at night. You can't mistake Cebere for Port Bou. And then what he hit was the R.R. yards and a couple of buildings next to them. Just what they would want to hit. But on the other hand he may have been an amateur who got dazed or blinded in the places that the Spanish caught him in from the mountain. He may have been trying to drop his load just anywhere and get away before the anti-aircraft started. The French anti-aircraft deliberately never fired a shot even after they heard him bomb the town. They said they had

orders not to fire on planes.

The next morning they took me to Perpignan on the train. Everybody was talking about it in the train. The Pyranees Orientele was getting really bellicose. They were all scared and mad. The *Guarde Mobile* were extra sympathetic to me—bought me cognac and tobacco out of their own money and forgot about handcuffs—But that was as far as the solidarity went.

At Perpignan I found out that I was up against six months. No alternative, no way out, except pull. I was scared. It was a nice jail and all that but the prospect of six months made me feel very bad. I wrote at once to [Robert] Desnos to get in touch with Martha [Gellhorn], who I remembered had some pull with the Radical Socialists at one time, and also Senator Hollis from N.H. who used to be a friend of my father's and who practices now in Paris. They all got started right away and Charley Sweeney, too, went to bat for me. But here was the funny thing. And if you think a minute—you will see the queer, uncomfortable position I was in. Father used to have a friend in Paris—a very rich man named James Johnson who helped father a lot—and I never could abide him. It was more than just a mild dislike. I often thought of him as standing for all the things that I hated. I knew stories about him—in fact I had even written one that thank God I never tried to publish—that were ugly enough in their way to make you want to vomit. So Desnos, on Senator Hollis's advice goes to Johnson. And the first thing I know—the first thought of Johnson that I have in two years I guess—there he is down at Perpignan—come all the way down from Paris to help me out of jail. He was doing everything, in Perpignan and in Paris, to get me out. He hired a lawyer; he was in touch with Sarrant; he saw the Prefect; he had special food sent in to me every day. I never felt like a more perfect son of a bitch in my life. I would no more have asked him for a favor—and yet there I was taking everything from him. He got me out. If I had gone to trial the judge under the new laws would have had no alternative but a minimum six months. The day before I was to appear the notice came through Sarrant and I was clear.

Marty and I did our best in Paris. We sent his wife a truck load of hortensias—we had them to a swell lunch at Maiabeau's—we took them to the Jockey Club—I (for a wonder) was able to repay him all the money. The end was that they asked us to a dinner the night before I sailed. We had to go of course. And I never have been through anything like that dinner. Marty was wonderful. I looked at him, and then I got a hold on myself and behaved. You would have thought that the one thing the people at that dinner would not have talked to us about would be Moscow and Red atrocities in Spain. Well the whole meal was devoted to a discussion of the raping of nuns and the burning of priests in gasoline. We spoke once, mildly and timidly, of things Franco did. We were cut short. "Did you yourself ever see any atrocities?" We had to say that we did not—although we thought later that some of those apartment houses in Madrid and Barcelona ought to be atrocities—enough for anybody. We were told all about the Spanish situation from the beginning—before the beginning. Oh how I wish you had been there not owing your freedom to anybody. Marty felt so responsible about me that he was tact itself all evening.

He and I had a cocktail every morning at the Chateau. We did not run into your friend Dart. If he has sold your play to people and you do not want to produce it and he

did not have power of attorney, you should get an injunction stopping them. Don't let some stupid producer spoil that play. Speaking of Dart, did you know that Frank Ryan was OK? He was captured, but DeValera and several Bishops sent a note to Franco saying that they wanted Ryan treated decently. He was very good to me and it was wonderful to hear that news about him.

Things down below were not going well at all when I left. I mean with the Americans. I am not talking about up at the front. That I don't know. But in Barcelona, Badalona, and back it was very bad. There were desertions, and I mean on a fairly big scale, all the time. The morale was terrible and I felt that there was no adequate political work being done. Al Cohn lost his job because of André Marty. Joe North was away. The *Service Sanitaire* was pretty much confusion with three or four good people doing the work of a dozen and hampered at every turn by jealousies and incompetence, often at the top. A man like Oscar Hunter, who really could have been of great value, was shunted into an insignificant job where he never had a chance to do his proper work. I believe that Marty understood all of this before he left. You know he wanted to stay if they would have used him in the right job, and I would have stayed with him. I would have been eager to. Also after he left I would have stayed if I could have been useful working with Oscar or with [Dr.] Minkoff [Sanitary Service]. But both of them had lost all their power. I knew that I by myself could get nothing—that it was only by working under someone who knew me that I could be useful. And I know, too, that that was my own fault. I spoiled all chances of getting ahead on my own first by being rank and file (for which I am glad) and second by always looking like such a bum. (But that I am going to change. I've been handcuffed by that too long.)

I guess you know that I want to tell you again how glad I am that I went to Spain. I owe Spain a great deal. I owe you a great deal. At the time I went, I was in a bad state in many ways, both discouraged and confounded. I am neither today. And again after such a long time, I feel a real eagerness for work. Again I have confidence in myself.

I hope that you are getting a real rest with Pauline and the children. And that that damn play business is not causing you worries. If there is anything I can do for you in New York, let me know. I should think it would be a good place for you to stay away from in the summer, but if you do come up I want to see you and Marty will too. In Marty you have a true friend. You know how silent he is, and at first you might not realize how much he understands beneath his silence—he is another reason for my being grateful to you.

As I said, apart from food, drink, and the races, Paris was terrible. Even the races are not worth it. Apart from Desnos, the only person I had a good time with in Paris was Charley Sweeney. He came around twice to see us and we talked everything from horses to war half the night. I really liked him and so did Marty. He told us some great stories. I never realized it before, but in a lot of ways he makes me think of Walter Cox.

This sends my love to Pauline, the children and you. Please try to write me once in a while. Let me know when you come north. Marty is going to stay with me until he is good and strong for his operation. If you and Pauline want to take a trip and would like me to take the children this summer and teach them I would love to do it. Remember to write—

 Evan

P.S. In putting it into the envelope I realize that this letter is a record, and the record will probably stand for some time!

Give my very best to Sully.

. .

from AVE BRUZZICHESI

45 East 3rd Street
New York City, N. Y.
January 26, 1940

My dear Dr. Eloesser,

Before discussing with you again my personal difficulties, I should like very much to tell you how we finally left Spain, as you requested in your letter.

For a time the Medical Bureau had so many of us on tour that I thought you were tired of hearing of the evacuation. However, at least I am able to tell you about some of our co-workers and friends and when last I saw them.

Since I've not written about this tragedy, I cannot tell how long it will take, but it seems to drag too much. I shall make this a sort of continued letter. Does that meet with your approval?

After we sadly bid you farewell in Mataro, the so-called West Coast Unit split up. Alice and Evelyn remaining at Mataro, Manuel and Pelegrin assisting Dr. Hart, Cleo in the southern section without any further news from her. Jack eventually obtained a position with the government as draftsman (electrical) in Barcelona, and I went with Dr. D'Harcourt at Valcarca.

Everything went fairly well for a time with the usual war time discomforts to make our lives miserable and sad because we could not work as efficiently under those circumstances. The cold continued (this was that winter) both at home and worst of all at the hospital. We continued to burn alcohol to heat the operating room during operations. Dr. D'Harcourt finally obtained electrical heaters but air raids were so frequent that the current was off half the time. Valcarca never improved and the way the O.R. was run broke our hearts. The sterilizing was never finished in time to start work promptly. The sterilizing and auto-claving continued in the same vein—wet gowns, burnt gloves, and shortage of even these, so in desperation Dr. D'Harcourt finally decided to open his own O.R. in pavilion number six, giving us one of those benzine auto-claves to use for all our sterilizing. It was inadequate, for most of the drums were too large to put in them and we always seemed to have a great deal of trouble getting benzine. After awhile I grew to be an expert at draining the gasoline tanks of cars parked outside of our pavilion. We therefore had to put the very large drums on a stretcher along with the instruments to be dry sterilized and wheel them to the main O.R. three or four times weekly, depending upon our O.R. schedule. The elevators never ran, of course, so all these had to be carried by hand. It was a lot of fun (when we weren't hungry!).

Dr. D'Harcourt's staff seemed to increase daily with *"enchufados"* [people who use contacts to get easy jobs] who needed some sort of *carnet* [ID card] as the government became more strict. The *Sanidad* needed a good thorough cleaning but never did get it, and what eventually happened remains proof of what we all realized might occur!

These *"enchufados"* filled our tiny O.R. in Pavilion 6. As many as twenty in those small rooms which were used as "yeso" rooms when you were there.

Dr. D'Harcourt's work tripled after you left. He had pavilions #4-5-6-7 besides consultations and private charity cases from the outside and officials, their wives and children and members of his staff, their friends or families to take care of.

The day before operating he made rounds and handed me a list of ops for the next day. On the list perhaps there would be twenty or twenty-five, but when the day of operating came along there were often ten more than listed, for our *"senioritos"* never completely made rounds or never showed all the cases to D'Harcourt. As a result the last ten or fifteen operations, dirty or clean we never knew, had to have boiled gloves, no gowns, etc. Two alcohol sterilizers, you remember the kind, had to be used (in the room for anaesthesia) for reboiling our instruments. [For] the instruments that did not fit into them we used the (Spanish) method of sterilizing. Burning them with alcohol!

You left in June, and in July an offensive was started by the government at the Ebro. We received orders to make preparations to leave on the hospital train. What a chaos before we finally got underway. Only a skeleton staff remained at Valcarca.

The hospital train itself was rather an elaborate passenger train before the war, but as a *"sanidad"* train to be stationed under a tunnel for weeks during an attack it proved a complete failure in many respects. No running water, no toilet facilities, no way of quickly washing laundry or cooking, etc. What an experience! All refuse was usually dumped just out of the train, and it was a real effort to get lazy *sanitarios* to dig holes to bury amputated limbs. It was not rare to slip and fall on a gangrenous limb as one left the train to obtain supplies from the *auto-chirs* camouflaged just outside the tunnel. We used one of the *chirs* for all our sterilizing and José (our dear chauffeur) kept it going night and day. His kindness, love, and cooperation were the only things that aided me during that nightmarish time under the tunnel. The lack of fresh air, the stench from accumulated body wastes etc., gave us all a peculiar pallor and our appetites waned. The loss was heavy during the offensive and *we worked!* Quemada with the English nurse, and Dr. D'Harcourt ceaselessly for days with no relief. Both teams going night and day and we had to make supplies and sterilize between ops. We all worked in a stupor-like state, our eyes heavy from lack of sleep. It was then I learned how much one's body can really stand.

This tunnel was near Falset, but after the river was crossed we moved forward to a small town and took over an abandoned villa and turned it into a hospital. This was in July 1938. Losses seemed great to us, for we were the first hospital behind the line and we took the brunt of the offensive. Even Teruel was nothing in comparison to this hot summer offensive. Wounded prisoners were almost as many as our *own* soldiers and so there was no resting. We were three teams. Dr. Hernandez from Madrid taking over when our Tiente Colonel had to visit the front or superiors.

The offensive was successful, we were recalled to Barcelona. When we arrived *a la estacion de Francia* we were ordered not to leave the train. We left the same night for Levante (possibly another offensive). There we stayed two weeks but nothing happened except that we rested. All I could think of doing was to sleep outdoors in the fresh air and sunshine and I awoke only when called for meals.

After returning to normal I began to appreciate the beauty of the place. The

beautiful mountains, chain upon chain as far as the eye could see, and so rich in color! Old castles broke the irregular mountain lines.

After two weeks we returned to Barcelona where we remained until late January 1939. You probably realized earlier than we how rapidly Franco's troops were advancing toward Barcelona at that time.

During those months in Barcelona we operated twice a week on older cases and D'Harcourt specialized in making temporary artificial legs out of walking-irons, felt, and plaster of Paris.

Then the Internationals went and the Mataro hospital was taken over by one of our younger doctors. Dr. D'Harcourt obtained permission from the government and the International Commission for me to stay on with him, though I was broken-hearted to bid farewell to our American friends and to the Internationals! The British nurses remained, however, so Rosita looked after us somewhat, in her own hysterical fashion.

I'll continue this tomorrow. I do hope I'm telling what you wished to hear. Let me know if there are any questions.

<div style="text-align: right;">

Sincerely,

Ave Bruzzichesi
</div>

...

from AVE BRUZZICHESI

<div style="text-align: right;">

January 29, 1940

45 East 3rd. St.,

Newark, New Jersey.
</div>

My dear Dr. Eloesser—

While listening to the Philharmonic Symphony this afternoon, I shall try to tell you about the evacuation of Barcelona.

Before we received orders to evacuate Valcarca to Gerona, Figueras, and Port Bou, the usual hardships of the cold weather in Barcelona plus shortage of food, etc., as you very well know, preceded it. To add to the care of the wounded, hungry, starved, frostbitten, the increased air raids kept even Valcarca full. To add to the burden, Villa Franca and points south were being evacuated just as rapidly as possible while "Franco's army," pushed ahead. Valcarca then became a sort of triage and evacuation center.

During the advance of the enemy many members of the old army, fifth column and *"enchufados,"* (even in the government ranks) showed their true colors. Those who had not actually helped Franco, abandoned their high posts (the *sanidad* had her share), and fled into France, often taking with them (government transportation) autos, etc., for their sole personal use and abandoning them when they reached Port Bou or Cerbere or Perthus. Some of the high officials got thru into France all right, if they had enough money, friends, or pull in France. There were many colonels, etc., whose passports were not valid and weeks later we met them at the border with their insignia torn off their uniforms. You can imagine how some of the soldiers felt at seeing their leaders in this state.

Dr. D'Harcourt worked day and night without many of the so-called *sanidad leaders* (deserted), attempting to evacuate all those loyal to the government and those well enough to be transported without danger under such difficult circumstances. There

was always a shortage of ambulances, more during the evacuation than before. Orders had to therefore be given on and before reaching Gerona, that those able to walk must do so. Thousands upon thousands therefore lined the roads, with a small satchel of their personal belongings slung over their backs. A crust of dry bread, a tin of sardines, a tin of milk, but always among these their personal belongings were pictures of their loved ones dead, or left behind. Sometimes an old family heirloom of only sentimental value accompanied these other precious articles.

D'Harcourt's *equipo* split into five or six units, all rushing on with what material could be quickly salvaged, establishing temporary hospitals along the route of evacuation toward France, caring for those arriving by ambulance or on foot. Others wounded by constant dropping bombs, especially in the large towns, like Figueras, Gerona, La Junkera, etc. During these trying times, the *intendencia* either deserted us or lost us in the frequent and ever-changing orders that we received by word of mouth, messengers, and—when the phone was not cut—by phone. Food became very scarce, "the senioritas," whom you knew very well at Valcarca, deserted us during the night, taking with them when we were half way toward France our only large ambulance. *They* were panic stricken and had attempted all day to persuade us to run for our lives and to leave the wounded behind. Such panic—such fear I have never seen! For your personal information young Ava Quistain, Lopez, the lab doctor, Dr. Ley's assistant (the one with infantile paralysis), and many others abandoned us completely. Dr. Moreno was left in charge. As the others had fled he was restless and during the following night he too wanted to leave with the remaining few of the group. I was trying desperately to reach Dr. D'Harcourt, who was somewhere near the border trying to keep order in this chaotic evacuation. After many desperate tries I got him on the phone and told him of the 500 or more patients awaiting evacuation, that our ambulance had gone, etc. He asked for our leader. I could not find him, but he told us to await orders from him that we were comparatively safe, the fascists were still near Mataro. He promised to send transportation. When we finally were evacuating "Caldas de Malanella" a skeleton crew had to go on ahead to make preparations to receive the wounded in an abandoned children's colony on the Costa Brava. No sooner had we gotten outside of the city limits when our own wounded, the ambulatory ones, halted us with their machine guns and called us deserters and rightfully so, for they knew what had happened to our ambulance and they had not seen the others come in. Explanations were difficult, but we finally drove back to the hosp., to show the authenticity of our story and continued on our journey, not without many harrowing experiences, however.

When we reached what we were informed would be an empty children's colony, we found children still there and they had to be evacuated. Do you know who came to our rescue? The mayor of the nearest town, (the Spanish mayor had fled) Kraus, remember from Hans Beimler? They had been stopping all cars & trucks heading toward the border filled with personal equipment. These occupants had to continue on foot, while cars and trucks were being sent back to aid the ever-increasing sufferers who loyally defended their country. So it was we got the children away safely—thanks to many internationals who were unable to leave Spain because no country would accept them. We obtained food from deserted farm-houses when we had time.

One night I was called by the ambulance driver to hurry to the ambulance to see

the two new patients who were badly in need of a laparotomy (The O.R. was set up). I thought two laps—oh my God—now of all times! As I approached the ambulance I heard what I believed to be grunts or moanings of pain. As I opened the rear-door I saw two huge half-ton hogs, one on top the other—and we hadn't eaten for days. That night we all enjoyed talking about how we were going to fry, barbecue, roast those pigs or hogs (what's the difference?) I never did find out how the driver got those hogs into the ambulance. Morning came with orders to evacuate immediately and the saddest thing in my life was that we had no room to evacuate our porcine friends with us.

As the half-million walked or moved toward France, one continued seeing dead donkeys—horses, goats, or sheep—along the road perished from cold, hunger, or disease. At night despite danger of air raids, refugees built fires to keep themselves warm. Hundreds of such small fires flickered in the night making excellent targets from the air. Still there was defensive fighting going on, especially by the Eastern Division (where Margaret Powell, my friend the Welsh nurse was). The Quakers and the C.S.I. already set up in Perpignan had canteens along the road to feed the hungry and we eventually had to improvise first-aid stations along the road too, as we moved along, for no one would remain behind—(except the dead).

So thousands of homeless Spaniards looked forward to entering France in early February 1939. Many had walked all that distance—women, children, and aged—for cars & trucks were mostly used for the wounded, although women and children often were given the wounded places by these fine men who could just about creep along themselves.

I'll write again to tell you what happened when we crossed the border.

Does this make intelligent reading? I write as I recall the events, so perhaps the thoughts are not consecutive.

So it was that I was a cog in the wheel of this tragic evacuation which has left an everlasting impression in both my heart and mind.

As I was writing this I could not help but think of Recartero and The Tiente Colonel who was so kind to us at Teruel and on our return. Do you remember his name? What has happened to the fine men who were in the Madrid section?

Now may I add a personal note telling of my present difficulties?

As ever, Ave.

January 29, 1940.

After being interviewed by the British Passport Division, I was informed that in order to obtain my visa to the United Kingdom I should have enough money to return to the U.S. if anything happened that I could not marry.

I have been inquiring as to the cost of transportation on the American liners to Genoa and find that it is $175 one way.

Would it therefore be possible for you to make me a loan of $300 sometime before the end of March?

This must be a loan, Dr. Eloesser, which both my future husband, Alan Lawson of 3 Brim Hill, London, and I will endeavor to repay just as quickly as possible.

Most sincerely

Ave Bruzzichesi

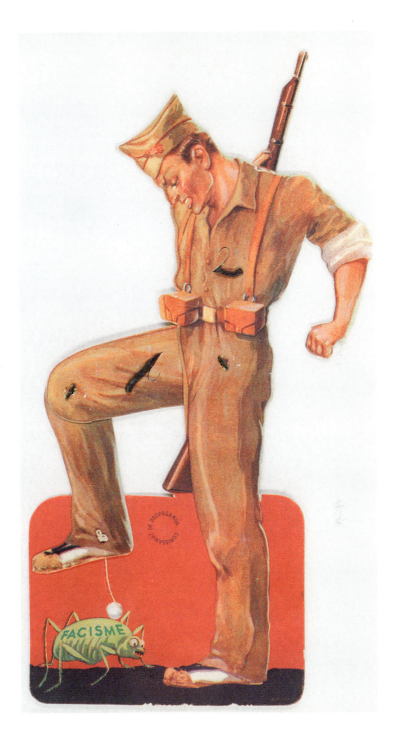

A cardboard, pull-string children's toy given to Edwin Rolfe by Langston Hughes in Madrid in September of 1937. The soldier's leg moves up and down to crush the fascist insect. Edwin Rolfe Archive, UIUC.

A color collage, honoring the 15th International Brigade, used as the cover illustration for the June 15, 1938 issue of *Volunteer for Liberty*.

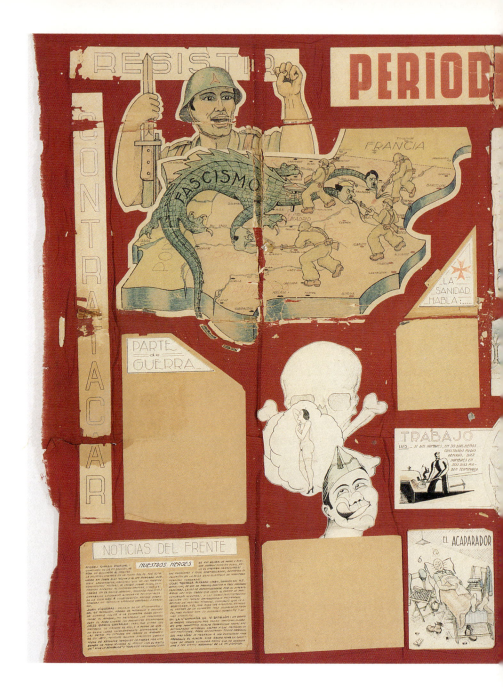

A 1938 wall newspaper on red cloth, five feet wide, brought back from the International Brigades hospital on the Mediterranean coast at Denia by Irving Goff and now in the Spanish Civil War collection in the Rare Books and Special Collections Department at UIUC. Goff worked behind the lines with Spanish guerrillas and was probably one of the inspirations (*sans* Maria) of Hemingway's Robert Jordan. At the upper left, Republican soldiers attack the three-headed dragon of fascism—Mussolini, Franco, and Hitler. Below that, "News from the Front" lauds heroes

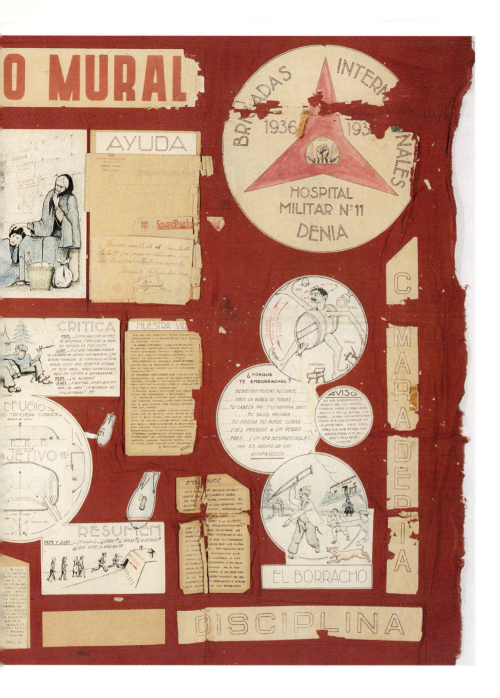

from the recent campaign. To the right, soldiers are warned against drunkenness. In the middle, "Pepe" and "Juan," recuperating at the hospital, debate whether or not to help build an air raid shelter on the grounds. The illustrated notice under the title announces S.R.I.'s "week of help for Valencia." Elsewhere, soldiers are warned against visiting prostitutes and taking food from farmer's fields, while those who have helped with special projects are named and thanked.

Above, the color cover to a July 1937 issue of *Volunteer for Liberty*. Below, Antonio Pujol's 1938 illustration for "activist" identity cards in the International Brigades. Pujol trained with the Lincolns in the spring of 1938.

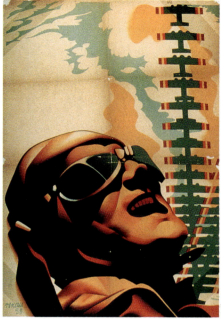
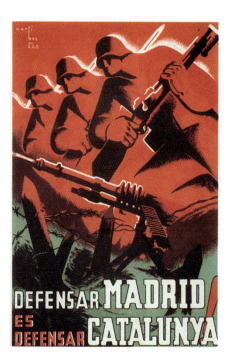
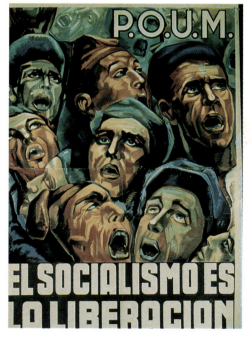

Four Spanish Civil War posters. Moving clockwise from the upper left: Baradasano: "España—Whose six resounding letters crackle in our soul with a war cry today and with an exclamation of joy and peace tomorrow"; Renau; (left half reproduced) "Victory: Now More Than Ever"; Anon.: "Socialism is Liberation"; Martí Bas: "To defend Madrid is to defend Catalonia."

Above, Corbera del Ebro today. On August 7, 1938, Edwin Rolfe made the following entry in his diary: "Last night walked through Corbera. Place ruined, wrecked, after almost two weeks of intense artillery and air bombardment. City stinks with the bodies of the dead, unburied, in the ruins of houses, and horses and mules in the streets." The town remains in ruins today. It overlooks the "Valley of Death of the Ebro campaign," with Gandesa in the distance. Below, John Cookson's memorial marker today, secretly tended by Republican sympathizers for decades. Hidden in a wild, uncultivated meadow near Marsa it was the only American grave marker not destroyed by Franco. Photographs by Nelson and Hendricks.

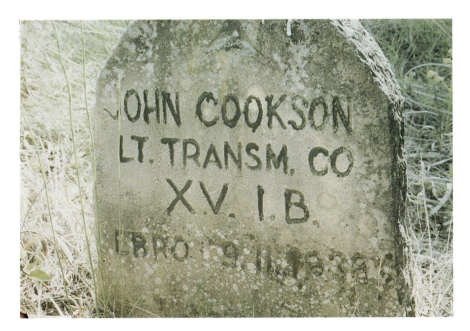

January 31, 1940
45 East 3rd Street
New York City

My dear Dr. Eloesser,

In this letter I shall really try to finish my story of the evacuation from Barcelona.

I did not dream it would take so long and still there are so many things that one would like to talk over with you. If I could only write well!

As the refugees entered French territory their troubles and sufferings did not end there. Those who came on foot had to continue another thirty kilometers or so to the camps that were to be their homes. They were considered "prisoners of war" and treated as such. Their valuables were taken from them and the army equipment, guns, ambulance, etc., were also taken over by the Daladier government and not allowed to go on to Valencia as the Spanish leaders desired.

I choose to call the camps where all the refugees were put concentration camps because they were, in my estimation, even worse than I had imagined the camps in Germany to be. They were nothing more than stretches of bare land, sectioned off by barbed wire and guarded chiefly by Senegalese guards. There was no shelter at all at least for the first month in France. It was February. The camps extended from Perpignan to the Pyrenees near the Mediterranean. It was bitterly cold and wind from the mountains blew over the camps almost continuously as did sand from the beaches. There was of course no sanitation. Herded together like so many animals these fine people had to eat, sleep, and defecate on the same little piece of dirt which was their home. In order to keep warm they dug holes in the ground and covered themselves with bits of blankets, twigs, tin, or anything they might get to protect them from the cold and wind. Four hundred thousand refugees and the majority in camps such as these. What an outrage!

It did not take long for typhoid epidemics to spread throughout these camps. Diphtheria, pneumonia, typhus, scabies too, were very common and those poor refugees who were not killed by diseases often died from hunger and exposure to cold.

Margaret Powell, the Welsh nurse, having foolishly left her passport in Barcelona had to remain in one of the camps until we found her (and took her away unauthoritively) as we visited the camps with the Mission Britannica ambulance. (It took Rosita over a week to obtain this permission). She told us of a Catalan soldier who had a few francs and wanted to leave the camp to buy some food. They only got a dark liquid in the morning, supposed to be coffee, and soup in the evening for which they had to stand in line for hours. This Catalan boy could not make the Senegalese understand what he wanted and as he innocently left the camp the guard bayonetted him thru the abdomen. He died instantly.

Thousands of such shameful incidents happened which would take days to recount.

As I was working with the British Mission then, I can tell you of what happened to some of our friends.

Do you remember the husky German doctor who became director of the hospital in Vich after you left? His wife took charge of the nurses. I've forgotten his name (Glaser).

He suffered from typhoid fever and, like the rest of the Internationals without a country, he too was put in the Argelese Camp. Women that we were (thank heavens) the French guards did not question our entrance and exits to the camp once seeing our permission from the camp. That is how we got the Welsh nurse out and Rosita with another friend got these doctors out. I did not recognize him when I saw him. He looked like a living skeleton. Once out, these refugees could make attempts to go to another country—but to get out was most difficult.

D'Harcourt went to Cite where the lab doctor lived with his French wife. He specialized in chest surgery too. Sorry so many of those names have escaped me.

Durand, the transfusion doctor, was being helped to London by the B.M.

Quemada had French friends in Marseilles who vouched for him.

All this happened after attempts to get to Valencia were squelched.

The hospital train #21 came into Cerbere filled with all the *"enchufados"* of the *Sanidad,* their family and furniture. In the entire train there were not more than 20 patients.

We stayed in Perpignan for almost a month and were sick at seeing food again which could not be shared. It took me over three months to learn to eat a small, full meal.

Fund-raising for the refugees still goes on. Many have found new homes as you know.

Please write and tell me if I can write you more in detail about anything.

Sincerely,

Ave

from CANUTE FRANKSON

Paris, France
July 23, 1938.

My dear:

To be in Paris seems more like a dream to me than the vivid reality which it is. Only, fortunately, a very pleasant dream. This is all because I do not feel like a pursued rat on which the filthy claws of jim-crowism may clamp any minute. Here, I'm a man; a human being among human beings; a respectful and respected visitor to, and guest of, this hospitable, democratic country. Paris, with its smart shops, great works of art, and mirrored cafes, knows and appreciates human values. The stigma of race hatred has not stained its revolutionary history.

It is only members of this persecuted race of ours that can really appreciate what it means to have social freedom, to be able to enjoy life as others do, and not be spat upon and treated as though we have no rights to the things which our slave parents have given centuries of their lives to create.

I walk into a cafe on one of the most popular boulevards of this city, take a seat in any part of it I choose, and am served with the same courtesy as any other human being. Do you blame me for thinking that this may be a dream? But it is so real; so naturally human. At first, the hundreds of white faces, the mirrored walls and my black face among them made me feel a bit strange. But after being here a few days my reaction became normal and natural.

There's a very large and popular cafe and restaurant on the Opera Place, one of the aristocratic centers of Paris. About a week ago I had an appointment to meet an American friend at a nearby subway station. As I got there about twenty minutes ahead of time I decided to stop in this cafe to have a cup of coffee and pass away the time. I sat at a table near three women who turned out to be Americans, I suppose. Anyway they spoke English.

After I was there about five minutes sipping slowly at the coffee, which incidentally was one of the best cups of coffee I had tasted since I left home, the three double-chinned, pot-bellied, ignorant parasites, wallowing in their filthy trough of morbid chauvinism, started in, quite earnestly, to discuss me. By all indications they either didn't care, or thought that I would not have understood them.

I just love Paris, one of the pig-faced hussies started, but I simply can't feel right sitting in the same place with niggers. Isn't it just too horrid for words, the other spewed out between sips and puffs, I simply can't understand why they allow such things. Paris is so lovely, the third chimed out over her balloon breasts, but the French are so peculiar. Then their voices were drowned by the noise of the traffic which was by this time signaled to move on.

I took a note-book from my pocket and wrote the following on one of its sheets:

You are so blinded by your ego and ignorance that you cannot see that the base is crumbling from under you, and the whole works is falling on your heads. My being treated here with a courtesy which I normally merit is not an accident, but the result of a popular front against such as you, and the revolutionary heritage of these noble French people. No. They are not strange. Watch your step.

In the meantime a very neatly dressed young French woman came in and sat beside me. The ladies were outdone. From then on they did not seem to enjoy themselves. My time was then up so I called the waiter over and paid him. Then I got up and deposited the note quite reverently, on the table in front of them, and walked slowly toward the entrance, watching them in the mirrors as I went out. Soon the one who read the note let out an Ohhhhh!!! which could have been heard all over the place. Undoubtedly she had forgotten her manners. She crumbled the piece of paper as if going to throw it away, but the one sitting nearest to her caught her hand, and took the note from her. By this time I had stopped in front of one of the mirrors pretending to be fixing my tie. I looked back at the French girl and she smiled. I hardly think she knew what was happening, but I think she guessed.

In the subway stations—all over the city—there are some posters advertising bananas, which stand out most in my mind. A girl, about eighteen years old, holds a small basket in her hands with some bananas in it. On the posters are these words: "Banana, the ideal food." Alright, you may say, you saw a poster advertising bananas. So what? *Plenty.* First it is the most beautiful ad in all Paris; second, the portrait is of a colored girl; third, and most important, the picture was made with the deepest feeling of appreciation for the beauty of our race; and fourth, that smeary grin which the Negro must wear for America's entertainment, was not there. The girl wears a smile which really lights up the heart and makes one feel wholesome. Not that mechanical, Aunt Jemima smile, or is it a grin? But the smile an intelligent, normal girl of eighteen would wear on receiving a sweet love-letter from the boy she loves, or possibly after the

thoughts of some of his passionate hugs.

No. Not the clown's grin of the Uncle Toms who sacrifice the honor of a race on the altar of greenbacks, but the happy smile of a happy, free people. Yes, free from the menace of the torch and rope. This picture is the symbol of a noble race, and the reflection of the French people's attitude towards us as a race. I often stand for several minutes in front of one of these posters, admiring it, only to find myself with a broad smile.

But, as I stated in my note to those parasites, who would that the Jim-crow law be established here, it is not an accident, but the result of the revolutionary tradition of a people who fought for, and maintain to a remarkable degree, true democracy. Nor will they, from what I can gather here, be content with the status quo. No. They are struggling every day to establish a more complete democracy for the whole people. A democracy which will be free from exploitation of man by man. And I'm quite sure that they will have that democracy. Hurrah for France and its whole-hearted, happy and affectionate people! I wish you could know them.

I'm sitting in the Jardin de Acclamatation across from a pool with children bathing, and among their mothers watching them as they romp around in the water. This is so unlike the fate of those unfortunate little fellows of Spain who must live under the constant terror of bombs and machine-gun fire from Fascist airplanes.

This massive garden is one of the beauty spots of Paris. Everything here reflects the culture and character of the French, and their appreciation for and the preservation of the arts. Here, the desire to create on the basis of size, which shows up the mercenary character of the West, is not evident. Beauty is considered in every case. And nowhere in the scheme of things, is the human element left out of consideration. In other words, things are made for the practical use of the people, and as an expression of the best in them.

I must also delegate you tell our people about the French and their attitude towards us. Here, we're not made conspicuous by the distinction of an antagonistic Press. Our achievements, successes, failures, or wrongs are all among, and an inseparable part of, the profit and loss record of the people.

Last week I saw the fourteenth of July celebration at the famous Bastille. This was really a demonstration of the organized strength of the people; a real lesson to the Fascist elements; and a commemoration of the death of those who fought, and have died, for the liberation of their country from the tyranny of their medieval rulers who had kept them during that period in virtual slavery.

We can never find rest until we have made America safe for our people; even as France is today. But this can only be accomplished by supporting the splendid start to a United Front of Action against re-action as is being sponsored by the National Negro Congress. To this we must dedicate ourselves. There will be sacrifices. Lives will be lost in the struggle. Many of us will be thrown in the jails of the masters. But they shall not always rule. Though they torture and kill us, our names and our work shall always live. Though they put us in their prisons, the pressure of the united people will free us. And eventually, we will not have only this liberal social regime, but a regime free from exploitation and the oppression of this noble race of ours.

There could be no better place for a Negro to live—excepting the Soviet Union—but I must soon leave here. Because there is so much to be done and so few of us to do

it. According to the words of Christ: "the harvest is ripe, but the laborers are few."

Take care of yourself, and give my love to the folks. So long. 'Til I see you.

> Yours as always.
> Salud
> Canute Frankson

● ●

from CANUTE FRANKSON

> Royal Magenta Hotel
> 7 Rue des Petits Hotels
> Paris (10e) France.
> August 23, 1938.

Dear Dr. [Frances] Vanzant:

I wonder what will be your first thought after you receive this letter. I do hope, however, that you will be well when it gets to you. And that you have been able since you went back home to continue working in the support of Spain, the Spain which you had the good fortune to know, but unfortunately which you saw struggling against such terrific odds, against such a ruthless enemy. I'm certain, though, that you will share with me the confidence in the ultimate victory of a people who though knowing the formidable enemy against which they fight never have lost hope in the final victory.

I wrote to you from Barcelona and do not know if you had received the letter. Things have been in such a turmoil that one could not tell where his mail may happen to be. So far I am about in the same physical condition. I have passed three stones since I left you: two in Spain and one here. Believe me I had a terrible time. My condition now is very poor, weak. I try to keep as busy as my strength will let me in order to keep up. I want to wait until I get back to the States before I submit to any further treatment. And what is most unfortunate about this is I do not have the slightest idea when I'll be leaving here.

I'm venturing a novel which Langston Hughes informed me has very good possibilities. That encouraged me greatly and I'm working feverishly on it. The only unfortunate thing is that I cannot sit at it for as long periods as I'd wish. Considering my physical condition the manuscript is getting along at a fair rate of speed. Unfortunately Langston is leaving here next week but he has promised to assist me with the finished manuscript when I get back to New York. This is quite encouraging as neither ego or naivete have succeeded in making me think that help will not be very valuable in such an undertaking.

This continent is sitting on a powder keg which may be set off any minute by Hitler. There is a real genuine war-scare here and there's every reason to believe that unless the democratic forces work quickly that before many weeks there will be a war here. The French people are very much concerned by the activities of Hitler and his allies. Because they know what it means to have a war, and from what I can see those elements who have nothing to gain by a war are working very feverishly to prevent one. While Chamberlain thinks he is fooling people by his capitulation before the fascists. Perhaps the average American worker is not well-acquainted with this individual but the French surely are.

I hate to have to spoil the motive I have for writing to you with this next paragraph but if you are in a position to help me I am quite sure that you will not think this is offensive. I'm also certain that you believe that if it were not for the pressing needs I would not mention it. Here we are having a little difficulty in regards to money to get some of the things we need. Those who spend a few days here and especially the native born Americans do not have our problem. I have been here since May 12th. We have expenses but not enough to get the other things we badly need. Out of the contingent of three hundred fifty I'm unfortunately the only left here from a democratic country. Now, if you could contact some of your sympathetic friends perhaps they would help me. Whatever it may be you know I will appreciate. It will be making my stay here a little more pleasant. I wrote to all the people I know and so far no answer. To save my life I cannot understand that.

Paris is very interesting. Everyday one can find new things to see, but there's a catch to it. There are very few things one can see of interest here, free. And if one should venture to see even a small portion of the things of interest off twenty-francs per day one must go without some meals. Living expense is awfully high. The exchange on the dollar is very high but if one does not have dollars to change what difference does that make?

Please do not let your not being able to help prevent you from writing. No one here is able to tell how long I'll be here as my leaving is dependent upon action of the people in Washington and they surely are not in any hurry. Personally, though I like Paris for its interest and its absence of discrimination, I would like to leave here. There's much to be done and for me to be wasting time here is nothing short of being criminal. If you are well enough, and I really hope you are, write to me. Perhaps you are very busy. Then write a postal.

Despite the odds which they are piling against us there's every indication that we will win in the end. Gradually the people are learning. In some instances they don't seem to be learning fast enough for us. And then now as ever the reactionary forces are busy in their demagogy, but we are not despaired. I have heard some very encouraging news even from the south.

Hope to see you some day. Perhaps not in your home state but somewhere in my part of the country. You may be visiting. Accept my fraternal greetings and my most earnest desire for your good health.

<div style="text-align: right">

Sincerely yours:
Canute Frankson

</div>

..

from SANDOR VOROS

<div style="text-align: right">

P.S. I still hope to see you before this letter gets there.

A Bord leNormandie (almost)
Le Havre Monday, Dec 5, 1938

</div>

Honey,

Here we are stuck away in a concentration camp in L'Havre waiting for the dock

strike to end so we can sail. We were scheduled to leave on the Normandie Saturday noon when the strike broke out. It's a general harbor strike against the lock-outs instituted by the shipping interest in retaliation for the general strike last Wednesday. Upon hearing the news we immediately sent a message of sympathy to the strikers and informed them we won't permit our presence here to become a lever with which to force them back to work. We also took up a collection that netted close to $100.00—

We have no idea how long we'll be stuck here. The French government is treating us like prisoners. We are not permitted to leave camp to visit the city or even do our most essential shopping although most of us lack even the most elementary things such as shoes, underwear, shirts, socks, towels, soap, etc.

I have been dreaming all along how beautiful our reunion would be & had it all figured out: arrival on Thursday—keep you from going to work all that weekend, loafing around in pajamas all day, etc. It was a really hard jolt to hear that all this had to be postponed indefinitely. *C'est la vida.*

<div align="right">Sanyi</div>

● ●

from WILLIAM SENNETT

<div align="right">

United States Lines
On Board S.S. Roosevelt
Oct. 1, 1938
</div>

Dearest,

Two days out on the high seas now—a slow tub this, due now to reach New York next Saturday the 8th. By the time this letter reaches you I'll be getting ready to leave for Chicago.

Charley, Rudy and Art were with me when we first crossed into France but they were picked up by French border guards and are probably in jail for a few weeks. However, as soon as they are released they'll be rushed home.

There are only four other vets beside myself on board, I being the only Chicagoan. I feel sorry about the other kids as I expected that we would all go home together. If they were a little more alert it wouldn't have happened.

Just a trifle sea sick right now and I'm trying to keep from getting worse.

In Paris the F.A.L.B. has a well functioning committee. When I arrived Thursday morning they said "you are taking the boat tonite." You could have knocked me over, as I expected to wait around for weeks before being shipped out. They took me out to a large department store and in one hour I had a suit of clothes, shoes, socks, hankies, ties, underwear, shorts, and a raincoat. I dressed up for the first time in 19 months—it felt funny.

Just before leaving Paris I met Joe Gibbons who is waiting around for his papers to be fixed up. He will leave in a few weeks.

The food on the boat is marvelous, only the change was so sudden for me that I can't eat too much just now. Last nite I kept the waiter busy bringing me ice cream and I know that I'll be eating plenty soon if sea sickness doesn't get the best of me.

What is really disturbing is the possibility of the outbreak of war. The news just came in that Italy, Germany, England and France have agreed on how to hand over the

Sudeten regions *peacefully!* Chamberlain has not only sold Czechoslovakia down the river but he has accomplished his aim of bringing the above four powers together and his four power pact (collaboration with fascism) is well on the way. He has been breaking France away from Russia, but the French people [will] have the last word yet.

Just left Ireland behind and now for seven days of water. And then home. I'll be in New York for a few days—no longer than necessary. Will telegraph when coming.

Wait'll I see you!

Love—Bill

One of Ramón Puyol's surrealist Spanish Civil War portraits. This one is titled "the Spy."

AFTERWORD

I am in the Abraham Lincoln Brigade, fighting for Spanish democracy and against world fascism...for those of us with a bourgeois background the transition from organizing one's life around personal interests to social interests is a tremendous emotional strain—it is the problem of *Peer Gynt.* [Yet] to be involved in solving social problems automatically solves most of one's personal problems...the more one is interested in social problems, the more personal hardships are passed by almost unnoticed, simply because they are too insignificant...in fact the words selfishness and altruism lose their original meaning and merge into one quality, namely social consciousness.

Thane Summers, June 2–21, 1937

So wrote Thane Summers, not long after abandoning his philosophy studies in Seattle and arriving in Spain. Though he did not survive the war and though his comrades came home from a war they could not win, their legacy retains its power. It is partly their devotion to the collective good, their willingness to put themselves at risk for a just cause, that so distinguishes these members of the 1930s generation. As for Summers himself, we may honor him individually by remembering that he continued to philosophize under fire until the end.

In this book we have gathered together some of the lineaments of the Lincoln Brigade's wartime legacy, but we have also tried to show the Lincolns as believable human beings, as people with different impulses and desires, sometimes with contradictory ones. Comparing, say, Milt Wolff's concise pictorial vignettes with the intricate personal reportage in Leon Rosenthal's or Edwin Rolfe's letters one can begin to gauge the varying roles they assigned to letter writing, as well as some of the personality differences among these men and women. Comparing Sandor Voros's sometimes quite poetic love letters to his girl friend with those in which he takes her sternly to task shows us the contradictions within one writer.

The history of the Lincolns, of course, continues to this day, and though this book is devoted to their wartime roles, it is appropriate to sketch some of their representative ongoing stories. For one of our letter writers that history was soon cut short. Canute Oliver Frankson reportedly died in an auto accident a year or so after returning home.

Edwin Rolfe, poet laureate of the Lincolns, also died young, of a heart attack suffered in 1954. He had never fully recovered from a bout of hepatitis in Spain and at the time of his death was under repeated attack by the House UnAmerican Activities Committee. But he continued to be haunted and inspired by his Spanish experience and left behind him a body of poetry unequalled, in two respects by any other American: the most sustained reflections on the Spanish Civil War and the most varied

and powerful attacks on the culture of McCarthyism. "Why are my thoughts in another country?" he asked in his signature poem "First Love," "Why do I always return to the sunken road through corroded hills / with the Moorish castle's shadow casting ruins over my shoulder?" His long 1948 poem "Elegia," a love song and lamentation for the Spanish capital and the international solidarity it stood for—"Madrid Madrid / I call your name endlessly"—was translated into Spanish and read aloud by exile groups all over Latin and South America. Forty years after his death, the *New York Review of Books* would say of his work: "Spain transformed his poetry…the lines now have a plangent, sometimes heart-breaking lyricism."

For other Lincolns the immediate prospect was fighting the larger war that they, almost alone among Americans, had seen on the horizon as early as 1936 or 1937. Milt Wolff tried to enlist in the Officer's Reserve Corps in 1939, but "premature antifascists" were judged untrustworthy. Eventually he ended up marching through Burma with General Stillwell and later joined William "Wild Bill" Donovan with the OSS in Europe. On a 1944 mission behind enemy lines in Italy and France, Wolff managed to connect with the Spanish resistance. Over four hundred Lincoln Veterans went on to fight in the Second World War; a hundred more served in the merchant marine. Predictably, some who survived Spain did not survive this next war. Private First Class Benjamin Gardner was wounded at Luneville, France, not far from Nancy, on October 2, 1944; he died the next day. Joe Gordon was on board ship as a merchant seaman in 1942, on the icy Murmansk route delivering Lend-Lease materiel to the Soviet Union; the ship was torpedoed and went down with all hands.

But most of the Lincolns made it through the Second World War. Harry Fisher was the oldest member of the six man crew of a B-26 bomber. Awaiting assignment in England, the crew was delayed because of Fisher's Spanish credentials. Eventually they flew twenty-one missions in 1945, mostly over Germany, with Fisher as engineer gunner in the rotating top turret. Once, when the plane was heavily damaged by flak, they had to make a forced landing in France, but Fisher survived to take up a long career as an editor in the New York office of Tass.

Bill Sennett's war service was more restricted. A visible Party functionary, mostly devoted to labor organizing, he was limited to stateside jobs, primarily teaching and training army recruits. Interestingly, he did have occasion to write and teach recruits a unit on "Democracy vs Fascism," a subject he was well prepared to address. In the late 1940s he was co-founder of a progressive weekly, *The Chicago Star*. Thereafter he rose through the ranks of the regional Party and ended up being assigned to go underground during the height of McCarthyism, making contact with his family only once every few months. A few years after surfacing, having digested Khrushchev's revelations about Stalin, Sennett left the Party and went into business. After a variety of jobs, he became president and Chief Executive Officer of Transport Pool, a truck leasing company. In the 1980s, after retirement, he returned part-time to political and cultural work, helping to put the independent socialist weekly *In These Times* on a secure financial footing.

A number of other Americans also went on to long and sometimes remarkable careers. Most of the nurses and doctors, including Toby Jensky, Anne Taft, Barney Malbin, and Edward Barsky, resumed their medical careers. John L. Simon returned

to complete his medical degree in Philadelphia and became a psychiatrist. Leo Eloesser at first returned to his Professorship at Stanford, but within a few years his internationalist conscience made him restless. By 1945 he was with the United Nations in China, where he stayed until 1949, training rural health workers. He returned to New York to work for UNICEF for a few years; after that, with McCarthyism at its height, U.S. opportunities disappeared and he took up a part-time medical practice in Mexico. There he coauthored a manual for rural midwives. He died in 1976, at age ninety-five.

Mexico would also become home for American nurses Lini Fuhr and Fredericka Martin, both refugees from the American inquisition that began in 1946-47. Martin, who was Barsky's head nurse and chief administrator of all the American nurses in Spain, found her way to Mexico after a stint in the Aleutian Islands, a stay that led her to learn enough Russian to translate a Russian/Aleut dictionary into an English/Aleut one. Among the important projects of Martin's last decades was the creation of a huge archive about the American medical services in Spain, an archive now preserved at Brandeis University. Fuhr spent a decade as a public health nurse, eventually completing her Columbia degree between jobs in New Mexico, Puerto Rico, Illinois, and California. But as she reports in her 1979 autobiography *Up From the Cellar* the F.B.I took an interest in her in the late 1940s, eventually persuading her employers to fire her. She fled to Mexico and before too long she was riding a mule through the mountains near Oxaca, teaching health in isolated Mixe villages.

The 1940s and 1950s were a difficult time for Carl Marzani as well. An Oxford University graduate and later a documentary filmmaker and author of numerous books—from *We Can Be Friends* (1952), on the origins of the cold war, to *The Dollars and Sense of Disarmament* (1960) and a novel, *The Survivor* (1958), to a multivolume autobiography completed just before his death in 1994—Marzani was transferred from the OSS to the State Department during World War II. The first employee to be fired under the provisions of the anticommunist McCarran rider to the 1946 Appropriations Bill, Marzani would spend three years in prison after his appeals were denied. Active in the Electrical Workers Union until that became legally and politically impossible, he eventually became a radical publisher.

Len Levenson spent the worst part of the McCarthy years living underground in the New York area, but surfaced again to take up a long career, also in progressive publishing, eventually shepherding over a hundred books into print, among them John Tisa's book of Spanish Civil War posters. Like Sennett and Levenson, Archie Brown also spent the first half of the 1950s in the communist underground, using assumed names, avoiding family members under surveillance, and moving regularly. Both before and after that, however, Brown became a celebrated labor leader on the waterfront. Twice he ran for public office, receiving over 20,000 write-in votes for California's governorship in 1946 and 33,000 votes for supervisor in San Francisco in 1959. He died in 1990.

Virtually all of the Lincolns found employment difficult or impossible during the heyday of McCarthyism, and for some the difficulties continued into the 1960s. Ted Veltfort, who drove ambulances in Spain and later became an electronics engineer, finally lost his patience with marginalized employment and employment on the fringes

of the defense industry. He left for Cuba in 1961 and taught applied physics at the University of Havana. As Peter Carroll tells the story, during the Cuban missile crisis Veltfort "garbed himself in military fatigues, carried a gun, and prepared to defend the island against an American invasion." Finally, in 1968 he returned to the U.S.

Throughout the decades following the war in Spain—through the Civil Rights movement to Vietnam and beyond—the Lincolns could be seen in demonstration after demonstration, sometimes marching together behind their banner. In the 1980s Veltfort organized a successful campaign to send ambulances to Nicaragua. In 1993 Milt Wolff went to Cuba to challenge U.S. travel restrictions and encourage normalized relations between the two countries. When he returned to the U.S. his passport was confiscated. A more politically pointed case of *deja vu* could hardly be devised, for he had last had his passport taken from him when he returned from Spain in 1939. Overall, through the years, when progressive issues were at stake, the Lincolns were there, applying their values to contemporary struggles and lending the power of their earlier witness to subsequent events. Part of the legacy of that witness, much of it previously unknown, is contained in the pages of this book.

INDEX TO LETTERS AND DIARY ENTRIES

GLOSSARY

Alba, Duke of (1870–1953)—Jacobo Stuart Fitzjames y Falcó. An important member of the nobility and major industrialist, he served as the Nationalist* representative in London and became the Ambassador to Great Britain after the Nationalist victory.

Albacete—Capital of the province of the same name of about 40,000 people (1936), located around 180 miles southeast of Madrid*; the headquarters and center of training for the International Brigades* until March 1938, when the base was moved to Barcelona.*

Alcalá de Henares—About 20 miles northeast of Madrid,* and the birthplace of Cervantes, Alcalá was the headquarters of Soviet tank operations in Spain during the Civil War.

Alicante—A major port city for the Spanish Republic. Located on the Mediterranean in southeast Spain, about 300 miles south of Valencia.

Almería—Capital of the province of the same name in southern Spain, located on the Mediterranean, about 110 miles south of Valencia.

Alvarez del Vayo, Julio (1891–1974)—Named by Largo Caballero* as Foreign Secretary of the Republican government when the war started, del Vayo also served as Spanish Representative at the League of Nations. He died in New York City.

Anarchism—The anarchists were one of the major political forces in Spain, particularly through the anarcho-syndicalist trade union federation, the CNT.* Opposed to all forms of centrally organized government and believing in direct action, they were especially important in Andalucia, Catalonia,* and Aragón.* The CNT organized militia units into columns that saw action on the Aragón front. There was a constant struggle between forces of the radical left (the CNT, FAI,* and POUM*) and the rest of the supporters of the Second Republic (principally the PCE* and various liberal democratic parties) over the conduct of the war. The radical left argued for a working-class revolution, the other supporters of the Republic for a popular front* democracy. This conflict continues to divide historians of the left.

Aragón—An arid, sparsely-populated province in northeast Spain; the site of several major battles during the last half of the war, among them Teruel,* Belchite,* and the Ebro campaign.

Argelès—A small town in southern France on the Mediterranean, about 20 miles north of the Spanish border. The site of one of fifteen internment camps for those escaping from Republican Spain at the end of the war. These camps were not closed until almost the end of the Second World War.

Ascó—A village on the Ebro* River in northeast Spain, about 55 miles west of Tarragona. One of the first towns to be taken by the Republican Army during its advance in the Ebro offensive of July 1938.

Asturias—A region in northwest Spain on the Bay of Biscay. It was the site in October
1934 of an uprising by anarchist and left-socialist miners who saw the government
as a clerical-fascist regime and hoped to establish a proletarian commune. This
uprising was brutally suppressed by troops commanded by General Francisco
Franco.* That gave the left a significant rallying point, both during the 1936 elec-
tions and in the war that followed.

ASU—The American Student Union, a popular-front student organization, was formed
in December 1935 in Columbus, Ohio. It helped organize anti-war campaigns dur-
ing the late 1930s.

Azaña y Diaz, Manuel (1880–1940)—Perhaps the most prominent Republican leader in
Spain, he was the first Minister of War in the Second Republic* and became Prime
Minister on October 16, 1931. Azaña's governing coalition was defeated in the
1933 elections, but his new coalition, the Popular Front,* won the elections of
February 1936 and Azaña returned as Prime Minister three days later. He became
President in May 1936 and remained in that position until he resigned on
February 27, 1939. He died in France after its capitulation to Germany.

Badalona—A suburb of Barcelona.*

Barcelona—Capitol of the province of the same name as well as the autonomous region
of Catalonia.* Spain's primary port, it was the capitol of the Second Republic* from
November 1937 and the object of intense bombing (as many as twenty raids per
day) by the Nationalist* air force. As the stronghold of the CNT* and the POUM*
the conflicts in Barcelona between the Republican factions were particularly
intense, leading to the "May Days" (May 3–8, 1937) street fighting. Barcelona fell
to the Nationalists on January 26, 1939. See the introduction and the chapter on
Barcelona.

Barsky, Edward (1897–1975)—A New York surgeon who left a successful practice to
lead the first American medical group into Spain, Barsky, as head of the American
medical corps, would come to be one of the most highly-regarded of the
Americans in Spain. He organized the first American hospital at El Romeral near
the Jarama front, and, by the end of the war, would be placed in charge of all the
International Brigade hospitals in Catalonia.

Batea—A small town in the Ebro region of the province of Zaragoza, Batea was one of
the villages through which the Lincolns fought during the Great Retreats* of
March-April 1938.

Bates, Ralph (b. 1899)—A British novelist who lived in Spain before the Civil War,
Bates joined the Republican army and worked significantly in the War
Commissariat as political leader of the Anglo-American forces in the International
Brigades. He edited the *Volunteer for Liberty*,* the English-language newspaper for
the I.B.'s, before leaving Spain in August 1937 to go to the United States to raise
money for the Republic. His successor was Edwin Rolfe.

Belchite—A small town about 25 miles south of Zaragoza,* Belchite was one of the

battles fought by the Lincolns in the Aragón offensive of August 1937. A victory for the Republicans, it was notable for its intense house-to-house fighting.

Benicasim—A small town on the Barcelona-Valencia coastal road, about 60 miles north of Valencia.* The site of an International Brigades hospital.

Béziers—A town on the French Mediterranean coast, about 45 miles southwest of Montpellier.

Bilbao—The chief city of the Basque provinces, Bilbao is the second-largest port in Spain. Important for its shipyards, steel mills, and nearby iron mines, it fell to Nationalist* forces on June 19, 1937.

Bliven, Bruce (1889–1977)—Liberal editor of the *New Republic* during the 1930s.

Bloor, Ella Reeve (1862–1951)—Known as "Mother Bloor," Bloor was one of the leading U.S. communist leaders and organizers during the 1930s.

Blum, Léon (1872–1950)—French socialist politician who lead the Popular Front* government in France from June 4, 1936 until June 22, 1937 and again briefly from March 13 to April 10, 1938.

Bolshevik—The faction of the Russian Social Democratic Party led by Lenin* from 1903. After the success of the Bolsheviks in the October Revolution of 1917 it was the dominant party in the country. It became the Communist Party in 1918 and took control of the Soviet Union.

Browder, Earl (1891–1973)—The leader of the American Communist Party during its Popular Front* successes in the 1930s and early 1940s. Browder visited Spain to speak to the Lincoln Brigade in February 1937, after the Battle of Teruel.*

Brunete—The Battle of Brunete was actually a series of battles that took place over three weeks between July 7 to July 26, 1937. Located less than 15 miles west of Madrid,* this campaign was an attempt by the Republican army to encircle the Nationalist forces besieging the capital. Even after vicious fighting, with extensive casualties, the battle lines would change little.

Bujaraloz—A small town mid-way between Zaragoza* and Lleida, north of the Ebro* River. In September 1937 it was the site of a conference for the anarchist collectives established in the Aragón* region.

Burgos—Capital of the Burgos province in Old Castile, Burgos became the site of Franco's Nationalist* government during the war.

Busch, Irving (1899–1960)—One of the American surgeons in the Medical corps, Busch would take leadership of the American hospitals in Spain when Edward Barsky* returned temporarily to America for fund-raising.

"Campesino, El" (Valentín González, d. 1965)—Nicknamed "the Peasant," El Campesino was a communist who rose quickly through the Republican army to eventually head a division and become one of the leading Spanish commanders.

Noted for his black beard, physical strength, and garrulousness, El Campesino was an ex-sergeant from the Spanish Foreign Legion who had later been trained in Russia. He died in France.

Capa, Robert (1913–1954)—Born André Friedman in Hungary, Capa worked in Berlin before he came to Spain. There he would begin a career as one of the world's most famous photographers. In Spain, as a young man shooting life in the Republican zone, he would find his great subject—war and its effects. He died after stepping on a mine in Vietnam.

Capronis—Italian-made bombers used by the Nationalist* air force.

Carbineros—Customs guards. When the war began, about 4,000 joined the Republic and about 10,000 the rebels.

Carlism—An ultra-conservative, ultra-Catholic, monarchist political movement that supported rival claimants to the Spanish throne. Opposed at once to liberalism and to many aspects of modernity, it was a focus of right-wing antagonism toward the Republic from the outset. The Carlists organized paramilitary militias (Requetés*) in anticipation of the military rising and were important elements of the events of July 18. They contributed perhaps 100,000 men to Franco's forces and were central in his campaign against the Basque region.

Castellón de la Plana—Capital of the province of the same name. A city on the Mediterranean coast about 55 miles north of Valencia.* It was the nearest city to the hospital at Benicasim.

Catalonia—The region in most northeastern Spain, bordered by France on the north and the Mediterranean on the east, Catalonia, and its capital, Barcelona,* have traditionally sought independence from the rest of Spain. Autonomous during the war, it was the site of many significant battles, particularly during the last year of the war. The fall of Barcelona to the Nationalist armies in January 1939 meant the war was essentially over.

Chamberlain, Neville (1869–1940)—Prime Minister of great Britain from 1937 to 1940. Known primarily for his appeasement of Hitler in signing the Munich Pact of September 1938, a pact which killed any hopes for British or French help for the Republic.

Chatos—A Russian fighter plane (Polikarpov 1–15) used by the Republican air force and flown largely by Russian pilots. Nicknamed "Chatos" (snub-noses) because of their shortened fuselages.

Cherta—Also spelled Xerta. A village on the Ebro* river about 6 miles north of Tortosa.

Chinese war—The second China-Japanese War began in 1931 with the Japanese occupation of Manchuria. It merged into World War II with the Japanese attack on U. S. and British forces in 1941.

churro—A popular breakfast pastry in Spain.

CNT (*Confederación Nacional del Trabajo*)—Founded in 1911, the CNT was one of the two important labor groups in Spain (the other was the UGT*), both having around a million members. Often referred to as anarchist,* the CNT practiced a form of syndicalism based in industrial unions and eschewed any belief that there could be anything but continuous class conflict between employers and workers. Independent of any political party, it often called on its members to boycott elections, but it was the absence of such a boycott which contributed to the electoral victory of the Popular Front* in 1936. The CNT advocated a revolutionary strategy for winning the war and the revolution, a policy strenuously opposed by the Republican parties and especially by the PCE.* Members of the CNT (and the FAI*) accepted four ministries in Largo Caballero's* reshuffled government of November 4, 1936. They left the government with Largo Caballero after he was forced out over the May Day conflict in Barcelona,* an outgrowth of the war/revolution fight within the Republic. The CNT did have another representative in the government after August 1938, but by then it had lost much of its revolutionary élan. After the war many leaders of the CNT went into exile in France and Mexico.

Comintern—Abbreviation for the Communist International (established 1919 in Moscow), an association of revolutionary Marxist parties that competed with the Socialist and Labor International. Controlled by the Communist Party of the Soviet Union, the Comintern reflected the foreign policy of the Soviet Union and became the primary organizer of the International Brigades.

commissar—A feature of the Republican army, modeled upon the Soviet Red Army, was that at every level of command—from division to section—a political commissar worked alongside the military officers. These commissars were primarily responsible for morale and political education. Until November 1937 Alvarez del Vayo* was Commissar-General.

Companys y Jover, Luis (1883-1940)—Popular President of the Catalan government from 1933 to 1939. Accused by those outside of Catalonia* of putting the Catalan interests ahead of the Republic's. A month after the fall of Barcelona* he went into exile in France. Due to the illness of one of his children, he remained there after the occupation and was turned over to Spanish police. Tried by military court on October 14, 1940, he was executed the next day and buried in an unmarked grave. Today he is honored throughout Catalonia.

Condor Legion—Over 19,000 German military personnel participated in the Civil War in support of the Nationalists.* The amount of material contributed by the Germans was immense and extremely important for the Nationalists' victory: advanced bombers, fighters (see Messerschmitt*), tanks, anti-tank and anti-aircraft guns, artillery, transports, communications, and seaplanes. The personnel was regularly rotated and new techniques tested, including one of the most infamous maneuvers of any war, the destruction of Guernica* by fire-bombing. Amazingly, many of the Condor Legion air personnel went on to participate in the creation of the West German air force after the Second World War.

Consejo de Aragón (Council of Aragón)—The CNT*-controlled governing body of the collectives that sprang up in Aragón* soon after the war began.

Convulsionaries—A New York musical and comedy group, noted for satiric political songs, two of whose key members—Ernest Arion and Harry Meloff—joined the Lincolns, performed in Spain, and died in battle.

Copić, Vladimir (1891–1938)—Yugoslavian commander of the 15th International Brigade; his military judgement was a source of debate among the Lincoln Brigade. Within a year of leaving Spain and going to the Soviet Union, Copi_ would be killed in one of the period's purges.

Coughlin, Father Charles Edward (1891–1979)—An American right-wing Catholic priest who, through the radio and press of the 1930s, vehemently opposed the New Deal policies of Roosevelt. Coughlin's anti-Wall Street rhetoric of the early 1930s would give way to rabid anti-Semitic and pro-Fascist statements by the end of the decade.

Córdoba (Also spelled Cordova)—Capital of the Córdoba province in Andalusía, about 150 miles east of Sevilla. Like most cities in Andalusía, Córdoba fell almost immediately to the rebels when the uprising started in July 1936.

Colmenar Viejo—A town in central Spain, about 20 miles north of Madrid.*

Daily Worker, The (also referred to as the D.W.)—The official newspaper of the American Communist Party, based in New York. The British Communist newspaper, based in London, was also called *The Daily Worker.*

Daladier, Edouard (1884–1970)—A French Radical-Socialist politician, Daladier was the Minister of War from 1936-1940 and served as Prime Minister from 1938-1940.

D.A.R.—A society organized in 1890 to perpetuate the memory of the patriots of the American Revolution, the Daughters of the American Revolution is known for its highly conservative political views.

Del Vayo (see: "Alvarez del Vayo, Julio" above)

Denia—A coastal town about 60 miles south of Valencia* on the road to Alicante.*

De Valera, Eamon (1882–1975)—American-born, Irish statesmen who was Prime Minister of Ireland from 1938-1948. He kept Ireland neutral during World War II.

dialectical materialism—Marx and Engels's materialist version of Hegel's idealist dialectic. This method of historical analysis sees historical change as the result of class conflict—a conflict structured by the struggle over the means of production.

Doran, Dave—A highly-successful Communist Party organizer and a member of the National Executive Council of the Young Communist League,* Doran was one of the highest-ranking Americans in Spain. The Brigade Commissar during the victory at Belchite,* he was noted for his strict authoritarianism. He died near Gandesa* on March 31, 1938 during the Great Retreats.*

Du Bois, W.E.B. (1868–1963)—One of the most outspoken and important American civil rights leaders in the first half of this century, Du Bois was one of the founders of the National Association for the Advancement of Colored People (NAACP) and long-time editor of its journal, *The Crisis*.

Dudley, Jane—A dancer with Martha Graham's dance company in the 1930s, Dudley was the wife of Leo Hurwitz,* one of the progressive filmmakers associated with Frontier Films.

Ebro—A major river in northeast Spain, the Ebro flows southeast almost 500 miles from the Cantabrian mountains near Bilbao* to the sea near Tortosa. Many significant battles in the last half of the war were fought around the Ebro region between Zaragoza* and the Mediterranean coast.

Einstein, Albert (1879-1955)—German Nobel-Prize winning physicist best known for his theory of relativity. Sympathetic to progressive causes, he emigrated to America in the 1930s to escape the Nazis.

enchufados—slackers who use personal contacts to obtain cushy jobs

escuela—school

Ethiopia—An ancient nation located in east-central Africa, Ethiopia was invaded by Italy in 1935 as part of Mussolini's* imperialist dreams. A black soldier in Oscar Hunter's short story "700 Calendar Days" (in Alvah Bessie, ed. *The Heart of Spain*, New York: VALB, 1952, p. 29) explains why he volunteered for Spain: "I wanted to go to Ethiopia and fight Mussolini....This ain't Ethiopia, but it'll do."

Euzkadi—The Basque name for their region in north-central Spain. Devoutly Catholic and not particularly sympathetic to revolutionary Socialism or anarchism,* the Basques nonetheless supported the Republican government during the Civil War because of the support of the Republicans and opposition of the Nationalists* to Basque autonomy.

Estremadura—Region of west-central Spain that borders on Portugal. It was taken by the rebels during the first few months of the war and was the site of one of the first widely reported massacres of Republican supporters of the war in Badajoz.

FAI (*Federación Anarquista Ibérica*)—The group of theoreticians and activists who made up the ideological vanguard of Spanish anarchism.* Its paramilitary cadres were responsible for some indiscriminate violence in the early days of the war. Historically somewhat at odds with the CNT,* its position moderated enough so that its members came to hold positions of leadership in the CNT. Barcelona* was its primary site of influence; its presence in Madrid* was minimal. One of the major slogans of the CNT-FAI was "The war and revolution are inseparable."

FALB—The Friends of the Abraham Lincoln Brigade. An organization set up to help the Americans in Spain and later to raise funds for the returning veterans.

Falange (*Falange España de las JONS*)—Spanish political party founded in 1933 by

José Antonio Primo de Rivera. Often identified as a fascist party, it stood for an authoritarian and centralized Spain and for Spanish nationalist traditions. Siding with the rebels during the Civil War, it was forcibly merged with the Carlists* to form a new political party, the *Falange España Tradicionalista*, controlled by Franco.*

Falset—A small town in Catalonia, about 12 miles east of the Ebro* nearby the Lincolns' training grounds at Marsa.

Fascism—A twentieth-century phenomenon, fascism emerged first in Italy after World War I with the rise of Benito Mussolini.* It is a counter movement to socialism and democracy and champions extreme state power, the abolition of individual rights, and aggressive nationalism. It typically idealized dictatorial leaders, promoted ethnic and religious hatred, and encouraged violence against opposing philosophies and political parties. Virtually all Lincoln Brigade members would have said they went to Spain "to fight fascism."

Figueras—A Catalan town about 20 miles south of the French border that served as the first stop for all International Brigade members entering into Spain.

Ford, James W. (1893–1957)—A former Alabama steel worker and the highest-ranking black member of the American Communist Party, Ford was the Party's Vice-Presidential candidate in 1932, 1936, and 1940.

Foster, William Z. (1881–1961)—A dedicated labor organizer and member of the Socialist Party from 1900 to 1909, Foster would be influenced by Lenin's writings and the Russian Revolution and join the Communist Party in 1921. He became one of the leaders of the U. S. Communist Party and ran as the party candidate for President in 1924, 1928, and 1932.

Franco y Bahamonde, Francisco (1892–1975)—Born into a naval family in Galicia, Franco would rise rapidly through the ranks of the Spanish military. He was posted early in his career to Morocco, where he became commander of the Foreign Legion, and where he developed a reputation for ambition, authoritarianism, and ruthlessness. One of several leaders in the insurrection, his political manoeuvering and military success gained him sole command of the rebel armies on October 1, 1936.

Fuentes de Ebro—A small town about 25 kilometers east of Zaragoza,* Fuentes de Ebro was the site of one of the battles of the Aragón Offensive. A defeat for the Republicans, it effectively signaled the end of the Republican Army's chance to capture Zaragoza and relieve pressure from the siege of Madrid.* The Lincolns would lose nearly 80 killed and 150 wounded in this battle.

Gandesa—A small town on the western edge of the province of Tarragona, about 66 miles south of Lleida, Gandesa was a familiar site for the Lincolns. During the Great Retreats of March and April 1938 many Lincolns, including Robert Merriman, were lost around Gandesa. During the Ebro offensive in the first days of August 1938 the Lincolns were stopped just outside Gandesa. Two weeks later,

the Lincolns would begin a ten-day stint overlooking Gandesa from Hill 666 just east of the town that would prove to be some of the most brutal days of the war.

Goebbels, Paul Joseph (1897–1945)—Propaganda Minister for the Nazi Party in Germany during the Third Reich (1933–1945). A bitter anti-Semite, Goebbels fomented racial and religious hatred in Germany with mob oratory. Vain and ruthlessly ambitious, he gained considerable power over domestic affairs when Hitler became preoccupied with World War II.

Gorki (also Gorky), Maxim (1868–1936)—Prolific Russian writer who emerged from a working class background to become the most famous writer in the Soviet Union during the first half of the 20th century. Supporting the Bolsheviks during the Revolution, Gorky, it has been said, was never refused a request by Lenin.*

Grañén—A small town in northeastern Spain, about 35 miles northeast of Zaragoza.*

Great Retreats, The—In early March of 1938 the Nationalist troops launched a blitzkrieg against the Republican army in Aragón, with the goal of breaking through to the Mediterranean and splitting Catalonia* off from the rest of the Republic. The Republican army retreated back through where they had triumphed the previous fall, and the Lincoln Brigade would fight a rear-guard action, often being the last group of Republicans through such towns as Belchite,* Caspé,* and Gandesa.* The Lincolns would lose over 400 men before Franco's forces were stopped at the Ebro River.

Guadalajara—A town in central Spain located about 35 miles northeast of Madrid* on the road to Zaragoza.* It was here that, beginning on March 8, 1937 (and lasting for about ten days), about 35,000 Italian and 15,000 Spanish troops began a campaign to attack Madrid from the north. The Republican army, aided considerably by the International Brigades, among them the Italian Garibaldi Battalion, decisively defeated the Italians. The propaganda value to the Republic, in being able to demonstrate that organized Italian units were being used by the insurgents, was considerable.

Guernica—On April 26, 1937 over forty German aircraft of the Condor Legion* appeared over Guernica, a historically-important but militarily-insignificant Basque town of 7,000. Within a few hours most of the city center was in ruins and over a thousand civilians were dead. Its fame enhanced by Picasso's painting protesting the bombing, this raid has become one of the signal events of the war.

Hearst, William Randolph (1863–1951)—A wealthy right-wing journalist and publisher, Hearst owned a news empire that included over 30 large daily newspapers, as well as numerous magazines. A "yellow" journalist, he argued *for* the Spanish-American War but *against* America's entry into World War I. Influential in New York politics, he abhorred internationalism and, therefore, left politics.

Hemingway, Ernest (1899–1961)—The most famous American writer of his generation, Hemingway journeyed four times to Spain during the Civil War. At the beginning of the war ostensibly neutral, he quickly turned to support the Republic

against "fascism...a lie told by bullies." The Republic's best-known and most-visible supporter among American writers, Hemingway not only paid the passage of American volunteers going to Spain but also wrote numerous news stories and worked on two documentary films (most notably *The Spanish Earth* with Dutch filmmaker Joris Ivens) and helped secure donations for several ambulances. Hemingway would use his experiences in Spain in his 1940 novel *For Whom the Bell Tolls.* Hemingway's feelings for the Lincoln Brigade can be seen in his prose poem "On the American Dead in Spain."

Herndon, Angelo (b. 1913)—A black Young Communist League member who was arrested in Atlanta, Georgia in July 1932 for his organizing activities on behalf of the Scottsboro boys and the unemployed. He was charged with "incitement to insurrection" and sentenced to 18–20 years in prison. His case was taken up by the International Labor Defense,* and after a long, well-publicized legal battle, the Supreme Court eventually overturned the decision and Herndon was freed in 1937. His brother Milton, a party activist from Chicago, was a section leader of the Frederick Douglass Machine Gun Company. He died in battle on October 13, 1937.

Himno de Riego—A nineteenth-century anthem composed by José Melchor Gomis and written as a protest against the absolutism of Fernando VII. A hymn symbolizing liberty and independence, it became the national anthem of the Spanish Republic. Excerpts from the lyrics (freely translated):

> "Calm and happy
> Valiant and bold
> We soldiers sing this hymn
> On the way to combat.
>
> The world wonders
> At our accents
> And sees in us
> The sons of the Cid.
>
> Soldiers: our homeland
> Calls us to the fight;
> We swear allegiance to her
> To overcome, or to die."

Hughes, Langston (1902–1967)—Probably the most popular and versatile of those writers associated with the Harlem Renaissance of the 1920s, Hughes was drawn to progressive causes during the 1930s. Attracted by the Communist Party's commitment to racial equality, Hughes visited the Soviet Union in 1932 and went to Spain in 1937 to report for the *Baltimore Afro-American.* There he befriended many of the Lincolns. Hughes wrote several poems about his experience in Spain.

Hurwitz, Leo (1909–1991)—A Harvard-educated, New York documentary filmmaker. He was involved in the early activities of the Film and Photo League and co-

founded Pioneer Films in 1937. He worked with the leading documentary film-makers of his era: Paul Strand, Pare Lorentz, and Ralph Steiner, among others. Among his best work is *The Plow That Broke the Plains* (1935) and *Native Land* (1942).

ILD—The International Labor Defense was formed in 1925 as an organization to give legal aid to those involved in progressive labor and organizing work. It worked closely with the American Civil Liberties Union and was involved significantly in the Scottsboro trials of the 1930s.

Internationale, The—The anthem of the international working class, "The Internationale" was written by Eugene Pottier in Paris in 1871 to celebrate the Paris Commune, March-May 1871. This government of the people was set up at the end of the Franco-Prussian War in opposition to the humiliating peace agreements the French government at Versailles had arranged with the Prussians. At the end of May, the military triumphed and, in the aftermath, over 17,000 men, women, and children were executed. Here is one version of the first stanza and the chorus:

> Arise ye prisoners of starvation!
> Arise ye wretched of the earth,
> For Justice thunders condemnation;
> A better world's in birth...

> 'Tis the final conflict,
> Let each stand in his place,
> The International Party
> Shall be the human race.

It Can't Happen Here—A novel published in 1935 by Sinclair Lewis, this is a cautionary tale about the rise of a fascist dictator becoming President of the U.S.

IWO—International Workers Order—A communist-inspired fraternal organization formed in the U.S. in 1930, the I.W.O. stressed teaching the native languages and history of American immigrants.

Jefatura—police headquarters

Jim Crow—After Reconstruction, the Southern states began adopting laws promoting segregation of the races. These "Jim Crow" laws made for extreme discrepancies between the legal rights of blacks and whites.

Krupps—A German family of armaments manufacturers, the Krupps were at the center of the rise of the Nazi military power after 1933.

Landon, Alfred M.—The governor of Kansas (1933–37) who was the Republican nominee for President against Franklin D. Roosevelt in the 1936 election.

Largo Caballero, Francisco (1869–1946)—A leader of the PSOE,* Largo Caballero became the Republican Prime Minister as well as Minister of War beginning in

September 1936. Considered by some to be too accommodating to the CNT* and FAI* representatives in his cabinet, he was ousted through Comintern* influence and was replaced in May 1937 after the Barcelona disturbances by another Socialist, the Finance Minister Juan Negrín.* He died in Paris after spending the Second World War in Dachau.

League of Nations—Founded in the aftermath of World War I, in 1919, the League was the predecessor of the United Nations. Headquartered in Geneva, Switzerland, it was an international organization which aimed to arbitrate international disputes and maintain peace. Because of the British and French power within the League (and their emphasis on "non-intervention") the Spanish Republican government was unsuccessful in getting the League's support against the rebel uprising.

Lemke, William (1878–1959)—A congressman from North Dakota, Lemke was the Presidential candidate for the far-right Union Party in the 1936 elections.

Lenin, Vladimir Ilyich (1870–1924)—One of the most significant figures in the twentieth century, Lenin was a St. Petersburg law student who turned to Marxism and revolutionary practice. The dominant figure in the Bolshevik* party which triumphed in the Russian Revolution and the subsequent civil war of 1918-1920, he became the chairman of the new Communist Party and helped create the Union of Soviet Socialist Republics.

Liberty Leagues—A wealthy, conservative organization formed during the 1930s in the U.S. to combat Roosevelt's New Deal policies.

Lister Forjan, Enrique (1907–1994)—A Galician who was trained in Moscow, Lister became one of the most popular and successful communist commanders in the Republican army. He rose to the rank of General by the end of the war.

Litvinov, Maxim (1876–1952)—Foreign Minister of the Soviet Union from 1930-1939, Litvinov was virtually alone in supporting the Republican government in international discussions centered around the League of Nations during the Spanish Civil War.

Long, Huey P. (1893–1935)—As governor (1928–31) and then U. S. Senator (1931–35) from Louisiana, Long became one of the most flamboyant political figures of the 1930s. A demagogic populist, he promoted his "Share-the-Wealth" philosophy and was a potential threat to Roosevelt's presidency before he was assassinated in 1935.

Maccabean tradition—The Maccabees were a Jewish family in Palestine during the 2nd and 1st centuries B.C. who resisted Roman domination.

Madrid—Capital of Spain, Madrid is located at the geographic center of the country. The inhabitants of the city stormed the military barracks and in hand-to-hand combat saved the city for the Republic in July of 1936. The International Brigades were thrown into combat in Madrid and the government moved to Valencia.* Madrid was the focus of several failed Nationalist* attempts to capture the city. Madrid

finally fell to the Nationalists in the last days of the war. See the chapter on Madrid.

Majorca—Largest of the Balearic Islands east of southeast of Barcelona, Majorca was overtaken almost immediately by the nationalist forces. During the war it served as an important naval and air base, especially for the Italian forces.

Málaga—A significant port city on the southern coast of Spain, Málaga was taken by the nationalist army on February 8, 1937, after the Republicans abandoned the city without much of a fight. Some of the most brutal reprisals of the war took place immediately afterwards.

Malraux, André (1901–1976)—A celebrated French novelist who had written *La Condition Humaine* (1933), a novel about the Chinese communists's struggle against the invading Japanese, Malraux was an ardent supporter of the Spanish Republic. Early in the war he procured airplanes and organized the *Escaudrilla España,* a group of international volunteers and mercenaries who flew for the Republic. Malraux's novel, *L'Espoir* (1938), would be one of the most important literary works to emerge from the war.

Marty, André (1886–1956)—After the Russian revolution, where he led a mutiny of French sailors in the Black Sea, denying the Czar their support, Marty became a trusted member of the Comintern and a Communist representative in the French parliament. In Spain he was the International Brigades' chief commissar* and commander of the training base at Albacete.* He was notorious for his paranoia toward the anarchists* and the POUM,* and he reportedly had many shot whom he did not trust. Hemingway* especially hated Marty and portrays him negatively in for *For Whom the Bell Tolls.*

Mann, Thomas (1875–1955)—The 1929 Nobel Prize winner for literature, Mann was a committed anti-fascist who left his native Germany upon Hitler's rise to power. He resided in the U.S. from 1936 until his return to Germany in 1952.

Mataró—A town on the Mediterranean coast about 15 miles northeast of Barcelona.*

Matthews, Herbert (1906–1977)—American correspondent for the *New York Times* who covered the Republican side of the Spanish Civil War. Matthews would fight the *Times* editors over what he considered their Nationalist* bias.

Maxim—A British-made machine gun used extensively in the Republican army.

May Day—The first day of May. Originating in western Europe as a pagan fertility celebration, in 1889 the Second Socialist International declared it a holiday for radical labor. Until the fall of the Soviet Union it was a very important day in Russia and other socialist states.

Mellon, Andrew (1855–1937)—President of the Mellon National Bank in Pittsburgh and a major stockholder in many significant American industries, Mellon acquired one of the U.S.'s great fortunes. He served from 1921 to 1931 as the U.S. Secretary of the Treasury.

Merriman, Robert—A graduate student in economics from the University of California at Berkeley who had been studying agriculture in the Soviet Union, Merriman traveled to Spain in January 1937 to see how he could help the Republic. With previous military experience (two years in the Reserve Officers' Training Corps at the University of Nevada), Merriman would evolve into one of the most popular commanders of the Lincoln Brigade. He died near Gandesa* in the disastrous Great Retreats* of April 1938.

Messerschmitt—Flown by the Condor Legion* and by Spanish pilots, the German Bf 109 was the most advanced fighter in Spain. Faster, with greater range and firepower than the Republican airplanes, it first appeared in October 1936 and by the summer of 1937 had enabled the Nationalists* to dominate the air war. Different models of the fighter continued to be used by Germany through the end of World War II.

Miaja, General José (1878–1958)—A career military-man, Miaja was an ambiguous supporter of the Republic. He was, nonetheless, given the role of defending Madrid* from Franco's advancing forces when the government moved to Valencia* in November 1936.

Minor, Robert (1884–1952)—Noted American artist who became one of the leading members of the American Communist Party during the 1930s. Minor traveled to Spain and worked at Albacete* helping to organize the International Brigades.

Morata—A small village just south of the Madrid-Valencia highway in the Jarama valley region. About 6 miles south of Arganda, it served as a base of operations for the Lincolns during much of the Jarama fighting.

Mosca—One of the Russian single-wing fighters (Polikarpov I-16) used by the Spanish Republic. A newer and faster fighter than the "Chato."

Mosquito Hill—A crest near the town of Boadilla just west of Madrid that was the site of brutal fighting for the Lincolns during the Battle of Brunete in July 1937.

Murcia—A provincial capital in southeast Spain of the province of the same name, Murcia was the site of an International Brigades hospital.

Mussolini, Benito (1883–1945)—Italian dictator and founder of Italian fascism, Mussolini was a socialist in his youth. After fighting in World War I, he organized fellow veterans into a strongly-nationalistic Fascist party. Having imperialistic designs, he conquered Ethiopia* in 1936 and annexed Albania in 1939. Siding with Hitler, he sent thousands of Italian troops to support the Nationalists against the Republican government.

National Negro Congress—Founded in Chicago in 1936, it was an attempt to bring together representatives of all classes of Black Americans. Anti-fascist and pro-union, it elected A. Philip Randolph as its President.

Nationalists—The forces of the Right, opposed to the Second Republic,* who supported a military coup to overthrow the democratically elected government. Also

referred to as Insurgents, Fascists, Rebels, and the Burgos* Junta, among other terms. General Francisco Franco* became their head of state on October 1, 1936.

Negrín, Juan (1889–1956)—The Finance Minister of the Republic under Largo Caballero, Negrín became Prime Minister in May 1937. A physiologist, he was one of the leading academics in the University of Madrid before the war. As Prime Minister he believed the only chance for the Republic was with Soviet support and, as a result, Soviet influence on Spanish policy was increased for the remainder of the war.

New Masses, The—Established in 1926, it became the leading Marxist cultural journal of the 1930s. Edited by such left writers as Joseph Freeman, Mike Gold, and Granville Hicks, *The New Masses* published a wide range of articles ranging from poetry and literary criticism, to political and social commentary.

Non-Intervention Committee—In the fall of 1937, led by France and England, the European countries along with the Soviet Union, initiated a Non-Intervention Pact regarding the Spanish Civil War. A Committee, made up of representatives from every European country except Switzerland, was organized to supervise the workings of this pact. The committee came to be viewed by many as an exercise in hypocrisy, as France and Britain's appeasement of Germany and Italy allowed Hitler and Mussolini* to strongly support the rebels.

"No Pasaran"—"They shall not pass." The rallying cry raised by the people of Madrid* early in the war as Franco's armies threatened their city, this phrase came to represent the fighting spirit of the people of the Republic.

North, Joe—A veteran communist journalist, North was for several months the correspondent in Spain for the New York *Daily Worker*.*

Partisan Review—Founded in 1934 as the publication of the communist John Reed Club in New York City, *Partisan Review* has been one of the leading American literary journals since its beginning. In 1938, lead by editors Philip Rahv and William Phillips, the magazine broke with the Party and became an independent left journal. One of the founding editors and early contributors was Edwin Rolfe.

Pasionaria, La (1895–1989)—The best-known Spanish communist, the Party's spiritual leader during the war, Dolores Ibarruri was given the name "La Pasionaria" (the passion flower) because of her power as an orator. Raised a devout Catholic in the Basque provinces, she married an Asturian miner and began her ascent towards the top of the Spanish Communist Party. Closely connected with the Soviet Union, she went into exile in Moscow at the end of the war. She returned to Spain after Franco's death to take back her seat in the Spanish Parliament.

PCE (*Partido Communista de España*)—founded in 1921, it was the Comintern's* Spanish affiliate (the PSUC* was from Catalonia). The party was small before the Civil War (estimated membership of 40,000) but grew into prominence because of its key role in the defense of Madrid,* its comintern connections, and the PCE's anti-revolutionary policies. These policies attracted broad support from a wide

range of classes so that membership had grown by 1937 to an estimated quarter of a million. The PCE stance of winning the war first and its support for the bourgeois revolution embodied in the Second Republic* attracted a huge following among both peasants and members of the middle classes, as well as industrial workers. The majority of the party's leaders went into exile in the USSR at the end of the war.

People's Front/Popular Front/United Front—Alternate terms for the communist-inspired policy in the 1930s designed to bring left and center political parties together to combat the rise of right-wing movements. It involved abandoning the Communist Party's earlier revolutionary stance. Officially adopted at the 7th International Congress of the Comintern* (Communist International) in July 1935. Popular Fronts soon formed in Europe and Latin America, winning political power in France, Spain, and Chile. In Spain the Popular Front won 34.3 percent of the vote versus 33.2 for the National Front (Right) in the national elections held in February 1936. The term also came to be widely applied outside of electoral alliances to coalitions in every field between Communists and others.

Perpignan—A city in southern France near the Mediterranean just north of the Spanish border. It was a city in which many Lincolns would spend a few days getting organized before they crossed over the Pyrenees into Spain.

Port Bou—A town in northeastern Catalonia* on the Mediterranean that borders with Cerbère, France. It was one of the major entry points for any materials that entered Spain from France during the war, and the exit point for many refugees fleeing Franco's armies in January 1939.

POUM (*Partido Obrero de Unificación Marxista*)—Revolutionary Communist Party. The smallest of the four major left organizations (the others being the CNT*-FAI,* PCE*/PSUC,* and the PSOE*/UGT*), the POUM was anti-Stalinist and was closely linked with the CNT and FAI in wanting a prompt anti-capitalist revolution. Their insistence on the immediate establishment of the revolution was at odds with the PCE's insistence on winning the war first. In addition, the leader of the POUM, Andrés Nin, had been a secretary of Leon Trotsky's,* so the PSUC and PCE accused the POUM of Trotskyism. After the POUM's participation in the anti-government disturbances in Barcelona,* its days were numbered. In June 1937 the Republic outlawed the POUM and arrested many of its leaders.

Prieto y Tuero, Indalecio (1883–1962)—One of the leaders of the Socialist Party in Spain, Prieto became Minister of Navy and Air in September 1936 and then Minister of Defense in May 1937 in the new Negrín* government. He was replaced in April 1938, with Negrín taking over defense.

PSOE (*Partido Socialista Obrero Español*)—The Spanish Socialist Party, founded in 1879. It was affiliated to the Socialist and Labor International and had close ties with the bourgeois Republican left.

PSUC (*Partido Socialista de Unificación de Cataluña*)—The United Catalan Socialist

Party was dominated by the Communist Party. It favored total support of the government in the war effort and was often in violent opposition to the CNT* and the POUM.* Juan Comorera, the leader of the PSUC, returned to Spain after the Second World War and participated in the underground until he was betrayed. He was executed by Franco* in 1960.

quartermaster—An army officer in charge of providing food and clothing for a body of troops.

Quinto—A small town about 25 miles east of Zaragoza,* Quinto was the first town taken by the Lincolns during the Aragón offensive of August 1937. It was a brutal battle in which much of the fighting was literally door-to-door. The Lincolns took about 1,000 prisoners and the Lincoln's losses were relatively small.

refugios—Air-raid shelters.

Renn, Ludwig (1889–1979)—A communist novelist from an aristocratic background, Renn (born Arnold Friedrich Vieth von Golssenau) served as a captain in the German Army in the First World War. In Spain he served first as the commander of the Thaelmann Battalion* and then later as chief of staff of the 11th International Brigade.

Requetés—Basque Catholic and monarchist paramilitary units of the Carlist* political organization. They joined Franco's nationalist army after the rising.

Reus—A town about 7 miles west of Tarragona in Catalonia.

Romanillos—One of the tiny villages just west of Madrid* that became the battleground of Brunete* during July 1937. The heights of Romanillos lie just north of Mosquito Crest,* the site of a series of assaults that cost the Lincolns many men.

Salud—Literally "health," it is the popular greeting used by members of Spain's working classes and the left and between supporters of the Spanish Republic.

San Sebastián—The summer capital of Spain and a fashionable resort city on the Bay of Biscay about 12 miles from the French border with Spain, San Sebastián was surrendered by the Basques without a fight on September 13, 1937.

Saragosa (see Zaragoza below)

Second Republic—came into existence in 1931 after municipal elections throughout Spain returned victories for Socialist and Republican candidates, demonstrating that the monarchy had lost popular support. The Republic was known as *La niña bonita*, "The Beautiful Maiden," because of its widespread support, but it was weakened by political, economic, and social strife. The Republican coalition around Azaña* lost the elections to a right-center coalition in 1933. But when the Republican forces won the Popular Front* elections of February 1936 the forces of the right organized a military coup that precipitated the Spanish Civil War in July 1936.

Sheean, Vincent "Jimmy" (1899–1975)—American writer who reported in Spain for the

New York *Herald Tribune*. Sympathetic to the Republic and to the Lincoln battalion, Sheean wrote about his time in Spain in *Not Peace But A Sword* (1939).

S.R.I.—*Socorro Rojo Internacional* (International Red Aid)—Organized by the Comintern in 1921 to promote the economic liberation of the working classes, it had been assisting the Left in Spain since 1934. During the Spanish Civil War it became involved in charitable fund-raising for a number of social welfare functions. With its assistance to front-line hospitals it became the equivalent of the Spanish Red Cross. The S.R.I. numbers on letters in this book are essentially secret location codes that enable mail sent to Spain to be delivered to the appropriate site or division.

Strand, Paul (1890–1976)—One of the great American photographers, Strand studied photography with Lewis Hine at the Ethical Culture School in New York City. During the 1920s and 1930s he spent as much time making films as shooting photographs and as President of Frontier Films was involved in editing *The Heart of Spain* (1937) and shooting *Native Land* (1942).

Tarancón—A town about 45 miles southeast of Madrid,* on the road to Valencia,* it was the site of three American hospitals and a garage.

Tarazona de la Mancha—A small town in southeast Spain about 25 miles north of Albacete,* Tarazona became a training base for the Lincoln battalion as well as the Canadians and the British.

Teruel—Just before Christmas 1937 the Republican army took the city of Teruel, in a battle that Edwin Rolfe describes as "Spain's Valley Forge." Located about 90 miles northwest of Valencia* in east-central Spain, Teruel's fall heartened the Republic. By the end of February 1938, however, with vastly superior firepower, the Nationalist* forces had retaken Teruel.

Thaelmann Battalion—One of the first international battalions and placed originally in the 12th Brigade, the Thaelmanns were primarily political refugees from Nazi Germany. They fought heroically throughout the war, and were vital in the defense of Madrid* during the winter of 1936–37. They would be later transferred to the 11th Brigade, which was reborn as the Thaelmann Brigade. Named for Ernst Thaelmann, a German communist leader imprisoned by Hitler.

Tortosa—A town near the mouth of the Ebro* river, where it flows into the Mediterranean. Located about 120 miles south of Barcelona,* it fell to the Italian forces in April 1938, cutting Catalonia* off from the rest of Republican Spain.

Trotsky, Leon (1879–1940)—One of the prime movers of the Russian Revolution, Trotsky helped command the Red army in its victory in the civil war of 1918-1920. After Lenin's* death, Trotsky lost in his battle against Stalin for control of the Bolshevik party and was thrown out of the party in 1927 and exiled from Russia in 1929. Settling in Mexico in 1937 he founded the Fourth International, a small but committed group of intellectuals dedicated to pure communism. The POUM* in Spain was inspired by Trotsky and suffered reprisals because of their anti-

Stalinism. Trotsky was murdered in 1940 by Ramón Mercarder, a Spanish communist.

UGT (*Unión General de Trabajodores*)—A socialist-led trade union, and one of the most powerful in Spain, numbering around a million members. Its leader at the beginning of the war was Largo Caballero,* quickly to become the Republic's Prime Minister.

Valarca—An International Brigade hospital on the northern outskirts of Barcelona.*

Valdemorillo—One of the small villages about 5 miles north of Villanueva de la Cañada, a site of some of the most intense fighting of the Brunete* campaign in July 1937.

Valencia—One of Spain's largest cities, located on the Mediterranean east from Madrid.* Near a major agricultural region, and noted for its port, Valencia became the refuge of the Republican government after November 6, 1936 when Madrid seemed ready to fall to Franco's advancing army.

Velasquez—The street in Madrid where the International Brigades Headquarters was located.

Velázquez (1599–1660)—One of the most important Spanish painters, he was court painter to Philip IV, and known particularly for his portraits of the royal family and members of the court.

Vich (also: Vic)—A cathedral town about 65 miles north of Barcelona.*

Villanueva de la Cañada and Villanueva del Pardillo—Small villages about 20 miles west of Madrid. For the Lincolns these were the sites of brutal fighting during the Battle of Brunete* in July 1937.

Volunteer For Liberty (also refered to as *The Volunteer*)—The English-language newspaper for the English-speaking volunteers in the International Brigades, *The Volunteer* was first published in Madrid,* but moved to Barcelona* in early 1938. Among its editors were Ralph Bates,* Edwin Rolfe, and Johnny Tisa.

wall newspaper (*periodico mural*)—Unique and individually designed collages of art posters, poetry, announcements, and miscellaneous information, wall newspapers were a cross between a bulletin board and a kiosk that were used by the Republican army to promote the cause of the Republic and by its soldiers to communicate publicly with one another.

WPA—The Work Projects Administration was established in 1935 by President Franklin D. Roosevelt (as Works Progress Administration; redesignated 1939) as a method of providing work for large numbers of unemployed workers during the Depression. Quite successful, it also included the Federal Art Project, the Federal Writers Project, and the National Youth Administration. It continued until 1943.

Wolff, Milton (b. 1915)—The ninth and last commander of the Lincoln battalion, Wolff had been an art student from Brooklyn. A member of the Young Communist League, he rose from a machine gun company to lead the Lincolns in the Ebro

offensive of the summer of 1938. His autobiographical novel of the Spanish Civil War, *Another Hill*, was published in 1994.

Woolf, David—The pen name adopted by progressive American writer Ben Maddow (1909–1922).

Y.C.L.—An outgrowth of the Young People's Socialist League, which folded soon after the Red Scare of 1918–1919, the Young Communist League was started in 1922 as an "underground" youth organization supported by the newly-formed Communist Party. Growing steadily during the 1930s, the Y.C.L. numbered almost 11,000 members at the beginning of the Spanish Civil War and was a significant force in organizing the Americans who would go to Spain.

Zaragoza (also: Saragosa)—An old and important city in northeastern Spain, in the Aragón* region, about 200 miles west of Barcelona.* A Nationalist* stronghold, Zaragoza was an elusive goal the entire war for the Republican armies. First besieged early in the war by Buenaventura Durruti's anarchist column, then later as the target of the Aragón offensive of August 1937 and the Ebro offensive of July 1938.